Quaker Aesthetics

Quaker Aesthetics

Reflections on a Quaker Ethic in
American Design and Consumption

Edited by Emma Jones Lapsansky
and Anne A. Verplanck

PENN

University of Pennsylvania Press
Philadelphia

The book is made possible in part by grants from Furthermore, a program of the J. M. Kaplan Fund, and the Chipstone Foundation.

10 9 8 7 6 5 4 3 2 1

Published by
University of Pennsylvania Press
Philadelphia, Pennsylvania 19104-4011

Library of Congress Cataloging-in-Publication Data
Quaker aesthetics : reflections on a Quaker ethic in American design and consumption / edited by
Emma Jones Lapsansky and Anne A. Verplanck.
 p. cm.
 Includes bibliographical references and index.
 ISBN 0-8122-3692-0 (cloth : alk. paper)
 1. Aesthetics—Religious aspects—Society of Friends—History. 2. Society of Friends—History.
3. Aesthetics, American—History. I. Verplanck, Anne A. II. Title.

BX7748.A77 L36 2002
289.6'749—dc21 2002028951

To all our families,
who gave us time and encouragement

Contents

List of Illustrations ix

Preface xiii

1 Past Plainness to Present Simplicity:
A Search for Quaker Identity 1
EMMA JONES LAPSANSKY

2 From Plainness to Simplicity:
Changing Quaker Ideals for Material Culture 16
J. WILLIAM FROST

Part I Quakers as Consumers

Introduction 43
PATRICIA C. O'DONNELL

3 Quakers and High Chests:
The Plainness Problem Reconsidered 50
SUSAN GARFINKEL

4 "All That Makes a Man's Mind More Active":
Jane and Reuben Haines at Wyck, 1812–1831 90
JOHN M. GROFF

5 Living in the Light:
Quakerism and Colonial Portraiture 122
DIANNE C. JOHNSON

Part II Quakers as Producers

Introduction 149
BERNARD L. HERMAN

6 Quaker Beliefs and Practices and the
Eighteenth-Century Development of the
Friends Meeting House in the Delaware Valley 156
CATHERINE C. LAVOIE

7 Eighteenth-Century Quaker Houses
in the Delaware Valley and the Aesthetics of Practice 188
BERNARD L. HERMAN

8 Edward Hicks: Quaker Artist and Minister 212
CAROLYN J. WEEKLEY

Part III **Quakers and Modernity**

Introduction 237
ANNE A. VERPLANCK

9 The Aesthetics of Absence: Quaker Women's
Plain Dress in the Delaware Valley, 1790–1900 246
MARY ANNE CATON

10 Sara Tyson Hallowell: Forsaking Plain for Fancy 272
CAROLYN KINDER CARR

11 What's Real? Quaker Material Culture
and Eighteenth-Century Historic Site Interpretation 287
KARIE DIETHORN

Notes 301

Glossary 371

List of Contributors 381

Index 383

Illustrations

Figures

1.1. Silhouettes, James and Rebecca Chattin 12
2.1. Traveling ministers, Indiana Yearly Meeting 31
3.1. High chest owned by Hannah and Levi Hollingsworth 54
3.2. Chest-on-chest owned by Charles Logan 55
3.3a. Chest-on-chest owned by David Deshler 56
3.3b. Detail, Deshler chest-on-chest 57
3.4a. High chest owned by Hannah and Samuel Moore 76
3.4b. Detail, Moore chest 77
3.5. High chest by Savery owned by Joseph Wharton 79
3.6. High chest owned by Wharton 80
4.1. Wyck dining room table 95
4.2. Wyck sugar bowls, etc. 98
4.3. Rembrandt Peale, *Reuben Haines III* 103
4.4. Wyck front parlor 106
4.5. Wyck pamphlet, etc. 112
5.1. Charles Willson Peale, *Hannah Lambert Cadwalader* 125
5.2. Benjamin West, *Thomas Mifflin* 133
5.3. Charles Willson Peale, *Dr. Thomas Cadwalader* 140
II Intro. 1. Free Quakers Meeting House 151
II Intro. 2. Lower Alloways Creek Friends Meeting 152
II Intro. 3. Quilt by Eliza Naudain Corbit 155
6.1. Plan, Merion Meeting House 160
6.2. Chichester Friends Meeting House 162
6.3. Sadsbury Friends Meeting House 163
6.4. Plan, Radnor Friends Meeting House 164
6.5. Bradford Meeting House 166

6.6. Upper Providence Friends Meeting House 168
6.7. Arney's Mount Meeting House 170
6.8. Roaring Creek Meeting House 172
7.1. Abel and Mary Nicholson house 190
7.2. Nicholson house 191
7.3. Plan, Nicholson house 192
7.4. Hall, Nicholson house 193
7.5. Ground floor closet, Nicholson house 195
7.6. Wright house 196
7.7. Ashton house 196
7.8. Miller house 197
7.9. Initialed bricks, Nicholson house 198
7.10. Hancock house 200
7.11. Cox house 202
7.12. William and Mary Pennell house 203
7.13. Plan, Pennell House 204
7.14. Isaac and Margaret Sharp house 208
7.15. Todd house 209
8.1. Thomas Hicks, *Edward Hicks* 213
8.2. Edward Hicks, *The Falls of Niagara* 218
8.3. Edward Hicks, *Penn's Treaty* 224
8.4. Edward Hicks, *Peaceable Kingdom* (1822–25) 225
8.5. Edward Hicks, *Peaceable Kingdom* (1826–28) 226
8.6. Edward Hicks, *Peaceable Kingdom* (1844) 227
8.7. Edward Hicks, *James Cornell's Prize Bull* 228
8.8. Edward Hicks, *Washington Crossing the Delaware* 232
III Intro. 1. Dedication of Friends Historical Library 244
9.1. Fall front plain dress, detail 251
9.2. Doll in plain dress 252
9.3. Quaker plain dress 254
9.4. Susannah Forsythe Sharpless and family 259
9.5. Ruth Abbott 260
9.6. West Chester (Hicksite) Meeting 261
9.7. Quaker plain dresses 263
9.8. Sarah Havard Miller miniature 264
9.9. Jane Pyle Brinton silhouette 265
10.1. Anders Zorn, *Sara Tyson Hallowell* 273
10.2. Anders Zorn, *Mary Morris Tyson Hallowell* 276
10.3. Robert Street, *Elisha Tyson* 278
10.4. Thomas Sully, *Thomas Morris Perot* 279

11.1. Gold lodging room, Stenton 292
11.2. Dining parlor, Cedar Grove 293
11.3. Law office, Todd House 294

Plates (after p. 146)

1. *Old Broadbrim Weekly*
2. Sheet music, "All the Quakers Are Shoulder Shakers"
3. High chest of drawers owned by Samuel Wallis
4. Chest-on-chest owned by Sarah Logan Fisher
5. Wyck, southern façade
6. Wyck rose garden
7. James Claypoole, *Ann Galloway Pemberton*
8. James Claypoole, *Joseph Pemberton*
9. Charles Willson Peale, *Mrs. John Dickinson and Daughter Sally*
10. Wilson/Kneller, *Mary Lloyd Norris*
11. Charles Willson Peale, *John Dickinson*
12. Charles Willson Peale, *John and Elizabeth Lloyd Cadwalader and their daughter Anne*
13. John Singleton Copley, *Thomas Mifflin and his Wife Sarah*
14. Bradford Meeting House
15. Buckingham Meeting House
16. Edward Hicks, *Residence of David Twining*
17. Edward Hicks, *Henry Vanhorn Signboard*
18. Edward Hicks, *Peaceable Kingdom* (1832–34)
19. Edward Hicks, *Leedom Farm*
20. Unidentified artist, *Caleb Hallowell*
21. Mary Fairchild MacMonnies, *Sara Tyson Hallowell*

Preface

The chapters in this volume analyze American Quaker material culture in the eighteenth, nineteenth, and early twentieth centuries, focusing on Philadelphia and the Delaware Valley. They illuminate some of the ways Friends have chosen to relate to capitalism, modernizing culture, and religion. The defining tension for Friends is how to live "in the world, not of it," and their relationship to both the creation and consumption of material goods is a dramatic manifestation of that tension.

The essayists took up the challenge not only to do interdisciplinary work on topics of their own choosing but also to undertake the project as a group, by meeting to ensure a unified voice. The fruitful discussions and ongoing correspondence among participants helped ensure that their essays meshed even when their interpretations diverged.

The scholarship in this volume relies on visual evidence, and thus we were particularly fortunate that two foundations generously supported our work. Furthermore, a program of the J. M. Kaplan Fund, and the Chipstone Foundation helped make possible generous illustrations and an index. We are deeply grateful to both foundations.

No scholarship exists in a vacuum; numerous scholars laid the groundwork for this volume. Frederick B. Tolles's early work on Quaker aesthetics deserves special mention. The scholarship of Philip Benjamin, Thomas Hamm, H. Larry Ingle, Barry Levy, and Arthur Raistrick also underpins this volume. The notes in this volume suggest how the work of many other researchers of Quaker history has provided a foundation for this volume.

If we were to include all the scholars whose work has shaped the discourse on Quaker material culture, we would have needed to include at least twice as many essays. Michael Chiarappa, Clarissa Dillon, Anne Gaeta, Patricia Keller, Deborah Kraak, Susanna Morikawa, Marcia Pointon, Leanna Lee-Whitman, William Woys Weaver, Nancy Webster, Jane Williamson, Elizabeth

Yarnall, and Don Yoder, among others, have enriched our understanding of this field.[1] Yoder, in particular, provided crucial guidance during the project, and for this and his ongoing work on country Quakers we are deeply appreciative. We are also grateful to Robert B. St. George, who provided a thoughtful critique of the final manuscript.

The staff of the Friends Historical Library at Swarthmore College and the Quaker Collection at Haverford College helped guide our essayists to crucial primary sources. We would particularly like to thank Patricia O'Donnell and Susanna Morikawa at Swarthmore, and Elizabeth Potts Brown and Diana Franzusoff Peterson at Haverford. They, their colleagues, and their predecessors have all helped shape this project. At the Chester County Historical Society, Ellen Endslow and her predecessor, Margaret Bleeker Blades, as well as Pamela C. Powell have been extraordinarily helpful. We also wish to thank the many institutions and individuals who allowed us to publish photographs of their collections.

At the University of Pennsylvania Press, Robert Lockhart provided skillful guidance and support for the project; we also thank Alison Anderson for her careful editing and Samantha Foster for her considerable organizational skills. Laurie Prendergast deserves thanks for the fine index he prepared. The whole was greater than the sum of its parts, and we are most grateful to all the participants.

Chapter 1

Past Plainness to Present Simplicity: A Search for Quaker Identity

Emma Jones Lapsansky

"What's Real?" asks the final chapter in this volume, a question that reduces the purpose of this anthology to its essence. What constitutes the exemplary Quaker life, what paraphernalia does it take to achieve it, and how does one indicate to one's peers that one has done so? How does the answer to this question change over time? How can modern interpreters of Quaker history help their audiences grasp the "real" Quaker notions of beauty and value? Historian David Thelen reminds us that "the challenge of history is to recover the past and to introduce it to the present."[1] A half-century ago, exploring the sinews in *Meeting House and Counting House*,[2] Frederick Tolles challenged us to try to recover what early American Quakers meant when they used the term "plain." More than a dozen scholars engage Tolles's challenge in the essays that follow here, which stretch across multiple disciplines to reexamine the connections between "Quaker" and "aesthetic." The tools of social history, art history, and the developing field of "public history," as well as anthropology, rhetoric, and even mathematical theory, are turned to this question.

In 1686, when British Quaker Joan Vokins (d. 1690) tried to help her children set guidelines for the practice of their faith, she wrote: "Be careful and take heed that you do not stain the testimony of Truth that you have received, by wearing needless things and following the world's fashions in your clothing and attire, but remember how I have bred you up." This admonition, powerful in its own day, acquires an added layer of meaning when we note that it was reprinted as a guideline in the 1995 edition of Britain Yearly Meeting's *Faith and Practice*.[3] Quaker theologian Robert Barclay (1648–1690), a contemporary of Vokins, joined the anti-vanity chorus, chiding "those who so adorn themselves in the use of their clothes as to beset

them with things having no real use or necessity, but merely for ornament sake, to gratify a vain, proud, and ostentatious mind."[4] So did British Quaker Ambrose Rigge (1634–1704), who left instructions to his family when he died in 1704: "be careful that you follow not the vanities of the age in pride and ostentation; keep plain in your habits and houses."[5]

Margaret Fell (1614–1702), wife of seventeenth-century Quaker visionary George Fox (1624–1691), expressed the opposite concern: "It's a dangerous thing to lead Friends much into the observance of outward things which may be easily done. For they can soon get into an outward garb, but this will not make them into true Christians."[6] Such warnings have been frequently reissued, bound together with works of later writers like eighteenth-century American abolitionist Anthony Benezet (1713–1784), who disdained the "folly and corruption" of those who listened to the "calls to follow fashion."[7] Clearly the concern with outward behavior and outward garb could sometimes be a distraction from—or even a *substitute* for—piety. Though the essays in this volume focus on a small region of America, this issue had become a source of tension for the first generations of Quakers on both sides of the Atlantic. "Epistles"—official letters exchanged between British and American Friends—ensured that the two groups stayed in close communication as they tried to codify and standardize correct Quaker faith and practice during the eighteenth and nineteenth centuries, and the guidance of founding Friends was quoted and requoted for both information and inspiration. Yet the tension remains today.

The seventeenth-century-born Religious Society of Friends in the Truth soon became known for—even prided itself on—its "peculiar" demeanor, dress, and lifestyle. Quaker houses of worship, devoid of stained glass, statuary, pulpit, vestments, or ordained minister, were the first things that called attention to their eccentricity. But it would not be long before observers remarked on other peculiarities. Eighteenth-century British abolitionist Thomas Clarkson (1760–1846), who spent a good deal of time among Quakers but was not one himself, wrote extensively about what he saw. "They adopt a singular mode of language," Clarkson reported. "They have renounced religious ceremonies, [and] they are distinguished by their dress [and] music, novels and the theatre, and all games of chance have been forbidden."[8]

The strength of Quakerism, which lies in its commitment to setting and monitoring high moral standards in its communities, depends on establishing ground rules that will attract and reinforce the idealist, the person who already possesses an inner "condition"—as George Fox called it—of being hungry for a morality that transcends shallowness, banality, and violence, in

pursuit of what one modern observer calls "a certain kind of perfection." Like their Puritan contemporaries and their nineteenth-century Holiness successors, early Quaker visionaries imagined that a child might be trained to walk a life path close to that walked by Christ.[9] Unlike that of many branches of Protestantism, however, Quaker theology has emphasized the loving and forgiving nature of God, contending that children were born not in sin but in innocence, and to the degree that the child could be protected from temptation, that state of innocence could be maintained throughout life.

The visible eccentricities of Quakerism were emblematic of the theological basis of Friends' faith. Set in the bedrock of a Christian tradition that is at once simple and complex, Quakerism is steeped in a number of contradictory values: equality and separateness; intellectual preciousness and anti-intellectualism; an emphasis on excellence and a focus on humility; and an appreciation for high-quality workmanship coupled with a ban on ostentation. In this volume we will explore some of the ways these contradictions were exhibited in Delaware Valley Friends' ideas of what was visually pleasing and appropriate, and how those ideas were shaped by social pressures and by changing forces inside Friends communities. Like all human beings, Friends lived their lives in multiple communities—shaped by family, geography, profession, or other parameters—each with overlapping or competing expectations. Quaker communities needed to set boundaries that would delineate their own "insiders" from the "outsiders," whom they often referred to as "world's people."

The challenge, then, has been to create guidelines that would satisfy the idealists' need for integrity and self-discipline without creating rules so stringent and joyless that these very same idealists are repelled. And while it was important to maintain standards, it was counterproductive to discipline members by expelling them and equally troublesome to have them choose to leave. Over time as Quaker zeal—and membership—dissipated, some strictures loosened, and it is tempting to present the changes as a linear progression from the seventeenth century to the present. In fact, however, the dialogue between past and present has remained dynamic with many memories of the past intruding into the conversations of the present.

Pennsylvania's Haverford College, the first Quaker institution of higher education, offers one example. The school was established in 1833 as a resident institution to provide a "guarded education" for Quaker youth—one that would shelter them from the temptations of the modern world. Its early curriculum banned fiction. But within two generations such curricular narrowness had caused even some devout Friends to be uneasy. The policy

stated by Allen Clapp Thomas (1846–1920), who became the librarian of the college in 1878, was that the college library "rejects current fiction." However, the faculty looked the other way while students established their own private clubs for reading and discussing literature. Though Thomas did not retire until the early twentieth century, the official ban had slowly began to relax by the 1890s.[10] Twentieth-century Quaker luminary Rufus Jones (1863–1948) "look[ed] back with mild pity on the generations of Haverford students who were deprived of the joy of music and art. The strong anti-aesthetic bias in the minds of the Quaker Founders and the early Managers [of Quaker Haverford College] was, I think, an unmitigated misfortune."[11] Although Jones drew some of his own religious inspiration from the past, he disdained this ban on artistic expression as a "relic of Puritan days," and he marveled that Friends, so liberal in their political ideas, could have clung to anachronistic aesthetic mores. A fine arts program was finally introduced at Haverford College in 1971. Meanwhile, the acceptance of art spread throughout Friends communities. As early as 1932, Philadelphia Yearly Meeting's *Faith and Practice* reminded Friends that "we need to guard against under-valuing the material expressions of spiritual things. It is easy to make a form of our very rejection of forms." And the same 1995 British *Faith and Practice* that quoted Joan Vokins's warning about "wearing needless things" also celebrated the "inspiration to be found in the arts."[12]

The early Quaker thinkers had indeed left a lofty legacy, an ambiguous message, and a daunting challenge to their heirs. As George Fox, Robert Barclay, William Penn (1644–1712), and later Quaker thinkers developed their notions of the perfectibility of humans, they became convinced that "Christ has come to teach his people himself,"[13] and that therefore, by dampening the noise of daily life, one might hear Christ speaking, leading one *inward* toward the Light of Truth. Hence Friends advocated worshipping in silence and following a closely monitored life path that was unlikely to conform to that of one's peers, unless the peers were also seeking the Light. Such a path, on the contrary, was likely to make one appear eccentric and "peculiar" outside the Friends community. (In support of that peculiarity, Quaker communities developed such a specialized vocabulary that we have included a glossary in this volume.) However, the degree to which one should *seek* and use that peculiarity as a way of distinguishing oneself, or as a marker of one's devotion to God, has remained a source of tension and ambiguity in Quaker doctrine. As we shall see in the following discussions, that tension would resurface whenever Friends faced challenges from inside or outside their communities.

The challenges came early and often. As early as the 1650s, Fox withdrew

his support from his comrade James Nayler (1617–1660), whose followers strew palm leaves in his path: such behavior—no matter how conscience-driven—smacked too much of a mockery of Christ for Friends to tolerate. Shortly after Fox's death, respected Quaker teacher George Keith (1639–1716) led a factional fight that began in Philadelphia, continued when Keith returned to England, and ended with Keith's abandoning Friends for the Anglican church and returning to America to try to convert his old Quaker comrades. In succeeding generations, New Jersey abolitionist John Woolman (1720–1772) would stir up controversy by taking up Keith's concern about Quakers' relationship to "the keeping of Negroes." English preacher Joseph John Gurney (1788–1847) and American farmer Elias Hicks (1780–1849) would also embroil Quakers in debate about how to worship and what to believe. Rippling underneath these debates were questions of what careers were appropriate for devout Friends and what were "Quakerly" things to do with one's spare time. These issues reverberate through the essays that follow.

Early Friends strove for a life of palpable integrity, and for over three centuries Quakers have acquired an array of shorthand phrases intended to call to mind certain ideals that have informed Friends' theology. But in modern popular parlance the theological context often has been stripped away. "Let your life speak" reflects founding Friends' idea that preaching the gospel was not nearly as effective as committing oneself to having no division between one's secular and sacred behaviors. But unlike many religious groups, Friends provided no seminaries or monasteries through which to shape lives that would speak; this was left to individual families and meetings.[14] Thus, in today's world, "let your life speak" is often taken to mean only that one should strive to make one's life meaningful. "Speaking truth to Power" at first denoted Friends' concern that they not be intimidated by wealth, status, or other outward trappings; yet Friends made no proscription about acquiring or holding wealth, and they did not focus on the biblical worry that a rich man might have difficulty getting into heaven. On the contrary, Quaker dictates have always encouraged honest labor and mindful attention to one's vocation, only cautioning equal mindfulness about not allowing the pursuit of wealth to distract one from religious growth or from careful "stewardship" (that is, nonwasteful use) of resources gained from honest labor. Even while suspicious of it, Friends have always wielded great social and economic power. Today, however, "speaking truth to power," having lost that larger meaning, is mostly used to describe the act of standing up to political misconduct.

Likewise, the idea that Quakers should aim to be "in the world, but not of it" was a reminder that Friends should not isolate themselves but partake

of the world's natural and invented resources, while remembering both to put them to "good" uses and not to become a slave to such resources or feel diminished without them. But it is difficult to be a banker or an industrialist, as were the Barclays, Cadburys, and Whartons, while remaining untouched by the "world's people." British Quakers, after all, were in the vanguard of the "one-price" system that sealed the success of capitalism by replacing the arbitrariness of barter.[15] In modern times, though, "in the world but not of it" can mean anything from being a stranger in a community to being a child who is daydreaming in school.

In today's world, these Quaker catch phrases—"let your life speak," "speaking truth to power," "in the world but not of it"—are used by Friends and non-Friends alike to help distinguish Quakerly behaviors from those of the "world's people." Yet, disembodied from their theological context, it is hard to know what they imply about Friends' internal disciplines. So it is, too, with the phrase "that of God in every man," a statement correctly attributed to George Fox. But in modern times it is often quoted without a context. Fox did indeed talk about "that of God," but he did not have naive notions that godliness would be easily and immediately apparent in everyone. Each of us, contended Fox as a result of his conversion in 1647, has the *capacity* to be inhabited by the living Christ, but each of us also has an "ocean of darkness" within.[16] As Fox developed his ideas, it became clear that he believed that unless the Inward Light were nurtured, it could be overwhelmed or extinguished by the darkness. When Fox admonished his followers to "walk cheerfully over the earth, answering to that of God"[17] in those they encountered, he implied that this quality might not be developed or discernible in everyone. Self-discipline, self-examination, and community support, presumed Fox, were necessary for locating and developing "that of God." In modern memory, this aspect of Fox's vision is often obscured.

Friends' self-imposed disciplines have proved hard to enforce—perhaps mostly because they are hard to define. Nonetheless, over three centuries members of the Society of Friends, as well as their admirers and detractors, have agreed that there is—or should be—something visible, tangible, and uniquely discernible that makes "Quaker-*liness*" (a way of looking, behaving, *being*) even more definable than the set of religious beliefs and principles that defines "Quaker-*ism*." Somehow, observers agree, a constellation of belief, lifestyle, vocation, community design, consumption patterns, and worship style should coalesce into a package designed to facilitate attention to the "still, small voice" of the Divine as it speaks in each individual. But disaggregating and codifying the discrete components of "Quakerliness" has confounded observers since the architects of Quakerism began defining

themselves in the 1650s. Friends principles have something to do with stripping away conspicuous consumption, but they stop far short of asceticism or hermitism. Friends are called to be alert to social injustice and to the pursuit of social equality, but they often concoct solutions that are religiously radical while remaining socially, politically, and economically conservative. "True Godliness," advised Quaker founder William Penn, "don't (sic) draw men out of the world, but enables them to live better in it more and excites their endeavours to mend it."[18] But in "mending" the world Penn himself neither eschewed slavery nor attempted to dismantle other economic or ethnic hierarchies in his society. It is no small task to make a coherent present-day story out of Quakerism's sometimes ambiguous principles and inconsistent past.

In 1996 Edward Linenthal published *History Wars: The Enola Gay and Other Battles for the American Past.*[19] Continuing his argument from an earlier publication,[20] Linenthal reinforced Thelen's point that history and memory are less about "facts" than about a dialogue between history's "professionals" and a public that has certain expectations. His message was clear: public history "consumers" resist interpretations that quarrel with their preconceptions. The essays included here explore some of what is in the American public's memory about "Quakerliness." Those memories are part of a complex portrait painted partially by Friends to tell each other who they are and partly by observers outside the Quaker communities who have used what they could see of "Quakerly" behaviors to mold symbols of a social phenomenon.

Twentieth-century Friends and stereotypes of modern Quakers further complicate the public's understanding of "Quakerliness." Today Friends are perhaps most noticed for their commitment to nonviolence, but unlike other pacifist religions, Quakers' antiwar posture has a peculiarly bellicose tone. As one historian has described it, Quakers have traditionally been "pacifist-aggressive"[21]: confrontational and often eliciting violent reaction to their provocative version of peace-seeking. "Quakerliness" also has long been associated with service to society's powerless. Focused on extending justice to all God's creatures, Friends who are active environmentalists and vegetarians also often feel called to "bear witness" in public and provocative ways. To legitimate such witness, activist Quakers frequently call on the authority of their forebears, who made conscience-driven—if sometimes astonishing— personal choices. Often quoted is John Woolman, for example, the eighteenth-century abolitionist who advocated not only for enslaved people but also for Native Americans and the poor. Describing a defining moment in his convincement of Quaker Truth, Woolman reports that after killing a mother robin he was so overcome with remorse that the bird's young "must now

perish for want of their dam to nourish them" that he then felt compelled to kill the young birds so they would not "pine away and die miserably."[22] While some may dispute Woolman's solution to his moral dilemma, the story certainly underscores the Quaker stereotype of seeking a purposeful and conscience-driven solution to the challenges of life.

Conscience-driven social justice work stamps the modern-day Quaker image, but the image is not untarnished. Agitation for women's rights has been carried over from nineteenth-century concerns, and nonviolence— expanded to include the conviction that "there is no peace without justice"— has in recent years embraced draft counseling as well as sexual and homosexual rights. And most modern Americans know Quakers best through the American Friends Service Committee (AFSC), which in 1947 accepted the Nobel Peace Prize for British and American Quaker relief efforts in war-torn countries during World War II. The AFSC and its British counterpart the Friends Service Council are still an important Friends interface with the larger world's communities. These are the markers of modern Quakerism that strike a familiar note in the American memory. More muted are the references to Herbert Hoover, the Quaker president who succeeded so nobly in feeding the hungry in Europe but was unable to move beyond his capitalist upbringing to think of ways to feed the hungry in America during the Great Depression.[23] Nor are many Friends anxious to hug to their bosom post-World War I Attorney General A. Mitchell Palmer, who led the 1920s Palmer Raid search for communists, breaking down doors and violating constitutional prohibitions against unreasonable searches and seizures.[24] The perceived deceit, profanity, and amorality of Quaker Richard Nixon makes many Friends squirm in shame.[25] And though it is difficult to imagine eccentric modern political zealot Lyndon LaRouche in plain dress, he proudly proclaims his birthright membership in the Society of Friends.[26] None of these figures conforms to Americans' memory of Quaker symbols, yet each was born and raised in a Quaker tradition, and each had a willingness to follow conscience no matter where it led him. Each is an example of a Quaker disconnected from the Friends community structures: in more traditional times, "eldering" or "clearness committees" might well have reined in their excesses as Fox reined in Nayler, reminding these errant ones that Truth is something more than simply "conscience." According to Friends tradition, Truth should be the result of a corporate process of discernment tempered by one's peers. But these subtleties are too complicated: popular audiences are much more at ease with flag-maker Betsy Ross and portrait-painter Benjamin West—both of whom had ties to Quaker communities that are somewhat tenuous.

So the "real" Quakers are probably stuck with some of the labels and images brought forward from the past or laid upon them by people who only partially understand their faith and practice. But perhaps that fact, too, offers Quakers the opportunity for more self-reflection and self-monitoring. And we can learn something about the evolution of Quaker plainness and art by following the career of Signe Wilkinson, the modern syndicated political satirist who has earned the moniker, the "Attack Quaker."[27] A sophisticated and subtle intellectual, Wilkinson is anything *but* a "simple" Quaker, though her outspoken liberal politics are consistent with the social concerns of the centuries-old Friends tradition in which she was raised. And though she advocates nonviolence, she does not shrink from confrontation. "Where people are angry," she contends, "that's where cartoonists ought to go."[28] Wilkinson, who in 1992 became the first woman cartoonist to win the prestigious Pulitzer prize, says that "every organized group wants to have control over their own stereotypes." "I'm sorry, they can't," she concludes. "We [the rest of the world] have joint custody."[29]

So how do we come by our popular notions of what is "Quakerly"? What was wrought by the "joint custody" of Friends and non-Friends in creating the Quaker imagery we embrace today? Some hints may lie in the portrayals of Friends in popular culture. Fiction is one telling example. As early as 1799, Charles Brockden Brown (1771–1810)—probably the first American Quaker novelist—wove some of his Quaker upbringing into *Arthur Mervyn*, a dark novel about a battle between good and evil, set in Philadelphia during the 1793 smallpox epidemic.[30] Brown's work represents one of three subgenres of "Quaker fiction": that created *by* Friends but not necessarily *about* Quaker topics. Brown, who eventually left Quakerism, never directly addressed his religious background in his writing. However, a generation later Sarah Stickney Ellis (1812–1872) certainly did. In her *Friends at Their Own Fireside*, published in 1858, Ellis's intention to publicize the value of the Quaker way—and the value of literature for reinforcing it—is evident in her title and in her defensive introduction: for Friends

there is no wandering of imagination into the forbidden fields of beauty and enjoyment, all the more attractive because of the contrast which they present to the dull routine of actual life. In this manner, perhaps more than any other, the Society of Friends have erred in judgment. Afraid of the evil without, they have neglected to provide against that within. Music being to them a forbidden indulgence, and until very recently the arts of design being rather discouraged there was nothing but reading left available to them in their leisure hours. Hence, there has probably never yet been such greedy and indiscriminate devourers of novels as occasionally might be found among the Friends.[31]

Ellis's goal, then, was to provide "wholesome" fiction, lest Quaker read-
ers get seduced by the lurid materials that were flooding the printed market,
and her romanticized view of a gentle and loving Quaker home life has en-
dured, periodically given new life in more recent novels such as Marguerite
De Angeli's *Thee, Hannah!*, published in 1940, which features a young girl
who is ashamed of her family's peculiar garb until she becomes aware that
fugitive slaves were guided to safety by recognizing that people so clothed
were trustworthy.[32] And perhaps best known of all modern Quaker images
is that of the frontier family in *Friendly Persuasion* by Jessamyn West
(1903–1984), where the son, struggling with the moral dilemma of war, finally
decides that combating slavery is more important than avoiding violence.[33]
Few writers depict the dark side of Quaker passion as strongly as does A. S.
Byatt in her 1967 semi-autobiographical novel, *The Game*.[34]

Finally, the image of the quintessential Quaker—dedicated, focused,
and disciplined—has been painted in the words of many non-Friends. Her-
man Melville's *Moby Dick* (1852) introduced nineteenth-century readers to
Captain Ahab, who could not be dissuaded from his religious mission to
stamp out sin, and his two comrades Bildad and Peleg, who exemplify other
aspects of a Quaker stereotype. In *Uncle Tom's Cabin*, New England romantic
writer Harriet Beecher Stowe portrays an exemplary Quaker household that
gave sanctuary to fugitive slaves. But perhaps one of the most incongruous
images of Quakers comes from the ubiquitous "dime novels" of the late nine-
teenth century. In these popular series—an early version of the comic
book—the cover art was often created first,[35] and then a writer was hired to
spin a tale to match the art (Plate 1). In these tales, a gunslinging but superbly
ethical detective named "Old Broadbrim" modernized the age-old battle be-
tween good and evil, peppering his language with "thee" and "thou" to re-
mind the reader that he was a Quaker and therefore to be trusted as the
embodiment of high morality.[36] One critic, Thomas Kimber, lamented that
the dime novel authors have only "a superficial knowledge of the ways of
Friends" that does not include "those deeper sources of spiritual motivation
which sent so many of them to prison for their religious convictions."[37]
Whether the dime novel authors understood the deeper spiritual motivation
was, however, irrelevant: thousands of readers who would never in their lives
meet a "real" Quaker "knew" them through these stories. And Kimber was
probably right that fiction writers used Quakers as "caricatures rather than
characters," as symbols of independent spirit and eccentric personalities. By
the twentieth century there was a panoply of moral Quaker characters folded
into novels as placeholders for virtue by both Quaker and non-Quaker
authors.

Other widely known sources further burned stereotypes into the popular consciousness. The abundant eighteenth- and nineteenth-century silhouettes of Philadelphia Friends continue to reflect contemporary strictures about plainness and reinforce modern ideas about simplicity (Figure 1.1).[38] Sheet music, widely distributed since the late nineteenth century, was another outlet for Quaker stereotypes. Typical was the tune, published by Waterson, Berlin, and Snyder in 1919 (Plate 2), with its tongue-in-cheek commentary on Quakers in the modern world:

Oh! I just got back today, From a town not far away;
I've been looking at the Quakers, In their clothes of gray:
And it struck me mighty strange, 'Cause there's been an awful change;
If you think those folks are slow, There's a lot that you don't know.
All those Quakers are shoulder shakers, down in Quaker town,
Things are upside down, The Jazz Bug bit 'em, How it hit 'em.[39]

The American fascination with Quaker images continues throughout the twentieth and into the twenty-first century. The portrayals of Quakers in fiction such as Daisy Newman's *Diligence in Love*, published in 1951 and reissued that same year in a "popular edition," with a cover illustration that delivered a romanticized image of the "simple" New England Quaker household, appealed to thousands of readers.[40] And in recent years writers such as Irene Allen and Chuck Fager have reclothed the Quaker detective in modern dress.[41] Allen's protagonist is an elderly woman who bakes her own bread and drives an outdated car. Fager's characters, somewhat more complex, are nevertheless caught up in trying to live the simple life of integrity in a complex modern world.

Some audiences have unquestioningly accepted the popular designation of Quakers as simple vessels and protectors of goodness. What could be more appealing than continuing to think of Quaker "convincement" as something that could have outward markers that are as satisfying as they were for impassioned abolitionist Angelina Grimké in 1821. "I changed my dress for the more plain one of the Quakers," reported Grimké. "I trust I have made this change in the right spirit, and with a single eye to my dear Redeemer. It was accompanied by a feeling of much peace."[42] No matter that in the twenty-first century most Quakers worship neither in silence nor in buildings that are "plain"; nor do they necessarily embrace pacifism or the notion that children are born innocent.[43] Many modern Quakers are so far evolved from Grimké's world that the "typical" member of the Religious Society of Friends not only dresses in bright clothing, but now celebrates

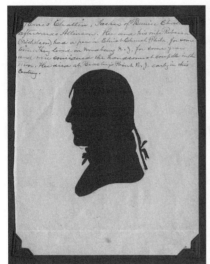

Figure 1.1. Silhouettes of James Chattin and Rebecca Chattin. Peale's Museum, probably Philadelphia, ca. 1800–1820. Paper silhouettes mounted in ca. 1880–1920 scrapbook. Allinson Papers, Collection 975C, Haverford College Special Collections. Popular audiences associate the silhouette with "Quaker plain," yet even while adhering to the humble, self-effacing medium, a sitter might display individuality and vanity, as does James Chattin with his pronounced queue. Details of the sitters' clothing, such as his stock and her collar, are readily apparent as well.

communion and religious holidays and includes singing in a worship service led by a paid minister in a church with a pulpit, statuary, and perhaps decorative windows.

Quaker Aesthetics focuses on the Delaware Valley, but the problem of squaring up belief with outward trappings and images was not unique to this region. Nineteenth-century Vermont cabinetmaker Stephen Foster Stevens apparently paid attention to Quaker limitations on ostentation.[44] So did cloth manufacturers in rural New England and the South.[45] In the 1870s Iowa Friends split into "Progressive" and "Conservative" branches, mostly over issues of lifestyle: appropriate use of money and other resources; plain speech and dress; limitations on entertainment; and limits about socializing with non-Friends.[46] Thus the past and present have continued a dialogue about "simplicity," "plainness," ostentation, and "stewardship." Across time and space, these themes recur in the essays presented here. Other themes emerge,

too: that "plain," and its enforcement, have always been subject to significant variation in meaning and emphasis among different Quaker meeting communities and across classes *within* the Quaker communities; that gender is somehow related to the interpretation of "plain-ness"; and that the "insiders' " vision of what constituted proper Quaker appearance and behavior often has had little relationship to the "world's peoples' " ideas of Friends ideals and intentions.

Friends' struggle to understand and interpret plainness often took its contours from the social, economic, or political events of the times. Hence it is not surprising that some historians argue that there was a significant watershed somewhere in the 1760s, when the distribution of Philadelphia's wealth became noticeably unequal. Anyone who chose to look at the city in 1768 could see the rich getting richer and the poor getting poorer.[47] Likewise, the social readjustment following the American Revolution seems to have been reflected in the Quaker discipline.[48] The religious revival movements, westward expansion, printing revolution, and Protestant Sunday School movement of the 1820s through the 1870s also unsettled the foundations of Quakerism, as it did other American religions.[49] And the romantic Puritan revival of the 1920s and 1930s, when Friends struggled to heal their own century-old wounds,[50] probably left its mark on Quaker plainness, as did the New Abolitionist civil rights movement of the 1960s and 1970s.[51]

In the 1970s young Friends were over-represented among hippies and back-to-naturists, and many new members or attenders of Friends meetings were attracted as much by these nonconformist liberal political and social behaviors and by Friends emphasis on the value of the individual than by theological concerns. Many of these modern Quakers, for example, took to organic farming, natural childbirth, and conscientious objection like wanderers who had found a home. Many modern Quakers also expanded the Friends tradition of social reform, seeking, for example, not just to assist the needy as their forebears had done, but to show solidarity with them. As we will see in the essays that follow, early Quaker social concern usually had less to do with *identifying* with the poor and more to do with offering them assistance. But while modern Friends have relaxed some of the rules, many of them struggle as much as their predecessors with how to actualize "simplicity" in their lives. Frank Levering, Jim Pym, and Scott Savage are among many twenty-first-century Friends seeking to define lifestyles that let their lives speak, for modern terms, the daily-life meaning of "plainness" and "simplicity."[52] But Fox's legacy on the importance of the community's combined wisdom in setting guidelines continues to be problematic.

In the years since Tolles awakened our senses to the notion of "the best

sort but plain," a new generation of scholars also has tackled the question of what—if anything—constitutes and distinguishes a Quakerly lifestyle and a "Quaker aesthetic," in the past or the present. In *Quakers and the Arts: "Plain and Fancy"*, David Sox highlights some of the evolution of Quakers' ideas about art, challenging modern Friends to see old Quaker strictures in a new light. The essays that follow here also weave some new interpretations from the threads of previous historians and early Quaker evidence. Drawing on techniques and styles ranging from Frost's matter-of-fact overview of Friends engagement with the theology of plainness, to O'Donnell's practical tips for orienting a researcher new to Quaker culture, to Garfinkel's and Herman's theoretical exploration of those dark crevices where communication between individuals and society transpires, these essays invite new dialogue.

In fact, the authors themselves are in dialogue, and their conclusions speculative since from outward manifestations a viewer can only triangulate inward intent. Frost argues that there is a progression through time from plainness to simplicity. He suggests that the disciplines were applied unevenly: "weighty" Friends were treated more leniently than their less pious peers. He then concludes that by the middle of the twentieth century simplicity and distinctiveness were rendered "amorphous" by the "theology of modernism." But Diethorn and Carr are less convinced that time is an important variable for understanding Quaker aesthetics, and Garfinkel and Herman raise questions about the discernibility of a "plain" style at all. Lavoie, Johnson, Carr, Weekley, and Caton present us with case studies, and Groff and Diethorn challenge historians and interpreters to take the story "to the streets," to make all this come alive for a public audience because, as Thelen reminds us, "storyteller and audience are partners in creating the memory to be told."[53]

Public audiences deserve to have us help them recover and introduce a past that is—in Diethorn's word—"real." They deserve to have interpretations that get *past* a one-dimensional notion of "plain," to reach a place where we can *present* "simplicity" with a new richness and complexity that does not trivialize, romanticize, or ossify notions of a Quakerism. Friends, after all, have forged a way of life that has remained dynamic for a small minority of people over hundreds of years and dozens of countries.

But there is still lots to be done here. You will not find any Quakers who fit the mold of Billy Smith's "infortunate"[54] in these pages, those whose bad luck, widowhood, infirmity, or orphaned state lent an edge of desperation to their interpretation of "plainness" and other religious concerns. The situations of Edward Hicks and Sara Hallowell hint at those questions, but the research on this topic awaits another volume. The essays here, of necessity,

focus mostly on the worlds of the most privileged and articulate Friends—those in a position to leave a material legacy. It is for future volumes to explore how working-class Quakers experienced the material prescriptions of their religion. The material lives of more rural Friends in Pennsylvania and elsewhere deserve greater scrutiny as well.

We do not yet have studies of those who passed through but did not remain in Friends communities, or about how the restrictions of plainness influenced such decisions. Weekley's study of Edward Hicks, included here, suggests something about how new members came to Friends through young men's friendship networks, but new scholarship is just beginning to uncover the relationship among Quaker behaviors, American notions of "manhood," and the intersection of these with modern capitalism. And though Herman gives us some hints in his discussion of Quaker homes, we have not yet really focused on how Friends plan, acquire, and maintain their material possessions.[55] Woven into the footnotes of these essays you will find the foundations laid by Joan Vokins, Robert Barclay, Ambrose Rigge, George Keith, Anthony Benezet, Thomas Pim Cope, Rufus Jones, Jack Marietta, Michael Bauman, Jack Michel, Don Yoder, Philip Benjamin, Jane Williamson, and many others. You will find the demons with which modern Friends like Jim Pym, Frank Levering, and Scott Savage still wrestle as they seek a community that can achieve "a certain kind of perfection." You will surely find much to enlighten and to irritate. If we have been successful, you will also find inspiration for further scholarship.

Chapter 2

From Plainness to Simplicity: Changing Quaker Ideals for Material Culture

J. William Frost

Quakers or the Religious Society of Friends began in the 1650s as a response to a particular kind of direct or unmediated religious experience they described metaphorically as the discovery of the Inward Christ, Seed, or Light of God. This event over time would shape not only how Friends worshipped and lived but also their responses to the peoples and culture around them. God had, they asserted, again intervened in history to bring salvation to those willing to surrender to divine guidance. The early history of Quakers was an attempt by those who shared in this encounter with God to spread the news that this experience was available to everyone. In their enthusiasm for this transforming experience that liberated one from sin and brought salvation, the first Friends assumed that they had rediscovered true Christianity and that their kind of religious awakening was the only way to God. With the certainty that comes from firsthand knowledge, they judged those who opposed them as denying the power of God within and surrendering to sin. Before 1660 their successes in converting a significant minority of other English men and women challenged them to design institutions to facilitate the approved kind of direct religious experience while protecting against moral laxity.

The earliest writings of Friends were not concerned with outward appearance, except insofar as all conduct manifested whether or not the person had hearkened to the Inward Light of Christ. The effect of the Light depended on the previous life of the person, but in general converts saw the Light as a purging as in a refiner's fire (the metaphor was biblical) previous sinful attitudes and actions. So being "convinced" (this term was more frequently used than "converted") was likely to be a prolonged and traumatic

process as the person gained insight into what was required to be a servant of God.[1] The acceptance of the Inward Monitor required converts to work out their salvation with "fear and trembling" (Philippians 1: 12), and it brought a denunciation of music, plays, gambling, and many recreations as wastes of time that distracted from a person's true destiny of following the Inward Christ. Early Friends proclaimed all outward religious forms as not just unnecessary but evil. What Christians had traditionally termed "means of grace," including liturgy, sacraments, hymns, theology, and ornamented "steeple houses," fell into this category of evil. These forms were products of humans' sinful will and had to be abolished so the voice or seed of God within could be heard or be fruitful—both metaphors were common.

In addition to religious taboos, Friends early developed many positive beliefs—silent meetings, women's spiritual equality with men, Christ's return inwardly to teach his people, the possibility of perfect submission to God, strict personal morality, for example—but the emphasis in this essay is on what they renounced as incompatible with true Christianity. These included the denunciation of tithes, paying ministers, oaths, using "you" for a single person (they used thee/thou), titles (like "Your Grace" or "Lord"), and the pagan names of days and months instead of strict numerical references (first day or first month). Later generations would call these standards of behavior "peculiar customs" (Titus 2: 14 or 1 Peter 2: 9) or "testimonies,"[2] but this is an artificial linkage and ignores the early rationales for opposition to these customs. In the 1680s distinctive dress and furniture would be added to these customs or testimonies in an attempt to create a Quaker culture separate from the world's people.

This essay explores three areas: why Friends created what they would later call a plain style of life; the period from the 1680s until the mid-nineteenth century when the plain style remained the norm; and finally the modern attack on plainness, first from evangelical Quakers and then from liberal Friends. By the end of the nineteenth century, except in a few enclaves, plainness had disappeared, replaced by simplicity. In the seventeenth century, plainness (associated with mortification) was the dominant symbol with simplicity in a secondary role; today simplicity is much more frequently invoked than plainness.[3] How did this come to be? Here we will examine the rationale for the plain style rather than how Friends implemented or maintained this testimony. The evidence is mainly from official statements, that is, meeting-approved writings of individuals, "Christian and Brother Advices" or disciplines of yearly meetings, and epistles issued by Friends. This is a prescriptive literature, telling more about the ideals by which Friends hoped to

live than about how individual Friends did live. Even in seventeenth-century America not all Friends were equally devout, and actual behaviors were determined by many influences besides what the meeting recommended.

The First Generation: Sobriety and Usefulness

Friends inherited a set of teachings about dress that they appear to have absorbed with little forethought. Like the many varieties of radical religious folk in Puritan England, Friends based virtually all their social interpretations on the Bible and assumed that God's inward revelations confirmed the truth of Scripture. In the Prophets, Proverbs, and Paul there are comments on proper deportment and what constitutes an abuse; for example, "women should adorn themselves modestly and sensibly in seemly apparel, not with braided hair or gold or pearls or costly attire" (1 Timothy 2: 9). In several places women's dress and deportment are singled out for detailed criticism, but in general the Bible equates dress with outward attitude.[4] Friends frequently quoted the Sermon on the Mount where Jesus says "Be not anxious about . . . what you shall eat or what you shall drink" (Matthew 6: 25). The Bible condemns ostentatious display by the rich, praises the poor, and contrasts the pride of self-righteousness with humble deportment before God. The prophets contrasted the costly garments of Jews with a coming dissolution from God's judgment. Wearing rich robes and having sumptuous food were signs of material wealth and moral flabbiness which, particularly in Luke, Jesus condemns. Because they essentially relived the Bible as an illustration of their spiritual journey, Friends condemned clothing designed for outward show.

Christianity has a long tradition of using mortification to prove the subordination of physical pleasures to spiritual awakening. Friends inherited this tradition, which is also found in Roman Catholic monasticism, the Anabaptists' code of dress, the Reformed or Calvinist teachings on conduct, and English Puritanism's somewhat deserved reputation for being puritanical. The Puritans were called "round heads" because they cut their hair short following the Pauline dictum that long hair was a sign of pride. During the English Civil War dress became a symbol of political affiliation with the king, the cavaliers wearing much fancier or more ornamental clothing than their Puritan opponents. Friends—led by their founders, including George Fox, Margaret Fell, William Penn, James Nayler, and Robert Barclay—took over Puritan attitudes to dress and turned them against the Puritans, whom they accused of a laxity that compromised true Christianity.[5]

In addition, Friends first took root in the remote north of England where country folk, ignorant or disdainful of London fashion and customs, wore traditional clothing. Oscillation between awe and repulsion at the lifestyle of the court characterized the relationships between crown or town and country and is a recurrent theme in the history of early modern England.[6] Such tensions would later characterize the relationship between wealthy London Quaker merchants and rural Friends.

There probably was nothing very distinctive about early Friends' material culture. For example, there is no heading about plainness of dress or ornate furniture in the very complete index to the John Nickalls edition of the *Journal of George Fox*,[7] though Fox was described as wearing "leather breeches," worn for their durability. Seventeenth-century critics seeking to warn communities against traveling Quaker ministers did not mention a set form of apparel by which they could be recognized. Early Friends dressed as others of their class and occupations, and none of the First Publishers of Truth—a name later applied to the early ministers who traveled seeking converts—ranked as a gentleman or lady, although a few persons of high rank including Margaret Fell and Anthony Pearson became Friends. Because most Friends were artisans, tradesmen, or farmers, these men and their families dressed like others: neither above nor below their station.

Early Friends were less concerned about any specific dress than about clothing as a sign of pride and reserved most of their condemnation for superfluities or excess. For George Fox, the word "vain" is so often used with fashions that it almost seems that it was one concept. Only on one occasion does Fox link the adjective "plain" with clothing,[8] remarking that it was wasteful for the rich to put ribbons and laces on their clothing. In all people, Fox explained—whether those seeking more status or attempting to confirm high outward position—luxurious dress was a sign of self-aggrandizing will showing that the wearer had not succumbed to the Light of God. The early condemnations of luxury did not mention specific colors, nor was there reference to the quality of the goods, for instance, that woolens were more durable than silks.

Although early Friends frequently condemned non-Friends' "vain fashions," references to Friends' preferences were offhand. George Fox purchased good quality scarlet cloth for his wife, Margaret Fell Fox, to make into a cloak. Sarah Fell's 1673 account book shows that the ladies of Swarthmoor Hall bought tartans, blue stockings, and red cloth.[9] Fox, like James Nayler, wore his hair long, but early woodcuts of other Friends do not indicate that others followed this example. Friends disliked James Nayler's and John Perrot's growing beards because they feared the implication of trying to look

like Jesus. The early Friends denounced many customs and beliefs, but neither they nor their opponents placed special emphasis on specific styles of furniture or dwellings. The first meeting houses were just houses or rented buildings where Friends met, and there was no distinctive architecture.

The Restoration of Charles II in 1660 brought a repudiation of Puritan plainness and morality and a new concern with ornamental fashion, as court aristocrats wore elaborate wigs, perfumes, laces, silks and satins, highheeled red shoes, enormous wigs, and elaborate, laced, long sleeved coats. And these were male fashions! Women added paint and patches and wore seductive gowns that Quakers thought were too revealing. It was an era of sex and debauchery, and King Charles's escapades with women and the resultant illegitimate children set the tone. Restoration comedies like William Wycherley's *Country Wife* made light of the game of sexual seduction, and historian John Spurr characterizes the Restoration as marked by "heroism, wit and masquerade."[10] By contrast, Quakers sought humility, truth, and openness.

The scandals of court are only one facet of the Restoration, a period of wars, plague, architectural creativity, philosophical innovation, and scientific revolution. In the aftermath of the 1664 fire of London, when Christopher Wren designed ornate new churches including the rebuilt St. Paul, a new style of church and domestic architecture emerged. Isaac Newton published his *Principia Mathematica* (1687) and included his work on gravity, Robert Boyle's experiments illustrated the nature of gases, and both men, along with William Penn, became members of the Royal Society for the Advancement of Science. John Locke wrote his essays on government and religious toleration. Yet at the same time there were executions for witchcraft. The Church of England attempted to suppress all religious dissent, though Quakers received some sympathy from the king—but not from Parliament.

Even though Friends, like most other English, were appalled by the dissoluteness of the court, they were influenced by the events, style, and new currents of thought of Restoration England. Friends reacted negatively by denouncing the elaborate male and female fashions and by wearing either the same kinds of clothes as customary during the Commonwealth or a plain or moderate version of whatever was fashionable. Responding to the chaos around him, Penn's plans for Philadelphia incorporated green space to protect against the plague and brick dwellings and meeting houses to reduce the risk of fire. The layout of the house and gardens at Penn's mansion at Pennsbury reflected Restoration ideals of balance and symmetry. The few English Quaker meeting houses surviving from this period when it was still illegal to be a Quaker show that no one type of architecture prevailed.[11] Clearly

Friends embraced part of the style of the Restoration while rejecting what they saw as the abuses of the age, in search of what they termed a "sober and judicious" Christian life.[12]

William Penn's *No Cross, No Crown* (1669) and two *Fruits of Solitude* (1693, 1702) assert three different rationales for plainness: one based on renunciation, a second on reason and moderation, and a third on utilitarian national interest. Robert Barclay's *Apology for the True Christian Divinity* (1676) provided a theological defense for a plain style that took into account differences of class. These men's efforts to defend what would later be called a plain style should be seen as a part of a general transformation of an expanding Quaker movement stimulated by the threat of persecution and schism.[13] Under attack from without and within, Friends created a system of meetings organized in a hierarchical manner. They also crafted a theological defense of their beliefs and practices. In essence, they tried to routinize the charisma of immediate revelation in silent meetings, and they intended to provide a method for making decisions and enforcing uniformity of conduct in monthly meetings for business when the leaders were absent, often in gaols.

Penn's *No Cross, No Crown,* written while he was imprisoned in the Tower of London for allegedly denying the Trinity, reflects Friends' concern about "the lust of the eye, the lust of the flesh, and the pride of life." The first two chapters oppose "vain titles" and doffing one's hat as a sign of honor. His consistent theme is how the quest for honor trumps the need for humility before God and destroys true worth. Penn couples a pragmatic attack on the uselessness of such outward deference with the gospel demand for self-denial, assuming the cross and embracing suffering in this life in order to receive a heavenly crown.

Using the same dual focus, Penn's third chapter denounces a long list of customs:

Several sober reasons urg'd against the vain Apparel and usual Recreations of the Age (as Gold, Silver, Embroyderies, Pearls, precious Stones, Lockets, Rings, Pendents, breaded and curl'd Locks, Painting, Patching, Laces, Points, Ribonds, unnecessary change of Cloaths, superfluous Provision out of state, costly and useless Attendence, Rich Furnitures, Plays, Parts, Mulbery and Spring-Gardens, Treats, Balls, Masks, Cards, Dice, Bowls, Chess, Romances, Comedies, Poets, Riddles, Drollery, vain and unnecessary Visits, &c.) by which they are proved inconsistent with a Christian life, and very destructive of all civil society.[14]

Notice the wide variety of practices excluded from a sober life: rich dress and furniture, ornamental gardens, plays, balls, games, poetry, riddles,

and social visits. Even leisure had to have a worthwhile objective, and "the best recreation is to do good." Penn supported his condemnation of all frivolity with quotations from sixty-eight authorities: ancient Greeks and Romans, the church fathers, and leading figures of the Reformation. The impressive display of erudition (though many of the quotations were taken intact from books Penn had read) was to demonstrate that sensible Christians and moral exemplars from all periods agreed with the Quaker positions on plainness.

Penn argued that dress should serve only three functions: to cover shame, therefore "plain and modest"; to keep out the cold, hence "substantial"; and to differ the sexes, thus "distinguishing." Going beyond utility was a sign of pride, he asserted, but he added a new element to the discussion: that it was also socially destructive. Until then Friends had not discussed the economic consequences of luxury. Responding to the argument that creating sumptuous feasts and houses gave employment to the poor, Penn countered this early version of trickle-down economics by claiming that producing luxury goods impoverished the realm. Instead of wasting labor, the kingdom would be benefited by having the tradesmen produce useful food and commodities that would increase trade and thereby help the poor escape poverty. The early radical Penn emphasized the need to conquer self-will, and a plain style was essential in this process, with moderation and reason as subordinate themes.[15]

The tone of Penn's *Some Fruits of Solitude* and *More Fruits of Solitude* contrasted markedly from *No Cross, No Crown*. Except for an occasional "thou," there is little in the contents to indicate that Penn was a Friend. Penn was much older, a proprietor of Pennsylvania, and out of favor with the court of William and Mary for his support of James II before 1688. During this time, while Friends gained toleration and prosperity, Penn experienced the death of his oldest son, Springett, and wife, Gulielma—both of whom had experienced long illnesses. Pennsylvania had proved virtually ungovernable and he was in debt. No longer a radical young Quaker, Penn was now a chastened man who advocated moderation as a product of reason and following the dictates of nature: "All excess is ill"; "In all things reason should prevail"; "Grace perfects but never spoils nature"; "Excess in apparel is another costly folly: the very trimming of the vain world would clothe all the naked ones." Penn also seems the first to have linked plainness in clothing with simplicity: "The more simple and plain they [clothes] are, the better, Neither unshapely, nor fantastical: and for the use and decency, and not for pride."[16] Note that the rationalist Penn does not condemn any one kind of dress or furniture; plainness is unornamented, useful, durable.

Very different in tone was Penn's advice to his children, probably written in 1699, before his second voyage to Pennsylvania (it was not published until 1726). Here Penn linked testimony, plainness, moderation, and simplicity as defining a Quaker style of religion: "You will also see that the testimony the eternal God hath brought our poor friends unto, as to religion, worship, truth-speaking, ministry, plainness, simplicity, and moderation in apparel, furniture, food, salutation."[17]

In 1676 Robert Barclay, like Penn a member of the ruling class, wrote in Latin *An Apology for the True Christian Divinity*, which Friends for the next one hundred fifty years would esteem a definitive summary of their beliefs. The last section (proposition XV) discussed the "practices," including the renunciation of war and the embracing of "plain and sober" dress and food. Barclay titled this section "Of Salutations and Recreations," even though dress, furniture, food, and pacifism are neither of these. His unsatisfactory title indicates that by 1676 Quakers had not yet found a satisfactory way of describing all elements of the "plain style."

Barclay insisted that for a Christian the essence of these testimonies (a term he did not use) was renunciation of vanities, but ascetic practice was not the same for rich and poor. "We shall not say that all persons are to be clothed alike, because it will perhaps neither suit their bodies nor their estates. And if a man be clothed soberly, and without superfluity, though they be finer than that which his servant is clothed with, we shall not blame him."[18] To be brief, it may be more mortification for a rich man accustomed to French sauces on his roast beef to give up the sauce than for a poor man whose purse will not allow frequent meals of roast beef to abstain. Each should use the material world according to his station, but plainly. Friends' early recognition of class is important, because it shows that the eighteenth-century practice of the "plain style, but finest" was not incompatible with Quaker tradition or a sign of declension—insofar as finest meant utility rather than ornamentation.

The Plain Style

Toward the end of the seventeenth century the official definition of the sober style of life changed dramatically. Now meetings referred officially to plainness. "It is our tender and Christian advice that friends take care to keep to truth and plainness, in language, habit, deportment and behaviour: that the simplicity of truth in these things may not wear out or be lost."[19] The new emphases (which seem to have originated in Ireland) became widespread in

England and America during the 1680s and endured wherever Quakers lived until the mid-nineteenth century.[20] The nonobservance of plainness now became a subject for discipline; that is, in theory at least, a person could be disowned for not observing the Quaker testimonies on dress or speech. In practice, however, this was rarely done.

In order to make certain that all members knew how Quakers should appear, meetings asserted exactly what was not plain. After all, it was easier to say what was wrong than to define exactly what moderation or utility meant. Meetings began to go beyond complaining about excess and to list in detail what kinds of fashion were not allowed. At various times, for example, Friends condemned any apron that was not green or white, plaids, and ruffled neckcloths, even prescribing the size of buttonholes.[21] In spite of protests from prominent Friends such as Margaret Fell Fox, who complained that the new "legalism" was a "silly, poor gospel," the plain style now began to evolve into drabness.[22] London Yearly Meeting in 1703 warned against "extravagancy in colour and fashion."[23] Plain dress, speech, and furniture became visible signs of godliness.

There were several causes for the new emphasis on plainness. By the late seventeenth century Friends had become far more prosperous. English and Irish Quakers moved into towns where they became merchants.[24] In this more lavish context, Quaker merchants who acquired the trappings of prosperity could argue that they were living plainly relative to their station. Devout Friends feared the effects of new wealth on religious commitment. Older Friends tended to sanctify whatever patterns of clothes they wore and to look on changes, particularly by the young, as a sign of a blind following of fashion. Enforcing a plain style would guard against declension, preserving what—as early as the 1680s—Quakers were calling their "ancient" testimonies—ancient because espoused by the first Christians and the first Friends. Quakers admitted that their taboo against ornamentation could not guarantee the experience of the Inward Light, but they believed that requiring plainness brought a self-mortification conducive to the type of "tenderness"—or openness—in which one could know God. Somehow even the rich had to learn how to conquer self-will and divest themselves of distractions so that God's tender plants of grace could grow.

The new emphasis on plainness was also a response to the decline in new recruits to Quakerism. Migration to America, the resurgence of Anglicanism under queens Mary and Anne, and the change of intellectual climate after 1690 (the Age of Reason or Enlightenment) meant that Quakers seemed to be slightly anachronistic, a relic of the religious passions of the Civil War. Now Quakers' protests seemed irrelevant. The English government had en-

dorsed toleration of all Protestants and allowed Friends an affirmation instead of oaths. Quakers no longer spent time in jail for nonpayment of tithes; instead, the authorities could legally distrain the amount required. Since these laws were to be renewed periodically and the government's support depended on the Quakers behaving as responsible subjects, the London merchants and ministers who dominated the Meeting for Sufferings no longer denounced injustice but rather thanked the crown and parliament for favors. No longer striving to reshape the entire society, Friends concentrated on improving themselves. Although Friends might see themselves as missionaries of the only true church, they also knew that they were one of several groups of dissenters. Unwilling to recognize that truth might be relative, the meeting had to find some way of ensuring its survival by establishing a recognizable discipline. The result was an emphasis on the family as the primary nurturer of a plain style and on the plain style as a marker of adherence to Quaker principles.

Until after the Glorious Revolution of 1689, family and children had played a distinctly minor role in Quaker apologetics, but in the eighteenth century these would emerge as major preoccupations. Somehow Quakers had to raise children so that they could be receptive to the Inward Light. The meeting advised that from infancy dress and speech be plain and self-will be controlled. By enforcing plainness, loving parents would create tender (sensitive) children accustomed to the mortification necessary to be truly Christian.[25]

Plainness would serve as a kind of hedge or "enclosed garden" that would help circumscribe correct behavior on children and their parents. The epistles of London and Philadelphia Yearly Meetings warned parents that either undue strictness or laxity would lead to excess, which could bring disownment. A good example coupled with loving-kindness would accustom children to living plainly. A child would have his or her "birth and education" among Friends, and book learning would be in a school with a Quaker teacher and pupils in which the peculiar customs would be observed. A boy's apprenticeship would be to a Quaker master. In time, a young man would be allowed to court a Quaker girl after consultation with parents and "weighty" Friends. They would be married in the meeting and would form another Quaker family.

In the eighteenth century Friends incorporated two tenets into the plain style: the necessity of marriage within the faith and the peace testimony. Based on Old and New Testament precepts such as Paul's "be not unequally linked with unbelievers," Friends insisted that a marriage to a non-Quaker would jeopardize the observance of the peculiar customs within the family

and cause conflicts over attending meeting. The peace testimony could be linked with plainness because it was an example of outward behavior in which Friends were unique. As Quakers rethought and expanded the meaning of the peace testimony in the eighteenth century, nonresistance was not only about war but also included gentle behavior within the family and community.

Plainness would distinguish which children really were Friends. Before 1737 among English Friends and the 1760s for Philadelphia Quakers, there was no formal test for membership other than birth among Friends, attending meeting, and observing Quaker customs.[26] Quaker plainness was a visible sign to everyone that the young person really was a member. Plainness would keep out the world's customs and enforce the close ties within the community of Friends. In fact, the meeting would become a kind of surrogate family. Elders and ministers would visit families periodically to encourage the practice of religious devotion; they could also discreetly point out deviations from plainness. The ideal was to create a unified Quaker culture so that a plain Friend would always be conscious of his religious distinctness, particularly when in association with non-Friends.

Whether the ideal of a plain culture was ever defined well enough to be realized in practice is difficult to determine.[27] The meetings' advices on plainness soon became stereotyped, the prescriptions reappearing in disciplines long after many Friends had ceased to observe them. For example, the 1912 book of discipline for Philadelphia Yearly Meeting Orthodox reprinted a 1694 advice on plain dress. Once an advice appeared it was difficult to repeal because some held it in esteem as a part of Quaker tradition sanctified by the martyrdoms of early Friends. Others defended it because it provided the basis to accuse innovators of proceeding from a worldly spirit. The Quaker practice of "sense of the meeting" required the consent of most "weighty" Friends—the devout older members who were most inclined to a strict definition of plainness.

The enforcement of plainness varied greatly depending on the offense and the era. For example, in America and Britain, marriage to a non-Friend or officiated by a non-Quaker minister remained a very visible and easily disownable offense until at least the mid-nineteenth century. Until the American Civil War, a violation of the peace testimony by joining the military would bring automatic censure. By contrast, in eighteenth-century Philadelphia and London having an ornate high chest might bring rebuke from a visiting minister but result in no official action by the monthly meeting. Quakers in Durham, England, between 1680 and 1725 repeatedly listed forbidden garments for women and reprimanded the young women who wore

them; men's dress was rarely mentioned, except for wigs, but men were often disciplined for drunkenness at the alehouse.[28] Philadelphia Yearly Meeting's epistles and disciplines often mention specific abuses in dress, but comments about houses and furniture are so vague that interpretation of what plainness meant here (if anything) must rely on surviving material objects.

Establishing and maintaining a firm formula for punishing infractions was not easy. At all times Friends seemed to agree that violations of moral codes (for example, sexual relations outside marriage) were more serious than superfluities and therefore required immediate disciplinary action. They also admitted—even in the eighteenth century—that hypocrites could be outwardly very plain and that the New Testament condemned undue legalism or straining over-pettiness.[29] A family who showed up regularly for meeting, contributed funds, and sent their children to Quaker school might receive more leeway even though their house appeared a little grand, particularly if the family could afford it. But woe be to them if after such indulgence the father got into financial difficulties due to speculation and declared bankruptcy, thereby defrauding his creditors. Then the grand house showed an unsound spirit and the man would almost certainly be disowned, that is, declared not a member. Above all, in analyzing the rigor with which discipline was applied, we should remember that the process involved neighbors imposing discipline on people they knew well, who might be close acquaintances, grandchildren, or nephews. Hence a meeting might be lenient with those who had important roles in the meeting and had fashionable new clothes if the case could be made that they conformed to plainness and utility.[30] Ministers came from all classes, but the elders and overseers who had primary responsibility to enforce the discipline usually came from wealthier classes. And because plainness differed from equality, high-ranking prosperous Philadelphia and London Quaker families could combine plainness with gentility.[31]

In addition, definitions of the moderation and utility required in plainness evolved according to the norms of the wider society as Friends interacted with outsiders in business and government affairs. The eighteenth-century Friends who dominated the Assembly and trade in Pennsylvania and the banking and the iron industry in England, the artisans who created furniture, clocks, clothing, and silver services or built houses, and the retailers who sold a wide variety of goods had to please customers who were not Friends. A Quaker printer or bookseller who worked exclusively on Friends tracts would probably soon have gone out of business.[32] Hence Quaker business people, constantly in contact with the "world's people," could not avoid subtle outside influences.

A few—country Friends, the most devout, or older Friends who were unhappy with the young—with some regularity condemned the growing worldliness of Friends. Yet disownment was a drastic step, and some reasoned that it was better to keep "gay" or "wet" Friends within the meeting in hopes they would mend their ways.[33] After all, membership in meeting was voluntary, and meetings' control over an individual's actions depended on his or her consent. And Friends did not always agree on the right of meeting to intrude in domestic affairs. Elizabeth Sandwith Drinker, for example, a strict Friend whose husband was a wealthy businessman and elder, complained about the intransigence of Philadelphia Monthly Meeting when her daughter sought to apologize for a marriage out of unity (by a priest). The Free Quakers of Philadelphia, who had been disowned for supporting the American Revolution, created a new meeting that would not disown for any cause. In the late eighteenth century supporters of Hannah Barnard in London Yearly Meeting decried the strict enforcement of the discipline.[34] I believe that in America there were always some Friends opposed to a rigorous imposition of plainness. They stayed within the meeting as "backbenchers" and rarely attended meeting for business or did tasks for the meeting, but they considered themselves and were seen by others as Friends. In theory meetings had enormous power over individual behavior, but considerable evidence suggests that to a large extent the implementation of plainness was self-imposed.

The quantitative data compiled by Jack Marietta in his study of Philadelphia Quakerism show that meetings rarely disowned in the early eighteenth century and that Friends would labor with individuals for years in an effort to persuade them to apologize.[35] But after 1755 the discipline was more rigorously enforced, many of those disowned had a variety of offenses, and the meeting operated more quickly to purge dissidents. Marriage out of unity and violation of the peace testimony were the primary causes for discipline, perhaps because these offenses resulted from conscious decisions and were known and understood by outsiders. So, as Friends phrased it, "the reputation of truth" was involved. Marietta demonstrates that the increased willingness to disown was a part of a revitalization movement in Philadelphia Quakerism. Similar revivals in discipline occurred in London in the 1760s and in New England and North Carolina in the 1770s. The Philadelphia reform was spearheaded by some of the wealthiest families, for example the Pembertons, whose wealth influenced their definition of plainness. Plainness as practiced by schoolteachers John Woolman or Anthony Benezet differed markedly from that of wealthy merchants in Newport, London, or Philadelphia. Often when people were disowned for violating plain-

ness in speech or dress they had violated several Quaker testimonies, and plainness was listed as a symptom of a person's total falling away from the faith. It is important, however, not to assume a uniformity in either the practice or the discipline of plainness, even within a given monthly meeting.

The ideal of a plain style could not have endured for nearly two hundred years unless it met the needs of Friends dedicated to preserving their community in the midst of a general society that was either apathetic or hostile. In essence, Philadelphia Friends acted as though the authority of the meeting were invested equally in silent meetings and plainness. To deny the need for distinctive dress or speech seemed to attack the very foundation of meeting, even the claim that God could be experienced in silence. Not recognizing the changes that had occurred at the end of the seventeenth century in legalizing the plain style, eighteenth- and nineteenth-century Friends saw an attack on any of the distinctive customs as undermining all the legacy of George Fox, William Penn, Robert Barclay, and other pillars of the faith. These men had proclaimed that mortification was a necessary good and that changing fashions were a sign of vanity. So even if to outsiders plainness in speech seemed an affectation, maintaining it was important to sustain a Quaker culture in Great Britain and America. Even on the street, a Friend should be always able to recognize a fellow Quaker.

Undermining Plainness

On both sides of the Atlantic, rethinking and eventually reinterpreting the meaning of or jettisoning the practice of the plain style came during the mid-nineteenth century as part of a new evangelical synthesis of Quaker faith and practice. In America evangelicalism is associated with the revivalism that stimulated the growth of Baptists, Methodists, and Presbyterians. The primary mechanism of evangelicalism was the revival, but revivalism became influential among southern, western, and midwestern Friends only after the Civil War and never became normative for evangelical silent-meeting Friends on the east coast of America and in Great Britain.

Evangelicalism was a reaction against the rationalism of the eighteenth century, which had ushered in deism, a religious perspective that responded to the emotionalism of the French Revolution by downplaying mystical experience. For evangelical Christians and their Quaker allies, the necessity of a personal, emotional experience of Jesus—conversion—defined the essence of the faith. They also insisted that salvation required emphasizing the outward authority of the Bible and the atoning death of Christ. Evangelicals

placed a strong emphasis on good works, forming societies to end slavery, promote temperance, and educate the poor in Sunday schools and the middle classes in public schools and colleges.

An evangelical emphasis appeared among English and Irish Friends at the end of the eighteenth century. The first Quakers on both sides of the Atlantic who became evangelicals tended to be well educated, prosperous, and activists for reforms such as asylums and penitentiaries. In their reading of Quaker history, they claimed to have discovered that the founders were evangelicals. Hence in their ministry and writings they sought to return Quakerism to its roots. They preserved the silent meeting and the plain style of life but stressed the outward work of Jesus' crucifixion and resurrection as the means to salvation.

Seeing the dangers from Enlightenment rationalism (and later of Unitarianism), the evangelicals sought to root out heresy among Quakers by promoting education and Bible reading. As traveling ministers, they propagated evangelical Quakerism along the eastern seaboard of America as well as in new meetings in Ohio and Indiana (Figure 2.1). American Quaker evangelicals were noted for their activism and cooperation with other Protestants in a wide variety of benevolent associations.

With the confidence of reformers who are certain they possess truth, the evangelicals sought to impose their definition of Quakerism on quietist and mystical Friends who had traditionally opposed theological learning— "head knowledge," they called it—which reduced the reliance on direct experience of God. For these country Friends, convincement (conversion) was a slow process fostered by the submissive or tender spirit engendered by the plain style of life. They emphasized the presence of an Inward Christ more than the historical Jesus, and they believed in a gradual purging of self-will rather than forensic salvation. For quietists, the self-denial that occurred by dressing in Quaker drab facilitated an inward tenderness. They remained suspicious of cooperation with non-Quakers in organizations to do good, eschewing Bible, tract, and temperance societies. Friends, the opponents of evangelicalism insisted, should resist becoming like Presbyterians.

By 1830 evangelicalism had replaced quietism as the dominant theme in British Quakerism—a process that occurred with some friction but without a major schism. In America, however, the evangelicals' attempts to reform Philadelphia Yearly Meeting brought such deep animosity that in 1827 a major schism occurred between the Orthodox (evangelicals and quietists) and the Hicksites (a mixture of rationalists and quietists united primarily in their determination to resist the Orthodox).[36] Proponents of each group then managed to spread the schism throughout most of the United States.

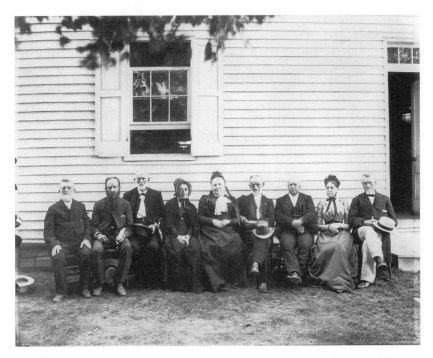

Figure 2.1. Traveling ministers at Indiana Yearly Meeting, 1899. Courtesy Friends Historical Library, Swarthmore College. From left to right, as noted in the original caption, Wm. Foulke, Alvan Shoemaker, Jos. Scoffield, M. Walton, R. Wilson, I. Wilson, J. J. Cornell, S. Cornell, Edward Coale. The minutes of the meeting, held in Fall Creek Meeting House, included minutes of unity from Margaretta Walton (Pennsylvania), Edward Coale (Illinois), John J. and Eliza Cornell (Baltimore), and Ruth C. and Isaac Wilson (Ontario).

The significance of the spread of evangelicalism to the plain style is threefold. First, in Britain evangelicalism brought an official repudiation of the plain style by the 1860s, though in practice it had occurred years before. Plainness seems to have disappeared in the American midwest at just about the same period. After the Civil War, Indiana and Ohio meetings no longer disciplined for violations of the plain style. Second, in the Delaware River Valley, the schism delayed the repudiation of the plain style as Hicksite and Orthodox each tried to prove that only they maintained true Quakerism. The schism effectively postponed by at least thirty years the official ending of plainness by the Hicksites, and it was not repudiated in the Orthodox

discipline until the twentieth century. Third, the evangelical repudiation of plainness brought a new emphasis on moderation in Quaker material culture called "simplicity," which would be continued by liberals in the twentieth and twenty-first centuries.

During the 1860s London Yearly Meeting stopped disowning for marriage out of unity, allowed gravestones and wearing mourning, and repudiated negative attitudes toward art, music, and literature. "Thee" and "thou" speech, affirmations instead of oaths, and plain dress were no longer mandatory.[37] Pacifism was the one element of plainness that was publicly maintained, although in the privacy of homes some Friends continued to use thee/thou speech. In the place of plainness would come new testimonies on strict observance of the sabbath, temperance, and missionary outreach to the poor at home and heathens abroad. The meetings still warned against superfluity in dress and furniture, but the key element would be an elastic definition of moderation and usefulness.

British Friends repudiated nearly two hundred years of Quaker tradition of plainness because they concluded that the testimonies were jeopardizing the survival of the Society of Friends. Many Quaker children were disowned for violations, and restrictions about plainness created barriers for new recruits. If present trends continued, the Society of Friends seemed destined to dwindle into numerical insignificance. Equally important, evangelicals found it difficult to defend the plain style as a product of divine revelation or to insist that only Friends understood the Bible correctly. Instead, British Quakers looked critically at the founders of their faith, trying to separate the chaff from the kernel of their message. And they concluded that Fox, Barclay, and Penn were often wrong; they had undervalued the historic Jesus and the Bible and placed too much stress on the Inward Light, thee/thou speech, plain dress, and refusal to take oaths. These and the anti-intellectualism of early Friends were chaff, but silent meetings and evangelicalism were the kernels that needed to be preserved.

Rather than seeing Friends as a "peculiar" people set apart, British Quakers sought to work along with other Protestants in proclaiming Christ crucified, particularly to the unchurched working classes who might be inclined to various kinds of social radicalism. The influence of prominent Quakers, including Joseph Sturge—an industrialist, abolitionist, philanthropist, and peace worker—persuaded London Yearly Meeting of the need for a new emphasis. Sturge promoted adult schools with Bible readings, hymns, and evangelical sermons for his factory workers and the unchurched poor. New members coming out these schools halted the numerical decline while bringing slow growth to British Quakerism.

Reformers did not abandon what they saw as the valuable elements of the plain style; instead, they sought to make the testimony relevant by stressing only part of its earlier meaning, moderation and utility. Bowing to fashion was still deemed wrong, as it came from a spirit of vanity. Late nineteenth-century tracts published in London and Philadelphia argued that young women wearing too frivolous dress would appeal to the wrong sort of men and might be seduced into prostitution. Quaker ladies, whose class would protect them from such contacts, should dress so as to provide an example for working-class girls.[38] Quaker dress should reflect the "means of the wearer" because "simplicity is not a contradiction of good taste." Friends should resist the "self-interest" of dressmakers who, while acting as "our servants," added fashionable excess as a means of increasing cost. Thrift was a sign of moderation, which defined a good wife; purchasing costly furniture was a sign of her excesses, which might lead to a husband's bankruptcy. Victorian plainness meant that Friends should practice "Simplicity, Moderation, and Self-Denial," remembering that Christianity required mortification of the will.[39]

In the post-Civil War period evangelical Friends in the American midwest repudiated both the plain style of life and traditional forms of silent worship. Instead, they embraced revivalism. Traveling evangelists—and by the 1890s paid ministers—conducted worship services including sermons, readings from Scripture, pastoral prayers, hymns, altar calls, personal testimonies, and choirs.[40] Like other evangelicals who became part of the holiness movement of the late nineteenth century, Friends who participated in what was now called "programmed" worship interpreted the Bible literally and strongly opposed what they saw as the corruption of the organized churches and the worldliness of too many Protestants. Holiness Quakers jettisoned many distinctive teachings of early Quakers: the Inward Light or Seed of God and plain language and dress. These testimonies stood as barriers to revivals. Instead, they made an instantaneous conversion experience necessary for church membership, advocated temperance and missionary activities at home and abroad, and opposed card playing, novel reading, makeup, and fashionable dress for women. In their buildings, which they called churches rather than meeting houses, they added steeples and stained glass. The interiors of such Friends churches resembled other Protestant churches, with pulpits, altars, choir lofts, pianos, and organs. The plain style now meant that Quaker conduct and appearance were like that of other Holiness Protestants. The holiness-revival emphasis brought rapid growth to the Quaker population and meant that the numerical center of American Friends shifted from the east coast to the midwest and far west.

However, a few Friends living in Ohio, Kansas, New England, and Iowa wished to continue to combine moderate evangelicalism with silent meetings and the plain style. The result was another series of schisms by groups called Conservative Friends. These Conservative Friends, who lived in rural areas, managed to preserve distinctive language and clothing into the twentieth century. But while they successfully maintained elements of a Quaker culture including quietist theology, eventually even they succumbed to machine-made clothing and store-bought furniture.

East coast Friends responded variously to increased questioning of the value of plainness. Before the Civil War a small group of self-named Progressive Friends centered at Kennett Square, Pennsylvania (and with adherents in New York and Ohio) had formed meetings opposing Quaker discipline and espousing individualism in religion and social reform.[41] The dress reform of most interest to Progressive Friends was not plainness but the right of women to wear bloomers. Photographs of pre-Civil War Pennsylvania Progressive Friends show no distinctive dress.

By the mid-nineteenth century Hicksite meetings began dropping plainness altogether. Genesee Yearly Meeting in upstate New York in 1842 allowed a Quaker and non-Quaker to marry, so long as it was done in the manner of Friends. Plainness was defended as rejecting "vain fashions" in the interest of "decency, simplicity, and utility." In New York Hicksite Yearly Meeting, as in London, the crucial debate on plainness originated in a dispute over whether Friends should now allow tombstones in Quaker cemeteries. This innovation was permitted in 1859.[42]

Soon after the 1827 schism Philadelphia Hicksites had accepted diversity in plainness, making no effort to control dress but exhorting members to observe moderation in all outward possessions.[43] Elderly Friends and ministers, however, tended to preserve traditional dress. Lucretia Mott, for example, dressed plainly with a bonnet, shawl, and dark-colored gown, yet she became a strong advocate for easing the discipline, had social connections with Progressive Friends and Unitarians, and worked alongside non-Friends for abolition and women's suffrage. She advocated better Quaker schools, helped found Swarthmore College, and demonstrated her modernity by supporting the Philadelphia College of Art.

By the 1860s there are photographs of ceremonial occasions—such as a gathering at Race Street Meeting House in 1865 and the opening of Swarthmore College in 1869—which for the first time allow accurate views of the way most Friends dressed. Their clothes can be described as Victorian Quaker; that is, no man is dressed in eighteenth-century knee breeches or a broadbrimmed or cocked hat; some men wear caps and others stovepipe hats; and

most have heavy coats, with or without collars. It is difficult to be certain, but coats with collars seem more prevalent than those without. A few of the older women, like Lucretia Mott, wear a distinctive plain dress, but younger women appear very fashionable. The women have shawls or scarves and several styles of bonnets; some of the dresses have ruffles and other signs of ornamentation, but there is no jewelry. Photographs do not show color; but it appears that plainness was established less by the cut of garments than by wearing drab—olive or brown. The early graduates of coeducational Swarthmore College are pictured wearing fashionable but dark-colored clothing. When the Hicksite Friends General Conference was organized in 1902, pictures of the gathering show that, except for a couple of elderly women, any distinct Quaker garb had disappeared.[44]

Swarthmore in its early years was both boarding school and college. The rules of the college on dress seem designed for the young: "Parents sending their children to Swarthmore are earnestly desired to aid the Faculty in controlling the growing tendency to extravagance and display. Although no form of dress is prescribed for either sex, such plain attire as is appropriate to school life is especially recommended; expensive materials and unnecessary trimmings are discouraged, and ear-rings, bracelets and necklaces prohibited."[45] This advice should be contrasted with Orthodox Westtown School, where parents were told that garments insufficiently plain would be altered.

Meeting houses and Swarthmore College buildings are another indication of the late nineteenth-century Quaker aesthetic. The original main building at Swarthmore had a very austere façade with a mansard roof, but after it burned in 1881 Parrish Hall was rebuilt with an elegant Second Empire convex hipped mansard roof, dome, and classical revival porch.[46] By contrast, the college's meeting house (ca. 1879) had no ornamentation inside or out and, unlike late eighteenth-century meetings, it has no separate entrances or interior partitions to separate men and women.

The Hicksite branch of Philadelphia Quakerism officially ended endorsement of eighteenth-century definitions of the plain style only when they revised their *Book of Discipline* in 1896. The main body of Hicksites managed to accept theological diversity between quietists and rationalists—some of whom identified with the Transcendentalists. These Friends began using the terms "Inner Light" or "Inward Light" in an effort to assert that Fox's "that of God in every man" recognized the inherit nobility of all peoples. Traditionalist quietists thwarted attempts by liberals to end disownment for marriage out of unity for nearly fifty years, even though nearly 40 percent of marriages were to non-Friends.

The conclusions seem clear. By 1900, for Hicksite Friends, outward manifestations of the plain style survived mainly in meeting houses. Neither speech, dress, furniture, nor houses remained distinctive. Friends still deplored excess and wanted moderation and simplicity, but the peace testimony was the only clearly defined surviving facet of eighteenth-century plainness. Pacifism meant that Friends would not serve in wars. Rather, they would work in the general society to create conditions to foster peace. Because the twentieth century was filled with wars, pacifism has remained a central focus, even though during two world wars most eligible Quaker young men served in the military.

For Orthodox Friends, the story of the decline of plainness is more complex. At the time of the 1827 schism the Orthodox, who made up about one-third of the members, were an amalgam of quietists and evangelicals, both of whom distrusted Hicksites. When later schisms in New England and Ohio between quietists and evangelicals threatened to spread, Philadelphia Orthodox Friends cut off formal contacts with all other Friends as the price of maintaining internal unity. The quietists (also called Conservative or Wilburite), who may have been a majority, succeeded in maintaining—virtually unchanged— all the testimonies on plainness until after 1900. These Conservative Friends kept to the plain style of dress and speech, refused to read novels and plays, disowned for marriage out of unity, and distrusted higher education.[47] The Conservative Friends lived in the country or had only recently moved to the city, and they identified the traditional ways with authentic Quakerism. So long as they occupied a significant role within the yearly meeting, no changes could be made.

The Evangelicals, unable to control the yearly meeting, instead created Quaker benevolent associations, including Bible and tract societies. Believing that intellect should be used in all facets of life, including religion, they supported Haverford College for men and, after 1885, Bryn Mawr College for women, each with architecture that reflected the tension between "stylish" and "plain." Pictures of the graduating classes at Haverford show that for men plain dress had disappeared by 1859. (The main variable was the tie, which went from bow to long in 1871 and back to bow by 1895.) The colleges gradually broke away from other restrictions, allowing singing, reading novels, and participating in plays (which were called "charades" in an unsuccessful effort to avoid criticism). At Haverford literary societies rather than the college had purchased poetry and novels; in 1887 these books became part of the college library.[48] Paintings of presidents and distinguished professors hung on walls.[49] Haverford had a newspaper, YMCA, social clubs, and intercollegiate sports, even competing in football against Hicksite Swarthmore.

Until the mid-twentieth century, there lingered in Quaker colleges a distrust of the arts as not really worthy of academic study, but this had more to do with valuing science and book learning than with adherence to the plain style.

Modernism and the Simple Life

Philadelphia Yearly Meeting Orthodox officially repudiated the plain style only after the rise of modernism or liberalism, associated in America with Haverford professor Rufus Jones (1863–1948). Jones rejected both evangelicalism and quietism as distortions of early Quakerism. He also opposed any legalistic codes of conduct. Like other Quaker liberals on both sides of the Atlantic, Jones argued that the evangelicals' literal interpretation of the Bible and dogma substituted manmade words for true spirituality. Historical events, he explained, had shaped both the Bible and Christian dogma, and a crucial task was to treat the words in creeds as symbols pointing to a deeper reality, that man at his highest place can meet God. Neither quietists who denied that thought could lead to God nor evangelicals who made God too transcendent had understood that the "spirit of man is a candle of the Lord."[50] As a result, Jones believed, Quakerism had ossified and needed to be liberated by a restoration of the original vision of George Fox. For Jones, Fox was a mystic who had overcome Puritan pessimism with a biblically based positive view that all could experience God. Such experience could become the foundation of a far-reaching transformation of society.

Modernists saw God as immanent in creation. Friends needed to emancipate themselves from the rigidity of a plain style that opposed beauty in order to learn to appreciate God in nature, music, and painting. Goethe, Bach, Beethoven, Rembrandt, Michelangelo—all the fine arts—should be appreciated as symbols of humans reaching for God. A mother's love for her child was similar to God's love for humanity manifested in Jesus Christ. The best of human culture showed the handiwork of God. Friends would continue to use silent meetings as their form of worship, but they now could appreciate all forms of creativity—even non-Christian religions—as vehicles by which God could communicate his love for all. For Jones, plainness was sectarian, legalistic, dualistic, and devaluing of nature. Simplicity was the opposite, in fact, a "quality of the soul," "a joyous companionship with God."[51]

Amelia Gummere's 1901 book *The Quaker: A Study of Costume* can be read as a liberal manifesto against the plain style, an announcement that plain dress was now a relic to be studied as history. Gummere claimed to

bring "higher criticism" to the study of plainness in an effort to show that Quaker costume had evolved over time according to the dictates of fashion.[52] She maintained that there was no one specific Quaker dress sanctioned by years of experience. Instead, Quakers had followed popular dress, only slightly behind, so that they always looked odd. The meetings' legalistic efforts to dictate correct dress had destroyed the true spirit of Quakerism. What needed to be restored was Fox's original vision of "a simple, unadorned costume of the men of his generation." On the title page, Gummere quoted Penn: "the more simple and plain they (clothes) are, the better." Her implied conclusion was clear: Philadelphia Yearly Meeting quietists, by insisting on distinctive drab clothes, had distorted Fox and Penn's original vision of simplicity in dress, had substituted a legalism, and had misunderstood the evolution of Quaker costume.[53] Modern dress was simple.

By the 1920s the two Philadelphia Yearly Meetings embraced theological modernism and their growing similarity helped enable them to unite in 1955. Friends came to resemble other white Protestant middle- and upper-class eastern Americans, and it became increasingly impossible to find any distinctive Quaker material culture. Friends dressed, talked, and lived like other Americans, with some living in elegant fashionable houses and others following what they referred to as uncluttered lives.[54] The *Discipline*, now renamed *Faith and Practice*, relies on persuasion rather than authority.[55] Members who have no contact with meeting or whose actions contradicted Quaker values can be asked if they wish to continue to be Friends; if no answer is received, such people can be dropped from membership. It is not uncommon for people to resign from Friends or to be removed because of lack of contact, but disownments are rare.

Plainness dissolved into the more amorphous concept of simplicity. The 1961 Philadelphia Yearly Meeting statement on simplicity incorporated elements of the older testimony:

Friends are watchful to keep themselves free from self-indulgent habits, luxurious ways of living and the bondage of fashion. . . . Undue luxury often creates a false sense of superiority, causes unnecessary burdens upon both ourselves and others and leads to the neglect of the spiritual life. By observing and encouraging simple tastes in apparel, furniture, buildings and manner of living, we help to do away with rivalry and we learn to value self-denial.

But this does not mean that life is to be poor and bare, destitute of joy and beauty. All that promotes fullness of life and aids in service for Christ is to be accepted with thanksgiving. Simplicity, when it removes encumbering details, makes for beauty in music, in art and living.[56]

Here simplicity is like "sincerity," removing "sham and artificiality" and facilitating "rectitude of speech" and avoiding "flattering titles." Clearly there are elements of the earlier testimonies implied, but the tone is new. Plainness as social justice, as mortification, as a boundary that distinguishes Friends is muted. Legalism is gone. There is no equation of Christianity with mournfulness and sobriety. Instead, a life "centered in God" now brings "gladness," "eases tensions," reduces "clutter," and does not require "conformity to uniform standard."

The 1997 Philadelphia Yearly Meeting statement dropped the section heading "Simplicity" and replaced it with "Stewardship," "Right Sharing," and "Walking Gently over the Earth." Friends were asked to consider whether their lifestyle was a seedbed for war, economic inequality, and destruction of the environment: "Voluntary simplicity in living and restraint in procreation hold the promise of ecological redemption and spiritual renewal."[57] "Simplicity" again linked with "integrity" appeared in the section of queries and by itself as the subject of sixteen quotations from George Fox, William Penn, John Woolman, Rufus Jones, and others using all the definitions of simplicity described here. It has become "an appreciation of all that is helpful towards living as children of the living God." Simplicity has become a basic ethical orientation involving right attitudes to dress, speech, furniture, gambling, alcohol, addictive drugs, family planning, moderation, voluntary poverty, generous giving, and social responsibility. Simplicity can now encompass all Quaker attitudes toward material culture and social responsibility, stretching from the seventeenth century to the present day. The expansiveness in the concept of simplicity echoes the variety in lifestyle of modern Quakers. The unanswerable question is, "Has the vagueness in the modern quest of 'simplicity' compensated for a loss of sobriety and mortification required by earlier formulations of Quaker plain style?" In repudiating a moralistic legalism, Friends made the individual the judge of simplicity.

Quaker attitudes toward material culture began with the earliest denunciation of superfluity and fashion and became during the 1680s an all-encompassing plain style that affected speech, dress, marriage, and family life. For the next two hundred years, plainness served as a hedge that kept Friends enclosed and the world out. Yet even while they condemned the world's fashions, Quaker dress and architecture reflected outside influences. By the mid-nineteenth century evangelicalism undermined the rationale for plainness in Britain and the American midwest. Change came more slowly to Philadelphia Friends, with official repudiation of plainness coming to the Hicksites in the 1890s and to the Orthodox not until after World War I, even

though the practice had changed years earlier. Simplicity became the new norm for the Quaker aesthetic. Simplicity allowed Friends to dress, talk, and build houses like their neighbors while cautioning against undue emphasis on material objects.

During the three hundred fifty years of Quaker life plainness has had a variety of meanings, and the practice of Friends has been shaped by geography and era, class and politics, the Bible and theology, conflicts and personalities. For Fox, Penn, and Woolman the testimony condemning superfluity and endorsing plainness required obedience to God; modern Quakers agree. The difference is that early Friends knew with certainty the lifestyle God demanded; modern Quakers find truth neither so plain nor simple.

Part I
Quakers as Consumers

Introduction

Patricia C. O'Donnell

When I orient new researchers to the Friends Historical Library, I like to stress that, while Quaker terminology has not changed much in three hundred years, its meaning has. Like other conventions of Quakerism, vocabulary has been subtly altered over time and through changing cultural contexts. I could give our researchers the same warning about the rules and principles of Quaker "style"—so-called aesthetics. Despite the static image of the face of the Quaker Oats man, the appearance of the Friendly world was never monolithic. In these chapters, scholars wrestle with some of the problems students of Quakerism face because neither Quakers nor their language could remain static in the face of change.

In the first discussion, Susan Garfinkel attempts to decipher the meaning of plainness, based on a study of third-quarter eighteenth-century high style Philadelphia case pieces with documented Quaker and non-Quaker provenance. She concludes that the end products are not substantially different from non-Quaker furniture of the same era. The physical expression of plainness in Philadelphia before the end of the eighteenth century was affected not only by attention to the Inward Monitor (a personal interpretation of the dictates of Truth) but also by a wide range of factors such as the purchaser's economic status, the maker's practices, the availability of materials, and fashion. She further argues that it "is not the form of the object which determines its theological meaning."

The personal interpretation of the dictates of Truth in the realm of material expression was also influenced by a concept eighteenth-century Quakers labeled "singularity." Friends struggled with the sometimes seemingly opposing forces of singularity and plainness. Nathaniel Luff (1756–1806), a physician trained in Philadelphia but who spent his professional life mostly

in Kent County, Delaware, was a convinced Friend who had difficulty explaining plainness to a craftsman he engaged in 1803:

and being somewhat exercised respecting the polish of coffins and ridging as things unnecessary, I requested the cabinetmaker to have the lid flat and without polish, reminding him, at the same time, that it did not proceed from fancy or a desire of being singular, but, as I apprehended from motives of duty. The same man made a cradle for this child, and I directed it to be made of poplar or pine, not of walnut, and without a top, as is pretty customary; my reasons were, it would be much lighter and easier moved about, better to put the child in and to take him out, and also as my first child by my former wife was rocked in a plain and not a costly one, and I did not wish this to have any better. When it was brought to my father-in-law's, G[arrett] S[ipple], for we then lived there, he seemed offended, and asked why we did not get a walnut one—or it might have been painted he said; so that when this duty appeared to be presented to my mind, these occurances were revived, and he being at our house a few days before, to see my wife, who was much indisposed. It seemed to be fixed in my imagination that if G.S. saw it in this unusual form, he would be displeased, and attribute it to whim or singularity.[1]

Singularity—a synonym for individuality or distinctiveness—could fuel pride, contrary to the dictates of Truth. Even a Quaker luminary like John Woolman (1720–1772) struggled to maintain a level of material consumption that would not call attention to himself or seem ostentatious. He noted while speaking of the plight of slaves in his journal in 1761:

thinking often on these things, the use of hats and garments died with a die hurtfull to them, & wearing more cloaths in summer than are usefull grew more uneasie to me, believing tm to be customs which have not their foundation in pure Wisdom. The apprehension of being Singular from my Beloved Friends was a strait upon me, and thus I remained in the Use of Some things contrary to my Judgment.[2]

The singularity of wearing an undyed hat—in recognition of the role of slavery in the production of certain dyes—was a trial to Woolman, which, by his own account, caused some Friends to avoid him. By adhering to one Quaker Truth—underscoring human equality by taking a stand against slavery—Woolman felt he might run afoul of others—appearing odd and out of unity with his fellow Quakers.

Wyck, the Quaker homestead that is the subject of John M. Groff's chapter, can be seen as a visual metaphor for nineteenth-century Philadelphia Quakerism. Remodeled by architect William Strickland in 1824 under the direction of Reuben Haines, Wyck can be said to represent the natural result of a community that withdraws from the public limelight to protect its

own integrity. Haines's withdrawal from direct involvement in the social and political life of Chestnut Street, symbolized by his move to Germantown in 1820, is somewhat emblematic of the withdrawal of many Friends in the nineteenth century. In addition, the renovation itself—with the retention of the outer shell of the plain stone farmhouse (except for the removal of the windows which faced the most traveled road)—did not call public attention to Reuben or his family. Inside, however, the "house was transformed in its practicality as well as simple beauty." Groff further states that "comparisons of upper-class Quaker households and non-Quaker households in Philadelphia and Germantown" in the 1810–30 period "suggest that the differences are of scale, and level and type ornamentation." Quaker families seemed to show an awareness of fashion as opposed to an obsession with it, and the differences were sometimes manifested in the amount of time and effort spent making choices. There should be no frivolous pastimes: one learns about art or enjoys beauty, but entertainment is not a goal. The Haineses did not appear to seek status enhancement through either knowledge or acquisition. Acts of private consumption, not public display, were the key. In his quote from Bronson Alcott's journal, Groff makes reference to Reuben Haines's "private cabinet of curiosities."

The third contribution focuses on Quaker portraiture in eighteenth-century Philadelphia. Dianne Johnson's thesis is that while today there is an expectation that Quakers should be unique in how they chose to be portrayed, the evidence of surviving paintings indicates that the choice was not as uniform as was previously thought. Like Garfinkel, she argues that for Quakers as consumers, theology merged with economics and social position in shaping such decisions. She further adds that material success, including patronage of the arts, was thought to be acceptable in the eyes of the Lord— and signaled evidence of diligence and God's favor—as long as it was not considered primary in life and was kept within moderation. Concurring with J. William Frost's earlier argument, Johnson finds that Philadelphia Quakers made no attempt to fly in the face of social convention. Johnson supports her thesis with a quote from Isaac Norris in a letter to Joseph Pike (1707/8) that although moderation should be emphasized, men of his social position should not "wear the same and live at the same rate within-doors. Every man ought soberly and discreetly set bounds to himself and avoid extremes, still bearing due regard to the society he is of."

However, Johnson asserts the difference between furniture and portraits in that the latter has little functional use other than to signal status. The so-called Quaker plain style was for some not merely the absence of excess ornament but the presence of an inherent usefulness. Hence some

Friends like John Woolman who condemned superfluity—defined as super-abundant excess, an amount greatly beyond what is sufficient, necessary, and advantageous—as evidence of corruption might well find portraiture inher-ently wasteful, the root of social and economic disharmony. He asserted in his journal in 1761:

I believe [God] hath provided that so much labour shall be necessary for mens Sup-port in this world as would, being rightly divided, be a Suitable Employment of their time, and that we cannot go into Superfluities, nor grasp after wealth in a way con-trary to his wisdom without having connection with some degree of Oppression, and with that Spirit which leads to Self exaltation and strife, & which frequently brings Calamities on Countries by parties contending about their claims.[3]

The number of Quakers in the middle of the eighteenth century who com-missioned portraits and later were disciplined or disowned as documented by Johnson is significant, even if the offense was not directly related to a de-viation from plainness.

It is clear from these essays and from original sources that the process of disciplining errant members was complex and often unrecorded. The act of disownment by one's meeting was only one aspect of the system of discipline within the Society of Friends. Much of the process of behavior correction never came to the attention of the meeting for business. There were at least three levels of such correction: by example and role models, particularly of ministers and elders; by private contact; and by formal action, possibly lead-ing to an acknowledgment or disownment. Ministers and elders—lay mem-bers who were publicly designated by the community—were expected to act as role models, and were themselves held to a high standard. John Hunt (1740–1824), a minister from Evesham, New Jersey, gently chastised Richard Reynolds (1735–1816), an English Friend traveling in the ministry in the New World in 1786 for wearing a "Red Spoted Handkerchief," for he observed that the offending article of dress was "one of the first things that our children be-gin to crave and teese their Parents about."[4] Ministers traveled throughout the Quaker world, and at other times signaled acceptable changes in style. Nathaniel Luff reflected in 1798:

It has been the practice for a long time for the Elderly Quaker women, and especially such as fill the superior stations in the church, to wear beaver hats; when fur was plenty, perhaps it might have been the invention of some ingenious Friend of that calling to advance himself in life, or extend his avocation, but from whatever cause it proceeded, it had the preceding effect, and it became a pretty certain badge of dis-tinction and respect. Not many years hence, a Friend or Friends from London, on a

religious visit to America, wore silk bonnets, which before would have been exempted against, but on examination were found actually to consist of less superfluity and expense; and as the mere habit cannot in itself add to, or diminish from (only our minds incline thereto), the beaver hat is now less frequently worn, and many appear in the line of the ministry differently appareled.[5]

In the eighteenth and nineteenth centuries, Quaker families were regularly visited by ministers. Family members were also expected to suggest appropriate behavior to those who appeared to stray; a written note attached to a plain checked silk dress stored in an attic in New York state and dating from about 1830 is indicative:

This is my dress when I was six or seven years old. I never had a short dress as Friends thought they were not plain. Aunt Sarah Merrit took me in hand once after meeting and told me the dress was too gay for a little Friend. She said not to wear it any more—to tell mother I did not want to wear it. After that I was afraid to wear it.[6]

Much of the business of the meeting for discipline was accomplished "out of doors,"[7] namely, not in the context of either the preparative or monthly meeting for business. Monthly meeting minutes suggest that the behaviors most likely to incur disownment in Philadelphia before 1780 were those which either occasioned financial risk to the meeting (like going into debt) or, even more important, exposed the meeting and the Society of Friends to public censure. Acknowledgments—read publicly and accepted by the meeting—were the desired result of the visit of the committee appointed to visit the offender. But meetings were also increasingly troubled by those who claimed to be Friends—and there was clearly an economic and social advantage in early Philadelphia to membership in the Society of Friends—but whose lifestyles threatened the survival of its testimonies. Quaker scholars have suggested that eighteenth-century reformers in Philadelphia Yearly Meeting could be divided into two overlapping groups, those who were primarily interested in reaffirming the discipline—like the Pembertons—and those like Woolman who were interested in issues of humanitarian conscience.[8] The result was an increase in the number of disownments after 1755 when a committee of Philadelphia Yearly Meeting revised the disciplinary code.

Dress and plain speech formed a barrier between the Quakers and the world. Elizabeth Gurney Fry (1780–1845), a plain English Friend, noted in her journal that wearing Quaker dress helped her avoid plays, dances, and other occasions of transgression.[9] It is not surprising that Quaker attire became more and more uniform toward the end of the eighteenth century. Dress was

the most public of symbols. But the increasing emphasis on a more out-wardly uniform façade was still challenged by some within the Society of Friends as detrimental to the life of the Spirit. Joshua Pusey, an elderly Quaker from London Grove, Pennsylvania, cautioned his neighbor, John Jackson, in 1797 that one should rely more on the Inward Monitor and less on an almost legalistic interpretation of the testimony of plainness:

> Thy company at our meeting the other day was very agreeable to me, but there were a few reasons thou gave in the Meeting for Business for Friends declining the use of Red, Black, and Blue Colours, which did not at that time, nor since, Appear clear to me as the real reasons; to the 1st—thou signified it was because that was the color the Military people were distinguished by in England, to the 2nd—because it was the colour that Clergy usually wore as a distinction from the Laity. To the 3rd—because the Presbyterians or their Clergymen wore it as a distinction. Now I do not undertake to assert these were not the reasons that some might have for declining these colours, But they do not appear to me to have been the most sound and most prevalent reasons amongst Friends for their disuse, I hope it will be considered as a friendly freedom, becoming Brethren desirous of Mutual benefit; I apprehend the power of Truth operating on the mind of man when given way to, has a tendency to subject his Will to that of his Maker, leading into a life of self Denial, Humility, Christian simplicity, and plainness, and as this is experienced to prevail in the mind it is found to stand oppos'd to many things which do not appear to cooperate therewith, and amongst others those colours alluded to being, perhaps, some of the most remote from that plainness, & Simplicity of Garb becoming a follower of the plain and 'umble pattern, I believe to be more probably reasons why Friends have rejected them; which I nevertheless submit to better information.[10]

It is interesting to observe that the Haines family belief that plain dress was a veneer that would not disguise character deficiencies, as cited by John M. Groff in the second essay, continued into the nineteenth century.

Veneer or not, foreign visitors and satirical prints found it easy to use dress and speech to caricature members of the Society of Friends in Philadelphia in the second half of the eighteenth century. A hundred years later, Amelia Mott Gummere suggested that Wilburites and Gurneyites could be distinguished by the cut of their bonnets. But was this the case in 1760? What were the visual signals that were read by their contemporaries—both within and without the Society of Friends—that implied membership in the denomination, the not-so-secret handshake of identification?

Although Mary Anne Caton addresses this question more directly, Dianne Johnson's work also allows us to examine dress by the way elite Philadelphians chose to represent themselves in their portraits. In the Quaker examples—and here I adopt Garfinkel's criterion of meeting participation to define "Quaker"—

the very fact that fabric was of the highest quality suggests that omitting jewelry and the more elaborate hairstyles was indeed a choice and not a budgetary necessity. In the middle of the eighteenth century, Peter Kalm, a Swedish naturalist who kept a journal of his travels in North America, was clearly shocked to note: "they censure all adornments [and] although they pretend not to have their clothes made after the latest fashion, they strangely have their garments made of the finest and costliest material that can be procured."[11] These visual contrasts were significant to their contemporaries.

As noted in Dianne Johnson's work, Benjamin Franklin remarked that, while certain members of Philadelphia's Quaker elite did indeed commission portraits, they did not expose the paintings to the public. Although it may be misleading at this point to make an assumption without further research, one wonders whether Norris ever expected his painting to be seen by those who were not privileged to visit his garden closet.

As a group, these essays argue against the assumed uniformity of the so-called plain style. For many Friends in the late eighteenth and early nineteenth centuries, attending the Inward Monitor was influenced by class and social position. What is not yet clear is the role of other factors such as rural/urban differences and convinced or birthright membership. And looking at Quaker decorative arts without determining the involvement of the consumer in the life of the meeting can be misleading. Yet it is also clear from these essays that the Quaker aesthetic involved a complex of meanings that we are only beginning to decipher.

Chapter 3
Quakers and High Chests:
The Plainness Problem Reconsidered
Susan Garfinkel

The Problem of Quaker Plainness

In a letter of 1768 to his brother Benjamin, Philadelphia Quaker David Ferris wrote,

> If I Believed, that Friends could not see, feel, smell, nor hear spiritually so as to Discover the Situation of their fellow members, to know whether they were sincere or not . . . I would as like be of another Society.[1]

His faith in the reliability of informed observation by a community of peers recasts the very senses in Quaker terms. In doing this, Ferris easily bridges that ontological gap between conception and perception, meaning and material, intention and interpretation that—like Inward Light and outward life—has riddled most scholarly attempts to make sense of the material world of Quakerism. Given Quakerism's internalized vision of God's word, our sole reliance on its outer, perceivable expressions has been unavoidable yet incomplete and at times unsatisfactory. Yet, unlike Ferris, we have neither the benefits of presence nor the certainty of shared belief to guide our understanding of his peers. Lacking a perceptual bridge between inner belief and its outer manifestations, how can we—as historians separated from our subjects by time and culture—gain as clear an understanding of Quaker practitioners as he does?

The dilemma of locating authentic meaning in Quakerism's outward expressions is nowhere more problematic than when it comes to the issue of plainness. A large and varied body of surviving documents and artifacts is

puzzlingly opaque about the meaning of Quaker plainness, both its defini-
tions and the degree to which members of the Society of Friends adhered to
their stated beliefs. In the absence of an articulated mapping between ideals
and always-imperfect practices, there seems to be no good way to interpre-
tively rely on what any one Quaker said or did. Nor is the problem just a
scholarly one. Some Quakers and many non-Quakers, in their own time, also
questioned the relationship of Quaker precepts to Quaker behavior in the
world.[2] Yet plainness has come to be seen as so central to any marked Quaker
aesthetic—and that aesthetic so central to perceptions of Quakerism—that
confronting the confusions of its meanings is nearly unavoidable.

This chapter addresses a question whose answers are both strikingly
straightforward and surprisingly complex. Were eighteenth-century Phila-
delphia Quakers who owned fancy, elaborate rococo furniture hypocritically
doing so despite their religious beliefs? If we are to trust the early but flawed
work of Frederick B. Tolles on Philadelphia's Quaker merchant community—
influential for describing the "growth of, or rather the decline into" world-
liness among pre-Revolutionary Friends—then the answer is probably yes.[3]
In his 1948 *Meeting House and Counting House*, Tolles first identified "of the
best sort but plain" as the supposed aesthetic compromise—and ultimate
failure—of wealthy Quaker merchants intent on enjoying the fruits of their
riches while maintaining their membership in the Society of Friends.[4] The
phrase has since become a truism among scholars seeking to reconcile a
Quaker rhetoric of religious plainness with the body of richly crafted objects
and buildings that survive. Unsure just what a "plain" Chippendale high
chest might look like, for example, most observers have assumed an inherent
dissonance in the very idea of such a thing.[5] Artifacts are seen as anomalous
and the integrity of their owners compromised. Yet, at the least, we risk
denying the validity of Quaker belief as a functioning system of meaning
if we so easily dismiss a generation of its followers as shallow, insincere, or
confused.

Our twenty-first-century sensibilities require a more richly ethnographic
approach to the eighteenth-century Philadelphia Quaker community. As-
sumptions that "plainness" is some timeless perceptual absolute devoid of
cultural context rightly leave us perplexed. By relying solely on our own
common sense we risk making what philosopher Gilbert Ryle has called a
"category mistake," in this case attempting to infer spirit from furniture.[6]
Similarly, British cultural marxist Stuart Hall argues that there is "no neces-
sary correspondence" between an ideology and its physical forms, here the
belief-based idea of plainness and the possible ways that that plainness might
look.[7] Yet the apparent dictates of Quaker plainness have for so long been

taken for granted that the possibility those surviving objects we find so puzzling might also be plain by Quaker standards has rarely been considered. A better explanation might be that the meaning of Quaker plainness is not what observers have assumed—that *within* its definition is a place for the rococo furniture some Quakers owned. Consider that, despite its emblematic rhetorical status, individual violations of plainness in possessions are never cited in the eighteenth-century records of Philadelphia's Quaker meetings. We must also consider that Quaker ideas of plainness in the third quarter of the eighteenth century were informed by a wide range of factors including— in addition to religious dictates—economic status, availability of materials, craft traditions and practices, material needs, and prevailing styles of the day. Just as belief informs objects and institutions, objects and institutions inform belief, so that each contextualizes the others within a coherent cultural system.[8] Plainness, further, is only one part of this larger complex dynamic. Not only wealthy Quakers, after all, but a wide variety of wealthy non-Quaker Philadelphians purchased and owned expensive case pieces during the pre-Revolutionary years.

The Philadelphia Chippendale high chest has often functioned as an icon of what is "best" in antique American furniture, and I trade on that strong iconic status here.[9] What if that same high chest were iconically linked to its owner who happened to be a prominent Quaker in good standing? To answer this unexpected image, this essay in fact has two subjects: the body of surviving furniture associated with original Quaker owners and the collective records of the Society of Friends in Philadelphia that reveal a code for interpreting them. Specifically considered are Philadelphia tall case pieces in the Chippendale style—both high chests and chest-on-chests—that have firm attributions to Quaker owners, and in some cases makers as well. The names of those owners are compared against records of the Society of Friends in an attempt to discern their relative religious status. Just as there is variation in the furniture, there turns out to be considerable variation in the relationships of these individuals to Quakerism, yet no strong correlation between the two emerges. Instead, I account for these variations in two important context-driven ways: by looking to Quaker religious statements about plainness for guidance in understanding both its essence and its limits, and by turning to a formal analysis of the furniture for clues about its own material meanings. An exploration of the worldview through which mid-eighteenth-century Philadelphia Quakers made sense of their spiritual and material lives—together—is essential if we are to accurately interpret them.

It is in the nature of the material world that intentions get too easily lost in translation: across time, across town, across social class, across the floor of

the meeting house. I argue here that Quaker beliefs about the material world, while prescriptive, are also fundamentally fluid and able to accommodate a wide diversity of material expressions—all the better, if intentions are hard to discern. Because Quaker belief is inherently discursive—that is, dependent on the interpretation of expressions by a community of believers rather than static texts—Quaker plainness is more important for what it does than for what it means. In the sections that follow I attempt to discover the meaningful contexts of Philadelphia high chests owned by eighteenth-century Quakers, and likewise to discover in what ways the markers of Quaker plainness were or were not embedded in their forms. Since for Friends plainness is a way of being in the world, we must likewise return Friends to their proper cultural contexts. Only by confronting the intricacy of Quaker plainness can we hope to make sense of their most complex material expressions.

The Case of Thomas Affleck, Among Others

Do Friends ever talk about high chests in their formal religious records? Consider the case of Thomas Affleck, whose name is familiar to students of eighteenth-century Philadelphia furniture. By trade a cabinetmaker, Affleck is thought to have produced some of the finest—and most ornate— furniture made in Philadelphia during the late colonial period. Among the many pieces attributed to his shop's production are the twin Hollingsworth high chests (Figure 3.1) and the Logan and Deshler chest-on-chests (Figures 3.2, 3.3a,b).[10] Affleck was also a Quaker. Meeting minutes show that upon his arrival in Philadelphia in 1763 he presented the standard certificates of removal from Aberdeen and London to the Monthly Meeting of the Religious Society of Friends.[11] He quickly became part of the Philadelphia Quaker community and was patronized by wealthy Quaker merchants who preferred to do business with members of their own religious group.[12]

Eight years later, on the 25th day of the fourth month (April 25), 1771, Affleck's name was again brought before the Philadelphia Monthly Meeting, this time in a less favorable light:

The Overseers acquainted the meeting, That Thomas Afflect (sic) has been treated with for his deviation from the Rules of our Discipline and Christian Testimony in Marrying by a Priest, Benjamin Sharpless and Samuel Wetherell are appointed to confer with him on the occasion, & use their Endeavours to convince him of his Misconduct, and Report to next Meeting.[13]

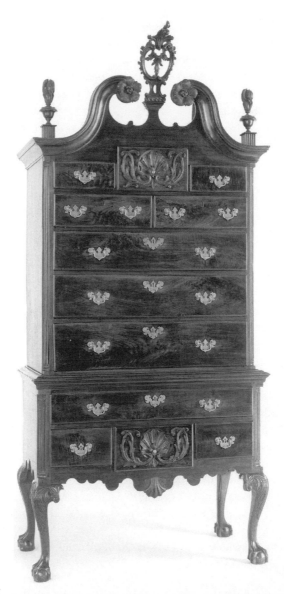

Figure 3.1. High chest of drawers owned by Hannah Paschall Hollingsworth and Levi
Hollingsworth, attributed to Thomas Affleck. Philadelphia, ca. 1777. Courtesy
Philadelphia Museum of Art: Gift of Mrs. W. Logan MacCoy, 1964-142-1. This piece
is one of a twin pair of high chests and part of a larger suite of matched furniture
made for the couple.

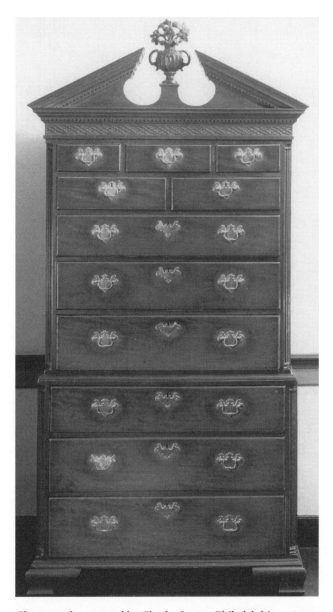

Figure 3.2. Chest-on-chest owned by Charles Logan. Philadelphia, 1760–1779.
Courtesy The National Society of The Colonial Dames of America in the
Commonwealth of Pennsylvania at STENTON, Philadelphia. 1967.015.

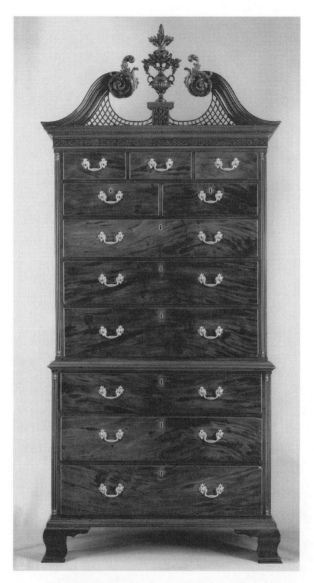

Figure 3.3a. Chest-on-chest owned by David Deshler, attributed to Thomas Affleck. Philadelphia, 1775. Colonial Williamsburg Foundation, 1983-292.

Figure 3.3b. Detail, pediment, chest-on-chest owned by David Deshler.

Note that the problem is unrelated to his furniture. Friends were expected to marry other Friends, and to do so according to the monthly meeting's requirements: the prospective couple would first make appearances at two consecutive meetings and only then marry by mutual declaration in the presence of meeting-appointed witnesses. When incorrect marriage or any other disciplinary violation was brought to the meeting's attention, the meeting initiated a formal investigation of its allegedly transgressing member.

Philadelphia Monthly Meeting of the Religious Society of Friends convened once a month for the purpose of regulating internal affairs. Both men and women met for business, but separately, and recorded separate minutes—the meeting that dealt with Affleck was the men's. The records of the Society of Friends are unusual in this way. While Quakers produced only a very small body of explicitly theological writing, they have left us instead a unique and extensive collection of minutes from meetings held regularly for business and discipline.[14] At these meetings Friends kept accounts, approved marriages, answered queries on the state of the meeting, and transmitted epistles. The bulk of business, however, was the consideration of disciplinary actions, in which the behavior of individual members was scrutinized to see that it fit within the bounds of God's Truth. The meeting "treated with" transgressing members in hopes that their errors might be corrected. In

addition to desiring group cohesion, Friends were also concerned with out-siders' perceptions of them. Thus members who continued to err despite the meeting's efforts were formally disowned by way of written testimonies.[15]

Thomas Affleck was not disowned for his marriage, although the early discussions of his case suggest that he was headed in that direction. In its minutes of fifth month 1771 the meeting noted that

The Friends appointed to treat with Thomas Affleck report they have had but little satisfaction in their visit to him, they are desired to prepare a Testimony against him if that continues to be the case on further treating with him.[16]

Affleck's case was then continued without further comment for the next two months, the second time "at his own Request," suggesting that the meeting's ongoing efforts were having their desired effect.[17]

Four months into the meeting's deliberations, Affleck's own initiative turned the proceedings of his case in a favorable direction. He appeared at the monthly meeting, as was required, with a written statement or "paper" admitting to and condemning his violation of Quaker practices. While sym-pathetic to this positive turn of events, however, the meeting did not imme-diately find the acknowledgment sufficient.

Thomas Affleck attended the Meeting with a Paper condemning his transgressions of the Rules of our Discipline and Christian Testimony in marrying by a Priest a person not of our Religious Society, and an account being given by the Friends appointed of his having manifested a desire of preserving his right of Membership; but as the Meeting has grounds to apprehend this step of his, must be a matter of Grief and Concern to his Mother, the same Friends are desired to labour to convince him of the Necessity of his showing a proper uneasiness on that Account.[18]

This situation was rectified the next time, however, when in the ninth month 1771 Affleck satisfied the meeting with a suitably revised acknowledgment:

Thomas Affleck now attending, the paper he offered last Month being altered more to the mind of the Meeting, it was Read, and Friends who have visited him acquaint-ing the Meeting that he continues in the same desire to be restored into Membership, there is ground to hope he is sincere in his acknowledgment.[19]

Affleck's return to good standing was now secured, and this sixth entry in the minutes was the last to appear concerning his marriage.

The proceedings of Affleck's case were fairly standard, as historian Jack Marietta's analysis of disciplinary actions taken by Delaware Valley meetings

in the late colonial period suggests. Between 1756 and 1783, a monthly meeting spent on average nearly five months on any particular case; two-thirds of all cases were resolved within seven months.[20] Further, from 1748 to 1783, one-third of all disciplinary cases were marriage delinquencies much like Affleck's, making incorrect marriage by far the most common offense.[21] Affleck's case was unusual, however, in one important respect. In a group of eight monthly meetings including Philadelphia's, two-thirds of marriage delinquencies for the years 1766–70 ended in disownment, while in 1771–75 three-quarters of such cases did.[22] The favorable outcome of Affleck's case placed him firmly in the minority.

As these statistics suggest, there are a variety of routes Affleck's case could have taken through the monthly meeting's proceedings. It sometimes took years before a disciplinary matter was fully resolved. Or sometimes a meeting acted quickly—Affleck might have found himself disowned after its first intervention, as that early directive to "prepare a Testimony against him" anticipates. He might, on the other hand, have felt such remorse that he appeared at the meeting on his own initiative, acknowledgment in hand, even before his marriage had been discussed. He could, perhaps, have told the Friends who came to visit him that he was interested neither in their opinions nor their Society, and resigned. Any one of these responses can be found among the many disciplinary cases dealt with by the meeting each year.[23]

As striking as the disciplinary proceedings against Affleck may seem, equally striking is the information omitted from the minutes relating to his case. What happened, for example, between the fifth and eighth months of 1771 to so drastically change Affleck's stand? The minutes remain silent concerning the particulars of this important turning point, just as they do not mention the date or location of the offending wedding, the denomination of the participating "Priest" (used in Quaker parlance to mean any sort of clergyman), who else attended, or, for that matter, the name of Affleck's bride.[24] We never see the text of his acknowledgment of wrongdoing, though disownment testimonies are always quoted in full in the minutes.

And what about Affleck's furniture? Also overlooked by the meeting, apparently, was the lavish quality of Affleck's productions, among them the mahogany tall case pieces adorned with rococo carving and gilded brasses that have helped earn him his lasting reputation as a cabinetmaker. His pieces were costly and elaborate and ornate. This omission from the minutes seems strange, considering Quakerism's concerns with issues of plainness. Plainness in speech, clothing, and furniture are all specified in Quaker documents, and Affleck's furniture just does not seem plain. How might we explain this? Were his productions some allowable exception to Quaker

precepts, perhaps a recognition by Friends that a craftsman might need to produce objects he did not necessarily approve of? Were transgressions of plainness simply seen as less important than marriage violations? Did Friends prefer to focus on only one breach of discipline at a time?

A second, concurrent example from the minutes may provide us with further insights. As it turns out, Affleck was not the only person associated with a surviving piece of tall case furniture to be brought before Philadelphia Monthly Meeting for marriage violation in 1771. Samuel Wallis was a wealthy merchant of the type who patronized Affleck. And while the Wallis high chest (Plate 3) is attributed to another Quaker cabinetmaker, William Wayne, it is very much in the same mode as known Affleck examples. The surviving bill of sale on which the attribution is made also shows that Wallis purchased the piece during the months he first came under the meeting's scrutiny.[25] Yet Wallis's high chest is not mentioned in the minutes, despite the multiple offenses he was cited for.

In the ninth month 1771, at the same meeting where Affleck's paper of acknowledgment was received and recorded, Wallis's was first considered:

Samuel Wallace (sic) produced a Paper to the meeting, condemning his Marriage by a hireling Priest, and his having been concerned in the purchase of Lands before they were bought of the Indians, and also his attending Stage Plays, and a satisfactory account being given of his disposition, consideration thereof is deferr'd to next Meeting, and in the Mean time his case remains under care of the Friends heretofore appointed.[26]

While no changes in the paper were required, it may be that the variety of violations cited made Wallis's sincerity questionable. A full fifteen months earlier, in the seventh month 1770, the meeting first recorded "That Samuel has . . . been treated with for Marrying by a Priest & attending to Stage Plays."[27] Initial progress in the case was slow: the next month's entry says only that "The Case of Samuel Wallis is continued; he having been Absent from this City since the last Meeting."[28] The added complication came in the twelfth month of that year—the fifth month of proceedings—when

The Friends appointed to treat with Samuel Wallis report, he still continues disposed to condemn his Transgression of the Rules of our Discipline in respect to his Marriage, but as there had been a charge exhibited against him in Public, which Affects his Moral Character, and requires an Enquiry into, the same Friends are requested to excite him to take the most speedy and Effectual Measure to Clear himself from the charges, as he Alledges his Innocence, and to make such further Enquiry, as the occa-

sion may be necessary, and John Reynell, Owen Jones and James Pemberton are added to the assistance of the said Friends.[29]

What was this "charge exhibited against him in Public"? What merited the appointment of such "weighty," influential Friends as Reynell, Jones, and Pemberton to the case? Specifics only appear in the following entry. Wallis's fault, as he later would acknowledge, was in "purchasing Lands, which were the property of the Indians, before the late Sale of the Proprietor." This was a more publicly visible action even than his marriage violation, and as such it invited possible criticism of Friends by their political opponents. Wallis's case was now continued further since these complications meant that "the dispute between him & the Proprietary officers is not yet accommodated, and a hearing is proposed by Each party."[30] The meeting would await a settlement, meanwhile seeing that "some further care" was taken in resolving the matter to Friends' liking.[31] It was nine more months before the presentation of his acknowledgment, which was accepted by the meeting in the Tenth Month, 1771:

The Paper of acknowledgment offered by Samuel Wallis to the last Meeting, being now read & considered, and the Meeting being informed of his continuance in the same agreeable disposition of mind, it is agreed to be accepted, in hopes, as he expresses he may manifest this sincerity by future care & circumspection.[32]

Wallis, then, was able to clear himself of the stigma attached both to violations of Quaker practice and to the embarrassment his public violation of these practices might cause. The length of the meeting's deliberations in this case may likewise reflect its concern that grounds for both internal and external complaint be completely resolved, given that the land dispute rather than the marriage violation delayed its final resolution.[33]

Wallis's dealings with the meeting draw attention to Friends' concern with the quality of public behavior. Yet furniture is also a form of public statement. It shapes a community's daily experience, and it broadcasts attitudes about the built environment to the world at large. Its absence from the meeting's discussions of the Affleck and Wallis cases is puzzling—doubly so if we consider that "The Rules of our Discipline and Christian Testimony," invoked by Friends in Affleck's case, calls for "plain furniture," among other plain things. Is it possible that the pieces Affleck produced and Wallis bought *were* plain? Surely they do not appear to be by common standards, yet there is no mention of the discrepancy by the monthly meeting when marriage

deviations expose these members to such careful scrutiny. And multiple, additive charges were common, as the Wallis case demonstrates.

As it turns out, no Philadelphia Friends were ever specifically cited in the minutes for their taste in furniture during the pre-Revolutionary years—the period for which Philadelphia furniture is recognized by many as the most sophisticated and ornate produced in colonial North America. A few references can be found among the disciplinary records to plain dress or plain speech, most often to "dress and address" or "conduct and conversation" that is "inconsistent" or violates discipline. Yet even these complaints are infrequent and are almost always cited in conjunction with other, more tangible offenses.[34] Either despite frequent scrutiny the furniture owned by Friends was never found to be problematic, or—more likely—in practice the meeting did not pay attention to the ornamental details of furniture when considering disciplinary measures.

Quaker Key Words: Plainness in Language

Philadelphia Monthly Meeting's written presentations of the Affleck and Wallis cases display striking similarities. Each set of minutes shares a common format, language, and informational typology. Both men were chastised for marriage, yet neither was cited for lack of plainness. Both were "treated with" over a period of months, and both were required to prove their continued sincerity with similar papers of acknowledgment. At any given time, in fact, the many concurrent cases reported in the minutes share similarly comparable features. Quaker meeting minutes, so similar month after month, reveal a structure and flow of proceedings that is stylized and streamlined, a framework that dictates the way events were viewed and recorded. Affleck's fault, for example, is not fundamentally his marriage itself. It is, the meeting claims, "his transgressions of the Rules of our Discipline." These rules are the central concern of the meeting's attention, and the posture, not the details, is important. Affleck's marriage, a concrete action, communicates his spiritual deviation to his peers; while he cannot retroactively correct the marriage, he can restore the disunity it has caused.[35] The same concern with the violation of Discipline appears when Wallis and his marriage are discussed. We see that a conceptual agenda regulates the meeting's disciplinary function, keeping it from becoming some transgression-seeking free-for-all.

The stylization and articulation of Quaker behavioral doctrine exists as a loose body of statements usually referred to as the *Rules of Discipline*, or

Discipline for short. Quaker Discipline might well be defined as that system of action by which Friends could best maintain their existence in the Truth. Friends also, confusingly, compiled a physical "Book of Discipline" where the rules of this system were recorded, whose title they likewise abbreviated. Since this published book's contents were subject to revision as knowledge of Truth might change or grow with time, a new one was produced when the old one was considered sufficiently outmoded—in practice, about once each generation. Early editions were copied longhand, while later *Disciplines* were typeset for wider distribution.

Two manuscript editions of the *Rules of Discipline*, each titled "A Collection of Christian and Brotherly Advices" and dated 1762 and 1781 respectively, cover the years of this inquiry. Each consists of directives extracted from the minutes and epistles of the region-wide Philadelphia Yearly Meeting of Friends, arranged by subject, with individual advices listed in chronological order by their original date.[36] While these advices bear dates ranging across ten decades, their inclusion makes them valid at the moment of compilation. Noticeable variation between the 1762 and 1781 versions—most frequently omissions from the later manuscript—indicates that choices concerning relevance were actively made with each revision. Yet, as a compilation of existing statements, the *Discipline* makes no specific claim to its comprehensiveness. Since by definition only those subjects discussed by the Yearly Meeting are included, we should not understand the absence of other statements or subjects to signal a lack of concern among Friends. A community whose members comply with certain rules, after all, might feel no need to discuss them. The Yearly Meeting, by the same token, should not be considered the only possible source of significant statements, but rather a high-density resource chosen by the *Discipline*'s compilers. Further, it is not always clear when Friends refer to *Discipline* if they mean the current compilation or the larger concept of a shared behavioral standard. Despite these limitations, however, the compilations of *Discipline* are important as a body of significant statements selected by Quakers themselves and as a set of consciously articulated behavioral rules. These are the precepts monthly meetings worked to enforce.

Unlike the Philadelphia Monthly Meeting minutes, the 1762 and 1781 *Discipline* manuscripts overtly discuss both plainness and furniture. In the ten-page section of the 1762 manuscript devoted to "Plainness" there are six references to material objects: two to "needless Things" and "vain Needless things," one to "Superfluity & Excess in Buildings and Furniture," and three to avoiding superfluity or promoting plainness of "Furniture of Houses" or "Furniture."[37] In each case these categories are mentioned either

in conjunction with apparel (three of the six) or with both apparel and speech together. Objects are never considered alone. The original dates of the twelve included directives ranging from 1682 to 1746, with the most recent calling for "The Primitive Simplicity & Plainness of the Gospel (in their Speech, Apparel, Salutations, & Conversation)" but no mention of built forms.[38] It is striking that even as Quakerism entered a period of religious reform in the 1750s, no additional statements on plainness were made.[39]

Even within a single entry, furniture is not treated in the same way as apparel and speech. The first paragraph of the 1695 advice on plainness is an early discussion of the details of clothing—and the only one that ever provides specific details. Furniture is mentioned in the same entry almost as an afterthought:

Advised that all that profess the Truth, & their Children, whether Young or grown up, keep to Plainness in Apparel, as becomes the Truth, & that none wear long lapped Sleeves or Coats gathered at the Sides, or superfluous Buttons, or broad Ribbons about their hats, or long curled Periwigs; & that no Women, their children, or Servants dress their Heads immodestly, or wear their garments indecently, as is too common; nor wear long Scarfs, & that they be careful about making, buying, or wearing (as much as they can) striped, or flowred Stuffs, or other useless or superfluous things; & in order thereunto, that all Taylors professing Truth, be dealt with & advised accordingly.—
 And that all Superfluities & Excess in Buildings & Furniture be avoided for time to come.[40]

Buildings and furniture seem here an appended extra. The brief yet comprehensive reference to "all Superfluities & Excess," however, may also indicate that Friends found the details so obvious that no further elaboration was required. Yet we would expect both clothing and furniture, as comparable facets of daily life, to be of equal familiarity to Friends. Why then did Friends describe ribbons and periwigs while glossing over turned legs and costly burled veneers? Why was it only "Taylors professing Truth," and not other types of Quaker craftsmen—cabinetmakers or silversmiths, for example—who were to be "dealt with" and "advised accordingly"? We are left to wonder why furniture and houses did not warrant the detailed description Friends required for other categories of potentially superfluous expressions.[41]

While they differ in degree of elaboration, the two paragraphs of the 1695 entry are still both formally and semantically parallel. This may account for the difference in length. Since the first explanation is so detailed, perhaps the second does not need to be—that is, the need for Friends to describe what constitutes un-plain furniture may be lessened by the already detailed language describing irregular clothing. While apparel is not furniture, the

specific concerns outlined for worldly apparel can easily be applied, by analogy, to other categories of familiar everyday artifacts. If so, then the superfluity of furniture need only be alluded to since discursively the parallels are obvious. By the same logic, this detailed discussion of physical plainness obviates the need for additional statements in later-dating disciplinary advices. Thus the details of clothing, found worthy of elaboration in 1695, were never again revisited. One statement stands in for all others—presumably the issues do not change even if the fashions do.

It is plainness in speaking and speech that is most frequently and consistently discussed by Friends, not only in the *Discipline* but in all Quaker writings. Historian and folklorist Richard Bauman points out, "From the beginning, Quaker ways of speaking were among the most visible and distinctive aspects of Quakerism."[42] From early on, Quaker plain speech operated according to specific usage rules, which included the substitution of "thee" and "thou" for the singular "you," and "first day" and "first month" for the Roman Sunday and January. Plain speech practices also called for the exclusion of all honorary titles, the refusal to swear oaths, and by extension the rejection of the doffing of hats and other polite formalities. These specific rules for plain speech are referenced repeatedly in the *Discipline*, as when a 1719 entry admonishes parents who "accustom themselves, or suffer their Children to use the corrupt & unscriptural Language of [you] to a single Person or call the Weekdays, or Months by the Names given by the Heathen, in Honour of their Idols."[43]

Other sources explicate the rules of Quaker plain speech even more thoroughly. Robert Barclay, whose *An Apology for the True Christian Divinity* of 1678 was the most commonly read Quaker theological tract throughout the eighteenth century, details the complete scope of these speech rules in over sixty pages of explanation.[44] Yet Barclay also omits specific details concerning other forms of expression, such as furniture. At the same time, such cryptic statements as William Penn's admonition, "the usefullest truths are plainest," are meant to elucidate, not complicate, day-to-day life.[45]

Bauman's sociolinguistic analysis of Quaker modes of speaking focuses particularly on their use as a powerful metaphoric tool in early Quaker belief. "Speaking and its associated principle of silence," he argues, are Quakerism's major symbolic states and thereby fundamental to its meanings. Continuing, he explains that since "speaking was basically a faculty of the natural man, of the flesh," yet Friends chose to live as part of the secular world, it was necessary to properly control these natural impulses. When speaking's source was dubious, it was best for it not to occur at all. Silence—as in the silence of Quaker worship—most accurately upheld the suppression of worldly self

necessary to dwelling in the Truth. "Silence," Bauman writes, "was not an end in itself, but a means of the attainment of . . . the direct personal experience of the spirit of God within oneself."[46] By practicing outward silence, then, a Friend was best able to attend to the message of the Inward Light.

What happened when it was necessary to speak? The Quaker practice of silent worship highlights the difficulties inherent in reconciling the silence of Truth with the practical need to communicate. Shared silent worship was a rarefied instance of Quaker communicative discourse, where Friends met to-gether not only to commune with God but to share that like experience of God in others. Yet silence as the desirable product of turning inward does not embody expressive potential, and Friends did indeed rise to speak during worship as the spirit moved them. The resulting meaningful tensions were reconciled by Friends through imposing controls and regulations over physi-cal speech and material activity, through the rules for plain speech or the ad-vices in the *Book of Discipline*, among other means. As Bauman states, "Silence precedes speaking, is the ground of speaking, and is the conse-quence of speaking."[47]

Quaker reliance on speech itself as metaphor—as the very foundation of theological expression—allows us to understand nonverbal communica-tive acts by their function within this larger discursive framework, just as did Friends themselves. The practices of speech, bracketed by the two idealized states of speaking and silence, serve as the central metaphor for all Quaker expressive behavior, characterized by a spiritual plainness emergent from the silence of God's Truth. The guidelines for speaking are most consistently and specifically articulated in the *Discipline* and other texts precisely because speech, by way of metaphor, stands in for all expressive forms. If the states of silence and speaking are respectively the most and least desirable end points of Quaker expressive behaviors, then by analogy these same states apply equally well to the physical world, since all forms of visible activity are first of all a means of expression.[48] Plainness in furniture, then, like plainness in speech, is emergent from the silence that goes with focused attention to the Inward Light. Yet we're still not sure what properly plain furniture should look like.

Partaking of Quakerism's speech-based paradigm, a series of highly charged and sometimes puzzling terms appear in Quaker texts, revealing themselves as a set of recurring keywords that carry special impact or multi-ple meanings, condensing or stylizing complex, multifaceted concepts.[49] We might say they bear the burden of what anthropologist Robert Plant Arm-strong has called "the tyrannies of a confused semantic life."[50] Plainness is part of this group of interrelated concepts for which Friends provide no easy

definitions. In Quaker texts, the term "plain" is used only within the particular bounded context of Quaker Truth—to describe that state, or something contextualized within it. Other terms including "simple," "innocent," "honest," "moderate," and "decent" appear along with it. These adjectives are collectively contrasted to others describing worldly society at its worst—among them "vain," "idle," "superfluous," "extravagant," "antic," and "evil."[51] As we have seen, the explanations provided by Friends for the meanings of plainness are sparse. The same can be said for these other keyword terms as well.

Mathematician Eliot Sober explains that "the more additional information a hypothesis needs to answer a question, the less informative it is relative to that question."[52] Here there is little additional explanation provided about Quaker keywords because they are meant to be meaningful in themselves. In fact, by this logic, the less new information needed to understand them, the more fully informative they are—to those already in the know. As Sober's point makes clear, Quaker documents fail to explicate the meanings of plainness precisely because plainness, within the Quaker discursive system, so thoroughly explains itself. Plainness, as a term describing expression behaviors in the world, functions in part as what anthropologist Sherry B. Ortner calls a summarizing symbol, which operates "to compound and synthesize a complex system of ideas, to 'summarize' them under a unitary form."[53] It does not elaborate because it does not need to; rather, it is an unglossed term meant to succinctly evoke the metaphor of speaking and silence so familiar to practicing Friends.

By scanning the 1762 *Discipline* manuscript we can extract whole phrases composed of relevant keywords. Two parallel phrases that each appear frequently in the manuscript, but never together, serve to establish systemic extremes. We might see these phrases as composite antonyms—compressed, ordered keyword sets defining binary oppositions—whose comparison will allow us to extract greater meaning from their tightly encoded usage. One is "the Plainness and innocent simplicity of Truth"; the other is "the Vain and Antic Customs of the World." Each phrase contains a variety of Quaker keywords, ranging from the adjectives that describe positive or negative qualities, respectively, to the nouns that name the opposed extremes. What happens when we separate these composite antonyms into their constituent parts?

Assuming that for each element of the first statement there is one directly opposed to it in the second, then "Truth" becomes semantically not-"World," while "plainness-and-innocent-simplicity" becomes not-"vain-and-antic-customs." If we follow this logic and break down our keywords still further, however, we see that "plainness" and "simplicity," the nouns in the first phrase, are incommensurable with "customs," the noun in the

second, since they come from distinct semantic domains. The first pair evokes an abstraction, while the second single element is more finite and bounded—customs, that is, are a specific set of shared rules, either written or unwritten, for concrete human behaviors. But once we recognize that Quaker Discipline, too, is a specific set of shared rules for concrete behavior, we see where the juxtaposition comes from. Though abstract by common usage, plainness and simplicity—both as terminologies and as categories of Quaker practice—are as concretely meaningful to Friends as any worldly customs. They are also polar opposites. By definition alone, a Friend who is plain eschews worldly customs.

This juxtaposition helps us understand the larger underlying opposition of "Truth" and "the World" in Quaker discourse. To community members within a Quaker framework, the World's customs are outside and alien, beyond the realm of Quakerism's organizing principles. They are also visible behaviors, clearly identifiable to Friends and non-Friends alike. The behaviors associated with Quakerism, by contrast, receive labels whose abstract character flags them without fully explaining their operation. So, too, are "Truth" and "the World" fundamentally different in their nature, like two interdependent logical universes whose permeable boundaries always touch but can never overlap. The opposition of "Truth" and "the World" in Quaker discourse is a difference not just in degree but in kind—unlike the end points of a single continuum, "Truth" and "the World" fundamentally diverge. Across some fine line where worldly society's influence outweighs the Truth, individual behaviors become different not only in content but in quality. Worldly behaviors are still recognized within the Quaker framework, but they are not subject to the framework's criteria; that is, they are simply not dictated by the Truth. Quaker rhetoric has a place for the non-Quaker— or the incorrect Quaker—within it, while recognizing that this "outside" individual subscribes to a different scheme altogether. Thus the two extremes—the plainest Truth and the most superfluous world—are mutually exclusive. It is impossible to be in both states at once, though a person might verge closer to one or the other.[54]

Yet, as a religious ideal, Quaker plainness is more like a mental state than a list of rules, which are merely outward markers of the silence within. How do cognitive states relate to actual objects? For Delaware Valley Quakers, plainness had primary meaning in a properly conceptual context; it describes the orientation of a mental state. The plainness of objects is a secondary problem of usage—of interfacing systems of meaning with systems of action. In the behavioral sphere speech rules are elaborated while others are not, and plainness is used most pragmatically in the description of

speaking behaviors. Why might this be? Recall how clothing was used to explain, through comparison, furniture and houses. This comparison functions as a cultural metaphor—likening one aspect of existence to another. The idea of plainness is linked, through a metaphor, with an object (or other expression) that is then considered to be plain. Ortner defines metaphor as that which "formulates the unity of cultural orientation underlying many aspects of experience, by virtue of the fact that those many aspects of experience can be likened to it."[55] Lack of explication flows from the fact that the metaphoric comparison *is* the explanation. If something is plain, then, it is really plain-like-the-Truth. If this is still too abstracted, it becomes plain-like-plain-speech. Invoking the metaphor is meant, in itself, to be a clear explanation. Plainness, like silence, is a rhetorical stance and only secondarily an adjective describing objects. If we do not know what those objects should look like, it is because we, as outsiders, are not suitably part of Quakerism's own discursive context.

Meeting House Practices: The Forms of Expression

Despite their best efforts, eighteenth-century Friends could not help but engage in worldly practices. Too many facets of their lives originated in the social and cultural assumptions of their time and place for us—or them—ever to suppose otherwise. If negotiating the complexities of secular necessity and religious expectation were a straightforward task, Friends would have had no need for ongoing disciplinary measures. Instead, because of the individual nature of Quaker belief, each member of the Society was called upon personally to confront the problem of living "in the world, but not of it."[56] In this context the meeting house and its practices serve as a bridge between belief and practice, both as the site where religion's accommodations to material life were met with heightened understanding by Friends, and as a physical example of that merger in its own right. If any part of the built environment was subject to Quaker precepts, then surely it was the meeting house. If speech is the primary metaphor of Quakerism, then the meeting house is likewise the likeliest primary site of its use. Thus, if we are still not certain how Quaker belief was applied to the secular, material world of objects, observing its function in the forms of the meeting house should help us gain this understanding.

Consider monthly meeting minutes as artifacts of Quaker practice. Written language, the use of pen, ink, and paper, the idea of keeping minutes in the first place—these basic components of record keeping come directly

from European culture and are in no way specific to Friends. Do these conventions reflect on their plainness? Other aspects of the minutes' physical production—such as who penned and composed them, in what setting, for what audience—are more intrinsic to Quakerism's sphere. As the product of the consciously marked practice of convening meetings for business, these minutes are not, as some have assumed, a straightforward record of what happened at the meeting house on a given day. Rather, they are carefully chosen statements recorded in a deliberate fashion and meant to best represent those happenings for the meeting's own purposes. They are shaped within a meaning-laden framework outside which they cannot be properly understood. Just as for any group of associated artifacts, when we compare examples of the minutes to isolate their typologies and characterize their forms, we discover that meaningful patterns emerge—only some of which are related to their specific content, or to Quakerism. The same can be said for any activity or form located in the meeting house.[57]

The interplay of uniformity and variation we find within Quaker meeting minutes lends itself to this comparative approach, by which we can begin to discern the grammar of Quaker social usage. The minutes are marked by their temporal depth, representing two levels of disciplinary process. One is the ebb and flow of specific activity carried on by the meeting through its decision-making process: the month-by-month entries of progress in each of its tasks. The other is the longer term maintenance of group unity, as reflected in the relationship of individual Friends to their reference group over time. In the Affleck and Wallis cases discussed above, we find the makers and owners of high chests selectively scrutinized in the context of the meeting house. A material form not usually associated with Quakerism is thus juxtaposed with that material form most fully identified with Quaker religious expression. The disciplinary process provides that now familiar bridge from the realities of furniture production and selection back to the metaphor of plainness in speech. By understanding the meeting house as part of its larger performative context, then—by taking account of what happens there and its ripple effects—we see that Quaker belief is most fully an interpretive system realized through its practices, which are explicitly situated in communal negotiations around shared activities deliberately labeled "Quaker." From the meeting house we find Quaker discourse radiating outward, working its way through—or around, or over, or under—the everyday practices of worldly life in which each Friend also took part. Even if Friends never discussed furniture at their meetings, they talked about other things that helped give furniture a context.

But the fit between Quakerism and daily life was far from exact: selec-

tive at best, it was too often contradictory at its boundaries. Like some confounding semi-permeable membrane, Quaker theology's ability to squeeze in or filter out aspects of worldly life was selective, contextually variable, and by turns both straightforward and complex. Ideas traveled both ways, from outside to in as well as from inside to out. In fact, the practices of Quakerism and the forms of its material world worked together, interdependently, as components of an interpretive system realized in the necessities of material practice. This applies as much to high chests as it does to meeting houses and to all that takes place within them—along with clothing, cooking, eating, sleeping, and sex, work, craft, agriculture, government, and business—all the things people do with their bodies in the physical world. Yet some of these activities and the forms that go with them are more closely aligned with Quaker beliefs than others. We can surely argue, after all, that unlike the case of high chests where theology is seemingly tangential to use, the form and structure of the meeting house is at its core *about* Quaker belief—as are the activities, events, and artifacts produced within it. In the meeting house the interchanging functions of text and context, shared among the various spoken, written, and other performed or material aspects of Quaker practice, were ultimately centered on that crucial issue of interpreting, processing, and negotiating the non-Quaker but still shared cultural modes for living in, and finding meaning in, the day-to-day, "worldly," physical world.

If the Quaker meeting house is a stylized, meaning-laden genre, so too is the range of Quaker-related things—objects, spatializations, performances—that are situated within it at specific moments in time. Examining the relationship of form to meaningful content in the more obvious case of the meeting house, then, may help us understand Quaker interpretations of furniture, clothing, houses, and the rest—the full range of possible worldly possessions. What we find is a series of interrelated genres of the meeting house that worked together to contextualize Quaker meanings. Like the minutes recounting marriages, removals, disownments, and disciplinary actions in near formulaic regularity, everything from the arrangement of windows, doors, and benches to the proper posture for reciting a spontaneous prayer during worship contributed to the dynamic, belief-based exchange of the meeting house's sphere.

The central activity of the eighteenth-century Delaware Valley meeting house was worship. Though no specific written instruction dictated its form, the meeting for worship had an understood agenda and a set of behavioral forms drawn upon by participants according to their status. A prayer preceded the spontaneous sermonizing. Speakers were most often proven

ministers or elders, whose gift had been previously recorded during monthly meetings for business. The assembled listened to these spoken interludes in seated silence, and no direct response to the speaking was provided. Elders seated at the front ended the meeting by turning to shake hands at just the right moment of spiritual completion. Thus a set of designated roles was based on experience and religious understanding but also on worldly relationships: race, gender, seniority, and economic or social class. Along with the form of the meeting house itself, a series of patterned behaviors and activities emerged within Quaker discourse. These were marked as peculiarly Quaker and meant to be understood particularly by conversant members of the Society of Friends. From the wearing of hats during worship to the patterned recitation of prayers, each genre interacted with and contextualized the others.

Genre-based differentiation in role and status among individual Friends was even more apparent in monthly meetings for business and discipline, the Society's primary mechanism for self-governance. Unlike the meeting for worship, the monthly business meeting was open only to members of the Society of Friends. Proceeding on the principles of group decision-making, Friends considered in variable sequence a number of items of meeting business: marriages, certificates of removal (transferring membership between meetings), financial matters, disciplinary inquiries, and disownment from membership (for violations of the *Rules of Discipline*). Periods of silent reflection might also occur. A clerk ran the meeting and worded the minutes based on his understanding of the meeting's decisions. Minutes reflected only this final sense; since any individual's thinking was irrelevant to the outcome, minutes were not an accounting of all that was said or considered. Theoretically, there was no differentiation among participants. In practice, however, the clerk—but also ministers, elders, and overseers—held interpretive power, as did members prominent in worldly society. Stratification was extended as high-status men and their wives or close female relatives were more often appointed to committees or to quarterly and yearly meetings.[58] Attenders—those who came to worship but were not official members— were absent from these deliberations, while women Friends met separately in a monthly meeting of their own. These various roles within the meeting permeated its activities, to the extent that a single action is incompletely understood without awareness of them.

By attending to its own affairs while selectively intruding into the affairs of its members, the Quaker meeting for business most directly ties the space of the meeting house to the larger public sphere beyond. A step closer to "the World" if not to worldliness, here we find inside and outside inseparably

conjoined, if still symbolically distinct. Disownment, in this period, most often occurred over incorrect behavior in worldly affairs. Yet the issue in question was always brought to the meeting, to be dealt with in the protected meeting house space before it was returned to the outside world. The meeting house likewise served as interpretive resting point through each step of the disciplinary process. For Delaware Valley Friends in this period, the process of (re)interpretation during meetings—for business, but also to a lesser extent for worship—was not so much about the presence of the light within as about managing that light and using it effectively. It is tempting to say that for Quakers context was everything, but this was not precisely true. Context was the *important* thing, because Friends realized that in the material world there were no absolutes. If we find Quakerism so permeated with practices of the world even in this rarefied context, what expectations can we have for the secular sphere?

Quakers Who Owned Chippendale Furniture

Our inquiry into the Quaker rhetoric of plainness should not leave us with the false impression that wealthy Quakers did not talk about their furniture. They did—just not in the meeting minutes. In September 1779, for example, Elizabeth Drinker, wife of a wealthy Quaker merchant, made the following entries in her journal:

14th. this morning at meeting time (myself at home) Jacob Franks and a son of Cling the Vendue master, came to seize for the Continental Tax; they took from us, one Walnut Dining Table, one mahogany Tea-table, 6 han[d]som[e] walnut Chairs, open backs crow feet and a Shell on the back and on each knee—a mahogany fram'd, Sconce Looking-Glass, and two large pewter Dishes, carri[e]d them of[f], from the Door in a Cart to Clings.

18 HD [Henry Drinker, her husband] and Sister went to Frankford, found old Joseph our Tenant, ill in bed; ordr'd some of our Furniture to be brought to Town.[59]

Here, for once, is a Quaker describing furniture in terms of physical characteristics, and Drinker is clearly attuned to her furniture's specific appearance, describing it down to the stylish carved "Shells on the back and on each knee." Yet Elizabeth Drinker was no questionable Friend—a member in good standing herself, her husband was one of twenty-two leading Quakers exiled as suspected Loyalists by the insurgent Provincial Council in 1777.[60] It is ironic, though perhaps not accidental, that Drinker's prized possessions were carried off publicly at meeting time, to be paraded through

city streets temporarily devoid of their usual Quaker presence. Such seizures of goods for public auction, meant as a substitute for war taxes left unpaid by pacifist Friends, were personally degrading and exposed Quakers to charges of hypocrisy.[61] But Drinker expresses neither anger, fear, embarrassment, nor remorse—she just describes the furniture as if she cares about it. And only four days passed before more furniture was brought in to replace the loss—a fact given equal rhetorical weight to the illness of the family's tenant.

If anything is indicative of the multiple frameworks through which Quakers defined their object world, it is the juxtaposition of issues—both implicit and explicit—in Drinker's journal entries. One important aspect of the ownership of goods is the way that they signal—as markers of daily activity, economic status, or shared taste, among others—participation in a community or one of its subgroups. The events of the Revolution have, for a short span of days, turned Elizabeth Drinker's furniture itself into an explicitly political statement as well as a public one. Consider the set of chairs she describes, about which she provides the most detail. We can recognize in their "open backs," "crow feet," and carved shells the markers of the most fashionable 1770s style. Described in modern terminology, Drinker has just been parted with a matching set of Chippendale walnut side chairs with pierced splats, cabriole legs, ball-and-claw feet, and rococo carved decoration. These were expensive, ornate, and sophisticated items, much in the same class as the high chests manufactured by Thomas Affleck—and recognizable as such to most Philadelphians on the street that day. Those passersby would easily comprehend their costly stylishness as a sign of elite status in Philadelphia's mercantile community. Would they also know that the owners were Quakers? In 1779, at meeting time, in the context of the vendue master's cart—the answer is probably yes. And in that context the chairs perform a dual function of meaning, because they signify not only participation within the shared hierarchy of goods, but an even stronger religious affiliation—one that privileges pacifism over property and conviction over conformity, in the most public of ways. Drinker's diary tells us that on the day they were taken, these were Quaker chairs. If the same chairs were simply displayed at auction with no reference to their origin, however, viewers would have no way to distinguish them from stylistically similar sets, owned perhaps by Anglicans or Presbyterians, offered for sale due to death or bankruptcy. Without the contextual clues Drinker provides, we too are back to the question of Quakers and plainness that we started with. Particular objects owned by particular Quakers give us no firmer an idea of what constitutes visible plainness in furniture than the *Discipline* did.

Quaker expressive codes rely on outward signs because they have to—recall the metaphor of speaking and silence with all its interpretive complications. Philadelphia Chippendale furniture, like other groupings of regional furniture produced in colonial America, embodies a series of codes and patterns as varied and complex—and singular—as Quaker ones. Within the Quaker expressive framework the essential meaning of furniture is not its furniture-ness (those carved shells, open backs, and cabriole legs) but rather its role in the implementation of a shared religious discourse. Objects are understood within religious discourse as they relate back to speech by way of metaphor—what they *are* is less important than what they *mean*. From some non-Quaker vantage point, that of the craftsman, for example, initial meaning lies in a very different sector, where tools, skills, styles, materials, and customers take precedence. Even for the most devout Quaker, not only religious precepts but a whole set of learned cultural behaviors, "the modes, fashions and customs of the world," necessarily contribute to an object's form and meaning. Learned behaviors might easily reflect, in a subconsciously secular way, on specific ornamental conventions, for example, or on the ownership and placement of certain domestic furniture forms over others.

If we are to learn what complex Chippendale pieces of furniture meant to their Quaker owners, we must unravel the multiplicity of codes they embody, since overall meaning is provided in the interaction of many meaningful factors.[62] In our search for these codes that guide the conception and construction of Quaker-owned objects, it still seems reasonable to turn to the objects themselves. And when we do take a closer look at Quaker-associated furniture, it is not surprising that we learn more about furniture than religion. A group of twelve surviving tall case pieces, all in the Philadelphia Chippendale style and each associated with its original owner, well demonstrates this point. Each piece is slightly different from the others, as is the story of its owner's relationship to Quakerism.[63] Each embodies multiple expressive codes that in turn selectively influence its physical characteristics.[64]

High chests of drawers perched on curved legs high off the ground are today the more recognized form of Chippendale tall case furniture. An early bonnet top high chest of drawers dated November 14, 1753 was made in Philadelphia for Hannah Hill Moore, wife of Dr. Samuel Preston Moore, and signed by craftsmen Henry Clifton and Thomas Carteret (Figure 3.4a); it features upper and lower shell-carved drawers in the distinctive Philadelphia style (Figure 3.4b).[65] Both Hannah Hill Moore and her husband were wealthy but devout Quakers in good standing.[66] A similar high chest (one of an identical pair) of slightly later date was made for Levi and Hannah Paschall Hollingsworth, also in Philadelphia, in 1779 (Figure 3.1). This piece is attrib-

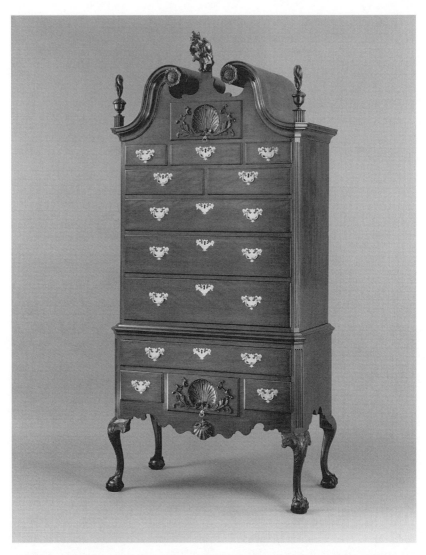

Figure 3.4a. High chest of drawers owned by Hannah Hill Moore and Samuel
Preston Moore, made by Henry Clifton and Thomas Cartaret. Philadelphia, 1753.
Colonial Williamsburg Foundation, 1975-154.

Figure 3.4b. Detail, skirt of high chest of drawers owned by Hannah Hill Moore and Samuel Preston Moore.

uted to Thomas Affleck, the Quaker cabinetmaker whose incorrect marriage was dealt with by Philadelphia Monthly Meeting.[67] Hannah Paschall was a Quaker in good standing, but when she married Levi Hollingsworth in 1768 the monthly meeting chastised her because the wedding had taken place at the Anglican Christ Church. Levi Hollingsworth was the son of Maryland Quakers, but his name never appears in the records of the Society of Friends in Philadelphia. Yet, Hannah Paschall was not disowned for her deviation, and Levi Hollingsworth was, at his death in 1824, buried at the Quaker burying ground in Haverford, Pennsylvania.[68]

Chest-on-chests have more drawers in their lower case than high chests, resting on bracket feet low to the ground, but are otherwise similar to the more familiar high chests. A Logan family chest-on-chest is also attributed to Thomas Affleck. It was made for William Logan's daughter Sarah at the time of her marriage to Thomas Fisher in 1772 (Plate 4).[69] All three were good Quakers and influential in both religious and secular circles.[70] A second

surviving chest-on-chest belonged to Charles Logan, William's youngest son (Figure 3.2). Charles Logan married Mary Pleasants, a Quaker from Virginia, in 1779; he is known to have owned the chest-on-chest at that time. Three years later, in July 1782, Charles Logan was disowned for "joining himself in an association with a number of men engaged in war."[71] Sarah Logan's diary suggests that she and her brother were, despite the disownment, on fairly intimate terms.[72] At the death of William Logan in 1776 his own probate inventory included "A Mahogany Chest of Drawers" worth £18, which by its price could only be a high chest.[73] Elaborate tall case pieces were evidently acceptable to the Logan family overall, independent of their individual relationships to the meeting.

What is the functional difference between one case piece and the next? Stylistically these four examples are typical of contemporary Philadelphia productions. Is there perhaps a more subtle correlation between the degree of detailed ornamentation and the status of the owner among Friends? In fact, when we compare the Moore and Hollingsworth pieces (Figure 3.4a, Figure 3.1), we find that the latter is somewhat less elaborated, although it was Hollingsworth who married inappropriately. Since by 1779 the use of rococo ornament had reached its fully developed state, the lack of applied carving on the tympanum area of the Hollingsworth piece is striking. Thus a Quaker in good standing has a fancier piece than his not-so-good counterpart. In the same way, the Charles Logan chest-on-chest shows more ornamental restraint than the one owned by his more devout sister. The pierced latticework pediment and carved phoenix cartouche on her Affleck-made chest-on-chest are exceptional (Plate 4), particularly in contrast to the solid pediment and more ordinary carved flower basket of her brother's piece (Figure 3.2). Ornamental details are simply not obvious clues to the theological meaning of Quaker-related pieces.

Distinguishable theological criteria are similarly lacking in two surviving pieces that belonged to a single Quaker merchant. Joseph Wharton, Sr., owner of the mansion Walnut Grove, is thought to have kept there two high chests, one labeled by the Quaker William Savery (Figure 3.5) and one of unknown manufacture (Figure 3.6). Both Wharton high chests are of the detachable pediment variety, more common to chest-on-chests than high chests. The Savery piece is unusual for its lack of the typical shell-carved drawer; it is otherwise quite unornamented. In common with the more ornate Wharton-owned example, however, it does have the diamond pierced latticework usually found on detachable pediments. The unattributed high chest has the typical lower shell drawer, fretwork, dentils, and cartouche associated with Philadelphia pieces. What might explain this seeming inconsis-

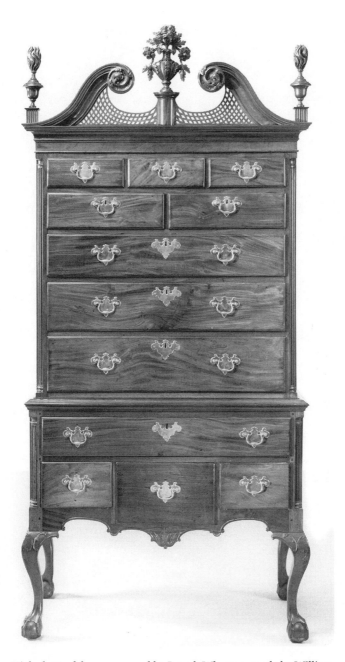

Figure 3.5. High chest of drawers owned by Joseph Wharton, made by William Savery. Philadelphia, 1765–75. Private collection.

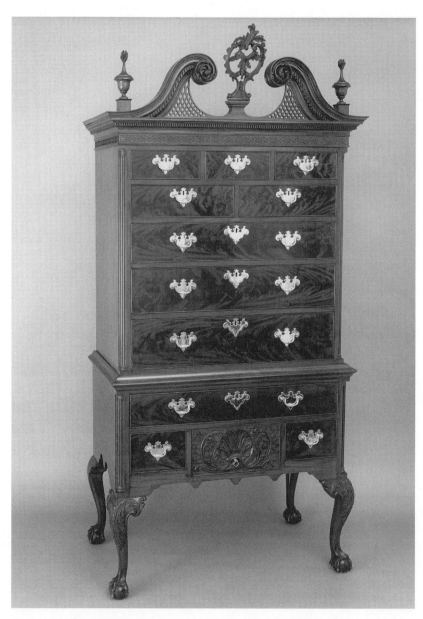

Figure 3.6. High chest of drawers owned by Joseph Wharton. Philadelphia, 1760–75. The Museum of Fine Arts, Houston; Bayou Bend Collection, gift of Miss Ima Hogg, B.69.75.

tency, where even for a single owner one piece seems more stylistically simplified than the other? Taste perhaps, or a whim, or any number of possible reasons why each of the pieces was purchased. Clearly Wharton was willing to own an ornamented piece; just as clearly, he did not always have to. If shells or flame finials were in themselves delineators of a Quaker aesthetic, then the seeming anomaly of these two Wharton high chests would become inexplicable.[74]

This ambiguous pairing of objects, not surprisingly, corresponds to a certain ambiguity in Wharton's relationship to the meeting. In 1762 Joseph Wharton was treated with by Philadelphia Monthly Meeting for purchasing a Negro slave—incorrect behavior for a member of a society hoping to gradually rid itself of what it saw as a morally troublesome practice.[75] Wharton claimed agreement with the testimony against slavery but was able to convince the Meeting that his actions had been justified. A provision in his will that would set his slaves free was found sufficient—that is, the eventual freeing of Wharton's slaves would have few personal consequences as it would not occur in his own lifetime. Wharton's disciplinary case, in addition, dragged on for nine long months due to his repeated failure to expedite the situation. While Joseph Wharton, Sr., was not himself disowned by the meeting, it is telling that during the 1770s five of his sons were disowned, some after particularly complicated and messy proceedings.[76] No doubt Friends were as confused about Wharton's intentions toward Quakerism as we are.

Even when we take account of their owner's religious status, the variations we find among these Quaker-associated pieces are minimal, in the sense that all fall firmly within the bounds of Philadelphia Chippendale style—and Philadelphia furniture of the rococo or Chippendale style is a complex matter in its own right. The pedimented tall case pieces of the late colonial period fall into two categories, high chests and chest-on-chests, which are, in fact, closely related in both appearance and function.[77] Pieces range from eighty to ninety inches in height, made up of two cases of drawers placed one upon the other and visually joined by a decorative mid-molding. The chest-on-chest rests on bracket feet just a few inches off the ground, while the high chest is raised on cabriole (or curved) legs a foot and a third from the floor and contains one fewer bank of drawers. Thus raised off the ground, the lower section of the high chest—its bottom drawers and skirt—becomes an area of embellishment not present in the chest-on-chest (Figure 3.4b). The elaborate treatment of the pediments of both types and the regionally distinctive design of the shell-carved drawers are perhaps the most conspicuous ornamental features. These tall case pieces are often made

from imported mahogany, although highly figured walnuts and maples were also used.

In his catalog of the Metropolitan Museum of Art's furniture collection, Morrison Heckscher traces the stylistic components of Philadelphia case piece forms:

The earliest Chippendale examples (one dated 1753) are of mahogany, and have a shell drawer in a broken-scroll pediment, large drawers flanked by quarter columns, an oversize bottom drawer with smaller drawers on either side, leaf-carved knees and claw feet. In the succeeding phase the pediment shell drawer is replaced by applied carving; in the final phase, in a perfectly harmonious design, the scroll pediment is separated from the drawers by a continuous cornice.[78]

While this proposed evolution is not necessarily chronological (all three types were made concurrently, at least in the later part of the period), it recognizes stylistic variations within the form and suggests a progression of design sophistication.[79] Heckscher's description also touches on the degree of complexity visible in the configuration of these objects. There is allowable—even desirable—variation present within the quite specific requirements that govern the Philadelphia Chippendale aesthetic. The variations we find among Philadelphia Chippendale tall case pieces represent not so much a temporal evolution as a developmental hierarchy of stylistic options. Those typically referred to as the most "high style" examples today are merely those that most fully articulate the configurational system employed at the time of manufacture. A comparison of multiple survivals reveals the allowable scope of variation.[80]

Setting aside for a moment the question of Quakerism's influence, we can clearly see how all twelve of our Quaker-attributed pieces fit into this universe of typical Philadelphia productions. Similar to the Moore high chest of drawers (Figure 3.4a) is a high chest originally owned by the Quaker Acquilla Jones and now at the University of Pennsylvania.[81] Like the Moore piece, it also has a bonnet top and an upper shell drawer placed above the top tier of small drawers, rather then centered between them as in the open-pedimented Hollingsworth piece (Figure 3.1). Samuel Wallis's high chest made by the Quaker William Wayne (Plate 3) has no upper shell drawer at all, but is decorated instead with applied foliate carving on the upper case. A similar piece at the Metropolitan Museum of Art is also decorated with foliate carving rather than a shell-carved drawer; in this instance Sarah Carlisle was disowned by Friends for her marriage to its owner Joseph Moulder.[82]

The two Joseph Wharton pieces (Figures 3.5, 3.6), rather than having upper shell drawers or applied carving, are ornamented by the continuous cornice Heckscher describes. But the Wharton high chest made by Savery (Figure 3.5) does not include the lower-case shell drawer that all the other examples in this group possess. Within the realm of Philadelphia high chests, these are typical, with typical variations.

In addition to the two Logan chest-on-chests (Plate 4, Figure 3.2), a chest-on-chest owned by the Quaker David Deshler and documented to Thomas Affleck as its maker (Figure 3.3a),[83] and one owned by Benjamin Chew, a birthright Friend who left the meeting in adulthood,[84] feature the same type of detachable pediment with continuous cornice (Figure 3.3b) found on the high chests owned by Wharton. None of these chest-on-chests, however, have the finials found on the two high chests. They likewise share the lack of a typical Philadelphia-style carved shell. A seemingly small detail, by contrast, the central plinth in the pediment, is different for each chest-on-chest: the Chew example has a squared-off column, the Deshler example has applied fretwork, the plinth on the Sarah Logan piece is carved with diapered swagging (Plate 4), and that of her brother's is a flat silhouette (Figure 3.2). An unusual chest-on-chest originally owned by disowned Quaker James Bartram and now in a private collection is of the continuous pediment variety, similar to the Wallis piece in the placement of carving on its upper case, yet in style more closely resembling the shell-carved drawers of the Hollingsworth chest.[85] The Bartram chest has finials as well, unlike the other chest-on-chests discussed.

Each of these dozen Quaker-owned pieces qualifies as a stylistically recognizable, typical high-end Philadelphia case of drawers, but they are only similar, not identical. Where they do not share common features, they display alternatives that are equally acceptable within the array of available options. Take as an example the placement of shell-carved drawers, one of the most typical ornamental features we find. A chest-on-chest will not have a shell-carved drawer in its lower case because Philadelphia Chippendale chest-on-chests simply do not. While a comparable high chest will likely have a shell-carved drawer in its lower case, it does not have to—variations of applied carving on or near the skirt provide other decorative options. Meanwhile, a detachable pediment with continuous cornice will not rest directly above a shell-carved drawer, no matter the piece's overall form. Thus we can find both high chests and chest-on-chests with upper shell-carved drawers—or without them—because it is cornice construction rather than configuration of the lower case that allows or prohibits its inclusion. When

certain fabricational choices are made, they preclude other options, so that no one case piece can ever include every feature that makes up the full stylistic vocabulary.[86]

To qualify as a Philadelphia Chippendale high-style tall case piece, an individual object would have to possess some minimum of the style's required characteristics. Which characteristics are chosen is not as important as that they work together to suggest the piece's generic and stylistic derivation, representing the ability of craftsman and client to recognize and work within a particular stylistic competence. The resulting object group, as a record of that competence, reveals that separate stylistic elements are incorporated through a system that is both developmental and additive in nature. Features both define the configurational system and represent aesthetic choices allowable within it as established. The two Wharton high chests, for example, show us that pieces might share one sort of characteristic (formal configuration) while not sharing another (ornamentation).

For practical reasons, the original price of a piece may be the best indication of its systemic complexity, since the skills, labor, and materials associated with its production are additive. Surviving from Philadelphia are several handwritten copies of a cabinetmaker's price book used by a number of craftsmen as a guideline for placing the value on their products. The more complete version is dated 1786, while another corresponding copy suggests that both were transcribed from a 1772 printed edition not known to survive.[87] In the price list high chests and chest-on-chests are intermixed, just as their appearance suggests the similarity of their conception. The various case-piece options (as found in the more fully descriptive document) are listed in order by significant features and in increasing order of cost. Familiar with the cumulative stylistic competence within which surviving tall case pieces were constructed, we can use the price list both to reconfirm and reexplore the nature of the stylistic system.

There is, as both the objects and the price list make clear, an increasingly elaborate hierarchy of available elements. The more elements incorporated into a single piece, the more that piece would cost. This hierarchy would be partly a matter of construction practicality, but it also suggests a conceptual object order. Any given piece, with whatever features it may possess, is brought to rest at a different phase of stylistic articulation. A high chest, according to the list, might have "Clawfeet & quater Columns" but no pediment, or "Pitch pediment Head" but "Square Corners Plain Feet." Cabriole legs, ball-and-claw feet, and inset quarter columns are each one step in the articulation, a pediment is another—but these can be accumulated in ei-

ther order. The path to elaboration is variable. Progression is likewise variable, but it is also highly evident. A piece described as "without dentils or fret" presupposes that dentils and fretwork represent a logical progression not achieved. Likewise, there seem to have been no scroll-pedimented pieces without quarter columns or legs; we find none surviving today. If such an object was ever made (as it very well might have been), it did (and does) not carry the marks of a recognizable Philadelphia example.

Once all the elements have been selected and put into place—claw feet or swelled brackets, pitch pediment head, quarter columns, dentil fret and shield, leaves on the knees and shell drawers in the frame, and upgraded scroll pediment head (finials or "blazes" are not explicitly mentioned in this list), the last step is carved work—the icing on the cake, so to speak. Carving, in the list, is defined in terms of price—while a certain amount of carving is called for, its relative concentration on different parts of the piece is not specified. Thus, the carving might be in the form of the tympanum carving on the Wallis high chest (Plate 3), the phoenix-like cartouche on the Sarah Logan chest-on-chest (Plate 4), or the elaborate rosettes on the Deshler example (Figure 3.3b). Circumscribed variation according to the wishes of the craftsman or the patron was allowed. As more and more options were incorporated into a single piece, they followed certain rules of position and interrelation—both the features and their interrelation place the objects within a referential system. While there are multiple options for pediment decoration for both case types, there is no carving at the base of either the Deshler or the Logan chest-on-chests because the base of a chest-on-chest is not a stylistically recognized site for carved decoration.

A logically ordered system, of course, establishes a range of possibilities. In reality, however, certain tall case configurations are more common, as they survive, than others. Whether this is a consequence of manufacture or survival is hard to say. The continuous pediment is consistently of the swan's neck variety, while the detachable pediment may have either a swan's neck or a pitch silhouette and is almost always decorated with fretwork. High chests frequently have continuous pediments, while chest-on-chests rarely have shell drawers or applied carving. Yet this follows from the logic of a system that dictates that upper-case shell drawers never rest below detachable pediments and that the lower case of a chest-on-chest never be carved. Some standard options seem to be slightly more standard than others; almost every surviving Philadelphia tall case piece has quarter columns and moldings at the pediment and waist. Yet a piece of unusual but allowed configuration is not surprising, merely unusual. If it uses familiar features and combines

them in familiar but less-than-common ways, its existence speaks more to the creativity of the craftsman or his patron than to deviation from the system.

A particular high chest, then, or chest-on-chest, is not in its formulation some mysterious configuration of latent meaning. If it has shell-carved drawers it may not have dentils and fretwork, or vice versa. The significance in a particular combination of elements is exactly that the variability exists—and that each piece ties into the same organizational logic. For this same reason, high chests and chest-on-chests are clearly part of a common system, as the objects and the price list suggest. They merely represent two different logical terminations of the system's articulation. Yet consider that there is an alternate way to formally group the pieces based in pediment construction rather than typology of the lower case. The continuous type of pediment is constructed as an extension of the front of the piece's upper case, while the detachable pediment type either slides onto the front of the top case, or is lowered onto it from above. On these grounds the Bartram chest-on-chest with its continuous pediment has more in common with the Wallis (Plate 3) and Moulder high chests than it does with the other chest-on-chests discussed, since both high chests and chest-on-chests can be constructed in either fashion. Likewise, the Wharton high chests and the Affleck-attributed chest-on-chests pictured here. Notice that the initial choice of pediment construction will influence some of the piece's ornamental features, regardless of which type of case is selected. The more elaborate Wharton high chest (Figure 3.6) has no upper shell drawer, yet we know that the craftsman who made it was interested in shell drawers because he included one in the lower case. It does not have an upper shell drawer because it cannot, given its pediment type. Thus there is the possibility of combinatorial choice at both formal and ornamental levels, which will determine the appearance of particular pieces. Given the way case pieces are conceived, we could not, for example, determine that the labeled Savery piece (Figure 3.5)—one of only three certain attributions in the group—is somehow outside the allowable norm because it does not have a shell-carved drawer at all. The differences we find between one piece and the next are not deviation so much as variation. An unusual piece challenges the norm, highlights it, and brings it into focus.

Within the set of Philadelphia furniture, one high-style case piece is functionally equivalent to the next. It serves the same ends and embodies the same code. Within Quaker discourse, however—or Philadelphia society for that matter—formally similar expressions are not necessarily equivalent. Tall case pieces and Quaker individuals are respectively parts of larger sys-

tems, which intersect in places but are far from identical. Deviation from the norm within each system has its own unique qualities. Furniture typically demonstrates stylistic variation, but this variation has no primary religious or theological base. A Philadelphia high-style high chest displays only, and completely, its maker's and owner's competent use of a configurational grammar of tall case furniture. Quaker expression is open to ambiguous interpretation, so that variation may or may not be important—and may or may not indicate competent understanding of Quakerism. This means that the furniture, by the very nature of its variation, invites religious ambiguity when it enters the Quaker sphere. Quakerism tolerates high chests just as high chests tolerate Quakerism. Within the Quaker theological system based on the uniqueness of individual understanding, after all, the interfacing of two disparate frameworks for interpreting the same artifact would *also* be open to individual interpretation. If an individual's mediation of the spiritual and physical worlds still appears correct to Friends, there is no real reason it cannot differ a little from the norm. As the product of a spiritual-physical mediation, a high chest can vary as well.

Philadelphia furniture exists first of all in a frame of reference specific to itself. The Quaker referential system exists elsewhere, where the details of high-chest fretwork and dentils are not directly operative. High chests and Quaker precepts cannot be directly compared—they represent coexisting systems of discourse that are yet not coextensive. The paradigm for Quaker expressive understanding is centered in a metaphoric comparison to speech, and there is no obvious correspondence to words in an object form. Objects and theology represent radically different systems of thought, not only in content but in conception and format as well. Thus plainness in theology does not readily translate into the object world. Quakerism carries this problem within it by choosing not to explicate rules for the appearance of objects—a system focused on speaking as a central metaphor cannot easily translate itself into other expressive realms. The expressive metaphor of speaking and silence is here indeed a metaphor—a figurative comparison linking together two radically disparate ideas.

Plainness in Context

If we were to arrange our Quaker furniture owners in a continuum, from "best" to "worst," that is, from most to least deviant within the realm of religious disciplinary activity, what would we find? That there is no obvious pattern in the high chests—no piece of furniture is more revealing than the

next. Both the wealthy but correct James Pemberton, clerk of Philadelphia Monthly and Yearly Meetings, and Joseph Galloway, a former Quaker and secular political leader who replaced Pemberton and others in Pennsylvania politics, are known to have owned tall case pieces valued at over £20.[88] If we tried, instead, to arrange the furniture in a similar deviational progression and then compare the owners, we'd be lost. Such a value-laden continuum based on the forms of the objects simply does not exist. Instead, we are left with a continuum of intentions toward Quakerism, each expressed through a functionally equivalent piece of furniture.

If furniture embodies deviation, it is subtle. Transgression from Quaker *Rules of Discipline* most directly reflects on the *Discipline*. Violating specific rules whose violation carries specific penalties—marrying a non-Quaker or engaging in war or some other explicitly forbidden action—is a direct and individual statement within the belief-based discursive system. By comparison, the ambiguous ownership of an ambiguous object is a reflection of allowable ambiguity. That an individual owns a certain piece of furniture is a sign of Quakerism's adaptability and inclusiveness rather than of an inability to define its boundaries.

The lack of functional difference between high-style Philadelphia case pieces owned by Quakers exactly corresponds to the multiplicity of their possible meanings, since Friends who own ambiguous furniture are not so much transgressing with the furniture itself as they are dealing with the possibility of transgression, exploring the fact that their allowable object world had boundaries. Such possessions are "Little Things in Appearance but Great in Consequence," notes the *Discipline*, precisely because through them "the Spirit of the World may seek and gain an Entrance."[89] Worldliness may or may not take hold, depending on the individual's relationship to God. Thus, if a conversant Quaker in good standing owns questionable furniture this is not some lapse into worldly society but an exploration of the bounds of worldliness. If a Quaker of questionable relationship to the meeting owns that furniture, well, we already knew the relationship was questionable.

The same piece of furniture is not the same no matter who owns it. The intent of actions defines the actions themselves and Quaker practice defines those intentions that are otherwise—in the larger material world—so fundamentally hard to discern. Thus Sarah Logan and her brother Charles can own similar pieces of furniture while maintaining quite different religious positions, while Joseph Wharton, Sr., can all by himself own two pieces of significantly different ornamental intensity. It is the individual's place within the Quaker expressive system that makes sense of the object in question, not the form of the object that determines its theological meaning. The exact ap-

pearance of a high chest did not make all that much difference, since it was the spiritual state of its owner that mattered in the end. Just as Quaker plainness is part of a theoretical discursive process, so is its embodiment in some particular sphere of material expression. If the two do not always correspond, this only enriches the discourse they allow. Objects could function as belief-based statements of religious intent, but they did not have to.

In the end we find that Philadelphia Chippendale high chests not only were allowed by Quakerism but contributed to the potential diversity of religious expression, since Quakerism encourages individuals to engage fully with the secular object world. Furniture was not belief and was not seen to be. Belief in part informs objects, but it is only one of many contexts that affect their final form. The object itself ties theology and secular existence together in a single, if complex, interpretive universe. In accommodating with more or less grace the ambiguity that was so central to their fundamental shared beliefs, eighteenth-century Philadelphia Quakers, collectively, were neither hypocritical, capricious, nor insincere. They were simply an intelligent people functioning together in a culturally multivalent, discursively complex physical world.

Chapter 4

"All That Makes a Man's Mind More Active": Jane and Reuben Haines at Wyck, 1812–1831

John M. Groff

Wyck, a historic house museum in the Germantown section of Philadelphia, offers an unusually complete picture of multigenerational Quaker family history. It was home to nine generations of a family from 1689 until 1973, and this family's choices of how to use their time and resources tells us much about acceptable norms of beauty and material display in their community.[1] The colonial era house, remodeled in 1824 by architect William Strickland and little changed from that time, is filled with family furnishings and natural history collections. The library and over 100,000 documents, including letters, diaries, bills of sale, and estate inventories, also survive, mainly through the efforts of family members in the later 1800s and early 1900s, who had a strong sense of their family's historical significance.[2] An early nineteenth-century ornamental garden, which features old roses, evokes the family's love of horticulture and their talent at shaping beauty in the natural world. The inhabitants of Wyck demonstrate the rise in prosperity of Quaker families and the assimilation of German and Dutch Quakers into the English mainstream of the eighteenth century. Ascent of the social ladder was rapid. This essay focuses on the sixth generation to live at Wyck (Plate 5).[3]

For the first three generations, ownership of Wyck passed through the female side of the family, an acceptable way of bequeathing property for Quakers, who were less gender-biased in distribution of family assets than Anglican and Presbyterian families. The general pattern of inheritance in the colonies before the Revolutionary War favored primogeniture. However, many Quakers would divide their estates equitably among their children. Husbands often managed property for their wives, but the title was in the

wife's name. By 1770 Wyck was linked to the Haines family when Margaret Wistar married Reuben Haines I, and that would remain the surname of the owners into the 1970s.[4] Through much of the second half of the eighteenth century and until 1820 Wyck served as a summer house, a simple retreat at a high elevation, about seven miles northwest of the center of Philadelphia. A working farm, it contrasted with the more formally furnished family houses in Philadelphia where the Wistars and Haineses figured prominently in business and in Quaker society. By the 1790s it also served as a healthful alternative to the yellow fever-plagued city.[5] In 1793, as George Washington was finding refuge several blocks south of Wyck on the Germantown Road, Caspar Wistar Haines (1762–1801) brought his young family to Wyck, having just witnessed the death of his parents from that disease.[6] In the next few years he would undertake an ambitious transformation of his Germantown farm into a stylish country retreat. In 1796 he built a branch of his family's brewing business—the Germantown Brewery—on the edge of the property, constructed a massive stone barn, and added a coach house, smokehouse, and other buildings. The interiors of Wyck were repainted. Windowsills and surrounds were at first brightened in yellowish and pink tones but then grained to look like mahogany.[7] In 1799 the remodeling was completed with the addition of a stylish coat of plaster (stucco) to the exterior walls, scored to look like cut ashlar, a rustication in the current neoclassical fashion. Sofas, chairs, card tables, and new ceramics were purchased for the house, completing the change from rural retreat to gracious countryseat. Complementing the house renovation was an ornamental garden with formal parterres and extensive orchards.[8] It is in this setting that Reuben Haines III (1786–1831) was raised, a place that balanced rural sensibilities with city fashions and appreciated past legacies but looked optimistically at the modern world and its opportunities. It is here that Reuben began his pursuit of useful knowledge.

Reuben Haines and his wife, Jane Bowne Haines (1790–1843), in many respects personify the tensions, inconsistencies, and search for balance within the prosperous circle of Quakers who were their extended family and social and business connections. They fully participated in the expansion of Philadelphia in the Federal period, especially in the arts and sciences, but they were not part of the so-called Republican court that evolved from the time of George Washington's residency in the city. Beatrice Garvan writes in *Federal Philadelphia*, "When George Washington was elected president, it was as if a king were crowned."[9] Lavish clothing, expensive entertainments, theater parties, and balls defined the social whirl. The Haineses were swept up by the enthusiasm for French style and counted in their circle of friends Prince Charles Bonaparte, Jacques Milbert, and Charles Le Sueur, but they

did not frequent the gatherings of the wealthiest and most fashionable residents who made up this "court." They lived in a large and well-furnished town house on Chestnut Street and retreated to their summer place in Germantown for a few months of rest. Notable craftsmen like Jacob Super (? –1820) and Jacob Wayne (1760–1857) rented shop space from the Haineses, and the Haineses patronized these men for furnishings. Countless letters and ledger book entries reveal their pattern of consumption of material goods, their quest for enlightenment about the natural world, and their desire to stay on the cutting edge of technological change.

During this time Reuben and Jane Haines's spiritual lives and participation in the affairs of Arch Street Meeting take surprisingly little space in correspondence or journal entries. Letters laced with biblical quotations or religious ponderings from family or friends did not generate replies in kind. Correspondence to Reuben or Jane reflected the various concerns and controversies erupting among the Quakers in the 1810s and 1820s but suggests that they were interested observers rather than active participants.[10] This attitude of Reuben's is foreshadowed in his visit to New Lebanon, New Hampshire, in 1810 and his observation of Shaker worship. He noted that the Shakers believed they had gone far "beyond the formative Quakers" and, although he disapproved of their self-righteousness, he did view it in the larger context of their ideas of perfectibility. Their simple life and their inventiveness were what most attracted him. He wrote, "Their houses, workshops, stables and in fact everything about them is the most perfect neatness, order and convenience."[11] Reuben's travels through New England were quite differently motivated from the 1790 pilgrimage of his father. This was not an "inward journey" but a series of trips to see family and friends, explore scenic and natural wonders, and observe differences in culture and lifestyle. Observation and secular experience were the motivating factors. Resort hotels and spas were often the resting places. When Reuben established his family at Wyck in 1820, he may have had in mind impressions from his visits to the Shakers. He characterized it as "a perfect Democracy where everything is done by universal consent, and still every man and woman possessing his or her own inclinations, where everything at least carries the outward appearance of tranquility and happiness."[12]

At other times Reuben was stimulated more by the spectacle of controversy than by outward manifestations of spiritual peace. In a letter to his uncle Richard Hartshorne in December 1810, he relishes his account of a contentious episode that brought the *Disciplines* into the unpleasant light of the courtroom, creating a difficult situation for his meeting's overseers. He reported,

Our old friend John Evans has at length had the gratification of exposing to a Court and Jury the discipline, Minutes, and unjust & tyranical proceedings of friends in his case . . . by an action instituted in the highest court of the Commonwealth for assault & battery and forceable entry into his house committed by the weak and infirm Hannah Clark, aided by Susannah Haycock and Jane Pearce, the committee of Womens meeting appointed to "endevor to obtain a conference with Barbara Evans" his wife after he had sent them a letter accompanying her resignation informing them that she would see no committee on the subject. As the Committee to raise the discipline had entirely overlooked the subject of resignations women friends hesitated what to do but after two months deliberation concluded to endevor to obtain a conference.[13]

Reuben continued at great length in his retelling of the occasion of the visit, almost comical at times as the old and deaf ladies force their way inside. He described the resulting suit and trial, the packed courtroom, and the satisfactory verdict, which, although it found for the plaintiff, awarded "one half of a cent and no costs." He concluded, "many strangers have been much better informed of the principles of friends than ever could have been before," bemused at the extremes of the case and the occasional absurdity of the community. Reuben seemed to have little patience for the disputes and growing controversies within the Society of Friends.

As the Quakers moved toward schism in the 1820s, the Haineses were firmly part of the Orthodox sphere, yet there is no strong evidence of a deep Christian spirit or devotional reading of the Bible. As early as 1816, Reuben's cousin Ann Haines wrote with impatience that "nothing is going on but "Prayer Meetings—Bible Classes—Bible Societies—Tract Societies and divers other good things."[14] She did not attend, not necessarily for lack of interest, but perhaps from frustration with the theological controversies. Social connections, family position, business interests, and intellectual and educational affiliations defined their allegiances to fellow Quakers. Yet in many ways Reuben's love of farming and horticulture and his pantheistic faith in the natural world would have made him more comfortable allied with Hicksite doctrine. If the family actively took a side, it was derivative more of their position among the Quaker elite than of any strong beliefs. Jane Haines commented in 1824, "Elias [Hicks] spoke a very long time in the Quarterly Mtg in his usual strain—thee would have left the house. I think there were many wished to but had not quite courage enough."[15] But there is no analysis of his discourse, no refutation. When the "Separatists" at the quarterly meeting at Abington locked them out in August 1827 they simply met under the trees, indicating displeasure rather than rage.[16]

Reuben and Jane Haines were not passionate about their religious life. It did not transform them in obvious ways. It was simply a fact of their being and an identifier, a mechanism for choosing friends and establishing patterns of familial behavior. They lived "in the manner of Friends." Their deep pleasure in natural beauty and the accomplishments of man was conditioned by their upbringing and education. Still, their choices about their material possessions, their dress, and the appearance of their homes were the result of being steeped in certain aesthetic and spiritual values.

The Haineses' lives reflect the tension between the ideal of living in simplicity and a reality that included elaborate silver tea services, bright-colored wall-to-wall carpeting, window hangings framed with gilded cornice boards, and a costly mahogany dining room table around which twenty-four could dine in satinwood-grained "fancy chairs" (Figure 4.1). How might they have reconciled their material life with their own self-image? Is saying that you embrace simplicity enough? In 1816 Jane Bowne Haines wrote, "we live very much in simplicity—I know of no person more adverse to show than my Reuben."[17] Yet in this same year Reuben wrote to his close friend James Pemberton Parke, "I have had the Haines coat of arms stereotyped but upon getting it explained by Brown the seal cutter to my disappointment the three horses as I took them to be turn out to be birds!!!"[18] Is this hypocrisy? Or does an explanation require a more complex deciphering of both how this family defined plainness and simplicity and how their day-to-day lives reflected their understanding of style, fashion, and aesthetic taste? If they could afford so much more than they purchased, yet restrained their consumption to a small sampling of fine things or references to a more elegant life, does this equate with simplicity?

Reuben Haines personifies many other characteristics of wealthy Quakers of his era: an interest in natural history and agriculture, an enthusiasm for exploration, and experimentation with technology and engineering. In Reuben's case this led to the invention of everything from a flexible hose for fighting fires and a device for sweeping chimneys, to sponsorship of canals, coal companies, and the first Philadelphia area railroad. It was as if he had to grab at every opportunity offered to him—his pursuit of knowledge often became a race. His life was characterized by boundless energy contrasting with periods of lethargic depression; perhaps he was a victim of bipolar disorder like his father. Although it fueled his many activities and accomplishments, it is apparent from Jane's correspondence and her frequent absences visiting family in New York that life at Wyck was stressful. Prince Charles Bonaparte, although a great friend and admirer, characterized Reuben as

Figure 4.1. Wyck dining room, table by Jacob Wayne, 1812. Courtesy Wyck Association.

suffering from "monomania," which made him a stimulating but at times exasperating friend and companion.[19]

His education at Westtown School, beginning in 1799, nurtured his later interests. This boarding school was founded that year by Philadelphia Yearly Meeting primarily for students from rural areas where Friends' schools did not already exist. Reuben's aunt and uncle were associated with the school, so it was logical for him to attend. At a remote location in Chester County, Pennsylvania, false pride and worldliness were discouraged, providing a "guarded" experience with moderation helping define learning. Here Quakers hoped to renew traditions of dress and speech. A remove from the evils of the city would facilitate the revival. For lessons, geography, mathematics, and Shakespeare were mixed with gardening and farm chores. Students were encouraged to strive for perfection in their work and their understanding of the world. Writing home at age sixteen to his mother, Reuben noted, "I received my hat, and do not think it very handsome, but if it is the best to be got, I am willing to wear it." His aunt, with whom he boarded, was affronted

by Reuben's obdurate remark and appended to the letter that "we have rea-
soned with him that he ought to have more sense to sacrifice convenience
for fashion."[20] While Reuben often appeared oblivious to the subtle line be-
tween that which was practical and that which was visually pleasing, he was
not extravagant or wasteful, behavior that would have precipitated more
consistent admonishment. Regular small reminders from family and friends
were enough to keep him in balance. Themes developed in his early letters
and diaries that are found in his later life. While he acknowledged the idea of
simplicity and understated display, he also thought about decoration of
clothes and interiors and furnishings, and reveled in both the beauty and the
mechanics of nature.[21] It was almost as if by describing something as simple
he could make it so. Thought or characterization, in some ways like the
Quaker *Disciplines* themselves, could substitute for daily reality.[22] Sometimes
they could be seen in something as basic as the choices they made when set-
ting up their household.

Material Life: The City, 1812–1820

Many observers of the Haines material record have written about Reuben
and Jane's choices of housing, furnishings, and decorations, concluding that
they display no direct correlation with their Quaker faith but perhaps reflect
Quaker values. As both Sandra Mackenzie (Lloyd) and Sara Pennell have
argued, the way the Haineses furnished their houses and lived their lives is in
many ways consistent with the mainstream of wealthy Quakers of that era.[23]
Pennell notes that their renovations at Wyck in 1824 were driven more by
scientific and pedagogical interests than by anything religious. This was not
Quaker space as much a reference to Quaker spatial tradition, an "effort to
accommodate in comfort the various spheres and interests of the extended
family."[24] Mackenzie Lloyd adds economic motivations to the list and goes
further by suggesting that Reuben Haines "willfully combined agriculture
with science, an old fashioned farmhouse with architectural renovations,
and the traditionalism of established wealth with progressive social reform
theories."[25] The question is whether their consumption of goods, the way
they shaped their interiors, and their more emotional relationship to their
gardens create an image that is Quaker, or specific to this one family.

In 1812 Reuben Haines persuaded Jane Bowne of New York to marry
him, an alliance of wealthy and prominent Quaker families already con-
nected through common mercantile business interests and marriage. Reuben

had pursued Jane for some time before she accepted his proposal and in one letter he lamented that for his nine letters he had received but three replies.[26] If there was reluctance on Jane's part it appears to have been because of family concerns more than lack of affection. Jane had been raised in a large and well-decorated house on Pearl Street in Manhattan, the daughter of leading printer, publisher, and banker Robert Bowne. She was the descendant of one of the New York area's earliest Quaker families, who had settled in Flushing. Well-educated and comfortable in wealthy circles, her social group would have eclipsed that of the Haineses. After they married and settled in Philadelphia, Jane felt at home in the house that Reuben rented, as it was in a fashionable neighborhood and of appropriate scale for newlyweds of position. To establish housekeeping they acquired parlor furniture and from Jacob Super a large mahogany dining room, a pair of striped-maple grained beds with gilded cornice boards, and two elliptical bureaus. Twenty-four fancy chairs in the latest Greek style were purchased from Haydon and Stewart.[27] As early as these first purchases, the tension between elegance and restraint is evident. Reuben noted, "I am sure it is my wish and I believe it is thine to use all due economy in our housekeeping establishment."[28] He rationalized the purchase of fifty yards of Brussels carpeting for their "mansion" as "cheaper," although he does not describe the less expensive alternatives. At $2.50 per yard it was not an inexpensive carpet for its time. Probably chosen for the hall and two parlors, it featured colors of brown and blue. Orange wool moreen curtains hung at the windows and also covered Reuben's father's sofa made by Jacob Wayne in the 1790s.

Their letters establish that they intended to entertain often. Jane was accustomed to welcoming guests to a conservatively fashionable setting where style and comfort provided a backdrop for lively conversation. While the Quaker rituals of entertaining were not as formalized as those for upperclass Episcopalian or Presbyterian families, the Haineses were aware of the habits of good society. Although they eschewed dancing assemblies, card parties, and more raucous entertainment, they made sure their china dinner services, silver tea sets, and glassware were of the latest taste (Figure 4.2). Jane frequently used the term "handsome" rather than elegant to describe her purchase choices. Her days would be carefully scheduled and her domestic setting provided the necessary accouterments for her social life. In the morning Quaker families traditionally visited with each other. In the afternoon and evening the circle was extended and casual dinners or teas were their preference. Stopping by uninvited and being asked to remain for a meal was a common occurrence. Visitation and conversation took on multiple levels

Figure 4.2. Left to right, ceramic sugar bowl, Staffordshire, England, ca. 1815; silver sugar bowl by Richard Humphreys, Philadelphia, ca. 1785; miniature card table, probably by Jacob Super, ca. 1810; porcelain pansy pots, Coalport, England, ca. 1830s; glass whimsy, "Schnappshund" by Wistarburgh glassworks, New Jersey, ca. 1740s; porcelain sauce tureen by Tucker, Philadelphia, ca. 1830, from a dinner service of over 100 pieces at Wyck. Photo: Eric Mitchell. Courtesy Wyck Association.

of meaning, being both social activities and opportunities for discussion of pressing matters within the community and the offering of instructive guidance.

The furnishings of upper-class Quaker and non-Quaker households in Philadelphia and Germantown in the first decades of the nineteenth century suggest that the differences were of scale and of level and type of ornamentation. In Quaker households there was an awareness of fashion but not an obsession with fad. A varied and gracious social life was one aspect of the Haines family existence, but its importance was overshadowed by education, scientific inquiry, horticultural pursuits, and social activism. Art and music had their appropriate place, not as frivolous entertainment but as exercises

to bring the mind closer to its highest ability for alertness and attention. If there is simplicity, it is in the direct appreciation of the art, not in the social pastime of artistic patronage. Jane Haines often visited the Pennsylvania Academy of the Fine Arts, of which Reuben was a founder, though he was more deeply involved in the Franklin Institute and the Academy of Natural Sciences, which he also helped organize. While the Haineses might admire Prince Charles Bonaparte's Van Dycks, Rubenses, and Brueghels at his estate in New Jersey, Point Breeze, their own bills and accounts show that they made little attempt to purchase art or engravings or to display their wealth and taste on their walls. Books that reproduced art, particularly classical works and old masters, were purchased from bookseller James Pemberton Parke, but the Haineses never attempted to create room settings that included works of art. The Haineses were no different from non-Quakers in finding aesthetic satisfaction in the works of various artists, but they did not seek to enhance their own status through either displayed knowledge or acquisition of art works.

Although the rooms in the Haines house in town were relatively large, they were not grand. Architectural detailing was modest, with modern configuration of space often being the boldest expression of style. Reuben Haines enjoyed the study of architecture and the friendship of men like William Strickland, on whom he called to remodel Wyck. Haines's notes from a series of lectures on classical architecture given by Strickland at the Franklin Institute show his enthusiasm for understanding the order and mathematical principles of architecture. Strickland's illustrations, which accompany the notes, are finely rendered images of moldings, capitals, and columns; it appears these written and drawn documents satisfied Reuben's desire to know and understand buildings as artistic expressions and points of historical reference.[29] This was private consumption, not public display to seek admiration or elicit envy.

While marble and gilt defined the upper-class house in this period in Philadelphia, faux marble and finely grained wood were sufficient for the Haineses and many other Quaker families. Painted looking-glass frames were satisfactory as opposed to gilt. Wool damasks or moreens instead of silk for furniture coverings expressed style but not ostentation. This was reductive consumption, emphasizing the form, not superficial and costly embellishment. The shape of a klismos chair or even the imitation of costly woods such as the Haineses' satinwood-grained dining chairs would make a statement, whether consciously or unconsciously, to family and friends, but they did not spend the money on chairs made of the most expensive woods or ornamented with gilded brass or painted or stenciled decoration.

This preference also was evident in their selection of ceramics. Reuben wrote to Jane in 1820, "Mothers present of mantle ornaments are really beautiful and I think thee will admire them very much. they are very much like a set Sally Ann Lea has which I believe thee has seen. hair colored landscapes on white china with a deep gilt edge form a flower pot elevated on the stand not placed in it."[30] The Spode mantle pots with rural English scenes and a simple gilded rim have hand-painted decoration in tones of dark brown and black. They are elegant and evocative of neoclassical style, a fashionable selection but one befitting the Haineses' overall mode of restraint. Fifteen years later either Reuben or his Cousin Ann acquired a large dinner set of white porcelain from the Tucker porcelain works on the Schuylkill River in Philadelphia. Very reminiscent of the Spode set and perhaps inspired by it, this service was somewhat old-fashioned when made and a distinct contrast to the elaborately polychromed wares from the same manufacturers. The Tuckers, who were Friends, like many Quaker manufacturers adapted their products to the demands of the clientele. The Haineses, like many Quaker families, tended almost exclusively to patronize Quaker craftsmen. Production of even highly ornamented pieces does not appear to have caused any discomfort among Quakers. But care must be shown in the purchase and display of costly items.[31] Pennell observes that "the domestic landscape" at Wyck evidenced "aspirations to conformity superseded by a desire for constancy and comfort in context."[32]

It is also not possible to characterize upper-class taste in this period as being derivative of one country's style. Moreover, it cannot be said that wealthy Quakers followed one style and those from different faiths another. There were multiple sources of inspiration partially conditioned by mercantile connections and availability of goods. Family tradition suggests that Jane Haines desired Meissen botanical chinaware but was content with a hand-painted English set when no agent could secure the former.[33] Her silver tea service from Harvey Lewis in the Empire manner was made in the latest English style as inspired by French design, but her friends did not analyze the source, just quietly acknowledged the quality—handsome—and enjoyed its use. The tea service was an accouterment of a social ritual—visiting friends for tea—not the opportunity for ostentatious display. Other furnishings would be made by cabinetmakers of English descent and training, who selectively adapted examples from English design books most comparable to English furniture of the middling sort. Furniture for the Quaker Morris or Wistar family clearly reveals this manner.[34]

The Haineses, like many wealthy Philadelphians, were to a degree captivated by a fashionable trend in the period shortly after their marriage. The

fondness for the Marquis de Lafayette had long sustained an American interest in French style. Benjamin Franklin's importation of French chairs and those in the French mode chosen by Washington and Jefferson while in residence in Philadelphia in the 1790s meant that many upper-class households included some French furnishings.[35] But in the mid-1810s French style had become truly de rigueur, emblematic of good taste.[36] Napoleon Bonaparte's overthrow in 1815 had sent numerous exiles to Philadelphia, including lofty Parisians such as the duke of Orleans and Talleyrand-Perigord. At the pinnacle of this refugee society was Prince Joseph Bonaparte, who in 1816 acquired a house a few blocks from the Haineses. Bonaparte's nephew (and son-in-law) Prince Charles became a friend and admirer of Reuben Haines. Houses in the city were soon displaying scenic wallpapers, Louis XVI chairs, mahogany armoires, and sleigh beds. The Haineses frequented the Bonaparte residences both in town and their country estate on the Delaware River in New Jersey, but their enjoyment of the art collection, notable library, and elaborate furnishings did not foster a need to emulate them.

The highly descriptive nature of the Haineses' correspondence records in detail the possessions of these notable exiles and the layout of their gardens, but nowhere does Haines indicate a desire for similar objects or a similar way of life. Reuben's report of dining off of silver plate at Point Breeze strikes a tone of anthropological observation, not envy. He wrote, "I partook of Royal fare served on solid Silver and attended by six waiters who supplied me with 9 courses of the most delicious viands, many of which I could not tell what they were composed of."[37] His interest in many ways may have been piqued more by the new form of dinner service than by the grandeur of the table. Reading further, it is evident that Reuben reserved his true passion in describing the natural history collections, herbariums, and library. He took in suites of rooms with "Rubens! Vandyke! (sic)" on his way to a "library of the most splendid books I ever beheld." He wrote his Cousin Ann, who was staying at a simple rustic retreat, somewhat in a jesting manner, "Say now in truth what has Pine Cottage to offer in exchange for these and a thousand other luxuries I could enumerate if I had time."[38] The remark struck the wrong chord with Ann Haines and provoked her to remind him to not think too highly of this way of living.

References in correspondence and Ann Haines's own writings indicate that she more actively focused on her religious life than did other family members. Firmly on the Orthodox side during and after the separation, her letters demonstrate a broad devotion to Christianity. Her closeness to a number of relatives who were Episcopalians may have derived from her own beliefs. Ann's opposition to the Hicksites was grounded in religion but was also affected by her identification with the more worldly and wealthy Quaker

elite of Philadelphia. An interesting note is that, although born an illegitimate child, she was warmly accepted by the wealthy Quakers of the city and does not appear to have been generally stigmatized by her birth, although it may have limited her possibilities for marriage.

For both Reuben and Jane Haines, observation of elegant ways of life and artistic expression was more than sufficient for their needs. There was neither condemnation nor approbation in their writings. They placed greater value on the natural beauty of a flower, seashell, or bird than on things manmade. They held in higher esteem those who gave to others and supported worthy social causes than those who indulged in selfish acquisition, particularly that which led to competition of the most wasteful type. For the Haineses what mattered was not showing off but showing awareness of style and quality, as it made for comfort and durability and facilitated the enjoyment of greater pleasures of the mind, and, as Reuben expressed it, the company of good friends.

A Move to the Country: 1820

In 1820 Reuben Haines reached a decision that at first distressed his family and set them on a radically different course in the way they lived (Figure 4.3). They would give up their city house to live year-round at Wyck. Jane and the children worried about the isolation of this community in the months other than summer, and Jane in particular was reluctant to give up her busy social and cultural life. Reuben's motivations were several. He had suffered a number of financial losses in this period of recession, which made the move away from the city a wise decision. His interest in scientific agriculture was growing and he wanted to devote more time to it. Several years before he had imported America's first Guernsey cow, and he frequently attended livestock sales of prize herds and rare breeds.[39] All this was part of an effort to identify crops and animals that would flourish in the region. An active member of the Society for the Promotion of Agriculture, he subscribed to numerous farming and horticultural journals and regularly purchased books on the subject. In addition he had long considered the prospects of perfecting community and living conditions in an idealized or utopian manner. It is not surprising that he was attracted to the ideology of Robert Owen and would later support some of the ventures at New Harmony in Indiana. Wyck could be Reuben's own Arcadia, a place where his children could be raised connected to nature, perhaps recapturing some of the pleasure he had found

Figure 4.3. Rembrandt Peale, *Reuben Haines III*, ca. 1831. Oil portrait on canvas. Courtesy Wyck Association.

at Westtown School. He noted to his mother soon after the move that he had left Chestnut Street "with out one single feeling of regret."[40]

Jane was not prepared to leave the civility of city life completely behind. Furnishings were moved to Wyck to supplement older family pieces that

remained in the house. Reuben noted that all arrived "without a single frac-
ture and scarcely a scratch."[41] Curtains were hung in parlors and halls; mats
put down (it was summer when they moved) in living rooms and bedcham-
bers. The sofa purchased from Duncan Phyfe the previous year found a place
of honor in the front parlor where it is still seen today. About that piece of
furniture Jane's sister had written,

The sopha we fear will not be ready by the time thee wishes—there has been great
pains to select the handsomest wood—the nicest hair etc. and Phyfe says he must not
be hurried as he wishes to finish it in a manner to do himself credit and give satisfac-
tion to the lady who sent for it. He seemed much pleased when he heard it was to go
to Phila. and said he should exert himself to have it surpass any that could be made
there—in doing so Aunt Lydia says he will waste enough to make three or four pieces
of furniture & perhaps then not succeed. but I have no doubt it will please us all—he
promises to pack it & put it on board the vessels for $120.[42]

Note again the concern about wastefulness. Its ornamentation is derived
more from the quality of the figured mahogany chosen than from carved
decoration.

While some substitutions were necessary for beds that were too tall or
tables too long, the furniture generally accommodated itself to its new, far
less spacious setting. Four yards of scrap carpet was purchased to supple-
ment what was needed for the dining room and selected so that it matched
the purple in the existing carpet.[43] Concerns about their current financial
condition may have limited the extent of redecoration, but at least for
Reuben the simplicity of his family's country house meant that fashion
would play a far less obvious role in their daily existence. His pleasure came
from the gardens, farm, and his museum collections, not his furnishings.
However, he did not abandon the city, as he was able to partake of its
intellectual and social life by renting a large chamber with two beds at
22 North Second Street to use as a pied à terre.[44]

Over the next four years Reuben expanded the farm to more than a
hundred acres. His children had daily responsibilities milking cows and
tending their own garden plot (not unlike his own experience as a youth at
Westtown). Jane attempted to gain control of the overgrown ornamental
garden but with limited help it seemed an endless task to her. Working in
small sections she cleared tangled plants and replaced them with roses.
Reuben's business investments improved such that by 1824 he was in the po-
sition to acquiesce to Jane's frequent entreaties about repairing the old
house. Jane lamented to Reuben that the house was so drafty at times that
she felt "we shall all be congealed to statues."[45] They were worried about all

the rotten floorboards, and Reuben reported after work began that "not one single foot of sound joice remained and the whole could have easily have been pushed through a sieve!!"[46] What began as a project of repair escalated into a complex remodeling, producing state-of-the-art modern interiors inside an old house shell. Reuben never undertook anything in a limited way; his exuberance spurred others into large actions. With Jane and the children removed to the Bowne home in New York, work could progress unimpeded. Jane must have read with some trepidation Reuben's letter that noted, "Thee very well knows few if any ever begin a career of vice! or commence the repair of an old building that stop exactly at the point intended."[47] Descriptions made by Reuben or Ann Haines of walls being knocked out and fireplaces moved did not provide any composite picture of what might emerge. Under the skilled guidance of Reuben's friend William Strickland, walls were opened, the fireplace in the front parlor relocated around a corner, cabinets moved three rooms over, and a massive eighteenth-century stone fireplace and brick bake oven disappeared (Figure 4.4). The house that faced Germantown Road with three windows in its best parlor only a few feet from the sidewalk now turned away from it, as the windows were bricked in. The noise and filth from the hundreds of wagons that traveled it each day no longer intruded. A park-like lawn and flower garden were the improved vistas from the windows that remained along the sides.

The house, which had included many small and inefficient spaces, particularly for a large extended family, now had only four principal rooms on the first floor, each one room deep. Light and air could flood the rooms, drawing the eye to the lawns and gardens beyond. The arrangement also functioned far more efficiently for the servants, allowing them to pass more easily between rooms and maintain them. Staff included a cook, a dairy maid, a chambermaid, and a general helper for the household. If the remodeling produced elegance, it was in the spareness of line, the lack of architectural moldings and ornamentation, and the radical reconfiguration of space. The wall plaster was tinted with ground smalt, producing a cool blue color that was offset by white woodwork and trim. The paint schemes at Wyck are consistent with those of other Quaker houses in the country around Philadelphia. For example, at a house in Delaware County called Collen Brook a wealthy Quaker named Abraham Lewis III in the 1820s offset more decorative colors with what Sara Pennell has described as "non-colors": gray, buff, and white. These were done with a "flatted finish" quite fashionable in its muted tones.[48]

Strickland's innovations also included pivoting doors that swung on a 90-degree angle, allowing spaces to transform from more private spheres to

Figure 4.4. Wyck, front parlor, ca. 1900. Courtesy Wyck Association.

an enfilade of rooms 65 feet long. A large looking-glass anchored the front parlor wall, reflecting an elliptical statuary niche across the halls in the new dining room/library. Fielded paneled doors and wainscoting were the applied ornament. Strickland's plans had called for more elaborate decoration inside and modernizing outside in the Greek Revival mode, but Reuben rejected those schemes, because of either expense or a sense of family history and desire to preserve his past.

The house appeared little altered from the exterior. No grand statement or demonstration of wealth was intended. This was space to serve and please family and friends. In the layout the design was modern and somewhat radical, allowing the family to open out compartmentalized spaces when so desired. But most of the furniture remained the same. A modest balance was made between the old and new. As the time came for Jane to return with the family, Reuben tried to pave the way by writing that the "flatterers who praise the alterations so much [they] are sure my wife will highly approve of them."[49] Being marginalized during the process had upset her, but the house was transformed in its practicality as well as simple beauty. A few small additions would suffice. Jane ordered new carpet and one dozen mahogany

chairs from Charles White (1796–1876), klismos style decorated with sheaves of wheat.[50] Her real attention would now be on the garden.

The Gardens

Horticulture has played a multifunctional role for the Haines family. It has been a beloved pastime, an expression of scientific interest and inquiry, and, for many family members, a profession.[51] It has been their most evident way of expressing aesthetic sensibilities. Planning, creating, and maintaining the ornamental garden was an artistic act whose goal was to provide delight through the senses of sight, smell, and touch. In the 1790s Caspar Wistar Haines laid out his first formal garden plan in an area between the house and the fence separating his "Germantown Brewery." A symmetrical plan of parterres, lined with low boxwood or some other border plants, allowed him to grow a mix of flowers, herbs, and vegetables. A center oval in the plan was probably a fishpond not unlike that at the Highlands, the country home of his cousin Anthony Morris.

In the 1810s Jane Bowne Haines began to shape this garden to her own vision, which was primarily ornamental. She wrote her sister in June 1814,

we have not however many beautiful views or a fine garden to show our visitors as the house is immediately on the street—the gable end of it—and the farm extends behind it—the position of the ground does not admit of much ornament—and that which one bestowed on it is almost obliterated by a succession of neglectful tenants—we have plenty of excellent vegetables and there will be plumbs and apples but no peaches—a very shady yard in front where my little Sarah plays quite half her time and where she is now sitting in a wheelbarrow having just had a ride.[52]

Jane's floral preference was for roses and she soon began to acquire different varieties. Her plant lists and diagrams from the 1820s show accelerated activity in this garden aided by a paid gardener. Dozens of varieties of gallicas, damasks, and bourbon roses filled the parterres and climbed trellises in the garden and on the front of the house (Plate 6). The fishpond was now a bed for roses and annuals. Flowering shrubs and some perennials extended the seasons of color beyond the few weeks in late May and early June when the roses bloomed. Consider the words Ann used to describe the garden in 1824: "Our garden and yard are beautiful—; all the trees that were started last year and I believe this also, are in luxuriant growth. The Laburnum is almost in full blossom . . . the mountain pent. [?] in the garden is splendid, and even the crown imperials has delighted me."[53]

Beautiful, luxuriant, splendid—these words figure in many of Ann's, Jane's, and other family members' descriptions as they expressed their great pleasure in the garden's beauty. There is no hesitation in being effusive about this visual enchantment. Mary Ann Donaldson, the children's governess at Wyck, wrote to Ann Haines in August 1832, "I wish you could take a peek at my pet Mexican vine it is so very beautiful. I have made a fanciful frame for it which is entirely covered with the most luxuriant foliage you can imagine and full of buds."[54] In 1839 Mary Ann described a May day at Wyck to Jane:

I am often amused when sitting under the Linden—hidden by the embowering foliage of its pendant branches which already sweep the ground—to hear exclamations of how sweet! how fresh! how beautiful!—and many other ejaculations expressive of the admiration of the passerby. . . . How I wish you could inhale the delicious fragrance of the fringe tree which is wafted on every breeze which enters my window.[55]

There is a release from constraint in the observation of the gardens and the natural landscape that has no parallel in the degree of feeling in their writings when describing furnishings or art. This Quaker family found its deepest aesthetic fulfillment in their gardens.

While the ornamental garden gave visual pleasure, Reuben Haines also approached horticulture from a practical point of view. As part of the general contemporary mania developing around silk he planted mulberry trees, and family tradition suggests that sufficient silk was harvested to make a dress.[56] Reuben also planted a native variety of grape to experiment with wine making. Eight gallons were made from these fox grapes and, although his impressions are not recorded, it is doubtful this bitter grape produced a palatable wine. The fox grapes survive on the north trellis at Wyck, but it does not appear that they were planted elsewhere on the property.

A great interest in gardening is found in descendants of Reuben and Jane Haines who had careers in horticulture or were devoted amateur horticulturists. Reuben and Jane's eldest son, Robert, had extensive commercial nurseries, the Cheltenham Nurseries, in Montgomery County, Pennsylvania. Their granddaughter, Jane B. Haines, founded the School of Horticulture for Women in 1910 in Ambler, Pennsylvania, which is now Temple University's Ambler campus. The last owners of Wyck, Robert Haines III and his wife Mary, had extensive fruit orchards (Skyline Orchards) in Berks County, Pennsylvania.[57]

Clothing and Apparel

Plain dress is often referred to as characteristic of Quakers of this period. Perhaps in no other area of consumption and public definition does the adage about "of the best sort but plain" create an ongoing behavioral stereotype. But clothing choices were also subject to guidelines like "not very plain, but handsome."[58] Haines's receipts for purchases of fabric, examples of surviving clothing, and descriptive passages in letters suggest that "handsome" meant of high quality and therefore quite expensive. The Haineses appear to be typical of Philadelphia Quakers of their economic and social position. For example, Levi Morris, an iron manufacturer, selected similar fabrics for his clothing.[59] But there is also some difficulty in determining whether styles and fabric choices were motivated by perceptions as to what is appropriate for Quakers to wear and how they presented themselves to the world or were reflective of current fashion. When a Quaker purchased a "drab" hat in this time period it is hard to ascertain whether he was buying plainness or fashion; in the later 1820s and 1830s, drab—grays, olives, tans—was in vogue for all wealthy Philadelphians. Fashionable clothing, especially for women, was less decorative, more focused on such essentials as quality of the fabric, line, drape, and emphasis on the subtlety of pattern, all of which may have ideally suited the Quaker archetype. And there was also ongoing wariness lest plain dress be a veneer that might disguise flaws in character. Ann Haines observed in 1818 of Reuben's friend Thomas Gilpin, "for tho the gentleman wears a broad hat and a plaincoat—yet the gentleman has a proud heart."[60] Among Friends, many people debated whether the mindless adoption of a Quaker uniform masked a disregard for the meaning of the dress. Reuben Haines's receipts show that he generally purchased "casimere" breeches, seersucker, linen, or wool coats. Jane and Ann Haines purchased silks and linen and their letters indicate they were very aware of current trends in dress.[61] In 1827 Jane wrote to Ann:

As to neck kerchiefs the ladies all wear them high in the neck, inside the frock, which with an elegant collar lying flat all around completely hides them. . . . I heard it lately stated that flat collars would not long continue the ton (sic) for one of the most fashionable has appeared at a party with a Quadruple plaited ruffle—does thee not thank me for this most important information.[62]

It is unclear whether Jane was mocking this keen interest in fashion in her concluding words or observing a need to keep up with new styles. A year

later Jane referred to the making of a merino dress. She notes that 4 1/4 yards of fabric will "make a plain one—but according to the present rule of trimming with the same material as the dress it would take seven yards—as broad bias folds reaching to the knee are indispensable."[63] Jane continued to note that "handsome satins" were available at less cost, but "they are not fashionable dresses."[64] Surviving clothing shows a limited range of colors, tending to browns, grays, tans, and neutral tones. They are very well made, but ornamentation and decoration is limited—nothing superfluous. It appears that in the area of dress the Haines family kept a more muted palette than they did for their furnishings, floor coverings, and window fabrics. This is apparel without extravagance. Jewelry appears to be minimal. Comfort and durability are important considerations, as is presenting an attractive appearance without seeming vain. Jane Haines in 1829 discussed the purchase of a bonnet, noting that her precise directions had been for one that was " 'fashionable but not gay of either silk or straw' mine was 650 [$6.50] without strings."[65] When Jane wrote this letter, her husband was the second wealthiest man in Germantown and the family enjoyed an income in excess of $5,000 per year. Her attention to cost and appropriateness is consistent with all aspects of her domestic life and emblematic of the household she kept for her family.

Beyond Home

It is worthwhile to examine the business affairs of Reuben Haines and his family's civic involvement to understand the context of their consumption and material lives. As a young man, Reuben Haines made the effort to learn business by working in the mercantile firm of his uncles Christopher Marshall and Abraham Garrigues. It was evidently not to his liking. Agricultural and natural sciences held far greater attraction, and in this his circle of well-educated friends including James Pemberton Parke and Roberts Vaux encouraged him. In 1809, when Reuben was twenty-six, his friend Nicholas Wilson observed,

you say you have thought it not best to engage in any business. Ah my dear friend—what gladness ought to fill your soul while you feel your independence, while you know you are not obliged to resort to the meanness that the exalted mind will ever find enriched with mercantile transactions, no my dear Reuben if I were in your situation . . . I would cultivate, I would cherish the noble qualities I found myself possessing . . . my whole attention should be engrossed in the pursuit of knowledge, the

Society of genuine friends, and the soft endearments of that most delightful of passions when should mingle into bliss in the sweet extacies of love.[66]

Finance was neither his passion nor his strength, but over several decades he amassed a sizable fortune built on the foundation of a large inheritance. Overall improvement of living conditions and improved technology and communication were at the heart of his investment decisions, but he made wise choices that would keep his family comfortable for generations to come. From 1826 to 1828 his holdings included family breweries, warehouse and shop space along the Delaware riverfront, land in Northumberland County, and shares in the Delaware and Chesapeake Canal, Union Canal, Fairmount Water Works, Schuylkill Permanent Bridge, Franklin Institute, Pennsylvania Slate Company (coal), Lancaster Turnpike, and Germantown Turnpike. For the latter his father had been an original stockholder.[67] As Mackenzie Lloyd notes, "In contrast to traditional use of real estate as the principal investment for liquid capital, Reuben's loan and stock purchases represented direct involvement in new theories about a capitalist economy."[68] Those who wanted to see the city grow and prosper understood that transportation and technological innovation would be key. Others realized that investment in manufacturing and industry were rivaling real estate or trade in return of profits and growth on investment. Shortly before his death in 1831, Reuben joined with other business partners to organize the first railroad in the region, the Philadelphia, Germantown, and Norristown Railroad. The effort had multiple goals. It would provide access to the limestone district of Plymouth Township, as Reuben wrote, and it would "supply us with coal at a very cheap rate, and induce many citizens of Philade [sic] to settle in Germantown as they will be able to get to the city by cheap and easy conveyance in forty minutes."[69]

When Reuben Haines retired from business at such an early age, he turned his prodigious energies to other activities. With often manic zeal he juggled his scientific and intellectual pursuits and his forays into venture capital with the stylized life of a gentleman farmer. He built a substantial library of volumes on farming and husbandry and discussed and debated with gentlemen both in America and in England about relative desirability of crop types and plant varieties. Glass vials filled with seeds and labeled in his handwriting demonstrate the range of his connections, including wheat from the duke of Bedfordshire in England. Reuben experimented with lime as a fertilizer, soap products as insecticides, and advocated varieties of plants that seemed more disease resistant and better suited to the climate of Pennsylvania. If he was extravagant in his spending, it was not on furnishings or

clothing but on rare breeds of livestock and costly books. He had a collector's instinct that is evidenced by everything from his mineral and shell collections to his rare Greek and Roman coins, and this fervor extended into his acquisition of plants and animals (Figure 4.5). But there was also a useful purpose as he sought to identify suitability and potential for economic return.

Figure 4.5. Left to right, pamphlet, Academy of Natural Sciences, 1816; phrenology head, ca. 1830s; experimental sun dial by Reuben Haines, III ca. 1820; shells from museum room at Wyck; stuffed wood duck, taxidermy by Reuben Haines III, 1825. Photo: Eric Mitchell. Courtesy Wyck Association.

Natural History and Science

After Reuben Haines's death in 1831, a testimony was written for the Academy of Natural Sciences, of which Haines had served as the first corresponding secretary. The Wyck Papers include many letters and receipts that document his key role in helping form that institution's collections. "When Reuben Haines joined the Society it was composed of a few members and

was just struggling into existence. He brought to it indeed no peculiar stores of scientific knowledge & yet to no one, except its magnificent President is the Academy, more indebted for its present prosperous condition, than to our former Friend."[70] This was the era of the amateur scientist, the gentleman whose interests might fall into many disciplines of research and who would balance them successfully. In the age before specialization, Reuben, like many of his friends, was able to be a renaissance man, to sample and in some cases excel in a wide range of endeavors. His wealth certainly gave him access and time for his pursuits. The same testimonial also recorded, "His ample income was liberally & usefully spent; his house was a resort of some of the most eminently literary men of our country & his benefactions to those he found in distress were solid, intensive and unobtrusive."[71] Perhaps there is an element of the dilettante, but Haines's voracious acquisition of information and objects was not undertaken to enhance his status among his peers or to in some way set himself up for public admiration. It was knowledge for knowledge's sake. Haines's charitable acts and his support of scientific research or collecting expeditions were usually accomplished anonymously or with him playing a secondary role.

Haines enjoyed a remarkable circle of friends and generously supported their projects. He was in regular contact with members of the Peale family, John James Audubon, Thomas Nuttall (the author of *Genera of North American Plants*, 1818), Thomas Say, the father of American entomology, and utopianists William Maclure and Robert Owen.[72] It is difficult to see how he had time for his farm and family when he was regularly attending lectures on a wide range of subjects. Sometimes alone, or often accompanied by his Cousin Ann, Reuben attended Dr. John Godon's lectures on mineralogy. These prompted his own collecting expeditions, which he recorded in his journals. On one "Lithological expedition" to New Jersey he joined Dr. Godon, Rubens Peale, Dr. White, R. Logan, and others.[73] As he accumulated mineral specimens, he commissioned specially built cabinets for his Chestnut Street house to store and display them. Later they were moved to his museum room at Wyck. If there is pride, it is pride in his collections, in showing off God-made wonders, not those fabricated by man and dependent on changing whims of taste. These were classical and enduring things, much like the collections assembled by the Peale family for their museum, but in this case for more private contemplation.

Reuben was also fascinated by medical discoveries and investigation, especially as they advanced general well-being. Having suffered the loss of his eldest daughter at age eleven, he had an added element of self-interest in seeking improvements to medical care. His inquisitiveness about engineer-

ing was often melded with his striving for good health. In 1817, after benefiting from taking the baths and drinking mineral water at spas in northern New York, he purchased his own "mineral water apparatus." Copper piping and gasometers were acquired from Israel Roberts for over $100. A pump and tap cost $77. And from well-known silversmiths Fletcher and Gardiner he acquired a silver "Water Cock." When all the pieces were assembled he had spent $220.[74] Recalling that a just a few years earlier Reuben and Jane had spent less then this amount to purchase a large mahogany dining table and twenty-four fancy chairs puts Reuben's purchasing patterns and how he used his wealth into perspective. He was not opposed to spending, sometimes extravagantly; he was averse to doing it for show or for sensual gratification. Despite its silver water cock, this was health and science.

Medicine was an increasingly respected profession at this time, particularly among Quakers, and Reuben's cousin Dr. Caspar Wistar, the noted anatomist at Pennsylvania Hospital, was an intimate and friend.[75] Wistar was considered one of the city's premier citizens. He held a prominent position in Philadelphia society as the host of the Wistar parties, a tradition that to this day is centered around the American Philosophical Society. The parties, convened on Sunday evenings or Saturday nights, were to entertain respected out-of-town guests and to show Philadelphia in its best light at gatherings in Wistar's elegant house on Fourth Street. Reuben Haines was a regular participant, enjoying the enlightened conversation and conviviality. Although they were not exclusively Quaker gatherings, a large proportion of those who attended were Friends. As described in a later history, the occasions "diffused a spirit of true and elegant, but simple and unambitious hospitality. They made strangers acquainted, on easy terms, with the worth, wit and learning of Philadelphia." The parties were further explained as intellectual banquets, especially focusing on pure and experimental science.[76] After Wistar's death in 1818, Reuben Haines joined with several others to continue the tradition, often hosting the parties at his Chestnut Street house. *Sketch of the Wistar Party,* printed in 1898, notes that traditionally "sumptuous and expensive banquets, are not high claims even to private favour; they certainly give little title to public respect, and furnish no guarantee of public usefulness." It concludes that the "entertainments should be marked by inexpensive, if not frugal, simplicity."[77]

Dr. Caspar Wistar was also honored in many ways. Thomas Nuttall, who had brought back a cutting of an ornamental vine from China, named it wisteria for his friend; Isaac Wistar named the Wistar Institute, a medical research center, in honor of his grandfather. Medical tradition is strong in the Haines family, and Friends Hospital, which introduced radical theories of

care including horticultural therapy for the mentally ill, still has descendants of Wistars and Haineses on its board of overseers. Among the founders of Germantown Hospital was Reuben and Jane's son John.[78] This constantly evolving web that moves out from the early Philadelphia Quaker families to later generations until recent years dominated many of the social service institutions in the region. The necessity to marry within meeting assured the close sanguinity. Mutual interests in the natural world derivative of basic spiritual concepts made participation in these organizations an outward manifestation of their beliefs.

Haines was the consummate observer. Functioning on little sleep, he balanced each day with a variety of regularized tasks and then found time for new investigations. He kept detailed records of weather conditions at Wyck several times per day, annotating observations about temperature and cloud formations as well as general conditions.[79] He studied these records to decipher patterns and anticipate storms that might be destructive to his crops, as well as to discern ways to improve living conditions within his home. As early as 1816 he experimented with a coal-fired furnace in his basement, which most likely efficiently warmed the rooms just above and those beyond far less effectively. Strickland chose individual coal grates in each fireplace when he remodeled in 1824.[80] In summer the use of windows and shutters, fans, and netting addressed the high heat and the incessant nuisance of insects. In each experiment, the goal was more efficient and comfortable home management.

If Reuben's attentions were primarily focused on pursuits of the mind, the women and children of the family were more active in agencies promoting welfare and aid for the sick and poor. Reuben was not uncaring, but he had broader social agendas through his institutional networks and was less aware of individual needs and suffering. Although Reuben Haines was one of the founders in 1819 of the Infant School for "poor" children, it was his wife Jane and Cousin Ann who more actively participated in its governance and fund-raising activities. Ann served for many years as treasurer. Some of the efforts to raise money were as pedestrian as making sewing implements and needle holders to sell at a fair.[81] The action of producing something to sell may have been viewed as more of a commitment to the cause than simply writing a check, a concept fundamental to much of women's fund-raising activities in Philadelphia in the nineteenth and twentieth centuries. In addition, making these pieces was a social activity and an important opportunity for Quaker women to gather together.

Many surviving tracts and pamphlets also indicate the Haines women's involvement in the Female Anti-Slavery Society and abolition activities. But

in contrast to their Johnson cousins on the neighboring farm, who were far more radical in their abolitionism, they concentrated on strategies that fell within the law. Jane was responsive to many entreaties she received to help find jobs and housing for freed slaves.[82] In her own household she employed a number of African Americans as servants, while non-Quaker families at this time were more likely to employ white servants. She worried when she was unable to take on another employee or find a job for someone who had been recommended to her. Several objects at Wyck today testify to the dedication of Jane and Ann Haines. One is a sampler made for Jane Bowne Haines in 1815 by an eleven-year-old African American child named Lucy Turpen. Turpen attended one of the Female Association Schools in New York, eventually becoming a teacher there. Founded by Quaker women in 1802, it fostered education for African American children. Members of the Bowne family were active supporters of the school.[83] Wyck also houses a gilt-edged cake plate with rococo style border. The 1840s plate, made by England's John Ridgway and Sons, bears a kneeling slave, the symbol of the Anti-Slavery Society. The somewhat ornate shape and decoration send conflicting messages to a modern viewer. The image of the manacled slave is disconcerting as one envisions fancy teacakes covering it as the plate is passed around at a social gathering of women. But considering the common venues for women to meet and discuss issues, even of a highly controversial nature, it is evident that the niceties of polite society still prevailed. The emblem of their cause reminded them of their purpose. For wealthy Orthodox families like the Haineses, parameters for their activism were established by their social position and customary habits.

Education

The Haines children were not educated at home but were sent to be schooled in the "guarded" manner encouraged by Quaker communities to protect their children from the temptations of materialistic and frivolous society. They studied a variety of subjects but also had chores around the household or the farm, for manual labor was valued as a way to promote humility and to remain in close touch with the natural world. Reuben wrote to Jane in 1818 while she was visiting family in New York,

With what additional pleasure will I not aid thee in imparting instruction to our daughter and after the daily task has been cheerfully performed lead her forth into the garden and the field & teach her to admire the economy of vegitation in the bursting forth of the pumula and radioles of the legumes her little hands have deposited in the earth, point out the bees as examples to stimulate her industry, and see our mantle decked with the wild flowers which she has assisted to gather.[84]

Reuben held that it is the balance of mental activity and physical activity that forms the well-rounded life. In searching for the best way to teach this ideology, Reuben flirted with a variety of progressive educational methods. He at first advocated the Lancasterian method promoted by his friend Roberts Vaux, in which older children would teach younger children in what can be described as open classrooms. When the family moved to Germantown in 1820, schooling became more difficult. At first Cousin Ann tutored Sarah, the eldest, but it was noted that the "dear child did not love the confinement."[85] So a boarding school in the city was chosen where children were instructed in the Pestalozzian method by a French woman named Mme Fretageot. Reuben and Jane were attracted to the theories of Johann Heinrich Pestalozzi (1745–1827), a Swiss educator who drew on the ideas of Rousseau. Jane Haines noted that his method was "oral communication with reference to sensible objects" that encouraged "the habits of attention and observation."[86] Teaching in the Socratic method and emphasizing the importance of personal observation would become recurring themes in Reuben's quest for sound educational methodologies.

In 1830 Reuben Haines extended an invitation to Massachusetts educators William Russell and Bronson Alcott to come to Germantown and revitalize Germantown Academy. Haines was interested in instruction for both girls and boys following the Pestalozzian method Russell and Alcott employed. Alcott's pamphlet, *Observation on the Principles and Methods of Infant Instruction,* struck a chord with Reuben.[87] By October he was able to observe their teaching techniques, visiting their school in Cambridge after a pleasant morning spent with Thomas Nuttall at the Botanic Garden. He had planned to walk to the granite quarries in Quincy, but poor weather provided the fortuitous opportunity to change his schedule and he journeyed to Cambridge instead. He effused to Jane, "there is no man I have ever seen or heard of that I should prefer, to Wm. Russell to direct the Education of my son or my daughter."[88] Returning to Philadelphia, Reuben began negotiations with Russell and Alcott and by December they had arrived in the city.[89] Although Alcott was reluctant at first to move to Germantown, characteriz-

ing it as a summer resort, he acquiesced partly because of the charismatic na-
ture of Reuben Haines. He wrote of Haines:

Mr. Haines is a very active busy man, chiefly interested in practical matters, meddling
very little with theories and systems. He is engaged in agriculture, having extended
landed estates—Horticulture, brewing, his properties in the city, occupy much of his
attention. He is particularly curious in improving his breed of cattle having imported
some from England. . . . At his residence in Germantown he has collected an extensive
private cabinet of curiosities, minerals, prints, etc. etc. . . . He seems destined for ac-
tion rather than thought.[90]

Settling into a house provided for his school and his family by Reuben
Haines, Alcott observed, "Those who patronize our school are, without ex-
ception, people of wealth, intelligence, and refinement, residing in German-
town in preference to the city, to enjoy the advantages of health and rural
scenery."[91]

The school mixed intellectual lessons with physical labor and included
a yard where several hours of play and activity took place each day. Lessons
included "spelling, reading, definition, expression, drawing, etc.," and in a
surprisingly modern way Alcott noted "nothing is presented to them without
first making it interesting to them, and thus securing their voluntary atten-
tion. They are made happy by taking an interest in their own progress and
pursuits."[92]

Reuben Haines's death in November 1831 and Alcott's general inability
to handle practical matters meant that the school soon declined and eventu-
ally folded. Without the patronage of the Haines family, tuition was not suf-
ficient to cover costs. Jane Haines, Ann Haines, and Mary Ann Donaldson, a
governess for the younger children at Wyck, remained close to Alcott's wife,
Abba, and provided assistance to the family, especially caring for their baby
daughter, Louisa May.[93] However, Alcott's attempt to establish a school in
Philadelphia for Unitarian families also failed and by July 1834 he and his
family had returned to Massachusetts.

The various experiments in education that Reuben Haines fostered
were consistent with his Quaker background and his enlightened ideas about
education. A document in his handwriting summarizes his feelings. It is not
clear if the words are his but they reflect his values. He wrote, education is

all that makes a man's mind more active, and the ideas which enter it nobler and
more beautiful is a great addition to his happiness whenever he is alone and to the
pleasure which others derive from his company when he is in society. Therefore it is
most useful, to learn to love and understand what is beautiful, whether in the works

of God, or in those of man; whether in the flowers and fields, and rocks and woods, and rivers, and sun and sky; or in fine buildings, or fine pictures, or fine music; and in the noble thoughts and glorious images of poetry.

This is the education which will make a people good, and wise, and happy.[94]

The Arts

Reuben Haines's meticulous notes from William Strickland's lectures at the Franklin Institute in 1824 contain the following passage:

The association of men of wealth and taste for the construction of Buildings of a public nature, and for the establishment of institutions for the promotion of the Fine and liberal arts, are highly honorable to the Genius and liberality of the American character. And it is entirely owing to such associations and exertions that we can trace the perfections which now exist in every department of the arts.[95]

Although Reuben and Jane Haines apparently did not purchase paintings, sculpture, or prints to adorn their homes, they maintained connections to the world of art and artists, and valued character-building contributions of creativity. Reuben was one of the founding members of the Pennsylvania Academy of the Fine Arts, formed by a group of friends who belonged to the American Philosophical Society.[96] His friendship with members of the Peale family and other artists, as well as his admiration for the works of notable architects, demonstrates a well-defined aesthetic sense. As a new bride living in the city, Jane Haines attended the exhibits at the academy, enjoying both old masters and more contemporary art. These were social opportunities to be with friends and places to enjoy cultured urban life. One of the highlights at the academy at this time was the loan of works from the Bonaparte collection.[97]

Books and prints at Wyck also show that Reuben and Jane enjoyed art through publications and in portfolios of works of art on paper. Public enjoyment and edification from art were acceptable, but the absence of art for display in the home might indicate adherence to guidelines about "plainness."[98] Haines family members regularly visited Charles Willson Peale's house Belfield in Germantown and were intimate with his sons, Rubens, Titian, Franklin, and Rembrandt. There was thus ample opportunity to acquire art or information about it, but it was not until Rembrandt Peale gave a portrait of Reuben Haines to the family in 1831 that any significant work was hung (Figure 4.3). The Haineses admired works of art, but they did not buy

or display them. No statement in their letters defines this as purposeful choice, but the lack of material evidence suggests it.

Art as a means for education was an area that did appeal to Reuben Haines. He collected Roman coins because of their antiquity and historical associations, but he also prized their appearance. He purchased a set of plaster reproductions of medals commemorating Napoleon's great victories and campaigns and had various other castings in his cabinet of curiosities. He actively collected American Indian objects that were acquired from family visits to tribes, and he appreciated the quality of the craft and art in the manufacture of everything from moccasins to a lacrosse stick and arrows. Reuben was captivated by the dioramas and panoramas that were popular displays in the city, and he acquired a panoramic view of Constantinople that is over fourteen feet in length and hangs at Wyck today.[99] But there is no indication that this panorama hung in any principal rooms of his house where others would have viewed it. Reuben also corresponded with artist John Vanderlyn about the establishment of a "panoramic institution" in Philadelphia. Vanderlyn had clearly been concerned about Reuben's proposal to have it under the "same roof as a riding school," but Vanderlyn was satisfied when Reuben explained that it would be in an adjoining building. Vanderlyn concluded, "I hope you may be induced into carrying out your plans."[100] Earlier, Reuben had provided money to G. Persico to create a large model of an Italian village, probably of Roman times. Is it history as art or art as history that attracted him?[101]

Reuben Haines's friendship with the Peale family connected him with the larger cultural world of Philadelphia and beyond, and he in turn was a stockholder and patron of the Peale Museum ventures. In 1828 Reuben lent Rembrandt Peale money to travel to Paris and Rome. Peale wrote to Reuben: "The purposes of my visit to Italy are partly known to you. Not merely to gratify myself with the arts at their Birth-place & in their home, but to employ my taste, my judgment & my industry in selecting the most beautiful objects to copy for this country."[102] Peale's gift portrait of Reuben followed the repayment of the loan.[103] He also then created a second example that was purchased by the family.[104]

Conclusion

The Haines family of Wyck cannot be viewed as archetypes of Quakers in the early nineteenth century. Their somewhat nonconformist lives centered on farming and gardening, scientific discovery and experimentation, and the

many interactions with notable individuals of the period, not the norm for even wealthy Quakers. However, the choices they made about how they furnished their houses, the clothes they wore, their mode of speech, and what they found of aesthetic interest are consistent with those of other Orthodox Quakers of their economic and social level. "Handsome" clothing of costly fabric, fashionable furniture from leading Quaker cabinetmakers, and silver and ceramic tea services for the table contrasted with the more simple dress and furnishings of many rural Quakers who followed Elias Hicks. The family were worldly: well traveled, widely read, friendly with both American and European individuals of high social and economic standing. They were conscious of style and fashion, but that awareness was tempered by a sense of appropriateness and moderation. They were often amused by excesses rather than intolerant of them. They were comfortable in others' elegant—even extravagant—surroundings, but they were evidently not tempted to emulate opulence and were circumspect in their own consumption. Reuben and Jane Haines were not "weighty Friends," and though they identified themselves fully as Quakers and adapted their behaviors and purchases to Quaker community norms, their involvement with meeting did not extend beyond attending worship services and being active observers and commentators on issues that affected their family and friends.

Comfortable living underpinned with the efficiency and careful husbanding of resources, generous modes of entertaining family and friends, and purchase of fine furnishings were balanced with charitable contributions and acts. Their greatest indulgence or pleasure was in the accumulation of books and natural history and scientific collections, and the creation and maintenance of ornamental gardens. While there is little in their personal records to reveal the depth and complexity of their decisions about having their consumption conform to Quaker values, the few verbal hints, combined with what we can reconstruct of their material life, suggest that for them "beauty" and "useful knowledge" were linked values, growing out of the culture of Quaker community life more than out of personally adopted convictions. This was a culture in which they were deeply steeped and invested. And though it was a culture that did not eschew consumption, it was one that prized energy and enterprise over acquisitiveness and self-aggrandizement.[105]

Living in the Light: Quakerism and Colonial Portraiture

Dianne C. Johnson

Joseph Pemberton appeared to enjoy spending money. His lifestyle and the cost of maintaining a large house on Chestnut Street caused the family to run deeply into debt. By 1776 their financial situation was such that Philadelphia Monthly Meeting felt obliged to read Joseph out of the meeting for owing large sums of money and because he "hath been in the practice of gaming."[1] Joseph also had lavish family portraits painted (Plates 7, 8), yet there is no record of the Pembertons ever being disciplined for the commissioning of portraits.

The modern idea of Quakerism carries with it a suggestion of peculiarity in dress, speech, manners, and lifestyle. There is a temptation, based on some interpretations of eighteenth- and nineteenth-century writings, to expect Quakers to have had—and continue to have—lifestyles that are somewhat ascetic and withdrawn from the world. George Fox's dictates on the spirit and simplicity of truth have been interpreted as implying a life that remained true to the Light of God by emphasizing only the necessities.[2] Pre-nineteenth-century Quakerism discouraged any ostentation in speech, manners, and daily surroundings.[3] The visual arts were shunned, as they were held to exist only for the purpose of pleasing the senses.[4] In particular, portraiture was discouraged, as the early Friends preferred to be remembered by their deeds, preserved in the Quaker writings, though some late eighteenth-century Quakers had their likeness captured by the "simple" technique of a silhouette.[5]

Early records indicate that the first generation of Friends disapproved of portraits. Observing Friends, Benjamin Franklin wrote, "The primitive Quakers us'd to declare against Pictures as a vain Expence; a Man's suffering his portrait to be taken was condemn'd as Pride."[6] Later Thomas Clarkson

echoed this in *Portraiture of Quakerism* (1806): "Friends belonging to the first generation of Quakerism consistently refused to have their portraits drawn or painted."[7] However, there appear to have been no formal disciplines banning paintings or portraits.[8] In fact a much larger body of likenesses exists than previously thought, including examples from both the main Quaker settlements in America, Delaware Valley and Rhode Island, as well as from Friends communities in England.[9]

One of many new religions that developed during the latter half of the seventeenth century, Quakerism grew out of the Established Christian Church of England, its adherents shaping autonomous beliefs and rituals. Fox and his followers claimed that communion between God and the individual required no theologically trained priests or prescribed outward rituals. God's truth or the Inward Light was present in and available to everyone. Believing in the sacredness, integrity, and equality of all men and women, they refused to bear arms or swear any oaths, and they rejected intolerance.

The early years of Quakerism stressed a simple devotion to the service of God. A very similar pattern was evident during the nineteenth century, which accounts for the more familiar, stereotypical image of Quakers—a sober, ascetic people clothed in identifying brown or gray. Yet despite these widely accepted notions, closer examination of various Quaker writings and artistic expression from the eighteenth century yields a fuller picture of the artistic patronage and lifestyle led by colonial Friends. The manner in which Friends chose to have themselves portrayed closely followed the prevalent or popular style, as wealthier Friends during the colonial period appeared to view this patronage as a symbol of their success, in the eyes of the Lord as well as in the secular world. Were these "fallen" Quakers, or did they have different notions of plainness from those we have today? How closely did Friends' portraits conform to Anglo-American standards of representation? I suggest that there were variations in how Friends chose to live in society and that their portraits were a profound embodiment—not merely a reflection—of these choices.

Patrons of the commissioned portrait during the colonial period, most often merchants and planters of some financial means, included both Quakers and non-Quakers. Their self-fashioning through the production, display, and use of portraiture has been explored by scholars, though with little attention to religious affiliation or conviction.[10] Margaretta Lovell has focused on the active role that portraits played, asserting identity within a household and to the world beyond it.[11] Scholars such as Timothy Breen, Robert St. George, and Paul Staiti have also seen portraits as a type of good that, in a larger world of goods, presented a sitter in a conscious, deliberate way, albeit

within conventions.[12] Recognizing that a portrait commission represented an artist's ability to read and respond to a culture, and involved shared ideas on the part of the artist, patron, and viewer in creating a likeness, is also central to our understanding of Quakers' exterior mappings of their interior selves.[13] Members of the mercantile elite on both sides of the Atlantic used portraits as a way of presenting themselves as they would like to be seen and remembered. Extant portraits of Friends suggest that the artist and the patron made subtle choices about plainness that need to be viewed within the context of Anglo-American portrait standards.

Assumptions about the role of portraiture in developing identity—and self-identity—within the Quaker faith must also incorporate what we know about portraiture as fiction. Eighteenth-century English and American artists relied on mezzotints as sources for poses, clothing, and props. Different artists incorporated conventions from mezzotints to varying degrees, and this reliance vacillated during individual artists' careers. Portraits of women tended to rely strongly on mezzotints, while portraits of men were more likely to show them wearing their own clothes and props that were specific to their lives.[14] Other scholars have found that much of the women's clothing depicted in portraits is fictive. The loose wrap of Mary Dickinson (Plate 9) is typical of the garb worn by many female portrait sitters. Such wraps invoke leisure, timeless fashions, and knowledge of British portrait conventions.[15] Others wore clothing they very likely owned. Some women, particularly of older years such as Hannah Lambert Cadwalader (Figure 5.1), were depicted in modest clothing that was often out of date. Given this range of choices, how did individual Quaker sitters choose to be portrayed? How did their choices dovetail with their degree of religiosity at the time of their sitting? These questions bring us back to the idea of whether or not there is a Quaker aesthetic in portraiture. I would argue that there is one, but that, as in other material and behavioral choices, Quakers acted individually. Economics and social position both played integral roles with theology in establishing an eighteenth-century Quaker aesthetic of plainness. If the idea of a Quaker aesthetic and its relationship to colonial portraiture is to be reevaluated, then each must be accorded equal importance and viewed within a larger context of Quakerism and the artistic climate in the Philadelphia region.

The idea of "plainness" or "simplicity" in terms of Quaker theology and its relationship to objects has been touched on in recent scholarship, but many questions and seeming contradictions remain unresolved. Scholars have often analyzed Quaker material culture from the perspective either of theology and thought or artistic construction, thereby interpreting artistic

Figure 5.1. Charles Willson Peale, *Hannah Lambert Cadwalader*, 1770, oil on canvas. Philadelphia Museum of Art: Purchased for the Cadwalader Collections with funds contributed by the Mabel Pew Myrin Trust and the gift of an anonymous donor, 1983-90-2.

works within set parameters of theological plainness or a deviation from this theology.[16] In Raymond Shepherd's discussion of Stenton, the Philadelphia home of prominent Quaker James Logan, the author concluded, "The larger view of Stenton and its furnishings as an expression of the Quaker aesthetic [could be] left for a subsequent study."[17] But the "subsequent study" has not yet come. Similarly, other scholars have had trouble reconciling the purchase of elaborate furniture, silver, or paintings with the accepted definition of Quaker plainness. Frederick Tolles's tantalizing analysis of a Quaker aesthetic focused only on how artistic considerations tested the religious doctrine. Therefore, when Tolles found many Quaker objects to be consistently un-plain, he concluded that these objects violated strict Quaker practices.[18] Recently there have been several more nuanced studies that examine Quaker doctrine in conjunction with physical evidence. Deborah Kraak's and Le-anna Lee-Whitman's individual studies of Quaker dress, Susan Garfinkel's study of furniture in Philadelphia, and Patricia Keller's interpretation of Quaker quilts are part of this evolving scholarship.[19]

In tracing the evolution of the "Quaker Plain Style" dress, Lee-Whitman found that colonial Friends did not differ from non-Quakers in their choices of costume. She points out that the gray uniform, or "badge of identity," did not become commonplace until the nineteenth century.[20] Although acknowledging that numerous Friends had their portraits painted, she, like Frederick Tolles, concludes that the wearing of stylish, contemporary dress indicated a degree of deviation from the Quaker tenet of "plainness and simplicity" and that the "average wealthy Quaker . . . [used] a special kind of plainness."[21] However, she does not consider that the concept of plainness may have had a different meaning during the eighteenth century.

Garfinkel, in studying Philadelphia Chippendale furniture created by Quaker craftsmen, argues for a reinterpretation of the concept of plainness itself: that it must be defined by exploring the "worldview through which Quakers made sense of their spiritual and material lives."[22] She suggests that colonial Friends may have interpreted "plainness" as "a theological idea [in which] A high chest, in other words, [might be] plain if it exists in silence according to the plainness of God's truth."[23] Garfinkel suggests, then, that plainness can be defined as a relative term, thereby dispelling the apparent disparity between theology and the object, particularly if viewed within a wider context.

George Fox's search for a religious ethic that would "speak to his condition,"[24] the condition of being disillusioned with the shallowness of the general society, was also a reaction to the narrow dictates of Calvinism.[25] He found no consolation in the doctrine of predestination and felt that the

Calvinist message encouraged the development of a few "elect" individuals. Turning his search inward, he eventually heard a voice from within that said, "There is one, even Christ Jesus, that can speak to thy condition."[26] By keeping Christ in one's heart and living according to his teachings, Fox concluded, one could find perfect truth and peace.

The distinctive style that accompanied Quakers soon gained recognition.[27] Jacques-Pierre Brissot de Warville described a Philadelphia meeting in August 1788:

The deepest silence was observed for almost an hour. I was seated facing a bench raised above the others, which I later learned, was reserved for the ministers or preachers . . . One of the Friends sitting on this bench rose, began to speak, said four words, and delivered his whole talk in this manner. This style must be quite common among Quaker preachers, for the next speaker also spoke with the same long pauses between his words.[28]

The idea of an Inward Light was the key component of Quaker theology. George Fox stated that true Christians must "wait on God, in his Light to receive his counsel; [for] how else do Friends differ from the world?"[29] Thus Quakerism's encouragement of an intensely personal vision of the Lord and adherence to spiritual guidelines led to great emphasis on a "call to perfection," a dictate to seek the continuing revelation of God's will and of man's duty.

Rules of Christian Discipline, which provided a framework by which Quakers could best remain in the Light in their daily lives,[30] stressed simplicity and harmony in a society that precluded the bearing of weapons and embraced an austere lifestyle. This emphasis on austerity was reflected physically in their plain clothing and an egalitarian practice of refusing to use titles, preferring instead forms of address such as "thee" and "thou." Hard work and moderation were encouraged; William Penn, when addressing his fellow Quakers, stressed that diligence "is the Way to Wealth: the diligent Hand makes Rich . . . Frugality is a Virtue, too . . . the better Way to be Rich."[31] A plain and simple yet diligent lifestyle proved to be very successful for Quakers, both socially and financially, not only in England but in America as well.[32]

In the 1660s when the first Quaker colonists set sail from England for Pennsylvania as part of William Penn's Holy Experiment, George Fox sent them with the words, "My Friends, that are gone, and are going over to plant, and make outward plantations in America, keep your own plantations in your hearts, with the spirit and power of God, that your own vines and lilies

be not hurt."[33] Fox's religion allowed his peers to live in and with this world and encouraged material success in it, and for many their diligence quickly resulted in material prosperity. Prosperity and success were considered to reflect God's approval and were therefore encouraged.[34] Several Delaware Valley Quakers amassed vast fortunes, among them Isaac Norris (1671–1735), Jonathan Dickinson (1663–1722), and Edward Shippen (1639–1712). However, Friends also stressed that material wealth was transitory and that the only permanent thing in life was the Inward Light. As Thomas Chalkley (1675–1741), minister, sea captain, and merchant, wrote, "It appears that we not only have Liberty to labour in moderation, but we are given to understand that it is our Duty so to do."[35]

As the material prosperity of the Quakers grew, so did the concern for their spiritual well-being. William Edmundson wrote longingly of the time when "the things of this World were of small Value with us" and "Great Trading was a Burthen."[36] Many older Friends' letters and diaries also indicate a fear of the distractions of wealth. The younger generation obviously did not agree. Plainness and simplicity took on new meanings and greatly affected choices of surroundings, lifestyle, and attire. The dove-colored uniform dress that would become characteristic of nineteenth-century Friends was not considered a necessary symbol of faith by eighteenth-century Quakers; rather, they merely chose a certain simplicity in the decoration on contemporary clothing. The best materials were used and colors were welcomed, but useless ornament and decorations like lace and ribbons were frowned upon.[37] Margaret Fell (1614–1702), wife of George Fox, spoke her mind concerning the stricter spirit of some Friends when she stated, "We must not look at no colours, nor make any thing that is changeable colours, as the hills are, nor sell them, nor wear them. But we must be all in one dress and one color— That is a silly poor gospel."[38]

The female Friends in Philadelphia tended to agree, as can be seen in portraits of women in the Norris family. Mary Lloyd Norris, daughter of Deputy Governor Thomas Lloyd and wife of Isaac Norris I, was painted in a now lost portrait ca. 1720, traditionally attributed to Sir Godfrey Kneller. Mary is portrayed in a waist-length composition set against a dark background in the nineteenth-century copy of this portrait (Plate 10). Restrained in its use of accessories, the painting still contains an air of elegance. Although she is dressed very simply in a blue and crimson gown,[39] the richness of the material is evident, particularly in her scarf, as it gracefully drapes over her head while the end is lightly grasped in her right hand. Her gown is likely not a real one, but the loose wrap worn by many female portrait sitters on both sides of the Atlantic at the time. She gazes out at the viewer with a gentle and calm de-

meanor, an illustration of Richard Allestree's advice in *The Ladies Calling*, emphasizing modesty, which "appears in the face in calm and meek looks. . . . Certainly there is nothing [that] gives a greater luster to a feminine beauty."[40] The portrait has a style and composition very similar to the Knelleresque formula of painting being practiced by popular early eighteenth-century English artists such as Jonathan Richardson and Charles Jervas.[41]

Sarah Logan Norris, daughter of James Logan and wife of Isaac Norris II, was painted in a similar manner (Appendix, 5.1). The artist of this portrait is unknown and the technique appears to be less sophisticated. Still, she wears a dress of deep blue[42] with a stylishly low-cut neckline, which emphasizes bare shoulders, in emulation of the latest English fashion in fictive portrait dress. The likeness captures an appealing directness in Sarah's gaze.

The same directness is captured in the half-length portraits of Charles (Appendix, 5.2) and Isaac Norris II (Appendix, 5.3), the sons of Isaac Norris I. Charles, a Philadelphia merchant, was painted by Gustavus Hesselius in 1736.[43] The portrait of Isaac Norris II, merchant and speaker in the Pennsylvania colonial legislature, is a copy ca. 1850 after a painting by an unknown artist.[44] In a gesture that acknowledges his knowledge of deportment, his right hand is partially inserted in his coat. Using a traditional composition, both sitters are portrayed as fashionable, successful members of the mercantile class.[45] Looking steadily out at the viewer, they are dressed in dark brown coats with white steinkirk cravats (a new French fashion in the early eighteenth century), illustrating a middling interpretation of aristocratic English style.[46] Charles's unremarkable suit is likely of linen. Although not consistently adhered to, a minute noted in the yearly meeting of 1704 asked Friends to "keep clear from . . . unnecessary extravagant wigs."[47] Thus it should be noted in his portrait Charles wears a wig, albeit a short, modest one. Isaac Norris wears no wig, which would have been a statement to both non-Quakers and Quaker viewers in 1739, a time of broad popularity of wigs. The Norrises were a mercantile family, and this may also explain their moderation about wigs.[48] The realistic, albeit modest attire conforms to the conventions of male portraiture and contrasts with Sarah Norris's fictive dress (Appendix, 5.1).[49] This was also in keeping with the sentiments expressed by Jonathan Richardson, an English theorist and follower of Sir Godfrey Kneller, who in advising portrait painters in 1715 wrote:

The Figure must not only do what is Proper, and in the most Commodious Manner, but as People of the best Sense and Breeding (their Character being Consider'd) would, or should perform such Actions. . . . There must be no Awkward, Sheepish or Affected Behavior, no Strutting, or Silly Pretense to Greatness.[50]

He went further in codifying the Knelleresque formula:

A Portrait-Painter must understand Mankind, and enter into their Characters, and express their Minds as well as their Faces: And as his Business is chiefly with People of Condition, he must Think as a Gentleman, and a man of Sense, or 'twill be impossible for him to give such their true, and proper Resemblances.[51]

The Knelleresque portrait style, which was designed to combine the ideal of sophistication and enlightenment of an individual, emphasized certain formal characteristics. A likeness to the sitter was expected, but physical resemblance would always remain subordinate to the image of good breeding indicative of the sitter's position in society. Manner, pose, and dress, therefore, were considered essential components in achieving this ideal style.[52]

Within this stylistic milieu, staunch Quaker Isaac Norris I, progenitor of the colonial family and merchant and mayor of Philadelphia, also had his portrait painted, although the canvas is now lost. The likeness was purported to be by Sir Godfrey Kneller and painted during a visit to England in 1706–8.[53] Sidney George Fisher recorded seeing the painting during a visit to Stenton in 1860:

On the walls in the house are some family portraits, James Logan, William Logan, George Logan, the old lady [Mrs. George Logan], and Algernon, also one of Isaac Norris, the emigrating ancestor of the Norris family, a copy which Dickinson [Dr. John Dickinson Logan] had made from a picture by Sir Godrey Kneller. It is a striking face full of character & admirably painted.[54]

The Norris family were at the top of the Quaker hierarchy and were also highly regarded local politicians. A clerk for Philadelphia Yearly Meeting from 1711 to 1729 and a strict Quaker, Isaac Norris I was often called the king of the Quakers.[55] In 1739 Isaac Norris II became very involved with Philadelphia politics and was often considered to be even more consistent than his father in adhering to Quaker strictures. The stricter Friends who surrounded Isaac Norris II during this period were referred to as the "Norris Party."[56] It is within this very conservative Quaker environment that the entire Norris family had their portraits painted.

By contemporary standards the Norris family lived quite opulently, as evidenced by their family home, Fairhill, built in 1716. Modeled on Dolobran, the family seat in Wales, it had several outbuildings, one of which housed the library containing about 1,500 volumes and "beautiful specimens of some of the arts," as well as formal gardens laid out in the British man-

ner.[57] Isaac Norris I had evidently examined his own good fortune and behavior in the context of his Inward Light. In response to the criticism of a fellow Friend, he agreed that, although moderation should be emphasized, he did not think it proper that a man of his social position should "wear the same and live at the same rate within-doors" as the lower working class. He continued, "Every man ought soberly and discreetly to set bounds to himself and avoid extremes, still bearing due regard to the society he is of."[58]

William Penn supported this hierarchical view of society when he wrote, "For tho' [God] has made of one Blood, all Nations, he has not ranged or dignified them upon the Level, but in a Sort of Subordination and Dependency."[59] Robert Barclay, in writing more specifically on the nature of Quaker principles in relation to this idea, stated:

Our Principle leaves every man to enjoy that peaceably, which either his own Industry, or his Parents, have purchased to him. . . . The several Conditions, under which men are diversely stated, together with their Educations answering thereunto, do sufficiently show this: the servant is not the same way Educated as the Master; nor the Tenant as the landlord; nor the Rich as the Poor; nor the Prince as the Peasant. . . . Let the Brother of high degree rejoice in that he is abased, and such as God calls in low degree to be content with their Condition, not envying those Brethren, who have greater abundance, knowing they have received abundance as to the inward Man; which is chiefly to be regarded.[60]

These statements suggest that wealthy Quaker families were at ease with societal norms of hierarchy and were content to approve many of society's markers of success.

Reconciling the tension between dictates of simplicity and behavior in daily life, however, seems to have engaged a good deal of Quaker thought. On the one hand, Norris advised his son Joseph to return from his first business trip to London in 1719 as plain as when he left if he hoped to maintain business success: "Come back plain, this will be a reputation to thee and recommend thee to the best and most Sensible people."[61] Yet in 1722 he directs his son Isaac, who was also traveling:

If thou Should meet with—by an Accident Cheap a Good Landscape or Two the prospect Geometrically Extended—Well and beautifully Shaded—and good painting in which thou may take Judgement of Somebody of Skill—I did not Care If thou bought them—for my Garden Closett—but as thou Remembers my begun designs on the Chimney piece there—think of Such as may be Coppy'd for my finishing and well Shading the figures, rivers, hills, Fields, &c.[62]

Philadelphia's citizens were absorbed by an interest in the arts, and Friends were as active in their pursuits as were non-Quakers. James Hamilton's art collection at Bush Hill received several Quaker visitors, including John Smith and William Logan. Hannah Callender remarked in her diary that she admired in particular "a picture of St. Ignatius at his devotions, exceedingly well done."[63] Benjamin Franklin, in a letter to Lord James, wrote, "I know some eminent Quakers have had their Pictures privately drawn, and deposited with trusted Friends; and I know also that there is extant at Philadelphia a very good Picture of Mrs. [Hannah Callowhill] Penn, his [William Penn] last wife."[64] It is doubtful however, that the Norrises and other Friends were secretive regarding their interest in the arts, as many of the artists they chose for their portraits were quite popular and well known. The Penn family, which included a particularly devout Quaker among its successful merchants, were active consumers of portraits and other material possessions. One is left to wonder what Franklin's motives were in creating an image of private, perhaps reluctant, consumers of art.

Jonathan Richardson not only codified the style of painting popular during the early eighteenth century but also provided a means by which Quakers could justify their interest in the arts. When Benjamin West first began to paint, the issue of art as an occupation or pastime was hotly debated by the Society of Friends.[65] It was discussed by the members at a monthly meeting, where it was concluded that such remarkable talent should be encouraged. Influenced by Richardson, who wrote, "The way to an excellent painter, is to be an excellent man,"[66] the elders concluded that art could be seen as a moral endeavor and therefore acceptable within the confines of Quaker doctrine.[67]

The very nature of painting was undergoing a reevaluation by Quakers during the middle of the eighteenth century, as is illustrated by the portrait of Thomas Mifflin by Benjamin West of 1758–59 (Figure 5.2). A very early portrait by West, it illustrates the influences of his tutors, John Wollaston and William Williams. Wollaston was emulating the popular Georgian rococo, or "fancy-dress" style of Allan Ramsay and Thomas Hudson being practiced in London. The emphasis on precise rendering of details is indicative of West's debt to Williams.[68] Portrayed as a young gentleman after a hunt, Mifflin, dressed in a dark blue coat and green waistcoat, firmly grasping a rifle, is posed in a typical standing position patterned after one of the many popular European mezzotints.[69] His ruffle is of fine lawn, its beauty and whiteness signaling the sitter's status. To West's credit as a young artist, it is not an exact copy but an interpretation. The clothing appears to be Mifflin's own rather than an artist's creation. The pose is much more relaxed and the setting more characteristic of an actual Pennsylvania landscape. Mifflin's portrait reflects the growing interest in realism, within portrait conventions, that character-

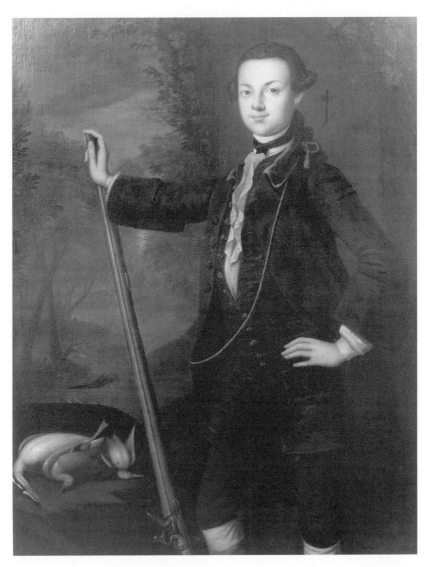

Figure 5.2. Benjamin West, *Thomas Mifflin,* ca. 1758–59, oil on canvas. Historical Society of Pennsylvania, 1910.6.

ized male Anglo-American portraiture; Friends' portraits increasingly conformed to this practice.

There were etiquette manuals that governed the pose and stance expected of an eighteenth-century gentleman. As *The Rudiments of Genteel Behavior* suggests, "The whole body must rest on the right foot and the right knee, . . . the Back to be kept straight; the left leg must be foremost and only bear its own weight, and both feet must be turned outwards."[70] From his direct gaze, as well as his fine dress and other accouterments, it does not seem that Thomas or his family had any qualms about having his portrait painted—and in such a fashionable pose and attire.[71]

At mid-century a lighter, rococo style of painting had come into vogue, emphasizing the sitter in an environment, often quite specific, that indicated wealth and social status. The Quakers were no exception in patronizing the new manner. Thomas Mifflin is portrayed in a composition that illustrates his social position through pose, gesture, attire, and surrounding landscape environment. It is in keeping with the prevalent hierarchical view of society and not very different from the portraits of the Norris family except in painting style. There were testimonies on simplicity written in the rules of discipline regarding extravagance, such as be "Advised, that all Friends, both old and young, keep out of the worlds corrupt Language, Manners, vain and needless things and fashions, in Apparel, Buildings, and furniture of House . . . avoid also such kinds of stuffs, colours and dress, as are calculated more to please a vain and wanton, or proud mind, than for their real usefulness."[72] Yet the wealthier Quakers were as concerned with fashionable goods as were non-Quakers.

Ann Galloway (Plate 7) married Joseph Pemberton (Plate 8) in June 1767 and commissioned portraits from James Claypoole, Jr., about a year later.[73] A bill from Claypoole charges for "gilding the carv'd work of two Picture Frames" on August 2, 1768.[74] Though both Joseph and Ann came from strict Quaker families (Joseph's father, Israel, was reputed to hold a severe interpretation of Quaker doctrine),[75] they also lived within the milieu of wealthy Philadelphia society.

The Pemberton family, like the Norrises, do not appear to have wrestled with any religious conflict regarding the commissioning of portraits. Their family portraits are lavish and bold. Painted by Claypoole ca. 1767, the couple is portrayed in gleaming silks in a manner reflecting the height of rococo fashion. Joseph, dressed in a flowing gray coat with overspun buttons and a silver-colored waistcoat,[76] stands in front of an open window, resting against an elegantly upholstered and elaborately carved high-style Chippendale armchair. The chair, with its carefully delineated pattern, is likely as real as

the clothes he wears and the jewel at his neck. Despite the precariousness of his fortunes, he is obviously comfortable with the evidence of his material wealth. His portrait differs very little from portraits of non-Quakers of the same period and shows him in actual clothes. In the choice of accessories and stance, Joseph's portrait is very similar to the 1764 portrayal of Philadelphia doctor John Morgan by Swiss painter Angelica Kauffman (Appendix, 5.4) and similarly portrays him in actual clothing. Claypoole was emulating a style popularized by Kauffman where the sitter is portrayed in an elegant but informal pose and setting.[77] Although Kauffman employs a more fluid European painting style in her depiction of Morgan, a comparison of that work with the portrait of Pemberton yields nothing specific or different that would identify the latter sitter as a Quaker.

Ann, portrayed in a fashionable dress of gray silk of the open robe style, yet noticeably lacking in excess lace and frills, holds a book in her hand and sits on a low stone wall that opens onto a formal garden. Claypoole used a popular mezzotint as a model (after Sir Joshua Reynolds's portrait of Lady Caroline Russell, ca. 1760). Lovell has pointed out that paired marriage portraits from the eighteenth century often used gender-specific attributes and props; the men are associated with worldly and often manmade objects and the women with home-oriented or natural forms, such as flowers, fruit, and animals.[78] The dress was likely a real one rather than a costume and was a bit old-fashioned at the time. Moreover, the apron she wears, particularly in the context of the flowers to her left, signals her domestic role. Unlike the painting of her husband, the comparison of Ann's portrait to contemporary works, such as *Deborah Hall*, 1766, by William Williams (Appendix, 5.5), and *Mrs. Jerathmael Bowers (Mary Sherburne)*, ca. 1763, by John Singleton Copley (Appendix, 5.6), yields a different conclusion. Hall is depicted in an ornate gown trimmed with silk ruffles and white lace amid a lavishly decorated setting. Bowers wears a sumptuous dress that is not real; her hairstyle and the dog she holds mimic that in the print of Russell.[79] Pemberton's air of restraint, calm and pensive expression, and lack of superfluous accessories speak more to an emphasis on Quaker attitudes of plainness and simplicity. Both portraits of the Pembertons, however, can be seen as clear indicators of the wealth, status, and high-style taste of the sitters. Ann's portrait, with its reliance on English mezzotints for pose and props but not costume, can be contrasted with that of her husband. His portrait more fully conforms to Anglo-American standards of representation for men, albeit with a slightly more restrained choice of fabric in his coat.

James Logan, the son of a Scottish Quaker schoolmaster who came in 1699 to Pennsylvania as William Penn's secretary, also commissioned por-

traits of his family. Logan's own portrait was painted by Gustavus Hesselius (Appendix, 5.7). In remarking on the direct, frank style of Hesselius's painting, Logan described the artist as one who "generally does Justice to the men, especially to their blemishes, which he never fails shewing in the fullest light."[80] Evidently it was this direct, honest style that appealed to Logan. However, his wife, Sarah, apparently felt quite differently, as he went on to state further that Hesselius "Is remarked for never having done any [justice] to ye fair sex, and therefore few care to sitt to him. Nothing on earth could prevail with my spouse to sitt at al, or to have hers taken by any man."[81]

Portrayed in a bust-length composition, Logan wears a brown coat, a white steinkirk, and a short white wig reminiscent of the portraits of the Norris family. His pose conforms to that of others during the period who chose to be portrayed as professionals. Besides his daughter Sarah, whose portrait was described earlier, Logan's second daughter, Hannah Logan Smith, also had her likeness painted.[82] Married to John Smith, Hannah had religious convictions that deepened to such a point that in 1756 she became a Quaker minister. At this time she apparently eschewed portraiture, and in 1758 her brother, William Logan, wrote to her husband regarding the portrait: "I sent for my sister's picture with an intention to make thee a present of it, but . . . my sister intends when she gets possession of it, to destroy it. If so, I can assure her I shall not part with it."[83]

Probably the most influential person in Philadelphia next to William Penn, Logan was much involved in politics until the 1750s. He wrote on a variety of topics and collected an extensive classical library that eventually became the nucleus of the Library Company of Philadelphia. In 1728 he built Stenton, a large country home.[84] The interior, decorated in the latest fashion, showed a certain restraint in the use of decorative details.[85]

James Logan believed that material success was most assuredly a sign of God's approval. He wrote to a friend, "Should I with open eyes give away those advantages that by God's Blessing my own Industry and management have . . . thrown on me to others who have had no part in that Management . . . I could never account for it to my Self and family."[86]

It was perhaps inevitable that with this diligently acquired wealth, a true indication of God's favor, Philadelphia Quakers would wish to manifest it in their surroundings and art, particularly if this wealth was viewed within the context of eighteenth-century Philadelphia. As the century progressed, Philadelphia had become the largest and wealthiest city in the American colonies. A center for political debate during the years surrounding the Revolution, Philadelphia was also a meeting ground for many of America's intellectual leaders. The account books, correspondence, and diaries of both

Quakers and non-Quakers from the period suggest that a great deal of atten-
tion was paid to aesthetic issues.[87] The lifestyle considered appropriate for
highest levels of society, which included patronage of the arts, was carefully
cultivated by Philadelphians and seemed to have no religious boundaries.
Rather, it was a subtle mixture of social, political, and economic criteria.[88]
During the eighteenth century the artistic community flourished; painting,
music, and the theater enjoyed tremendous activity.[89] There was a strong in-
terchange among the colonial cities, as well as with England, with various
pattern books providing additional information about the latest fashions
and techniques.[90] Benjamin Franklin perhaps summarized this situation best
when he wrote to Polly Stevenson in 1763, "The Arts delight to travel west-
ward. After the first cares for the necessities of life are over, we shall come to
think of the embellishments. Already some of our young geniuses begin to
lisp attempts at painting, poetry, and music."[91] In addition, Franklin received
with satisfaction a letter from Charles Willson Peale in 1771 in which the
painter noted, "Since my return to America the encouragement and patron-
age I have met with exceed my most sanguine expectation. . . . The people
here have a growing taste for the arts, and are becoming more and more fond
of encouraging their progress amongst them."[92] Peale also wrote to other pa-
trons: "The Quakers are a principal part of the moneyed people there and if I
can get a few of the Heads to have their family portray'd, I need not fear."[93]
And, "I think I have some prospect of the Quakers encouragement for I find
That none of the Painters heretofore have pleased [their] likeness."[94]

This growing patronage is perhaps best noted in Peale's portraits of the
Dickinsons. John Dickinson (Plate 11) was raised in a Quaker family and
worshipped as a Friend in his youth, but after leaving home to study law he
became separated from Quakerism.[95] Upon marrying Mary Norris, however,
he moved back into the very heart of Philadelphia's Quaker community.[96]
The Dickinsons used plain language in their home, and Mary and their
daughters were active members, but there is no evidence that John ever re-
ceived a certificate of membership or participated in meeting.[97] He is dressed
in a simple yet elegantly cut brown suit and white lapel, silk-lined waistcoat
with brass buttons, and a white neckcloth; his attire is fine but restrained in
color, cut, and fabric. John was portrayed by Peale as a thoughtful and reso-
lute individualist. He stands on a wooded hill, with the Schuylkill River in
the background, holding a three-corner black hat and a riding crop. In de-
scribing the man, William T. Read wrote:

Tall and spare, . . . his garb uniting with the severe simplicity of his sect a neatness
and elegance peculiarly in keeping with it; and his manners, beautiful emanations

of the great Christian principles of love, with the gentleness and affectionateness which . . . the Friends . . . exhibit more than other, combining the politeness of a man of the world, familiar with society in its most polished forms.[98]

By 1770 Dickinson was already well known through the publication of his *Letters from a Pennsylvania Farmer* three years earlier. The portrait described above was commissioned by Edmund Jenings, who at the same time requested portraits of John Beale Bordley and Charles Carroll of Carrollton. For all three, Jenings, who was a patron of Peale, specifically wanted the views to be uniquely American.[99] He hoped that these commissions would lead to further commissions for Peale among other Americans of stature.

Jenings's strategy was successful, as Peale was next commissioned by John Dickinson himself to paint a portrait of Mrs. Dickinson (Plate 9). The actual painting was delayed so that their daughter, Sally, soon to be born, could be included. Peale wrote of the completed portrait, "Mrs. Dickinson & Child . . . a portrait of a Quaker lady who is very perty, in the dress of the Sect, which I shall have the liberty to Exhibit when finished and not before."[100] The reference to the "dress of the Sect," despite Mrs. Dickinson's quite fashionable attire, is best explained when compared with the description noted earlier by William T. Read regarding John's suit of clothes.[101] Quaker dress imposed a simplicity on the latest fashion while still allowing for an elegance in style and material.

Mary Dickinson is depicted in portrait drapery of dark red silk with a diaphanous scarf on her shoulders and a string of pearls around her neck. She gently holds her daughter, who sits on top of a stone pedestal. Clothed in a swaddling of transparent material, with a necklace of coral beads around her neck, Sally holds a bunch of lilacs in her arms. The entire image is very suggestive of Madonna and Child. The pair are portrayed against a background of Philadelphia, where the spires of Christ Church and First Presbyterian Church are visible, possibly a view from the Norris family home, Fairhill.[102]

Hector St. John de Crèvecoeur wrote concerning the taste of Friends, "They hold everything that is called fashion in the utmost contempt, yet they are as difficult to please, and as extravagant in [their] choice and price."[103] This statement suggests that in evaluating a Quaker aesthetic, the manner in which Friends judged things must be taken into account. The society may have eschewed excess frills and decoration, but beauty and quality also exist in simplicity. Theology and worldly existence are inextricably tied together to form a single expression of Quaker life.

John Cadwalader and his family also demonstrate the relationship of the Society of Friends with a new, more sophisticated world. Peale may have been indebted to the Cadwaladers' cousin, John Dickinson, or to John Beale Bordley, a close friend, for the many commissions received from this family.[104] Writing to Bordley on July 29, 1772, Peale mentions having Mrs. Dickinson's portrait then on exhibition, together with a "composition of Mr. John Cadwalader Lady & child," which, he adds, "is greatly admir'd."[105] In this group portrait (Plate 12), the family is shown in the parlor of their Second Street home. Their clothing is real, in the height of fashion, and of a type to be worn in public rather than at home. John Cadwalader is dressed in a lavishly embroidered gray silk vest and brown coat; his waistcoat is trimmed in gold braid and he wears a wig. He apparently has just come in from the garden and is holding a peach, which he offers to his daughter Anne. His wife, Elizabeth Lloyd, wears a fancy silk dress ornamented with an unusually large amount of lace at the collar and sleeves; she wears a hairpiece, and particular effort is expended on her earrings and necklace. She gently holds the baby, who is dressed in the finest muslin and seated on an elaborately carved card table. Lovell has suggested that such portraits represent the increasingly companionate nature of marriages.[106] Probably crafted by Philadelphia cabinetmaker Thomas Affleck, the table is considered to be one of the masterpieces from the period.[107] This painting is a prime example of an American conversation piece and its high-style appointments reflect the social level and aspirations of the Cadwalader family.[108]

During the period 1770–72, Peale was commissioned to do several other family portraits for John Cadwalader, including his parents, Dr. Thomas Cadwalader (Figure 5.3) and Hannah Lambert Cadwalader (Figure 5.1).[109] Designed to be displayed in the large parlor of their new home, the canvases were finished with elaborately carved frames crafted by another well-known Philadelphia cabinetmaker, Benjamin Randolph.[110] This must have been a handsome gallery of family ancestry. The progenitor of the family was John Cadwalader, a Quaker from Wales, who came to the colonies with William Penn as a councilman in 1699. His son Thomas, the future doctor, received his early education at Friends Academy in Philadelphia and from there pursued his medical studies in London. Eventually settling in Trenton, New Jersey, he became that city's first chief burgess.[111] In 1738 Thomas married Hannah Lambert, the daughter of Trenton's prominent Quaker merchant, Thomas Lambert, Jr. Following their marriage "after the manner of the people called Quakers and according to the good order used among them,"[112] the Cadwaladers returned to Philadelphia, where Thomas became a highly respected physician and civic leader. Associated with Pennsylvania Hospital, he was one

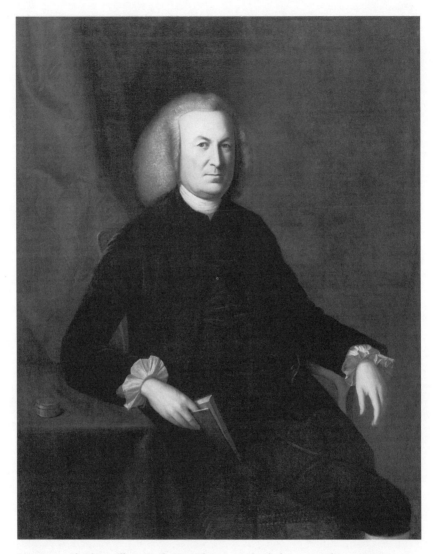

Figure 5.3. Charles Willson Peale, *Dr. Thomas Cadwalader,* 1770, oil on canvas. Philadelphia Museum of Art: Purchased for the Cadwalader Collections with funds contributed by the Mabel Pew Myrin Trust and the gift of an anonymous donor, 1983-90-1.

of the founding members of the Library Company and the American Philosophical Society.[113] Thomas was described by Dr. Alexander Hamilton in 1744 as "a fallen-off Quaker,"[114] and in 1745 he was disowned for being "concerned in Privateering vessels contrary to our antient testimony and the discipline established among Friends . . . and refusing to give satisfaction."[115] However, descriptions also indicate that in other areas of his life he maintained a Quaker manner of living. A contemporary acquaintance described Dr. Cadwalader as

A ripe scholar, an exact logician, a sound philosopher, and a perfect gentleman. . . . But pre-eminent over his intellectual acumen and his boldness and honesty of purpose shone his character as a christian and philanthropist. That it was rare to find so much ability combined with so much simplicity; his religion was entirely free from fanaticism or ostentation; and that his politeness arose from pure benevolence of heart, and was therefore not an occasional manifestation, but an habitual characteristic.[116]

Peale portrayed Dr. Cadwalader in a manner that is very suggestive of the character just described. He is dressed in a black suit with white wrist ruffles and neckcloth and a wig, and is seated at a table covered with dark green cloth. Holding a book in his hand, he steadily gazes out at the viewer. Similarly, his wife, Hannah Cadwalader, who remained an active Friend throughout her life, is clothed in a simple yet elegant and fashionable silk dress with a plain, transparent gauze fichu and modest white hat, sitting by a window at a tea table covered with fruit.[117] Like other older women, both Quakers and non-Quakers, she is portrayed in modest clothing.[118] She is painted in a straightforward manner suggesting a gentle demeanor; very simple and very different from the way her daughter-in-law is portrayed, perhaps providing a statement about her religious convictions as well as her age.

The contrast between the manner in which father and son are portrayed is indicative of a changing set of cultural and personal expectations. The portraits of the doctor and his wife emphasize their character rather than their belongings, strongly reflecting Quaker emphasis on the interior, spiritual world. John, although raised a Quaker, converted and joined the Anglican church sometime before marrying Elizabeth Lloyd.[119] There is a distinct difference in his perception of what a portrait should portray and tell about his family's lifestyle. Quakerism's emphasis on the transient nature of material life would appear to have been too much of an impediment to Cadwalader's life goals. Like many Philadelphians who subscribed to the theories of Jonathan Richardson, Cadwalader may have regarded portraiture

as a reflection of the aristocratic English manner, as concrete memories and records of his family lineage.[120] As Jonathan Richardson succinctly stated:

The Picture of an absent Relation, or Friend, helps to keep up those Sentiments which frequently languish by Absence and may be instrumental to maintain, and sometimes to augment Friendship, and Paternal, Filial, and Conjugal Love, and Duty . . . to sit for one's Picture is to have an Abstract of one's Life written, and published, and ourselves thus consign'd over to Honour, or Infamy.[121]

Another portrait that serves to illustrate the different interpretations of Quaker discipline is that of Thomas and Sarah Mifflin (Plate 13), painted by John Singleton Copley in 1773. Thomas, whose youthful portrait by West was discussed earlier, was a merchant, born of a Quaker family, who married Sarah Morris, daughter of Morris Morris of Philadelphia, at a meeting on March 4, 1767.[122] Sarah was described by John Adams as "a charming Quaker girl"[123] and remained an active Friend throughout her life.[124] Thomas was soon drawn away from mercantile activities into a political career, which included participation in the Revolutionary War and eventually governorship of the state of Pennsylvania. Thomas's military activities caused him to be disowned from the society in 1775.[125]

The Mifflins, like the elder Cadwaladers, are portrayed in a very restrained manner. Their dress is simple, with the only superfluous item being the small bouquet of flowers tucked into a bow at Mrs. Mifflin's breast; note that it is flowers rather than jewels that she wears. Thomas is portrayed in a gray coat with overspun buttons, and Sarah wears a gray silk dress—an actual one—with a white fichu and a transparent gauze apron and cap.[126] The apron is of the finest lawn, rather than lace. They are seated at a table, where Mrs. Mifflin works at a small loom making a fringe, and Mr. Mifflin has obviously just turned from reading a book that he holds in his hands. His suit is of excellent quality, the best broadcloth available, and embellished with thread buttons rather than the gold ones John Cadwalader wears (Plate 12). The background is plain and dark, with a gray column that stands against a nonspecific outdoor setting. Mrs. Mifflin's tape loom and apron assert the domestic nature of the setting. This portrait does not emphasize the couple's status but rather their industriousness and the diligent nature of their character. And, as with other double portraits of the time, it puts the female sitter on equal footing with the male. Copley painted this portrait while the Mifflins were visiting Boston during the summer of 1773.[127] When it was completed, S. Eliot of Boston wrote to William Barrell of Philadelphia: "This

Town will have the Honour of furnishing Phila with one of the best pictures it has to boast."[128]

It is interesting to compare the Mifflins' portrait with a similar double portrait painted by Copley that same year. Mr. and Mrs. Isaac Winslow (Appendix, 5.8), an elite Boston Congregationalist couple, are portrayed in a similar manner, seated by a table against a dark, unspecific background.[129] Mrs. Winslow is wearing a fashionable patterned, blue-gray dress with elaborate lace at the cuffs and neckline and a necklace of gems. Her hands are at rest as she looks at her husband. Mr. Winslow, grasping a palette and brush, wears a black coat with cream-colored riding breeches and gazes steadily out at the viewer. Although the differences in this comparison of the two paintings are subtle, Mrs. Mifflin's dress is more subdued than that worn by Mrs. Winslow, and she is engaged in a useful occupation. Perhaps more striking, however, is that, while Mrs. Winslow gazes at her husband as he commands the viewer's attention, it is Mrs. Mifflin who looks out at the viewer while her husband addresses her. It has been suggested that this difference can be viewed as an indication of the emphasis by Quakers on the importance of family and the equality of men and women.[130]

The portraits just discussed represent two versions of Quaker adaptation to mid-century Philadelphia society. As symbols of wealth and status became more desirable within the Philadelphia upper classes, some Quakers responded by fully embracing this emphasis on materialism (the Pembertons), while others seemed to prefer a more conservative approach and exercised restraint in their lifestyle (the Mifflins). Friends who had their portraits painted were neither the exception nor the rule; instead, Quaker communities were in step with the aspirations of wealthy colonial Philadelphians, reflecting social and economic conditions, kept in check by theological concerns. A wide latitude existed in the manner and style of painting a patron could choose, and this latitude indicates the individual's response to both the Quaker community and Philadelphia society.

By 1750 the dominance of the Society of Friends in Philadelphia had significantly waned, while the importance of the Anglican and Presbyterian communities increased. From a city that was predominantly Quaker during the early part of the century, Philadelphia experienced a decline in Quaker membership such that only one-quarter of the population were Friends. By the 1770s only one out of every seven citizens was a Quaker.[131] Reasons for this decrease can be found in the stricter nature of many of the Quaker disciplines. Many members were marrying out of the meeting, while the requirement of pacifism presented problems for others. Rather than tolerate a

greater range of attitude toward maintaining the Inward Light, Philadelphia Quakers chose a more strict interpretation, which included a greater enforcement of its discipline.[132] Many of the reforms were imposed specifically to address ways to combine the spiritual and the secular in daily life.

Even though the Quakers constituted a smaller and smaller proportion of Philadelphia's population, they remained an influential force in the economic and political life of the city. The Philadelphia tax list for 1769 records that nearly half the seventeen wealthiest individuals were practicing Quakers, and many of the others had been Quakers in their youth or, as in the case of William Shippen, had inherited their wealth from Quaker ancestors.[133] For eighteenth-century Quakers, material success, including the patronage of the arts, was acceptable in the eyes of the Lord as long as it was not considered primary in life and kept within moderation, with moderation obviously being a relative term.

The portraits discussed above suggest the growing importance of materialism and display, the manner in which individual Quakers chose to live within this changing environment, and how these ideas were embodied in painting during the colonial period. The eighteenth century saw Quakerism transformed from a theology that emphasized religious conviction as the sole means for individual fulfillment to a more rational, secular approach that defined God's approval by material success. However, there was a clear understanding by Quakers of a distinct difference between an appropriate display of one's success and an ostentatious or frivolous manner of living.

The members of the Norris family chose to have themselves portrayed in the fashionable Knelleresque manner of the early part of the century, which gave a clear indication of their place in society. At this point their portraits differ very little from those of non-Quakers. It is at mid-century, with the shift in style from the baroque to a Georgian rococo that emphasized a sitter's environment, that the different levels of adherence to Quaker doctrine became evident.

In comparing the portraits of Mr. and Mrs. Joseph Pemberton and Mr. and Mrs. Thomas Mifflin one is immediately struck by a different overall emphasis. The Pembertons are portrayed amid luxurious surroundings, both specific and nonspecific. Although the artist is striving for a more informal composition, the props, the sitters' elaborate attire, and their pose are all indicators of their wealth and social standing. The only suggestion of their character comes from a sense of pride of possessions. The emphasis in the portrait of the Mifflins is primarily on the relationship between husband and wife—here, a companionate one—and the pursuit of an activity. Their attire and surroundings are subordinate to the suggestion of a diligent character.

Based on the limited examples of multifigure portraits of Friends, I would suggest that Anglo-American portrait conventions and broader social practices, rather than religious standards alone, influenced the positioning of the Mifflins. Mrs. Mifflin firmly holds the threads to her loom, as compared to Mrs. Pemberton, whose grasp barely secures the book. Mr. Mifflin's attention is solely on his wife, suggesting the importance of family in Quaker life; Mr. Pemberton, through his stance, gesture, and surroundings, appears to be more interested in illustrating his wealth and success. These portraits indicate the range in lifestyle that existed within the Society of Friends during this period.

In their degree of elaboration and emphasis on wealth, the portraits of the Pembertons are much closer to the likeness of the John Cadwalader family. No longer a practicing Quaker, Cadwalader felt no obligation to have his portrait indicate a moderation acceptable to the Society of Friends. Instead, the family portrait falls within the parameters dictated by colonial Philadelphia society (non-Quaker), which allowed for a much wider latitude. This is particularly noticeable in a comparison with the portraits of his parents, Thomas and Hannah Cadwalader. Their likenesses are more similar to the Mifflin portrait in the emphasis on character over environment and materialism. Although their attire is appropriately fashionable and elegantly cut, it does not include frivolous or useless ornamentation; and their environment is nonspecific and serves only to highlight the figures.

By the middle of the eighteenth century there was a growing trend away from the plainness and self-denial of the founding generation of Quakers. However, during the 1770s the debate over military participation and wide interpretation and casual adherence to Quaker doctrine caused great divisiveness among Friends. In response, reforms were enacted during the last quarter of the century, and the majority of the society became more conservative of ancient traditions, customs, and doctrine, more separate from the world, and more introspective in spirit than they had ever been, even in their early years. As a result of this narrowing of doctrine and behavior, Quaker communities evolved into what is now the more familiar and stereotypical images—a sober people, clothed in gray with old-fashioned manners, that is, the nineteenth-century Quaker.

One of the foundations of Quakerism during the colonial period was its responsiveness to the individual and the individual's interpretation of his or her own Inward Light. It grew out of a need to worship freely and individually and carried over into all parts of Quaker life. As Quakerism is highly individualistic, a Quaker could rationalize religion to coexist with his or her other beliefs. Like their non-Quaker brethren in colonial mercantile elites

discussed by Breen, St. George, Staiti, and others, some Friends commissioned portraits that represented their lavish existence—or one they aspired to—as testimony to their diligence and God's favor at that point in their life. Other Friends' portraits—or absence thereof—embody their preference for moderation. As a philosophy of life, Quakerism gave one the option to choose change and follow one's inner conscience, thereby encouraging and allowing a personal definition of plainness and simplicity.

Appendix: List of Paintings Discussed But Not Illustrated

5.1. *Sarah Logan Norris,* ca. 1739; original lost, black and white study photograph is unlocated. See Tolles, *Meeting House and Counting House,* illustrations located between pp. 62–63.

5.2. Gustavus Hesselius, *Charles Norris,* 1736, oil on canvas; original lost, nineteenth-century copy by unknown artist. Historical Society of Pennsylvania, Philadelphia. An inscription on th back of the canvas reads, "C. Norris Aetdt: 24."

5.3. *Isaac Norris II,* ca. 1739, oil on canvas; original lost, nineteenth-century copy by unknown artist. Historical Society of Pennsylvania, Philadelphia.

5.4. Angelica Kauffmann, *Dr. John Morgan,* 1764, oil on canvas. National Portrait Gallery, Smithsonian Institution, Washington, D.C.

5.5. William Williams, *Deborah Hall,* 1766, oil on canvas. Brooklyn Museum, New York.

5.6. John Singleton Copley, *Mrs. Jerathmael Bowers (Mary Sherburne),* ca. 1763, oil on canvas. Metropolitan Museum of Art, New York.

5.7. Gustavus Hesselius, *James Logan,* ca. 1716 or 1735–1745, oil on canvas. Historical Society of Pennsylvania, Philadelphia.

5.8. John Singleton Copley, *Mr. and Mrs. Isaac Winslow,* 1773, oil on canvas. Museum of Fine Arts, Boston.

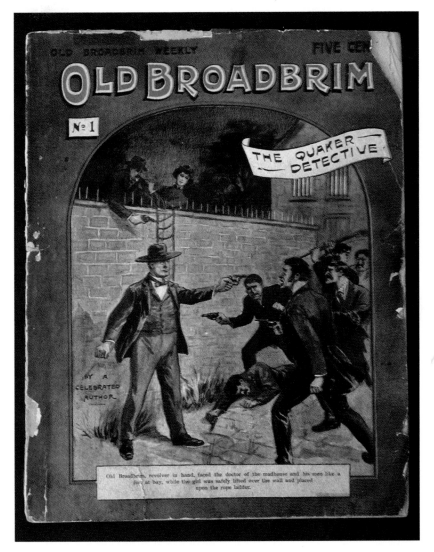

Plate 1. Cover from *Old Broadbrim Weekly* No. 1, 1884. Haverford College Special Collections. "Old Broadbrim," readily identified by his stereotypical Quaker hat, graced the covers of more than two dozen popular "dime novels" between 1884 and 1904. In some editions he was joined by his partner, "Young Broadbrim."

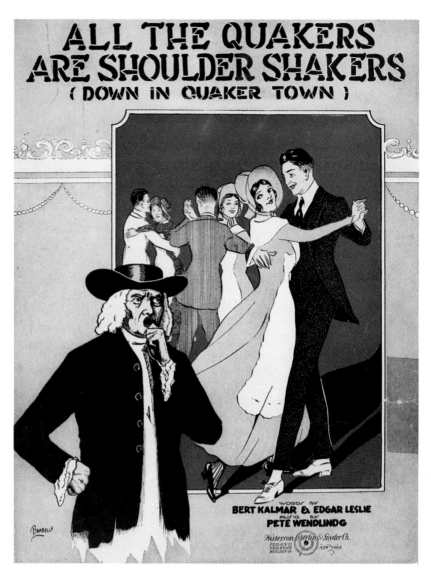

Plate 2. Cover from sheet music, "All the Quakers Are Shoulder Shakers (Down in Quaker Town)." Words by Bert Kalmar and Edgar Leslie, music by Pete Wendlind. Waterson, Berlin, & Snyder Co., New York, 1919. Collection of Theresa Leininger-Miller. An older Quaker man in a broad-brimmed hat shows his concern over young Quaker women, in gray dresses and bonnets, dancing with men in modern suits. The song's words also satirize the disjunction between "Quaker plain" and Quaker behavior.

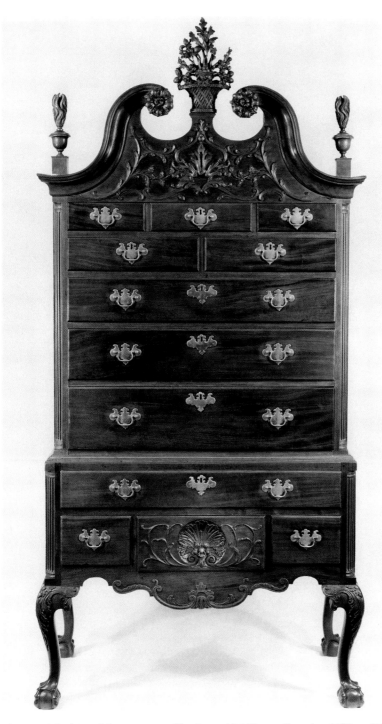

Plate 3. High chest of drawers owned by Samuel Wallis, attributed to William Wayne.
Philadelphia, 1770. Private collection. Photo: Israel Sack, Inc.

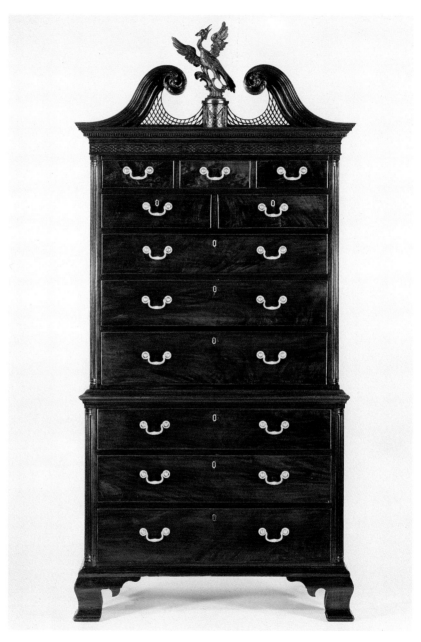

Plate 4. Chest-on-chest owned by Sarah Logan Fisher, attributed to Thomas Affleck and James Reynold, carver. Philadelphia, 1772. Metropolitan Museum of Art, Purchase, Friends of the American Wing and Rogers Funds; Virginia Groomes Gift, in memory of Mary W. Groomes; and Mr. and Mrs. Frederick M. Danziger, Herman Merkin, and Anonymous Gift, 1975 (1975.91). Photo: Richard Cheek; photo © 1984 The Metropolitan Museum of Art.

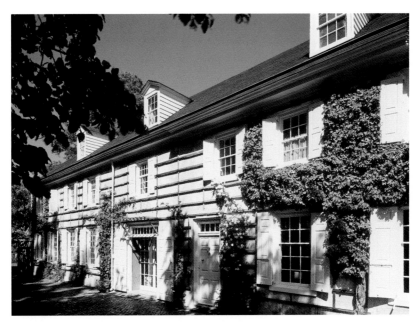

Plate 5. Wyck, southern façade. Courtesy Wyck Association.

Plate 6. Wyck rose garden viewed through early nineteenth-century arbor. Courtesy Wyck Association.

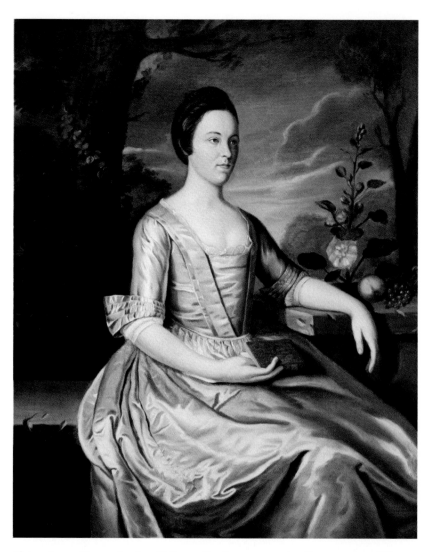

Plate 7. James Claypoole, *Ann Galloway Pemberton,* ca. 1767, oil on canvas. 50½" x 40 ½". Pennsylvania Academy of the Fine Arts, Philadelphia. Gift of Henry R. Pemberton, 1968.6.

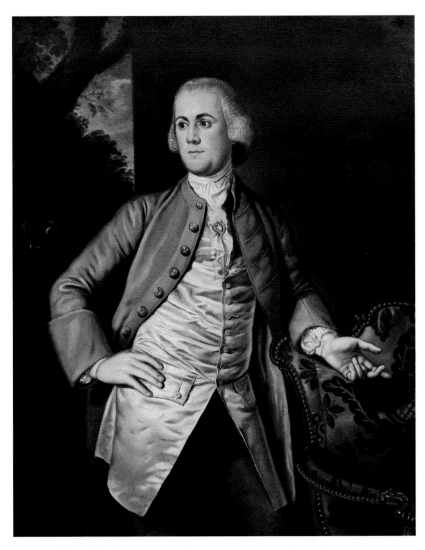

Plate 8. James Claypoole, *Joseph Pemberton*, ca. 1767, oil on canvas. 50½" x 41".
Pennsylvania Academy of the Fine Arts, Philadelphia. Gift of Henry R. Pemberton,
1967.15.

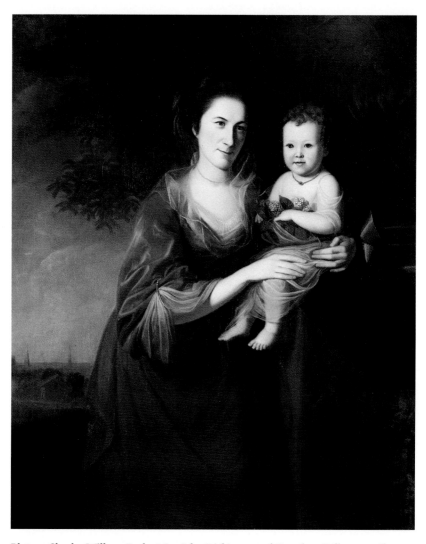

Plate 9. Charles Willson Peale, *Mrs. John Dickinson and Daughter Sally*, 1773, oil on canvas. Historical Society of Pennsylvania, 1926.2.

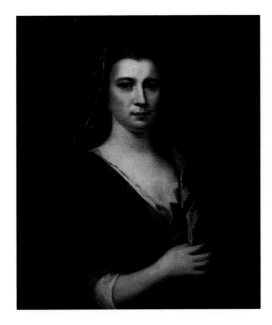

Plate 10. Attributed to Sir Godfrey Kneller, *Mary Lloyd Norris*, ca. 1720, oil on canvas; original lost, nineteenth-century copy by Matthew Wilson. Courtesy The National Society of The Colonial Dames of America in the Commonwealth of Pennsylvania at STENTON, Philadelphia. Gift of George William Norris, 1959, 67.401. Photograph by Will Brown.

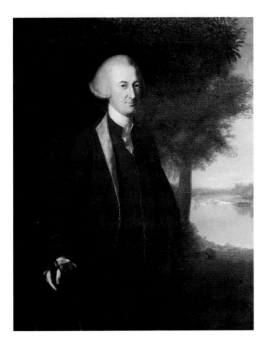

Plate 11. Charles Willson Peale, *John Dickinson*, 1770, oil on canvas. Historical Society of Pennsylvania, 1926.1.

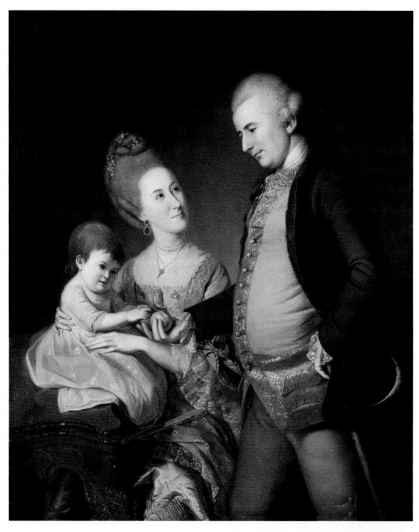

Plate 12. Charles Willson Peale, *John and Elizabeth Lloyd Cadwalader and their daughter Anne,* 1772, oil on canvas. Philadelphia Museum of Art: Purchased for the Cadwalader Collections with funds contributed by the Mabel Pew Myrin Trust and the gift of an anonymous donor, 1983-90-3.

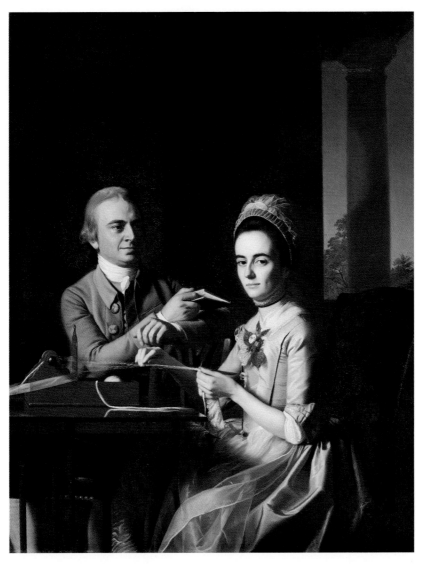

Plate 13. John Singleton Copley, *Thomas Mifflin and his Wife Sarah*, 1773, oil on canvas, 60¼" x 48". Philadelphia Museum of Art: Bequest of Mrs. Esther B. Wistar to the Historical Society of Pennsylvania in 1900 and acquired by the Philadelphia Museum of Art, EW 1999-45-1.

Plate 14. The interior of Bradford Meeting House, Marshallton, Pennsylvania, is an illustration of the dual apartments used for separate men's and women's business meetings that were characteristic of the "doubled plan." Also illustrated are the retractable wood paneled partitions that separate the apartments, and the "Plain Style" interior. Photo: Jack B. Boucher, Historic American Buildings Survey, 1999.

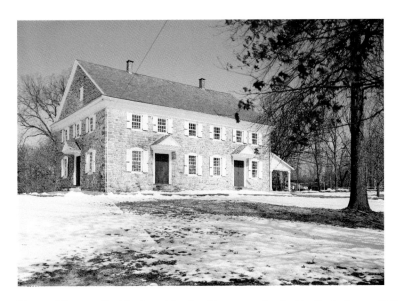

Plate 15. The 1768 Buckingham Meeting House was the first in the Delaware Valley (and probably the nation) to be built on the "doubled plan" that became a standard for meeting house design during the late eighteenth and first half of the nineteenth century. Photo: Jack E. Boucher, Historic American Buildings Survey, 1999.

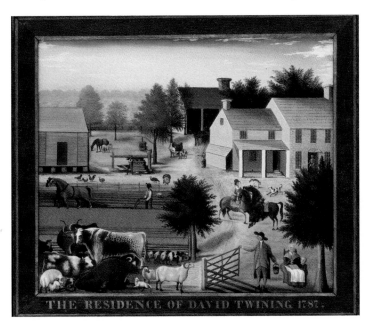

Plate 16. Edward Hicks, *The Residence of David Twining*, 1845–47, oil on canvas, 26" x 51 ⁹/₁₆". Abby Aldrich Rockefeller Folk Art Museum, Colonial Williamsburg Foundation.

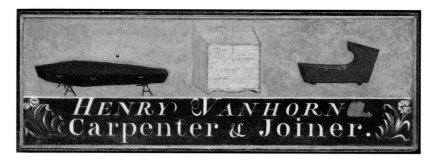

Plate 17. Edward Hicks, *Henry Vanhorn Signboard*, 1800–1805, oil on wood, 17⅛" x 54⁵⁄₁₆". Abby Aldrich Rockefeller Folk Art Museum, Colonial Williamsburg Foundation.

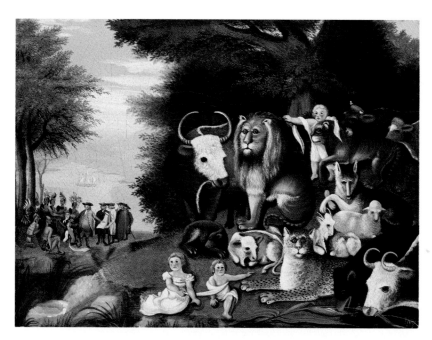

Plate 18. Edward Hicks, *Peaceable Kingdom*, 1832–34, oil on canvas, 17¼" x 23". Abby Aldrich Rockefeller Folk Art Museum, Colonial Williamsburg Foundation.

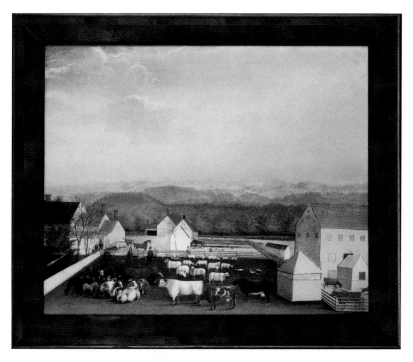

Plate 19. Edward Hicks, *Leedom Farm,* 1849, oil on canvas, 40⅛" x 49¹⁄₁₆". Abby Aldrich Rockefeller Folk Art Museum, Colonial Williamsburg Foundation.

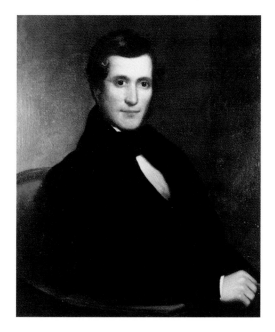

Plate 20. Unidentified Artist, *Caleb Hallowell,* undated, oil on canvas, 30" x 25". Private collection.

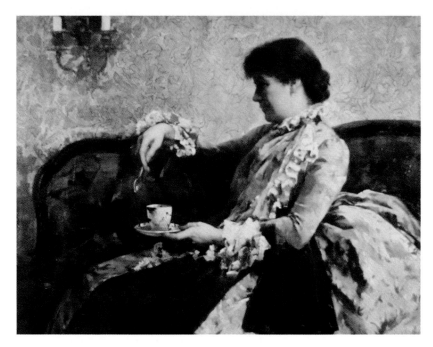

Plate 21. Mary Fairchild MacMonnies, *Portrait de Mille S. H. (Sara Tyson Hallowell),* 1886, oil on canvas, 44" x 38¼". Robinson College, Cambridge University, Gift of Marion Hardy.

Part II
Quakers as Producers

Introduction

Bernard L. Herman

Edward Hicks's *Peaceable Kingdom* paintings succeeded in part because they drew on a visual language central to ongoing debates within the Quaker community. Kinship, community, craft, and consensus: these concepts are central to understanding Quakers as producers. The following three essays on Quakers as producers and the aesthetic nature of their productions reflect more than a century of discussion on what constitutes Quaker material culture. The critical core for these debates returns again and again to the notion of a Quaker aesthetic steeped in an evolving doctrine of plainness and simplicity. The examinations here of the Quaker meeting house, the dwellings of Quaker families erected in the colonial period, and the paintings of Edward Hicks reveal the fact that any discussion of a Quaker aesthetic begins with a fundamental tension between Inward Light and the necessity of living in the world. The flashpoints for these discussions are the definitions of plainness and simplicity and the persistent belief that the expression of plainness and simplicity are to be found in the Quaker material culture of the everyday. The chapters in this volume discuss the definitions and implications of plainness and simplicity in detail, but, more important, they begin to map the contours of Quaker material life. In doing so, they begin to assess how Quakers resolved the paradoxes of living in the material world. Moreover, although each explores a different genre of Quaker material culture, they are united around a set of shared themes. Chief among these are kinship, community, craft, and consensus.

Kinship and community have remained powerful forces for members of the Society of Friends from the seventeenth through the twenty-first centuries, manifest in a variety of forms in material culture. The eighteenth-century mansion builders of the lower Delaware Valley monumentalized family by ornamenting their houses with dates and initials. Meeting houses

celebrated community through the adoption of a pared down classical language that emphasized Quaker identity.

The central paradox inherent in a Quaker aesthetic that privileges kinship and community, however, is that it can only work through a process of outward show that places an emphasis on distinctiveness. The design of the meeting house, for example, was not so much plain as it was different from the ecclesiastical architecture of Anglicanism. Arguments that eighteenth-century Quaker meeting houses were plain ignore their very fabric. The Philadelphia Free Quakers Meeting, complete with its giant engaged pilasters, was commissioned in 1783 by disowned Quakers who tapped into the worldly and academic language of classicism (Figure 1).[1] Similarly, the Orthodox Quakers who undertook the remodeling of Lower Alloways Friends Meeting in the 1780s installed classical columns to support the gallery in their place of worship (Figure 2). The inclusion of such stylish architectural elements in meeting houses is consistent with a Quaker doctrine that emphasizes the importance of the practice of living in the world. The elegance (as opposed to sumptuousness) of meeting houses codified that practice. The same is true of houses, rural and urban, that reference current worldly fashion in both their interior and exterior appearances. To look at a mid-eighteenth-century Quaker family's two-story brick or stone house in Chester County, Pennsylvania, and to claim it as plain misses the importance of its original context in a landscape dominated by small single-story dwellings built of logs.

Hicks's paintings provide a crucial insight into a Quaker aesthetic based in part on the expression and perception of the Quaker community. Carolyn Weekley situates the *Peaceable Kingdom* paintings in the context of a symbolic disquisition on the schism between Orthodox and Hicksite Quakers. She also demonstrates that his painterly style was the product of an active choice rather the limitations of ability, a characteristic shared with many "plain painters" throughout early nineteenth-century United States. In this sense, the paintings are visual arguments for a doctrinal position in an artisanal mode.[2] Importantly, Hicks draws directly on his trade as a sign painter to state his position. Hicks's choices are compelling. First, his appropriation of a sign-painting tradition to the purposes of doctrinal debate draws on a medium that is central to the worldly arena of commerce. Hicks literally advertised his position. Second, the culture of signs in the eighteenth and early nineteenth centuries presumed a readership—and by extension a community—defined by its shared ability to engage that text. What renders Hicks's work even more problematic, though, is his own conversion to Quakerism, a process that lent his work an almost evangelical fervor. Like the Quaker builders of meeting houses and dwellings, Hicks was conflicted

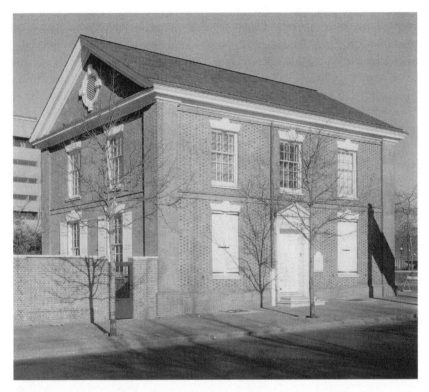

Figure 1. Free Quakers Meeting House (ca. 1783), Fifth and Arch Streets, Philadelphia. Photo: George A. Eisenman, Historic American Buildings Survey, 1976.

in his representation of self and community. His incorporation of patriotic motifs in his compositions drew on one aspect of worldliness that troubled many of his Quaker contemporaries.

Craft or workmanship complicates the idea of Quaker aesthetic even further. Three basic assumptions about craft underpin discussions of a Quaker aesthetic. First, there is the sense that Quakers elevated the art of craftsmanship in the production of their material world. Second, craftsmanship functioned as a kind of surrogate value system for fashion; that is, craft was the proper vehicle for the expression of worldly attainment. Third, the aesthetic propriety of Quaker craft drew heavily on vernacular practices, an assumption that implicitly places plainness in the context of everyday objects. Catherine Lavoie is particularly attentive to issues of craft and vernacular design as central to a Quaker aesthetic. Meeting houses (at least those that

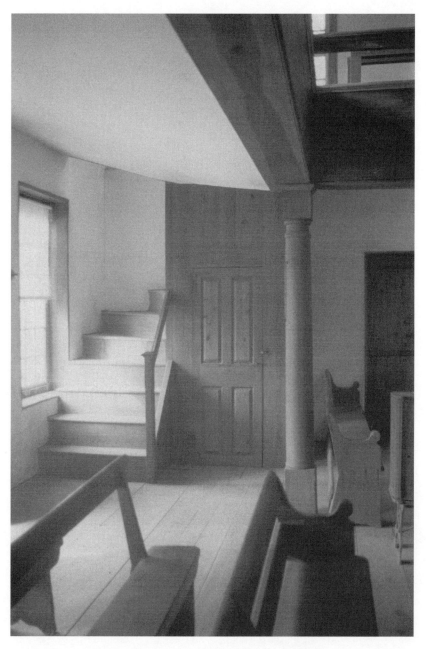

Figure 2. Lower Alloways Creek Friends Meeting, Hancock's Bridge vicinity, Salem County, New Jersey, interior. Photo: author.

survive) arguably blend domestic design and local practice in the production of worship space. The difficulty inherent in this position, though, stems from the architectural reality that Quaker meeting houses are not particularly domestic in design and that in matters of construction and ornament they are consistent with the best buildings in their contemporary landscapes. What Lavoie underscores is the extremely high quality of these buildings, a degree of fineness that renders them comparable to the best and most durable religious architecture of their age. In matters of construction, eighteenth-century Quaker meeting houses are much the same as their Anglican, Lutheran, Reformed, Baptist, and Presbyterian cousins. What makes the Quaker meeting houses distinct in a landscape defined by nonconformism is the outward show of nonconformity. While Lutheran and Presbyterian congregations appropriated the architectural language of provincial Anglican churches and auditory chapels to their own needs, Quakers opted to codify the nature of their differences in a move that created a more uniform meeting house architecture. The high level of craft in the building trades evident in extant Quaker meeting houses monumentalizes the distinctiveness of design. It is in the interplay between craft and design that the basis of a Quaker aesthetic defined on the practice of living in the world becomes apparent.

Each of these essays also locates a Quaker aesthetic in a process of achieving and articulating consensus in the material world. The historical evolution of the meeting house is particularly instructive. Catherine Lavoie and others have noted a transformation in meeting house design beginning in the third quarter of the eighteenth century and accelerating through the early 1800s.[3] Meeting houses erected prior to 1760 drew on a variety of design solutions that extended to the creation of meeting spaces in private houses. From the late 1760s onward a new meeting house idiom incorporated symmetry, uniformity, and equality in its plan. Lavoie notes that the Buckingham model was the product of an evolving design process; she attributes its rapid and widespread diffusion throughout the region to the habit of building committees visiting structures that could serve as models for their own circumstances. Critical to this process of architectural consensus is the movement of individuals through the landscape and the very likely role that Philadelphia Yearly Meeting played as the site for the exchange of ideas and information of all sorts. Certainly, a comparable architectural consensus is visible in the dated and initialed houses of the early eighteenth century, a consensus sustained within a larger colonial culture steeped in the worldly practices of emulation and display.[4]

The paintings of Edward Hicks, meeting houses, and Quaker dwellings provide only a narrow view of the material world of Quaker producers, and

of the processes that shaped their work and its reception. Central to under-standing these objects in light of an evolving Quaker aesthetic is the recognition that these objects are systemically linked in a larger expressive culture. The degree to which houses, allegorical paintings, and meeting houses are aspects of a larger cultural system at work in a common landscape is encapsulated in Quaker quilts from the close of the eighteenth century through the mid-1800s.

The same conundrum surrounding plainness and worldliness in architecture and allegorical painting is apparent in Quaker quilts. Interpretations that rely on restrictive notions of plainness have had the result of relegating a great many Quaker quilts to the status of objects that deviate from a doctrine of plainness. In quilts, as in houses and other material culture genres, the challenge is presented as "developing a framework for reconciling Quaker doctrine regarding plainness and simplicity with the recurrent presence of opulent and ornamental objects in Quakers' material lives."[5] The Quaker quilts that survive from the late eighteenth and early nineteenth centuries are demonstrably elite productions that situate their makers and owners in multiple contexts, including social rank, gender, wealth, taste, and faith. It is precisely the ability of these objects and their makers to occupy multiple contexts in a single gesture that has confounded attempts to locate a Quaker aesthetic in terms of readily recognizable attributes. Quaker quilters drew on a variety of fashionable and popular patterns, ranging from whole cloth quilts in the 1770s to album quilts in the 1840s. What truly distinguishes these quilts is how energetically they engage the larger popular culture of the day. Thus, for example, Quaker quilts from the Delaware Valley differ little from those made by Episcopalian elites in early nineteenth-century Baltimore.[6]

Quaker quilts, like houses and meeting houses, achieved their identity and power through the ways in which they engaged the same issues of kinship, community, craft, and consensus explored in these three essays. In her final illness in the early 1840s, Eliza Naudain Corbit of Cantwell's Bridge (now Odessa), Delaware, mediated her own death through an eighty-one-block pieced signature quilt.[7] The individual blocks were distributed to friends and relations, inscribed in ink, and returned to Eliza Corbit (Figure 3). The finished quilt served many functions. It provided the medium through which she literally drew family and community around her. It was a remarkable demonstration of a craft that by the mid-nineteenth century linked elite and vernacular material culture in the expression of shared values. Finally, like the paintings of Edward Hicks, the houses of Quaker elites,

and the architecture of the meeting house, the aesthetic that informed Eliza Corbit's signature quilt was performative. The aesthetic that defined Eliza Corbit's final work cannot be found in pattern, fabric, or needlework, but is located in the ways in which her quilt stood in the world.

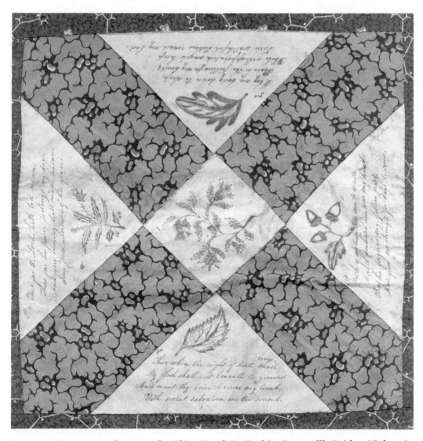

Figure 3. Signature quilt, 1840s, by Eliza Naudain Corbit, Cantwell's Bridge (Odessa), Delaware. Courtesy Winterthur Museum, 1971.1317.

Chapter 6

Quaker Beliefs and Practices and the Eighteenth-Century Development of the Friends Meeting House in the Delaware Valley

Catherine C. Lavoie

The Delaware Valley provides a unique opportunity to study the evolution of the American Friends meeting house as a building type. Historically under the care of Philadelphia Yearly Meeting, the area has been a cultural stronghold of the Society of Friends from the late seventeenth century to the present. As the heart of Penn's colony, it was the scene for some of the earliest Quaker settlements, often established by first-generation "convinced" Friends. It still has one of the largest concentrations of Friends in America. Over 150 Quaker meeting houses still stand, ranging in construction date from as early as 1695 to as late as the 1970s. Religious persecution and their own beliefs regarding the unsuitability of "Steeple Houses" to Quaker worship had prevented the early English Friends from developing a building specifically for use as a meeting house much before the 1689 Acts of Toleration.[1] They chose instead to meet out-of-doors, in houses, or in farm buildings adapted for meeting. Unfettered by the persecution experienced by their English counterparts, the Friends who began relocating to the Delaware Valley in the 1670s were free to create public meeting houses. Here Penn's fervor for religious toleration spawned a lively period of experimentation in religious practice and building design. Although colonial Friends continued to look to London Yearly Meeting and initially followed a pattern of meeting established by the English, they soon developed local architectural vocabularies. Thus the colonial period is distinguished by the variety of meeting house types produced as Friends worked through various ideas about building forms conducive to their meetings for worship and for separate men's and women's business.

While plan was determined by program, the design of meeting houses was shaped by individual interpretations of the Quakers' aesthetic preference for the simplicity prescribed by their theology. The architectural elements and iconography used to identify the architecture of other religions were not applied to the Friends meeting house. Instead, meeting houses were created in harmony with the local built and natural environments. The Friends of the Delaware Valley used indigenous materials, such as locally quarried stone. They drew from vernacular building traditions to create meeting houses particular to the region; meeting houses within the same district or organizational unit of monthly or quarterly meetings share many building traits but often vary greatly from those in neighboring quarters. The regional similarities were also a factor of the communal nature of Friends design and construction process. Building form was determined by a committee appointed by the meeting, who then acted on the consensus of the group. Although construction was the responsibility of the individual meetings, they often sought the advice and assistance of the larger monthly or quarterly meetings. The variations in meeting house design from the colonial period also illustrate the decentralization of power that then existed within the Society of Friends. The individual meetings were given relative autonomy in defining architectural as well as meeting program. By the close of the eighteenth century, however, a prototypical meeting house form emerged within the Delaware Valley. Although the Quaker tenets and building practices that shaped design remained fairly constant, an attempt was made by Philadelphia Yearly Meeting to codify rules and procedures, thereby shifting the balance of power away from the individual meetings.

The power shift, resulting in part from pressures placed on Friends by the larger society, was ultimately responsible for establishing standards for both meeting procedure and meeting house design. As Friends came under fire for their beliefs during the decades preceding the American Revolution, they retreated from politics and public life. In an effort to solidify their membership, they launched a campaign of spiritual reform aimed at reviving the "deep spiritual inwardness" that characterized the earlier period in their religious practice.[2] Prosperity and rising consumerism were making it increasingly difficult for them to live outside "worldly" influences. Reacting to the tension between adherence to Quaker tenets and existence within the larger society, Philadelphia Yearly Meeting leaders put out a call for strict obedience to Quaker doctrine. Attempting to regain control through uniformity in Quaker thought and practice, Friends exercised constant vigilance toward the newly codified *Book of Discipline*, or rules governing conduct. Emphasis on discipline and procedures eventually manifested itself in the

design of meeting houses with the emergence of the "doubled" prototype, a two-celled structure that provided for equal men's and women's sections separated by a retractable or swinging wood partition (Plate 14).[3] Philadelphia and London Yearly Meetings maintained close communication, but American Friends deviated from the English pattern of meeting and subsequently developed their own distinct building form. This form, first exhibited in Buckingham Meeting House in Buckingham Township, Pennsylvania, in 1768, provided a model for the American Friends meeting house. Thus, experimentation in meeting house design within the Delaware Valley over the course of nearly a century led to a period of relative standardization. More important, the development and proliferation of a standardized meeting house reflected Friends' attempts to adhere staunchly to their beliefs and practices in the face of mounting pressures imposed by the conflicting mores of the larger society.

The Period of Experimentation: Without a Prescribed Standard

George Fox, the founder of the Society of Friends, advocated no set building form for Quaker worship. He, in fact, saw no need for distinct buildings, asserting that God dwells not "in temples made with hands . . . but in the hearts of men."[4] Fox equated the meeting with people and not with a building. To protect against the tendency of church buildings to inspire idolatrous and patterned worship, Fox advocated open-air meetings, as did many of the first ministers and traveling Friends. In his treatise titled *Concerning Meeting in Houses, Ships, Streets, Mountains, By-Wayes,* Fox cited biblical references to the many instances that Christ and his apostles preached outside a church structure to demonstrate his convictions.[5] The lack of a prescribed building type was consistent with Fox's religious philosophy that eliminated programmed worship and professional ministry. Instead, individuals were to be guided by the Inward Light or "that of God in every man."[6] Hence Friends met, without sermon, silently waiting upon the Lord. Emphasis in Fox's day was on proselytizing rather than defining meeting space.

Practicality dictated the use of some type of structure, however. In 1687 Fox provided guidance as to a proper form in response to an inquiry regarding the retrofitting of an existing structure for use as a meeting house. He stated, "And as concerning the meeting place itself whether the Barn or the House, I shall leave it to you. But if the Barn will do better, if you could make it wider . . . and the ground may be rais'ed that you may go up a step or two to go into the Meeting House & it will be more wholesome . . . you have

stones enough, and poor men to dig them. And I would have all the Thatch pulled off all the Houses. . . . Let all the Houses be slated, and the Walls about it to be made substantial to stand, and laid in Lime and Sand. . . . I would have a porch made to the Meeting place of the common side of the yard. . . . And I would have the meeting place large, for truth may increase."[7] Fox, then, advocated structures that were well built; he recommended engaging the assistance of the local Quaker population and using indigenous materials in the building's construction. Equally significant is what Fox did not discuss, such as interior furnishings and fittings or adornment of any kind. This approach to design was dictated by the Quaker tenet of simplicity. Unlike most ecclesiastical buildings, nothing about the meeting house revealed or dictated its purpose. Uncluttered by iconographic imagery, meeting houses were intended to avoid outward distractions and focus on the goal of cultivating one's Inward Light and listening for the "still small voice" of the Divine. These concepts have persisted for centuries, guiding the development of American Friends meeting houses to the present.

The oldest standing meeting house in the Delaware Valley is Merion, located in Lower Merion, Pennsylvania. Merion was begun as early as 1695 and was completed by 1714. Its near cruciform plan is unprecedented in a meeting house design, making it the subject of some controversy (Figure 6.1).[8] Many observers resist the idea that persecuted immigrant Friends would adopt a plan so closely resembling one used by the Anglican Church when they rejected all that such a structure represented.[9] Much of the misunderstanding stems from the fact that Merion's plan is in stark contrast to the identical two-cell or doubled type that later became the standard meeting house design. However, the builders of Merion Meeting House were among the first generation of Welsh Quaker converts and the first to settle in Penn's colony, some arriving as early as 1682. Many were fleeing from persecution, leaving Great Britain prior to the Acts of Toleration. The Friends who left Merionshire for the colonies had no purpose-built meeting houses in Wales and therefore no preconceived notions regarding proper form.[10] Lacking prescribed standards, the Merion Friends may have merely constructed a building that was an adaptation of the familiar: the rural parish churches of their homeland. Despite Merion Meeting House's conventional church plan, its design was still a vast departure from the ecclesiastical structures of its day, which were arranged and outfitted to facilitate ordered rituals and sacraments.

Merion was not the only early meeting house in the Delaware Valley that appears unconventional by modern Friends standards. Among other noteworthy designs was the hexagonal Burlington Meeting House of 1686, in

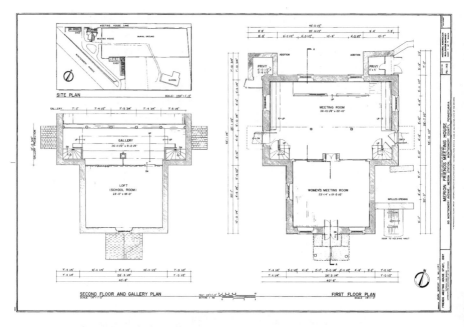

Figure 6.1. The T-shaped plan of Merion Meeting House (ca. 1695–1714) is unprecedented in a meeting house design, demonstrating the lack of prescribed standards indicative of the early settlement period. Drawing: Adam Maksay, Historic American Buildings Survey, 1997.

New Jersey. Legend has it that Burlington was modeled after the kitchen of Glastonbury Abbey that served as an early meeting place for a group of English Friends. Burlington was obliquely lit by a lantern projection that sat atop it, seeming to speak to the importance of natural light in facilitating one's own Inward Light. A similar lantern topped one of Philadelphia's early meeting houses, Great or High Street Meeting House of 1696.[11] The lantern on Great Meeting House rested on a hipped roof, square shaped structure. Compared to the hexagonal plan of Burlington, the square configuration better accommodated one of the defining features of the Friends meeting house, the facing benches (also known as the stand or minister's gallery) on which the ministers and elders were seated. Generally running the length of one wall, the facing benches became the focal point of the meeting's attention and the feature around which the other interior elements of the meeting house were arranged.

The hipped roof and near-square configuration characterized a number of Philadelphia's early meeting houses including the Boarded (1683), Center

Square (1683–ca. 1689), First Bank (1685), and Second Bank (1703). The square shape probably reflected the positioning of the apartment created for the women's business meetings to the rear of the principal apartment that contained the facing benches and was used for the men's meetings. This was becoming the standard plan among English meeting houses and was employed in many meeting houses built in the Delaware Valley during the early period. Chichester Meeting House (1769) in Boothwyn, Pennsylvania, is a good example. Among the last of its type in the Delaware Valley, Chichester still contains back-to-back apartments with a facing bench in the front apartment only, a plan that was conducive to the English program (Figure 6.2). American Friends of the colonial period adhered to the English pattern of meetings whereby the entire meeting—male and female—met for worship in a single room. Once worship concluded, the women would retire to a separate room to conduct their meeting for business.[12] The distribution of space within numerous early meeting houses was conducive to such a pattern. This pattern of meeting was also in evidence within Philadelphia Monthly Meeting and was recorded in 1684: "Where friends being mett in ye fear of the Lord and after several Testimonies borne and several Papers from George Fox and the Generall Meeting was read, the *men and women separated and proceeded to Business*" (italics mine).[13]

Although none of the early Philadelphia meeting houses are still standing, perhaps most is known about Second Bank Meeting House, due in part to the survival of a period depiction.[14] In addition to its near-square proportions and hipped roof, Second Bank Meeting House possessed what was likely another important distinguishing feature of the early square type: prominent entries on the two contiguous south and east façades corresponded to gender specific meeting rooms, which had the effect of creating two front elevations. This form still exists in Sadsbury Meeting House erected in 1747 near Christiana, Pennsylvania (Figure 6.3).[15] Second Bank originally was divided by a curtain that was later replaced by a wood partition like that seen at Sadsbury.[16] In both cases, the centrally located doorway forced the dividing line between the apartments to one side, thereby creating the unequally sized (often back-to-back) meeting rooms indicative of the English pattern. Because the women's business meeting needed to accommodate only about half the total population of the meeting, their apartment constituted a significantly smaller space within the meeting house. The women's meeting section also did not require the facing benches from which the ministers and elders (and later, overseers) presided over the meeting for worship.[17] It was not until the construction of Great Meeting House in 1755 that meeting houses in Philadelphia and the surrounding areas fixed on the

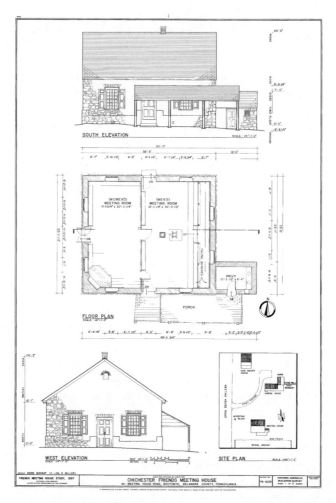

Figure 6.2. The 1769 Chichester Friends Meeting House in Boothwyn, Pennsylvania, is the best extant example of a plan conducive to the English pattern of meeting in the Delaware Valley. Here, Friends met together for worship in the front room containing the facing benches, and the women later removed themselves to the rear apartment to conduct their meeting for business. Note the articulated watertable and the corner fireplace. Although fireplaces were not common to American or English meeting houses, when they did appear it was usually as an accommodation made to that section designated for use by the women's business meeting. Fireplaces were not provided during meeting for worship as a hedge against drowsiness. Drawing: Adam Maksay, Kevin Lam & Roger Miller, Historic American Buildings Survey, 1997.

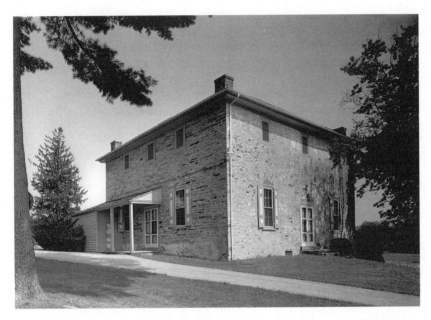

Figure 6.3. The 1747 Sadsbury Friends Meeting House near Christiana, Pennsylvania, is among the few early square-plan meeting houses extant. It is distinguished by the two front elevations that originally corresponded to gender specific meeting rooms. Photo: Jack B. Boucher, Historic American Buildings Survey, 2001.

rectangular configuration and side-gabled roof that became dominant features of meeting house design. The rectangular form suggested a shift to a side-to-side placement of men's and women's apartments, which later became part of a standard design.[18]

In the more isolated countryside of Pennsylvania, early meeting houses often took on a different form that resulted from adding a section for women's business meetings to an earlier structure. The best surviving example of this type is Radnor Meeting House in Ithan, Pennsylvania (Figure 6.4). It began in 1718 as a one-story, three-bay-by-three-bay stone building. Like the Second Bank Meeting House, it appears as a single-celled structure. Rather than having dual entryways and a partitioned interior, a smaller addition was later appended to accommodate women's business meetings and a school.[19] The lowered height of the addition is in proportion to its overall diminutive size. This building type probably evolved from the desire to erect a meeting house for worship as soon as possible, with the idea that Friends

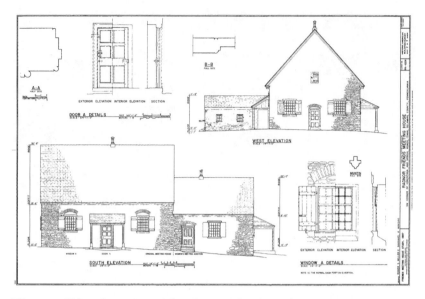

Figure 6.4. Although once a prevalent form, Radnor Friends Meeting House is the only extant telescoping meeting house in the Delaware Valley. Its plan resulted from the addition of the women's meeting section to the original 1718 structure. Drawing: Roger Miller, Christy Barnard & Adam Maksay, Historic American Building Survey, summer 1997.

would add a section to accommodate separate business meetings when they were better able, or perhaps when their numbers necessitated it. Preoccupied with establishing their own homes and farms, early Friends were often hard pressed to contribute to the construction of a meeting house. Thus it was not uncommon during this period for Friends to meet in a structure that was not fully completed.[20]

Although Radnor is the only surviving meeting house of the telescoping form, this pattern of development is described in meeting minutes and other sources. The variations that existed between these early women's meeting additions and the meeting house proper are significant. From the standpoint of design and proportion, women's meeting additions appear almost as separate structures and in some cases may actually have been treated as such. For example, the addition to the one-celled 1708 Plymouth Meeting House looked much like Radnor prior to the reconstruction that was necessary after a fire in the 1860s.[21] According to oral tradition, there was no passageway be-

tween the main block and the women's meeting section, which actually was referred to in the minutes as "the little meeting house."[22] There is evidence to indicate that the three earlier meeting houses that stood at the site of Buckingham also consisted of a main block with a smaller women's meeting addition. For example, in 1720, Buckingham Friends recorded that they were "fully concluded to go forward *with enlarging the meeting house twenty foot square* and appoints John Scarbough, Enoch Pearson and Thomas Canby to agree with workmen and it is concluded by this meeting *to build no higher than the old meeting house*" (italics mine).[23] The same was true of London Grove's former meeting house, in London Grove, Pennsylvania. In 1784 the London Grove Friends met to "consider the inconveniences attending the present manner of siting this meeting." They discussed making an alteration "between the old and new apartments" that would allow their meeting house to more efficiently accommodate meetings for worship and separate men's and women's business. They proposed that "the middle wall that divides the two houses be taken down & falling partitions substituted in its room."[24] Likewise, a surviving image of the first meeting house of the Little Egg Harbor Friends in Tuckerton, New Jersey, depicts a five-bay, gambrel-roofed main structure with a very different and lower three-bay, gabled-roof women's meeting section appended to it.[25] Discussion in 1844 over the feasibility of merely creating "shutters to devide the hous instead of repairing the little part" again bears witness to the former relationship between the two components of the meeting house.[26] Adherence to a pattern of meetings established by English Friends (that did not dictate the placement of the women's meeting apartment with regard to the men's) combined with the lack of prescribed building standards allowed for greater flexibility in meeting house design and plan. These factors contributed to the broad range in meeting house forms during the early settlement period.

The Influence of Quaker Beliefs on Architectural Design: The Tenet of Simplicity

The architectural design of meeting houses is shaped foremost by the Quaker tenet of simplicity. Simplicity is most overtly demonstrated through the rejection of ecclesiastic models and the lack of high-style architectural ornamentation. But it is also manifested through the application of vernacular building traditions to include elements of domestic architecture and through the use of indigenous materials (Figure 6.5). Although the latter factors contributed to great regional variation, continuity among meeting

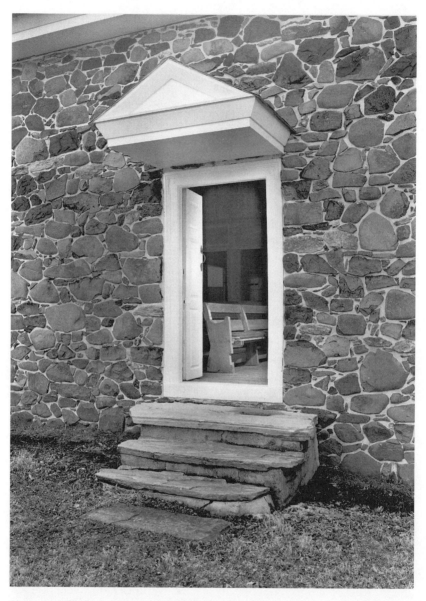

Figure 6.5. The doorway hood on Bradford Meeting House (1767) in Marshallton, Pennsylvania, is an example of the application to meeting houses of architectural elements common to domestic architecture, and the use of indigenous materials. Although built of rubblework, the skill applied to the masonry is exceptional. Photo: Jack B. Boucher, Historic American Buildings Survey, 1999.

house designs is achieved through adherence to the "Quaker Plain Style."[27] Some Quaker-built structures exhibit refined motifs seen in high-style architecture, but their meeting houses remained staid outward symbols of the Quaker faith. The steeples, bell cotes, crosses, and other traditional elements of religious architecture are missing from Friends meeting houses. Furthermore, the Quaker demand for simplicity, which stifled the impulse to add to meeting houses fashionable elements taken from the latest architectural pattern books, lent a certain timeless quality to their design. Although finish elements such as doorway surrounds might reflect the classically derived detailing then popular—particularly when located in more urbane surroundings—they were less ornate. Friends meeting houses are distinguished not by stylish embellishments but by the high quality and careful restraint exhibited in their craftsmanship. For example, rubblework is generally favored over a more decorative pattern of ashlar block, but the skill applied to the masonry work is usually of exceptional quality. Rubblework is used to create quoining, window heads, water tables, belt courses, stoops, and (horse) mounting blocks. Interior elements such as the wainscoting, partitions, facing benches, flooring, and other furnishings and fittings that characterize the Friends meeting house are unpretentiously executed and without a finish. But, despite the "plain styling," careful attention is paid to detail (Figure 6.6). The partitions are made from raised panel sections, and the wainscoting of beaded tongue-and-groove boards. The stairway balustrades and support posts, while often somewhat primitive in profile, are made of turned wood. Simple, movable wood benches provide seating in the meeting house, yet the profile of the bench ends differs from meeting house to meeting house. The natural treatment of the woodwork serves as a unifying force within the interior of the meeting house that is enhanced by neutral whitewashed plaster walls. There are no cornice moldings or ornamental plasterwork, and the bare white walls are effective in reflecting natural light throughout the structure.

Meeting houses blend with the local built environment through the adaptation of vernacular building traditions. Because individual Friends meetings were responsible for the construction of their own meeting houses, they often employed the same craftsmen who applied the same building techniques they had used to build dwellings and other domestic structures. The result was the creation of the distinct regional variations that are among the most dynamic features of early designs. The meeting houses in the same general location or, more specifically, in the same monthly or quarterly meeting, exhibited shared building traits but often varied greatly from those in neighboring areas. While most early meeting house forms were based on the

Figure 6.6. The interior of Upper Providence Friends Meeting House, Montgomery County, Pennsylvania, is an illustration of the "Plain Style" and the careful attention to craftsmanship and detail indicative of Quaker meeting houses. Note the raised panel doors and partition panels, the wainscoting, and the profile and joinery of the benches. Also note the use of the carriage door, positioned along the rear wall. Photo: Jack E. Boucher, Historic American Buildings Survey, 1999.

essential single-celled unit, they differed in general configuration or specific details.

Each region or quarter developed its own meeting house types or defining characteristics. Unlike Philadelphia's square-shaped, hipped-roof buildings, those in the Burlington and Salem quarters of southern New Jersey beginning about the same era, such as Woodbury (1715), Bordentown (1740), Hancock's Bridge (ca. 1756), Greenwich (1771), Copany (1775), and Arney's Mount (1775), were two-story, single-cell, rectangular structures with side-gable roofs. In Bucks Quarter the extant meeting houses are almost exclusively of the two-cell or doubled form, with few earlier types remaining. They are also almost all two-story buildings with a gallery in the upper story. As late as the 1850s, the same doubled form appears throughout the Chester and Western quarters, but they are rarely more than one story high. Carriage doors appear only in a scattered sampling of Pennsylvania meeting houses, and generally not after the 1760s, but rear-entry carriage doors were a fairly regular feature of New Jersey meeting houses well into the nineteenth century.[28] Among the more unusual variations are a number of meeting houses in the westerly quarters, such as Uwchlan, Chichester, and Sadsbury, with corner chimneys. Some regional features were subtle. The Concord Quarter meeting houses at Concord, Willistown, Chester, and Lansdowne have paired windows in the first story. In Salem Quarter, meeting houses like Upper Greenwich and Mullica Hill have no second-story windows over the doors. In Abington Quarter, structures such as Plymouth, Gwynedd, and Upper Providence have tiered fixed benches to the rear of the meeting house to offset the facing benches to the front. In other cases, the shared traits may be the result of the diffusion of old-world building traditions brought to the colonies by recent immigrants. The early Welsh-built stone meeting houses at Merion and Radnor possess the steep pitch characteristic of English thatched roofs. The structural system at Merion includes timbers cut to resemble cruck or bent principal rafters, and remnants of its original windows indicate that they had been casements with leaded glazing. The Welsh people were versed in stone construction, owing to the availability of that material in their homeland, and likely brought those traditional skills to the construction of Merion and Radnor meeting houses as well.

Vernacular building traditions are further demonstrated through the application to meeting houses of many of the building elements commonly found in dwelling houses. The most significant of these elements are the doorway hood, pent roof, sash window, and diminutive use of scale. The gabled hoods that appeared over the doorway of colonial residences became one of the standard features of meeting house design, as did the pent roof in

the ends of gable-roofed structures.[29] Unlike the ornamental windows found in most churches, the windows of meeting houses are of sash glazed with colorless light as found in most residences. These characteristics are responsible for creating structures much more attuned to local domestic architecture than to ecclesiastic building forms. Despite the fact that some wealthy Friends built residences in as high a style as their non-Quaker contemporaries, from the exterior early single-cell meeting houses such as Arney's Mount, in New Jersey, are barely distinguishable from the neighboring vernacular dwelling houses, exhibiting similar features, proportions, and scale (Figure 6.7). From the standpoint of interior design, unlike churches, very little in the way of furnishings or fittings were required in order to facilitate the meeting's program. Although interior features such as the facing benches and partition became standard, their absence would not have hindered the loose structure of Quaker worship. As Quaker historian Hubert Lidbetter at

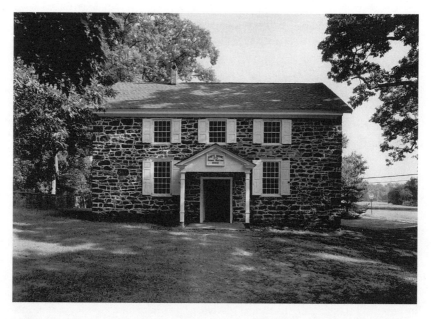

Figure 6.7. Arney's Mount Meeting House, built in 1775, is an example of the single-cell type that more closely reflects domestic than ecclesiastic building forms. It is built of the bog iron stone indigenous to this portion of southern New Jersey. Photo: Jack E. Boucher, Historic American Buildings Survey, 2001.

tests, "With no necessity to provide for music or any set form of service a Friends meeting house is much more a domestic than an ecclesiastical building, with little or no architecture pretensions; it makes no effort to be other than a meeting place—unconsecrated and sanctified only by the purpose for which it was designed and used."[30] And like residential architecture, the colonial-era meeting houses demonstrate respect for human scale. The fairly diminutive scale of a fair portion of meeting houses is likely a byproduct of the desire to maintain a sense of community conducive to the spiritual support of the meeting.[31] Rather than erect a larger structure when a meeting house exceeded capacity, a group generally would break away and form another meeting. With the exception of urban examples, when large meeting houses were built it was usually to accommodate quarterly meetings, and intimacy was maintained during the smaller preparative meetings by cordoning off a portion of the building through the use of partitions or upper galleries.

Vernacular building traditions are also manifested through the use of indigenous building materials. Rubblestone, readily available, dominates the meeting house construction of rural Pennsylvania. Many early settlement-era meeting houses in the Delaware Valley were constructed of logs but quickly replaced. In the furthest-reaching locations in Philadelphia Yearly Meeting, at Roaring Creek and Catiwissa, Pennsylvania, however, log construction was still being used around the turn of the nineteenth century, and it still exists today (Figure 6.8). In urban locations, such as Philadelphia, the meeting houses are all of brick construction. This is also true in southern New Jersey. Generally lacking the rich stone deposits found in Pennsylvania, southern New Jersey developed a tradition of brick construction, and the region became known for its patterned brickwork. This tradition made its way into some of the meeting houses, such as Woodstown, Rancocas, and Moorestown, where it was used in lieu of a date stone. Only Arney's Mount was built from the local bog iron stone on which it sits. Coastal New Jersey, where the soil is sandy and timber abounds, is the only area where wood frame or shingled meeting houses are prevalent, such as the meeting houses of Shrewsbury, Barnegat, Squan, and Little Egg Harbor. During the late eighteenth and early nineteenth centuries, when regional distinctions were somewhat blurred by the large-scale adaptation of the standard doubled form, the practice of using indigenous materials continued, often becoming the single most identifying feature of the meeting houses of this era.

Although manifestations of simplicity are readily apparent in the meeting houses of the Delaware Valley, discussions of its application to architectural design are absent from Friends records. General references to simplicity appear routinely in directives distributed by Philadelphia Yearly Meeting, but

Figure 6.8. Built in 1796, Roaring Creek Meeting House near Numidia, Pennsylvania, is of interest for both its log construction and its two-cell design with unequally sized meeting rooms; the structure faces south, with the partition running north-south between the three westerly bays and the east doorway. The unequal apartments were indicative of the English pattern of meetings, and reflected a plan that was generally not incorporated into American meeting house designs of this period. Its rustic construction and outmoded plan may be a factor of its "frontier" location, then among the furthest outreaches of the Philadelphia Yearly Meeting. Photo: Jack E. Boucher, Historic American Buildings Survey, 2001.

it is not until the twentieth century that simplicity is more self-consciously stipulated in the building plans recorded in meeting minutes.[32] The tradition of simplicity was achieved not by written mandate but through a deeply held understanding that was reinforced through the administration of Quaker discipline. As a key component of their religious doctrine, simplicity was an accepted truth attesting to an underlying principle of the Quaker faith: a return to a primitive form of Christianity and the elimination of ritualistic and material displays of religious practice. But simplicity could be more generally applied as the absence of all that was unnecessary. Friends believed that, if individuals confined themselves to the "necessities of life," oppression and

strife would end.[33] As William Penn once wrote, "The very trimmings of the vain world would clothe all the naked one," and thus for the early Friends simplicity was a means to social justice rather than a matter of style.[34]

Moreover, adherence to the simplicity tenet was viewed as an outward expression of one's inner conviction to "Truth," or the value system on which the Society of Friends was based.[35] Influential Quaker minister Joseph Pike, writing in 1726, explained, "Religion does not consist in bodily conformity, or plainness of apparel, but is in and from the heart . . . yet true religion leads into simplicity in all outward things." He goes on to reveal, "Thus did true religion in the heart lead our first elders and fathers in the church, out of the fashions, customs, finery and superfluity of apparel, and furniture, and to testify against it, as not preceding from the Spirit of Truth, but from vain, unsettled spirit of the world."[36] But Pike was quick to add that the Friends understood that if "kept within the bounds of true moderation, no fault would be found them." The pressure exerted by both their tenets and fellow members of the society to remain "in unity" with the ways of Friends was generally enough to discourage would-be offenders.

Philadelphia Yearly Meeting advocated following Quaker tenets or testimonies through its *Book of Discipline* and periodic advices. These were distributed by the yearly meeting to the quarterly meetings and on down through the hierarchy to the individual monthly and preparative meetings. Interpretation and enforcement of the discipline were generally left to the discretion of the monthly or preparative meeting (with the quarterly meetings acting in appeals). But it appears that few such directives were called for in the early decades, a likely indication of the Friends commitment to Truth. At this time, the yearly meeting minutes reflect a greater concern for matters of worship than for business and discipline. And it was not until 1695, fourteen years after the first yearly meeting was held, that "some queries" aimed at promoting proper Quaker conduct were addressed. Following a discussion on the topic, a committee was appointed to outline the principles necessary "for the restraining of any that are or may get into practices unbecoming our profession & to endeavor to follow as near as may be, the methods used by Friends in England for the prevention of evils."[37] The subsequent list of six queries includes a rare direct allusion made by Philadelphia Yearly Meeting to simplicity as applied to architectural design. Prominently appearing in the first and second queries respectively, it is mandated, "all that profess truth keep to plainness in apparell" and that "all superfluity & excess in buildings and furniture be avoided for time to come."[38] Mention of these guidelines can be found within the minutes of the individual quarterly meetings. In 1701, for example, Chester Quarterly Meeting clearly stated its intention to

enforce the discipline with regard to simplicity, recording that "if any launch out into any suporflusity in apparell or fashions or customs of the world, [it is this meeting's intent] that they will be speedily advised to the contrary."[39] Disciplinary action was generally taken at the monthly meeting level, and rarely would the yearly meeting intervene in the proceedings of the individual meetings. Instead, to assist the meetings in their efforts to monitor behavior, in the late seventeenth century the yearly meeting instituted the position of "overseer." Charged with disciplining "disorderly" Friends, the overseers' duties included home visits to ensure that members upheld Friends testimonies. As the yearly meeting instructed, "It is the advice of this Meeting to the several Quarterly Meetings, that care may be taken that substantial Friends may be appointed to visit every family amongst us, where they think there is occasion to suspect they are going backward in their worldly estate, and to enquire and see how things are with them, and if they will not take the advice of Friends, then . . . proceed therein against them."[40]

In 1702 Philadelphia Yearly Meeting minutes note that "a paper" relating to "Discipline and orderly behavior" had been drawn up and sent out to the several quarterly meetings.[41] It was also sent to London Yearly Meeting, as was common practice in such matters. Through the exchange of yearly epistles and other regular forms of correspondence, as well as the steady flow of traveling ministers, Philadelphia and London Yearly Meetings attempted to maintain moral support by keeping in close contact, with the latter often providing guidance. In 1704 Philadelphia Yearly Meeting compiled this and other prior "papers" that they thought "needful for discipline & to rectify practices" to produce their first book of Quaker discipline.[42] Looking to the example set by London Yearly Meeting, Philadelphia Yearly Meeting included in its *Book of Discipline* a quotation from an epistle received from London: "And the meeting, being under a deep sense that Pride [and] the vain Customs and fashions of the World Prevail over some under our profession, particularly of the Truth take care to be exemplary in what they wear and use, so as to avoid the vain Customs of the World and all Extravagancy in colour and fashion."[43]

In 1743 the *Book of Discipline* was revised, and a longer list of twelve queries was developed. The queries, presented in the form of a list of questions to be read prior to each quarterly meeting, were intended to bolster members' adherence to Quaker principles. Suggesting that compliance was not an issue among older members, the testimony on simplicity was directed specifically toward the training of children and appears sixth on the list. Among other things, it requests that Friends "keep them to plainness of speech and apparel."[44] When the queries were revised in 1755, however, sim-

plicity appeared third in a list of thirteen queries, and its application was all-encompassing, instructing meetings to "bring those under their direction in [accordance with] plainness of speech, behavior and apparel."[45] The fact that the tenet of simplicity resumed some of its former prominence indicates that there was newly found concern by the mid-eighteenth century.[46] In fact, a thirteenth query was added in 1755 urging members to deal swiftly with those who stray from the principles outlined in the Discipline.

The Influence of Quaker Building Practices on Architectural Design

The vernacular character of most eighteenth-century Friends meeting houses is a testimony to the communal nature of the building process whereby meeting members shared in the design and construction. The individual meetings determined meeting house form, where members were allowed the freedom to develop a plan that was specific to their needs. As occurred within Concord Quarterly Meeting in 1704: "New=ark [Newark] friends request the consent of this meeting for to build two meeting houses, who are left to their liberty to build according to their own proposall."[47] More often, however, the meeting members sought the advice and assistance of neighboring communities through their monthly or quarterly meetings. Such was the case in 1717, when the Radnor Friends were planning for the construction of their meeting house. As stated within the minutes: "Some friends of those appointed [by the monthly meeting] to assist Radnor friends in ye contrivance of a new meeting house there bring acct yt they have accordingly met and given ym their thoughts as to ye bigness and form therof to wch Radnor frds then there present seemed generally to agree with."[48] Particularly during the period of early settlement, the construction of a new meeting house often required the combined resources of the larger community.

In 1710 Bucks Quarterly Meeting was asked to give advice on the construction of a meeting house at Bristol. Their minutes present a scenario that typified the design and construction process for Delaware Valley meeting houses during the eighteenth century:

This meeting having under their consideration the building of a meeting house at Bristol; its concluded that there be a good substantial house built of brick or stone and the friends appointed to take ye demintion & see for the convenient place [in which to build] is Joseph Kirkbride, Joshua Hoopes, John Satcher, Thomas Stevenson, Thomas Stakehouse, & Adam Hawkes, together with who of Bristol friends they

think fitt; who are likewise to compute ye charge as near as may be & to appoint he they think fitt to manage ye work & give account of their proceedings to next meeting.[49]

The following year the minutes report on the same structure:

The friends appointed to take care about the meeting house at Bristol report they have made some progress therein having obtained a grant for a lot of land of Samuel Carpenter to set the meeting house on likewise has agreed of dimensions, [seen to] the carpenters work, [and] has computed the charge of the whole & think it will be about £200 and this meeting appoints Joseph Kirkbride, Thos Stevenson, Wm Crossdale & George Blaugh to undertake to [see to] the rest of the work belonging it & take care to see it well & carefully done & with what expediation may be.[50]

Here again, the extent of the involvement of the larger Quaker community is apparent.

The process began with the quarterly meeting, whose endorsement was needed to establish a new meeting or erect a meeting house. Permission was granted only after it was determined that the meeting in question was in good standing or in unity with the ways of Friends. A committee of members from the local quarterly and monthly meeting often joined with the new meeting to assist them in making general determinations (particularly in cases where the meeting house would be used to hold quarterly or monthly meetings as well). A building committee was created within the specific meeting involved. The building committee, selected by and working with the oversight of the larger meeting, then developed the architectural design. Lists of building committee members generally appear in the minutes. These individuals are often the most influential or "weighty" members of the men's business meeting, a station that was usually reflected in their generous building subscriptions.[51] Building committees were also likely to include members with skills in the building trades. The committee was first charged with developing a more refined plan and a cost estimate. This plan was then presented to the larger meeting for approval.

The Quaker process of reaching a "sense of the meeting" was important in attaining a collective understanding of the meeting's goals, and the effort to achieve such unity might entail the alteration or even cessation of plans. If agreement could not be reached, the issue was generally set aside until further determinations could be made. Because little of the specific discussion that preceded agreement is recorded in Friends minutes, the level of involvement by the larger group and the types of concerns raised by them are difficult to gauge. Certainly inability to reach agreement could delay

decision-making—sometimes for many years until the principal opponents died or moved away. Friends were encouraged to work toward consensus building, since harmony was viewed as an indication of the divine rightness of a course of action. The 1762 case of Buckingham Preparative Meeting required the intercession of the quarterly meeting

We the subscribers appointed by the Quarterly Meeting to assist you with some advice respecting some difficulty arising among you in regard to the building [of] a new meeting house and having fully heard the members of your meeting on the matter and it appearing evident to us that there is a great disgracement amongst you concerning the place whereon to set the building and considering the danger & hurt that may arise to a religious Society if such Disunion should subsist. . . . We earnestly advise that Friends endeavor to divest themselves of private views & consider what may most contribute to the general good of Friends and be more unanimous before they undertake the work.[52]

In this case, the matter was laid down and construction of a new meeting house delayed for nearly five years before agreement could be reached. In other cases, the information that is available suggests that the debates often concerned the appropriateness of building at all. Friends were wary of large financial outlays that could result in debt or otherwise hinder their ability to assist with issues of social welfare.[53] Hence, for a *new* meeting, construction might be postponed by conducting meetings in a house or other preexisting building. With regard to older meeting houses, every effort was made to repair rather than rebuild and to make use of old building materials if rebuilding became unavoidable. While potentially there was economic benefit to be gained from the reuse of materials, the extent to which the Friends pursued this pattern of reconstruction is noteworthy. The expense of dismantling an old meeting house and incorporating its parts into a new one at times exceeded any economic gain, suggesting that the practice was as much grounded in philosophical beliefs as in the pursuit of their financial best interest.[54]

Once the plan for a new meeting house was approved, the building committee was charged with overseeing the various phases of construction, in essence acting as a contractor. The committee was required to report regularly on the progress, often using this as an occasion to request additional funds and offering meeting members the opportunity to consider alternatives. When constructing the meeting house, individual members contributed their construction skills, building materials, and subscriptions (financial contributions) according to their ability.[55] Because Friends dissuaded their members from dealing with individuals outside the society,

whenever possible capable members would undertake the actual construction. And among the queries was one regarding the apprenticing of children to those of the faith, thereby ensuring that Quaker builders passed on their skills to other Quakers.[56] The names of artisans and builders are generally omitted from meeting minutes, however. Similarly indicative of the communal nature of Quaker practice, individual contributions were not acknowledged. Singling out one's own efforts was viewed as self-glorification and frowned upon. In one case, the attempts of an eighteenth-century builder (and meeting member) to include his initials in the date stone was such an obvious affront to Quaker sensibilities that it is *still* being recounted as part of their oral tradition.[57] Where financial records exist, however, the names of meeting members can often be found among the lists of expenditures as being paid for labor or for material contributions made toward the construction of the meeting house.

Records for Merion Meeting provide an illustration of the early Quaker building process. The members of the building committee orchestrated the construction of the meeting house, which included gathering indigenous materials, assigning specific individuals various aspects of the building's construction, and managing funds. The extant preparative minutes indicate that members of both the preparative and monthly meetings undertook work or supplied materials for the construction of Merion Meeting House. The process of "seeing for stone" indicates that the building material was gathered from the surrounding area by meeting members. John Roberts, who conducted a sawmill, probably paid the balance of his subscriptions by "sawing [timbers] upon the account of the meeting."[58] Meeting members Richard Jones and Edward Roberts were also engaged in "sawing." Various members of the meeting supplied other building materials, such as nails and lime, and finishes, such as locks and hinges. Still others provided loans to be repaid through the collection of subscriptions.[59] Everyone within the meeting participated in some way in the process of planning, financing, and constructing the meeting house, and the products of such Quaker craftsmen probably also assured adherence to desired standards of simplicity.

While general practices can be inferred and some information gleaned from meeting minutes, detailed accounts of the design and construction process are conspicuously absent. The reports of the building committees are often referred to, but they are rarely enumerated in the minutes.[60] Instead, only instructions to building committees appear, such as "agree with workmen" or "conclude upon a plan."[61] The Burlington Quarterly Meeting minutes in 1715, for example, record, "It is agreed at this meeting that a meeting house be built in Burlington for the Service of ye Yearly Meeting and that

this meeting will defray the charge. This meeting appoints Samuel Smith, Daniel Smith, Samuel Bunting, and Peter Frottwoll [?] to agree with workmen and set them to work about the same."[62] The scarcity of more explicit instructions suggests that common values were at work in determining meeting house form. Moreover, the lack of discussion reflects Friends' distaste for material concerns and the still strongly held notion that the building is subordinate to the meeting itself and therefore of little significance.

Factors such as the variations in meeting house form, use of vernacular building traditions and indigenous materials, and communal nature of the design and construction process all help illustrate the decentralization of power that existed within the Delaware Valley's Society of Friends in its early development. Individual meetings had relative autonomy to design meeting houses, free from guidelines other than the dictates of general religious tenets such as simplicity. The only written guidelines for meeting house design are English and do not appear until 1820, well after the institution of a standardized American meeting house plan.[63] The random timing with which changes were introduced in various meeting houses also attests to the freedom Friends had in interpreting religious and business programs. Friends of the colonial period were not obligated to follow strict procedures or adopt programmatic changes that influenced design. The appointment of women as elders provides just one example of the many inconsistencies in meeting practice allowed by the power of local authority. Philadelphia Yearly Meeting encouraged the practice of including women, but it was left to the discretion of the individual meetings to put it into practice. In 1741 Bucks Quarterly Meeting advised the meetings under its care to "consider [the matter] relating to [the] appointment of women friends as elders to sit with the ministers." Thus, after much discussion, "it is agreed that each monthly meeting be left to their liberty to appoint them as they may see a service."[64] The freedom to adopt procedures as they saw fit and the lack of written mandates makes it hard to pinpoint the exact time that changes were initiated either to the program or to the physical structure of meeting houses. Some meetings never bothered to alter their meeting houses to conform to new meeting patterns, underscoring the fact that Quaker program required no set building form. Until the mid-eighteenth century, individual meetings continued to exercise local discretion in deciding basic issues of practice with minimal intervention from Philadelphia Yearly Meeting.[65]

Quaker Tenets, Worldly Influences, and the Development of a Meeting House Prototype

Beginning in the mid-eighteenth century, response to external pressures had a tremendous impact on Quaker thought and practice. The outbreak of the Indian Wars in the 1750s provided the catalyst for a growing opposition to pacifist Quaker leadership. Adherence to the "peace testimony" precluded support for the war cause, opening the Quakers to harsh criticism from the general population. The reputation of the Society of Friends and their entire value system, or Truth, came under attack. As their ideologies conflicted with the realities of pre-Revolutionary War America, Friends turned further inward, relinquishing their hold on the state assembly and other governmental positions. At the same time, an important spiritual reform movement arose in Quaker communities. An influential segment of the Quaker population, worried that the inwardly derived convincement that had motivated the first generations of Friends had lost its vigor, asserted that a complacency had fallen over the later generations of "birthright" members.[66] They blamed a rise in affluence and involvement in "worldly" affairs for the decline of the society. As historian Philip Benjamin explains, "The earnestness and honesty which characterized the Quaker enterprise in both England and America earned them a prosperity which made their testimonies of simplicity and democracy difficult to maintain."[67] The reformers believed that these factors had resulted in a weakening in the Discipline. In order to revive the "deep spiritual inwardness" that characterized the earlier period, these reformers called for greater separation from the non-Quaker world and stricter adherence to Quaker doctrine.

In 1755 Philadelphia Yearly Meeting responded to the reformers' adamant convictions by appointing a committee to revise the *Book of Discipline* and by making provisions for its enforcement. The committee of fourteen included some of the most influential and avid of the reformers, such as John Churchman, Samuel Fothergill, and John Woolman. The new edition (amended in 1765) reflected their desire to uphold the testimonies outlined in the *Discipline* as a mechanism for reversing the spiritual decline they felt was overtaking the society. As stated, "Elders, overseers, and all others active in the discipline [are] to be zealously concerned for the cause of Truth and honestly to labour to repair the breaches too obvious in many places that there may be some well grounded hopes of the primitive beauty and purity of the Church may be restored."[68] Most important, the queries were revised and procedures regarding their administration were codified. Whereas the

queries were initially intended for self-introspection, the yearly meeting now required that they be periodically read in meetings *and* that written responses be submitted to the yearly meeting. Philadelphia Yearly Meeting later proclaimed:

It is agreed that the nine following queries be distinctly read, and deliberately considered, in each preparative and monthly meeting preceding each Quarterly Meeting at which time friends may have opportunity to make such observations as may tend to excite to vigilance and care in the diligent exercise of our Christian discipline, and promote an united labor for the good of the Church. . . . Full and explicit answer be given in writing to the first, second, and ninth of the said queries three times in the year; and once in the year, that is to say, at the Preparative, Monthly and Quarterly Meetings, next proceeding the Yearly Meeting, that the said nine queries be in like manner read and considered, and each of them particularly and distinctly answered in writing, in order to convey to the yearly meeting the most clear account of the state of the said meetings.[69]

The first and second queries concern maintaining regular attendance and "love and unity" respectively, while the ninth query urges members to "Take care to deal with all offenders in the spirit of meekness & wisdom *and without delay*" (italics mine). The yearly meeting also established a committee of both men and women Friends to inspect each meeting and ensure adherence to the *Discipline*. Thus, in addition to home visits, the yearly meeting encouraged elders and overseers to monitor carefully their members' behavior. Failure to comply could result in "disownment" or expulsion from the society.[70] Under the centralized influence of Philadelphia Yearly Meeting, upholding the discipline would thereafter play a more significant role in meeting business.

The strict intervention of Philadelphia Yearly Meeting was not something Friends were accustomed to, and there appears to have been some initial resistance. The clerk of Bucks Quarterly Meeting noted the introduction by Philadelphia Yearly Meeting of the revised *Discipline*, underlining parts of his minutes that now serves to gauge their response to the changes being imposed. According to his entry: "The Yearly Meeting extracts contain various queries what are to be prepared and answered to, which is now recommended to each monthly meeting with desires that an account of the use they have made of them may be made to our next quarterly meeting; & likewise its desired that they report to that part which directs the establishing monthly meeting of ministers & elders, & the appointement of solid women friends to sit with the meeting of ministers & elders."[71] But a year later the meetings in Bucks Quarter were still not in compliance with the new regula-

tions. As the quarterly minutes inform us, "The monthly meeting not hav-
ing given regular answers to the queries as directed, are advised to do so
for the future. The representative of other friends report that the appointe-
ment of monthly meeting of ministers & elders is generally done, & the
appointement of women elders is <u>under consideration.</u>"[72] Within a few
months, however, the minutes indicate that their monthly meetings had be-
gun to acquiesce. At the next quarterly meeting: "Falls [Meeting] reports that
women friends have apointed 3 to sit with the ministers & elders in their
meetings."[73]

Despite what some meetings may have viewed as an affront to their au-
tonomy, they eventually complied with the new rules governing discipline
and procedures. One only needs to examine the minutes of any given
monthly meeting to understand the significance of the diligent attention to
the *Discipline*. The increase in the number of Friends who were admonished
or disowned for offenses is striking. According to historian Jack Marietta, the
prosecutions of erring Friends in six of the largest monthly meetings in-
creased by 75 percent between 1755 and 1756. By 1760 the total number had
doubled and in some cases even tripled. By 1775, the society had disowned
22 percent of its members. Adding to the significance of these statistics is
the inconsequential number of cases appearing during the entire first half of
the century.[74] Looking back to Bucks Quarter, the compliance of this once-
resistant meeting to the revised *Discipline* can be measured by the rise in the
number of admonishments administered to its members. In 1757, the Buck-
ingham Preparative Meeting minutes record,

As in the previous year, Friends had much to do in maintaining their high excellence
in Christian discipline. So, too, this year their labors in looking after those who had
gone astray were not diminished but largely increased. Outgoings in marriage with
improper relations between young people were a common occurrence. The too free
use of strong drink had assumed proportions hitherto unknown and cases of brawls
and fightings were not uncommon . . . care and labor were required to bring the
erring one to a sense of their transgressions. While many were reclaimed not a few
were necessarily disowned.[75]

In addition to the increased administration of admonishments and dis-
ownments, there was an increase in the distributions by Philadelphia Yearly
Meeting of written advices. The advices were intended to draw Friends away
from the affairs of the larger society. Many were directed specifically toward
discouraging political involvement. The advices could, however, be more
generally applied to other aspects of daily life; in order to combat the exter-
nal societal pressures, a retreat into "Quietism" was prescribed. The term

refers to a state of consciousness conducive to divine insight, as in the Quaker approach to worship whereby they sat in silence, "quietly waiting upon the lord." Quietists argued for the submission of self-will before the will of God. The yearly meeting of 1770 urged its members to "seek after Quietude and stilness of Mind, in order that under the direction of true Wisdom, we may be enabled to administer advice to any of our Brethren who may be inadvertently drawn aside to join with or countenance . . . the Commotions prevailing."[76] Quietism was practiced by Friends of earlier generations, but it took on added meaning as it came to define an era rife with conflict, one in which Friends became more insular as a group. As another coping mechanism, Friends turned to the words of founding Friends for inspiration. The Meetings for Sufferings, a highly influential group sponsored by Philadelphia Yearly Meeting, compiled and distributed to each quarterly meeting the ground-breaking works of three influential Friends: William Penn, Robert Barclay, and Joseph Pike. The intent was clearly the reaffirmation of their values. The yearly meeting leaders asserted that within these three documents the Society of Friends "fundamental principles, doctrine, worship, ministry, and discipline are plainly declared."[77]

An important element of the reform movement was a strengthening of the marriage discipline. Among the offenses most frequently recorded within meeting minutes was "marrying out of meeting." Viewed as a threat to the purity of the society and thus to Friends values, marrying a non-Friend was officially declared grounds for disownment in 1762. Because marriage arrangements fell under the purview of the women's meeting, the 1762 enactment appears to have significantly elevated the importance of the role of women within the meeting. Certainly the new rules governing marriage had consequences for the individual meetings. Throughout Philadelphia Yearly Meeting, monthly meeting minutes reflect a substantial increase in the amount of time devoted to addressing violations of the 1762 enactment. The men's business meetings took greater interest in the women's proceedings as they initiated cases for review, and the men generally found more frequent occasion to address the women's meetings (particularly during yearly meetings).[78] A byproduct of the elevation in status of the women's business meeting was a programmatic change that centered on the treatment of the women's apartment. Instead of separating after worship per the pattern established by English Friends the men and women now sat to either side of a partition for worship *and* business meetings, merely lowering the partition for the latter meetings. This new arrangement necessitated the equally sized apartments for men and women that were the cornerstone of the doubled plan.

Some historians have suggested that it was the American Friends' staunch belief in the equality of the sexes that was responsible for the development of the doubled form. Englishman David Butler asserts that it stemmed from American Friends' "even-handed equality."[79] Butler's assertion was based on the fact that George Fox had advocated separate men's and women's business meetings, and although London Yearly Meeting promoted them as early as 1671, they were never universally adopted in England.[80] By contrast, Philadelphia Yearly Meeting established separate business meetings for men and women during the very first yearly meeting held in Burlington, New Jersey, in 1681.[81] It is also true that women—in England and America—played an equal role in the meeting for worship, serving as ministers, organizers, and decision-makers. On both sides of the Atlantic, however, they were generally excluded from financial issues, which were decided in the men's meeting for business. Instead, the women's meeting was confined to more socially based issues such as marriage and aid to the needy. Although somewhat of an equalizing force, the change in the American Friends program did not constitute a leveling of the roles played by men and women but probably reflected more pragmatic concerns. More than likely, if not a purely logistical decision, it was an outcome of the spiritual reform movement that regarded marriage within the society as crucial to its viability. After the revisions to the *Book of Discipline* in 1755 and the 1762 enactment against marriage outside the society, the women's business meeting now dealt with issues weighty enough to capture the full attention of their male counterparts. While the reform movement was responsible for codifying rules and procedures that helped balance the roles played by men and women, it also contributed to building standardization.

The Buckingham Model

Built in 1768, Buckingham Friends Meeting House is the earliest known example of the two-cell, symmetrically balanced or "doubled" meeting house that became a prototype for American Friends meeting houses for the succeeding century (Plate 15). The Buckingham type was unique in that the two sections, the men's and women's apartments, were treated as two equal parts of a whole structure.[82] Prior meeting house forms had usually consisted of either a three-bay building partitioned to create unequally sized apartments, or a telescoping form with distinct sections for men's and women's business meetings. About mid-century the development of a few new meeting house forms indicated that a synthesis of concepts leading to the creation of the

doubled type was taking place.[83] The telescoping form that developed from the addition of a smaller, generally two-bay section to the original three-bay meeting house evolved into a structure with a women's section that maintained that same roofline and general design of the original, like the Frankford, Birmingham, and Roaring Creek meeting houses in Pennsylvania. Another development was the five-bay, dual-entry structures erected at Maiden Creek (1759), Eavesham or Mt. Laurel (1760), and Hardwick (1763, no longer extant). Built as a single, symmetrically balanced unit, these meeting houses still included a larger meeting room with a smaller women's meeting apartment used to facilitate English meeting patterns. Again, the 1755 construction of the Great Meeting House in Philadelphia may also have helped fix the placement of the men's and women's apartments side-by-side. Exeter Meeting House, erected in Exeter, Pennsylvania, in 1758, was likely the only meeting house built as a two-cell structure containing equally sized apartments for men's and women's business meetings prior to Buckingham. Unlike Buckingham, however, the two sections varied in fenestration and were therefore treated as separate, dissimilar units.[84] The Buckingham prototype combined the new American meeting program with a construction based on the duplication of the original single-cell unit. It was the first in the Delaware Valley to truly achieve a *doubled* plan.

As news of Buckingham's attributes spread, building committees sent delegations to study its design and emulate its form in their own meeting houses. The first committee to record doing this was Chesterfield Meeting in Burlington County, New Jersey. Seeking models on which to base the design of their proposed meeting house, which was completed in 1773, they reported, "We have also considered of the size of the house and plan, and are of the opinion the Buckingham Meeting House is nearest to what we would recommend."[85] Chesterfield is likewise documented as having provided the model for the doubled-plan Burlington Meeting House of 1784. Beginning in 1789 with the construction of Wrightstown and Falls meeting houses, virtually every meeting house erected in Bucks Quarter adopted the Buckingham form. For example, when members of Buckingham Meeting living in nearby Solebury decided to build their own meeting house in 1805, the building committee recommended "erecting a house 63 feet long and 36 feet wide, on the model of the one at Buckingham."[86] While meeting houses such as Middletown (1793), Newtown (1817), Horsham (1803), Byberry (1808), and Gwynedd (1823) follow the Buckingham model, each meeting carefully modified the size and details of its meeting house to suit the needs, tastes, and budgets of its members. In the Concord and Western quarters, the doubled form appears mostly in a single-story building, as seen in meeting

houses such as Marlboro (1801), Chester (1829), Parkersville (1830), Lansdowne (1831), London Britain (1834), and Middletown (1835). In addition, a number of earlier single-cell meeting houses were made to conform to the new standard through the construction of additions that constituted a doubling of the original structure. This was done with meeting houses such as Abington (1787/1797), Hancock's Bridge (1756/1784), and Rancocas (1772/1830). Even Third Haven Meeting House in Easton, Maryland, said to be the oldest standing Friends meeting house in America, was altered in the 1790s to conform to the plan of the doubled prototype. News of Buckingham also made its way outside the Delaware Valley. In 1774, New York City's Queen Street Monthly Meeting sent a delegation to inspect Buckingham Meeting House. According to their minutes, "The committee appointed to superintend the building are requested to procure a plan of Buckingham Meeting House. Take a plan of it and inquire if there are any parts of it that can be made better."[87] Queen Street Meeting House is responsible for introducing the doubled form to New York, where it appears in numerous examples built thereafter.[88]

Conclusion

Social and political events of the mid- to late eighteenth century correlate closely with the development of a meeting house prototype. As Friends become more focused on upholding the *Book of Discipline*, conformity was seen as central to the continued survival of the society. The exponential rise in disownments between 1755 and 1775 bears witness to the stricter code of conduct, and stronger adherence to the rules of discipline, like submission to the will of God, was a dominant theme within Quaker writings of the period. As Frederick Tolles explains, the tenet of simplicity began as "a valid protest against the tendency of men and women in other religious traditions to substitute sensuous enjoyment from spiritual perception, to let the minds and spirits be distracted from religious truth by the pleasures of the ear, the eye, and the imagination." But as time went on, the simplicity testimony was "hardened into a dogma."[89] Likewise, by codifying the rules and procedures, the didacticism of the reformists may have helped facilitate uniformity in meeting house design and well as meeting practice. The disownment of dissenters clearly left Friends of the Delaware Valley with a much more homogeneous population, which eased the task of developing unity about meeting house design and construction. The standard form also may have provided a constant in the somewhat turbulent Quaker world of the late eighteenth and

early nineteenth centuries. But the doubled type was also significant in that it was uniquely American. In his comparison of Quaker meeting houses in England and America, David Butler notes that the American form in which "there is nothing to distinguish the men's side of the building from the women's" did not appear in England. As he concludes, "There is no doubt that this is the principal American contribution to the design of meeting houses."[90] And so in some ways, the development of the doubled form also signaled a coming-of-age for the American Friends whose building forms and meeting program no longer reflected the practices of London Yearly Meeting.

The spiritual reform movement and quietist outlook that contributed to a heightened sense of Quaker identity and separatism in the eighteenth century would eventually give way to philosophical differences that divided American Friends in the early nineteenth century. The schism between Hicksite and Orthodox factions that erupted within Philadelphia Yearly Meeting in 1827 continued to fracture the Society of Friends into the twentieth century. The decline in theological uniformity was mirrored in meeting house designs. By the latter part of the nineteenth century, as changes in Quaker practice began to manifest themselves in the plan and design of modern meeting houses, the doubled prototype fell out of popular use. Within existing structures, features once considered defining elements of the Friends meeting house, for example the facing benches and the partition, were dismantled. To minimize any hierarchy among members and introduce united business meetings, meeting house designs of the early to mid-twentieth century created by committees that now included women eliminated such features.

Despite changes in meeting house form over time, certain underlying principles have remained constant. Dictates such as simplicity, the desire to blend with the natural and built environments, and practices such as the communal nature of the design and construction process continue to guide the design of Delaware Valley Friends meeting houses up to the present day. Adherence to the tenet of simplicity also contributes to the vitality of earlier structures, allowing them to retain their outmoded style while being retrofitted for modern use. Many pristine early meeting houses even continue to be used despite a lack of plumbing or electricity and the dependence on a wood stove for heat. Perhaps for generations of contemporary and more "worldly" Friends, the earlier, seemingly rustic meeting house serves as a reminder of the virtues of the plain life.

Chapter 7

Eighteenth-Century Quaker Houses in the Delaware Valley and the Aesthetics of Practice

Bernard L. Herman

What can we say about a notion of a Quaker aesthetic based on the spatial organization and appearance of houses? This discussion should begin not with a recitation of the tenets of a spiritual doctrine but with the straightforward questions of how the houses of early eighteenth-century rural Quaker elites were spatially organized and why they took the shape they did. We might consider the aesthetics of the house as a reflection of the practices through which individuals place themselves in relationship to others and to the material world they occupy. Hence my use of aesthetics here departs from conventional definitions of what constitutes a philosophy of the beautiful and concentrates instead on the idea that aesthetics are a vital aspect in the practice of everyday life.[1] A Quaker aesthetic is not intrinsic to the physical appearance of objects but is grounded instead in the circumstances of individual and group expression and reception. It is situational, provisional, and selective. Thinking of aesthetics in this way deflects our attention away from the world of fashion that glosses the text of the house and toward concerns about the ways the physical and visual qualities of domestic space shape those relationships. With those questions in mind, we can turn our attention to the world of appearances and the rhetoric of architecture.

Discussions of the aesthetics of Quaker domestic architecture almost invariably begin from a flawed understanding of "plain." Working from a presumptive understanding of what constitutes plainness, historians of Quaker houses have promoted a problematic set of assertions regarding the character and meaning of Quaker dwellings. These arguments present at their very core the idea that, no matter how elaborate or how stylish a Quaker family's dwelling might be, it somehow projects an air of restraint.

Even the most insightful readings of a Quaker style that link buildings to the nonsectarian design traditions of English vernacular architecture often fall prey to this tendency to equate "Quaker" with "plain."[2] However, given the range of housing options in the early colonial period, the surviving dwellings of the Delaware Valley's well-to-do Quaker families were truly extraordinary mansions in their own day. In fact, there are numerous examples of Quaker-built dwellings that contain in a single room the total area of the average residence. Moreover, there is scant evidence for members of the Society of Friends being read out of meeting because their house was too grand. The close examination of eighteenth-century houses throughout the Delaware Valley suggests that reading plainness into these residences is a product of more modern interpretive needs and stereotypes, projecting late nineteenth-century values. Thus, we need to raise the question: plain—compared to what?[3]

Extant Quaker houses that date to the colonial period are characterized by their durability, monumentality, and elaboration. Two paths of inquiry present themselves. First, what are the architectural characteristics of houses associated with Quaker families? Is there a definable, visible, and distinguishing aesthetic at work in Quaker houses? If so, what are its characteristics? If not, where do these buildings fit in the larger regional context? Second, if houses provide settings for social and family life, are there elements in plans and finishes of Quaker dwellings that speak to either the practice or sensibility of faith? At odds with prevailing interpretations, the evidence of documented houses suggests that Quaker builders both drew on and shaped the broader architectural aesthetics of the region. In doing so, they rendered their architectural identity simultaneously public and private. The manner in which Quaker houses reflect the negotiation of those tensions is the subject of this essay.

The houses considered here follow a range of plans. Most common are dwellings consisting of one or two rooms on a floor, plus a kitchen wing. But few dwellings better exemplify the issues surrounding a Quaker architectural aesthetic than the Mary and Abel Nicholson house in Salem County, New Jersey (Figures 7.1, 7.2).[4] This house was never designed to be "plain"; it was intended openly to assert individual achievement and Quaker community prominence. As built in 1722, the Nicholson House contained three rooms on the main floor (Figure 7.3). The exterior of the house displays the date of its construction in a patterned brick gable consisting of interwoven diamonds (diapering) and the year laid with blue-gray glazed brick. Individual bricks on either side of the main doorway into the house are also inscribed with the date as well as family initials and the initials of Quaker neighbors. The

interior of the Nicholsons' mansion is furnished with heavily molded chimney pieces, paneled cupboards and closets, and plaster walls and ceilings. To truly understand the house in its Quaker and regional contexts, we need to examine it through the successive lenses of its plan, construction and exterior appearances, and its interior finishes.

Figure 7.1. Abel and Mary Nicholson house (1722), Elsinboro Township, Salem County, New Jersey. Photo: author.

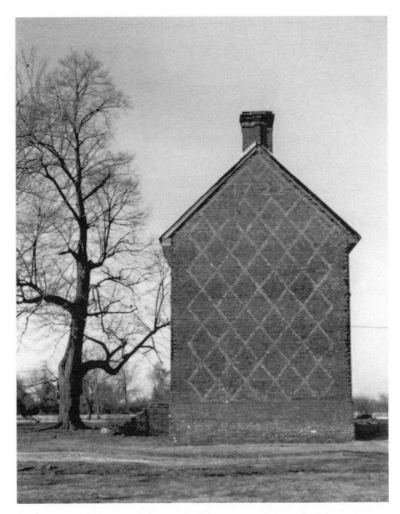

Figure 7.2. Dated gable, Abel and Mary Nicholson house. Photo: author.

A large hall or common room and adjoining parlor occupy the ground floor of the Nicholsons' two-story brick dwelling. Service functions were contained in an original single-story frame kitchen (demolished in the mid-nineteenth century) attached to the gable of the common room in the brick portion of the residence.[5] Entry into the house was gained either through a doorway into the largest room in the middle of the house or from the work-

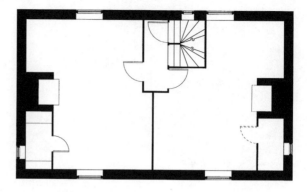

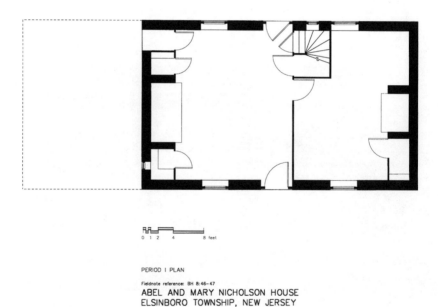

PERIOD I PLAN

Fieldnote reference: BH 8:46–47
ABEL AND MARY NICHOLSON HOUSE
ELSINBORO TOWNSHIP, NEW JERSEY

Figure 7.3. Abel and Mary Nicholson house, reconstructed first and second story plans. Drawing: Jeff Klee.

yard into the kitchen. The overall arrangement of ground floor spaces ran in a linear hierarchy: best downstairs chamber or inner room, large hall or common room, and kitchen. The individual rooms communicated their

relative status in a number of ways. The downstairs chamber, for example, is buffered by the common room from direct exterior access. Its chimney piece incorporates a double cornice in its design and it backs on the most elaborate patterned exterior wall. In contrast, the kitchen was erected in frame and was reached internally down a flight of stairs leading from a closet-like opening in the common room's paneled fireplace wall.

The most important space in the house and the room that yields a sense of the spatial dimensions of a Quaker aesthetic is the common room or hall (Figure 7.4). The largest room in the house, it was also the most public. It served as the crossroads between best chamber and kitchen. A stair in one corner provided access to the upper-story chambers and attic. Family and visitors alike reached this room by ascending a flight of stairs from the front garden; they then entered passing between the initials of Mary and Abel Nicholson and those of their neighbors, all "weighty" Friends.[6] The common room contained architectural features that enhanced its public functions. The paneled fireplace wall enframed a large open fireplace as well as a series of doorways that led variously to a writing closet, cupboard, and kitchen. The common room fireplace, despite its size, was not for cooking but provided instead a strong visual focus that underscored the room's social char-

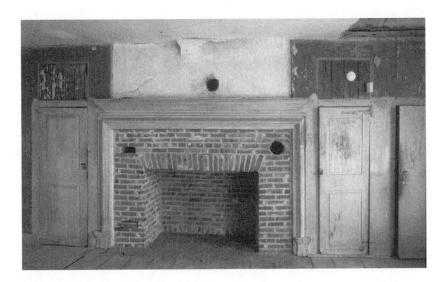

Figure 7.4. Abel and Mary Nicholson house, hall or common room interior. Photo: author.

acter. The polite nature of this room is evident in the heavily molded wooden fireplace trim run to the very edge of the firebox opening and the compound ogee molded mantel cornice with a groove cut in its upper surface for tilting plates against the overmantel. The writing closet to one side of the fireplace was illuminated by its own window and provided with a desk surface and bookshelves (Figure 7.5). With its door open, visitors could glimpse its interior and see the material culture and power of literacy displayed; with its door shut, the closet served as a sanctuary for study and as a private office for business. The pantry closet on the other side of the fireplace served for both the display and security of the family's wealth in plate and tableware. The third door connected this room to the kitchen, from which it could be served on both public and private occasions. The physical act of serving the table required those who worked in the kitchen to ascend to the common room. The essence of the Nicholsons' common room was its role as the theater for display and the performance of social and economic power. It was also a space that reinforced linkages between the elite Quaker houses of the early eighteenth-century Delaware Valley landscape.

With a few variations in the particulars of its internal arrangements, the Mary and Abel Nicholson house was one of a family of Quaker colonial mansions. The Wright family house (ca. 1726) on the outskirts of Salem, New Jersey, for example, consisted of three rooms on the ground floor but in a slightly different configuration (Figure 7.6). The Wrights' common room lacked a writing closet, but it possessed a cupboard for storage and display as well as access to kitchen, parlor, and the upper story. In size, the Wrights' roughly 18-by-20-foot common room was the same as that of the typical house at the end of the eighteenth century. The original configuration of the Quaker-built Ashton house (ca. 1705) in New Castle County, Delaware, and the Miller house (ca. 1730) in Chester County, Pennsylvania, both followed comparable three-room arrangements centered on a large common room with a massive fireplace and cupboards (Figures 7.7, 7.8). Even smaller early eighteenth-century two-room houses, often without clear evidence for a separate kitchen, were organized around the spatial aesthetic of a common room and all the social values it superintended.

As for many of the brick houses of southern New Jersey, the builders of the Nicholson house drew on a regional style of decorative brickwork that used glazed bricks to create patterns in the exterior walls of the dwelling. The most distinctive elements in both Quaker and non-Quaker New Jersey houses were their patterned gables combining dates and initials within geometric motifs including checkerwork, zigzags, and lozenges or diamonds. The Nicholsons used these decorative conventions and added to them by en-

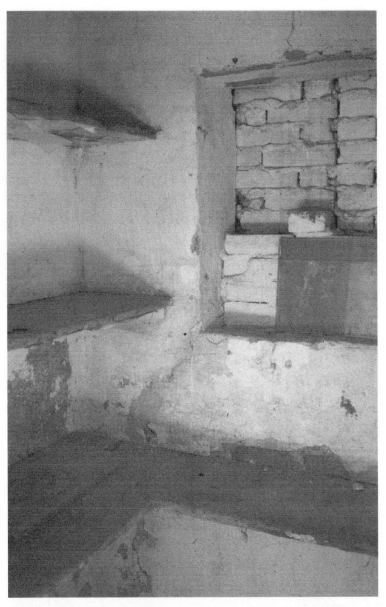

Figure 7.5. Abel and Mary Nicholson house, interior of ground floor closet with writing surface and bookshelves. Photo: author.

Figure 7.6. Wright house (ca. 1726), Salem, New Jersey. Photo: author.

Figure 7.7. Ashton house (ca. 1705), Port Penn vicinity, New Castle County, Delaware. Photo: author.

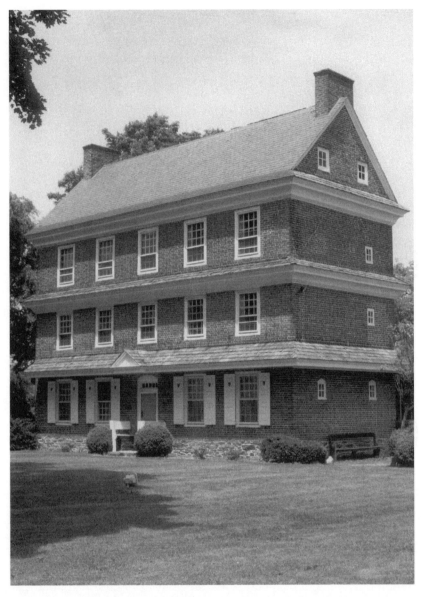

Figure 7.8. Miller house (1730, raised to three stories 1770), Avondale vicinity, Chester County, Pennsylvania. Photo: author.

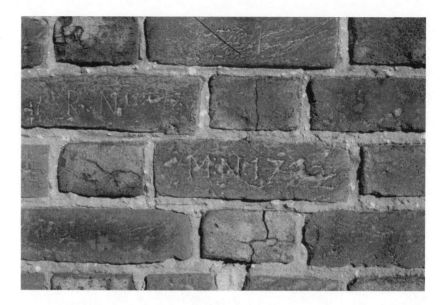

Figure 7.9. Abel and Mary Nicholson house, initialed bricks. Photo: author.

framing their doorway with bricks inscribed with the initials of many of their Quaker neighbors (Figure 7.9). The location of these individually initialed bricks on either side of the main entry into the house reinforced the importance of movement in and out of the house. Access from the front yard into the main room carried family members and visitors up a high stair to a porch and then across the threshold into the hall or common room, the most important space within the dwelling. Access into the Nicholsons' house thus required a literal act of elevation that brought individuals to a threshold. Stepping into the hall, they passed the initials of Salem County's Quaker elites, who symbolically bore witness to their entry. The presence of the date high in the gable recorded the Nicholsons' passage on the land; their initials and those of their friends and neighbors ritualized passage in and out of the most formal room of the house. Thus the aesthetic of these decorative elements documented the liminal moments of everyday Quaker life.[7]

A brick house in southern New Jersey in the 1720s was a notable visible assertion of wealth and permanence. An index to the visual scale and importance of the Nicholson house emerges from a 1798 tax assessment for neighboring Lower Alloway Creek Township, where a number of patterned brick

houses were erected in the early eighteenth century.[8] Over seventy-five years after the Nicholsons built their house, only 22 (12 percent) of the 183 listed residences were built of brick. While all but one of the brick houses stood one and a half or two full stories in height, fewer than half the log and frame dwellings possessed an upper story. Finally, on average, brick houses contained 50 percent more area on a floor. The Nicholsons' house, after three quarters of a century, still stood among the tallest, largest, and best built houses in the Salem County countryside. The incorporation of decorative brickwork rendered the visual importance of the house particularly public. Although the Nicholsons chose only to have the masons incorporate the date of their house high up in the gable end, within five years their neighbors opted for the inclusion of initials. Thus the builders of colonial Quaker mansions in southwestern New Jersey advertised the identities of their owners in worldly and public ways.

There is a celebration in these houses of a monumentality that is about family and faith. A key feature in the Nicholson house brickwork is the presence of the initials of both husband and wife. In later local houses, like the Hancock and Denn dwellings, the initials of husband and wife are placed high up in the gable in a composition where the surname initial is the peak of a triangle, with forename initials describing the base (Figure 7.10). The date underscores the initials. The surname initial roots family bloodlines in the earth itself. In this sense there is a consanguinal Quaker architectural aesthetic: it literally implants family bloodlines in the physical fabric of the landscape. Because the forename initials are those of husband and wife, they are companionate in nature and can be linked to Quaker doctrine expressed by George Fox: "For man and woman were helpsmeet . . . in the dominion before they fell; but after the Fall . . . the man was to rule over the wife. But the restoration by Christ . . . they are helpsmeet, man and woman, as they were before the Fall."[9] Thus the houses built by wealthy eighteenth-century Quaker families like the Nicholsons unabashedly assert both consanguinal and companionate relationships in a single gesture. In their monumentality, they exert familial claims that anticipate the first stirrings of local genealogical research in the mid-1800s.[10]

The Nicholson house and its contemporaries were not local anomalies limited to the marshy landscapes of southern New Jersey. Quaker families on the western shore of the Delaware River and Bay engaged similar strategies that proclaimed their stature in the public world. A handful of patterned brick gables with dated and initialed gables are recorded along the Delaware coast. More common, however, was the practice employed in the Piedmont of Delaware and southeastern Pennsylvania, where Quaker families erected

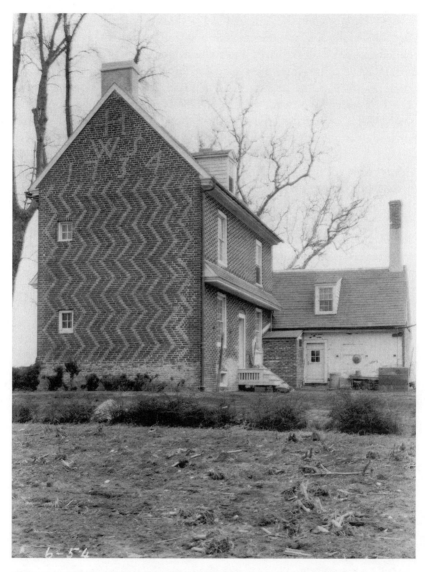

Figure 7.10. Hancock house (1737), Hancock's Bridge, Salem County, New Jersey, ca. 1885. Photo courtesy Historic American Buildings Survey, 1936.

houses of brick and stone and celebrated their presence in the landscape with date plaques set in the front elevations or up in the gable. The builders

of the much altered Cox house near Yorklyn, Delaware, included a plaque composed of rubbed and sculpted redbrick that depicted the initials of husband and wife, the date of 1725, and a small floral element within a recessed niche (Figure 7.11). Local builders later placed those signature elements within classically inspired rubbed brick surrounds. The message incorporated in the exterior surfaces of all these houses emphasizes several values: wealth, display, authority, and monumentality. That dates and initials were incorporated into the very fabric of these early Quaker houses renders those buildings personal in very specific ways. Family, faith, and house were literally rooted in the countryside. Even when the builders died and their mansions passed into the possession of children or the hands of other families, that first identity remained nearly indelible. If early Quakers were "plain," they were clearly not self-effacing.

The aesthetic that shaped the design and appearance of Quaker houses was as much about social status and the natural order of a hierarchical society as it was about family. Prosperity and rank were part of the natural order of society and their selective outward faces placed individuals in a hierarchical relationship to one another. Few dwellings make this point more directly than the William and Mary Pennell house (ca. 1735) in Middletown Township, Delaware County, Pennsylvania, which followed a very different interior arrangement than the Nicholson house (Figure 7.12). Two rooms deep and only one room wide, the dwelling placed a small formal room in the front and a larger, more private room to the back (Figure 7.13). A single-story kitchen, likely of log construction, abutted one gable.[11] What distinguished the house, though, was the architectural face the Pennells chose to present to the world. Built of brick laid in Flemish bond with glazed headers, the dwelling followed local precedent for the display of status. The families that commissioned these dwellings shared several characteristics as rural elites. They occupied the uppermost rungs of the economic ladder, tended to be engaged in extensive economic networks such as milling, and held local political office. The magnificence of their houses commanded the attention of both neighbors and strangers and provided a visual assertion of their owners' importance. In this context, the Pennells' house connected them to the larger visual culture of asserting claims to social and economic power through the medium of domestic architecture. The Pennells' use of finely rubbed brick arches above the ground floor door and windows, a molded brick watertable, lightly rubbed brick at the corners, and circular window openings in the gable were on the cutting edge of local architectural fashion. More dramatic was the full-length balcony that ran across the front of the building.

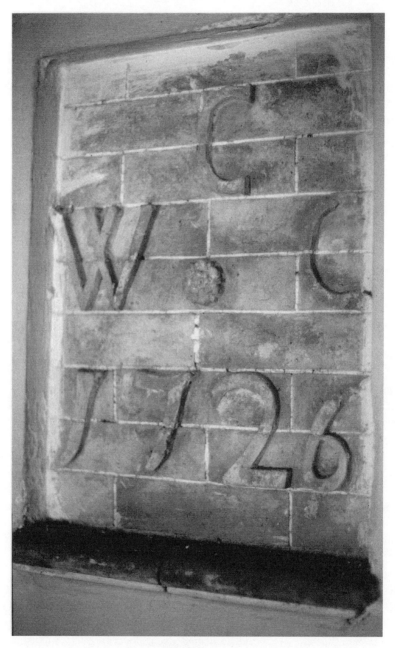

Figure 7.11. Cox house (1726), Yorklyn vicinity, New Castle County, Delaware, rubbed brick date plaque. Photo: author.

Figure 7.12. William and Mary Pennell house (ca. 1735), Media vicinity, Delaware County, Pennsylvania. Photo: author.

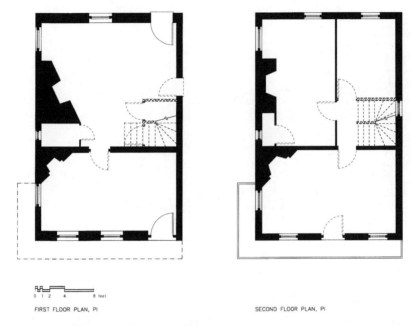

FIRST FLOOR PLAN, PI SECOND FLOOR PLAN, PI

Figure 7.13. William and Mary Pennell house, reconstructed first and second floor plans. Drawing: Jeff Klee.

What was the proper stance for Quaker comportment through the material culture of a larger secular society? The complex design sources for the Pennell house point to an answer. This design includes a fusion of contemporary regional architectural features associated with a landed rural elite as well as those more often linked to Philadelphia town houses.[12] The latter connection is especially apparent in the second-story parlor that opened onto the balcony and contained a glass-paneled chimney breast display cupboard. From the outset the Pennell house intended to communicate not only the wealth and worldliness of its Quaker owners. The obvious paradox that emerges from this reading is the reconciliation of worldliness with Quaker life.[13] The answer lies in part in our understanding that the issue for early eighteenth-century Quakers was not so much one of living in the world but one of how people properly lived in the world. In plan and appearance, the Pennell house was far from unique. The Kirkbride-Palmer house in Bucks County, Pennsylvania, for example, drew on a variation of the same plan and was erected in the same materials, though without a balcony.[14]

Like the Pennells, both the Kirkbrides and Palmers were prosperous Quaker members of high standing in their rural contexts. Other families, many non-Quakers among them, built their own interpretations of these houses in a variety of materials. In the case of the Churchman family (Presbyterians in southern Lancaster County), their house was raised in log, but even in that medium stood out from the great majority of its neighbors in the mid-1700s. What emerges in the Pennell, Palmer, and Churchman houses is an architectural practice that linked Quaker families to the larger landscape in a manner that visually asserted their economic and social authority within the framework of a larger Anglo-American regional culture. Where Quaker meeting houses created a collective visual identity around the outward expression of faith, Quaker dwelling houses remained steadfast expressions of individual and family attainment.

How Quaker families lived in these houses, however, is another matter, one described in the successive occupation and alteration of the Pusey family house in southern Chester County. The Pusey house underwent two major building episodes between 1720 and 1760. First, William and Elizabeth Pusey commissioned their house in the early 1720s. Their two-story stone dwelling contained two rooms on each of its principal floors and may have possessed a single-story kitchen wing. In plan the Pusey house was cut from the same broadcloth as the Abel and Mary Nicholson house. The primary interior space was the ground floor common room with its large fireplace. The adjacent parlor was smaller and contained a writing closet in a corner next to the fireplace. The use of stone, a durable material requiring considerable labor from quarry to construction, conveyed the same visual sense of monumentality. Although the Puseys appear not to have marked their house with date and initials, many of their Quaker neighbors did. The simple fact of a two-story masonry structure in the early colonial landscapes of southern Chester County and adjoining Delaware and Maryland, however, was enough to communicate its owners' wealth and rank. Like the Pennells, the Puseys were well-to-do local elites who owned a plantation and mill and held local political office.

The house erected by William and Elizabeth Pusey stood largely unaltered until their deaths in the 1730s. Their heirs, Joshua and Mary Pusey, took possession of the house in 1736 and by mid-century had enlarged the old dwelling dramatically with a two-story brick wing. The new wing, with its glazed header Flemish bond front, contained two rooms on the ground floor, an imposing front parlor and a smaller back chamber. Upstairs, the house followed the same plan but had no direct access between the front chamber and the garret behind it. The additions to the old house did not simply make

it larger, they rendered the dwelling more complex in its interior arrangements and more monumental in the way it occupied its setting.

Both generations of the Puseys left estate records that provide a sense of how these wealthy Quakers inhabited their rural mansions. William Pusey's 1731 inventory of personal property describes a house furnished with four beds, four tables, six chairs, and chest. In terms of consumer goods found in the average household in the lower Delaware Valley during the early colonial period, William Pusey's house stood well above the mean, firmly ensconced in the top 10 percent of inventoried estates. The fact of an inventoried estate was in itself a mark of wealth in a landscape where a great majority of individuals owned no real estate and few consumer items beyond what they could carry. Only the wealthiest inhabitants of the countryside owned the constellation of objects found in the Pusey dwelling. While the Pusey house and its contents were far from luxurious by standards that would emerge as early as the mid-eighteenth century, it nonetheless conveyed a powerful visual message about the status and wealth of its occupants.[15]

Thirty years later a second delegation of inventory takers visited the enlarged house to record the possessions of Joshua Pusey. Their record specified not only the contents of the house but also the rooms in which objects were located. The most significant room in Joshua and Mary Pusey's house was the "Front room" in the new brick addition. A large oval table, rush bottom "couch and couch bed," numerous chairs, tea table, and looking-glass furnished the room. An array of tableware including sets of Delft plates and serving dishes, china teacups and saucers, and silver tea utensils further defined the space as a place where the behaviors of polite sociability and gentility were displayed and enacted.

The brick addition clearly transformed the character of the two ground floor rooms in the old house. Here the inventory takers identified the old parlor or inner room as "his Desk room in old house," a reference to both its new use and diminished status. Joshua and Mary Pusey had remodeled the old writing closet into a cupboard for storing linens and other household objects. The closet's original function was now contained in an old desk, an article of furniture that lends the room the character of an office where Pusey could manage the business of the family mill across the road. The presence of an old bed in this room possibly suggests a temporary accommodation for Joshua Pusey's failing health, but it is also an item commonly associated with old ideas of the parlor.[16]

Finally, the old common, the most prominent room in the house erected by William and Elizabeth Pusey, appears to have been relegated to the status of an everyday domestic work space and family dining room. Almost

everything in this room was old, including "two old square tables," "6 old fraime Chairs," and "his old Clock," and possibly represented William and Elizabeth Pusey's furnishing scheme for the room. Clearly the social importance of this room had declined and the impact of its furnishings diminished with age and changing fashions.

In terms of a Quaker aesthetic, both generations of the Pusey family designed and enlarged the house and furnished and refurnished it in the context of the material culture of worldliness. William and Elizabeth Pusey's common room in the 1720s and subsequently Joshua and Mary Pusey's parlor in the 1750s engaged a conversation with the world. A central factor in this transgenerational conversation, however, is the distinction between worldliness and living in the world. Both generations of the family used the house and its furnishings to announce their status to the world. Their dwelling was monumental in a rural landscape largely populated by much smaller wood and log houses. When, for example, Isaac and Margaret Sharp erected their log house nearby in 1782, they built at a much more modest level (Figure 7.14). The carpenters left the logs unhewn in the roughly 17-by-22-foot dwelling with the result that both the interior and exterior surfaces presented an almost corrugated appearance. Later coats of plaster applied on the interior did nothing to relieve the undulant aspect of the walls. With the largest of the five ground-floor windows measuring less than eighteen inches square, the interior was poorly lit and ventilated. The kinds of furnishings found in the Pusey house would have fallen well beyond the means of Isaac and Margaret Sharp, who, as property owners, ranked among the well-to-do. In 1802 tax assessors valued their house at $30, well above the township low of $15 and significantly below the high of $75. The Puseys' furnishings resonated with the fashionable behaviors of eighteenth-century sociability such as tea drinking and formal dining. In the sphere of the everyday, succeeding generations of the Pusey family deployed their wealth toward the acquisition and display of objects that demonstrated their social and economic stature. The material life of the Sharps reflected a very different reality. Even after the house had been dramatically enlarged in the early 1800s, the Sharps' possessions remained largely utilitarian in nature.[17]

To read these objects in their most literal sense, however, misses the fact that the meanings invested in objects are neither fixed nor singular. The artifact of the Puseys' mansion house was the tangible sign that communicated their wealth and status within the community. The same artifact signaled to their fellow Quakers that they knew how to live in the world without falling prey to worldliness. The evidence of their ability to negotiate these two contexts is not visible in the material world; it is reflected instead in their con-

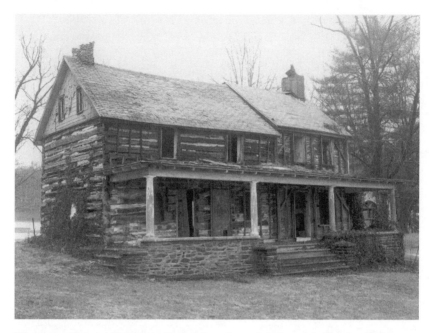

Figure 7.14. Isaac and Margaret Sharp house (ca. 1782), Avondale vicinity, Chester County, Pennsylvania. Photo: author.

tinuing prominence in Quaker meeting. In this sense, their house and its contents (as well as those of the Nicholsons, Pennells, and other wealthy Friends) were didactic conversations about the practice of living in the world. Their aesthetic merit lay in the tension between outward show and the ways in which these houses were lived. The measure of their success was their continued prominence within the Quaker spiritual community.

The Pusey house was not without its peers in the Quaker countryside of the lower Delaware Valley. The Woodward and Pennock families in nearby London Grove, Pennsylvania, for example, followed a similar course of action through the eighteenth century.[18] The house begun by the Woodwards in the early eighteenth century as a two-story dwelling contained a single room on the ground floor but was soon enlarged with a separate one-story kitchen. In the early 1760s the house was enlarged again with a two-story brick wing that contained a broad stair hall and two parlors heated with corner fireplaces. The addition transformed the house from an older arrangement where the principal room in the house was entered directly from the

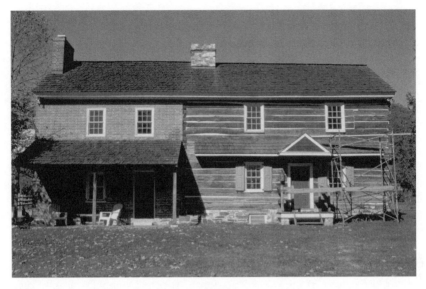

Figure 7.15. Todd house (early eighteenth century with additions), New London vicinity, Chester County, Pennsylvania. Photo: author.

outside into a configuration that created spatial divisions. In each iteration, the house kept pace with fashion without asserting a "peculiar" Quaker vernacular.

The Todd house near London Grove passed through a similar set of alterations (Figure 7.15).[19] Begun as a log dwelling with a single chimney in one gable, the house went through at least four major building episodes. First, the house received a separate kitchen adjacent to the old hall. At the same time, it appears as if the owners erected a second chimney designed to heat the rooms in the parlor end of the dwelling. A third construction project at the close of the eighteenth century resulted in a two-story brick wing that contained a new dining room and filled in the space between the old kitchen and original house. At roughly the same time, the owners demolished the parlor chimney and built a new one incorporating a corner fireplace. Finally, they replaced the old kitchen in the mid-1800s with a new one that included a bake oven, built-in kettle stands, and a cooking fireplace.

The efforts of the Pennock and Todd families and their neighbors, Quaker and non-Quaker alike, also increased the number of rooms within the house and embraced an emerging culture of privacy as well as sociability

and a new sense of utility in terms of the location of service rooms like kitchens. A series of changes in the Pennock house, completed at the turn of the nineteenth century with the construction of a two-story brick fronted wing, transformed the house into a four-bay, center-entry mansion. The completed house now incorporated a back kitchen and a front family parlor or dining room. Like the Puseys a generation earlier, the Pennock family created not only more, but also more specialized spaces within their dwelling. More significant, though, is the fact that there was also nothing particularly Quaker about the changes they made. Houses enlarged to contain more rooms and more specialized and private spaces were common currency in the rural landscapes of the lower Delaware Valley.[20]

The same observation holds true for smaller, vernacular houses in the English countryside. In English counties where nonconformist groups, including Quakers, were legion from the late seventeenth through the mid-eighteenth centuries, there appears to be no area of architectural design that distinguishes Quaker dwellings from those of their neighbors. What does occur in the course of the transplantation of British ideas about house form and ornament from the Old World to the America's Delaware Valley, however, is what might be described as the perfection of the yeoman's house. The internal organization and appearance of these houses reflect English regional practice, but the level and quality of finish within the American dwellings are generally much higher than what are found in their English cousins.

Houses of the sort erected by families like the Nicholsons and their contemporaries can be found in English source areas for the out migration of Quakers to the American colonies—but with three key provisos. First, the English parallels seem to have been relatively uncommon. Houses similar in plan have been recorded in Northamptonshire, Gloucestershire, and elsewhere, but their numbers appear small in the context of the larger array of plan options exercised by English builders.[21] Second, these houses are often associated with a decline in localized vernacular building practices and a rise in a broader-based architecture for the middling sort. In Aynho, Northamptonshire, a strongly Quaker community from which a number of Quakers emigrated to the Delaware Valley, houses reflecting the range of those documented in the colonies were seen as unpretentious and of the "middling sort." The better houses consisted of two rooms on a floor with a hall where the bulk of day-to-day activity took place and a parlor or ground floor chamber.[22] Moreover, these houses were indistinguishable in plan and construction from comparable houses erected and occupied by their non-Quaker neighbors. Third, the American "interpretations" of these middling houses, as a rule, tended to be more elaborate in terms of interior finishes and the number of heated rooms

they contained. In this regard, the houses of Anglo-American Quakers in the Delaware Valley are comparable to those of their Pennsylvania German contemporaries. In Pennsylvania, Germans of the "middling sort" adopted an apparently little favored three-room Continental plan and perfected it in the context of the middle Atlantic landscape to the point that it is often held as the quintessential Pennsylvania-German house form.[23]

Significantly, the development of English provincial houses comparable to those found in the best colonial Delaware Valley houses dates to the latter half of the seventeenth century. Houses like Upper Hempton Farm in Almondsbury, Avon, and the Old Malthouse in Tadmarton, Oxfordshire, may look different from their Delaware Valley cousins, but they share common features.[24] Most notable among the architectural features that define these houses are clearly articulated spaces for formal display and service. The best houses of English settlers in the Delaware Valley echoed these developments in dwellings of the English yeomanry, and well-to-do Delaware Valley Quaker families like the Nicholsons, Pennells, and Puseys eagerly embraced that image and built accordingly. Their architectural choices bound them to a larger material culture that had little to do with their Quaker identities.

What are the sources for assertions of a Quaker plain style expressed in the design and appearance of houses? Part of the answer lies in the desire by later chroniclers to make Quaker identity visible in all things they made, acquired, and used. Because houses are at once the most public and private of possessions, they become a prime repository for asserted identities. Essentially, we retrospectively read identity into the object. In fact, as studies of dress and meeting houses suggest, the expression of Quaker identity was selective. Clothing and speech, two measures of the person, were material genres through which Quakers made themselves visible as individuals. The assertion of a broadly expressed Quaker material culture also derives from romanticized nineteenth-century perspectives on the American past. Houses provide convenient touchstones for the creation of historicized mythologies. The necessity for those myths stemmed directly from a collective nineteenth-century need to celebrate all aspects of early American life that expressed distinctiveness and exceptionalism. The material fact of eighteenth-century Quaker houses, however, describes a different past. Early American Quakers exploited Anglo-American building traditions to impose their continuing presence on the landscape. A doctrinal emphasis on frugality and temperance may have assisted in the effort to amass the means to build these houses. In the end, however, it was the Quaker dogma of family and community that made houses like the Nicholsons' mansion necessary, enduring, monumental.

Chapter 8

Edward Hicks: Quaker Artist and Minister

Carolyn J. Weekley

The name Edward Hicks usually conjures up his painted images of domestic and wild animals huddled peacefully together in a sunny, verdant landscape. Words such as "delightful" and "charming" are often used to describe these pictures, since most of the sixty-two known versions of Hicks's *Peaceable Kingdom* are colorful, engaging, and apparently innocent. There is a naive and romantic notion that these paintings reflect an earlier time when life in America was simpler and tranquility was experienced with some regularity.

Perhaps because of the popular interpretation of his *Kingdom* pictures Hicks also has been characterized as a simple, honest man working quietly at his trade in rural Bucks County, Pennsylvania. Ironically, these notions of the artist and his art have ignored the real intent of the *Kingdom* and related pictures and diminished our understanding of Hicks's important role in the Religious Society of Friends. The story of his life, his skill as a painter, and his ability to balance and reconcile his art with his religion is richly complex and sometimes marked by contradiction.

Edward Hicks (Figure 8.1) was born in Attleborough, Bucks County, Pennsylvania, on April 4, 1780. His parents, Isaac and Catharine Hicks, were second cousins. It was the artist's grandparents, Gilbert Hicks and Mary Rodman Hicks of Long Island, who first settled in the area of Bucks County where the artist was born. Catharine Hicks was, according to her son Edward, an Episcopalian; his father and grandfather also attended the Anglican Church. Gilbert Hicks and the artist's parents were all well educated, accustomed to well-appointed residences, the services of slaves, and other material and social comforts associated with wealth. Both Gilbert and Isaac served in public offices and were often addressed as "Squire." By the 1780s Gilbert had been appointed to the office of Chief Justice of the Court of Common Pleas.

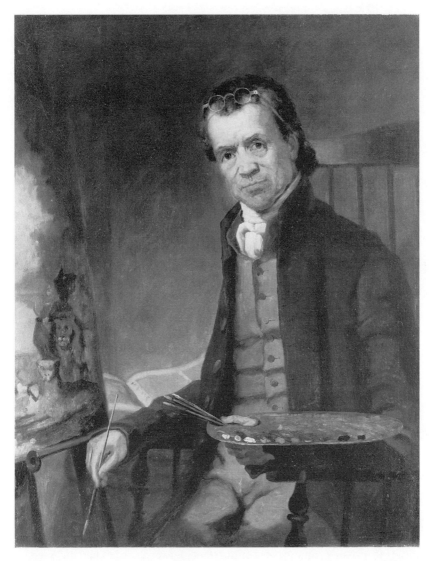

Figure 8.1. Thomas Hicks, *Edward Hicks,* 1839–41, oil on canvas, 27″ x 22⅛″. Abby Aldrich Rockefeller Folk Art Museum, Colonial Williamsburg Foundation.

At the time of Edward's birth his family's fortune had been considerably reduced due to the "tremendous turnings and overturnings that took place at the time of the Revolution."[1] Edward later wrote that these events "pro-

duced a great change in my mother's family, and the success of the American patriots, in laying the foundation of the present excellent government, deprived the royal aristocrats of their lucrative offices, reducing our family to comparative poverty."[2] The family's poverty resulted from the public work of Gilbert Hicks, who continued his "attachment to his royal master, in opposition to the American patriots, whom he imprudently insulted, he was driven from his home, his country, and property . . . becoming exiled in a foreign land [Nova Scotia, where he died, probably in late 1786] . . . his property being all confiscated, and his family was reduced to indigence."[3]

It was sometime during 1780 or early 1781 that Edward's mother, "Kitty" Hicks, being without a permanent residence in Newtown, moved with her four children to her parents' home in Burlington, New Jersey. Several months later, on October 19, 1781, Kitty died, "leaving her poor little feeble infant [Edward] under the care of her colored woman, Jane, who had been a slave in the family."[4] Jane apparently returned to Newtown with Edward in the ensuing months and continued in the service of Isaac Hicks by caring for his young son and siblings. These were difficult days for the Newtown Hicks family since Isaac could not keep the family together and eventually boarded most of the children with neighbors and friends. Edward went to live with David and Elizabeth Twining, wealthy Quaker farmers living in Bucks County. The Twining farm (Plate 16) became Edward's childhood home. He would fondly remember and write about various members of the family throughout his lifetime, especially Elizabeth, and their daughter Beulah.[5] It was at Twining farm that Edward was first exposed to Quaker religious life, although he would not join a meeting until spring 1803.

Edward continued to live with the Twinings "under the care of my adopted mother, as a boarder, until I was turned of thirteen; when my father finding himself disappointed in his prospect of making a great man out of a weak little boy, by scholastic learning or education, and did the best thing that he could have done, by binding me out an apprentice to an industrious mechanic."[6] Thus, in 1793 Edward went to live with the coach-maker William Tomlinson and his wife, Rachel, at Four-Lanes-End (now Langhorne). In addition to learning some aspects of the trade, Edward's father had included, as a condition of the indenture contract, one year's schooling for Edward to learn reading, ciphering, and math.

The "weak little boy" undoubtedly gained a general knowledge of all the various skills required for coach and carriage making during his ten years in the Tomlinson shop. This would have included carpentry, several sorts of metal smithing, leather and harness work, and especially painting. Coach and carriage painting was an important part of ornamental painting during

these and previous decades. There were few published manuals on the subject and no American versions of British treatises until much later in the nineteenth century. Edward learned his skills from the masters and journeymen working in the Tomlinson shop.

Later in his life, Edward may have read the essays on ornamental painting published by Rufus Porter in his *Scientific American*. They chronicle all the sorts of work Edward learned and practiced throughout his career, including ciphering, signboard painting, gilding, imitation (meaning faux wood and stone finishes), lining, heraldry, ornamenting furniture, fire buckets and banners, and even landscape and flower painting. In nineteenth-century America some ornamental painters also advertised portraiture, watercolor views, and copies of existing paintings. Others advertised as portraits artists while also having to do ornamental painting in order to make a living.[7]

Extant works by Edward Hicks include decorated furniture with lining, gilding, signboards (Plate 17), banners, landscapes, drawings, ornamented boxes, ciphering, and lettering. We know from his sole surviving account book that Edward also painted floor cloths, fire buckets, cornice boards, and gilded weathervanes, provided faux painting on interior building trim, decorated fireboards, and provided all sorts of ornamental work for coaches and carriages. These types of painting may be classified as shop work since Edward's easel art—the *Kingdom* pictures, farmscapes, historical pictures, and pastoral scenes—were more personal in nature and created by him outside of the shop business. With the exception of his earliest years of business, when several "landscape" pictures are listed, there are no other references in his accounts to the easel pictures.[8] There are several reasons why these references do not appear, including the fact that Edward created many of the *Kingdom* and other pictures as gifts for family and friends, many of whom were Hicksite Quakers who frowned on such frivolous things.[9]

Important components of Edward's training would have been laying out compositions, drawing human and animal figures, and some generic landscape elements. Even at this early date it is likely that Edward copied or improvised many of these from prints, common source material for most ornamental painters and some studio artists of the period. A quick survey of Edward's easel art and some of his signboards indicates that he relied heavily on prints for inspiration, often combining elements from several prints in a single composition of his own contrivance. He also is known to have radically modified some print elements to suit his particular compositional needs.

The Tomlinsons would have instructed Edward in mixing and grinding pigments, driers, binders, and varnishes. At the end of his apprenticeship he

would have been adept at color matching, selecting appropriate color combinations to create certain effects for signboards, carriage panels, and similar objects. In sum, the trade of ornamental painting required considerable practice and involved mastering a number of specialized procedures and techniques.

Once his apprenticeship was complete, Edward worked from 1800 to 1801 in at least two journeyman positions—with the Tomlinson firm until probably mid-1801 and for Joshua C. Canby of Milford from 1801 until spring 1811. These were formative, critical years for Edward in both his domestic and religious life. In 1800 Edward met John Comly and James Walton, young Quakers from the Byberry area of Bucks County. Comly was a gifted speaker and scholar as well as a gentle man whom Edward considered exemplary in his plain dress and manner. Comly became a lifelong friend and supporter of the artist, helping him through some of his worst financial and spiritual difficulties. It was likely Comly, and perhaps Walton, who encouraged Edward to attend Quaker meeting.

Edward professed great misgivings about the youthful frolics in which he was a participant during his apprenticeship years and just after he left the Tomlinson shop. Even before he met Comly and Walton, Edward had considered joining meeting, although that seemed unlikely to some of the artist's colleagues. Edward recalled telling one acquaintance that "if I should think myself fit, I should join the Quakers. He [Edward's friend] expressed his astonishment that a young man of my turn would think of joining so simple and lifeless a people, and if it ever took place he should think that miracles had not ceased."[10]

In 1800 and continuing into 1801, Edward began to attend Quaker meetings regularly. He continued this when he moved to Milford, walking the two and one-half miles to Middletown Meeting every week. In 1803 he applied for admission to this meeting and was received into membership.[11] There was another reason Edward was attracted to Middletown Meeting: his future wife, Sarah Worstall of Newtown, was a member. Edward and Sarah married on November 17, 1803.[12]

By 1809 Edward had become more deeply involved in religious work and was clearly beginning to make plans to move his family and open his own business. In 1811 he was recommended and appointed a minister by Middletown Meeting. The meeting also appointed him to treat with several persons, including members of his employer's family, for trafficking liquor. It is not surprising that Edward's chastisement angered the Canbys and the Hulmes, who were in-laws. The encounters caused the artist to reflect many years later that during the early 1800s he had become a "great talker, and

a great fault finder." The incident clearly contributed to Edward's need to relocate.

Newtown was an obvious choice because Sarah Worstall Hicks's family lived in this area, the Twinings were nearby, and Edward's father also lived in the town, though father and son were somewhat estranged. In 1811 the painter and his growing family moved into the house he had purchased from Dr. Abraham Chapman, a Newtown lawyer who became an ardent supporter and admirer of Edward's easel paintings. It was soon after this that Edward opened and advertised his own business as an ornamental painter. According to Edward, Newtown in 1811 contained "not more than about four or five families of Friends . . . no meeting of Friends nor hardly such a thing thought of. No coach-making and very little mechanical business of any kind, for the people of the place seemed principally to depend upon the courts and the spoils of litigious contention . . . and principal men of the place . . . were mostly *free masons*, among whom religion and morals were at a very low ebb."[13] Thus much of Edward's first business came from sources outside Newtown, including a large quantity of coach painting from his former employer Joshua C. Canby and other carriage and coach makers in the area. Within two years Edward's repertoire of work had greatly expanded as had the number of his clients. Edward's surviving accounts attest to the broad range of work performed, typically that associated with ornamental painting.

It was likely his most elaborate signboards (Plate 17) displayed publicly on area businesses, and probably the landscape pictures like those for Drs. Chapman and Phineas Jenks, that caused the first concerns (Figure 8.2). The nature of these pieces brought open criticism from fellow Quakers. Some considered his work too elaborate and ostentatious, in conflict with Quaker codes of simplicity, plainness, and usefulness. Edward's growing role as a popular gospel minister made the situation urgent in the minds of some Quakers. Edward traveled widely to attend and address other meetings; his reputation as a gifted speaker was increasing, even in areas as remote as rural Indiana and Ohio. The situation posed very serious problems for Edward since much of the income he needed to support his family came from his most elaborate painting commissions. The "plain" utilitarian painting preferred by his critics was the least lucrative means of earning money, and he had incurred several debts through high-interest loans. For the artist and his family, the issues were not easily resolved. Throughout his life Edward worried and occasionally wrote about the matter. In explaining the reasons for his "pecuniary embarrassments" the painter gave this explanation in one section of his *Memoirs*:

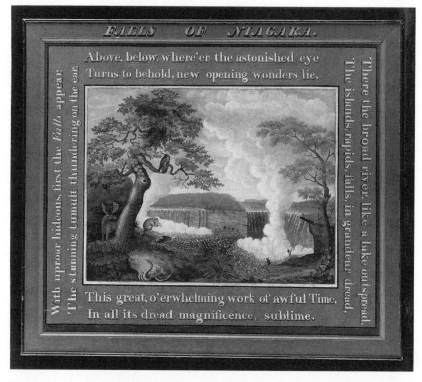

Figure 8.2. Edward Hicks, *The Falls of Niagara*, 1825, oil on wood, 22" x 30⅛". Abby Aldrich Rockefeller Folk Art Museum, Colonial Williamsburg Foundation.

In addition to a constitutional weakness, I quit the only business I understood, and for which I had a capacity, viz. painting, for the business of a farmer, which I did not understand, and for which I had no qualifications whatsoever. I verily thought then, and still think, farming more consistent with the Christian, and was willing to sacrifice all my fondness for painting. But it would not do, for notwithstanding I worked hard, I went behind hand daily. The cruel moth of usury was eating up my outward garment, soon to expose me a poor naked bankrupt; for my father, who I thought had given me forty acres of land in the vicinity of the village, altered his mind and took it from me, leaving me with only twenty acres, for which I had given eighty-six dollars per acre at public sale, and which I had to sell for forty dollars.[14]

The artist continued, explaining his opinion of "fine painting":

If the Christian world was in the real spirit of Christ, I do not believe there would be such a thing as a fine painter in christendom. It appears clearly to me to be one of those trifling, insignificant arts, which has never been of any substantial advantage to mankind. But as the inseparable companion of voluptuousness and pride, it has presaged the downfall of empires and kingdoms; and in my view stands now enrolled among the premonitory symptoms of the rapid decline of the American Republic.

These are strong words from one who freely admitted that he enjoyed painting, suggesting that throughout his lifetime Edward endured continuing guilt for the work he loved and performed so well. Other passages of his writings reinforce this notion. He claimed that there had been

formidable obstacles to the attainment of that truly desirable character, a consistent and exemplary member of the Religious Society of Friends, one of which is an excessive fondness for painting, a trade to which I was brought up, being connected with coach making, and followed the greatest part of my life; having been unsuccessful in every attempt to make an honest and honorable living by a more consistent business; and now in the decline of life, near my seventieth year, with a body reduced to a mere skeleton, racked by a tremendous cough, with scarcely breath and strength at times to breathe or walk, I should be a burthen on my family or friends were it not for my knowledge of painting, by which I am still enabled to minister to my own necessities and them that are with me, through the kind patronage of a few noble, generous Friends, and friendly people, who, in my case, practically answer that query in our Christian Discipline, "Are poor Friends' necessities duly inspected, and are they relieved and assisted in such business as they are capable of?"[15]

Edward managed to live with this tension—a need to earn income from his skilled profession of ornamental painter while also maintaining an exemplary role as a Quaker minister—because he believed that ornamental painting could be rationalized and justified as a useful profession:

But there is something of importance in the example of the primitive Christians and primitive Quakers, to mind their callings or business, and work with their own hands at such business as they are capable of, avoiding idleness and fanaticism. Had I my time to go over again I think I would take the advise given me by my old friend Abraham Chapman, a shrewd, sensible lawyer that lived with me about the time I was quitting painting; "Edward, thee has now the source of independence within thyself, in thy peculiar talent for painting. Keep to it, within the bounds of innocence and usefulness, and thee can always be comfortable." The apostle Paul exhorted the primitive believers to content with their outward situation, even if they were slaves, and the primitive Quakers seemed to manifest the same spirit. As to the calling or business by which they got their living, Thomas Elwood informs us a particular

friend of his was a barber, and followed dressing noblemen's heads. And from my own observations and experience, I am rather disposed to believe that too many of those conscientious difficulties about our outward calling or business that we have learned as a trade to get our living by, which are in themselves honest and innocent, have originated more in fanaticism than the law of the spirit of life in Christ Jesus.[16]

Edward quit the painting business in 1815, although it is not known whether he gave up only the elaborate work or all categories, including plain painting that would have been acceptable according to Quaker standards. Relinquishing the fancy painting business was a terrible decision for several reasons. Edward was physically weak and had suffered chronic respiratory illnesses since childhood. Farming required sustained hard labor that the artist could not endure. Also, his financial situation was very serious. He was unable to reduce any of the principal of his debts and was barely keeping up with the interest payments. Finally, his gospel ministry, to which he was deeply devoted, took him away from home and his shop or farming for long periods of time. These things combined to make Edward's alternate career of farming a complete failure.

Edward did not close the shop while he was farming but turned the business over to Thomas Goslin, who advertised coach, sign, and house painting in Newtown's *Herald of Liberty* beginning in April 1815. Interestingly, Goslin did not mention a broad menu of ornamental painting, a curious absence. It is unclear whether such work was no longer offered, simply not advertised because Edward, the owner of the shop, could still be held accountable for its production, or because there was no painter in the shop who could provide such variety. When Edward returned to the business as an ornamental painter in 1817, he and Goslin were both named in their advertisements, suggesting that Edward made him a partner.

Were it not for John Comly, it is unlikely that Edward could have reduced his debts, although Comly was a strong opponent of Edward's ornamental painting. It was Comly, assisted by James Walton, who wrote to several of Edward's wealthy relatives for financial assistance. Some of Comly's observations about Edward are especially helpful in understanding how he, the artist, and probably other Bucks County Quakers felt about ornamental and easel painting:

It appears that from the time he gave up to the heavenly vision, and joined in fellowship with Friends—he felt convictions in his mind on the subject of ornamental painting—These scruples he sometimes attended to—but not so fully as he believes he ought to have done, tho for some years past, he declined to indulge what is called a native genius for such paintings,—a genius, and taste for imitation, which if the Di-

vine law had not prohibited, might have rivaled Peale or West—but as the indulgence of it, appeared to him, to feed a vain mind, and promote superfluity—and having a testimony given him to bear in favour of Christian simplicity, he clearly saw the contradiction and inconsistency of such a calling . . . Thou wilt wonder to think that with such impressions . . . [what] should induce such a man as Edward to return again with eagerness and such application so often keeps him up till near twelve o clock at night painting pictures—and to make the thing more glaring has advertised in the Bucks county papers.[17]

Hicks's controversial advertisement appeared several times in late spring 1817 and mentioned "Coach, Sign, and Ornamental Painting, of all descriptions, in the neatest and handsomest manner." The ornamental work "of all descriptions" was of great concern to Comly since it was nonspecific and all-encompassing. In another letter to Isaac Hicks, Comly reported that he and James Walton had attempted to convince Edward that his advertisements promoted work viewed as inappropriate by Quakers. The following passage describes the result of that meeting:

By farming he cannot support his family and pay his interest, and he dreads the idea of failing so as that his creditors shall lose and the cause of Truth suffer by him, he has resorted to the forbidden tree, to retrieve himself, and appears as he thinks under a necessity to make money, even at the expense of his own peace—His plans are to pursue this very lucrative branch of his business, for a time, hoping to clear $1200 a year by it—a delusive dream!! And then when his debts are paid quit it.[18]

Several months later, in October 1817, Comly wrote again to Isaac Hicks about Edward's plans and financial situation: "Whether this will be effected is yet to prove. . . . Were he to dispose of his house and lot on which he resides—and continue farming and plain painting. I think there is a rational prospect of his being able to hold the rest."[19] But Comly did not believe this scenario would occur since he was well aware of Edward's stubbornness and inability to consider any other solution to financial gain except ornamental painting. The final lines of Comly's letter reveal his frustration with the artist:

What then is to be done? Shall we let him sink, and all his usefulness to society be lost? Or shall we let him pursue his chimerical scheme of extricating himself by ornamental or portrait painting, in violation of the scruples in his own mind, and in contradictions to the testimonies has borne. . . . He even requests us to let him alone . . . unless he can be relieved, without being exposed, I fear, you will never see him on Long Island or elsewhere as a preacher of the gospel.

Comly's observations are very important in understanding Edward's dilemma, his capabilities as a painter, and the artist's and probably other Quakers' perception of "fine" versus "plain" painting. Comly also gives us valuable clues as to how Edward rationalized his work as useful and innocent through precedent, interpretation of the Scriptures, and the interpretation of *Rules of Discipline*. The latter do not provide guidance on specific aesthetic qualities, nor do they reference particular material things. There are no mentions of art or paintings in the *Rules of Discipline*. Art was neither forbidden nor encouraged. Some surviving Quaker furnishings from the eighteenth and early nineteenth centuries are not especially plain while others are. There are individual testimonies that specifically address aesthetic qualities, the need to adhere to plain styling and avoid worldly goods that enlist sensuous appreciation. Changing attitudes among Quakers toward what was and was not permissible in dress and ornament were evident long before Edward's time. It is not surprising that these ambiguous attitudes were known to Edward and added to his confusion about what he could and could not paint. While he lived in the countryside, some distance from Philadelphia, he was neither naive nor unacquainted with urban Quakers and their meetings, as well as the cosmopolitan fashions they enjoyed. Edward visited Philadelphia many times during his life, as well as Baltimore and New York City.

But there were differences between urban and rural Quakers that contributed to their tastes and aesthetic sensibilities. Rural Friends living in small towns like Newtown often sensed an unacceptable degree of worldliness among members living in large cities like Philadelphia. During Edward's time, his famous cousin Elias Hicks ranked among the society's leaders who recognized and repeatedly addressed the breakdown in rules and the consequences for Quakers. His views along these lines were popular among rural Quakers but challenged by urban Friends.

Edward's writings indicate that he also held a conservative view on household furnishings and dress, despite his penchant for painting what some would have called fancy, superfluous pictures. Quakers in Newtown would have defined plain painting as house painting, solid expanses of painted surface for objects, occasional lining or pin striping, as it is called today, lettering unadorned signboards, perhaps simple grain painting of trim, cornices, doors, and other wooden items, gilding weather vanes, varnishing, and simple lettering on coaches and carriages. After moving to Newtown, one Edward's first jobs was painting the town's "directors." These were small rectilinear street and milepost signs of black lettering on a plain white background.

The more elaborate work that was considered unacceptable by Hicks's Quaker neighbors included large and elaborate signboards with scenes or views and gilded or painted lettering, easel paintings of scenes that had no practical or useful purpose, portraits (as noted by Comly), and highly ornamented work that might include decorative flourishes, flowers, and heraldic and similar devices. It was this sort of work that earned Edward his reputation and prospective customers. One observer of an elaborate sign Edward had painted for the Willow Grove Hotel noted that it "is such a one as we would expect to emanate from this eminent artist. It is one of the best specimens of the skill of the painter now hanging between Philadelphia and Doylestown, or even Easton; and we do not doubt that thousands will call, if for no other purpose than to take a leisure view of this beautiful work of art."[20]

Fine painting, as described by Edward, was probably the same sort of work that Comly attributed to Benjamin West (1738–1820) and Charles Willson Peale (1741–1821) in his letter to Isaac Hicks. Both these artists were well known in Pennsylvania. Edward undoubtedly knew of Peale, who painted the portraits of numerous Philadelphia Quakers and whose second wife, Hannah Moore, was a Friend. Edward was especially aware of Benjamin West, who was of Pennsylvania Quaker heritage but apparently not a practicing Quaker. An engraved version of West's view, *Penn's Treaty with the Indians,* served as the design source for Edward's paintings of the same subject (Figure 8.3). Although no portraits have been documented to Edward, he did not reject such formats. Edward's young cousin Thomas Hicks worked in Edward's shop as early as 1836, probably as an apprentice.[21] Thomas was allowed to use an old daybook to record any of his portrait commissions and their price. To aid Thomas in learning to paint likenesses, Edward borrowed a portrait for the young artist to study. Edward also posed for Thomas, whose portrait of the older man painting a *Peaceable Kingdom* is well known (Figure 8.1).

Admittedly, the line between fine painting and ornamental painting was faintly drawn in Edward's mind, just as it likely was for many other early American painters. Ornamental painting, as defined by Rufus Porter and practiced by him, Edward, and others trained in the trade, could be as inclusive as one wished. There were many options, allowing some artists in urban areas to specialize in order to better compete for specific kinds of business. The majority of painters working in rural areas offered a wider range of services; their easel art spanned the gamut of formats—landscape, portrait, genre, seascape, and floral—often with uneven results. What distinguished fine and ornamental painters in Edward's or Comly's estimation may have

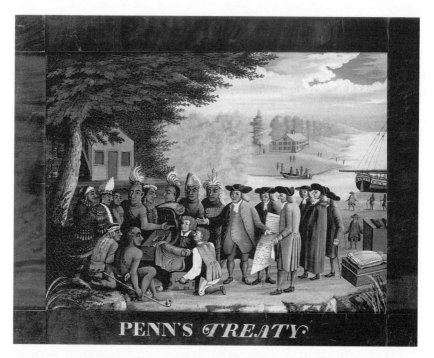

Figure 8.3. Edward Hicks, *Penn's Treaty,* 1830–35, oil on canvas, 17⅝" x 22". Abby Aldrich Rockefeller Folk Art Museum, Colonial Williamsburg Foundation.

included the quality of the art, the character of patronage, and perhaps the artist's specific training as an easel painter. Just as there were specific painting techniques required for shop and trade painting, there were also distinctive methods required of the easel painter. The two types of painting also utilized a number of different tools and materials. Many questions remain about these two approaches and Edward's perception of them. It could be argued that his easel pictures fit either category. He was not unique in this regard but pursued his career in a manner typical of many trades-trained artists who created pictures of all sorts to decorate their clients' houses.

Another point that must be emphasized is that Edward was not a Quaker when he was an apprentice in the Tomlinsons' thriving coach business that catered to all levels of society and offered elaborate and plain painting. Edward apparently had no scruples about the tasks he learned there or the elaborate devices he was taught to lay out and paint. He knew by the close of his apprenticeship that future clientele would judge him less by his mechanical abilities than by his skill in rendering details such as shaded let-

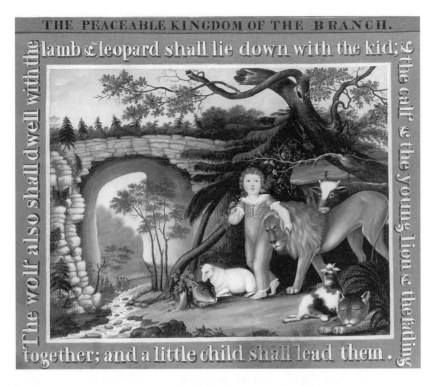

THE PEACEABLE KINGDOM OF THE BRANCH.

The wolf also shall dwell with the lamb & leopard shall lie down with the kid; & the calf & the young lion & the fatling together; and a little child shall lead them.

Figure 8.4. Edward Hicks, *The Peaceable Kingdom of the Branch*, 1822–25, oil on canvas, 32" x 37". Abby Aldrich Rockefeller Folk Art Museum, Colonial Williamsburg Foundation.

tering and his ability to apply clear, pleasing colors. Many of his earliest *Kingdom* pictures (Figure 8.4) feature ochre or yellow borders with black lettering (or vice versa), a particularly difficult technique in sign painting that required great skill and practice.

Ultimately it is the body of Hicks's surviving artwork—especially the easel pictures—that make it difficult to place Edward in the Quaker aesthetic of "simplicity" or plainness. His surviving paintings are neither simple nor plain in their color and design. Yet most of the pictures are, compared to studio work, simply painted, using a restrictive though not drab palette and the techniques of a sign painter. Two easily discerned characteristics of this are seen in Edward's drop shadows (like those used in lettering) for many of the *Kingdom* animals and the tendency to overlap major components in the

composition (Figures 8.5, 8.6, Plate 18). The latter is exemplified, for instance, by entire skies being fully developed first, the landscape elements overlaid on the skies, and finally the animals painted over portions of the landscape and occasionally portions of the sky. The majority of the subjects featured in Edward's pictures would have qualified as "innocent" and agreeable in principle to the various Quakers who received them.

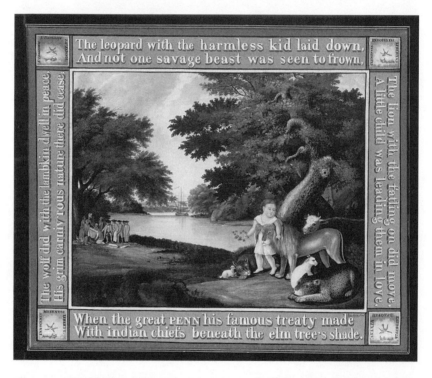

The leopard with the harmless kid laid down,
And not one savage beast was seen to frown,

The wolf did with the lambkin dwell in peace.
His grim carnivrous nature there did cease.

The lion with the fatling on did move
A little child was leading them in love.

When the great PENN his famous treaty made
With indian chiefs beneath the elm tree's shade.

Figure 8.5. Edward Hicks, *Peaceable Kingdom*, 1826–28, oil on canvas, 29" x 35". Abby Aldrich Rockefeller Folk Art Museum, Colonial Williamsburg Foundation.

Perhaps the most important of Comly's statements on Edward's art is the suggestion that "if the Divine law had not prohibited," the Quaker artist might have become so skilled as to rival Charles Willson Peale or Benjamin West. An analysis of Edward's easel paintings dating from about 1817 to his death in 1849 indicates that he generally avoided highly representational drawing and brushwork in favor of a flat, linear style associated with sign

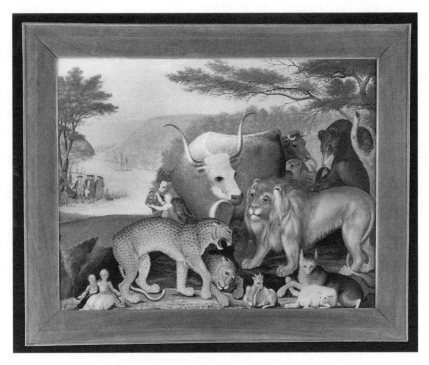

Figure 8.6. Edward Hicks, *Peaceable Kingdom,* 1844, oil on canvas, 24" x 31 ¼".

and related trades paintings. However, on rare occasions viewers will find passages in the *Kingdom* paintings or, in one instance, an entire painting that demonstrates Edward's ability to imitate studio painting. This is especially obvious, for instance, when one compares the pictures of *James Cornell's Prize Bull* (Figure 8.7) with the cattle and cows shown in *Leedom Farm* (Plate 19). The paintings date from the 1840s, the late decade of the artist's life, when he was experimenting with a significant number of subjects and formats. The farm scene and most of his other paintings from the 1840s are in the same linear, ornamental painting style Edward had used for years. On the basis of style and technique alone, few viewers of the more formal and finished *Prize Bull* would attribute the picture to Edward. Yet detailed history, the artist's inscription and signature on the verso of the canvas, and the surviving receipt from the artist to Cornell are unquestionable.[22] In-depth examination of the picture also has shown that the coloration and construction are completely consistent with Edward's known paintings. In *Prize Bull*

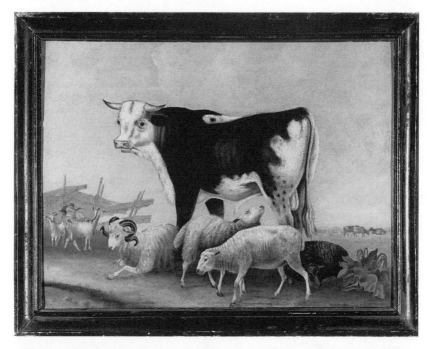

Figure 8.7. Edward Hicks, *James Cornell's Prize Bull*, 1846, oil on wood, 12" x 16⅛".
Abby Aldrich Rockefeller Folk Art Museum, Colonial Williamsburg Foundation.

and other pictures, Edward first drew the overall composition in graphite on
the canvas or wood support. Such preparatory under-drawings cannot be
seen without magnification and special photography. In *Prize Bull*, Edward
traced the bull, ram, and several of the sheep from nineteenth-century litho-
graphs by European artist Gustavus Canton. Examples of these prints had
descended in a Newtown, Pennsylvania, family and were discovered by Hicks
scholar Eleanore Price Mather in the 1980s.[23] A comparison of Edward's ani-
mals and those in the prints reveals that even small details like folds and
creases in the wool correspond to the line work in the prints. It appears that
Edward traced the images from the prints, reversed the tracing paper and
laid it on the canvas, and then pounced the graphite onto the canvas. This
technique resulted in the ram, sheep, and bull appearing in reverse positions
in Edward's painting.

The importance of Cornell's bull and Comly's statement are one and
the same: throughout his career, Edward understood and knew how to effect

a more formal painting style but rarely exercised his "native genius." He chose to paint in a far simpler, ornamental style because he wished to follow the "Divine law" and adhere (as far as he possibly could) to acceptable Quaker aesthetics. The subjects that Edward painted are also a telling indication of his effort to limit his art to ideas and messages that were acceptable or at least palatable to Quaker tastes. The earliest evidence of his care in selecting themes dates to 1817 when Edward returned to his shop. It was this year or perhaps the next that he created the first of the *Peaceable Kingdom* pictures. Whether the idea originated with Edward or someone else is unknown, although correspondence between Edward and Elias Hicks often uses animals, including leopards, bears, and lions, as metaphors for Quakers having Orthodox leanings.

Many of the most successful early *Kingdom* pictures have lettered borders that include a rhymed couplet version of Isaiah's prophecy authored by the artist. Edward favored this subject throughout his lifetime, refining and changing the compositions, animals, and figures to suit his particular needs and religious viewpoint. Of all the subjects painted by Edward, none were repeated as often or refined as carefully as the *Kingdoms*. They represent the outward expression of the artist's inward feelings and the tensions he experienced as a Quaker in early nineteenth-century America. His preoccupation with these paintings was deeply personal yet reflective of well-known Quaker beliefs. Edward would have known that Isaiah's prophecy addressed key issues associated with inward and outward life and the denial or relinquishing of the willful self. Edward, like many Quakers, believed that he must suppress participation and interest in superfluous worldly material things, concerns, and passions. Creaturely concerns were the lowest priority. Those that were undesirable should be purged from one's life so that it could be filled by the divine grace of God.

Edward's original rationale for painting the *Kingdom* pictures remained throughout his lifetime, but it became refined and closely focused on his understanding and interpretation of issues associated with the so-called Quaker schism, resulting in the division of the Society of Friends in 1827–28 into two groups—the Hicksite and Orthodox Quakers. Matters pertaining to worldliness were among those debated during the 1820s and even earlier, although they alone were not the cause of the division. In Edward's hands, the carnivorous beasts and all that they represented symbolized the behaviors and attitudes of Quakers with orthodox leanings. The domestic, gentle beasts in these paintings represented the innocent, abiding Quakers, many of whom lived in rural areas and who tended toward the teachings of early, primitive Quakers and Elias Hicks.

As Edward became more involved in the schism during the 1820s, he also became more obsessed with the *Kingdom* pictures. Toward the end of the decade and the early 1830s he made numerous changes that would better interpret the Hicksite position. In addition to the two broad categories of animals, Edward used his knowledge of the four medieval humors to assign each animal certain traits of human nature. The first class was symbolized by the wolf and called the melancholy; the second, representing the sanguine, was exemplified by the leopard; the third group included the phlegmatic or cold and unfeeling creatures as represented by the bear; the lion, the fourth class, was the choleric and dominated by the element of fire. The lion and leopard and their various traits figured prominently in Edward's paintings since he used them to represent some of the worse failings of British Quakers and the Orthodox.

Edward fully developed his meaning for the animals in a sermon he gave at Goose Creek Meeting in Loudon County, Virginia, on February 22, 1837. Titled *A Little Present for Friends and Friendly People*, it was published first as a pamphlet in the 1830s, and again in 1851 when it was included in the volume containing the artist's memoirs.

The sermon remains the most important source for understanding the *Kingdom* pictures and their evolution throughout the artist's lifetime. The roughly three decades of refinements to these paintings is fully discussed and documented elsewhere, but it is important to summarize here the most significant ones. Key changes included: (a) by 1829–1831, the inclusion of vignette featuring a large group of Quakers with a Banner; Elias Hicks is prominently placed in the front of the group, addressing William Penn and other early leaders; (b) the inclusion of banners that bear the inscription "Mind the Light"; (c) significant changes in the facial expression and positioning of the animals as well as an increase in the number of animals; the bear, lion, leopard, and wolf demeanors change drastically from the quiet, sleepy creatures seen in the early *Kingdoms* to tense and then angry beasts by the early 1830s; (d) in the late *Kingdoms* (Figure 8.6), a change in the carnal animals' expressions and postures. Near the end of the artist's life, the leopard and lion become fatigued and aged, less prominent and disinterested. The mass of animals seen in the 1830s versions becomes dispersed. The addition of two felled trees in the last two *Kingdoms* from the 1840s suggests the further erosion of both Hicksite and Orthodox through additional divisions.

In summary, the *Kingdom* pictures painted by Hicks until the very eve of his death in 1849 had specific meaning for Hicks and for those Quakers who received them. As engaging and innocent as they appear to modern eyes, these canvases were interpreted quite differently by their creator and

their owners. The images recalled loss of unity, perhaps even the shame of disunity, as well as the hope for reconciliation, and the behaviors and attitudes of the Orthodox that must be relinquished to establish unity. In their final manifestation, the *Kingdom* pictures betray Edward's awareness that there would be no reconciliation or unity before his death. As a group, Hicks's *Peaceable Kingdom* sequence is unique in early American painting as a series featuring one subject evolved over more than three decades.

Edward completed nearly half the sixty-two known *Kingdom* pictures during the last fifteen years of his life. It was during this period that he also developed other easel painting formats that seemed to have been acceptable to many Quakers. These were Noah's ark, *Penn's Treaty with the Indians*, views of William Penn's grave at Jordans in England, the Declaration of Independence, and George Washington crossing the Delaware (Figure 8.8). The paintings associated with Penn obviously found acceptance, while that of Washington and his soldiers might seem an inappropriate endorsement of armed confrontation. Edward, unlike some Quakers, was rarely negative or ambivalent about the events and good results of the Revolutionary War. Writing about this in the 1860s he voiced his strong position:

I am ashamed of my brethren and sisters that have been permitted to live in the golden age of the best government under heaven,—in the land of Penn, and the vicinity of the city of brotherly love,—the lap of indulgence and luxury, and some, with a mushroom popularity, that is dangling them about like doll-babies, standing within the walls of a peaceable Quaker meeting house, prating against the government that furnished the asylum. . . . Poor, contemptible, womanish weakness, which never felt the noble spirit of patriotism our Lord alludes to when he says, "Greater love hath no man than this, that a man lay down his life for his friend." Upstarts, whose narrow contracted, self-righteous souls were never capable of entering into sympathy with the poor soldiers of 1776, their hardships, privations and sufferings,— whose footsteps were marked with their own blood,—whose tedious nights and wearisome days, involving the most awful responsibility, were so marked in the lines and configuration of the face of the illustrious Washington.[24]

Edward viewed George Washington as the embodiment of all that was good and decent in American government, painting several versions of him crossing the Delaware River on Christmas eve 1776, prior to the Battle of Trenton the next day. Edward borrowed the composition from an engraving by George S. Lang (1825 version) after Thomas Sully's *Washington at the Passage of the Delaware* was completed in 1819. Edward's first versions were likely the two signboards he was commissioned to paint in 1833. They were placed on either side of the Delaware to commemorate the January 1, 1834, opening

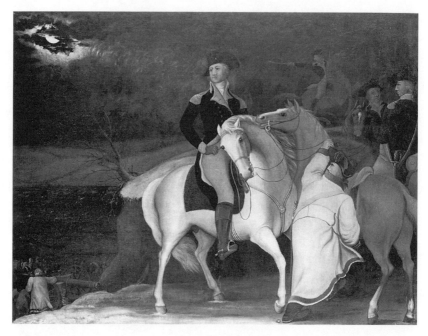

Figure 8.8. Edward Hicks, *George Washington Crossing the Delaware River,* 1848, oil on canvas, 36⅛" x 47⅛". Abby Aldrich Rockefeller Folk Art Museum, Colonial Williamsburg Foundation.

of a bridge that spanned the river from Taylorsville, Pennsylvania, to the New Jersey side.[25]

The 1840s were an especially productive time for Edward as an artist, although he was not in good health much of the time. Prone to fits of coughing and what he called a pulmonary condition, he was unable to continue his gospel ministry into areas remote from Newtown. He wrote often of working in his shop during the day hours and by himself at night, probably on easel pictures of the kind that survive for those years. In addition to the history paintings and *Kingdoms,* Edward completed several important versions of *Twining's Farm* (Plate 16) and two monumental farmscapes for the Cornell and Leedom (Plate 19) families, both of which had intermarried with the Twinings. For Edward, these views were of family places, peopled by Friends and those he considered family. Each is somewhat idealized in its orderliness and harmonious arrangements of animals and humans. The Twining pictures were intended to show the farm as Edward remembered it from his

youth. Just as he had written in his memoirs about the idyllic childhood on the farm, he sought to capture it on canvas. The focal point of the picture is Mary Twining Leedom riding sidesaddle on her horse. Edward wrote that she was his best friend; her husband, Jesse Leedom, is mounting the other horse (with the wrong foot since he would be facing the horse's tail once in the saddle!). Edward shows himself as a child standing by his beloved Elizabeth, while David Twining stands by the half-opened gate.

Leedom Farm (Plate 19), with its expansive, softly colored hills, fields, and buildings set against a luminous sky, might easily be called the artist's masterpiece. It was created about three months before his death. This scene is also idealized and romantic in nature, a powerful affirmation of Edward's faith in peaceable coexistence among man and beast. As has been pointed out by other scholars, there is no work activity in *Leedom Farm*. It may be that Edward imagined this gathering of loved ones and gentle, domestic animals as a personal statement of the peace he longed for throughout his life and found among his family and friends during his last days.

Taken as a whole, Edward's easel paintings represent what he believed were suitable subjects and acceptable themes for Quaker consumption as well as his love of painting. The *Kingdom* pictures occupied much of his career; the look and content of most were fueled by the turnings and difficulties associated with the Quaker schism. Edward used these painted images to voice his opinions and understanding of events, perhaps intentionally since he had a hot temper that was quickly awakened. He often admitted this and once described himself as "an uncommonly dogmatical disputant."[26] Over the years of their development, he paid close attention to the *Kingdom* paintings' symbolic content, making adjustments that better reflected his position as well as that of other Hicksite Quakers. The most captivating and intriguing versions were produced in the early to mid-1830s because their coloration, expressiveness, and clever compositions captured the tensions among Quakers during those years. The monumental and centrally placed seated lion in most of these pictures represented the dangers inherent in secular kingdoms, the misuse of temporal power, and ultimately Edward's dislike of interfering British Quakers.

By the 1840s, when the artist began to paint other subjects such as the historical pictures, several other religious topics, the farmscapes, and related pastoral subjects, Edward was no longer busily engaged in the affairs of the Society. He continued to attend local meeting, but the issues that had been of great concern to him and associated with the schism were less critical to younger members. Most of Edward's friends who understood and participated in the heated discussions of the 1820s and 1830s were deceased.

The criticisms he had received about his most elaborate ornamental painting from about 1815 to 1820 seemed less important and unnecessarily rigid by mid-century. The introduction of other subjects, some of a personal nature, was permissible since they either captured important moments in American history that aided liberty, both civil and religious, or expressed the serenity of rural Quaker life. For the most part Edward continued to restrict himself to the somewhat flat and simpler style of painting associated with shop work, although *James Cornell's Prize Bull* and modest passages observed in several of the other works reveal an occasional loosening of restraints. Even in these late years Edward's preoccupation with easel painting remained distinct and separate from shop production. He knew all too well that some Quakers considered easel painting fine painting and thus avoided it. By limiting his techniques and censoring the subject matter Edward believed he had made his art useful and acceptable to most Friends.

The acceptance of Edward's paintings by his Quaker peers who occasionally commissioned them or more often received them as gifts was likely unconditional, although there is very little documentation to prove it. By the time of his death in 1849, the members of his meeting recognized his shop painting as a useful occupation. The testimony prepared in 1851 by Joseph and Sarah P. Flowers, clerks of Makefield Meeting, stated that "while he was 'fervent in spirit, serving the Lord,' he was also 'diligent in business,' laboring with his hands for the support of his family, so that he could say with the apostle 'these hands have ministered to my necessities, and those that were with me.' "[27] His same testimony also states, as if to provide some justification for his easel art, that a friend called on Edward several days before his death and found him in his shop "busily engaged in painting (it being the only business he was able to follow)." Family history indicates that Edward was working on a *Peaceable Kingdom* for his daughter just before his death.

The passing of years and the journey of historic objects often illustrate how and by whom they were valued. Many of Edward's easel pictures were proudly preserved in successive generations of the Quaker families for whom they were originally painted. Most of these pictures have detailed histories that often suggest the importance the paintings held for early owners. Although documented provenance is not unusual for early American painting, rarely is there a body of artistic work surviving by an artist that has a collective, coherent history associated with a particular clientele. Edward's patrons were largely Quaker; after 1827, they were of Hicksite persuasion. The large corpus of written material dating to Edward's time, including his account book, receipts, published *Memoirs*, and letters to, from, and about the artist, also make his story exceptionally well documented.

Part III
Quakers and Modernity

Introduction

Anne A. Verplanck

Much of the modern conception of Friends is a construction of preservation and interpretation efforts, particularly during the late nineteenth and twentieth centuries, when Philadelphia and the Delaware Valley preservation activities—involving Quakers and non-Quakers alike—made Philadelphia's centennial celebration of 1876 a central event in the colonial revival movement. During the preceding decades, residents of the city and environs had preserved historic buildings and landscapes and collected and displayed objects and manuscripts. A closer look at these broad civic activities suggests that, even when Friends were involved, it was rarely a specifically Quaker past that they preserved or interpreted. Rather, Friends focused on collecting artifacts related to their own families' pasts, assembling family and institutional records and histories, and preserving meeting houses. Their efforts dovetailed with the larger colonial revival movement but seldom included a public focus on specifically Quaker activities. Yet the public's perception of the city and region as "Quaker" has much to do with this interpretation by amateur and professional historians. The essays in this section look at how people moved about in the world of the late nineteenth and early twentieth centuries, melding their lives, sometimes quite self-consciously, with what they perceived as significant parts of their heritage. How did Friends blend their expressions of modernity and conservatism with those in the world around them? One could argue, as previous essayists have, that they did so very individually. There was a range of Quaker expressions of interest in the past, just as there was a range of Friends.

The following three chapters remind us that Quakers' proscriptions about material culture were shaped by time, place, and mindset. In "Sara Tyson Hallowell: Forsaking Plain for Fancy," the second chapter in this section, Carolyn Kinder Carr looks at how art agent Sara Tyson Hallowell

reconciled her career as an art agent with her Quaker upbringing. Hallowell's ties to generations of prominent, often devout Friends appears at first glance to be unrelated to—and even at odds with—her choice to become involved with the business of art. But in the context of earlier Friends' production and consumption of art we see the broad diversity in Quaker attitudes toward art. Dianne Johnson's essay has demonstrated that Friends did not prohibit portraiture and that many Quakers in colonial Philadelphia had their portraits painted in the same way, and by the same artists, as non-Quakers.[1] Yet Carolyn Weekley's research on Edward Hicks shows us that some Friends, in their roles as either artists or patrons, had clear ideas about what art was appropriate to make or own in more rural Bucks County, Pennsylvania, in the first half of the nineteenth century.[2]

Hallowell probably did not stretch the boundaries of what was appropriate for an urban Quaker in the late nineteenth century. She may have instead pushed some accepted standards of women's roles in the art world by expecting to be paid and by regularly interacting with men in a business setting.[3] Was her desire and ability to undertake a career as an art agent influenced by her identity as a Quaker woman? And how do we reconcile her career choice with her later decision to undertake a more traditional Quaker woman's role as a philanthropist in Moret, France? What role did Quaker values play in her choices? Was it her Quaker heritage, and that of her family members, that permitted her to undertake such a range of roles in her lifetime and still retain her ties to her family? Examining how and why Friends engaged in collecting and interpreting certain aspects of their own history reinforces the range—and acceptance—of choices made by individual Quakers.

Indeed, as Hallowell advocated the purchase of some of the most modern art available between 1880 and 1914, other Philadelphians—Quaker and non-Quaker—chose to look backward rather than forward. Mary Anne Caton's chapter, the first in this section, helps us understand how certain Friends' emphases in saving and collecting practices in the nineteenth and early twentieth centuries shaped modern understandings of Quaker history and life. In "The Aesthetics of Absence: Quaker Women's Plain Dress in the Delaware Valley, 1790–1900," Caton analyzes how Quaker women used plain dress as an individualized strategy of self-expression in the nineteenth century. She provides us with a chronology of Quaker women's dress and its connection—and sometimes lack thereof—to strictures regarding plainness repeated from the seventeenth century onward. Some Quakers, particularly Wilburite (Orthodox) Friends, older Hicksites, and ministers, chose to codify their religious beliefs by wearing plain clothing. Later generations of

Friends collected, saved, and sometimes modified this clothing, valuing it as a material manifestation of their heritage.

In the final chapter, "What's Real? Quaker Material Culture and Eighteenth-Century Historic Site Interpretation," Karie Diethorn analyzes the interpretation of Quaker life in historic houses in Philadelphia. Diethorn examines the histories of three houses—Stenton, Cedar Grove, and the John Todd house—before turning to the current interpretation of each site. The essay points out the wide range of Quaker dwellings and furnishings in the urban setting of Philadelphia. In highlighting how the houses embody the contemporary needs of the non-Quaker organizations that oversee each house and how these changed over time, Diethorn invites us to contemplate how preservation movements affected the perception—and perhaps the persistence—of certain aspects of Quaker material culture, while relegating others (for example, Quaker novels and First Day [Sunday school] literature) to a shadowy background. It is fascinating that Quakerism plays a relatively minor role in current and past interpretations of the houses, their occupants, their contents, and the cultural landscapes in which they are embedded. One might conclude that the houses embody the findings of some of the other essayists—that it is arguable whether there is indeed a Quaker aesthetic. Diethorn suggests as well that the interpretation of these houses has not historically—and might profitably be—focused on religion in its historical context.

Regardless what facet of late nineteenth- and twentieth-century Quaker material culture one examines, one needs to come to terms with the colonial revival movement. The colonial revival movement involved collecting, preserving, and honoring a specific part of America's past. Early leaders, their achievements, and their descendants' connections to these people and their accomplishments were memorialized through the preservation of buildings, the founding of filiopietistic organizations, the creation of monuments, and the documentation and, sometimes, exhibition of self-promoting objects and documents. These activities were far from benign, as they often magnified the prominent families while minimizing the contributions of non-elite individuals or communities. Colonial revival activities fostered the development of a broadly construed mythic past, but varied across time, space, and stated or unstated reason.

In Philadelphia and environs, the intensive saving and collecting practices of the late nineteenth century were preceded by significant earlier efforts, such as the preservation of the State House (Independence Hall) following the Marquis de Lafayette's visit in 1824. Numerous historical societies were founded throughout the nation in the first half of the nineteenth century;

the Historical Society of Pennsylvania (HSP) began in 1824. Although the HSP acquired important items related to the region's Quaker past, these acquisitions were, significantly, not at first identified as "Quaker." The HSP purchased a large cache of William Penn's papers in 1833, but these manuscripts appear to have been acquired for their relation to early Pennsylvania—and national—history, rather than to early Pennsylvania Quaker history (despite the presence of several Quakers on the HSP's board).[4]

Today Quaker history takes George Fox's *Journal* or William Penn's *No Cross, No Crown* as its points of departure, but this focus is relatively modern and related to other historical impulses in the late nineteenth century.[5] The founding of the Friends Historical Association in 1873 parallels the broader American desire to embrace British ties in the face of increased immigration from eastern and southern Europe. Similarly, the creation of Friends Historical Library at Swarthmore College (1871) corresponds with the founding of other libraries that focused on the interests of specific religious or ethnic groups.[6] By 1872 Westtown School published its history, and in 1901 Amelia Gummere produced *The Quakers: A Study in Costume.*[7] This litany of activities and publications suggest Friends' interest in their own history, both separate from and connected with a broader late nineteenth-century fascination with the past.

A brief survey of centennial publications finds no mention of Quaker contributions to Pennsylvania's past, even while we recognize today that many of the state's enduring institutions were led by Friends who envisioned their leadership as part of their Quaker identity.[8] Although Hannah and William Penn's portraits were included in the Pennsylvania display at the World's Columbian Exposition in Chicago in 1893, their presence needs to be viewed in the context of the description of the intended exhibition: "The portraits, busts, photographs, etc. of distinguished and noted persons are desirable for this historic exhibit, with relics illustrating the life and times of such persons."[9] This language certainly suggests that the portraits, like the Penn papers at the HSP, were seen as representative of Pennsylvania's—and the nation's—history, rather than having anything to do with the state's Quaker past.

The history of Wyck, the house in Germantown, Pennsylvania, discussed by John M. Groff in an earlier chapter, contributes to our sense of the dual public and private nature of Quaker saving and collecting practices. The sheer quantity of manuscripts and objects saved by the Haines family makes it clear that from the eighteenth century onward the family saw its history as worthy of preservation. In the late nineteenth century, Jane Reuben Haines purchased family possessions to supplement what remained at Wyck. Inter-

estingly, when Wyck was discussed in *House and Garden* in 1902 during Jane Haines's residence, the word "plain" was used repeatedly, but no reference was made to its Quaker history. However, the author noted that the second floor bedchamber "is so quaintly simple so as to seem almost Puritan."[10] Research in progress suggests that Jane Haines's collecting, and later that of her nephew, Caspar Haines II (1853–1935), was related to reinforcing the family's social position. Caspar Haines was involved in the local historical group, the Germantown Site and Relic Society (later Germantown Historical Society), in which he shared his historical impulses with other Philadelphians who had both Quaker and non-Quaker pasts.[11]

Wyck did not open to the public regularly until 1973. Although the primary reasons for its date of opening are related to the Haines family's needs, it is useful to note that, as Karie Diethorn has shown, other Quaker historic houses in the region became public sites in the twentieth century rather than the nineteenth. Further, Wyck's twentieth-century occupants varied in their faith and religiosity. Some family members, such as Caspar Haines, emphasized their eighteenth-century Philadelphia roots but not their Quaker origins. Like the houses Diethorn examines, Wyck's Quaker connections are noted to visitors but not central to the current interpretation.

Quaker meetings, with their eighteenth- and nineteenth-century buildings, cemeteries, and, often, open spaces, serve as some of the most prominent reminders of the region's rural past and exemplars of Friends' dual public and private preservation impulses. Various meetings celebrated their centennials or bicentennials around the turn of the twentieth century— Merion, Pennsylvania (1895) and Medford, New Jersey (1914), to name but two—and created publications to mark these events.[12] In his preface to Arch Street Meeting's centennial (1904) publication, Isaac Sharpless noted: "It is well occasionally to look backward into the past, and gather up the standards and principles of our ancestors in the faith."[13] Examining the scale and focus of specific projects, the differences between urban and rural preservation impulses, and the people behind these efforts might help us comprehend the reasons why projects were undertaken.

Analyses of changes in Quaker meeting house celebrations and restoration projects bring us to the question of how Friends' efforts fit into a broader picture. The colonial revival, though eloquently addressed in many sources, has not fully been unraveled in terms of variations over time and space. When did the colonial revival movement end, and when do the preservation movements begin—in the 1920s, 1930s, or 1940s? Are there subsets as well as overlapping aspects of both movements? How does the preservation of Quaker structures fit into these broader movements? Urban preservation

of meeting houses, at least in Philadelphia, appears to have been part of the larger preservation movement in the latter half of the twentieth century. Writing in 1956 on the centennial of Race Street Meeting House, Frances Williams Browin noted: "Yet the meeting house itself has remained, forming with its peaceful yard, a quiet Quaker island in the midst of a noisy and somewhat run-down urban sector whose clangor is no longer softened by the tanbark-covered streets of yesteryear."[14] How Friends' ideas about urban renewal intersect with others' viewpoints, particularly during the 1950s and 1960s, and who was involved in commemoration and preservation is worthy of analysis.

In 1936 Walter Price published his studies on Quaker meeting house architecture. Equally important, he consciously incorporated his research into his design of new meeting houses.[15] Two years later Quaker T. Chalkley Matlack produced his *Brief Historical Sketches Concerning Friends Meetings of the Past & Present, with Special Reference to the Philadelphia Yearly Meeting.*[16] For Friends, older meeting houses were historic structures, spaces for meeting and worship, and templates for new structures. Perhaps most important, meeting houses provided a tangible reminder of Quakers' roles in developing the region.

Historical societies and archives can also help us understand Quaker saving and collecting practices in southeastern Pennsylvania. The Chester County Historical Society (CCHS), founded in 1893, has primarily focused on the stories and objects of rural Friends and their neighbors. The dearth of early records (a not unusual circumstance for museum collections) regarding collecting makes generalizations difficult, but it is interesting to note that only for materials acquired after 1950 do accession records identify materials as specifically Quaker, with attendant histories and genealogies. The names of earlier donors suggest Quaker heritage but, as Mary Anne Caton notes, ownership and use by a specific Quaker household is often difficult to ascertain.[17] Did earlier gifts arrive at CCHS with similar information that is now lost, or was it not until well into the twentieth century that owners felt it necessary or appropriate to call attention to the Quaker ownership of specific objects? One must also ask whether the increasing professionalization of the staffs of museums, historic sites, and archives since the 1950s and the broadening of interpretive efforts to include issues of race, gender, class, religion, and ethnicity in collecting and exhibition efforts have contributed to people's desire to contribute their objects and stories. And we must ask how allying contributions—in both recent and historic times—with a family name can be viewed as an opportunity to strengthen one's own place in history and to bolster the declining Quaker communities.

Although the broad preservation activities noted earlier have influenced Quakers' giving of collected objects to public organizations, other factors have also shaped the deposits of family heirlooms in the public trust. Individual collecting and preservation of objects related to a family's Quaker history is perhaps one of the most significant and least visible reminders of Friends' roles. Saving and collecting impulses can be tied to individuals and their sense of their own family's history, whether part of a broader Quaker history or not. Some Friends' desire to save, to remember earlier Friends, or to "look backward" can be tied to changes in the Quaker faith, such as the Orthodox-Hicksite schism of 1827–28.[18] At the end of the nineteenth century, specific branches of Quaker sects, such as the Wilburites, were particularly conservative in their outlook and looked to earlier times to reinforce their place in history and, by extension, in the present. Others have pointed out that Friends' "economic conservatism" contributed to saving much Quaker material.[19] Did the broader acceptance of Quakers with the passing of World Wars I and II (when conscientious objectors' choices were perceived by some as unpatriotic) lead to a more visible presence for Friends? Was preservation an acceptable form of patriotism during times of war in the twentieth century? Were there other reasons, personal and religious, that made many Friends reluctant to call attention to themselves? Which Quakers desired to use ancestry to help define elite status, and which ones studiously avoided this practice? Were Friends, like many others involved in colonial revival activities, reacting to the increasing immigration from eastern and southern Europe, urbanization, industrialization, and mass culture? How did the Great Depression and the cold war affect their preservation activities? And why did Friends seem to escape the scrutiny of historians in a way that Puritans have not? One might also ask why, even today, though there is a vigorous tradition of Quaker history *within* Friends communities (see Figure 1), Quaker history is conspicuously absent from broad, public celebrations of Pennsylvania's history.

Personal or familial saving and collecting practices continue to intersect with institutional needs. One must ask how trends in downsizing and decedence affect the transfer of materials to public collections. Large caches of materials, such as those owned by the Haines family (at Wyck) and the Vaux family (at Haverford College and elsewhere), lend themselves to studies of collecting, preserving, and philanthropic habits over several generations. Quaker material culture appears not to have garnered much interest from many collectors of this region, except those for whom their own Quaker heritage drew them to assemble, preserve, and sometimes make public. In the late twentieth and early twenty-first centuries, the inclusion of family

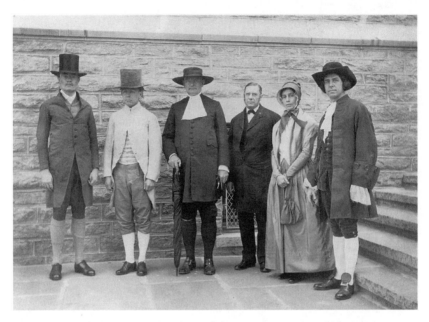

Figure 1. Quakers' commemoration of the past took many forms. This group is celebrating the dedication of Friends Historical Library in 1929. Left to right: Bernard Walton (Elias Hicks), Elliot Richardson (John Woolman), Howard Cooper Johnson (George Fox), Ellis Bacon (Edward Parrish), Margaret Palmer (Lucretia Mott), and probably Roland Ullman (William Penn) in "genuine" costumes. Courtesy, Friends Historical Library, Swarthmore College.

histories allows viewers and users of public collections to analyze the objects and manuscripts in terms of religious, regional, and ethnic significance.

Philadelphia and the Delaware Valley have been and continue to be perceived as "Quaker," long after Friends' economic, political, religious, and social power have declined. But the emphasis placed on Quaker history—by Quakers and non-Quakers—has waxed and waned in a relationship to other historical influences. These dynamics have influenced interpretive goals and helped shape the public's perception of historic sites related to the Society of Friends. The cultural landscape—whether Quaker meeting houses, schools and colleges, or homes—maintained by Friends but in the public view—has furthered a static perception of the Quaker aspects of the region's past, often equating Quakerism—rightly or wrongly—with pastoralism, serenity, justice, integrity, and a nostalgically peaceful past—a "plain, simple" life, now

lost in the bustle of modernity. Margaretta Archambault, in compiling her 1924 *A Guide Book of Art, Architecture, and Historic Interests in Pennsylvania*, notes in her introduction to the section on Chester County: "Third county formed by William Penn; named for Chester, England. This is a rich agricultural district; its broad, well-kept farms, great gray barns, and comfortable homesteads of stone or brick, many still occupied by descendants of the original Quaker settlers; together with the gently rolling surface of the country and its many beautiful streams, all combine to the county a character all its own, of quiet pastoral charm. Both the family names and place names indicate in a general way the character of original settlement."[20]

This vision, particularly of Chester County's past, is described in similar terms more than seventy-five years later. In October 2000 the publicity for Chester County Day (an annual tour of historic properties) included the following: "The Southwest [tour] contains some of Chester County's earliest farms, homes and meetinghouses. Be sure to visit London Grove Meeting, a meeting nearly three centuries old, and the mighty Penn Oak beside it, already beyond its three hundredth birthday."[21] Whether in 1924 or 2000, Quaker meeting houses and other historic structures, Quaker and not, were employed in descriptions of historic landscapes. More thorough research would no doubt show how and why Quakers and non-Quakers used Quaker history and material culture in the twentieth century toward a range of goals. Urban and suburban or rural invocations of a Quaker past may also differ over time. But in the late twentieth and early twenty-first centuries, the built past, seemingly frozen in eighteenth-century time, helps people continue to embrace a rural nostalgia in the face of skyscrapers, malls, and housing developments.

Chapter 9

The Aesthetics of Absence: Quaker Women's Plain Dress in the Delaware Valley, 1790–1900

Mary Anne Caton

The exact nature, meaning, and appearance of plainness, much debated in Quaker material life, is a challenging one for scholars interested in women's clothing. The challenge of interpreting women's plain dress comes from the complex relationship of the Society of Friends to the larger, non-Quaker world and from the Society's written and ambiguous *Rules of Discipline*. The varied styles worn by Quaker women and permitted by the meeting have complicated the understanding of plainness. Styles ranged from colorful clothing indistinguishable from worldly fashion to clothing that displayed a limited range of colors. An added complexity comes from colonial revival scholarship about plain dress, which often emphasizes British meetings' *Rules of Discipline* and seventeenth-century English dress styles noted in literary sources, as if they encompassed norms in both Britain and America. Dominated by Amelia Mott Gummere's 1901 study *The Quaker: A Study in Costume*, early work on plain dress often emphasizes the more unusual components of early plain dress or celebrates the character of those women credited with its origins (like Elizabeth Fry and Margaret Fox). Gummere emphasizes that Quaker "attention to plainness, and to all the details of everyday life, was a natural reaction from the dogmatism, royal prerogative and worldly extravagance." She notes that "the Quakers in Pennsylvania, . . . after 1756, [which was] their period of withdrawal from the public arena, . . . preserved many little particularities of their most conservative sect."[1]

Fortunately, recent work that has untangled the relationship between plainness and Quaker self-expression in portraits, clothing, and furnishings has added sophisticated detail to our understanding of how nineteenth-

century Friends interpreted the society's doctrine of plainness in their dress and in their representations of themselves.[2] This paper discusses a specific group of Quaker women's plain dresses and accessories, and explores questions about the changing meaning of plainness in the Delaware Valley in the nineteenth century.

What constituted plainness in the nineteenth century? What was the meaning of plainness to the individual wearer and its significance to the larger group of the Society of Friends? Quaker institutions clearly played a role in shaping how individuals understood plainness. But how did an individual's choice to go plain in dress fit into the *Rules of Discipline* issued by Philadelphia Yearly Meeting? How did Quaker schools address the issue of plainness among their students? What can be learned from comparing documented plain dress with the prescriptions and disciplines issued by Philadelphia Yearly Meeting? How did plain dress change over the course of the nineteenth century? How did the increased interest in colonial history and material culture in the years following the 1876 Philadelphia Centennial Exposition affect understandings of plain dress?

The dresses included here were exhibited in 1990 as part of a larger exhibition of Quaker plain dress at Chester County Historical Society (CCHS) in southeastern Pennsylvania. Together with materials from Westtown Friends School and Winterthur Museum, these garments are material evidence of Quaker plain aesthetics, reflecting personal interpretations of plainness created within the very broad guidelines presented in the *Rules of Discipline* about dress.[3] Plain dress combined personal belief and taste, with an understanding of what was allowable within one's own meeting. Some wealthy urban Quakers wore bright colors while other Friends adopted clothing limited to a few colors and textiles. Despite the variety of these individual interpretations, they nonetheless shared one characteristic: the avoidance of certain features of high-style worldly fashions and fads. Thus the Quaker plain aesthetic was one of recognizable absence.

For certain members of the Society of Friends the adoption of plain dress signified a deep commitment to the Quakers' basic testimonies: honesty, simplicity, equality, and peace. Turning away from the ever-changing ideals of fashion allowed women to train their thoughts inward and to review the details of their faith. Plain dress was an individualized strategy of self-expression that marked a separate identity from more worldly Friends and from the world at large. But it was not a uniform of prescribed garments, fabrics, or colors. This aesthetic was defined by the dresses' lack of fashionable details (extreme cut, pattern, or color, or details like trims and ruffles). For women, the first step in going plain was adopting a Quaker-style

cap. At the same time, wearing a neckerchief pinned outside rather than under her bodice was another signal that a woman was going plain. With these two changes a woman signified her adoption of a clothing style that reflected her religious conviction.

Five *Rules of Discipline* issued by Philadelphia Yearly Meeting between 1682 and 1711, under the management of London Yearly Meeting, offer the most specific guidelines for what was considered plain clothing and how to achieve it. The language used in these rules originated with the society's founder, George Fox, and reflected the then fashionable court style of dress often characterized by elaborately trimmed dresses made of brightly colored printed fabrics. Following biblical criticisms of luxurious dress, Fox wrote of his dislike for any garments that were "superfluous" or designed for public display. Though he condemned several fashionable accessories of the 1650s—colored ribbons, gold, and powdered hair—in his *Epistle*[4] he did not advocate any particular clothing. The *Rules of Discipline* echoed Fox's writings by describing clothing and stylish details to be avoided because they were "superfluous" and promoted pride.[5] They served as a guide for using clothing to show an increased attention to God rather than to worldly fashions.

Late seventeenth-century *Rules of Discipline* echoed Fox's distaste for luxurious dress. In 1682 members were reminded to avoid "superfluity in apparel." Avoiding the changing fashions of the world allowed one to listen to one's inner Truth. The 1694 rule warned Friends to "keep out of the world's vain & useless things, & Fashion, in apparel." The following year, Friends were urged to

keep to plainess in Apparel as becomes the Truth & that none wear long lapp'd sleeves or Coates gathered at the sides or Superfluous Buttons or Broad Ribbons about their hats . . . & that no women, their children or servants dress their heads immodestly, or wear their garments indecently, as is too common, nor use long scarves, & that all be careful about making, buying, or wearing, (as much as they can) striped or flowered stuffs, or other useless & superfluous Things.[6]

The censured striped and flowered textiles, ribbons, and scarves reflect the height of popular fashion in the late 1600s, as imported textiles from China, Persia, and India became widely available to middle-class consumers.

Over time Philadelphia Yearly Meeting guidelines remained focused on avoidance of superfluity. The 1704 *Discipline* listed more worldly fashions to be avoided: scarves, coats with nonfunctioning buttons, and large ribbons. Outlawed striped and flowered textiles mentioned in these rules echo the wording of contemporary English laws designed to promote domestic tex-

tiles rather than the popular printed cottons imported by the British East India Company.[7] And in 1711 Philadelphia Yearly Meeting warned that "further care be taken to discourage all superfluity in furniture of house and apparel whatsoever." Women were to avoid "gaudy stomachers," commonly used as a decorative ornament on their bodices, as well as striped or flowered cloth. But no specific colors were suggested as desirable although fashionable patterned textiles were to be avoided. Head coverings and ribbons were a particular focus of attention, based on Fox's writings and Friends tradition of not removing hats indoors. Thus a search for information about what *was* worn and what *was* considered plain means weaving together surviving garments, images of Friends, and contemporary comments by Friends about their dress to understand how "the intentionally vague" language of plainness was interpreted by individuals. Clearly early Delaware Valley Friends were more clear about what effect they sought than about the specifics of achieving that effect.

As Anne Verplanck has argued, Friends rarely mentioned material goods in meeting or disciplinary records. This lack of disciplinary records about plain dress suggests that Friends who transgressed what was considered appropriate in dress were dealt with informally, outside meeting, and that plainness in clothing was open to individual interpretation. After 1711 the *Rules of Discipline* repeat earlier advice without describing offensive textiles, garments, or styles.[8] A typical emphasis on pride and utility is found in the 1797 *Discipline*:

all Friends, both old and young, keep out of the worlds corrupt Language, Manners, vain and needless things and fashions, in Apparel, Buildings, and furniture of Houses, some of which are immodest, indecent, and unbecoming. . . . avoid also such kinds of stuffs, colors, and dress, as are calculated more to please a vain and wanton, or proud mind, than for their real usefulness.[9]

But by the mid-eighteenth century the plain dress transplanted to the American colonies from England had become so distinct that many of its older wearers were easily identifiable.[10] Contemporary travelers' accounts report that Quaker dress retained the general outline of worldly dress without fashionable details. In his American travels in the 1770s, Peter Kalm noted that the Philadelphia Friends he saw wore "no clothing that differs from that of other women, except [they wear no] cuffs." Hence, cuffs were evidently one example of a late eighteenth-century "superfluous" fashion avoided by plain Friends. The absence of that detail, at once apparent to Quakers and other viewers, and signified the religious identity of those women who chose

not to wear cuffs. Kalm's observations mark the central puzzle of plain dress: "although I have seen them censure all adornment I have seen them wear just as gaudy shoes as other English women. . . . Although they pretend not to have their clothes made after the latest fashion, or to wear cuffs and be dressed as gaily as others, they strangely enough have their garments made of the finest and costliest material that can be procured."[11]

After the American Revolution, American Quaker women's plain dress followed the styles of mainstream 1790s fashion, which was characterized by five separate garments: a fall-front gown, neckerchief or fichu, shawl, cap, and bonnet. Not all women who chose plain dress wore all five pieces, or wore all at all times. A woman might put on a Quaker cap and pin a neckerchief over her dress bodice, or she might only wear a Quaker cap. Before 1840 plain dress included a gown closed at the center front bodice and on either side of the skirt at the waist in what was called an apron, or fall, front (Figure 9.1).[12] A square neckerchief was folded diagonally and half pinned over the bodice, and a shawl worn over all completed the costume. A cap sewn with sides and front ties cut from one piece of cloth was worn indoors, or outdoors, covered by a bonnet with a rigid, wide brim.[13] This corresponds to the uniform nineteenth-century plain dress described by Leanna Lee-Whitman, although variations existed. In the late nineteenth century, I argue, this uniform disappeared as plainness was replaced by simplicity in Quaker discipline.

During the 1830s and 1840s, descriptions of Quaker plain dress in urban newspapers and in household management guides included clear descriptions of the range of plain colors and cut. These descriptions, though at times satirical, would have resonated with readers on the varieties possible within a plain wardrobe. Newspapers circulated widely in America, courtesy of low postage rates that made the news available through lending libraries, taverns, coffeehouses, and individual subscriptions.[14] An 1832 literary souvenir in the New York City *Atlas*, for example, gave this tongue-in-cheek report of the subtle color choices in Quaker dress: "Quakeresses . . . are restrained . . . to garments composed of scarcely more than two colors, [but they can] contrive from these simple elements to extract as much food for vanity as a painter from his seven primitive colors." The author's list of seven gradations in white, grey, fawn, and "endless subdivisions" of each color acknowledges variations available to plain Friends who nonetheless avoided bright colors and patterns.[15] Similar color choices were offered in Philadelphia by the merchants Cooper and Conrad in their store's shawl department in the 1860s.[16] Contemporary sewing manuals like *The Workwoman's Guide* (1838) also suggest that color choice for plain shawls was limited to "fine

Figure 9.1. Detail, fall front plain dress, ca. 1850, worn by Sydney Way (d. 1882). Courtesy Chester County Historical Society, West Chester, Pennsylvania. Photo: author.

white, or very pale drab, grey or other quiet colored cloth."[17] This account confirms that, although plain Quaker women ostensibly avoided the superficial concerns of the fashionable, they nonetheless could distinguish their wardrobes within limited palettes.

A doll dressed in Quaker plain dress, dated 1835–45, in the collection of the Winterthur Museum (Figure 9.2) illustrates how plain dress was combined with fashionable accessories by some women. The daughters of Mary Ann Warder Bacon, using remnants of their mother's clothing, including her wedding dress, dressed the doll in clothing that includes both plain and fashionable elements. While doll clothing was made at home by either the owner

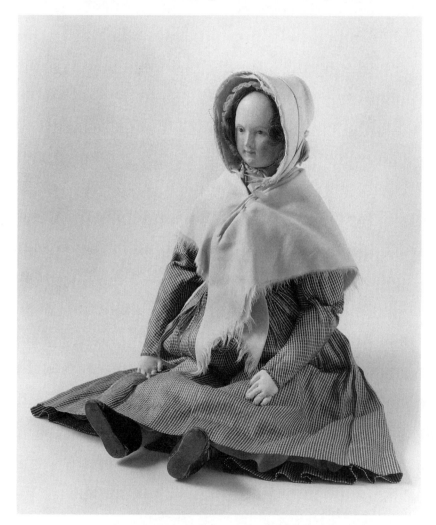

Figure 9.2. Doll in Quaker plain dress, ca. 1835–45, dressed by the daughters of Mary Ann Warder Bacon. Courtesy, Winterthur Museum, gift of Ms. Ruth Young Buggy.

or her female relatives, this doll's clothing shows the owners' desire to dress their toy in familiar styles seen in their immediate family and community. The doll's fashionable, 1830s-style silk bonnet and calico pockets balance her plain Quaker cap, kerchief, shawl, and brown-checked dress. The dress is constructed with a center front bodice closure and the prevailing bell-shaped skirt silhouette of the 1830s, as is the accompanying corset.[18] Thus, while the doll's appearance adheres to colors that are more restrained than in worldly fashion, making her accessories (bonnets and utilitarian pockets) of more worldly fabrics shows the Bacon girls' blend of plain and worldly elements in their doll's costume. The bonnet echoes a strategy used by plain Friends: wearing plain dress with fashionably shaped bonnets created from fabrics that harmonized with the wearer's dresses.

The austerity of worldly fashion in the 1840s made plain Quakers less conspicuous. Dresses were "nearly devoid of ornamentation," with stylish details derived from minimally trimmed dresses.[19] Elizabeth Richardson Hodgson (1812–1867) appears to have worn plain dress in the 1840s. Her black silk twill dress at Winterthur Museum (Figure 9.3) is plain but closely resembles the minimalist styles of the 1840s.[20]

Although Quakers wrote about their dress, their discussion of plainness often left open to interpretation how plain each woman chose to be. Abby Hopper, a Hicksite Friend writing in Philadelphia in 1829, described her choices with rare detail. Her comments show how personal the definition of plainness was. Hopper wrote:

I like simplicity. I never yet felt the least disposition to wear gay colors of any kind, or trimming, or ornamental work. I acknowledge I am a little particular about the cut of a garment. Our tastes differ and we cannot all agree as to what is most becoming. Therefore, everyone is to his liking. [21]

While Hopper dressed very plainly, avoiding bright color and stylish detail in her clothes, she was aware that plainness was partly defined by individual taste.

Rachel Scattergood (b. 1832) also wrote about her struggles to achieve plainness. The daughter of Joseph Scattergood, a chemist, and his wife Mary, Rachel lived in Philadelphia and kept a diary starting in 1840, in which she recorded her efforts to please her parents in behavior and in dress. Her father chided her about her love of finery, as Rachel reported: "Father thinks I am too fond of decorating my head with ribbons and he hopes I will try not to allow my mind to be engaged upon such silly things but that I may desire to grow up a plain simple dressed little girl."[22] Plainness in the Scattergood

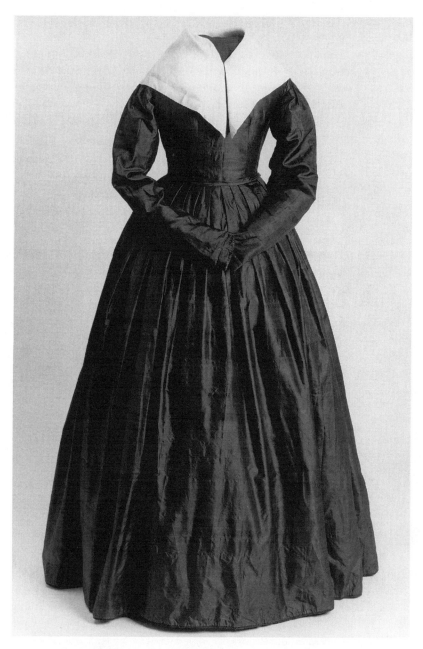

Figure 9.3. Quaker plain dress, ca. 1840, black silk, worn by Elizabeth Richardson Hodgson (1812–67). Courtesy, Winterthur Museum, gift of Eleanor A. Murphy.

family meant avoiding finery like the hair ribbons and the strings of beads that repeatedly drew comments from Rachel's father. Rachel was often warned that these "useless practices" were for "those whose minds are light and airy."[23] Joseph Scattergood objected to ornament and finery because they wasted valuable time, but it is interesting to note that he apparently *suggested* rather than *insisted* that Rachel change her apparel. This equation of ornament with laziness is a recurring theme in Friends' writings about plainness. Moreover, the absence of ornament defined her clothing's aesthetic as morally superior to that of the mainstream. Yet, consistent within Friends belief that religion must come from within, Rachel's father apparently left the final judgment of what was appropriate in dress to his daughter.

English Quaker minister Elizabeth Fry (1780–1845) is one of the more eloquent speakers about her decision to adopt plain dress and the consequences of that choice. Her decision to adopt plain dress took her a long time. As a minister, Fry's clothing was subject to greater scrutiny as a symbol of the Society of Friends. In 1798 she wrote of her decision to go plain, "I used to think and do now how little dress matters. But I find it almost impossible to keep to the principles of Friends without altering my dress and speech. . . . They appear to me a sort of protector to the principles of Christianity in the present state of the world."[24] Among the surviving images of Fry is a full-length portrait, dated 1824 by George Richmond, and illustrated by Alice Morse Earle in her 1903 *Two Centuries of Costume in America*. Fry's clothing in the painting includes four of the five pieces of "full" plain dress in subdued tones: a "pearl color" shawl, soft brown gown, and white cap and kerchief. Earle argues that "drab and grey and brown had not been selected as Quaker colors" during Fry's lifetime.[25] Nevertheless, Fry's clothing that included identifiable "Quaker" elements in subdued colors marked her religious identity. Her use of dress as "a hedge against the world" parallels the ways officials at Westtown School constructed students' plain dress.

Westtown School

Chartered in 1799 by Philadelphia Yearly Meeting, the Friends Boarding School in Westtown, Pennsylvania, enrolled students of both sexes from ages nine to sixteen in a rural setting modeled on Ackworth Friends School in England. The first class enrolled twenty male and twenty female students. After the Hicksite-Orthodox schism of 1827–28, the school became the stronghold of Orthodox families. Students were offered "besides the requisite portion of literary instruction, an education exempt from the contagion of vicious

example, and calculated to establish habits and principles favorable to future usefulness in religion and society."[26] The administrators' concern for separating children from worldly vanity is a recurring theme throughout school guidelines. Students' dress was regulated, but in a manner that made both parents and school officials responsible for maintaining plainness as a barrier against the world.

The *Information for Parents* notice printed on 11 day 4 mo 1799 apparently provided insufficient guidance about what dress was suitably plain, as some school staff found student dress too worldly. The clothing listed was probably intended to be efficient and functional. Girls were to bring six shifts, three short gowns, six neck handkerchiefs, two pair pockets, four pair stockings, two worsted upper petticoats, one flannel petticoat, three frocks or habits, four aprons, four pocket handkerchiefs, three night caps, two pair shoes, two linen underpetticoats, and bonnets, a cloak, and mittens. Boys' supplies were fewer, including "two suits to consist of coat waistcoat, and trousers or breeches."[27] It is interesting to note that boys were given the option of either trousers or breeches, the latter having been traditionally regarded as being more plain. The matron inspected students' clothing in their trunks for acceptable plainness. Students were cautioned,

Any article of dress not sufficiently plain or requiring much washing, shall be returned; but if the make only be exceptionable, to be altered . . . It is desired, that parents . . . in the make of children's clothes, should regard the simplicity of our religious profession, confining their views to decency and usefulnes, and carefully avoiding those imitations of changeable fashions of the world.[28]

That same year, rules for student clothing balanced concern for students' religious growth with concern for their appearance. A letter written to the Acting Committee shortly after opening by the staff dated 16 day 5 mo 1799, critiques the students' appearance:

We believe that something more than a mere library education is designed for the dear youth under our care, that their religious improvement was intended and that with other hurtful things, the seeds of pride may as much as possible be eradicated from their tender minds. . . . Some amongst us have been deeply exercised in observing the garb of many of them which by their too great conformity to the vain customs and fashions of the world appear to us inconsistent with that simplicity of plainness which our religious profession calls for and which we are at times clearly convinced ought to be observed at an institution formed under the care and by the direction of so large a body of friends.[29]

The first two signatories were those of school superintendent Richard Hart-shorne and his wife, Catharine, who served as matron. Other staff signed the letter, claiming that "parents may be impressed with a necessity of *their* bearing a part of the burthen and not leave that to be done by us which we apprehend ought to be done by them at home. . . . We therefore request relief may be afforded by informing such parents thereof, as may be desirous of having their children educated under our Care."[30] The Westtown guidelines, like the *Rules of Discipline*, were open to interpretation. While elder Friends often visited with meeting members whose behavior or dress was inappropriate, here that role was assumed by the school staff who examined students' trunks upon their arrival each term.

Westtown students' letters to their parents reveal how young people's perspectives of plain dress affected their daily lives. The letters show that plainness and usefulness were nearly always considered together. Several students describe their clothing's examination by the matron while asking their parents for more, different, or plainer clothing. One student wrote to her father in July 1799: "They have made a rule that we are not to wear calico pockets, nankeen mittens, nor white underpetticoats, for the washes are so exceedingly heavy, they thought this would be a means of lightening."[31] The goal of plainness was always tempered with concern about wastefulness, and so one student is required to wear her coat turned inside out to conceal its plaid cloth rather than discard the coat.[32] Another student, writing in 1821, comments that "we dress very plain no curls nor puffs and plated hair but plain in manners word and dress their has been a great many gay people here [but] I think I will always dress and speak plain."[33]

Plainness was thus both a function of practicality and an avoidance of ornament and pattern. Moreover, as evidenced from the letters, varying degrees of plainness existed. Fitting in with the group affected one student's desires and dress. Mary Wood wrote to her mother in 1825 asking for a new dress: "I told Father when I wrote to him . . . that I did not want another worsted frock but he sent me one not any of the girls wears green frocks here and I don't like to put mine on." The color green, formerly considered acceptable, was by the 1820s insufficiently plain at Westtown. In her postscript, Wood hopes that her parents will not judge her extravagant. She apologizes and explains, "I am very sorry that I got them kind of frocks as I did before I come here for there is not one like them and I would like to have my clothes like the rest of the girls."[34]

"Grave, dark colors" were recommended. Variety came from the "worsted, cotton, or small, figured calicoes" that the girls were allowed to wear. By 1816

the school employed several staff to care for student clothing. Two tailors altered boys' clothes and made coats and breeches. Two cobblers and a mantua maker were also listed on staff.[35] The matron altered girls' clothes. The administrators' concern for the usefulness of clothing and for the range of cloth allowed—including small-figured, printed calicos—suggests that a variety of fabric choices were acceptably plain. As the exchanges between school officials, students, and parents cited above indicates, however, there were clear limitations to the choices allowed in student dress.

Plain clothing for students at Westtown School was produced both at home and by seamstresses. Accessories like shawls, bonnets, and men's hats could be purchased ready made from Philadelphia department stores. Materials for Westtown students' clothing or ready-made garments were available from businesses in the nearby county seat of West Chester and in Philadelphia. Samuel Augee made both fashionable and plain hats from 1837 to 1850 in West Chester. After 1841 he advertised with his partner that "All kinds of country produce, including Hickory and Oak wood, [would be] taken in exchange" for haberdashery.[36] Philadelphia department stores also carried plain clothing. In the 1860s, Cooper and Conrad advertised a Friends shawl department. Some Westtown School staff and students also made hats, headdresses, and bonnets in the 1870s and 1880s for sale to the students.[37]

The clothing choices of one matron and her children show how plainness changed into simplicity in the late nineteenth century.[38] Susanna Forsythe Sharpless (1840–1900) was matron at Westtown from 1869 to 1874 and a member of Orthodox Birmingham Meeting. In an 1888 family portrait with her daughter Sue and two granddaughters, Susanna wears her kerchief pinned outside her dark dress and covered by a silk shawl. A second family portrait taken by Gilbert Cope in 1888 gives a glimpse of a variety of plainness within one family (Figure 9.4). The image taken in December at "Susanna Sharpless's family gathering" shows her plainly dressed wearing a Quaker cap with her kerchief worn pinned outside her bodice. While two Sharpless relatives wear caps and collarless dresses with kerchiefs underneath their bodices, the other women wear dark, conservatively cut dresses with high collars.[39] Susanna stands out with her kerchief pinned outside her dress and shawl. The other women in the group appear simply dressed with few of the large patterns or immense sleeves common in fashionable 1890s dress.

Sharpless's daughter Ann (1860–1943) taught at Westtown from 1872 to 1881 and again from 1882 to 1904 while also active as a "recorded minister." Ann's essay "Dress in Early Times" provided a history of Quaker plain dress. Looking back to the eighteenth century, she noted "But ideas of plain colors change. Green and blue were then called plain. Flowered or striped dress

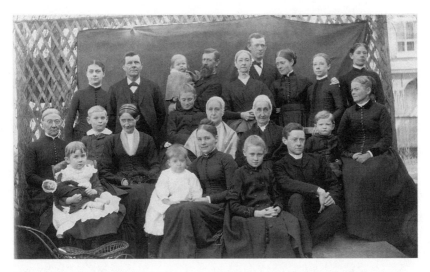

Figure 9.4. Susannah Forsythe Sharpless and family, 1888. Courtesy Chester County Historical Society, West Chester, Pennsylvania. Photo: Gilbert Cope.

goods were to be avoided as much as possible. The coming of calico later caused much consternation. It was classed with tea and tobacco as most objectionable."[40]

Photographs of Ann taken around 1890 show her wearing clothes basic enough to fit Westtown's wardrobe guidelines and may show a simpler late nineteenth-century plain dress.[41] Like many other Westtown faculty and students photographed between 1880 and 1900, she wears dark dresses that appear more conservative in pattern, color, and cut than worldly fashions of the same period. The exaggerated colors and leg-of-mutton sleeves common in mainstream dress are absent. No plain accessories like kerchiefs, caps, or "coal scuttle bonnets" are worn by any of these women. Their dress appears to follow the general functional spirit of the guidelines for student wear. Examination of Westtown School student photos, and Gilbert Cope's photos of Westtown (where his daughter Ellen was a student in the 1880s), and Media Friends Schools show students and faculty in similarly simple clothing. Cope also photographed older Orthodox Friends, like minister Ruth Abbott (1826–1916), in their own plain dress (Figure 9.5).[42] His staged photos sometimes included his great-niece wearing "Quaker plain dress" as a costume.

Sharpless's history and Cope's photos show that earlier notions of plainness had been outmoded and even become objects of historical curi-

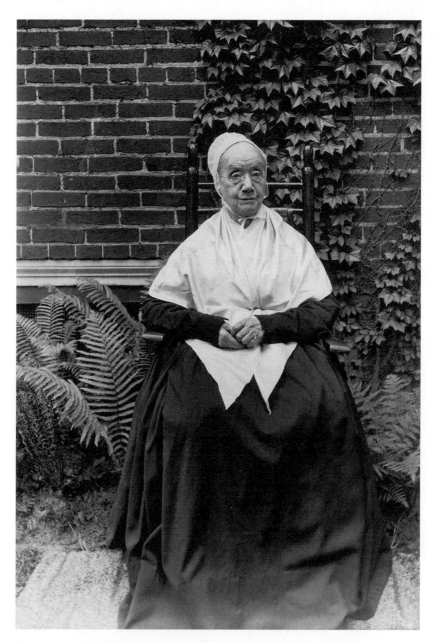

Figure 9.5. Ruth Abbott (1826–1916), 1915. Courtesy Chester County Historical Society, West Chester, Pennsylvania. Photo: Gilbert Cope.

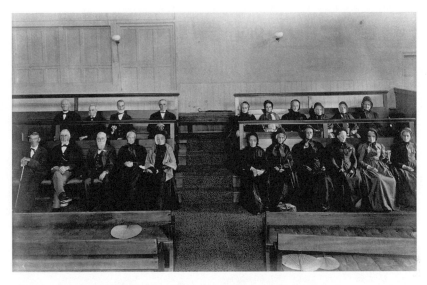

Figure 9.6. West Chester (Hicksite) Meeting, 1898. Courtesy Chester County Historical Society, West Chester, Pennsylvania. Photo: Gilbert Cope after Albert Biles.

osity, like the 1898 photo of West Chester (Hicksite) Meeting (Figure 9.6). Sharpless indicates that bright colors were no longer permissible but that certain patterned fabric was no longer considered objectionable. Some aspects of plainness remained the same. Westtown's late 1800s dress code still emphasized frugality and simplicity. However, the list of rules now more clearly defines acceptable and taboo clothing. Girls were allowed

separate skirts made simply, without trimming of any kind. Dresses and waists should also be simple in style and make, easy fitting, without trimming, and of quiet colors. Figures, stripes and plaids should be small and inconspicuous. Collars should be without tucking or shirring. Buttons may be used for fastening only, and should be neat and inconspicuous. White dresses are not allowed.

The emphasis on functional clothing made whites impractical, for they required extensive labor to keep clean. Frequent washing of petticoats and underwear was discouraged. Embroidery, lace trimming, or colored ribbons on underwaists were not allowed.[43] Plain clothing thus served two functions. On the one hand, it marked the Quaker identity of the wearer. On the other, it ensured that the garments worn by women at Westtown would not require excessive labor to maintain, as fashionable clothes of the time certainly did.

Chester County Historical Society Dresses

Quaker dresses at the Chester County Historical Society span the period from 1803 to 1910. The clothing collection includes twenty dresses traditionally considered to be Quaker clothing by either plain features or a Quaker provenance. In this study, I have chosen to concentrate on the garments whose histories can be reliably documented to a member of the Society of Friends. Several dresses in the CCHS collection are stylistically plain but lack provenance. Other dresses are not plain but have Quaker histories. Of the initial larger group, eight made between 1803 and 1890–1910 are stylistically plain and have reliable Quaker histories. The material characteristics of the group confirm the general sense, gained from a study of documentary sources, of how plainness was interpreted by women in the Delaware Valley during the period, even as plainness declined after the mid-nineteenth century.[44]

Plain wedding dresses like Deborah Dickinson Walker's 1803 medium-brown silk are characteristic of survivals in many clothing collections, as dresses associated with important events are often saved.[45] Deborah, the daughter of Gaius and Mary Dickinson, lived in Sadsbury, Lancaster County, and married Isaac Walker at Sadsbury Meeting in 1803. With the center front closure and apron front skirt characteristic of plain dress, this dress is a good example of the early nineteenth-century high-waisted silhouette (Figure 9.7), made of a textile probably woven in China. What distinguishes the dress from fashionable garments of the same period are its lack of embellishment (trim, embroidery, etc.) and its muted color.

Sarah Havard Miller (1775–1843) and Jane Pyle Brinton both left portraits as well as clothing now at CCHS. These forms of self-representation suggest another view of their plain choices. Miller's miniature, possibly made in 1803 when she married Jonathan Miller, shows her wearing a plain dark blue dress, a transparent kerchief, a gray shawl, and a Quaker cap (Figure 9.8).[46] Brinton wears a Quaker cap in her ca. 1810 silhouette (Figure 9.9). Brinton's surviving cap, and bills for textiles and for seamstress work by Sarah Marshall, all offer insight into her view of plainness in the early nineteenth century. Brinton's cap and silhouette suggest that she dressed somewhat plainly. The bills from Sarah Marshall in 1826 for five "fine garments," two night dresses, a cap, and a bed ticking suggest that Brinton's purchase came from an established seamstress familiar with local Quaker clientele who may have required her to make clothing with atypical style or construction. Brinton purchased the ticking and perhaps other cloth used by Mar-

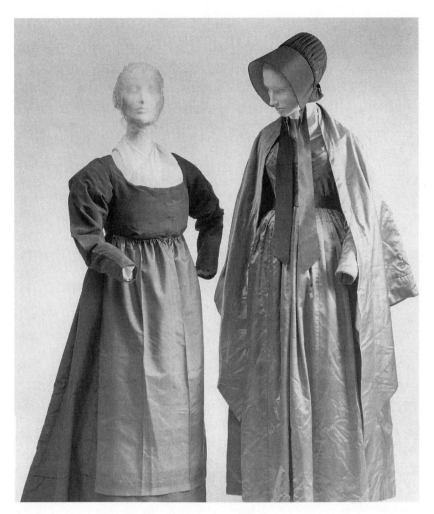

Figure 9.7. Quaker plain dresses. The dress on the left was worn by Deborah Dickinson Walker at her 1803 wedding. The ca. 1837 dress on the right was worn by Hannah Builder Trusted to her children's weddings. Courtesy Chester County Historical Society, West Chester, Pennsylvania. Photo: George Fistrovich.

shall from Philadelphia merchant Townsend Sharpless. She also purchased ready-made goods including "a Fig[ure]d border Waterloo shawl," two pairs of gloves, and quantities of cassimere, chintz, calico, and other textiles from

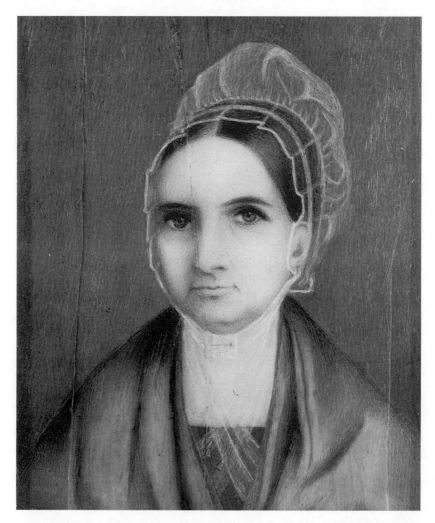

Figure 9.8. Sarah Havard Miller (1775–1843), watercolor on ivory, ca. 1803. This miniature was probably made for Miller's wedding in 1803. Courtesy Chester County Historical Society, West Chester, Pennsylvania. Photo: George Fistrovich.

Sharpless, suggesting that she outfitted her family with a combination of goods made locally and elsewhere.[47]

To sew Brinton's cap, Marshall may have used a manual like *The Work-woman's Guide*, published in 1838 by Sarah Josepha Hale, which contained

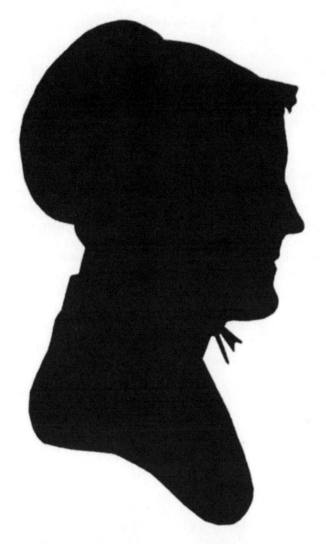

Figure 9.9. Silhouette of Jane Pyle Brinton (1776–1860), paper, ca. 1810. Courtesy Chester County Historical Society, West Chester, Pennsylvania. Photo: author.

patterns and instructions for a shawl, bonnet, and caps for elderly and young members of the Society of Friends. The book was intended to "provide instructions to the inexperienced in cutting out and completing those articles of wearing apparel, &c., which are usually made at home." Hale empha-

sized practical needlecrafts, giving detailed sewing instructions for a variety of household goods—shawls, caps, slippers, aprons, undersleeves, etc.—commonly made at home. Quaker shawls, for example, were made from a square of about one yard "of fine white, or very pale drab, grey, or other quiet coloured cloth, with a satin ribbon, the same shade . . . laid on all round it." Interestingly, Hale dictated the use of pale and subtle colors, and although she allowed for decorative trim, the monochromatic palette she recommended would have worked against the effect of the detailing.[48]

Hale clearly distinguished between caps intended for young and old plain Friends as well as a plain cap "for an elderly lady." Quaker cap shapes generally conformed to the prevailing fashion and often were covered with frills.[49] By contrast, the plain cap for a young Friend is gathered all around the crown and finished with a single self border and "narrow" hem. Unlike the fancier dress morning cap, the plain version has neither ribbon nor lace trim nor multiple trimmed bands. The cap for an elderly Friend has a fuller crown along the headpiece. For both Quaker caps, the front border is one with the headpiece, a feature noted in plain caps at CCHS. Bonnet colors were black, white, gray, or fawn silk. Manuals like Hale's may have also familiarized non-Quaker seamstresses in the Delaware Valley with different forms of Quaker plain caps.[50]

Hannah Builder Trusted's dress (Figure 9.7) qualifies as plain not by virtue of following a specific pattern for Quaker clothing but because it is a more subdued version of a stylish prototype. An extremely short-lived sleeve fashion—four rows of gathered smocking at the top of each sleeve—dates this dress to between 1837 and 1842. However, its muted colors (in this case gray) mark it as the garment of a plain Friend. Trusted was English, and she wore this dress to several family weddings in Britain. Her daughter Elizabeth immigrated to the United States after her own 1852 marriage and possibly brought her mother's dress as a remembrance.

The six CCHS Quaker plain dresses made between 1850 and 1870 suggest the cloth, color, and construction choices used by Friends as plainness waned. All the dresses are silk except for one made of cotton gauze. Most are brown, although one has a pronounced red cast to the fabric. The survival of outdated construction techniques, like eighteenth-century-style seam construction and fall-front skirt closures, suggests that some dresses were made at home by hand by women familiar with outmoded techniques. None of the dresses have any trim more elaborate than a self-piped arm hole. By the mid-nineteenth century, plainness, as J. William Frost suggests, had been rejected in England as an outdated custom. In the Delaware Valley, however, divisions between the Orthodox and Hicksite branches delayed this change until the

end of the nineteenth century for the Hicksites and even longer for Ortho-
dox Friends. An emphasis on moderation in Quaker life called "simplicity"
became instead the system around which material life was organized.[51] While
elderly Friends and ministers retained traditional plain dress, other Friends
did not, modifying fashionable shapes and textile colors and patterns into
muted versions of popular styles as seen in the Sharpless family photograph
(Figure 9.4).

Plain dress was often remarked on by contemporaries in the later nine-
teenth century as a style associated with the elderly and the devout. Several
mid-nineteenth-century plain dresses at CCHS are in fact associated with
older plain women. Sydney Jeffers Way retained the style of her youth into
old age. She married John Way of Avondale at Birmingham Meeting in 1809
and died in 1882. Her brown silk dress, made in the 1850s, has the plain fall-
front skirt and eighteenth-century style seaming characteristic of her youth
(Figure 9.1). Way's unadorned dress would have contrasted sharply with the
fashions of the mid-nineteenth century in that it lacked skirt flounces, velvet
trim, or ribbon belts.

Phebe Thompson Richards's (1813–71) brown silk dress dates to
1850–70. She was a birthright Quaker and married John Richards in 1833 at
New Garden Meeting. Her dress lacks the fall-front skirt associated with
early plain construction. The bodice, flanked by three darts on either side of
the center front closure, is constructed in a style similar to the 1840s silhou-
ette but lacks the braided buttons, draped fichus, or other embellishments
often found on fashionable dresses of the period. Phebe Richards's way of
dressing plain, avoiding elaborate detailing while keeping a fashionable pro-
file, was a common one in the period in which simplicity replaced plainness.
A lack of fashionable details on sleeves, skirts, and bodices also makes dating
these dresses more difficult.

Rachel Kester Hambleton (1762–1856) married at Kingwood, New Jersey
Meeting in 1780 and later joined West Grove Meeting. Her brown silk dress,
which dates from later in her life (around 1850), like Richards's, lacks the
most traditional plain construction features. Nevertheless, her color choice
was somber. Other clothing owned by Hambleton demonstrates a consistent
avoidance of bright colors and includes a cotton apron, a mottled brown
wool cape, a dark brown printed dress, and an 1840s brown wool cape.

Clothing associated with three women Friends from the 1850s and 1860s
illustrates the challenge of dating mid-nineteenth-century plain dresses, as
well as the evolution of plainness into simplicity. Hannah Yeatman, a
birthright Quaker, married Jesse Pusey in 1859. Her brown silk dress (1865–70)
has five pleats flanking the center front bodice opening. Mary Corlies Baker

(1787–1869) married in Philadelphia in 1818. Her red-brown cotton broadcloth dress dates from 1865–70 and includes a pleated fall-front skirt. Anna Canby Smyth (1784–1867) married in Wilmington in 1815 and belonged to the Hicksite meeting there. Her red-brown cotton gauze dress (ca. 1850–70) is made with a fall-front skirt, low drawstring neckline, and eighteenth-century-style whipped seams and lining. These construction anachronisms suggest that Smyth chose to make her dresses using styles and techniques known to plain Friends in her youth in the early 1800s. The skirt lacks the extreme fullness found in later 1850s and 1860s fashionable dresses that were supported by cage crinolines. No braid or fringe trims the skirt, bodice, or sleeve, all elements that could have been found on a fashionable dress of the day. The long fitted sleeve closes at the wrist, unlike the popular fashion for bishop sleeves that flared open below the elbow in order to show off elaborately trimmed undersleeves.

Several dresses made between 1890 and 1910 further illustrate the change from plainness to simplicity in Quaker dress at the turn of the century. These dresses are similar to those worn by Westtown School students and faculty (including Ann Sharpless) in photos taken between 1890 and 1910.[52] Details of these dresses—including unusual bodice construction, pocket placement, and exceptionally lightweight textiles—are all inconsistent with features of mainstream dresses of this period.

Fashionable clothing, like the dresses and everyday shirtwaists published in *Harper's Bazaar* for 1891–98, for example, featured enormously wide balloon sleeves and full skirts that accentuated waists corseted into an hourglass shape. One published shirtwaist is trimmed on the waist, neck, center bodice, and sleeves with "cherry velvet ribbons," and skirts are finished with rows of stitching or contrasting color trim.[53] Materials were generally of heavy weight, like silk brocades and satins. Bright colors derived from aniline dyes like dark petunia, arsenic green, heliotrope, yellow, and magenta were popular throughout the 1890s, as were strong color combinations. One writer in 1892 described the popular color combinations for women's dress, concluding that "Simplicity as far as coloring is concerned is seldom thought of."[54]

Of course, simplicity was precisely what concerned many women members of the Society of Friends. The unusual appearance of the Quaker dresses, especially in light of contemporary fashions, may reflect the changed meaning of plainness in the late nineteenth century that followed from some Quakers' adoption of an evangelical stance. After the mid-nineteenth century, fewer women Friends went plain. As numbers of Friends declined, plainness became less about signaling group identity and more about

moderation and performing good works. The lack of updates to the early eighteenth-century *Disciplines* on clothing coupled with the decline of recorded actions about dress indicate that plain dress became less significant an issue—perhaps replaced by concerns about slavery, Indian rights, women's and other national issues. Plain dress was formally abandoned by British Friends in 1860, long after the practice had actually died out. In the Delaware Valley the practice began to wane after 1840, but the official rejection of plainness by both branches of meeting took another fifty years.

During the increased evangelism of the mid-nineteenth century, plainness became less "a badge of correct behavior" that fostered recognition among Friends. Plainness began to mean moderation and functionality, and the eighteenth-century sense of the plainness testimony was lost. Early nineteenth-century plain style construction details like fall-fronts were no longer used, as the generation that had preferred them had died out. While the lack of trim and ornament still characterized the clothing of some plain Friends, the lack of clothing restrictions for students at newly opened Swarthmore College suggests that the Hicksite Friends gave up the earlier meaning of plainness. Plainness thus became an extreme simplification of fashionable cut rather than a continuation of construction details associated with early nineteenth-century plain dress. Drab, "Quaker" colors were no longer the main identifier of plain dress.[55]

Small-scale patterns like dots and stripes were allowed in this simple dress. Some CCHS dresses from the period are black with conservative construction and may simply reflect the widespread nineteenth-century preference for black that was common to older devout women of any faith. This suggests that the wearers wanted to continue using conservative, possibly plain dress. One unusual dress from this group illustrates how late nineteenth-century Quaker simplicity may have looked as worn by an older woman. Jane Edge Mason's lightweight black silk dress with tiny white dots dates to 1890–1910. Although a dress like this, with its full skirt and lightweight, subtly patterned fabric, would have been extremely conservative by late nineteenth-century standards, it does have full sleeves and a rear skirt fullness that recall non-Quaker styles of the 1890s. Jane was born in Chester County in 1822, attended Westtown in 1833, and married Samuel Edge, a member of Germantown Meeting, in April 1856. By the time this dress was made, Mason would have been in her seventies and therefore more likely to have worn black according to nineteenth-century convention. However, it is not improbable that she could have worn this dress as her statement of simplicity.[56]

Some dresses have only a few features consistent with the early

nineteenth-century plain dress.[57] A few dresses, misidentified as Quaker, show characteristics of Mennonite dress such as matching capelets and were probably worn by conservative Mennonite women rather than by Quakers.[58] A tentative conclusion drawn from these dresses is that they are examples of what might be called simple rather than plain dress. As characterized by CCHS Quaker dresses made between 1890 and 1910, this type of clothing was functional and lacked fashionable trims, details, and extravagant fabric patterns. Unlike the more extreme plainness of the early nineteenth century, simple dress did not use outdated construction techniques (like the fall-front skirt) or incorporate accessories like the Quaker cap or the kerchief worn outside the dress.[59]

Colonial Revival

During the late nineteenth-century tricentennials of many Chester County towns, newspapers were filled with photos of local dignitaries portraying Quaker settlers dressed in "plain dress" handed down from an ancestor. Newspaper clippings files at CCHS, Friends Historical Library, and Haverford College are full of these images. Howard Pyle was one of many local artists using Quaker clothing as props in depictions of old Philadelphia. Pyle's paintings and Cope's photographs, using old Quaker plain dresses altered for the purpose, created a regional icon in the colonial revival that deserves further attention. Surviving 1880s photographs of Westtown students and their contemporaries at the nonsectarian Malvern School show students dressed in simple clothes that follow the overall fashionable silhouettes of the period. But later interpretations of plain dress have created confusing stereotypes of Quaker plainness that have often obscured how dress was interpreted by Friends in the late nineteenth century. The lack of detailed, mid-nineteenth-century meeting directives itemizing acceptable plain garments caused historians to misinterpret early comments about plainness. Plain dress became less familiar to younger Friends as fewer members chose to wear clothing so out of step with the world's attire. While plainness had largely been a matter of individual interpretation, many accounts of Quaker dress reinforce the stereotype that equated plainness with drab colors and eighteenth-century styles. The Hicksites, who loosened eighteenth-century interpretations of the plainness testimony in the 1870s in order to retain members, preferred simplicity in dress as a less visible separation from the world.[60] Following the Philadelphia Centennial Exposition, Quaker dress became an icon for Pennsylvania's historic past, and the so-called coal scuttle

bonnet came to symbolize plainness. Plain Friends seen in several images of the Philadelphia Centennial Exhibition stand out from the rest of the crowd in their bonnets, shawls, and full, unbustled skirts.

Beginning at this time, then, the process of retrospectively codifying "plain dress" began in earnest and continued for two generations. Gilbert Cope's photos of Chester County residents, tourist postcards showing "Quaker Homes of Old" in Nantucket, and visions of "olde" Philadelphia are all examples of how a static concept of plainness was marketed as a symbol of the colonial past. Cope's images of Friends in plain dress taken in the 1880s and 1890s, which fall into three groups, illustrate this trend. Cope documented mostly fellow Orthodox members of meeting.[61] Several images, including a 1915 copy of Albert Biles's 1898 photo of the West Chester High Street (Hicksite) Meeting Gallery, record older Friends as images of a soon-to-be-past era (Figure 9.6). Others, like the Sharpless family photos, show plain dress among different generations of families. Some images of younger women Friends are staged historical moments. These images, together with the pageant photos of costumed town bicentennials throughout the late nineteenth century, helped obscure the nuanced original meanings of plain dress. So did the use of plain Friends in paintings by Brandywine River School artists like Howard Pyle and Alice Barber Stephens. A stereotype of plainness as uniformly drab was repeated by Alice Morse Earle in her costume history of America, although she referred extensively to Amelia Mott Gummere's work. This perception of uniformity erased the individual choices made by Abby Hooper, Sarah Miller, Rachel Scattergood, and others who made plainness and later, simplicity, fit their respective Inner Truths.

Plain dress was retained in the twentieth century only among some elderly members of the Society of Friends. As plain dress became symbolic of colonial Eastern Pennsylvania and of Quakers generally, it became ossified into a limited set of colors and garments. The CCHS Quaker dresses demonstrate that plain women Friends constructed their clothing in a variety of ways. Certain common features, like the predominance of brown and continued use of 1840s-style bodice forms, make up the later 1800s simplicity that replaced plainness and remained outside of changing worldly fashion but no longer followed the eighteenth-century *Rules of Discipline.*

Chapter 10
Sara Tyson Hallowell:
Forsaking Plain for Fancy

Carolyn Kinder Carr

By April 1890, less than two decades after the devastating fire of 1871, the city of Chicago had persuaded the U.S. Congress that it had the financial resources and civil leadership to host the 1893 World's Columbian Exposition.[1] That fall, forty-three-year-old Sara Tyson Hallowell applied for the position of chief of the Department of Fine Arts for the forthcoming international fair. Hallowell, a Philadelphia native who had been a resident of this dynamic Midwestern city since her early twenties, felt confident that the significant reputation she had established in the 1880s as the organizer of large and critically well-received art exhibitions at the Chicago Inter-State Industrial Expositions made her a strong candidate. Regrettably, her decade-long experience assembling shows, which often contained more than four hundred works of art, her contacts with lenders and artists, and the support of several socially and politically powerful members of Chicago's elite were not enough. As newspaper accounts of the day made clear, her gender rendered her ineligible for this high-profile job (Figure 10.1).[2]

Hallowell was subsequently appointed an assistant chief of the art department at the fair, where she organized an exemplary exhibition of European art in American collections. In 1894 she moved permanently to France. Although she never regained the professional momentum and clout that she possessed during the previous decade, she continued to work in the field while living abroad. While she occasionally advised collectors and assisted artists with sales, her main means of support was serving as an agent for the Art Institute of Chicago. This position lasted until the beginning of World War I. Never one to be idle, Hallowell turned her administrative talents to supporting a hospital run by the Sisters of Charity in Moret-sur-Loing, a pic-

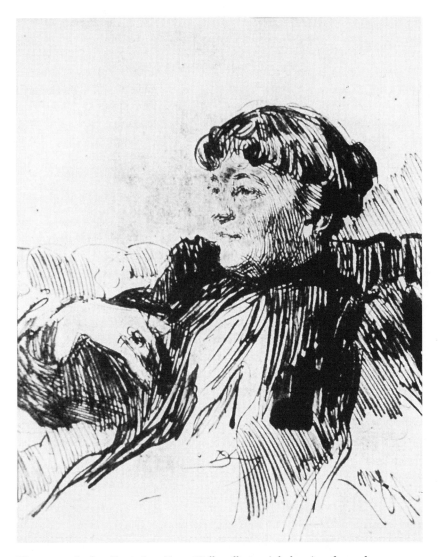

Figure 10.1. Anders Zorn, *Sara Tyson Hallowell*, 1893, ink drawing, formerly collection of Sara Tyson Hallowell, unlocated. Published in *Art Amateur* 29, 1 (June 1893): 3.

turesque village and artists' colony southeast of Paris, not far from Fontainebleau, where by about 1912 she began living year round.[3]

Hallowell's career ran afoul of gender inequities, but as a young woman she was clearly a leader in her field. Even when her role in the art world became less visible, she remained a pacesetter as a woman who supported herself using sophisticated professional rather than domestic skills. What, it is logical to ask, led her to become a pioneer in the field of arts management? Was it solely temperament? Did her heritage as a birthright Quaker play a role in shaping her choices? Or was she merely swept along by the dramatic changes taking place in the political and social landscapes that enabled numerous women to take on trendsetting roles not previously available to them? This chapter explores the various forces that may have intersected to create Hallowell's lively and innovative history.

Hallowell was born on December 7, 1846, to Caleb W. (1815–1857) and Mary Morris Tyson Hallowell (1820–1913).[4] The fourth of six children and the eldest daughter, she had deep roots in the Quaker community.[5] Her father was a seventh-generation descendant of Quaker John H. Hallowell (1602–1706), who immigrated to America in 1682.[6] Her mother traced her distinguished Quaker ancestors to both Anthony Morris (1654–1721)[7] and Rynear Tyson (1659–1745),[8] both of whom also immigrated to America in the early 1680s. Her maternal great-grandfather was Baltimore-based Quaker Elisha Tyson (1750–1824), a fourth-generation descendant of Rynear Tyson and a noted champion of African American civil rights.[9] Her broader circle of intimate family included as well the descendants of Christopher Marshall (1709–1797), a Revolutionary War supporter who was a founder of the Free Quakers.[10] Throughout her life, Sara Tyson Hallowell was in close contact with various members of the Perot family, who had likewise married descendants of Anthony Morris.[11] Although a more distant relationship, intermarriage also provided her with a tie to the Ellicott family of Maryland, prominent mill owners and direct descendants of Quaker founder George Fox.[12]

Sara Hallowell's comfortable existence in Philadelphia was first disrupted by the death of her father, a silk merchant, in January 1857.[13] A decade later the Civil War took its toll as well. Three of Hallowell's brothers served with the Union forces, and each was either wounded or permanently disabled by disease.[14] None returned to reside permanently in their birth city after the war, nor did their mother, who spent the rest of her life living in proximity to one or another of her children. In all likelihood the cumulative economic impact of these events led Hallowell to seek gainful employment in her early thirties.

By 1870 Hallowell was living in Chicago with her mother and four of her five siblings.[15] What impelled Mary Morris Hallowell to leave Philadel-

phia, where she was surrounded by an extended and loving family, and move with her children to the Midwest is not known (Figure 10.2). Likewise, little is known about Sara's life in the early 1870s. Her activities are not documented until 1878, when her name appears in the art catalog of the Chicago Inter-State Industrial Exposition—a fair established in 1873 as a symbol of the city's resurgence and civic vitality. There she is cited as "in attendance at the Art Hall to furnish information to purchasers."

Hallowell advanced rapidly in the exposition's art department. In 1879 she was named an assistant clerk and in 1880 clerk of the Art Committee. With the exception of the fair of 1886, Hallowell held this position until 1890, when the fair ceased in anticipation of the 1893 World's Columbian Exposition.[16] Her title understates her responsibilities, for it was her task to select and assemble the mammoth shows that were a highlight of this industrial fair.

How Hallowell obtained her position and why she chose this occupation remain a mystery. As the first female to make exhibition management a career, Hallowell had no ready professional role models. Nevertheless, her decision to take the job in the art department and to mold it into a position that gave her status and authority in the late nineteenth-century art world was no doubt informed by the leadership models she found in her own extended family. In addition to her great-grandfathers—Christopher Marshall, Elisha Tyson, Thomas Morris—who had been prominent spokesmen for political and social causes, relatives in both her parents' and grandparents' generation could easily have provided Hallowell with examples of management excellence. Her Perot cousins owned a prosperous brewery and ironworks; her Tyson cousins developed flour mills and railroads; her Hallowell cousins were successful merchants until they were forced into bankruptcy by the Civil War; and her great-aunts Elizabeth Marshall (1768–1836)—"the first woman in Philadelphia to engage in trade upon a large scale"—and Mary Ann Marshall (1789–1881) assembled considerable wealth, managing real estate and the pharmacy left to them by their fathers, Charles and Benjamin Marshall.[17] Hallowell must have been inspired, too, by her mother, who received national recognition for her lead role in providing charity to Union soldiers in Tennessee.[18] In her own generation, Hallowell could have observed the efforts of Anna Hallowell (1831–1905), daughter of her father's cousin and business colleague Morris Longstreth Hallowell, who was a distinguished educator and welfare worker.[19] Sarah Catherine Fraley Hallowell (1833–1914), editor of *The New Century for Woman* (the newspaper sponsored by the Women's Centennial Committee), founder and first president of the New Century Club, and an editor at the Philadelphia *Public Ledger*, was related

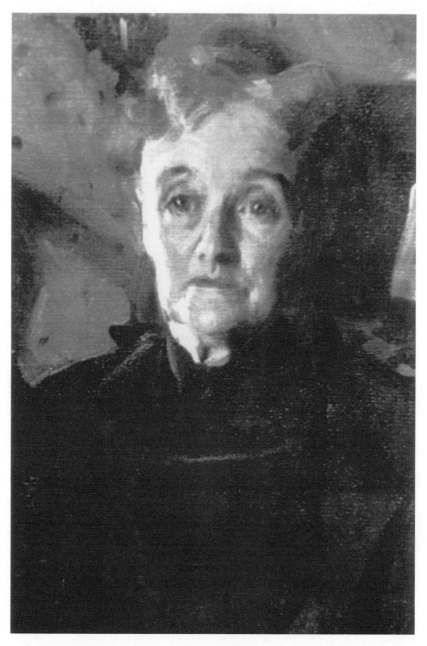

Figure 10.2. Anders Zorn, *Mary Morris Tyson Hallowell*, 1893, oil on canvas, 25" x 18". Private collection.

only by marriage, but in close-knit Philadelphia that may have been enough to provide a close-at-hand role model.[20]

Outside the confines of her Quaker family, Hallowell undoubtedly observed the significant role that numerous Quaker women played in the nineteenth century both as antislavery activists and as promoters of women's rights and suffrage.[21] Many trace the activism of Quaker women to the equality of voice—that is, the right of women to express themselves at a Quaker meeting—and to the organizational structure within the Society of Friends, which allowed women to exercise leadership through their own business meetings.[22] Presumably the Quaker heritage that shaped the dynamic leadership of these women had an impact on Hallowell's thinking and actions as well.

Although Quaker and familial examples of leadership and organization can be seen as instrumental in Hallowell's ability and willingness to assume leadership and organizational responsibilities, there is nothing in either tradition to suggest a focus on the fine arts. What, one can therefore ask, made her turn to art and exhibitions management rather than to another field of endeavor? Possibly she was inspired by the organizational role that women—both Quakers and others—played in the Sanitary Fairs, which were undertaken during the Civil War to raise funds for the Union forces.[23] The role of these volunteers, including her mother, in orchestrating this mammoth undertaking in Philadelphia in 1864 would have been readily visible to a perceptive eighteen-year-old.[24] Hallowell's whereabouts in 1876 are not known, but it is not unreasonable to assume that she returned to Philadelphia, where numerous relatives still lived, to visit the centennial, the first major international exposition, or world's fair, held in America.[25] But whether she toured the site or merely read about the centennial from afar, the role of women in coordinating this event, particularly the exhibition of women's art, would not have escaped Hallowell's attention.[26] It is also possible that the male Art Committee's willingness to entrust the major Inter-State Industrial Exposition task to a young women was conditioned by their awareness of the successful way women had managed sanitary and other fairs.

We do not know whether Hallowell had any artistic talent or training that might have also qualified her for the job in the art department at the Inter-State Industrial Exposition.[27] But the impact of Philadelphia's rich artistic environment on a receptive young woman should not be discounted. Within a few blocks of her home and those of her extended family was the Pennsylvania Academy of the Fine Arts, where art was both taught and displayed. Commercial galleries and artists with nationally recognized professional reputations, who commanded the interest and respect of educated

citizens, were likewise a familiar sight.[28] Moreover, an interest in art—or at least the desire to have a portrait made—was a tradition within both her immediate and extended families. Her great-grandfather Elisha Tyson, her grandfather Elisha, Jr., and her father had their portraits painted (Figure 10.3,

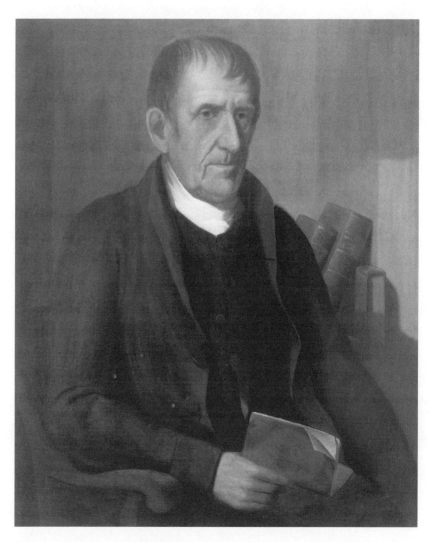

Figure 10.3. Robert Street, *Elisha Tyson*, ca. 1823, oil on canvas, 32" x 26". National Portrait Gallery, Washington, D.C.

Plate 20).[29] Her great-grandfather Thomas Morris (1774–1841), a member of the Association of Artists in America, sat for Thomas Sully in 1825 (Figure 10.4).[30] In addition, various members of her grandmother's generation were patrons of the Peale Museum and had their silhouettes cut.[31] As a group, however, these portraits were modest in size and style and thus quite acceptable for Quakers with "plain taste."[32]

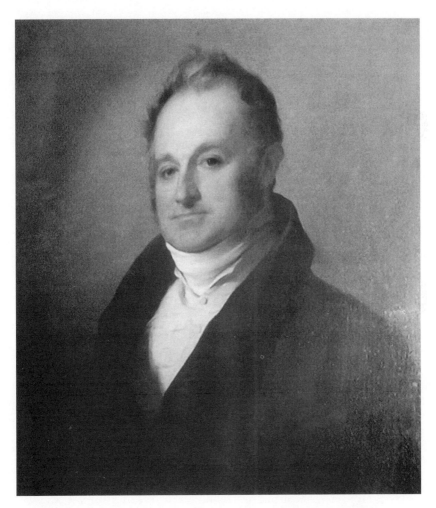

Figure 10.4. Thomas Sully, *Thomas Morris Perot,* 1825, oil on canvas. Private collection.

If one can see threads in Hallowell's Quaker heritage and family back-ground that might have influenced her and her career choice, other as-pects of this choice and the way she implemented it are not particularly Quaker-like—at least in the customary sense. Hallowell clearly eschewed a life devoted to traditional "good works." She was not an advocate of social re-form, she promoted no charitable causes, and she had no interest in teach-ing, a traditional occupation for many nineteenth-century women with financial constraints, Quaker or not. Only if one couches her decision in the context of the rhetoric of the times, which extolled the moral mission of art and its role as a "powerful agent for the cultivation and enlightenment of man," is it possible to see her choice as motivated by serving the great good of humankind.[33]

Hallowell's lifestyle in the 1880s was also not a "plain" one. Her 1886 portrait by Mary MacMonnies, which was painted in the artist's Paris studio when Hallowell was forty, shows an elegantly dressed subject having tea (Plate 21). Her dress and demeanor suggest a woman accustomed to the most fashionable echelons of society. Portraits by Mary Cassatt or Julius Le Blanc Stewart of the well-to-do having tea make ready comparisons.[34] Hallowell clearly relished the perquisites of an upper-class way of life, although any tendencies toward lavish living were limited by the fact that she was a single woman supporting herself in a field that has traditionally paid modestly. If there is a Quaker model in her choice of the fancy or "gay" rather than plain, it would be those late nineteenth-century Quakers who increasingly saw no discrepancy between their religious values and the enjoyment of the luxury goods their success in the mercantile world afforded them.[35] Foremost among family members who might have served as an example was her mother's cousin and her mentor, T. Morris Perot (1844–1902). From his com-fortable city and country residences, he reconciled his prosperous lifestyle and the tenets of his religion through charitable donations and service on community boards.[36]

Hallowell presumably enjoyed the contacts afforded by her position at the Inter-State Industrial Exposition. Through her job she met numerous wealthy collectors. In the 1880s, as clerk of the Art Committee, she reported to men such as James H. Dole, Charles L. Hutchinson, Potter Palmer, Edwin Lee Brown, Henry Field, and Charles B. Farrell, a veritable who's who of Chicago's civic and social leadership and quintessential representatives of the Gilded Age.[37] She probably met her most important patron, Bertha Honoré Palmer, through her husband, real estate magnate Potter Palmer, who had long been affiliated with the Inter-State Industrial Exposition and was a member of its executive committee in 1879 when Hallowell first assumed the

job of assistant clerk.[38] Their friendship, which lasted until Mrs. Palmer's death in 1918, was most intense in the late 1880s and early 1890s. Hallowell frequently advised Mrs. Palmer both on her growing contemporary art collection and on the art for the Woman's Building at the 1893 fair.[39] In 1891 Hallowell became the Palmers' official art agent in France. Not only did she introduce her benefactor to significant artists such as Claude Monet, but it was she who recommended Mary MacMonnies and Mary Cassatt as muralists for the Woman's Building.[40] As Hallowell wrote to her second cousin T. Morris Perot, Jr. (1872–1945) in 1921, "the news of Mrs. Palmer's death was a great shock to me. . . . I owe much that has been wonderful in my life to her. . . . With her, I have met kings and queens and talked with them. This fact, wonderful though it is in a way for a plain mortal like me, is not the one that will loom up forever in connection with Mrs. Palmer, the most wonderful woman I ever knew."[41]

Hallowell often approached leading collectors of the day, asking them to lend paintings and sculptures to the inter-state art exhibitions. Her initial introductions to prominent Philadelphia collectors were provided by her relative Thomas Morris Perot. In 1913 she wrote to his son, T. Morris, Jr., and with Quaker phrasing customary in her letters to him, reiterated her gratitude toward his father. "Thee knows, I hope, that it was thy dear father who gave my work such an impetus. I was a novice at it all and he wrote letters introducing me to distinguished or well-known Philadelphia gentlemen-collectors. That was the beginning of my successful work, all of which I owed to his loving interest."[42] In 1879, she appears to have used her Philadelphia connections to secure loans from W. B. Bement, Fairman Rogers, and E. B. Warren, each of whom lent several European works to that year's inter-state show.[43] In the 1880s other Philadelphia collectors who responded positively to her entreaties for loans included Thomas A. Scott and Mrs. E. M. Furness. Among the Chicagoans who lent were committee members Dole, Hutchinson, Potter Palmer, and A. F. Stevenson, as well as Chauncey J. Blair, N. S. Bouton, Walter Cranston Larned, Thomas S. Phillips, William C. Stephens, George Mason, and C. C. Collins.[44] In 1887 Hallowell extended her reach and persuaded Brooklyn-based George Seney to show more than one hundred European and American works from his collection.[45]

Hallowell also knew the major dealers of the day. She did not hesitate to borrow from the Paris firm of Durand-Ruel, which also had a New York branch; from M. Knoedler's, a New York firm with strong ties to Europe; and from the Boston firms of Doll and Richards and Williams and Everett. She also arranged loans from major arts organizations such as the New York Etching Club and the Society of American Artists. Selecting works for her

shows also put Hallowell in touch with leading artists of the day, both European and American, including French painters Adolphe-William Bouguereau and Charles Emile-Auguste Carolus-Duran and Americans William Merritt Chase, Thomas Eakins, Winslow Homer, George Inness, Theodore Robinson, and Albert Pinkham Ryder, to mention only a few randomly chosen examples.[46] Hallowell seemingly reveled in the travel both to the east coast and to Europe that her job necessitated.

If "small," "modest," and "simple" are words often associated with the Quaker taste in art, particularly earlier in the nineteenth century, these are not words one would necessarily apply to the paintings Hallowell exhibited.[47] Whether landscapes, genre, figure studies, or religious and historical narratives, the works she selected were ones that would find a welcome place in any Gilded Age mansion. In 1883 Hallowell sought to cater to collectors by bringing to the Midwest works by Americans who had won prizes at the Paris Salon, then the art world's most distinguished juried exhibition.[48] That year she imported fifteen paintings, among them the much discussed *Les Amateurs* by Alexander Harrison.[49] Hallowell repeated this triumph again in 1884, with another fifteen paintings from the Salon that had been featured, for the most part, in that year's spring display.[50] The significance of her efforts is reflected in the accolade for her 1885 exhibition that appeared in *Art Amateur*: "Largely due to the personal efforts of that extremely intelligent and energetic lady, Chicago this year has anticipated New York, Boston and Philadelphia in exhibiting the important American pictures from the last 'Salon.' "[51] Hallowell was also complimented for showing Dannat's famous Spanish tavern scene *The Quartet*. It had been shown in New York at the Shaus Gallery and the dealer, its owner, the reviewer noted, had asked $1,000 to lend it. Hallowell, ever the entrepreneur, charged a special admission fee of ten cents to meet the extra expense. "Bravo, Chicago! and particularly bravo, Miss Sara Hallowell!"[52]

Hallowell also did not hesitate to feature the work of women artists. In the 1880s an increasing number of women attended art school in America, went abroad to study, and participated in juried exhibitions.[53] Hallowell's shows reflected this new professionalism among women artists. Paintings by Ellen K. Baker, Kathleen Greatorex, May Hallowell (a distant cousin), Mary Fairchild MacMonnies, and Anna Lea Merritt were an integral part of her exhibitions.[54] As always, Hallowell's discriminating eye was central to the process of selection. She did not support these women just because they, like her, were breaking new ground. She was keenly aware that there were strong and weak artists among women as there were among the men in the field. Indeed it was this awareness of the relative merits of various women artists that

made her caution Bertha Palmer in her role as Chairman of the Board of Lady Managers for the World's Columbian Exposition against the concept of a Woman's Pavilion at the 1893 fair. "There are," she wrote to Palmer in January 1891, "too few fine women artists to warrant their making a COLLECTIVE exhibition worthy to compete with their brothers."[55] She also knew that ambitious females wanted their work compared to that of their male counterparts: "No woman artist of *ability* would I believe be willing to have her work separated from the men's."[56] Hallowell could, as well, be speaking of her own work and career.

Most of the American artists that Hallowell showed in the Inter-State Industrial Expositions—women as well as men—would again be featured in the Art Pavilion at the 1893 World's Columbian Exposition, where the announced intention of the organizers was to show the best that America had to offer.[57] Not only had Hallowell had been the first in the Midwest to show many of these artists, but often specific works she had chosen for display, such as Frank Benson's *Girl with a Red Shawl* (Museum of Fine Arts, Boston), William Merritt Chase's *Lady in Pink* (Rhode Island School of Design, Providence), Robert Koehler's *The Strike* (Deutsches Historisches Museum, Berlin), Gari Melcher's *The Sermon* (Smithsonian American Art Museum, Washington, D.C.), Stacy Tolman's *The Etcher* (Metropolitan Museum of Art, New York), Robert Vonnoh's *Fais le Beau* (private collection) and *November* (Pennsylvania Academy of the Fine Arts, Philadelphia) were selected for the 1893 show.[58]

In 1890 Hallowell produced the most radical of all her inter-state exhibitions. In addition to displaying the works of American artists, she showed paintings by such leading French impressionists as Jean-Charles Cazin (2), Edgar Degas (1), Claude Monet (6), Camille Pissaro (4), Pierre-Auguste Renoir (3), and Alfred Sisley (4), all of which she borrowed from the Durand-Ruel Gallery.[59] To present these cutting-edge artists in the last Inter-State Industrial Exposition was an act of intellectual and personal daring. Today these individuals are, with perhaps the exception of Cazin, household names, but in the last decade of the nineteenth century they were known only to a handful of the most sophisticated art connoisseurs. These works reflect an aesthetic preference that was not timid, constrained, or traditional. Hallowell was on the cutting edge of a taste shared at the time by only a limited number of American collectors. Alexander Cassatt, Louisine Havemeyer, Bertha Palmer, and John Graver Johnson, a Philadelphia lawyer of Quaker origins, are among those that come to mind.[60]

Hallowell's confidence in her ability to organize major exhibitions and her sense that she was a major player in the contemporary art world led her

to apply for the position of director of the American art exhibition at the 1893 World's Columbian Exposition. She did not hesitate to call on her art world contacts to support her petition. At the October 23, 1890, meeting of the selection committee, a petition signed by Henry Marquand (then president of the board of trustees of the Metropolitan Museum of Art and a noted collector) and "other well-known lovers of art" was presented advocating Hallowell as director of fine arts at the fair.[61] Patron and collector Thomas B. Clarke wrote in support of her application, saying "that if a manageress of the Exposition is to be chosen, Miss Hallowell among women applicants is first choice. She has a good knowledge of pictures and knows how to collect and sell some."[62] In addition, the committee received a petition signed by seventy-five leading American artists, including William Merritt Chase, Augustus St. Gaudens, and numerous others whom Hallowell had shown in the inter-state exhibitions.[63] Moreover, Bertha Honoré Palmer, at that time chairman of the fair's Board of Lady Managers, waged a six-month campaign on Hallowell's behalf.[64] Regrettably, this was to no avail. As the committee noted at its initial meeting, "the general trend of opinion seemed to be that, owing to the fact that Miss Hallowell was a woman, such a position could not well be filled by her."[65]

Halsey Ives, director of the St. Louis Art Museum, was appointed director of American art at the fair. Both politically astute—he undoubtedly knew it would be advantageous to have a cordial relationship with Bertha Palmer—and practical—he knew that Hallowell was both a knowledgeable connoisseur and a capable administrator—he persuaded her during a multimonth correspondence to become, along with Charles Kurtz, an assistant director of art at the fair.[66] The biggest stumbling block during the protracted negotiations with Ives was her salary. Hallowell insisted that she be paid $3,000 for her services (the salary given to Kurtz for his), not the $2,500 originally offered. "My circumstances do not warrant my considering patriotic motives," she wrote from France, "and as my personal expenses can hardly be less than $3,000 a year, and as I am in a position to earn more than this amount in another channel than that of the great Exposition, I must abandon the idea of connection with a work in which, naturally, I would have taken much pride." Ultimately, the fair's board of control and Ives acquiesced.[67] Hallowell's frankness and tenacity regarding financial issues are another indication that she was a woman who not only defied the stereotype often associated with females—particularly those in the nineteenth century—but one who was ahead of her time in demanding equal pay for equal work.

Hallowell's task at the fair was to arrange an exhibition of foreign mas-

terpieces from major American collectors. Hallowell's vision was to create a loan show that focused on the previous half-century of French art.[68] This exhibition, which began with examples of the work of Eugène Delacroix and Jean-Baptiste-Camille Corot and included paintings by Manet, Degas, Monet, and Alfred Sisley, was a visual explanation of Impressionism and its sources. In retrospect, it was a daring concept, but it was built on her deep understanding of recent art history. It again made use of her numerous ties to important collectors. Among the willing lenders were John G. Johnson and Alexander Cassatt of Philadelphia, Mrs. S. D. Warren and Henry C. Angell of Boston, and Henry Marquand, Alfred Corning Clark, and Mrs. Henry O. Havemeyer of New York. Chicago lenders included Henry Field, R. Hall McCormick, Charles T. Yerkes, and Martin A. Ryerson. After several entreaties Hallowell was also able to persuade the Potter Palmers to lend thirteen pieces, including works by Corot, Camille, Jean-François Raffaelli, and Sisley.[69] If the goal of the show organized by Charles Kurtz was to display the ample talent of contemporary American artists, Hallowell's goal was to reveal the sophistication of American collectors. Whether consciously or otherwise, Hallowell may also have used this exhibition to justify her recommendations of art and artists to Bertha and Potter Palmer as she assisted them with the formation of their collection.

As with her inter-state exhibitions, Hallowell received rave reviews for her show. The critic for the *Chicago Herald* wrote: "Thanks to the liberal public spirit of so many owners of fine pictures in the United States and to the expert zeal and diligence of Miss Hallowell, the ablest person connected with the fine arts department, the rooms in which the borrowed pictures are hung furnish a perfect foundation for the history of Impressionism."[70] The Boston *Daily Evening Transcript* declared, "The only thing that makes you feel any respect for the French is their collection of French pictures owned in America, got together by Miss Hallowell, which includes the finest pictures in Chicago today."[71]

In spring 1894, after she had shipped the last borrowed painting to its owner, Hallowell returned to France. Her first stop was a visit to Mary Cassatt at her mother's home in at Cap d'Antibes.[72] Hallowell probably returned to Europe for a variety of reasons. Foremost among them may have been the fact that Paris was then viewed as the center of the art world, much as New York is today a magnet for those in the field. Hallowell also had numerous friends in this cosmopolitan city and the cost of living was less. Initially, her main means of support was as an agent for the Art Institute of Chicago. Her close friend William M. R. French (1843–1914), who was director of the Art Institute, asked her to work with American artists living abroad and arrange

for their works to be sent to the museum's annual exhibition of American art. This working relationship lasted until French's death.[73]

In about 1912, Hallowell gave up her Paris apartment and purchased a small house in Moret-sur-Loing, a town to which she had often made extended visits. She lived out her life there with her mother, who died in 1913, and her niece Harriet (1873–1943), an artist who was known for her miniatures.[74] With the advent of World War I, Moret-sur-Loing, which was near a main interchange of train lines, was transformed from a tourist center and haven for artists into a refuge for wounded and battle-weary soldiers. From the letters written to her cousins T. Morris Perot, Jr., in Philadelphia and Anthony Morris Tyson (1866–1956) in Baltimore, it is apparent that Hallowell turned her well-developed administrative talents to assisting the sisters who ran the Hospital Auxiliaire no. 26. Fund-raising became a primary task.[75] Quakers, both her cousins and others, were her main source of funds. Thus, at the end of her life Hallowell turned to her Quaker connections and her Quaker heritage, using its traditional notion of service for the common good to shape her life.

In retrospect, Hallowell's genius, although undoubtedly motivated as much out of economic necessity as philosophical conviction, was to marry her Quaker roots and family traditions with the myriad social and intellectual changes taking place in the late nineteenth century and fashion a life that was ahead of its time. It was a life that would also speak to future generations, both Quaker and otherwise.

What's Real? Quaker Material Culture and Eighteenth-Century Historic Site Interpretation
Karie Diethorn

A Quaker from Carolina, who, going to dine with one of the most opulent [Friends] at Philadelphia, was offended at finding the passage from the door to the staircase covered with a carpet, and would not enter the house; he said that he never dined in a house where there was luxury; and that it was better to clothe the poor, than to clothe the earth.[1]

Published in the late eighteenth century, this impression of a Philadelphia Quaker home might describe the preconception of today's visitor to an historic house museum that interprets the lives of its past Quaker occupants. This popular definition of Quakerism generally lacks an understanding of Quaker philosophy (the concept of Inward Light) and its moral code (simplicity, truth, harmony, equality). Instead, museum visitors frequently recognize only a few (if any) isolated aspects of Quaker behavior: the use of familiar forms of address in "thee" and "thou," the refusal to remove a hat as a sign of respect, the refusal to swear oaths in God's name, and the practice of pacifism. Among the most popular modern beliefs is one that identifies "plainness" in dress and surroundings as representative of Quakerism's quintessential nature. Apparently, the expectation that the material life of early Society of Friends members should be recognizable as austere and humble, not luxurious and urbane, influences many museumgoers.

For some time, the degree to which restored sites have met public expectations of the "truth" about history has been under scholarly scrutiny. Happily for historic sites, the public report that their visits are like "experiencing a moment from the past almost as it had originally been experienced."[2] This experience certainly relies on the strong authority of accuracy

perceived in a historic site's three-dimensional reality; even though the historical people are absent from the scene, their world remains for modern visitors to study. And to interpret this reality, some visitors rely on personal observation to make their new experience relevant. Much of this observational knowledge comes with visitors; issues in their own lives can provide the framework for their understanding of the past. And most sites acknowledge this by presenting a combination of important historic events within their contemporary context as a way of relating to many visitors' personal concerns in their own time.

Beyond such obvious hurdles to visitor understanding of the past as evolving technology or political systems, there are complex and subtle aspects to every past place that represent the daily expression of what mattered to the people who lived there. Rules for social interaction, mores, and definitions of taste are generally unique to their time. Although elements of them may be familiar to people in a later era, historic societies can inspire many more questions in visitors' minds than they do answers. Often misinformation and oversimplification (on both the public's and the site's part) can confuse visitors about the historic place they are studying.

This essay looks at the recreations of eighteenth- and early nineteenth-century Quaker life at three southeastern Pennsylvania sites (Stenton, Cedar Grove, and the Todd House) to inquire whether certain objects materially can and should represent Quaker ideals when displayed in a restored historic setting. Initially, the essay examines what many visitors to historic Quaker sites might expect to see and why they might expect to see it. Following this is a discussion of how the three specific sites have addressed these suggested expectations, and whether their interpretive programs provide visitors with meaningful and accurate information about the past. The essay concludes with some thoughts about the relationship between Quakerism and the other cultural themes presented at the historic sites in question.

Non-Quaker assumptions about the Society of Friends expressing material austerity stem from both accurate and extrapolated evidence. Certainly mid-seventeenth-century Quakers dressed in somber clothing that contrasted markedly with the sumptuous attire of Stuart England's gentry. As the eighteenth century progressed, however, the popular concept of Quaker plain dress fell out of step with the reality of Quaker experience. This was particularly true in colonial Pennsylvania, where Quakers had attained significant political and economic status. As a result, many wealthy Philadelphia Quakers had the financial means to purchase homes, household furnishings, and clothing of high-quality materials in the latest fashion.[3] Despite this cultural development, the then contemporary public's image of the drably clad

Quaker remained current. One widely circulated example of the strength of this parochial image lay in Benjamin Franklin's carefully crafted presentation of himself as an unassuming colonial amateur visiting the opulent court of Louis XVI in 1777:

Dr. Franklin, who arrived a short time ago from the English colonies . . . lives in seclusion which is said to be prescribed by the government. This Quaker wears the full dress of his sect . . . fur cap which he always wears on his head, no powder, but a neat appearance. Extremely white linen and a brown habit are his sole ornaments.[4]

Franklin, who was never a member of the Society of Friends, used a visual trope to assure the French government that his presence there on behalf of the American Revolutionary War effort was an honest and simple one. In part, he owed his subsequent diplomatic success to the perception that Quaker plainness connoted individual (and collective) sincerity.

Like their predecessors in Franklin's time, the modern public continues to identify Quakers as living within a historically simple material world. This may be due in part to an error in association. Quakerism's central theological tenet (individual enlightenment through direct communion with God), when imperfectly understood, may seem akin to the religious practice of other eighteenth- and nineteenth-century Protestant sects. For example, the Shakers' gender separation and communal economics formed no part of the religious practice of the Society of Friends. However, popular association of the two groups in their outward appearances (for example, dress) and generalized philosophy (for example, piety) might popularly occur. As a result, the Shakers' readily identifiable material aesthetic (described by a nineteenth-century observer as one in which a chair was constructed as though "an angel might come and sit on it")[5] can be accurately associated with their religious philosophy but incorrectly extended to Quakers by a loosely informed museum-going public.

To a certain extent, past scholars may have unintentionally contributed to popular confusion about the nature of Quakerism's material world. Frederick B. Tolles's seminal essay, " 'Of the Best Sort But Plain': The Quaker Esthetic," used a 1738 Pennsylvania Quaker's characterization of the furniture he wanted to buy as a material representation of what Tolles called "the Quaker merchant's practical resolution of the conflict between his Quaker instincts and his sense of status in society." Subsequent authors also quoted early eighteenth-century Quaker *Rules of Discipline*, which cautioned Society of Friends members about "ye Excess of Apparell and Furniture." However, these scholars suggested that literal interpretation of words like "Plain" and

"Excess" ignored the contemporary context of the predominantly non-Quaker world in which Friends lived. In addition, scholars cautioned that although Quakerism defined the relationship between spiritual integrity and its outward manifestations (for example, behavior) as being in the eye of the beholder, this definition was fraught with "inherent ambiguity."[6]

Acknowledging the danger in contextually isolating and conceptually simplifying the subtlety of the Quaker aesthetic, scholars continue to reexamine the few historic sources that address Friends' views on the subject of Quaker material culture. Susan L. Garfinkel suggests that Quakers themselves never specifically defined "plainness" because its meaning was already self-evident in the totality of the Society of Friends belief system. And Patricia J. Keller terms her use of the 1738 quote popularized by Tolles as "ironic and confrontational" in order to focus attention on the more complex individual (or "situational") expression of the Quaker group dynamic.[7]

With visitors expecting literal representations of the past and academics warning against oversimplifying that past, how do historic Quaker sites interpret material life? Fundamentally they address the same questions that non-Quaker sites do: How extended is the time frame interpreted at the site? How much specific primary source (documentary and material) evidence is available? How do the site's geographic locale (for example, urban or rural), occupant socioeconomic status (for example, trade or profession), and family structure (for example, old or young, large or small) change over time and affect the interpretation of the primary source information?

The familiar association of the Society of Friends with the founding of Pennsylvania ensures that historic sites in the state's oldest areas of settlement draw the public's attention to the subject of Quakers. Three particular Philadelphia sites represent a range of eighteenth- and nineteenth-century Quaker occupants from an early provincial governor to a pre-Revolutionary family to young residents of the new national capital. Each site uses historic documentation to identify and explain the relationships between the objects and their original owners.

Stenton, completed in 1730, is a three-story "plantation" situated approximately five miles north of central Philadelphia. Stenton's original owner, James Logan (1674–1751), immigrated to Pennsylvania in 1699 in the service of the colony's proprietor, William Penn. During the next fifty years Logan built a merchant fortune, political power, and the Georgian-style brick Stenton, where he housed a growing family that included his wife, son, and daughters. A scholar of classical literature who spoke seven languages (including several American Indian dialects), Logan represented one of Pennsylvania's most erudite and cosmopolitan men. He purchased both fine

English- and Philadelphia-made furnishings for Stenton, adding to them his unparalleled library and collection of scientific instruments. Logan and his heirs, son William (1718–1776) and grandson George (1753–1821), who adapted Stenton's contents to their own families' subsequent needs, all espoused membership in the Society of Friends.[8]

Stenton's preservation as a historic house museum began in 1899. In that year, the National Society of the Colonial Dames of America in the Commonwealth of Pennsylvania (NSCDA/PA) accepted management of the site from the Logan family. The NSCDA/PA, led by Mary (Mrs. Samuel) Chew of Germantown, repaired the house and installed in it a variety of antiques to create a colonial ambiance for the story of Pennsylvania's founding. Stenton's first interpretive program also featured James Logan's role in the colony's political history and an associated story on the life of Logan's granddaughter-in-law, Deborah (Mrs. George) Logan (1761–1839), who collected James Logan's papers and collaborated with John Fanning Watson on his history of Philadelphia. After the Logan family sold Stenton to the City of Philadelphia around 1910, the NSCDA/PA continued to administer the property as a public museum. In subsequent years, the interpretive focus at the site narrowed to that of the Logan family's earliest generations. The NSCDA/PA solicited documented furnishings and personal effects from the Logan descendants and researched the building's construction. Today the public can visit the house for a program that emphasizes aspects of James Logan's political and cultural life in two floors of rooms furnished to his occupancy with occasional objects from subsequent generations added (Figure 11.1).

Just before Logan's death, Elizabeth Coates Paschall (1702–1768) built her family's two-and-one-half-story stone summer retreat Cedar Grove in Frankford (what is now northeast Philadelphia) in 1748–50. A widow with three children, Paschall ably managed her husband's dry goods business, passing Cedar Grove on to her unmarried daughter Beulah (1732–1793). Beulah's niece and her husband, Sarah (1772–1842) and Isaac Wistar Morris (1770–1831), enlarged the house in 1798–99. Nine of Sarah and Isaac's eleven children reached maturity, and they all returned regularly to the house with their own families. The Quaker Paschalls and Morrises filled Cedar Grove with comfortable furnishings reflecting their families' changing requirements.[9]

In 1928 the City of Philadelphia moved Cedar Grove west to Fairmount Park for restoration as a museum. Two years earlier, Lydia Thompson Morris (1849–1932) had given the building and many of her family's furnishings (some of them once used in Cedar Grove) to the city for the Philadelphia Museum of Art. During the next few decades the museum restored the house

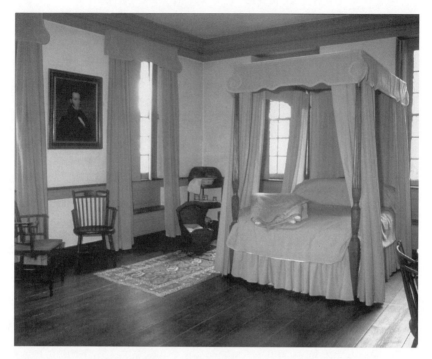

Figure 11.1. Gold lodging room, ca. 1740, Stenton, Philadelphia. Courtesy The National Society of The Colonial Dames of America in the Commonwealth of Pennsylvania at STENTON, Philadelphia.

and installed Miss Morris's collection in it according to her suggested arrangement. At that time, interpretation of Cedar Grove and its contents focused on American decorative arts history. More recently, the museum (using the Morrises' extensive family papers) has reinterpreted the house to its late eighteenth- and early nineteenth-century history. Reinstalled on two and a half floors of the building are furnishings (over 80 percent of which have Morris family provenance) to represent its occupancy by the family's first three generations (Figure 11.2).

In 1791, a few years before the Morrises enlarged Cedar Grove, newly-weds John (1763–1793) and Dolley Payne (1769–1841) Todd, Jr., bought their three-story brick row house on the northeast corner of Philadelphia's Fourth and Chestnut Streets. Both from Quaker families, Todd (an attorney) and his wife reared two young sons in their well-furnished home before John's sud-

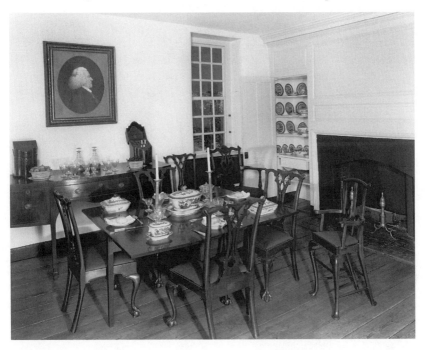

Figure 11.2. Dining parlor, ca. 1795, Cedar Grove, Philadelphia. Courtesy Philadelphia Museum of Art.

den death and Dolley's subsequent remarriage (to Virginia Representative and future President James Madison) dissolved their household.[10] The Todds' brief residence in the house coincided with the early years of Philadelphia's history as the capital of the United States.

Conceived of as historic shrines to America's eighteenth-century founding, the buildings in Independence National Historical Park (including the Todd House) expanded the National Park Service's resources to include both public and private structures. Independence, created by act of Congress in 1948, established the Todd House as a suitable property for inclusion in the park due to the building's relatively intact physical fabric and to the historic significance of its early occupant Dolley Payne Todd (later Madison). Built as part of a speculative venture in 1775, the Todd House held a variety of tenants, both private and commercial, during its existence. The National Park Service conducted extensive physical and documentary research on the building during the late 1950s and early 1960s in order to restore it to the

period of the Todds' occupancy. None of the Todds' Philadelphia furnishings are known to survive. However, a studied comparison of John Todd's inventory (cursory, due to its execution following the chaos of a virulent yellow fever epidemic) with those of twenty-two Todd contemporaries from various occupations and age groups and of Todd's father (who died in the same year as his son) establishes a context for the Todd household. The house opened to the public just prior to the 1976 bicentennial, and now visitors tour two furnished floors of the Todds' 1791–93 restored residence (Figure 11.3).

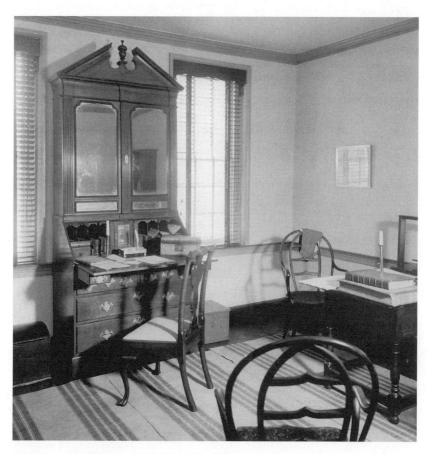

Figure 11.3. Law office, Todd House, Philadelphia, 1790–93. Courtesy Independence National Historical Park, National Park Service.

Beyond describing basic chronologies of building construction and residential occupation, the interpretation at each of the three historic sites includes various levels of complexity in detail and scope. Estate inventories for James and William Logan, Elizabeth Coates Paschall and Isaac Wistar Morris, and John Todd, Jr., and Sr. provide specific references for the range of furnishings and their placement in the respective houses (at least at the time of each owner's death). More detailed in the surviving documentation are the historic accounts of daily activities: children playing, daughters being courted, illnesses treated, housework completed, and business conducted at the individual sites. As a result (and because both site interpreters and the public most readily identify with them), the themes of family and work hold center stage in the interpretation presented at these museums. And although specific site documentation may be lacking, the impact of mainstream political events and social forces on each of the families also flows relatively easily through interpretive extrapolation. As a result, both mundane and contextual themes (as represented by combinations of material and anecdotal evidence) are fairly apparent to site visitors.

Compared to contemporary examples in England, Stenton was a rather modestly sized country house. But to its Delaware Valley neighbors Stenton and its contents represented a significant investment of capital and taste. When local quarries were unable to provide the stone Logan originally wanted as a cost-cutting measure, he used brick to build a large and fashionable house with features based on current architectural design books. Furnishings for the house then (and today) included several sets of matching chairs, silver and porcelain, wool damask upholstered easy chairs and window seats, draped beds, and the largest library in the American colonies. When fellow Quakers called the building improperly ostentatious, Logan replied that "Riches have been shewn, to be the natural Effects of Sobriety, Industry and Frugality." Logan further expressed confidence in his prerogative to live elegantly by having his portrait painted by local artist Gustavus Hesselius. Although absent from the 1752 estate inventory, Hesselius's portrait of James Logan hangs at Stenton today in the form of a nineteenth-century replica.[11]

Designed and altered by successive Morris generations, Cedar Grove was built to serve the resident family's health and comfort. The large 1799 kitchen features a built-in cupboard with glass-paned doors for keeping dishes and foodstuffs clean and dry. Morris family women prepared homeopathic medicines here, as well as preserving fruits and vegetables, and the presence of an array of kitchen equipment suggests it. Throughout the rest of the house numerous closets for clothing and linens suggest that textile main-

tenance consumed considerable time at Cedar Grove. An ironing table stands in a small room next to the dining parlor, contrasting the presence of heavy sad irons with that of delicate Chinese export porcelain. Upstairs, a small room with a low bathing tub, dressing tables, and looking-glasses illustrate the family's personal care activities. Despite its rural setting, Cedar Grove also provided a comfortable and tasteful setting for guests; the dining and front parlors contain furniture made by Philadelphia craftsmen, a monumental silver tea urn, and mahogany knife boxes all according to popular taste.

At the Todd House, the interconnectedness of family life and public business is evident. With immediate access from the street for clients, the first floor front room served as John Todd's law office. The room's contents, including a secretary desk and bookcase and a two-hundred-volume library, reflect the investment made by the family in its patriarch's profession. Todd's legal skill had earned him the right to practice before the United States Supreme Court (which met a block away from his home), a distinction that promised increased business and profit. The juxtaposition of the law office in the first floor front room and the family parlor across the narrow entry hall serves to illustrate the potentially close association between Dolley Todd's domestic responsibilities and her role as her husband's informal business associate. The multipurpose parlor, with its sideboard and creamware dishes, served as Mrs. Todd's workroom, schoolroom, and dining area during the day while her husband worked in his office. Throughout the Todds' home, furnishings for comfort—leather- and cloth-covered chairs, carpeted floors, venetian blinds, and window curtains—represent the Todds' professional income level. Decorative, though educational, elements are also present; the 1793 John Todd, Sr., inventory lists two maps and five framed prints. This reference to printed items has been interpreted in the refurnished Todd House as a map, a set of allegorical prints, and an engraving of Benjamin West's *Penn's Treaty with the Indians.*

In the hierarchy of furnished historic house museums, the three sites discussed here represent a range of interpretive philosophies. Stenton, the oldest of the three, retains residual evidence of its creation as a patriotic shrine. The NSCDA/PA celebrated Pennsylvania's founding by restoring Stenton and establishing the Logans as one of the state's first families. To a certain extent, the presentation at Stenton today continues to project elements of ancestor worship through the display of Logan family relics (for example, family clothing). A different interpretive quality governs Cedar Grove. This site interprets the longest time period of the houses studied here and seeks to incorporate several generations of one family into its story. As a

result, different eras are depicted in individual rooms of the house. This type of interpretive approach fosters eclecticism in the selection and arrangement of historic objects. A third kind of program characterizes the Todd House. This structure has the least surviving amount of historic documentation of those studied, and no original furnishings survive. Consequently, interpretive extrapolation is most evident in this house's refurnishing.

In effect, the Todd House presents a rather typical urban, professional home of its era. Museum tours of the Todd House begin in the building's kitchen, located at the back of the structure. An open hearth dominates this small room (approximately ten feet square), which contains a variety of wrought-iron cooking equipment and two worktables. A winding stair leads to a second-floor chamber furnished with a low post bed, chest of drawers, simple desk, and side chair. Up a step into the next room is a bedchamber with chimney breast closets surrounding the hearth and with furniture of a moderate quality—a high post bed, dressing table, and small tea table. Next to this room is a short hallway with a closet-like alcove containing a blanket chest and the entrance to a second winder stair, one that extends the full height of the house to include the third floor (with its two presently unfurnished bedchambers) and the (now empty) garret. Past the stair to the third floor is a second-floor room furnished as a carpeted parlor with a tall case clock, matching settee and chairs, two tea tables, and writing desk. Down the stairs to the first floor, visitors view John Todd's law office, the front entrance hallway, and the first floor parlor (as described above).

By necessity, the Todd House refurnishing combines limited site documentation with a sampling of contemporary estate inventories. These inventories were selected to coincide with one or more of the following criteria: economic status, profession, and family composition. Religious affiliation was not considered in the selection of sample inventories. As a result, the outcome represents a reasonable, albeit somewhat generic, collection of objects from a time and place equivalent to that in which the Todds lived. This approach makes the Todd House (of the three discussed here) more representative of house museums in general; historic sites seldom have comprehensively detailed documentation or object survivals to support precise refurnishings.

Each of the three sites examined emphasizes that the quality of furnishings now displayed in it represents what its occupants considered affordable and comfortable, as can best be determined from surviving documentation. Clearly, each site presents this as reflective of the historic occupants' time. Less clear is whether this also represents a function of the historic occupants' Quakerism. There appear to be no material traces of Quakerism identifiable

in the documentary evidence for these three sites. Three factors may account for this dearth. Primarily, compared to daily life activities, philosophical tenets are much less readily defined by entries in an account book or estate inventory. Second, Quakerism is both inclusive of behaviors shared with contemporaries outside the group (as we have seen in the descriptions of work and family life at the above sites) and unrepresented by objects unique to that group (for example, religious icons). Third, some elements not traditionally expected to be present in Quaker homes are dictated by these sites' documentation. As an example of this, early Quakers admonished against the fine arts as distractions appealing to the pleasures of the senses rather than the edification of the mind. Portraiture, in particular, was considered vain and "worldly." Yet James Logan commissioned a portrait and all three families studied here hung prints in their homes.[12]

If these three historic sites are promoting their occupants' Quakerism, how do they define its representation, and is that definition accurate? In their interpretive written materials and programs, all three sites profess to interpret some tangible evidence of a uniquely Quaker sensibility. Cedar Grove is "Typical of a Pennsylvania Quaker summer house . . . simply decorated." Stenton lacks curtains in all but one of the rooms as "they are considered inappropriate [read: excessive] in a Quaker country house with interior shutters." The Todd House has a piece of furniture identified as "Quaker Quality"—"of the best sort but plain." In fact, such statements reflect more generalized nostalgia or quaintness than they do interpretive evidence of documented social practices.[13]

In another vein, occasionally objects are given a decidedly Quaker character when their use corresponds to a perceived Quaker tenet. At Cedar Grove, the presentation of daily life tasks like food preparation and laundry (illustrated in the interpretation of kitchen equipment and the proliferation of closets and built-in cupboards) is interpretively associated with Quaker tenets of thrift and economy. While a commitment to thrift can certainly lead to efficient storage behavior, it need not mean the thrifty one subscribes to Quaker beliefs. Quakers and non-Quakers alike in pre-industrial eras like the eighteenth century generally did attempt to maximize expensive resources whenever possible.[14]

Perhaps the most sustainable characterization of the eighteenth- and early nineteenth-century lifestyles at Stenton, Cedar Grove, and the Todd House is one that emphasizes economics viewed through the lens of religion. The Logans, the Paschall-Morrises, and the Todds did not live austerely. They clearly lived in what one historian has called the "empire of goods." And although concern for the corrupting influence of luxury was widespread

among all Protestant sects (including Quakers) from the seventeenth century onward, eighteenth-century denizens came to see gentility as a civilizing rather than a barbarizing force. Yet the need to balance faith and profit generally remained a Quaker preoccupation. Many Quakers, like James Logan, maintained the balance. Perhaps they saw no need to articulate the balance with specific examples of prohibiting material wealth because "by not writing about goods, Quakers maintained their sense of separateness whilst continuing to live in the metropolitan world." This suggests that representing Quakerism at historic sites is not as simple as identifying an object (like the Morris family Bible at Cedar Grove—a genealogical relic, not a religious instrument) or describing a philosophical system. Rather, it requires the portrayal of individual lives filled with family and work contoured by personal faith.[15]

In sum, the sites studied here provide detailed representations of the eighteenth and early nineteenth centuries as lived by three separate Philadelphia families sharing one religious faith. Distinct social, economic, and political forces governed the world within which each family practiced adherence to their Quaker beliefs. However, Quakerism informs the recreation of these lives at a subtle level. Each site avoids the simplistic characterization of Quaker furnishings as austere. Instead, the sites emphasize the wide variety and quality of objects documented in inventories and by including family pieces in the restored installations. Concern for comfort, beauty, and utility in the things that furnish a home was as relevant to people in the past as it is to us today. And sites that include reference to their occupants' Quakerism may tell a story of religious commitment. Herein lies the potential for both the affirmation and the elimination of incorrect characterizations about Quaker material life. If Quaker historic sites identify and represent the individual material decisions of their occupants in the context of their era, visitors to these sites will experience the richness of the past, a "reality" of immediate and lasting value.

Notes

Preface

1. Michael Chiarappa, " 'The First and Best Sort': Quakerism, Brick Artisanry, and the Vernacular Aesthetics of Eighteenth-Century West New Jersey Pattern Brick-work Architecture," Ph.D. dissertation, University of Pennsylvania, 1992; Clarissa Dillon, "A Large, a Useful, and a Grateful Field: Eighteenth Century Kitchen Gardens in Southeastern Pennsylvania," Ph.D. dissertation, Bryn Mawr College, 1987; Anne Gaeta, "The Quaker Influence on Nantucket Architecture: A Case Study," M.A. thesis, College of William and Mary, 1990; Deborah E. Kraak, "Variations on 'Plainness': Quaker Dress in Eighteenth-Century Philadelphia," *Costume* 34 (2000): 51–63; Patricia J. Keller, *"Of the Best Sort But Plain": Quaker Quilts from the Delaware Valley, 1760–1890* (Chadds Ford, Pa.: Brandywine River Museum, 1997); Leanna Lee-Whitman, "Silks and Simplicity: A Study of Quaker Dress as Depicted in Portraits, 1718–1855," Ph.D. dissertation, University of Pennsylvania, 1987; Marcia Pointon, "Quakerism and Visual Culture 1650–1800," *Art History* 20 (1997): 397–431; Jane Williamson, "Stephen Foster Stevens, Quaker Cabinetmaker," *Old-Time New England* 76, 265 (Fall/Winter 1998): 5–27; Don Yoder, "Plain Dolls and Friendly Whirlygigs: Toys and Amusements in Quaker Culture," *Delaware Antiques Show Catalog* (1989): 49–56.

Chapter 1. Past Plainness to Present Simplicity: A Search for Quaker Identity

I am grateful for the diligent, intuitive, and good-natured research assistance of Caroline Boyd (Haverford College, 2001).

1. David Thelen, "Memory and American History," *Journal of American History* 75, 4 (March 1989): 1117.

2. Frederick B. Tolles, *Meeting House and Counting House: The Quaker Merchants of Colonial Philadelphia, 1682–1763* (Chapel Hill: University of North Carolina Press for Institute of Early American History and Culture, 1948).

3. Britain Yearly Meeting, *Faith and Practice* (London: Britain Yearly Meeting, 1995), 19.42.

4. Philadelphia Yearly Meeting (Orthodox), Tract Association of Philadelphia

Yearly Meeting of Friends, "Remarks on Gay and Costly Apparel," no. 104, 1876, p. 9 (Haverford College Special Collections). Nineteenth-century American Friends invoked the authority of Barclay to make their point about plainness.

5. Ambrose Rigge, *A Brief and Serious Warning to Such as are Concerned in Commerce and Trading* (London: n.p., 1678; reprint London Yearly Meeting, 1771).

6. Britain Yearly Meeting, *Faith and Practice*, 20.30.

7. "Remarks on Gay and Costly Apparel," 12.

8. Quoted in David Sox, *Quakers and the Arts: "Plain and Fancy"* (York and Richmond, Ind.: Sessions Book Trust, Friends United Press, 2000), 6.

9. Margery Post Abbott, *A Certain Kind of Perfection: An Anthology of Evangelical and Liberal Quaker Writers* (Wallingford, Pa.: Pendle Hill Publications, 1997).

10. Michael Stuart Freeman, "Innocent Scandals: The Secret Library of the Everett Society," Haverford College *Alumni Magazine* (Winter 1994): 34.

11. Rufus M. Jones, *Haverford College: A History and an Interpretation* (New York: Macmillan, 1933), 200.

12. Sox, *Quakers and the Arts*, 7.

13. George Fox, *The Works of George Fox* (New York: Marcus Hopper, 1831; reprint State College, Pa.: New Foundation, 1990), 4: 249.

14. J. William Frost, *The Quaker Family in Colonial America: A Portrait of the Society of Friends* (New York: St. Martin's Press, 1973) offers a compelling portrait of the importance of the family and meeting for sustaining Friends principles. It was not until the nineteenth century that Quakers developed formal Sunday schools or catechisms, and though two Quaker study centers—Woodbrooke in England and Pendle Hill in Pennsylvania—were opened between 1900 and 1931, it not until 1968 that Earlham College opened its ecumenical School of Religion.

15. The intimate relationship between Quaker values and the development of modern capitalism is explored by (among others) Arthur Raistrick, *Quakers in Science and Industry: Being an Account of the Quaker Contributions to Science and Industry During the 17th and 18th Centuries* (1950; reprint York: Sessions Book Trust, 1993); James Walvin, *The Quakers: Money and Morals* (London: John Murray, 1997); Ian Bradley, *Enlightened Entrepreneurs* (London: Weidenfeld and Nicolson, 1987); and Rhodes Boyson, *The Ashworth Cotton Enterprise: The Rise and Fall of a Family Firm, 1818–1880* (Oxford: Clarendon Press, 1970).

16. Britain Yearly Meeting, *Faith and Practice*, 19.03.

17. *Journal of George Fox*, ed. John L. Nickalls (Cambridge: Cambridge University Press, 1952), 263.

18. William Penn, *No Cross, No Crown*, ed. Ronald Selleck (London: Andrew Solle, 1669; reprint Richmond, Ind.: Friends United Press, 1981), 36.

19. Edward T. Linenthal and Tom Engelhardt, eds., *History Wars: The Enola Gay and Other Battles for the American Past* (New York: Henry Holt, 1996).

20. David Chidester and Edward T. Linenthal, eds., *American Sacred Space* (Bloomington: Indiana University Press, 1995).

21. This term, which I first heard used by Stephanie Grauman Wolf in a casual conversation, seems so apt that I am surprised it has not been more widely adopted.

22. *The Journal and Essays of John Woolman,* ed. Amelia Mott Gummere (New York: Macmillan, 1922), 152–53.

23. Martin L. Fausold, *The Presidency of Herbert C. Hoover* (Lawrence: University of Kansas Press, 1985), 111–12. Though Fausold contends that Hoover was not an advocate of capitalism's emphasis on individuality, he nevertheless concludes that during his presidency, Hoover maintained a "corporatist ideology" that was too rigid to provide relief for Americans in a weak economy.

24. Stanley Coben, *A. Mitchell Palmer: Politician* (New York: Columbia University Press, 1963).

25. Joan Hoff, *Nixon Reconsidered* (New York: Basic Books, 1994).

26. Lyndon H. LaRouche, Jr., *The Power of Reason: A Kind of an Autobiography* (New York: New Benjamin Franklin House, 1979), 35.

27. Nancy M. Davis, "This 'Attack Quaker' Spares No One from Her Lampooning Pen," American Association of American Editorial Cartoonists *Notebook* (Spring 1995): 21; Jack Colldeweih and Kalman Goldstein, eds., *Graphic Opinions: Editorial Cartoonists and Their Art* (Bowling Green, Ohio: Bowling Green State University Popular Press, 1998), 257–65.

28. Colldeweih and Goldstein, *Graphic Opinions,* 267.

29. Davis, "This 'Attack Quaker.'"

30. Charles Brockden Brown, *Arthur Mervyn, or the Memoirs of the Year 1793* (Philadelphia: H. Maxwell, 1799); reprint in Brown, *Three Gothic Novels* (New York: Penguin, 1998).

31. Sarah Stickney Ellis, *Friends at Their Own Fireside: or, Pictures of the Private Life of the People Called Quakers* (London : R. Bentley, 1858), iii.

32. Marguerite De Angeli, *Thee, Hannah!* (New York: Doubleday Doran, 1940).

33. Jessamyn West, *The Friendly Persuasion* (New York: Harcourt Brace, 1945).

34. A. S. (Antonia Susan) Byatt, *The Game: A Novel* (London: Chatto and Windus, 1967).

35. J. Randolph Cox, *The Dime Novel Companion: A Source Book* (Westport, Conn.: Greenwood Press, 2000), viii.

36. Ibid., 196–97.

37. Thomas Kimber, "The Quaker in the Dime Novel," *Bulletin of the Friends Historical Association* 43, 2 (1954): 110.

38. For a full discussion of nineteenth-century silhouettes and their meaning, see Anne Ayer Verplanck, "Facing Philadelphia: The Social Function of Silhouettes, Miniatures, and Daguerrotypes, 1760–1800," Ph.D. dissertation, College of William and Mary, 1996.

39. "All the Quakers Are Shoulder Shakers (Down in Quaker Town)," words by Bert Kalmar and Edgar Leslie, music by Pete Wendlind (New York: Waterson, Berlin, and Snyder, 1919).

40. Daisy Newman, *Diligence in Love* (Garden City, N.Y.: Doubleday, 1951); Newman, *Diligence in Love* (New York: Popular Library, 1951).

41. Irene Allen, *Quaker Silence* (New York: Villard Books, 1992); Chuck Fager, *Un-Friendly Persuasion: A Quaker Mystery* (Media, Pa.: Kimo Press, 1995).

42. Mark Perry, *Lift Up Thy Voice: The Grimké Family's Journey from Slaveholders to Civil Rights Leaders* (New York: Viking, 2001), 63.

43. See Abbott, *A Certain Kind of Perfection,* 15, for a breakdown of how many Friends in the modern world are "evangelical."

44. Jane Williamson, "Stephen Foster Stevens, Quaker Cabinetmaker," *Old-Time New England* (Fall 1998): 5–27.

45. Adrienne D. Hood, "The Material World of Cloth: Production and Use in Eighteenth-Century Rural Pennsylvania," *William and Mary Quarterly* 3rd ser. 53, 1 (1996): 66.

46. Thomas Goodhue, "Division in the Heartland: Iowa Quaker Culture in the Late Nineteenth Century," unpublished manuscript, May 2001.

47. Gary B. Nash, *The Urban Crucible: Social Change, Political Consciousness, and the Origins of the American Revolution* (Cambridge, Mass: Harvard University Press, 1979), 312–38.

48. Jack Marietta, *The Reformation of American Quakerism, 1748–1783* (Philadelphia: University of Pennsylvania Press, 1984).

49. Thomas Hamm, *The Transformation of American Quakerism: Orthodox Friends, 1800–1907* (Bloomington: Indiana University Press, 1988) and H. Larry Ingle, *Quakers in Conflict: The Hicksite Reformation* (Knoxville: University of Tennessee Press, 1986), explore these issues in fascinating detail.

50. John M. Moore, ed., *Friends in the Delaware Valley: Philadelphia Yearly Meeting, 1681–1981* (Haverford, Pa.: Friends Historical Association, 1981).

51. See Howard Zinn, *SNCC: The New Abolitionists* (Boston: Beacon Press, 1965).

52. Frank Levering, *Simple Living: One Couple's Search for a Better Life* (New York: Penguin, 1992); Jim Pym and Wanda Urbanska, *Listening to the Light: How to Bring Quaker Simplicity and Integrity into Our Lives* (London: Rider, 1999); Scott Savage, *A Plain Life: Walking My Belief* (New York: Ballantine, 2000).

53. Thelen, "Memory and American History," 1118.

54. Susan E. Klepp and Billy G. Smith, eds., *The Infortunate: The Voyage and Adventures of William Moraley, an Indentured Servant* (University Park: Pennsylvania State University Press, 1992).

55. The family papers of the Maier family of Bryn Mawr, Pennsylvania, who moved into a farmhouse in 1820 and kept the receipts for every purchase from that year until the late twentieth century, offer a rich cache for pursuing such questions. These papers have recently been donated to Haverford College Special Collections.

Chapter 2. From Plainness to Simplicity: Changing Quaker Ideals for Material Culture

1. The best account of early Quaker thought is in Rosemary Moore, *The Light in Their Consciences: The Early Quakers in Britain, 1646–1666* (University Park: Pennsylvania State University Press, 2000). Putting Quaker belief in context is Hugh Barbour, *The Quakers in Puritan England* (New Haven, Conn.: Yale University Press, 1964). A general history of Quakers is Hugh Barbour and J. William Frost, *The Quakers* (Richmond, Ind.: Friends United Press, 1994).

2. The word "testimonies" was used by early Friends as a synonym for confession of faith. One makes a testimony, as in court, of what he or she believes. Later Friends grouped their outward practices such as plain dress or pacifism as testimonies. The first use of testimony in this second sense is in Penn's "Fruits of a Father's Love," published in 1726 but probably written before his second journey to Pennsylvania in 1699. Rhode Island Friends referred to "plain language" in 1676. Considering the prominence of the "Plain Style" to Puritans, it is surprising that Friends did not employ the terminology earlier. Meredith Weddle, *Walking in the Way of Peace: Quaker Pacifism in the Seventeenth Century* (New York: Oxford University Press, 2001), 223; Perry Miller, *The New England Mind: The Seventeenth Century* (Boston: Beacon Press, 1961), chap. 12.

3. Separating plainness from simplicity is no easy task because dictionaries use each word to define the other. Yet Milton in his prose works described "the simplicity and plainness of Christianity," showing that there was a distinction. And the terms changed meaning over time. The negative of plainness was ugliness; of simplicity was simple or foolish. To liberals of the twentieth century, plainness had connotations of legalism, sectarianism, and mortification, whereas simplicity was natural, unaffected, and uncluttered. Laurence Sterne and Harold Kollmeier, eds. *A Concordance to the English Prose of John Milton* (Binghamton, N.Y.: Medieval and Renaissance Texts and Studies, 1985).

4. The Bible contains many references to rich apparel. Sometimes it is used negatively, as in Luke's story contrasting Lazarus and Dives; elsewhere fine clothing is used as a symbol of the prosperity for those who follow the Lord. In Proverbs 30: 32 a good wife clothes her husband with wool and fine linen; in Isaiah 23: 18 after the eschaton, Tyre will supply "abundant food and fine clothing for those who dwell before the Lord." Ezekiel 16: 8–16 has God make Israel beautiful by bestowing on her silks, ornaments, bracelets, rings, and earrings.

5. Anna Bryson, *From Courtesy to Civility: Changing Codes of Conduct in Early Modern England* (Oxford: Clarendon Press, 1998), 212–21, contains a discussion of the similarity of Puritan and Quaker critiques of civility and manners.

6. Peter Zagoran, *The Court and the Country: The Beginnings of the English Revolution* (New York: Atheneum, 1970).

7. *Journal of George Fox*, ed. John L. Nickalls (London: Religious Society of Friends, 1975), 169, 205. Fox's 1655 epistle bases his condemnation of colored ribbons, gold, and powdered hair on the Bible. The 1655 epistle is more specific than all of the other thirty-four references to plain dress listed in Lewis Benson's index to the writings of George Fox. Copies of this index are at various Quaker libraries. About the only specific fashion that can be identified from Fox is what we would call a ponytail, which Fox described as "children hair tied up, (like horse-manes with ribands,) like horse-tails." George Fox, "The Serious People's Reasoning and Speech, with the World's Teachers and Professors," *Doctrinals*, Book I, *The Works of George Fox* (Philadelphia, 1831), 4: 198.

8. Fox, *Epistles*, Book I, *Works*, 7: 140. On the use of vain fashion, see *Works*, 4: 211; 7: 96, 168, 253, 284, 300, 328; 8: 85.

9. Amelia Mott Gummere, *The Quaker: A Study in Costume* (Philadelphia: Fer-

ris and Leach, 1901), 125–26, 133; Bonnelyn Young Kunze, *Margaret Fell and the Rise of Quakerism* (Stanford, Calif.: Stanford University Press, 1994), 69.

10. John Spurr, *England in the 1670s: "This Masquerading Age"* (London: Blackwell, 2000), chap. 4.

11. Before 1680 Friends began building galleries (a raised space) at the front of meeting houses for ministers. They also had men and women sitting separately.

12. Robert Barclay, *Apology for the True Christian Divinity,* 13th ed. (Manchester: Irwin, 1869), Proposition XV. There were twenty editions before 1800.

13. The best study of this period remains William Braithwaite, *The Second Period of Quakerism* (1919; rev. ed. Cambridge: Cambridge University Press, 1961). This should be supplemented by Richard Vann, *The Social Development of English Quakerism, 1655–1755* (Cambridge: Cambridge University Press, 1955).

14. William Penn, *No Cross, No Crown* (London: Andrew Solle, 1669), preface, n.p., chap. 3. This heading of the chapter is all in italics.

15. Penn, *No Cross, No Crown,* 20, 32, 44, 50. There are incidental references to plainness. Adam and Eve had "primitive Innocence by modest plainness" (19); Jesus was a man of "great plainness" in dress (22); a desired life is "humble, plain, meek, holy Self-denying and exemplary" (53). Nowhere does Penn discuss a plain style of life.

16. Penn, *Some Fruits of Solitude* (London: Thomas Northcott, 1693), #72, 140, 528; Penn, *More Fruits of Solitude* (London: T. Sowle, 1702), #155, 164. Neither Fox nor Barclay uses the word simplicity. According to the *OED*, 2829, simplicity in this period meant "Freedom from artifice, deceit or duplicity, sincerity, straight-forwardness, also absence of affectation or artificiality; plainness, artlessness, naturalness."

17. Penn, "Fruits of a Father's Love," reprinted in *The Peace of Europe, The Fruits of Solitude and Other Writings,* ed. Edwin Bronner (Rutland, Vt.: Tuttle, 1993), 92, 96, 115. I believe that Penn is reflecting what had become by 1700 normal Quaker usage for plainness.

18. Barclay, *Apology,* Proposition 15, p. VI, 326; p. VII, 337.

19. Philadelphia Yearly Meeting, Epistle, 1691. In the 1719 PYM *Discipline,* plainness is listed in both index and text as a descriptive term: "Such as do not keep themselves or their Children to moderation and plainness in gesture, speech, apparel, and furniture of Houses." PYM, *Discipline* (1719), 8. Friends Historical Library (FHL), Swarthmore College, Swarthmore, Pennsylvania.

20. Nicholas Morgan, *Lancashire Quakers and the Establishment, 1660–1730* (Halifax, Eng.: Ryburn Academic, 1993) shows that enforcing a rigorous discipline helped strengthen Lancashire Quakers. Unfortunately we do not have a comparable study of Irish Quakers in this period. Isabel Grubb, *Quakers in Ireland, 1654–1900* (London: Swarthmore Press, 1911), 83–85 and Maurice Wigham, *The Irish Quakers: A Short History of the Religious Society of Friends in Ireland* (Dublin: Historical Committee of the Society of Friends in Ireland, 1992), 35, do not provide dates so that one can determine the origins of practices.

21. Braithwaite, *Second Period of Quakerism,* 505–10; Leanna Lee-Whitman, "Silks and Simplicity: A Study of Quaker Dress as Depicted in Portraits, 1718–1855,"

Ph.D. dissertation, University of Pennsylvania, 1987, 10–11; Gummere, *The Quaker: A Study in Costume*, 141, 153.

22. Fell quoted in Braithwaite, *Second Period of Quakerism*, 519.

23. London Yearly Meeting, *Rules of Discipline* (London: Darton and Harvey, 1834), 207. There are eight pages of quotations of epistles on plainness, two-thirds dated before 1800. The word "simplicity" is often used as in "simplicity of heart" or "simplicity of truth" and sometimes linked with plainness as "plainness and simplicity of truth." Here plainness is not the same as simplicity, though clearly the two are linked. My guess is that for Quakers a plain style had a religious connotation of mortification while simplicity involved being unaffected and both terms merged as straightforward.

24. Richard Vann, *The Social Development of English Quakerism* (Cambridge, Mass.: Harvard University Press, 1969), 78.

25. J. William Frost, *The Quaker Family in Colonial America* (New York: St. Martin's Press, 1973), chap. 4. Barry Levy, *Quakers and the American Family* (New York: Oxford University Press, 1988), 58–61, uses the term "holy conversion" to refer to the plain style. The document considered the first discipline of Philadelphia Yearly Meeting, drawn up in 1704, was specifically addressed to youth. This document condemns "needless and wastfull fashions" and "all Extravagancy in Collour and Fashion" and advocates "modest apparel," "Modesty and sobriety," and "decent plainness." PYM, *Discipline* (1704), 8, 9, 13–14, FHL.

26. Friends much earlier had a conception of membership. For example, the 1719 Philadelphia *Discipline* exhorted "all Friends that are or would be accounted members of these Meeting," 4. The decisions of London and Philadelphia were designed to see who was eligible for charity. It was not until the nineteenth century that Friends began to debate whether "birthright" membership was theologically sound.

27. Lee-Whitman, "Silks and Simplicity," 47, 56, 74, 106, finds few distinguishing features in Quaker dress. She argues that drab colors did not become uniform until after the American Revolution. She finds Friends wearing bright colors and even jewelry in Quaker portraits. Although a testimony against portraits was never included in the discipline, many of the strictest Friends before 1800 refused to have their pictures painted. Lee-Whitman confirms Gummere's judgment that Friends followed fashion and there was no one kind of Quaker costume. *The Quaker: A Study in Costume*, 15, 183–84.

28. Erin Bell, "Quakers and Popular Culture in Durham, 1660–1725," paper delivered at Conference on Popular Culture and Religion, University of Northumbria at Newcastle, July 13, 2001. Bell raises the interesting subject that part of discipline was gender specific and meetings were somewhat more tolerant of male than female drunkenness.

29. London Yearly Meeting, *Rules of Discipline*, heading "Plainness," 1743.

30. Frost, *Quaker Family*, 59. Ann Cooper Whitall's diary has a litany of complaints about the difficulty of enforcing discipline, Whitall diary, October 24, 1760, p. 52. Mss, Quaker Collection, Haverford College, Haverford, Pennsylvania.

31. Isaac Norris I in 1708 used this defense to an Irish Quaker; Norris quoted in Lee-Whitman, "Silks and Simplicity," 14.

32. Frederick B. Tolles, *Meeting House and Counting House: The Quaker Merchants of Colonial Philadelphia, 1682–1763* (Chapel Hill: University of North Carolina Press for Institute of Early American History and Culture, 1948), chap. 6.

33. In the eighteenth century Friends who seemed mostly worldly or most lax in keeping plainness were termed "wet" or "gay" Quakers. The gay was for frivolity rather than sobriety; the term "wet" refers to a woman's wearing ribbons, gauzes, and laces. Tolles, *Meeting House and Counting House*, 142.

34. *Diary of Elizabeth Sandwich Drinker*, ed. Elaine Crane (Boston: Northeastern University Press, 1991), 2: 891, 901; Samuel Wetherill, *An Apology for the Religious Society Called Free Quakers* (Philadelphia: Folwell, 1798?). Charles Wetherill, *History of the Free Quakers* (Philadelphia: Free Quaker Society, 1894), 22; James Jenkins, *Records and Recollections*, ed. J. William Frost (New York: Mellon Press, 1984), 116.

35. Jack D. Marietta, *The Reformation of American Quakerism, 1748–1783* (Philadelphia: University of Pennsylvania Press, 1984), 64. Marietta donated copies of his composite printouts of all cases of discipline to Haverford and Swarthmore Colleges.

36. H. Larry Ingle, *Quakers in Conflict: The Hicksite Reformation* (Knoxville: University of Tennessee Press, 1986) is the standard account.

37. Elizabeth Isichei, *Victorian Quakers* (Oxford: Oxford University Press, 1970), chap. 5.

38. Josiah Leeds, *Simplicity of Attire, As Related to the Promotion of Social Purity*, 3rd ed. (Philadelphia: printed for the author, 1886), 6; Helen Balkwill, *On Dress, Viewed in Connection with the Society of Friends* (Philadelphia: W.H. Pile, 1873), 6. This tract was first printed in the London Friends *Quarterly Examiner*.

39. London's 1834 *Rules of Discipline* had linked "Plainness and Moderation"; the 1861 *Discipline* was an "Exhortation of Christian Simplicity, Moderation, and Self-Denial."

40. Thomas Hamm, *The Transformation of American Quakerism, 1800–1907* (Bloomington: Indiana University Press, 1988), chaps. 4, 5.

41. Few of the Progressive Friends in Pennsylvania were actually members of Quaker meetings; by contrast, Progressive Friends in New York and Ohio remained Quakers. Albert J. Wahl, "The Congregational or Progressive Friends in the Pre-Civil War Reform Movement," Ed.D. dissertation, Temple University, 1951, is the standard source. We need a history of the entire American Progressive Friends movement.

42. Genesee Yearly Meeting, *Discipline* (1842), 36, 38; New York Yearly Meeting, *Discipline* (1859), 66, 115; Marion Dobbert, "Friends at Clear Creek: Education and Change, 1830–1930," Ph.D. dissertation, University of Wisconsin, 1973, 171, 179–81, 200.

43. Lee-Whitman, "Silks and Simplicity," 102, 110, using a limited sample, discovered no disownments over plainness by either Hicksite or Orthodox in the period 1840–1850. She also discovered no differences in the dress of the two groups in portraits. See also Anne Ayer Verplanck, "Facing Philadelphia: The Social Function of Silhouettes, Miniatures, and Daguerreotypes, 1760–1860," Ph.D. dissertation, College of William and Mary, 1996, chap. 2. Verplanck found an unwritten code against miniatures that did not apply to silhouettes or, after 1839, to daguerreotypes.

44. Photographs, Picture file, FHL.

45. *Minutes of the Sixth Annual Meeting of the Stockholders of Swarthmore College . . . 1869* (Philadelphia: Merrihew and Son, 1870). Swarthmore offered literature courses in 1875, allowed a piano in 1888, and there were plays and dances before 1900. Richard J. Walton, *Swarthmore College: An Informal History* (Swarthmore, Pa.: Swarthmore College, 1986), 9, 14.

46. Non-Quaker Vassar's main building, dating from the same time, was a copy of the Tuileries Palace in France and is considerably more ornate than the 1869 Parrish Hall, but not than the rebuilt structure. The earlier Parrish was designed by Quaker architect Addison Hutton, who also designed buildings at Haverford and Bryn Mawr. The rebuilt Parrish was designed by Sloane and Balderston. Thanks to Susanna Morikawa for this information.

47. Westtown School as late as 1910 refused to teach Shakespeare or to allow students to read magazines or newspapers. Until after World War I music and drama were allowed only under "devious and unacknowledged disguises." There was no piano. The dress code allowed no jewelry, no silk dresses, and no frivolous ribbons. Yet an 1899 alumni gathering picture shows women wearing fashionable attire and flowered hats. Helen Hole, *Westtown Through the Years, 1799–1942* (Westtown, Pa.: Westtown Alumni Association, 1942), 290–92, 329. Quietist Friends had no pictures in their homes, forbade novels, continued to use the plain style of speech, and disdained "thinking" in meeting for worship. When Rufus Jones attended Haverford College in 1882–1885, he obtained on his own a copy of George Eliot's novels because the library did not have them. David Hinshaw, *Rufus Jones: Master Quaker* (New York: Putnam, 1951), 102; Rufus Jones, *The Trail of Life in College* (New York: Macmillan, 1929), 59, 85, 109–15.

48. Haverford Alumni Association, *A History of Haverford College for the First Sixty Years of Its Existence* (Philadelphia: n. p., 1892), 603, 605–6, 619, 650–51. The book concludes that the restrictions that "hedged in the old generations of Haverfordians have largely passed away." The "peculiarities" of Friends in language and dress "have largely departed," but the influence of Quakerism and required attendance at meeting remained.

49. It may be that the introduction of photography and Quakers' interest in this new form sounded the death knell to Quaker resistance to pictorial representation. I am grateful to Diana Peterson, Manuscripts and Photography Cataloguer at Haverford College, for this suggestion. See also Verplanck, "Facing Philadelphia," 184–86.

50. Jones, *The Trail of Life,* 69.

51. Rufus Jones, *Quakerism and the Simple Life* (London: Headley, 1906), 10, 19, 23. Dress and speech were minor parts of simplicity. Simplicity in dress meant one should look well, not slovenly, and keep the importance of dress in proportion and subordination. Simplicity in language was against exaggeration and duplicity; there should be no withdrawal because a "Religion of simplicity creates no lines of division." Any business conducted in the right spirit evinced simplicity. Rufus Jones, *A Simple Religion* (Malton, Eng.: Taylor, 1905), 10.

52. Gummere, *The Quaker: A Study in Costume,* iv, 14–15. Higher criticism was a method of examining how the language and concepts in the Bible had evolved over

the centuries. The Bible was now seen as a collection of books whose teachings had been influenced by history. It reflected changes in Hebrew religion; so proof texting was an inappropriate way to understand the Bible.

53. Amelia Mott Gummere was the wife of a Haverford professor. Her obituary claimed that her book on costume was one of the "first attempts to look at Quaker customs from an historical and objective point of view and to a few it seemed a mistake to meddle with what they regarded as sacred traditions." Elizabeth B. Jones, "Amelia Mott Gummere," *The Friend* 12 mo. 2 (1937): 198.

54. A few Quakers, often associated with Pendle Hill, took inspiration from John Woolman, whose advices are often quoted in *Faith and Practice*, and practiced voluntary poverty. Mildred Young, *Functional Poverty* (Wallingford, Pa.: Pendle Hill Publications, 1939).

55. PYM, *Faith and Practice* (1997), 42.

56. PYM, *Faith and Practice* (1961), 22–24. For an account of the influence of this formulation of simplicity on other yearly meetings, see Charles E. Fager's thoughtful essay, "The Quaker Testimony of Simplicity," *Quaker Religious Thought* 14, 1 (Summer 1972). Modern discussions of simplicity include Elise Boulding, *Friends Testimonies in the Home* (Philadelphia: Friends General Conference, 1953), 25–27 and George Peck, *Simplicity: A Rich Quaker's View* (Wallingford, Pa.: Pendle Hill Publications, 1973). There are sections on simplicity in virtually all yearly meetings' compilations of discipline.

57. PYM, *Faith and Practice* (1997), 80–81, 156–58.

Introduction to Part I

1. *Journal of the Life of Nathaniel Luff M.D.* (New York: Clark and Sickles, 1848), 196.

2. *The Journal and Essays of John Woolman,* ed. Amelia Mott Gummere (New York: Macmillan, 1922), 246.

3. *The Journal and Essays of John Woolman,* 246.

4. Deborah Padfield, ed., "A Libertine Appearance," *The Friend* 7 (March 1997): 11–12.

5. *Journal of the Life of Nathaniel Luff,* 61.

6. Judith Colucci Breault, *The World of Emily Howland* (Millbrae, Calif.: Les Femmes, 1976), 9.

7. *Journal of the Life of Nathaniel Luff,* 169.

8. Barry Levy, *Quakers and the American Family* (New York: Oxford University Press, 1988), 253.

9. *Memoir of the Life of Elizabeth Fry* (London: Charles Gilpin, 1947), 53.

10. Joshua Pusey to John Jackson, 4 day 5 mo 1794, Jackson-Conard Papers, Friends Historical Library of Swarthmore College, Swarthmore, Pennsylvania.

11. Frederick B. Tolles, *Meeting House and Counting House: The Quaker Merchants of Colonial Philadelphia, 1682–1783* (Chapel Hill: University of North Carolina Press for Institute of Early American History and Culture, 1948), 127.

Chapter 3. Quakers and High Chests: The Plainness Problem Reconsidered.

The chapter is based on Susan L. Garfinkel, "Discipline, Discourse and Devia-
tion: The Material Life of Philadelphia Friends, 1762–1781," M.A. thesis, Winterthur
Museum and University of Delaware, 1986. Many thanks are due to Philip G. Stewart
for his patient and thoughtful assistance with the revision.

1. Quoted in J. William Frost, *The Quaker Family in Colonial America* (New
York: St. Martin's Press, 1973), 51.

2. For example, John Adams while attending the Continental Congress in 1774
recorded that he "Dined with Mr. Miers Fisher, a young Quaker and a Lawyer. We saw
his library, which is clever. But this plain Friend and his plain, tho pretty wife, with
her Thee's and Thou's, had provided us the most costly Entertainment—Ducks,
Hams, Chickens, Beef, Pig, Tarts, Creams, Custards, Gellies, fools, trifles, floating Is-
lands, Beer, Porter, Punch, Wine and a long &c." John Adams, *Diary and Autobiogra-
phy of John Adams,* vol. 2, *Diary 1771–1781,* ed. L. H. Butterfield (Cambridge, Mass.:
Belknap Press of Harvard University Press, 1961), 126. In 1756 one British Quaker re-
former wrote of Pennsylvania Friends that "They settled in ease and affluence, and
whilst they made the barren wilderness as a fruitful field, suffered the plantation of
God to be a field uncultivated, and a desert. Thus, decay of discipline and other
weakening things prevailed." Samuel Fothergill to James Wilson, quoted in Richard
Bauman, *For the Reputation of Truth: Politics, Religion and Conflict Among the Penn-
sylvania Quakers, 1750–1800* (Baltimore: Johns Hopkins University Press, 1971), 40–41.

3. Bauman, *Reputation of Truth,* 39.

4. Frederick B. Tolles, *Meeting House and Counting House: The Quaker Mer-
chants of Colonial Philadelphia, 1682–1763* (Chapel Hill: University of North Carolina
Press for Institute of Early American History and Culture, 1948), 88. See also Tolles,
" 'Of the Best Sort But Plain': The Quaker Aesthetic," *American Quarterly* 11, 4 (Winter
1959): 484–502. In his groundbreaking work, Tolles fails to achieve cultural specificity
by freely intermixing the statements of both British and American Friends while fail-
ing to fully account for the political motives of British reformers. Further, the quote
"of the best sort but plain" dates from 1738, and in full refers to "a Handsome plain
looking-glass . . . and 2 raised Japan'd Black Corner Cubbards, with 2 door to each, no
Red in 'em, of the best Sort but Plain," when confirmed in the original source, but
Tolles fails to consider what those actual pieces of furniture might have looked like.
See John Reynell to Daniel Flexney, November 25, 1738, John Reynell Letter Book
(1738–41), 6, Historical Society of Pennsylvania. Tolles's analysis relies on statements
about artifacts without examining those that survive in any systematic way.

5. The terms "Chippendale" and "rococo" are used here, according to conven-
tion, to refer to a particular style of furniture popular in Philadelphia from approxi-
mately 1750 to 1785. Chippendale style as produced in Philadelphia is both similar to
and distinct from that found in other parts of America or in England. Stylistic ele-
ments include a combination of straight and curved lines and forms, and naturalis-
tic, asymmetrical ornamentation employing motifs such as shells or foliage.

6. Gilbert Ryle, *The Concept of Mind* (New York: Barnes and Noble, 1949). Since

the 1960s, an expanded practice of historical research and writing has been especially influenced by anthropological notions of culture and context. Especially significant here is the idea of cultural specificity. See, for example, Clifford Geertz, "Thick Description: Toward an Interpretive Theory of Culture," in *The Interpretation of Cultures* (New York: Basic Books, 1973), 3–30; Dan Ben Amos, "Toward a Definition of Folklore in Context," *Journal of American Folklore* 84, 331 (January–March 1971): 3–15. The concerns of postmodernism and post-structuralism have likewise drawn scholars' attention to the issues of institution and audience as well as authorial intention in the interpretation of surviving written texts. See John E. Towes, "Intellectual History After the Linguistic Turn: The Autonomy of Meaning and the Irreducibility of Experience," *American Historical Review* 92, 4 (October 1987): 879–907; Janice Radway, "Identifying Ideological Seams: Mass Culture, Analytical Method, and Political Practice," *Communication* 9 (1986): 93–112.

7. Stuart Hall, "The Problem of Ideology—Marxism Without Guarantees," *Journal of Communication Inquiry* 10 (Summer 1986): 28–44.

8. Dell Upton, *Holy Things and Profane: Anglican Parish Churches in Colonial Virginia* (Cambridge, Mass.: MIT Press, 1986), makes a similar argument in relation to religious architecture.

9. On Philadelphia pre-Revolutionary furniture, including high chests, see William McPherson Horner, Jr., *Blue Book: Philadelphia Furniture, William Penn to George Washington* (1935; reprint Washington, D.C.: Highland House, 1977); Philadelphia Museum of Art, *Philadelphia: Three Centuries of American Art* (Philadelphia: Philadelphia Museum of Art, 1976); Morrison H. Heckscher and Leslie Greene Bowman, *American Rococo, 1750–1775: Elegance in Ornament* (New York: Harry Abrams, 1992); Jack L. Lindsey, *Worldly Goods: The Arts of Early Pennsylvania, 1680–1758* (Philadelphia: Philadelphia Museum of Art, 1999).

10. Discrepancies in the construction of case pieces attributed to Thomas Affleck suggest that not all the attributions are accurate. I have accepted them here, however, and await a definitive study of Philadelphia case piece construction. It will subsequently become clear that a mistake in one of these attributions will not significantly alter my argument.

11. Philadelphia Monthly Meeting Minutes (men's), 25 day 11 mo 1763. Friends Historical Library, Swarthmore College, Swarthmore, Pennsylvania, and Quaker Collection, Haverford College, Haverford, Pennsylvania (hereafter referred to as PMM Minutes).

12. In an entry of December 7, 1749, Peter Kalm reports: "[The Quakers] cling together very close now, and the more well-to-do employ only Quaker artisans, if they can be found." *Peter Kalm's Travels in North America*, ed. Adolph B. Benson (1937; reprint New York: Dover Publications, 1966), 652.

13. PMM Minutes, 26 day 4 mo 1771.

14. See Frost, *Quaker Family*, 10. Frost in particular compares Quakers to their Puritan counterparts, pointing out the Quaker lack of interest in expanding the mysteries of faith. The extent to which Quakers have a theology at all is a matter of debate among scholars and current practitioners. In addition to the carefully preserved

records of the Religious Society of Friends, survival is quite rich in personal papers relating to Philadelphia Quaker families. The main repositories of Quaker documents are the Quaker Collection and Friends Historical Library. The Historical Society of Pennsylvania has by far the largest collection of Quaker-related family manuscripts; the Library Company of Philadelphia and the American Philosophical Society also house large collections. See Jack D. Marietta, *The Reformation of American Quakerism, 1748–1783* (Philadelphia: University of Pennsylvania Press, 1984), 283–86, for a detailed discussion of the available documents.

15. Seventeenth-century English Quakers were subject to severe religious persecution, both during the Puritan regime and after the Restoration. See Hugh Barbour and Arthur O. Roberts, "General Introduction," in *Early Quaker Writings, 1650–1700*, ed. Barbour and Roberts (Grand Rapids, Mich.: Eerdmans, 1973), 13–46; and Hugh Barbour, *The Quakers in Puritan England* (New Haven, Conn.: Yale University Press, 1964). In an effort to minimize misunderstanding of their beliefs, Friends chose to formally sever ties with wayward members. See also Marietta, *Reformation*.

16. PMM Minutes, 31 day 5 mo 1771.

17. PMM Minutes, 28 day 6 mo 1771; 26 day 7 mo 1771.

18. PMM Minutes, 30 day 8 mo 1771.

19. PMM Minutes, 27 day 9 mo 1771.

20. Marietta, *Reformation*, 55. The average time spent on a given disciplinary case was 4.8 months.

21. Marietta, *Reformation*, 6–7. From 1748 to 1783, 37.4 percent of all disciplinary cases were marriage delinquencies, while 9.9 percent dealt with fornication before marriage.

22. Marietta, *Reformation*, 63. In the period 1766–70, 67.4 percent of marriage delinquencies ended in disownment; in 1771–75, 75.2 percent of marriage cases did.

23. See Marietta, *Reformation*, 27, and Jack Michel, "The Philadelphia Quakers and the American Revolution: Reform in the Philadelphia Monthly Meeting," *Working Papers from the Regional Economic History Research Center*, ed. Glenn Porter and William H. Mulligan, Jr., vol. 3, no. 4 (1980), 59. The 1760 census of Philadelphia Monthly Meeting lists 2,250 members. Marietta counts 1,683 disciplinary cases for Philadelphia Monthly Meeting for the years 1748–83. This averages to 48 cases per year (2 percent of the 1760 population). Michel finds 1,260 cases for the period 1751–85, which averages to 37 per year (1.6 percent of the 1760 population). The discrepancy is partly due to a splitting of Philadelphia Monthly Meeting in 1772, after which the census shows only 1,062 members. Michel did not include the associated Northern District and Southern District meetings in his calculations.

24. Affleck married Isabella Gordon, daughter of a Northampton County lawyer. A good biography of Affleck is found in Philadelphia Museum of Art, *Philadelphia: Three Centuries*, 98–99.

25. Wayne's bill to Wallis is dated February 18, 1770, and was recorded as paid on December 24 of the same year. Kenneth T. Wood discusses the probability of the attribution in "The Highboy of Samuel Wallis," *Magazine Antiques* 12 (September 1927): 212–14. Luke Beckerdite, "Philadelphia Carving Shops, Part II: Bernard and Jugiez,"

Magazine Antiques 126, 3 (September 1985): 503–10, attributes the carving on the William Wayne piece to the Philadelphia carving firm of Nicholas Bernard and Martin Jugiez, discussing also that firm's collaborations with Thomas Affleck.

26. PMM Minutes, 27 day 9 mo 1771.
27. PMM Minutes, 27 day 7 mo 1770.
28. PMM Minutes, 31 day 8 mo 1770.
29. PMM Minutes, 28 day 12 mo 1770.
30. PMM Minutes, 25 day 1 mo 1771.
31. PMM Minutes, 27 day 3 mo 1771.
32. PMM Minutes, 25 day 10 mo 1771.

33. Marietta, *Reformation,* 10–26, divides disciplinary violations into several categories, drawing a distinction between sectarian offenses important only to Friends and other behaviors that were also condemned by secular society.

34. Marietta, *Reformation,* 22, finds eleven explicit references to plain speech and dress (1 percent of all offenses) for all of Philadelphia Yearly Meeting. This number is extended a bit if other adjectives such as "inconsistent" and more general categories like conduct, conversation, and deportment are considered relevant. For example: "her Conformity in Dress & Address, to the vain fashions & Customs of the World," PMM Minutes, 25 day 5 mo 1766; "the general tenor of his Conduct and Language not having been agreeable to our religious profession," PMM Minutes, 25 day 5 mo 1764.

35. Marietta, *Reformation,* 65, discusses the obvious difficulty faced by spouses when they were asked to publicly announce regret at the choice of their partner.

36. Philadelphia Yearly Meeting, Society of Friends, "A Collection of Christian and Brotherly Advices," *Book of Discipline* (1762); Philadelphia Yearly Meeting, Society of Friends, "A Collection of Christian and Brotherly Advices," *Book of Discipline* (1781), Quaker Collection (hereafter referred to as PYM *Discipline*). Arnold Lloyd, *Quaker Social History, 1669–1738* (London: Longman's, Green and Co., 1950), 176, discusses the evolution of a formalized Quaker Discipline. "By 1682 the leading Quakers had discovered that the system which had been devised to answer the queries of country Quakers about legal redress was equally serviceable for putting to them queries about the practice of Quakerism in most of the concerns of daily life." See also Rayner W. Kelsey, "Early Books of Discipline of Philadelphia Yearly Meeting," *Bulletin of the Friends Historical Association* 24 (1935): 12–23.

37. PYM *Discipline* (1762), 187–90.
38. PYM *Discipline* (1762), 195.

39. No further plainness directives are included in the 1781 *Discipline,* where the plainness section is quite abbreviated. PYM *Discipline* (1781), 90. The beginning of Quaker reform in Pennsylvania is generally dated to 1756, when influential Friends withdrew from government positions. Scholars have disputed, however, whether that exact year is significant to the movement. See Kenneth L. Carroll, "A Look at the 'Quaker Revival of 1756,'" *Quaker History* 65, 2 (Autumn 1976): 64. Books that take political withdrawal and religious reform as their central problem include Sydney V. James, *A People Among People: Quaker Benevolence in the Eighteenth Century* (Cam-

bridge, Mass.: Harvard University Press, 1963); Marietta, *Reformation;* Bauman, *Reputation of Truth.*

40. PYM *Discipline* (1762), 188.

41. Donald Preziosi, *Semiotics of the Built Environment* (Bloomington: Indiana University Press, 1979), 6, discusses the relative specificity applied to different modes of expressive behavior in the most general case: "One of the most striking aspects of architectonic codes induced by their formative media is a property of *object-permanence.* That is to say, architectonic formations manifest a permanence of 'broadcast' *relative* to other systems of signing such as verbal language and 'sign' language. An architectonic formation will continue to broadcast long after the more ephemeral transmission of a speech act, whose traces remain in the auditory channel only momentarily."

42. Richard Bauman, *Let Your Words Be Few: Symbolism of Speaking and Silence Among Seventeenth-Century Quakers* (Cambridge: Cambridge University Press, 1983), 7.

43. PYM *Discipline* (1762), 189. Brackets are shown as they appear in the original entry.

44. Frost, *Quaker Family,* 10. Barclay's *Apology,* first published in 1678, "went as deeply into the mysteries of Faith as Friends cared to go." Robert Barclay, "Concerning Salutations and Recreations," in *An Apology for the True Christian Divinity* (1678; reprint London: T. Phillips, 1780), 512–71.

45. William Penn, *Fruits of Solitude,* in *The Selected Works of William Penn* (1825; reprint New York: Kraus Reprint Co., 1971), 3: 367.

46. Bauman, *Let Your Words Be Few,* 9, 20, 21, 23.

47. Bauman, *Let Your Words Be Few,* 126.

48. Bauman explains, "The key symbols of speaking and silence were drawn upon by the Quakers for metaphorical extension beyond their primary verbal referents. Accordingly, speaking became a metaphor for all human action—'let your lives speak'—which were thereby encompassed by the same moral rules that governed verbal activity." *Let Your Words Be Few,* 30.

49. See Raymond Williams, *Keywords: A Vocabulary of Culture and Society* (New York: Oxford University Press, 1976). Williams attempts to define a series of highly charged words that exist in twentieth-century culture, such as "ideology," "science," "nature," and "status," by examining the evolution of their meaning and connotations. On paradigms, see Thomas S. Kuhn, *The Structure of Scientific Revolutions,* 2nd ed. (Chicago: University of Chicago Press, 1970).

50. Robert Plant Armstrong, *The Affecting Presence: An Essay in Humanistic Anthropology* (Urbana: University of Illinois Press, 1971), 3.

51. Sources for this analysis are, in particular, PMM Minutes 1762–81 and PYM *Discipline* (1762).

52. Eliot Sober, *Simplicity* (Oxford: Clarendon Press, 1975), 3. See also Richard W. Hamming, *Coding and Information Theory* (Englewood Cliffs, N.J.: Prentice Hall, 1980), 129–44, for a discussion of the related idea of "mutual information."

53. Sherry B. Ortner, "On Key Symbols," *American Anthropologist* 75, 5 (October 1973): 1340.

54. Harold Garfinkel, "Conditions of Successful Degradation Ceremonies," in *Deviance: The Interactionist Perspective*, 3rd ed., ed. Earl Rubington and Martin S. Weinberg (New York: Macmillan, 1978), 143. Garfinkel points out that when judgments on an individual's moral acceptability are made, these involve a perceived "transformation of essence by substituting another socially validated motivational scheme for that previously used." The person is seen to exist beyond the desired governing framework. See also Peter Stallybrass and Allon White, *The Politics and Poetics of Transgression* (Ithaca, N.Y.: Cornell University Press, 1986).

55. Ortner, "On Key Symbols," 1340.

56. George Fox's famous exhortation from Pardshaw Crag, 1652, as quoted in Bauman, *Let Your Words Be Few*, 26.

57. See Susan L. Garfinkel, "Genres of Worldliness: Meanings of the Meeting House for Philadelphia Friends, 1755–1830," Ph.D. dissertation, University of Pennsylvania, 1997, for a fuller discussion. Other important works on Quaker meeting houses include Hubert Lidbetter, *The Friends Meeting House* (York: William Sessions Limited/Ebor Press, 1961) and David M. Butler, "Quaker Meeting Houses in America and England: Impressions and Comparisons," *Quaker History* 79, 2 (Fall 1990): 93–104. See also Catherine C. Lavoie's essay in this volume.

58. See Jean Soderlund, "Women's Authority in Pennsylvania and New Jersey Quaker Meetings, 1680–1760," *William and Mary Quarterly* 3rd ser. 44, 4 (October 1987): 722–49, for a comparative analysis of women's familial status and meeting participation.

59. Elizabeth Sandwith Drinker, *The Diary of Elizabeth Drinker*, ed. Elaine Forman Crane et al. (Boston: Northeastern University Press, 1991), 1: 359–60. See also Drinker, *The Diary of Elizabeth Drinker: The Life Cycle of an Eighteenth-Century Woman*, ed. and abbr. Elaine Forman Crane (Boston: Northeastern University Press, 1994).

60. Arthur J. Mekeel, *The Relation of the Quakers to the American Revolution* (Washington, D.C.: University Press of America, 1979), 173–88; Theodore Thayer, *Israel Pemberton: King of the Quakers* (Philadelphia: Historical Society of Pennsylvania, 1943), 207–33. See Robert F. Oaks, "Philadelphia in Exile: The Problem of Loyalty in the American Revolution," *Pennsylvania Magazine of History and Biography* 96 (1972): 298–325.

61. Such seizures were common by the end of the decade, imposed on pacifist Friends who refused to pay taxes in support of the Revolution.

62. Roman Jakobson, "Closing Statement: Linguistics and Poetics," in *Semiotics: An Introductory Anthology*, ed. Robert E. Innis (Bloomington: Indiana University Press, 1985), 154. Here Jakobson discusses the political slogan "I Like Ike" in terms of its poetic content, but points out that its primary function is, even so, not poetic. See also Michel Foucault, "Of Other Spaces," trans. Jay Miskoweic, *Diacritics* 16, 1 (Spring 1986): 22–27.

63. Of the twelve pieces in the original study, eight are pictured here. See Garfinkel, "Discipline, Discourse and Deviation" for photographs and additional descriptions.

64. See Dell Upton, "Toward a Performance Theory of Vernacular Architecture: Early Tidewater Virginia as a Case Study," *Folklore Forum* 12, 2/3 (1979): 173–96 on the interplay of different codes within single objects.

65. Information on the Moore piece is obtained from Colonial Williamsburg; Tolles, *Meeting House and Counting House*, 122, 227, discusses Dr. Samuel Preston Moore.

66. I have considered as Quakers in good standing those who appear in William Wade Hinshaw's *Encyclopedia of American Quaker Genealogy*, vol. 2, comp. Thomas Worth Marshall (Ann Arbor, Mich.: Edwards Brothers, 1938), but are not listed for any disciplinary action, and for whom I have found no disciplinary discussion in the PMM Minutes.

67. See Christie's Sale Catalog, *Fine American Furniture, Silver and Decorative Arts* (New York: Christie, Manson and Woods International, May 23, 1985), 108–9; Philadelphia Museum of Art, *Philadelphia: Three Centuries*, 140–41.

68. PMM Minutes, 25 day 5 mo 1768; 24 day 6 mo 1768; 26 day 8 mo 1768; 23 day 9 mo 1768. Hannah Paschall was guilty of marrying "a person not professing with Friends." See William B. Hollingsworth, *Hollingsworth Genealogical Memoranda in the United States* (Baltimore: by the author, 1884), 21; Mary Hollingsworth Jamar, *Hollingsworth Family and Collateral Lines*, additions by Alexander du Bin (Philadelphia: Historical Society of Pennsylvania, 1944), 41. Levi Hollingsworth does not appear in Hinshaw, *Encyclopedia*.

69. The Logan-Fisher marriage was reported in PMM Minutes, 27 day 3 mo 1772. This chest-on-chest is discussed in Morrison H. Heckscher, *American Furniture in the Metropolitan Museum of Art, Late Colonial Period: The Queen Anne and Chippendale Styles* (New York: Metropolitan Museum of Art and Random House, 1985): 226–28.

70. Thomas Fisher, like Henry Drinker, was a Quaker leader exiled to Winchester, Virginia, in 1777. Thomas Affleck, a close friend of the Fisher family, was also included in this exiled group. See Oaks, "Philadelphia in Exile."

71. Mary G. Stoddart and Reed L. Engle, "Stenton," in Stoddart and Engle, *Historic Germantown* (New York: Antiques, 1983; reprint from *Magazine Antiques* 124 [August 1983]), 269; PMM Minutes, 26 day 7 mo 1782. On the left inside of the second drawer from the bottom of the top case is the message, "This chest was brought from Philadelphia to Virginia in the year of peace (close of American Revolution) by Charles Logan and Mary Pleasants Logan, his wife." Information on the Charles Logan piece obtained from Stenton.

72. Nicholas B. Wainright, " 'A Diary of Trifling Occurrences': Philadelphia, 1776–1778," *Pennsylvania Magazine of History and Biography* 82, 4 (October 1958): 411–65.

73. Frederick B. Tolles, "Town House and Country House: Inventories from the Estate of William Logan, 1776," *Pennsylvania Magazine of History and Biography* 82, 4 (October 1958): 403; Harold E. Gillingham, "Benjamin Lehman, a Germantown Cabinetmaker," *Pennsylvania Magazine of History and Biography* 54, 4 (1930): 291–92.

74. Likewise, we might wonder if the relative simplicity of this Quaker-made Savery chest compared to one of Affleck's production was a sign of relative religious purity as well, but a more furniture-centered explanation could be that Savery was trained locally while Affleck learned and practiced his trade in Britain before migrating. Philadelphia Museum of Art, *Philadelphia: Three Centuries*, 94–95; David B. War-

ren, *Bayou Bend: American Furniture, Paintings and Silver from the Bayou Bend Collection* (Houston: Museum of Fine Arts, 1975), 64; scattered references to the two Wharton high chests can be found in Horner's *Blue Book*. Additional information obtained from Bayou Bend.

75. Gary B. Nash, "Slaves and Slaveowners in Colonial Philadelphia," *William and Mary Quarterly* 3rd ser., 2 (April 1973): 229, points out that "The beginning of the Seven Years War in 1756 marked the onset of a decade in which slavery and slave trading reached their height in Colonial Pennsylvania." Marietta, *Reformation*, 114–20, discusses Philadelphia Yearly Meeting's position toward slavery. The 1755 advice against slavery was the first to be widely enforced, although earlier statements had been made in 1716 and 1730. Further directives appeared in 1758 and 1794. See also Jean R. Soderlund, *Quakers and Slavery: A Divided Spirit* (Princeton, N.J.: Princeton University Press, 1985).

76. On Joseph Wharton, Sr., see PMM Minutes, 26 day 3 mo 1662; 25 day 6 mo 1662; 20 day 7 mo 1662; 27 day 8 mo 1662; 24 day 9 mo 1662; 29 day 10 mo 1662; 28 day 1 mo 1763. Joseph Wharton, Jr., was under care with the meeting for a total of eight years before he was disowned, PMM Minutes, 24 day 4 mo 1772 through 31 day 3 mo 1780; Isaac Wharton was disowned over a fist fight with another Quaker for which he would not apologize, PMM Minutes, 27 day 3 mo 1772 through 24 day 6 mo 1774; Samuel Wharton was disowned because he incurred debts "and in other respects manifested a disregard to that humble self denying life which our Christian profession requires," PMM Minutes, 29 day 7 mo 1774; Carpenter Wharton was disowned for being married by a priest, PMM Minutes 27 day 9 mo 1771, although his wife Elizabeth Davis was pardoned, PMM Minutes, 27 day 3 mo 1772; Charles Wharton and his wife, Jemimah Edwards, were disowned for marriage before a priest, PMM Minutes, 27 day 3 mo 1772; Charles Wharton was reinstated, PMM Minutes, 28 day 2 mo 1777; Isaac Wharton was reinstated, PMM Minutes, 27 day 6 mo 1783.

77. Both high chests and chest-on-chests without pediments survive from Philadelphia for the same time period. While they are not discussed here, these pieces are also clearly a part of the same configurational system as their more elaborated counterparts.

78. Heckscher, *American Furniture*, 249.

79. Martin Eli Weil, " 'A Cabinetmaker's Price Book,' American Furniture and Its Makers," *Winterthur Portfolio* 13 (1979): 175–92, 177. Weil feels that it would be ridiculous to discuss any sort of "stylistic evolution" for pieces obviously made concurrently. "The contents of the Tyler manuscript corroborates currently held views regarding the variety and sophistication of Philadelphia furniture in the third quarter of the eighteenth century . . . the price list represents a wide range of furniture forms with high-style Queen Anne and Chippendale characteristics . . . the list suggests the simultaneous availability of Queen Anne and Chippendale characteristics."

80. Over one hundred examples of Philadelphia Chippendale high chests and chest-on-chests were compared to discover the rules of grammar by which they were formally and ornamentally developed. Main sources include Horner, *Blue Book;* Philadelphia Museum of Art, *Philadelphia: Three Centuries;* Heckscher, *American*

Furniture; Decorative Arts Photographic Collection (DAPC) at the Winterthur Museum; furniture in the collection of the Winterthur Museum; and other pieces personally observed. See also Henry Glassie, *Folk Housing in Middle Virginia: The Structural Analysis of Historic Artifacts* (Knoxville: University of Tennessee Press, 1975), particularly chap. 6, "The Mechanics of Structural Innovation," 66–113.

81. According to family history, the Jones high chest was broken open in 1778 by Pulaski's rebel cavalry while it was housed at Pynepoint, Cooper's Creek, New Jersey, the estate of Acquilla Jones's father-in-law. There is evidence that the locks had been forcibly broken. Information on the Jones piece obtained from the Wistar Institute and the University of Pennsylvania.

82. Heckscher, *American Furniture*, 253; PMM Minutes, 30 day 7 mo 1756.

83. This chest-on-chest is attributed to Thomas Affleck on the basis of a bill of sale from Affleck to David Deshler (dated 1775, now unavailable). See Horner, *Blue Book*, 104. A label pasted on the back of an upper drawer reads, "This chest of drawers was given by David Deshler to his daughter Catherine on her marriage to Robert Roberts in 1775." Information on the Deshler piece obtained from Colonial Williamsburg. Deshler was a German Quaker; a house that he built still stands in Germantown.

84. See Burton Alva Konkle, *Benjamin Chew* (Philadelphia: University of Pennsylvania Press, 1932). Chew left Quakerism in adulthood, served as a court justice, and remained a loyalist during the Revolution. His Germantown home, Cliveden, was the site of the Battle of Germantown, and still stands today as a historic house museum. The chest-on-chest is on display at Cliveden.

85. Christie's Sale Catalogue, *Fine American Furniture, Silver, Folk Art and Decorative Arts* (New York: Christie, Manson and Woods International, October 19, 1985), 90–91. James Bartram was the brother of John Bartram, the important botanist. Both were disowned and became members of the Free Quakers. See Charles Wetherill, *History of the Religious Society of Friends Called by Some the Free Quakers* (Philadelphia: Religious Society of Friends Called by Some the Free Quakers, 1894), 61.

86. William J. Macintire, in his study of a rural furniture tradition, "Creativity and Tradition: The Corner Cupboards of Southwestern Sussex County, 1790–1850," M.A. thesis, University of Delaware, 1989, has documented a similarly additive stylistic competence. By combining the many varied ornamental features used in corner cupboard fabrication, he has created a theoretical most-elaborated prototype. An example of this most fully articulated cupboard is not known to exist. Glassie, *Folk Housing*, 42, has located this single complete example. "It would not have been necessary to study all of the area's dwellings to construct the model of the design competence. Only one could have been chosen so long as it was the right one . . . and the analyst was a lucky genius." The situation here is different. Within the group of Philadelphia Chippendale high chests and chest-on-chests there are quite a few pieces that contain as many possible elements from the ornamental vocabulary as any one example possibly could. No one example can possibly include them all.

87. Weil, "A Cabinetmaker's Price Book"; Gillingham, "Benjamin Lehman," 291–92. The categories used here are taken from the Benjamin Lehman Price Book of

1786. Price books were often developed to settle disputes between masters and journeymen over appropriate wages, thus journeymen's wages are listed in a third column of the original price list.

88. Thomas Affleck's Account with James Pemberton, February 10–June 20, 1775. Pemberton purchased a chest-on-chest from Affleck valued at £21, as well as many other items, including a mahogany fretwork mantlepiece and a mahogany bedstead with fluted pillars. Galloway's estate was confiscated in 1778; an inventory shows a high chest in the upstairs chamber listed at £20. William Henry Egle, ed., *Pennsylvania Archives*, 6th ser. (Harrisburg: Wm. Stanley Ray, State Printer of Pennsylvania, 1897), 12: 511–16. On political relationships, see Bauman, *Reputation of Truth*; Thayer, *Israel Pemberton*; Bruce R. Lively, "Toward 1756: The Political Genesis of Joseph Galloway," *Pennsylvania History* 45, 2 (Spring 1978): 117–38.

89. PYM *Discipline* (1762), 48.

Chapter 4. "All That Makes a Man's Mind More Active": Jane and Reuben Haines at Wyck, 1812–1831

1. Wyck is the name given to the house and farm in 1807 by Reuben Haines III. He believed he was making reference to his ancestral home near Oxford, England. Haines acquired a print engraved by Kip of an English manor from the 1600s captioned, "Wyck the Seat of Richard Haines, Esq." Some twenty years later he discovered that he was mistaken in believing that this Richard Haines was his ancestor. By that time the Germantown property was well known as Wyck, so the name remained. For purposes of this chapter, the property will be identified as Wyck for all time periods of the family's ownership.

2. The Wyck Papers are on deposit at the American Philosophical Society in Philadelphia.

3. The earliest owner was an illiterate German husbandman named Hans Millan who purchased the land in 1689 as a farm. His son-in-law Dirck Jansen (?–1760), a Dutch linen weaver, by the 1740s had transformed himself into Dirk Johnson, English citizen, prosperous merchant, and "gentleman." Jansen built the current front section of Wyck in 1736. It is a three-bay stone structure that originally had a pent eave and a red clay tile roof. In his time period, Wyck was composed of a log house from the 1690s, an addition that may have been the weaving area, and then the newer stone house closest to the street. A tall case clock made by Peter Stretch ca. 1715–20 demonstrates Jansen's increasing wealth.

In the third generation, Jansen's daughter, Catherine (1709–1793), was a fashionable Quaker lady married to one of the wealthier men in Pennsylvania, Caspar Wistar (1696–1752). For biographical information on Caspar Wistar see Isaac J. Wistar, *The Autobiography of Isaac Jones Wistar, 1825–1905* (Philadelphia: Wistar Institute, 1914); Sandra Mackenzie Lloyd, for John M. Dickey, *Historic Structures Report: Wyck House*, 3 vols. (Philadelphia: Wyck Association, 1986); Rosalind J. Beiler, "The Transatlantic World of Caspar Wistar: From Germany to America in the Eighteenth Century," Ph.D. dissertation, University of Pennsylvania, 1994; Jack L. Lindsey, *Worldly Goods:*

The Arts of Early Pennsylvania, 1680–1750 (Philadelphia: Philadelphia Museum of Art, 1999).

Wistar died in 1752 with an estate valued at over £26,000. His house at Third and High (Market) Streets was a large and comfortable city residence. He also had a summer retreat in Germantown about five blocks south of Wyck. His surviving furniture demonstrates he was purchasing fashionable and costly items but they were not the most elaborate of the time period. Descendants of Wistar married into other prominent Quaker families besides the Haines, including the Morris and Sharples families. Descendants of his brother, John Wister, also figure prominently in the city's history. By the twentieth century the Morrises, Wistars, and Wisters were considered among the most socially prominent families in Philadelphia along with Biddles, Cadwaladers, and Chews. Members of these families often characterized themselves the city's "aristocracy," particularly through their club and patriotic society affiliations.

4. Lloyd, *Historic Structures Report,* 53–57, 139–66. Mark Frazier Lloyd, "Jansen/Wistar/Haines: From German Immigrants to American Gentry," paper read before the Friends of the American Philosophical Society, February 27, 1991. Caspar and Catherine Wistar's daughter Margaret was educated at an English girls' school in Philadelphia where she learned domestic skills and excelled at needlework. Two remarkable framed needlework pictures made and signed by her in 1738, when she was nine years old, are at Wyck today. They depict a vase of elaborate flowers with gamboling animals below, a popular design motif of the time being taught by needlework instructors. They demonstrate patience and skill as well as an appreciation of the natural world. Margaret married one of Philadelphia's leading brewers, Reuben Haines I, a descendant of English Quakers. Haines was also a successful merchant and agent. His outspoken behavior in the years before the Revolutionary War led to his being read out of meeting on more than one occasion, but his apologies or retractions gained him readmittance. In one instance this included printing of a broadside in December 1776 (Wyck accession number 89.45) that stated he had *not* indicated he would burn his breweries if the British occupied the city.

5. Richard G. Miller, "The Federal City," in *Philadelphia: A 300-Year History,* ed. Russell Weigley (New York: W.W. Norton, 1982), 181–88; Charles Francis Jenkins, *Washington in Germantown* (Philadelphia: William J. Campbell, 1905). In the 1790s Germantown was often a refuge for those fleeing the yellow fever epidemic, which was particularly virulent in the fashionable residential areas along the Delaware River. George Washington, members of his cabinet, and Congress all found refuge in the relatively disease free climate of Germantown.

6. Lloyd, *Historic Structures Report,* 167–73. Caspar Wistar Haines to Hannah Marshall Haines, Wyck Papers, II/10/19 and II/10/20. Caspar Wistar Haines took an active role in his family's brewing business but was able to take long absences from this work. Haines, who was a Quaker minister, had left his wife Hannah Marshall Haines (1765–1828), the daughter of a wealthy Philadelphia Quaker merchant, and young children in 1790 to preach on "truth's account," journeying for several years through the South, visiting other Friends, and seeking spiritual development. Correspondence with his wife suggests a man in quest of religious inspiration and one attempting to understand his own character and volatile emotions. Letters critical of

Hannah questioned her spiritual qualities and her worthiness of his company. Yet upon his return he resumed a comfortable, even stylish life as a brewer and merchant with little reference ever made to the trip. His vacillation between periods of strong religious activity and those when he was shaping his country estate at Wyck and purchasing many new furnishings may in part be explained by what appears to be a manic-depressive disorder. According to references made by his son, Reuben Haines III, Caspar took his own life in 1801. Although Reuben would oversee Wyck and make many improvements there, it remained the property of Hannah until her death.

7. Frank S. Welsh, "Paint Analysis," *Historic Structures Report*, vol. 3.

8. Sandra Mackenzie Lloyd, "Three Centuries of Earthly Delights: A History of the Wyck Garden," in *Germantown Green: A Living Legacy of Gardens, Orchards, and Pleasure Grounds*, ed. Ann Newlin Thompson (Philadelphia: Wyck Association, 1982), 19.

9. Beatrice B. Garvan, *Federal Philadelphia: The Athens of the Western World* (Philadelphia: Philadelphia Museum of Art, 1976), 22–25.

10. Reuben Haines wrote of Elias Hicks's disruptive attendance at Baltimore Yearly Meeting in 1822. Anne Ayer Verplanck, "Facing Philadelphia: The Social Function of Silhouettes, Miniatures and Daguerreotypes, 1760–1860," Ph.D. dissertation, College of William and Mary, 1996, 105–6; Reuben Haines III to Jane Bowne Haines, 30 day 10 mo 1822, Wyck Papers II/15/161.

11. Reuben Haines III to Thomas Gilpin, 19 day 9 mo 1810, Wyck Papers, II/14/122.

12. Ibid.

13. Reuben Haines III to Richard Hartshorne, 1 day 12 mo 1810, Wyck Papers, II/14/122. The meeting referred to is most likely Arch Street Meeting in Philadelphia. Spelling, punctuation, and emphasis in all quotes is as in the original.

14. Ann Haines to Hannah Haines, 9 day 9 mo 1816, Wyck Papers, II/25/368. Ann Haines (1793–1869), or "Cousin Ann," as the family referred to her, was a central figure at Wyck in the 1810s–1860s. Recent research has shown that many of the furnishings at Wyck belonged to Ann, as did some of the scientific collections. She was born out of wedlock in 1793 to Caspar Haines's brother Reuben II, who died shortly thereafter. His life appears to have been fairly troubled and he was read out of meeting for public drunkenness. Ann was warmly embraced by the family and brought up by various aunts and uncles. She formed a very close attachment to Reuben III and his family, particularly his wife, Jane. Educated at Westtown School and then Briarcliff School (College) in New York, Ann was accomplished in a number of disciplines and an avid student. While Jane took the domestic role, Ann accompanied Reuben to lectures and scientific demonstrations. Ann spent extended periods of time with family in Northumberland, Pennsylvania, where her Uncle Josiah had settled and the Haineses had extensive landholdings. Ann inherited substantial wealth from various family members, enabling her to live comfortably and independently. In the 1830s to 1850s, she traveled around the east coast and Midwest visiting friends and family. Ann was devastated by Reuben's death in 1831 but stepped in to help Jane, in particular when the last child, Jane Reuben Haines, was born in 1832. Ann, who never married, assisted in child care and after Jane's death in 1843 took over primary responsibility

for the children. Ann lived at Wyck until her death in 1869, with Jane Reuben caring for her in her later years. Ann remained a Quaker throughout her life and her consumption patterns are similar to Reuben and Jane's—costly items but free of elaborate ornamentation. Jane Reuben Haines became an Episcopalian in her twenties and later in life was persistent in her attempts to persuade other family members, who remained Quakers, to convert. However, she lived compatibly with Ann and often characterized herself as a Quaker woman. For a study of Jane Reuben Haines, see Kate Molumby, " 'Aunt Wyck Jane': The Material Life of Jane Reuben Haines," M.A. thesis, University of Delaware, 2000.

15. Jane Bowne Haines to Ann Haines, 23 day 4 mo 1824, Wyck Papers, II/20/271.

16. Reuben Haines III, Accounts, 9 day 8 mo 1827, Wyck Papers, IV/127/24.

17. Jane Bowne Haines to Hannah Collins, 23 day 2 mo 1816, Wyck Papers, II/20/263.

18. Reuben Haines III to James Pemberton Parke, 18 day 10 mo 1816, Wyck Papers, II/15/146.The Haines coat of arms appeared on the Kip engraving of Wyck in England, which Reuben mistook for his ancestral home.

19. Patricia Tyson Stroud, *The Emperor of Nature: Charles-Lucien Bonaparte and His World* (Philadelphia: University of Pennsylvania Press, 2000), 126.

20. Reuben Haines III to Hannah Haines, 25 day 6 mo 1799, Wyck Papers, II/14/106.

21. Reuben Haines III, journal, 1799, Wyck Papers, III/88/24.

22. Reuben Haines III to Dr. Caspar Wistar, 21 day 7 mo 1809, Wyck Papers, II/14/118.

23. Sandra F. Mackenzie (Lloyd), "What a Beauty There Is in Harmony: The Reuben Haines Family of Wyck," M.A. thesis, University of Delaware, 1979; Sara Pennell, "The Quaker Domestic Interior, Philadelphia 1780–1830: An Artifactual Investigation of the 'Quaker Esthetic' at Wyck House, Philadelphia and Collen Brook Farm, Upper Darby, Pennsylvania," M.A. thesis, University of Pennsylvania, 1993.

24. Pennell, "The Quaker Domestic Interior," 71.

25. Mackenzie (Lloyd), "What a Beauty There Is in Harmony," 51.

26. Reuben Haines III to Jane Bowne, 16 day 10 mo 1811, Wyck Papers, II/14/124.

27. Reuben Haines III, bills of sale and receipts, Wyck Papers, IV/146/208–218.

28. Reuben Haines III to Jane Bowne Haines, 11 day 10 mo 1812, Wyck Papers, II/14/173.

29. Reuben Haines III, notes from architectural lectures by William Strickland, 1824–25, Wyck Papers, III/90/65.

30. Reuben Haines III to Jane Bowne Haines, 20 day 9 mo 1815, Wyck Papers, II/22/311. Sally Ann Lea, a member of a wealthy family of publishers, was a friend of the Haineses.

31. For more on Tucker porcelain see Philadelphia Museum of Art: *Philadelphia: Three Centuries of American Art* (Philadelphia: Philadelphia Museum of Art, 1976), 293–94.

32. Pennell, "The Quaker Domestic Interior," 92.

33. Reuben Haines III, Accounts, 5 day 2 mo 1816, Wyck Papers, IV/125/14.

34. For examples, see William Macpherson Hornor, Jr., *Blue Book, Philadelphia Furniture: William Penn to George Washington* (Philadelphia, 1935).

35. Charles Francis Jenkins, *Lafayette's Visit to Germantown* (Philadelphia: William J. Campbell, 1911), 42. Reuben Haines owned a French chair that had belonged to Franklin. The Marquis de Lafayette sat in the chair to greet visitors to Wyck in 1825 during a reception held in his honor. Today the chair belongs to a Haines descendant.

36. Garvan, *Federal Philadelphia*, 54.

37. Reuben Haines III to Ann Haines, n.d. 1825, Wyck Papers, II/20/272.

38. Ibid.

39. American Guernsey Cattle Club, *The Story of the Guernsey Cow* (Peterboro, N.H.: American Guernsey Cattle Club, 1915). Reuben's livestock sale catalogs in the Wyck collection include "Mr. Powel's Stock of Improved Durham Short Horned Cattle"(Philadelphia, 1830), Wyck Pamphlet Collection, Box 8/Folder 98; "Catalogue of Thorough Bred Horses, Durham Short Horned Cattle and Improved Bakewell or New Leicester English Sheep, the Property of Charles Henry Hall" (New York, 1830), Wyck Pamphlet Collection, Box 8/Folder 92.

40. Reuben Haines III to Hannah Haines, 4 day 6 mo 1820, Wyck Papers, II/15/158.

41. Ibid.

42. Sarah Minturn to Jane Haines, 4 day 4 mo 1819, Wyck Papers, II/22/324.

43. Jane Bowne Haines to Hannah Haines, 20 day 12 mo 1820, Wyck Papers, II/15/159.

44. Reuben Haines III to Hannah Haines, 4 day 6 mo 1820, Wyck Papers, II/15/158.

45. Mackenzie (Lloyd), "What a Beauty There Is in Harmony," 60.

46. Reuben Haines III to Jane Bowne Haines, 23 day 5 mo 1824, Wyck Papers, II/15/163.

47. Ibid.

48. See Welsh, "Paint Analysis"; Pennell, "The Quaker Domestic Interior," 104.

49. Reuben Haines III to Jane Bowne Haines, 23 day 5 mo 1824, Wyck Papers, II/15/163.

50. Levi Morris, a cousin of Reuben Haines, also patronized cabinetmaker Charles White. See Morris/Shinn/Maier Papers, Haverford College Library Special Collections, receipts, 1832–1833.

51. Christine Doell and Gerald Doell, *Historic Landscape Report, Wyck* (Philadelphia: For the Wyck Association, 1991). Menke and Menke, *Wyck Landscape Master Plan* (Philadelphia, 1999).

52. Jane Bowne Haines to Hannah Collins, 24 day 6 mo 1814, Wyck Papers, II/20/262.

53. Ann Haines to Jane Bowne Haines, 29 day 5 mo 1824, Wyck Papers, II/25/373.

54. Mary Ann Donaldson to Jane Bowne Haines, 15 day 8 mo 1832, Wyck Papers, II/27/406. Mary Ann Donaldson, a distant relative of the family, served as governess and nursery maid until 1843. She was an integral part of the family and recorded in lyrical prose daily life at Wyck in her letters to Ann or Jane. In the same letter Mary Ann worried about the impact the new railroad would have on their beautiful woods.

In February 1833 she wrote, "After dinner I walked to the spot where once stood the beautiful trees whose untimely fall I have mourned . . . I wish I had the machine which was invented in England for transplanting full grown former trees." Mary Ann Donaldson to Jane Bowne Haines, 24 day 2 mo 1833, Wyck Papers, II/23/353. In 1834 Mary Ann wrote to Jane, "The lawn, orchard, and garden, are at this time most beautiful; I can hardly keep my eyes upon my paper for gazing at the luxuriant green covering the lawn and 1st flowery decorations." Mary Ann Donaldson to Jane Bowne Haines, 5 day 5 mo 1834, Wyck Papers, II/25/378.

55. Mary Ann Donaldson to Jane Bowne Haines, 27 day 5 mo 1839, Wyck Papers, II/24/360.

56. Mackenzie (Lloyd), "What a Beauty There Is in Harmony," 105. A silk dress that survives in the collection at Wyck is the purported dress. However, in terms of style and details of manufacture it is inconsistent for the time period and even American manufacture. Such a dress may have been made, as the tradition is so strong, but confusion has arisen as to which it was.

57. See Lloyd, "Three Centuries of Earthly Delights," 18–27.

58. Elizabeth Fry as quoted in Pennell, "The Quaker Domestic Interior," 9.

59. Reuben and Jane Haines, receipts and bills of sale, Wyck Papers, IV/146/208; receipts. Morris/Shinn/Maier Papers, Haverford College Library Special Collections.

60. Ann Haines to Jane Bowne Haines, 12 day 12 mo 1818, Wyck Papers, II/25/370. In 1807 Hannah Haines wrote to her son Reuben about a member of their meeting. "B. Morris spoke again yesterday . . . the meeting does not know what to think of him—He has put on a plain coat—but it is I believe generally supposed that he is deranged." 8 day 4 mo 1807, Wyck Papers, II/12/62.

61. Reuben and Jane Haines, receipts and bills of sale, Wyck Papers, IV/146/208.

62. Jane Bowne Haines to Ann Haines, 7 day 10 mo 1827, Wyck Papers, II/20/273.

63. Jane Bowne Haines to Ann Haines, 18 day 11 mo 1828, Wyck Papers, II/20/273.

64. Jane Bowne Haines to Ann Haines, 18 day 11 mo 1828.

65. Jane Bowne Haines to Ann Haines, 21 day 4 mo 1829, Wyck Papers, II/20/274.

66. Nicholas Wilson to Reuben Haines III, 5 day 3 mo 1809, Wyck Papers, II/16/186.

67. Reuben Haines III, account books, 1820–1831, Wyck Papers, IV/127/25. At his death in 1831 his estate was worth over $200,000.

68. Mackenzie (Lloyd), "What a Beauty There Is in Harmony," 25.

69. Reuben Haines III to Jane Bowne Haines, 13 day 11 mo 1831, Wyck Papers, II/15/172. Although the railroad did not reach Norristown and the Plymouth limestone quarries for many years because of construction difficulties, it did provide service to Germantown by 1832. Reuben was prophetic in his hopes for the development of Germantown. By the 1850s the land that had been the Wyck meadows and woodlot was so valuable his heirs sold it to be transformed into modest-size lots for Victorian suburban villas.

70. Wyck Papers, III/90/78.

71. Wyck Papers, III/90/78.

72. For a biography of Thomas Say, see Patricia Tyson Stroud, *Thomas Say: New World Naturalist* (Philadelphia: University of Pennsylvania Press, 1992).

73. Reuben Haines III, journal, June 1809, Wyck Papers, IV/125/11; Reuben Haines III to John Smith Haines, 1 day 7 mo 1809, Wyck Papers, II/14/118.

74. Reuben Haines III, receipts, 1817, Wyck Papers, IV/146/215. The silver equipment has not survived at Wyck, but glass tubes and piping from that time remain in the cabinets in Reuben's "museum room."

75. The name Caspar Wistar is present in many generations of the family. The first Caspar Wistar, who arrived in Pennsylvania in 1717, is best known for his manufacture of brass buttons and his Wistarburgh glassworks. His grandson was Dr. Caspar Wistar, known in the family as Dr. Wistar the anatomist. There were also later Dr. Caspar Wistars, although they did not enjoy the same renown. The Wistars married into the Morris family. Hence there are several individuals named Caspar Wistar Morris as well as Caspar Wistar Haines.

76. *Sketch of the Wistar Party* (Philadelphia: Privately printed, 1898), 6–7.

77. *Sketch of the Wistar Party*, 9.

78. The Wistar family's prominence in medicine has continued to the present, notably with Dr. Jonathan Rhoads, a direct descendant of Caspar Wistar, a leading physician for over sixty years at the Hospital of the University of Pennsylvania and chairman of the overseers at Friends Hospital.

79. These were meteorological tables at Wyck. The tables were continued after Reuben Haines's death, probably maintained by his cousin Ann, who assumed many of his roles in scientific inquiry and continued to attend lectures and meetings of the learned societies. By the 1840s the increased professionalism of these organizations had marginalized the role of the amateur scientist.

80. Merritt Ierley, *Open House: A Guided Tour of the American Home, 1637–Present* (New York: Henry Holt, 1999), 66.

81. Examples of these needle cases or pin cushions remain at Wyck. W. Edmunds Claussen, *Wyck: The Story of an Historic House, 1690–1970* (Philadelphia, Privately printed, 1970), 110–16. Wyck's last owner, Mary T. Haines, commissioned this book. It quotes extensively from the Wyck Papers, but often without date or citation, and some of the information is outdated or inaccurate.

82. Wyck Pamphlet Collection. The nearby house of the Johnson family served as an Underground Railroad stop.

83. Lucy Turpen, Sampler, 1815, Wyck accession number 88.564.

84. Reuben Haines III to Jane Bowne Haines, 29 day 4 mo 1818, Wyck Papers, II/15/151.

85. Mackenzie (Lloyd), "What a Beauty There Is in Harmony," 78.

86. Sarah remained at the boarding school until 1824. Reuben Haines gave Mme Fretageot financial assistance periodically. At the time of his death in 1831, she was living in New Harmony, Indiana, and her letters indicate that she had developed an animosity toward him. She actively spread the news of his death and his reported suicide. While it is not clear if he intentionally took his own life, he did overdose on laudanum and he had been known to be obsessing about his father's own suicide shortly before.

87. A. Bronson Alcott, *Observations on the Principles and Methods of Infant Instruction* (Boston: Carter and Hendee, 1830), Wyck Pamphlet Collection, Box 13/Folder 31.

88. Reuben Haines III to Jane Bowne Haines, 19 day 10 mo 1830, Wyck Papers, II/15/171.

89. Judith Callard, "The Alcotts of Germantown," *Germantown Crier* 47 (1996): 4–36.

90. Alcott's journal as quoted in Callard, "The Alcotts of Germantown," 6.

91. Alcott's journal, 9.

92. Alcott's journal, 15.

93. Ann Haines to Jane Bowne Haines, 9 day 12 mo 1832, Wyck Papers, II/25/376.

94. Reuben Haines III, writings, n.d., Wyck Papers, III/91/80.

95. Reuben Haines III, writings, 1824, Wyck Papers, III/90/65.

96. Edgar Richardson, "The Athens of America, 1800–1825," in *Philadelphia: A 300-Year History*, ed. Weigley, 242.

97. Jane Bowne Haines diary, 1812, Wyck Papers, III/92/93.

98. Family members including Reuben and Jane and their children did have silhouettes made at the Peale Museum. Miniatures and daguerreotypes of family members also survive. See Verplanck, "Facing Philadelphia."

99. A series of eight views forming a panorama of the city of Constantinople and its environs taken from the tower of Galalta by Henry Aston Barker, 1813, Wyck collection, accession number 89.133.

100. John Vanderlyn to Reuben Haines III, 21 day 7 mo 1829, Wyck Papers, II/29/249.

101. Reuben Haines III to James Pemberton Parke, 7 day 11 mo 1823, Wyck Papers, II/15/162. See also correspondence between Reuben Haines III, John Lowber, and G. Persico, Wyck Papers, 1823, II/18/228.

102. Rembrandt Peale to Reuben Haines III, 19 day 9 mo 1828, Haines Papers, Charles Roberts Autograph Letter Collection, Haverford College Library, Haverford, Pennsylvania.

103. Reuben Haines correspondence with Rembrandt Peale and Rosabala Peale, 1829–1830, Wyck Papers, II/15/169–170; Claussen, *Wyck*, 85–95.

104. See Wyck Object File, accession number 78.15. The second portrait now hangs at the Academy of Natural Sciences in Philadelphia.

105. Wyck passed from Jane Bowne Haines to her children at her death in 1843. Her youngest child, Jane Reuben Haines, lived at Wyck until her death in 1911. She then passed Wyck to her unmarried nephew and nieces, Caspar Wistar Haines (II), Jane Bowne Haines (II), and Mary Morton Haines. Caspar carefully preserved the buildings, family furnishings, and papers. With his sister Jane he also maintained his grandmother's rose garden but introduced some new plant varieties. Caspar was a devout Episcopalian, but his sisters remained Quakers. At his death in 1935, Wyck became the property of Robert B. Haines III and his wife Mary T. (Haines) Haines. They mainly used Wyck as a winter retreat, spending the rest of the year at their orchards in the country. Both were Quakers although they also attended the Presbyterian church at times. They made few alterations to the house or landscape and acquired little in the way of furnishings. Robert died in 1967; Mary left Wyck in 1973

328 *Notes to Pages 122–123*

to move to the Quaker retirement community Medford Leas in New Jersey. Their lifestyle was very modest and centered on their religion. They also were strong believers in temperance. Ironically, in many ways, they fulfilled stereotypes of simple and plain Quakers. In 1973 Mary T. Haines created the Wyck Charitable Trust. Since 1980 the Wyck Association has been the agent of the trust to administer the house and garden as a museum and resource center. The collection numbers over 10,000 objects and the family library has over 3,000 volumes.

Chapter 5. Living in the Light: Quakerism and Colonial Portraiture

1. Israel Pemberton to Joseph Pemberton, June 13, 1778, Pemberton Papers, Historical Society of Pennsylvania (HSP). Joseph was disowned by the Philadelphia Monthly Meeting (PMM), June 28, 1776. PMM Minutes, 27 day 6 mo 1788. The meeting still regarded Ann as a member as late as 1788, and records the presence of Ann and her children at a Philadelphia Monthly Meeting. PMM Minutes, 27 day 6 mo 1788.

2. *Rules of Discipline of the Philadelphia Yearly Meeting of Friends* (Philadelphia: Samuel Sansom, Jr., 1797), 102–5; *Journal of George Fox,* ed. John L. Nickalls (Cambridge: Cambridge University Press, 1952), 35, 401.

3. One of the minutes of Philadelphia Monthly Meeting makes note of the importance of "Moderation, Simplicity and Plainness, which truth ever leads its sincere followers into." PMM Minutes, 30 day 4 mo 1779. Howard Brinton, *Friends for 300 Years: The History and Beliefs of the Society of Friends Since George Fox Started the Quaker Movement* (Wallingford, Pa.: Pendle Hill Publications, 1964), 135.

4. Frederick B. Tolles writes, "Of Quaker theory as applied to . . . fine arts—to painting, sculpture, music, poetry, and the drama—there is almost nothing to be said, for the early Friends banished them almost totally from their lives . . . for the arts whose chief purpose was to please the senses they had nothing but scorn [fearful] of becoming entangled with the winsome delights of the 'world' if they once gave way to the human appetite for sensuous beauty." Tolles, *Quaker Profiles Pictorial and Biographical, 1750–1850* (Wallingford, Pa.: Pendle Hill Publications, 1964), 1.

5. Anna Cox Brinton, *Quaker Profiles Pictorial and Biographical, 1750–1850* (Wallingford, Pa.: Pendle Hill Publications, 1964), 1. See Anne Ayer Verplanck, "Facing Philadelphia: The Social Function of Silhouettes, Miniatures, and Daguerreotypes, 1760–1860," Ph.D. dissertation, College of William and Mary, 1996, chap. 2.

6. Benjamin Franklin, *The Papers of Benjamin Franklin,* ed. Leonard W. Labaree and Whitfield J. Bell, Jr. (New Haven, Conn.: Yale University Press, 1959), 9: 7–9.

7. Quoted in Brinton, *Quaker Profiles,* 1.

8. *Rules of Discipline,* 102–5.

9. The paintings discussed here are limited to a selection of portraits of sitters from Philadelphia and the surrounding Delaware Valley, as it became apparent that regional differences in manner of living and artistic style would have to be left for further study.

10. The role of religion and portraiture has been addressed by Lillian B. Miller,

"The Puritan Portrait: Its Function in Old and New England," in *Seventeenth-Century New England*, ed. David Hall and David Grayson Allen (Boston: Massachusetts Historical Society, 1984), 153–84.

11. Margaretta M. Lovell, "Reading Portraits: Social Images and Self-Images in Eighteenth-Century American Family Portraits," *Winterthur Portfolio* 22, 4 (Winter 1987): 257–59.

12. Timothy Breen, "The Meaning of 'Likeness': Portrait-Painting in an Eighteenth-Century Consumer Society," in *The Portrait in Eighteenth-Century America*, ed. Ellen Miles (Newark: University of Delaware Press, 1993), 37–60; Robert St. George, *Conversing by Signs: Poetics of Implication in Colonial New England Culture* (Chapel Hill: University of North Carolina Press, 1998), 300–302; Paul Staiti, "Character and Class," in *John Singleton Copley in America*, ed. Carrie Rebora and Paul Staiti, Erica E. Hirshler, Theodore E. Stebbins, Jr., and Carol Troyen with contributions by Morrison H. Heckscher, Aileen Ribeiro, and Marjorie Shelley (New York: Metropolitan Museum of Art, 1996), 53–77.

13. Richard Brilliant, *Portraiture* (Cambridge, Mass.: Harvard University Press, 1991), 31, 40, 89.

14. Painting manuals also provided separate instructions for painting men and women. Deborah Prosser, "Visual Persuasion: Portraits and Identity Among Colonial Artists and Patrons, 1700–1776," Ph.D. dissertation, University of Pennsylvania, 1997, 37, 219–20. On English portraiture during this period, see Louise Lippincott, "Expanding on Portraiture: The Market, the Public, and the Hierarchy of Genres in Eighteenth-Century Britain," in *The Consumption of Culture, 1600–1800: Image, Object, Text,* ed. Ann Bermingham and John Brewer (London: Routledge, 1998), 80–81.

15. Claudia Brush Kidwell, "Are Those Clothes Real? Transforming the Way Eighteenth-Century Portraits Are Studied," *Dress* 24 (1997): 3–15.

16. Susan L. Garfinkel, "Discipline, Discourse, and Deviation: The Material Life of Philadelphia Friends, 1762–1781," M.A. thesis, University of Delaware, 1986. In her introduction, the author provides a thorough review of the recent literature, noting the lack of integration among an aesthetic approach, a social or theological framework, and the physical evidence of surviving artifacts. Also see Garfinkel, "Genres of Worldliness: Meanings of the Meeting House for Philadelphia Friends, 1755–1830," Ph.D. dissertation, University of Pennsylvania, 1997.

17. R. V. Shepherd, Jr., "James Logan's Stenton: Grand Simplicity in Quaker Philadelphia," M.A. thesis, University of Delaware, 1968, vi; Garfinkel, "Discipline, Discourse and Deviation," 2.

18. Frederick B. Tolles, *Quakers and the Atlantic Culture* (New York: Macmillan, 1960), chap. 5.

19. My interest in this topic began in 1987 while doing research for my master's thesis. This essay is based on that research and seeks to question the very nature of the commissioned portrait itself and its relationship to Quaker doctrine. See Dianne C. Johnson, "Living in the Light: Quakerism and Colonial Portraiture," M.A. thesis, University of Delaware, 1991; Deborah E. Kraak, "Variations on 'Plainness': Quaker Dress in Eighteenth-Century Philadelphia," *Costume* 34 (2000): 51–63; Leanna Lee-Whitman, "Silks and Simplicity: A Study of Quaker Dress as Depicted in

Portraits, 1718–1855," Ph.D. dissertation, University of Pennsylvania, 1987; Garfinkel, "Discipline, Discourse and Deviation"; Patricia J. Keller, *"Of the Best Sort But Plain": Quaker Quilts from the Delaware Valley, 1760–1890* (Chadds Ford, Pa.: Brandywine River Museum, 1997).

20. Lee-Whitman, "Silks and Simplicity," 148.

21. Lee-Whitman, "Silks and Simplicity," 4, 28; Tolles, *Atlantic Culture*, 87.

22. Garfinkel, "Discipline, Discourse, and Deviation," 8.

23. Garfinkel, "Discipline, Discourse, and Deviation," 47.

24. *Journal of George Fox*, 11.

25. For a review of scholarship regarding the relationship between Quakerism and Puritanism, see Richard S. Dunn and Mary Maples Dunn, "Puritanism, Spiritualism, and Quakerism: An Historiographical Essay," in *The World of William Penn* (Philadelphia: University of Pennsylvania Press, 1986), 281–301.

26. *Journal of George Fox*, 11.

27. For an overview of the history of the Society of Friends, see William C. Braithwaite, *The Beginnings of Quakerism*, 2nd ed. (Cambridge: Cambridge University Press, 1955); Braithwaite, *The Second Period of Quakerism*, 2nd ed. (Cambridge: Cambridge University Press, 1961); Howard Brinton, *Guide to Quaker Practice* (Wallingford, Pa.: Pendle Hill Publications, 1951); and Brinton, *Friends for 300 Years*.

28. Jacques-Pierre Brissot de Warville, *New Travels in the United States of America*, trans. M. S. Vamos and D. Echeverria, ed. D. Echeverria (Cambridge, Mass.: Belknap Press of Harvard University Press, 1964), 168–70.

29. Thomas Lawrence and George Fox, "Concerning Marriage: A Letter Sent to G.F. And with it, a Copy of an Answer to a Friend's Letter Concerning Marriage" (n.p., 1663), 12; quoted in J. William Frost, *The Quaker Family in Colonial America* (New York: St. Martin's Press, 1973), 14.

30. See *Rules of Discipline*, 35. Also see *A Collection of Christian & brotherly Advices Given forth from time to time by the Yearly Meeting of Friends for Pennsylvania & New Jersey held alternately at Burlington & Philadelphia, 1762–1779*, Friends Historical Library, Swarthmore College.

31. "The Advice of William Penn to His Children," in *A Collection of the Works of William Penn* (London, 1726), 1: 908–9, 898; quoted in Wayne Craven, *Colonial American Portraiture* (Cambridge: Cambridge University Press, 1987), 375.

32. The older historians of Philadelphia history describe the first settlers as "well-to-do people at home"; however, as Tolles has established, contemporary records indicate that the majority of early settlers were either farmers or of the working class in the cities. Frederick B. Tolles, *Meeting House and Counting House: The Quaker Merchants of Colonial Philadelphia, 1682–1763* (New York: W.W. Norton, 1948), 38–39, chap. 2, n. 20. Also see Albert Cook Myers, *Immigration of the Irish Quakers into Pennsylvania, 1682–1750, with their early history in Ireland* (Baltimore: Genealogical Publishing, 1969); and G. Lyon Turner, *Original Records of Early Nonconformity Under Persecution and Indulgence* (London: T.F. Unwin, 1911–14).

33. "An Epistle to All Planters, and Such Who Are Transporting Themselves into

Foreign Plantations in American, &c." (1682), in George Fox, *The Works of George Fox* (reprint New York: AMS Press, 1975) 8: 218.

34. Although differing on many principles of religious doctrine, several of the Quaker ideas concerning material prosperity are closely related to those supported by the Calvinists or Puritans and often referred to as a puritan work ethic. For a comparison of Quaker theology and the Reformed and Nonconformist religions of New England and the British Isles, see Frost, *Quaker Family*, chap. 1.

35. "A Journal, or Historical Account, of the Life, Travels, and Christian Experiences, of that Antient, Faithful Servant of Jesus Christ, Thomas Chalkley," in Thomas Chalkley, *A Collection of the Works* (Philadelphia, 1749), 97–98, quoted in Tolles, *Meeting House*, 56.

36. William Edmundson, *A Journal of the Life, Travels, Sufferings, and Labour of Love in the work of the Ministry of . . . William Edmundson* (Dublin, 1715), 324–25.

37. See Amelia Mott Gummere, *The Quakers: A Study in Costume* (Philadelphia: Ferris and Leach, 1901); Lee-Whitman, "Silks and Simplicity"; and Kraak, "Variations on 'Plainness.'"

38. Quoted in Braithwaite, *Second Period*, 518; account books from Swarthmore Hall and the numerous letters written between mother and daughter give ample illustrations of Margaret's sentiments regarding Quaker dress. She resisted the idea that one could wear a piece of clothing as a badge to indicate one's degree of devotion. On the life and personal papers of Margaret Fell, see Isabel Ross, *Margaret Fell: Mother of Quakerism* (New York: Longman, Green, 1949).

39. Contrasting colors such as blue, crimson red, and white on the clothing worn for a portrait was a popular convention used by contemporary English painters such as Sir Godfrey Kneller and Sir Peter Lely. Lee-Whitman, "Silks and Simplicity," 39; Agnes Repplier, *Philadelphia: The Place and the People* (New York: Macmillan, 1925), 132. For information about specific costumes, I am indebted to Linda Eaton, curator of textiles, Winterthur Museum; responsibility for conclusions about them is mine.

40. Richard Allestree, *The Ladies Calling in Two Parts*, 2nd ed. (Oxford, 1673), 5; quoted in Craven, *Colonial American Portraiture*, 224–25.

41. Repplier, *Philadelphia: The Place and the People*, 132. The original portrait has been lost, and this version, located at Stenton, is a nineteenth-century copy. All the portraits of the Norris family discussed in this paper are nineteenth-century copies or photographs. While one wishes the original portraits were available for study, the copies still provide a useful comparison of painting style and patronage patterns. For a discussion on the Knelleresque style, see Craven, *Colonial American Portraiture*, ch. 12.

42. Craven, *Colonial American Portraiture*, 12. The location of this painting and the black-and-white study photograph is currently unknown. For a copy of the photograph, see Tolles, *Meeting House*, xiii (illustrations are located between pages 62 and 63).

43. Nicholas B. Wainwright, *Paintings and Miniatures at the Historical Society of Pennsylvania* (Philadelphia: Historical Society of Pennsylvania, 1964), 333. The original has been lost, and this version, located at the HSP, is a nineteenth-century copy.

44. This painting has alternately been identified as Isaac I and Isaac II. Unfortunately, there are only two nineteenth-century copies to judge from at the HSP. Based on the similarity in style, composition, and the sitter's attire to the portrait of his brother Charles, as well as numerous engravings that identify the portrait as Isaac II, I believe the likeness to be that of the son. One version is a nineteenth-century copy by an unknown artist; the other copy is by William Cogswell and is cited in Wainwright, *Paintings and Miniatures,* 199; also see William Sawitzky, *Paintings and Miniatures at the Historical Society of Pennsylvania* (Philadelphia: Historical Society of Pennsylvania, 1942), 116–17.

45. Most sitters in the first half of the eighteenth century seem to prefer a portrait that either portrayed them to the waist (most often not including the hands) or to the knees. These compositions closely follow the formats popular in England. Richard H. Saunders and Ellen G. Miles, *American Colonial Portraits, 1700–1776* (Washington, D.C.: Smithsonian Institution Press, 1987), 16.

46. For Quaker men, the basic coat and waistcoat were the standard uniform. Although there was a great deal of diversity in the particulars of dress during the colonial period, by and large the style and use of colors and ornamentation were restrained versions of English court and French gentry dress. The genre paintings of Arthur Devis (1711–1787) and Johann Zoffany (1733–1810) provide a frame of reference. Lee-Whitman, "Silks and Simplicity," 38–40; Ellen G. D'Oench, *The Conversation Piece: Arthur Devis & His Contemporaries* (New Haven, Conn.: Yale Center for British Art, 1980); G. C. Williamson, *English Conversation Pictures of the Eighteenth and Early Nineteenth Centuries* (New York: Hacker Art Books, 1975).

47. Quoted in Ross, *Margaret Fell,* 378 n. 1. This minute suggests only a warning against wigs, not an absolute ruling against them.

48. Merchants did not generally wear wigs as they were not of the social rank where it would be deemed necessary or acceptable. Saunders and Miles, *American Colonial Portraits,* 157; Craven, *Colonial American Portraiture,* chap. 3; Aileen Ribeiro, " 'The Whole Art of Dress': Costume in the Work of John Singleton Copley," in *John Singleton Copley,* 113.

49. Ribeiro, "The Whole Art of Dress," 105–7. Kidwell, "Are Those Clothes Real?" 6–12.

50. Jonathan Richardson, *An Essay on the Theory of Painting* (London, 1715), 180.

51. Richardson, *An Essay,* 24–25.

52. Craven, *Colonial American Portraiture,* 154–56; Breen, "The Meaning of 'Likeness,' " 39; Kidwell, "Are Those Clothes Real?" 4.

53. Wainwright, *Paintings and Miniatures,* 199.

54. Sidney George Fisher, *A Philadelphia Perspective: The Diary of Sidney George Fisher Covering the Years 1834–1871,* ed. Nicholas B. Wainwright (Philadelphia: Historical Society of Pennsylvania, 1967), 358.

55. John M. Moore, ed., *Friends in the Delaware Valley: Philadelphia Yearly Meeting, 1681–1981* (Haverford, Pa.: Friends Historical Association, 1982), 258; E. Digby Baltzell, *Puritan Boston and Quaker Philadelphia: Two Protestant Ethics and the Spirit of Class Authority* (New York: Free Press, 1980), 154–58.

56. The platform of this party, which was initially composed of Quakers, was antiproprietary and emphasized the people's right to liberty and property. Although the name and principles remained intact until the Revolution, by 1756 many of its members were non-Quakers. Baltzell, *Puritan Boston and Quaker Philadelphia*, 157; Tolles, *Meeting House*, 21; John W. Jordan, *Colonial Families of Philadelphia* (New York: Lewis Publishing, 1911), 1: 84–86.

57. Deborah Norris Logan, "Reminiscences," 13, HSP; also see Charles J. Stille, *The Life and Times of John Dickinson* (Philadelphia: Historical Society of Pennsylvania, 1891), 311–12; Jordan, *Colonial Families of Philadelphia*, 1: 87–88.

58. Quoted in Tolles, *Atlantic Culture*, 87 (Isaac Norris to Joseph Pike, February 25, 1707–8).

59. Quoted in Tolles, *Meeting House*, 110.

60. Robert Barclay, *An Apology for the True Christian Divinity being an Explanation and Vindication of the Principles and Doctrines of the People Called Quakers* (1678; reprint London: T. Phillips, 1780), 516–17.

61. Isaac Norris I to Joseph Norris, April 1719, Norris Letterbook, 1716–30, 183–84, HSP.

62. Isaac Norris I to Isaac Norris II, April 10, 1722, Norris Letterbook, 1716–30, 303, HSP.

63. Quoted in Carl Bridenbaugh and Jessica Bridenbaugh, *Rebels and Gentlemen: Philadelphia in the Age of Franklin* (New York: Reynal and Hitchcock, 1942), 214; Tolles, *Meeting House*, 130.

64. Benjamin Franklin, *The Papers of Benjamin Franklin*, ed. Leonard W. Labaree and Whitfield J. Bell, Jr. (New Haven, Conn.: Yale University Press, 1959), 9: 7–9.

65. Currently there is a question regarding the true nature of Benjamin West's "Quakerness." However, for the purpose of this paper the focus is more on the debate within the colonial Quaker community regarding the acceptability of painting and the arts as a pastime and its connection with moral behavior and religious beliefs. For further discussion, see Ann Uhry Abrams, *The Valiant Hero: Grand-Style History Painting* (Washington, D.C.: Smithsonian Institution Press, 1985), 36–38; and Susan Rather, "A Painter's Progress: Matthew Pratt and The American School," *Metropolitan Museum Journal* 28 (1993): 175–76.

66. Quoted in Kenneth Silverman, *A Cultural History of the American Revolution* (New York: Thomas Y. Crowell, 1976), 28. The author notes that eighteenth-century aesthetic theory commonly defended the arts on moral grounds and draws the connection between the elders and the writings of Richardson.

67. Ibid., 27–28; David Lawrence Barquist, "The Meaning of Taste for Wealthy Philadelphia, 1750–1800," M.A. thesis, University of Delaware, 1981, 29.

68. Saunders and Miles, *American Colonial Portraits*, 196–97.

69. See the engraving of *Prince Charles Edward Stewart*, 1746, after a painting of Domenico Dupra. Robert Feke based his painting *Brigadier General Samuel Waldron*, 1748–1750 (Bowdoin College Museum of Art), on this print, and it is certainly likely that West would have been aware of such models. Michael Quick, *American Portraiture in the Grand Manner, 1720–1920* (Los Angeles: Los Angeles County Museum of

Art, 1981), 17; Pennsylvania Academy of the Fine Arts, *Philadelphia Painting and Printing to 1776* (Philadelphia: Pennsylvania Academy of the Fine Arts, 1971), 40. This is one of numerous portraits painted in Mifflin's lifetime. Rebora and Staiti, *John Singleton Copley,* 318.

70. Francois Nivelon, *The Rudiments of Genteel Behavior* (London, 1737), n.p. Quoted in Lovell, "Reading Portraits," 245.

71. Thomas was a birthright Quaker and raised by his stepmother, Sarah Fishbourn Mifflin. Sarah was disowned by Philadelphia Monthly Meeting in 1766 for—among other things—"her conformity in Dress and Address, to the vain fashions and customs of the world." PMM Minutes, 28 day 11 mo 1766. Thomas remained a Quaker until 1775 when he was disowned for military activities. PMM Minutes, 28 day 7 mo 1775.

72. *Rules of Discipline,* 102.

73. Joseph Pemberton (b. 1745), the son of Israel Pemberton, Jr. (1715–1779) and Sarah Kirkbride, married Ann Galloway in 1767 at West River under the care of the meeting. Monthly Meeting Minutes, held at Herring Creek, Maryland, 29 day 5 mo 1767. Friends Historical Library, Swarthmore College.

74. Bill of August 2, 1768, Pemberton Papers, HSP, quoted in E. P. Richardson, "James Claypoole, Jr., Rediscovered," *Art Quarterly* 33 (Summer 1970): 172–74.

75. For information on the Galloway family, see J. Reaney Kelly, " 'Tulip Hill': Its History and Its People," *Maryland Historical Magazine* 60 (December 1965): 349–403; for the Pemberton family, see Judy Mann DeStefano, "A Concept of the Family in Colonial America: The Pembertons of Philadelphia," Ph.D. dissertation, Ohio State University, 1970; and Theodore Thayer, *Israel Pemberton: King of the Quakers* (Philadelphia: Historical Society of Pennsylvania, 1943).

76. The cut of the clothing is of a style popular since the 1740s, but the use of silk fabric is very fashionable. Saunders and Miles, *American Colonial Portraits,* 253. The use of neutral-colored clothing was common during this period and bears no relation to any religious conviction on the part of the sitter. Lee-Whitman, "Silks and Simplicity," 40; Kraak, "Variations on 'Plainness,' " 52–57.

77. Kauffman was influenced by the painting of Pompeo Batoni, which was very popular among the English. She painted *Dr. John Morgan,* 1764 (National Portrait Gallery, Smithsonian Institution), in this manner. Claypoole would have had access to this painting in Philadelphia. Saunders and Miles, *American Colonial Portraits,* 262.

78. Lovell, "Reading Portraits," 247.

79. Aileen Ribeiro, " 'The Whole Art of Dress': Costume in the Work of John Singleton Copley," in *John Singleton Copley,* 106–9. See also Staiti, "Character and Class," 63–64.

80. James Logan to William Logan, May 31, 1773, Logan Letterbooks, HSP.

81. Ibid.

82. This portrait is unlocated.

83. William Logan to John Smith, November 17, 1758, John Smith Correspondence, HSP.

84. Edwin Wolf, *The Library of James Logan, 1674–1751* (Philadelphia: Library

Company of Philadelphia, 1974); Frederick B. Tolles, *James Logan and the Culture of Provincial America* (Boston: Little, Brown, 1953).

85. Tolles, *Meeting House,* 127–28, concludes, based on the writings of Frank Cousins and Phil M. Riley in *The Colonial Architecture of Philadelphia* (Boston: Little, Brown, 1920), that there is very little difference between the architecture of Quakers and non-Quakers, but I believe this should be reevaluated.

86. James Logan to John Askew, July 9, 1717, Logan Letterbooks, HSP.

87. Barquist, "The Meaning of Taste," 2–3.

88. See Robert James Gough, "Towards a Theory of Class and Social Conflict: A Social History of Wealthy Philadelphians, 1775–1800," Ph.D. dissertation, University of Pennsylvania, 1977.

89. There was some division among Quakers regarding their patronage of the arts, with the theater being the most fiercely debated.

90. Philadelphia Museum of Art, *Philadelphia: Three Centuries of American Art,* xvi–xvii.

91. Quoted by Bridenbaugh, *Rebels and Gentlemen,* 135.

92. Charles Willson Peale to Benjamin Franklin (?), undated letter, Peale Letterbook, American Philosophical Society (hereafter cited as APS), as cited in Charles Coleman Sellers, *Charles Willson Peale* (New York: Scribner's, 1969), 1: 99. Based on the contents and Franklin's reply on July 4, Sellers dates this letter to April 2, 1771 (452 n. 1).

93. Charles Willson Peale to Edmond Jennings, Esq., April 20, 1711, Peale Letterbook, 1: 13–14, APS.

94. Charles Willson Peale to John Beale Bordley, July 29, 1772, Peale Letterbook, 1: 31–33, APS.

95. John was the son of Quaker parents. His father and sister gave up Quakerism, but his mother remained faithful. There is no indication that John was ever disciplined or disowned, but there are no records that he actively participated in the meeting. Baltzell, *Puritan Boston and Quaker Philadelphia,* 190.

96. Mary was condemned (but not disowned) by Philadelphia Monthly Meeting for marrying contrary to discipline. PMM Minutes, 28 day 12 mo 1770.

97. Mary and John Dickinson, along with their two daughters, Sally and Maria, were received by request to Philadelphia Monthly Meeting, which indicates John's direct involvement in the society but not his actual membership. PMM Minutes, (?) day 11 mo 1785. According to a letter from Milton E. Fisher to the assistant director of Friends Historical Library in 1874, Dickinson wrote to Samuel Miller late in his life asserting that he could never subscribe to a religious organization. Courtesy of Patricia O'Donnell, Friends Historical Library.

98. William T. Read, *Life and Correspondence of George Read* (Philadelphia, 1870), 570, quoted in Craven, *Colonial American Portraiture,* 390.

99. Peale accommodated his patron. In writing to Jenings, the artist noted, "In Mr. Dickinson's I have the falls of the Schulkyll river" (Peale Letterbook, APS). Peale often made use of symbolic detail and background in his portraits. Sellers writes that the use of the jimsonweed (which, when ingested, induces mad raving) in the painting of John Beale Bordley (1770) suggests the colonial warning "Don't tread on me."

Although not as literal, the reference to the use of a horse through the riding crop, land, and the Schulkyll River make John Dickinson's portrait very specific to the man, place, and time and illustrates his agrarian interests. Sellers, *Charles Willson Peale,* 85–86.

100. Peale to John Beale Bordley, July 29, 1772, Peale Letterbooks, APS; Lillian B. Miller, ed., *The Selected Papers of Charles Willson Peale and His Family* (New Haven, Conn.: Yale University Press, 1983), 1: 124.

101. Read, *Life and Correspondence of George Read,* 570.

102. The reference to antiquity in the relief carving on the stone pedestal and the Renaissance composition of Madonna and Child are very suggestive not only of Peale's access to the Old Masters, but of Dickinson's as well. Edgar P. Richardson, Brooke Hindle, Lillian B. Miller, with a foreword by Charles Coleman Sellers, *Charles Willson Peale and His World* (New York: Harry Abrams, 1983), 46, 48.

103. Jessamyn West, *The Quaker Reader* (New York: Viking Press, 1962), 283.

104. See Karol A. Schmiegel, "Encouragement Exceeding Expectation: The Lloyd-Cadwalader Patronage of Charles Willson Peale," *Winterthur Portfolio* 12 (1977): 87–102.

105. Miller, *Selected Papers,* 1: 123–24.

106. Lovell, "Reading Portraits," 253–59.

107. Saunders and Miles, *American Colonial Portraits,* 289–91; Philip D. Zimmerman, "A Methodological Study in the Identification of Some Important Philadelphia Chippendale Furniture," *Winterthur Portfolio* 13 (1978): 198, 200.

108. Sellers points out that this portrait is one of the few exceptions from this period where the sitters are all engaged with one another, ignoring the usual subject-spectator relationship preferred by most Americans and linking it more closely with a sophisticated London style. Sellers, *Charles Willson Peale,* 86.

109. Among this group were also portraits of John's brother, Lambert, and sister, Martha Cadwalader Dagworthy.

110. Nicholas B. Wainwright, *Colonial Grandeur in Philadelphia: The House and Furniture of General John Cadwalader* (Philadelphia: Historical Society of Pennsylvania, 1964), 47.

111. Eli F. Cooley, *Genealogy of Early Settlers in Trenton and Ewing, New Jersey* (Trenton, N.J.: W. S. Sharp, 1883; reprint Lambertville, N.J.: Hunterdon House, 1976), 22–23.

112. Thomas married Hannah Lambert in May 4, 1738. Chesterfield Monthly Meeting of the Society of Friends, Minutes, 4 day 5 mo 1738, Friends Historical Library, Swarthmore College; William Henry Rawle, "Col. Lambert Cadwalader: A Sketch," *Pennsylvania Magazine of History and Biography* 10 (1886): 2.

113. Charles W. Dulles, "Sketch of the Life of Dr. Thomas Cadwalader," *Pennsylvania Magazine of History and Biography* 27 (1903): 266–78; Francis R. Packard, "Thomas Cadwalader," *Dictionary of American Biography* (New York: Charles Scribner's Sons, 1933), 400–401.

114. Dr. Cadwalader died on November 14, 1779, and is buried in the Friends burying ground on East Hanover Street in Trenton. Trenton Historical Society, *A History of Trenton, 1679–1920* (Princeton, N.J.: Princeton University Press, 1929), 1: 640; Tolles, *Meeting House,* 226.

115. Chesterfield Monthly Meeting of the Society of Friends, Minutes, 5 day 10 mo 1745.

116. Quoted in F. French Stone, *Biography of Eminent American Physicians and Surgeons* (Indianapolis: Carlon and Hollenbeck, 1894), 72.

117. As recorded in Philadelphia Meeting Minutes, Hannah was buried on January 17, 1788. William Wade Hinshaw, *Encyclopedia of American Quaker Genealogy* (Ann Arbor, Mich.: Edwards Brothers, 1938), 2: 343.

118. Claudia Brush Kidwell, "Gender Identity in Two and Three Dimensions," paper delivered at the 1994 Winterthur Conference, "American Material Culture: The Shape of the Field," Winterthur, Delaware; Claudia Brush Kidwell, "Fashioning Feminine Identities in Colonial Portraits," paper delivered at the 1995 Organization of American Historians Conference, Washington, D.C.

119. Although there is no record of John's disownment in the Philadelphia Meeting Minutes, the Lloyd family of Maryland were Anglican, and John is buried at Shrewsbury Church, Kent County, Maryland. Allen Johnson, ed., *Dictionary of American Biography* (New York: Charles Scribner's Sons, 1933), 398.

120. Lippincott, "Expanding on Portraiture," 80–83.

121. Richardson, *An Essay on the Theory of Painting,* 15–16.

122. Thomas Mifflin and Sarah Morris were given permission to proceed in marriage on March 27, 1767. PMM Minutes, 27 day 3 mo 1767.

123. John Adams, *Familiar Letters,* quoted in Wainwright, *Paintings and Miniatures,* 175–76.

124. In October 1780 Philadelphia Monthly Meeting of Women Friends directed that a certificate be sent for Sarah and her sisters, Susanna and Rebecca, to Exeter Monthly Meeting, but later in the month it was reported that the trio was returning to reside in the city during the winter season. PMM Minutes, (?) day 10 mo 1780.

125. The Philadelphia Meeting Minutes note that Thomas was disciplined in March 1775, and disowned for "being active in the promotion of military measures." PMM Minutes, (?) day 6 mo 1775. Also see Johnson, *Dictionary of American Biography,* 606–8.

126. The use of neutral and dark colors such as gray for clothing was popular during the latter part of the colonial period. It was not an indication of faith. As the Quaker "uniform" developed, however, the faithful clung to older fashions, and there is a great deal of similarity between the fashionable neutral-colored dress of the eighteenth century and the Quaker "uniform" of the nineteenth century. Lee-Whitman, "Silks and Simplicity," 40, 102–4.

127. It has been suggested that the tape loom and absence of lace on their clothes indicates Thomas Mifflin's support of the Non-Importation Act in Philadelphia in 1773. Rebora and Staiti, *John Singleton Copley,* 320.

128. S. (probably Samuel) Eliot to William Barrell, August 24, 1773, Miscellaneous Collections, HSP; quoted in Jules David Prown, *John Singleton Copley* (Cambridge, Mass.: Harvard University Press, 1966), 1: 90 n. 5.

129. What makes this comparison so compelling is that the differences appear to be not regional but based on social, economic, and religious criteria and choices. For an interesting discussion on the interpretation of costume in Copley's portraits

see Rebora and Staiti, *John Singleton Copley,* 105–7; Kidwell, "Are Those Clothes Real?" 6–9.

130. Barry Levy makes this point when discussing the Quaker family. One wishes there were more double and family portraits of Quakers to draw further comparisons. Levy, *Quakers and the American Family* (New York: Oxford University Press, 1988), ills. 8, 9; Craven, *Colonial American Portraiture,* 348–49.

131. Bridenbaugh, *Rebels and Gentlemen,* 17–18.

132. Levy, *Quakers and the American Family,* 16–17.

133. Tolles, *Atlantic Culture,* 58; also see Gary B. Nash, "The Early Merchants of Philadelphia," in *The World of William Penn,* ed. Dunn and Dunn, 338–53.

Introduction to Part II

1. Richard Webster, *Philadelphia Preserved: Catalog of the Historic American Buildings Survey* (Philadelphia: Temple University Press, 1976), 54–55, 74–75.

2. Charles Bergengren, " 'Finished to the Utmost Nicety': Plain Portraits in America, 1760–1860," in *Folk Art and Art Worlds,* ed. John Michael Vlach and Simon J. Bronner (Logan: Utah State University Press, 1992), 85–91.

3. Carl Lounsbury, *Churches and Meeting Houses of Early America,* forthcoming; Bernard L. Herman, "Landscapes of Orthodoxy: Architecture, Dissent, and Identity," Visual Studies in Religion: Meeting-House, University of Wales, Aberystwyth, April 16, 1999.

4. Michael J. Chiarappa, " 'The First and Best Sort': Quakerism, Brick Artisanry, and the Vernacular Aesthetics of Eighteenth-Century West New Jersey Pattern Brickwork Architecture," Ph.D. dissertation, University of Pennsylvania, 1992; Gabrielle Milan Lanier, "A Region of Regions: Local and Regional Culture in the Delaware Valley," Ph.D. dissertation, University of Delaware, 1998.

5. Patricia J. Keller, *"Of the Best Sort But Plain": Quaker Quilts from the Delaware Valley, 1760–1890* (Chadds Ford, Pa.: Brandywine River Museum, 1996), 11.

6. Nancy E. Davis, *The Baltimore Album Quilt Tradition* (Baltimore: Maryland Historical Society, 1999), 26–39.

7. Jessica F. Nicoll, *Quilted for Friends: Delaware Valley Signature Quilts, 1840–1855* (Winterthur, Del.: Henry Francis du Pont Winterthur Museum, 1986), 12–13.

Chapter 6. Quaker Beliefs and Practices and the Eighteenth-Century Development of the Friends Meeting House in the Delaware Valley

1. Edward Mulligan refers to the years immediately following the Acts of Toleration as Great Britain's "golden age of Quaker building." First presented as an address to the Friends Home Service Committee, April 7, 1957, Mulligan's piece followed an architectural survey and called for the preservation of the old meeting houses. Edward H. Mulligan, "The Worshipping Community and Its Meeting House," *Friends Quarterly* 11, 3 (July 1957): 100.

2. Howard H. Brinton, *Friends for 300 Years: The History and Beliefs of the Soci-*

ety of Friends Since George Fox Started the Quaker Movement (Wallingford, Pa.: Pendle Hill Publications, 1952), 176–77.

3. The term "doubled plan" is used by Damon Tvaryanas in his master's thesis. It refers to the fact that the two halves of the structure are identical; the essential single-cell unit is doubled to create a single building that is conducive to separate men's and women's business meetings. Tvaryanas, "The New Jersey Quaker Meeting House: A Typology and Inventory," M.A. thesis, University of Pennsylvania, 1993.

4. Acts 17: 24, as cited in O. S. Chedburn, "Theology and Architecture in the Tradition of the Meeting House," *Friends Quarterly* 20, 2 (April 1977): 61–62. Fox went on to say, "Dost thou call the steeple house the church? The church is the people whom God has purchased with his blood, and not the house."

5. G[eorge] F[ox], *Concerning Meeting in Houses, Ships, Streets, Mountains, By-Wayes* (London: n.p., 1683). In a similar vein is another article from the period written by George Whitehead, *A serious Account in XXXV Reasons, (to All Who Desire Satisfaction) Why People of the Lord, Called Quakers, Cannot Go to Worship at Those Places Called Churches and Chappels* (London: Robert Wilson, 1661).

6. For more information on the Inward Light as it relates to the philosophical formation of the society and references to its use in the writings of George Fox and in the Bible, see Brinton, *Friends for 300 Years.*

7. George Fox, Letter to Thomas Lower, 28 day 2 mo 1687; "True Copy of a Letter from George Fox to Thomas Lower: 'Touching his intention how to dispose of Petty's House and Tenement as Followeth," Tuke Papers, Borthwick Institute, York (catalog no. 81); "A Letter from George Fox, Hitherto Unpublished, On Building a Meeting House," *Friends Quarterly* 20, 2 (April 1977): 68–69.

8. Structural evidence seen in the attic of Third Haven Friends Meeting House in Easton, Maryland, the only one to rival Merion in age, suggests that it once had a similar T-shaped plan, but it was later altered and the T section removed.

9. As one member of Merion Meeting stated, "The present ground plan of the meeting house is cruciform. That such would have been planned deliberately by the Friends of that time is unthinkable. As far as we know, this is the only case of an old Meeting House erected in this form in the world. The design could easily have originated from the addition of a new part of the original, which probably is what occurred." Samuel Bunting, Jr., *Merion Meeting House, 1695–1945: A Study of Evidence Relating to the Date* (Merion, Pa.: Merion Monthly Meeting, 1945), 2.

10. See David M. Butler, *The Quaker Meeting House of Great Britain* (London: Friends Historical Society, 1999). This two-volume set represents a complete inventory of English meeting houses, including earlier structures on site.

11. A similar lantern appeared on Wilmington, Delaware's 1738 meeting house.

12. David M. Butler, "Quaker Meeting Houses in American and England: Impressions and Comparisons," *Quaker History* 77, 2 (Fall 1990): 98; Butler, *Quaker Meeting Houses of the Lake Counties* (London: Friends Historical Society, 1978), ii–iii; Butler, *Quaker Meeting Houses* (Kendal, Cumbria: Quaker Tapestry Booklets, 1995), 10; Hubert Lidbetter, *The Friends Meeting House* (York: Ebor Press, 1961), 15–16. Lidbetter discusses the occurrence of completely separate women's meeting houses or the "small meeting house." All four publications include plans of English meeting

houses that depict an arrangement conducive to this pattern of meeting. Also in evidence are a number of extant meeting houses in the Delaware Valley that do likewise (such as Chichester, Randolph or Medham, Roaring Creek, Maiden Creek), as well as meeting houses no longer extant as discussed in this essay.

13. PYM Minutes, 2 day 10 mo 1684, Friends Historical Library (FHL), Swarthmore College, Swarthmore, Pennsylvania. With regard to quotations taken from minutes, owing to the number of misspellings, improper use of grammar, and the use of shorthand, I have chosen to ignore errors rather then riddle the quotes with (sic.) and other qualifiers (other than the occasional bracketed word or phrase needed to clarify meaning).

14. "Friends' Bank Meeting, Front Street abt. Mulberry," E. W. Mumford Collection (artist and date unknown); FHL, Photographic Collection, Meeting Houses. This image has been reproduced in numerous publications including John F. Watson, *Annals of Philadelphia and Pennsylvania in the Olden Time* (Philadelphia: E. Thomas, 1857), 390.

15. The interior of Sadsbury has been reoriented and partitions added to create a center hall and a library. However, the original plan can be deduced by examining the former gallery space in the attic, thus providing insight into this significant early form. Here, the former location of a tiered gallery is evident in the missing plasterwork. The gallery ran along the north, west, and south walls and was open to the east, where the facing benches were once located. The central partition remains in its original position. See Virginia Price, "Sadsbury Friends Meeting House," National Park Service, Historic American Buildings Survey, HABS No. PA-6675, 1999. Other noteworthy examples of extant meeting houses with unequally proportioned rooms include Randolph or Medham (near Dover, N.J.), Maiden Creek (Kindts Corner, Pa.), and Roaring Creek (Numedia, Pa.).

16. Pennsylvania Historical Survey Division, Works Progress Administration, *Inventory of Church Archives, Society of Friends in Pennsylvania* (Philadelphia: Friends Historical Association, 1941), 85–86; Watson, *Annals*, 390–91.

17. Without the shared facing bench that was among the salient features of the later "doubled plan," there was no clearly defined location in which to place the women's meeting in relationship to the men's. The T-shaped plan of Merion Meeting House is one example of this principle at work. Women's meetings might even be held in a space that did not adjoin the main meeting room, such as in a loft above.

18. Despite this change, the interior plan likely retained its unequally sized meeting rooms. Historic images indicate that the pattern of doorways on two contiguous sides remained constant; there is a single entry to the center of the front façade and another to the side.

19. Prior to the addition, the original meeting house may have been partitioned into two apartments. This pattern was used at Philadelphia's Frankford Meeting House. Recorded in the minutes for 24 day 10 mo 1797, clear indication of a partitioned three-bay meeting house is inadvertently given: "Our stove having been found not to make the meeting house sufficintly comfortable in cold weather, it is concluded to sell it and to purchase two new ones, and have them put up one in each

apartment . . . as soon as convenient." Frankford later received a two-bay-wide women's meeting addition, built in 1811–12.

20. Center Square Meeting House in Philadelphia was a prime example of this phenomenon. Its construction dragged on for at least four years. It was used while still unfinished because the individual preparative meetings that were to contribute to the cost of its construction were unable to do so because they were financing the construction of their own meeting houses. See Pennsylvania Historical Survey, *Inventory of Church Archives,* 55–58.

21. When reconstructed in the 1860s, the addition appeared more in keeping with the main block, with the roof height at the same level. The interior wall that divided the two sections was also removed.

22. Mary Corson, interview by the author, spring 1997. Plymouth Preparative Meeting Minutes, 4 day 9 mo 1806.

23. Buckingham Monthly Meeting Minutes, 2 day 1 mo 1720. A 1818 memoir reflecting upon the early history confirms that this addition was used as the women's meeting section, stating: "About that time [1720] an addition of a stone house was made to the upper end of the building to accommodate the women to hold their meetings of business." John F. Watson. "A Description of the Area and Account of Persons and Events, 1812–14," 25, FHL. A roughly twenty-foot-square structure now used as a utility shed is likely the women's meeting addition to a similarly constructed 1730 Buckingham Meeting House.

24. Western Quarterly Meeting, Minutes, 16 day 2 mo, 20 day 8 mo 1784.

25. Meeting House Photographs Collection, Little Egg Harbor, FHL.

26. Little Egg Harbor Preparative Meeting Minutes, 1 day 8 mo 1844.

27. This has become a standard term used to refer to Quaker architecture (appearing in almost every National Register nomination, for example).

28. The purpose of carriage doors is unclear; most likely acted as a mounting block, allowing women to dismount from their carriages or horses directly into the meeting house at the uppermost level of the facing bench. Such an arrangement would have been particularly useful in inclement weather. While the location of carriage doors directly onto the facing benches suggests that they provided exclusive entry for the ministers, elders, and overseers who occupied these seats, such a hierarchy seems contradictory to Quaker philosophy. And although it has been suggested that carriage doors were used to provide passage for coffins, they are generally not wide enough to do so. Carriage doors are still extant at Plymouth (1708), Buckingham (1768), and Abington (1786) meeting houses in Pennsylvania, and once appeared but have since been filled in at Old Kennett (ca. 1731) and Bradford (1767). Carriage doors were more prevalent in New Jersey, where they appear in such examples as Salem (1772), Chesterfield (1773), Mt. Holly (1775), and Hancock's Bridge (1784). They were used in some later revivals of early single-cell meeting houses such as Upper Dublin (1814) and Upper Providence (1828) in Pennsylvania.

29. Likewise, beginning in the 1860s, meeting house hoods gave way to porches that ran the length of front façades at the same time that they became popular additions to residential architecture.

30. Lidbetter, *The Friends Meeting House,* 4–5.

31. In a small group, the members are known to each other. The concept of maintaining an intimate space with regard to English meeting houses is suggested by historian David M. Butler: "During the eighteenth century a good deal of flexibility in the capacity of the room was gained by the use of shutters and an extreme example can be seen at Penrith where the main meeting room was extended by four distinct spaces, two of which could be added or isolated by use of the shutters. From the early days Friends appear to have been aware of the need to make the space suit the size of the gathering, as a hall too large for the number of worshippers may have a dampening effect upon their sense of community." *Quaker Meeting Houses of the Lake Counties*, ii. Robert L. Smith writes, "Quakers are unique in their appreciation of the spiritual power of group silence." Smith, *A Quaker Book of Wisdom* (New York: Eagle Brook, William Morrow, 1998), 11.

32. Such stipulations probably came in response to the challenges placed on the Society of Friends that began in 1827–28 with the schism that divided them into Hicksite and Orthodox factions. As evangelical Friends become more mainstream in religious practice, previously held truths are called into question. In 1901, for example, the Sadsbury Friends pronounced that their new meeting house would be, among other things, "Modern in its architectural simplicity and plainness, and should symbolize the principles of [our] society." Sadsbury Preparative Meeting Minutes, 29 day 5 mo 1901. And in 1903 the West Grove Friends agree to pursue the designing of a new meeting house with "due regard to the simplicity and plainness of our profession." West Grove Preparative Meeting Minutes, Report of the Building Committee, 29 day 11 mo 1904.

33. Such beliefs were articulated by well-known eighteenth-century Friend John Woolman, as cited in Brinton, *Friends for 300 Years*, 136.

34. For the quote and a discussion of simplicity as it relates to social justice see Frederick B. Tolles and E. Gordon Alderfer, *The Witness of William Penn* (New York: Macmillan, 1957), 175.

35. Truth refers to their testimonies or beliefs. The term "Truth" was used by Friends of the colonial period in their written advices against participation in both war and politics. It later became the title of a study from which more information on this topic can be obtained. Richard Bauman, *For the Reputation of Truth: Politics, Religion, and Conflict Among the Pennsylvania Quakers, 1750–1800* (Baltimore: John Hopkins University Press, 1971).

36. Joseph Pike, *Dress and Worldly Compliance; Addressed to the Members of the Society of Friends* (Philadelphia: Sold by Jacob Smedley Booksellers, 1872), 6–7. This is one of many reprints of Pike's original message published as Joseph Pike, *An epistle to the National Meeting of Friends in Dublin concerning good order and discipline in the church* (Dublin: Printed by W. Wilmot for S. Fuller, 1726). See also Pike, *Joseph Pike to his Friends, the people called Quakers: being two epistles of counsel, on covetousness, love of the world, height and false liberty . . . 1722 and 1726* (London: Darton and Harvey, 1837).

37. The first reference to "drawing up a paper" with regard to discipline "for the general meeting and the Epistle to London" that I found appears in the Philadelphia Yearly Meeting minutes for the 1689 meeting. At the 1694 meeting the issue of proper

behavior is once again introduced. Finally, in the minutes for the 1695 meeting there is mention of "some queries" proposed to the Yearly Meeting in London. It was then "agreed that something further be done and drawn up."

38. PYM Minutes, 18 day 7 mo 1695. The Friends appointed to this task were John Blunstone, Thomas Duckett, William Southbee, Alexander Beardsley, Edward Shippen, and Samuel Carpenter.

39. Chester Quarterly Meeting Minutes, 3 day 9 mo 1701.

40. PYM Minutes, 19 day 7 mo 1710, cited in Jack D. Marietta, "Ecclesiastical Discipline in the Society of Friends, 1682–1776," Ph.D. dissertation, Stanford University, 1968, 3. See also Marietta, *The Reformation of American Quakerism, 1748–1783* (Philadelphia: University of Pennsylvania Press, 1972).

41. PYM Minutes, 23 day 7 mo 1702. The minutes note that the "paper" was directed at preventing "disorderly marriage & against putting out [apprenticing] Friends children but to such as profess Truth."

42. PYM Minutes, 25 day 7 mo 1704.

43. From "Our Yearly Meeting held in Burlington the 20th of 7th month 1704: *A Generall Testimony Against all Looseness and Vanity or What else tend to the reproach of Truth,* (manuscript, FHL), 5–6. As cited in Frederick B. Tolles, *Quakers and the Atlantic Culture* (New York: Macmillan, 1960), 84–85.

44. Copy found within the handwritten *Book of Discipline* for Sadsbury Meeting, 1743 entry.

45. Ibid., 1755 entry.

46. Greater concern for issues of "tale-bearing and back-biting" is also expressed by the elevation of that query from fourth to second place, more succinctly requesting that "love and unity be maintained . . . and differences settled." Attendance (still number one) and basic issues such as maintaining proper financial and legal affairs, keeping clear of the buying or importing of slaves, and not (re)moving without a certificate remain a fairly consistent position toward the bottom of the list. New to the queries, although not new to Friends testimonies, is one guarding against oaths, the bearing of arms, and enlisting in military service.

47. Concord Quarterly Meeting Minutes, 7 day 6 mo 1704.

48. Radnor Monthly Meeting Minutes, 14 day 9 mo 1717.

49. Bucks Quarterly Meeting Minutes, 22 day 12 mo 1710.

50. Bucks Quarterly Meeting Minutes, 31 day 3 mo 1711.

51. The strictly male makeup of the committee is evident from meeting minutes. Although practice varied from meeting to meeting, during the mid- to late nineteenth century separate women's building committees begin to form in consultation with the men's committee but likely were subordinate to them. An example of this practice was seen during the construction of the Germantown Friends Meeting House in 1868.

52. Buckingham Preparative Meeting Minutes, 1 day 2 mo 1762.

53. The eighth query dealt with debt and cautioned Friends to live within their circumstances. Such issues remain a concern. When planning for a new meeting house in 1968, the Southampton Friends were fearful that focusing on a large building project would have a "deadening effect" on the meeting, detracting from "basic

Quaker concerns and the urgent problems of our day." Southampton Friends Meeting Minutes, 12 day 7 mo 1968.

54. There are countless examples of this practice through to modern times. A good example is Philadelphia's Frankford Meeting House, which is built half of brick and half of stone owing to the reuse of the old brick meeting house. If not of use to them, the Friends salvaged and sold old parts, down to the scantling. In 1768 the Bradford Friends tasked with dismantling the old meeting house were instructed to "sell ye old meeting house except ye frunt and end wall about a suitable height for ye grave yard incloser" (Bradford Preparative Meeting Minutes, 11 day 10 mo 1768). Among the best examples of the psychological benefit to Friends in reusing building materials is the meeting house located at the George School. It is said to be the reconstruction (in 1974) of the 1812 Twelfth Street Meeting House that was, in turn, built from the 1755 Great Meeting House that once sat at Second and Market Streets. While the building is clearly new, the old timbers were used somewhat ceremoniously. One timber—not even long enough to span the current space—is mounted into the wall for display.

55. Subscriptions appear to have been assessed according to one's means, often appearing in neat $10 or $25 increments. And oftentimes subscriptions were solicited from members of the monthly or quarterly meetings when funds were insufficient, or when the meeting house was to be used by the larger meetings: "Oxford frds informs this mg [the Abington Monthly Meeting] that they stand in need of some money for their assistance in rebuilding their mg. house, each preparative mg. is therefore desired to pay in their collections as soon as may be to the treasurer in order that he may hand to their assistance as [?] may require." Abington Quarterly Meeting Minutes, 26 day 6 mo 1775.

56. Philadelphia Yearly Meeting, Queries, 1765. The fifth query reads: "Are poor friends necessities duly inspected, they relieved or assisted in such business as they are capable of; do their [Friends] children freely partake of learning to fit them for business, and are they and other Friends children placed amongst friends?"

57. The builder of Buckingham Meeting House, Matthias Hutchinson, was denied permission to include his initials in the date stone. As legend has it, he made a second attempt when building the adjacent school. In order to distinguish the two structures he added "S.H." to the date stone of the schoolhouse and "M.H." to that of the meeting house. Reading into his intentions, the meeting removed his initials. Legend retold to author by Peter Barry, former headmaster and meeting member, June 1997. There are only two other instances I know of where initials appear blatantly on the façade of the meeting house. Although attributed to builders, they most certainly refer to benefactors. They are the meeting houses of Arney's Mount ("S. Smith") and Chichester ("R + D 1769" for Richard Dutton).

58. Merion Preparative Meeting Minutes, 6 day 6 mo 1703.

59. Minutes are extant during a few years of the construction process, from 1702 through 1704. Evidence is also found in Merion Preparative Meeting, (John Roberts account of) "Subscriptions and expenditures for the meeting house, 1713–1714," FHL, folder RG2/Ph/M47.

60. None appear to have survived from the eighteenth century. Beginning in the

later nineteenth century some meetings include an abstract of the building committee reports in the minutes.

61. The phrase "agree with workmen" appears with regard to the construction of Boarded Meeting House in 1684, Philadelphia Monthly Meeting Minutes, 3 day 4 mo 1684; and the 1702 Buckingham Meeting House, Buckingham Preparative Meeting Minutes, 28 day 9 mo 1702. The phrase "conclude upon a plan" was all that was given to Frankford Friends designing a structure in 1800, Frankford Preparative Meeting Minutes, 23 day 12 mo 1800. They were later asked to "digest a plan," Frankford Preparative Meeting Minutes, 20 day 2 mo 1816.

62. Burlington Quarterly Meeting Minutes, 28 day 9 mo 1715.

63. See William Alexander, *Observations on the Construction and Fitting Up of Meeting Houses, &c for Public Worship* (York: William Alexander, 1820).

64. Bucks Quarterly Meeting Minutes, 27 day 6 mo 1741.

65. Freedom in many areas of the meeting structure was renewed in later years following the schism between Hicksite and Orthodox factions and the resulting variations in Quaker beliefs and practices. For example, there are wide variations in the time that united meetings replace separate men and women's business meetings. Probably one of the earliest recorded was among the Arney's Mount Friends, who eliminated separate business meetings in 1850. The Friends of New West Grove Meeting eliminated them in the 1880s, actually altering their meeting house to accommodate the change, filling in the dual entries in favor of a single central entry and removing the partition. However, separate business meetings were not officially eliminated within the Orthodox yearly meeting until 1923.

66. The term "birthright member" referred to the policy by which individuals were automatically eligible for entry into the society if both parents were Friends. This became official policy in 1737. It meant that these individuals need not undergo "inward convincement," the standard means of acceptance for early members.

67. Philip S. Benjamin, *The Philadelphia Quakers in the Industrial Age, 1865–1920* (Philadelphia: Temple University Press, 1976), 50.

68. PYM, *Book of Discipline* (1755), cited in Marietta, *The Reformation of American Quakerism*, 54.

69. PYM, 1765 (copy of an abstract found in the beginning of the minute book for Mt. Holly Monthly Meeting, beginning 10 mo 1776).

70. Friends were not anxious to completely alienate individuals who were disowned or "read out of meeting," however. Thus disownment often referred to active participation only. Disowned individuals could attend meeting for worship and, if redeemed, regain full membership within the society.

71. Bucks Quarterly Meeting Minutes, 27 day 11 mo 1755.

72. Bucks Quarterly Meeting Minutes, 26 day 2 mo 1756.

73. Bucks Quarterly Meeting Minutes, 27 day 5 mo 1756.

74. Marietta, "Ecclesiastical Discipline," 148. For example, according to Marietta, the society stopped issuing periodic instructions on dress between 1701 and 1755, and there was only one case of prosecution. Between 1755 and 1776 there were fifteen, fourteen of which led to disownment.

75. Atkinson Family Scrapbook, 1804, 1835–ca. 1935 (includes newspaper clippings, 1889–1893), No. II, 1740–1760, FHL, SC 166.

76. Bauman, *Reputation of Truth*, 135.

77. Bucks Quarterly Meeting Minutes, 25 day 11 mo 1784. Interestingly enough, the Friends of Bucks Quarter did not agree with this assessment. A postscript added to the minutes by the clerk asserts, "If our discipline be plainly declared, fairwell to Orthodox authority."

78. Margaret Hope Bacon, "A Widening Path: Women in the Philadelphia Yearly Meeting Move Toward Equality, 1681–1929," in Bacon, *Friends in the Delaware Valley: Philadelphia Yearly Meeting, 1681–1981* (Haverford, Pa.: Friends Historical Association, 1981), 189.

79. David M. Butler, "Quaker Meeting Houses in America and England: Impressions and Comparisons," *Quaker History* 79, 2 (Fall 1990): 102–3.

80. One indication of the reluctance of the English to adhere to separate business meetings is that the subject had to be reintroduced before London Yearly Meeting in 1744 and 1745. In 1766 Philadelphia Yearly Meeting of Women Friends joined with the men's meeting in an attempt to press the issue of establishing a yearly women's business meeting in England. See Bacon, "A Widening Path," 179–80.

81. General or Yearly Meeting Minutes, Burlington, New Jersey (at Thomas Gardner's home), 31 day 6 mo 1681.

82. The women's section of Buckingham is actually slightly smaller than the men's, an interesting nod to tradition that was not repeated in subsequent structures of its type. The sections are otherwise indistinguishable.

83. There is no indication that these meetings were in contact with each other, or that Buckingham was developed in reaction to them. And therefore it is possible that they each developed in isolation although clearly in response to the same issues effecting attempts by PYM to standardize meeting procedures.

84. Viewed from the front, each section of Exeter is three bays across. However, the larger double door and the hood over the entryway into the men's section gives it prominence over the single, unprotected women's entry. And to the rear, there is symmetry in the fenestration only within the individual sections; the men's section is three bays with a central carriage door, while the women's has just two windows.

85. Burlington Quarterly Meeting Minutes, 30 day 8 mo 1773.

86. Atkinson Family Scrapbook, no. 4, 1805–20.

87. New York Monthly Meeting Minutes, 10 day 9 mo 1774. (Thanks to Patricia C. O'Donnell, Archivist, Friends Historical Library, for bringing this important piece of information to my attention.)

88. An inventory undertaken by the New York Yearly Meeting of Friends meeting houses in their region and other sources indicate that Queen Street was the first meeting house in New York built in this form. See New York Yearly Meeting of the Religious Society of Friends, *Directory 1993, The Yearly Meeting Regional and Local Meetings Pictures of Meeting Houses Places & Times of Worship, Travel Directions and Maps, Historical Sketches* (New York: New York Yearly Meeting and Mill River Press,

1993); Catherine Lavoie, "National Historic Landmark Nomination, Buckingham Friends Meeting House," National Park Service, August 2001.

89. Tolles, *Quakers and the Atlantic Culture,* 73.

90. Butler, "Quaker Meeting Houses in America and England," 103.

Chapter 7. Eighteenth-Century Quaker Houses in the Delaware Valley and the Aesthetics of Practice

1. Michel de Certeau, *The Practice of Everyday Life* (Berkeley: University of California Press, 1984); Erving Goffman, *The Presentation of Self in Everyday Life* (New York: Doubleday Anchor Books, 1959).

2. Arlene Horvath, "Vernacular Expression in Quaker Chester County, Pennsylvania: The Taylor Parke House and Its Maker," in *Perspectives in Vernacular Architecture II,* ed. Camille Wells (Columbia: University of Missouri Press, 1986), 152.

3. Bernard L. Herman, *Architecture and Rural Life in Central Delaware, 1700–1900* (Knoxville: University of Tennessee Press, 1987), 48.

4. The Abel and Mary Nicholson house is listed as a National Historic Landmark. The house has been illustrated in architectural surveys compiled since the 1880s. Among the earliest descriptions of the house is that of Thomas Yorke, who photographed the building circa 1886. The photograph and a brief genealogy of the Nicholsons were bound into an album of Salem County buildings and families compiled at the behest of the newly formed Salem County Historical Society and remains in the society's collections in Salem, New Jersey.

5. Circa 1860, the owners demolished the original frame kitchen and replaced it with a two-story brick service wing that included a dining room, kitchen, and upper story chambers.

6. Michael J. Chiarappa, "The Social Context of Eighteenth-Century West New Jersey Brick Artisanry," in *Perspectives in Vernacular Architecture IV,* ed. Thomas Carter and Bernard L. Herman (Columbia: University of Missouri Press, 1991), 31–43.

7. Victor Turner, "Variations on a Theme of Liminality," in *Secular Ritual,* ed. Sally F. Moore and Barbara G. Myerhof (Amsterdam: Van Gorcum, 1977), 36–52. See also Arnold van Gennep, *The Rites of Passage* (Chicago: University of Chicago Press, 1960); and Terence S. Turner, "Transformation, Hierarchy and Transcendence: A Reformulation of Van Gennep's Model of the Structure of Rites of Passage," in *Secular Ritual,* 53–70.

8. Peter O. Wacker, "Relations Between Cultural Origins, Relative Wealth, and the Size, Form, and Materials of Construction of Rural Dwellings in New Jersey During the Eighteenth Century," in *Géographie historique du village et de la maison rural,* ed. Charles Higounet (Paris: Centre National de la Recherche Scientifique, 1979), 201–30.

9. Quoted in Jody Ellen Cross, " 'That Which She Calls Her Own': Gender and Material Culture in Early Philadelphia Wills," M.A. thesis, University of Delaware, 2001, 18; Mary Maples Dunn, "Women of Light," in *Women of America: A History,* ed. Carol Ruth Berkin and Mary Beth Norton (Boston: Houghton Mifflin, 1979), 118.

10. Thomas Shourds, *History and Genealogy of Fenwick's Colony, New Jersey* (Bridgeton, N.J.: G.F. Nixon, 1876).

11. The original wood kitchen was replaced circa 1830 with a two-story stone service wing that included kitchen, dining room, and upstairs chambers.

12. Jack Michel, *"In a manner and fashion suitable to their degree": A Preliminary Investigation of the Material Culture of Early Rural Pennsylvania*, Working Papers from the Regional Economic History Research Center, vol. 5, no. 1 (Wilmington, Del.: Eleutherian Mills-Hagley Foundation, 1981).

13. The most thorough exploration of this paradox remains Susan Laura Garfinkel, "Discipline, Discourse and Deviation: The Material Life of Philadelphia Quakers, 1762–1781," M.A. thesis, University of Delaware, 1986.

14. Kathryn Ann Auerbach and Jeffrey Marshall, *The Palmer-Knight House: Research Report on Property Ownership in the Eighteenth Century* (Doylestown, Pa: Bucks County Conservancy, 1986), 1–7.

15. Michel, *"In a manner and fashion suitable to their degree"*, 10–35. Bernard L. Herman, "The Pusey House," unpublished paper, 2001. The Pusey inventories are located in the Chester County Archives, West Chester, Pennsylvania: William Pusey Inventory (1731), Probate #398; Joshua Pusey Inventory (1760), Probate #1886; Joshua Pusey Inventory (1804), Probate #5091; Hannah Pusey Inventory (1816), Probate #6336. I am indebted to Ann Stroud for supporting the Pusey House research and to Cynthia Falk and Jeff Klee for their research assistance.

16. The presence of beds in the parlors of eighteenth-century Delaware Valley houses is noted in Bernard L. Herman, *The Stolen House* (Charlottesville: University Press of Virginia, 1992), 196–99; and Herman, *Architecture and Rural Life in Central Delaware*, 23.

17. Cynthia G. Falk, "The Isaac and Margaret Sharp House, New Garden Township, Chester County, Pennsylvania, 1782," unpublished paper, 1996. Isaac Sharp was a birthright Quaker who married out of meeting.

18. Mark Myers, "The Pennock, Joseph Jr. Farmstead, London Grove Village, West Marlborough Township, Chester County, Pennsylvania, National Register of Historic Places Registration Form," unpublished National Register of Historic Places nomination, 1997.

19. For information on the Todd family, see J. Smith Futhey and Gilbert Cope, *History of Chester County, Pennsylvania, with Genealogical and Biographical Sketches* (Philadelphia: L.H. Everts, 1881), 183, 193–95.

20. Herman, *Architecture and Rural Life in Central Delaware*, 14–41.

21. Raymond B. Wood-Jones, *Traditional Domestic Architecture in the Banbury Region* (Manchester: Manchester University Press, 1963), 183–202; Linda Hall, *The Rural Houses of North Avon and South Gloucestershire, 1400–1720* (Bristol: City of Bristol Museum and Art Gallery, 1983).

22. Elizabeth B. Reynolds, " 'The Planters Wisdom': Four Eighteenth-Century Houses in Maryland's Nottingham Lots," M.A. thesis, University of Delaware, 2001; Nicholas Cooper, *Aynho: A Northamptonshire Village* (Banbury: Leopard's Head Press in conjunction with the Banbury Historical Society, 1984) 20: 141, 146–47.

23. William Woys Weaver, "The Pennsylvania German House: European Antecedents and New World Forms," *Winterthur Portfolio* 21 (1986): 243–64.

24. Hall, *Houses of North Avon*, 123–24; Wood-Jones, *Traditional Domestic Architecture in the Banbury Region*, 209–11.

Chapter 8. Edward Hicks: Quaker Artist and Minister

1. *Memoirs of the Life and Religious Labors of Edward Hicks, Late of Newtown, Bucks County Pennsylvania. Written by Himself* (Philadelphia: Merrihew and Thompson, 1851), 20. Information about Edward Hicks and his family is summarized from Carolyn J. Weekley, *The Kingdoms of Edward Hicks* (New York: Harry Abrams, 1999) and Eleanore Price Mather and Dorothy Canning Miller, *Edward Hicks: His Peaceable Kingdoms and Other Paintings* (Newark: University of Delaware Press, 1983) unless noted otherwise. See also Alice Ford, *Edward Hicks: Painter of the Peaceable Kingdom* (Philadelphia: University of Pennsylvania Press, 1952; rev. ed. 1998).

2. Hicks, *Memoirs*, 20.

3. *Memoirs*, 18. Gilbert Hicks owned considerable business property in the town of Langhorne, Bucks County, as well as in Attleborough. Among these were a saw and planing mill and the Four-Lanes-End Hotel in Langhorne.

4. *Memoirs*, 21.

5. *Memoirs*, 24. Edward believed that Elizabeth Twining was the best example of humble industry that he ever knew. He wrote that "she had the simplicity and almost the innocence of a child. . . . she read the scriptures with a sweetness, solemnity, and feeling I never heard equaled. How often have I stood, or sat by her, before I could read myself, and heard her read, particularly the 26th chapter of Matthew, which made the deepest impression on my mind." See Plate 16.

6. *Memoirs*, 25.

7. Charles Peale Polk (1767–1822), the nephew of Charles Willson Peale, painted signs, ships, and other items to augment his income in the late eighteenth century. Christian Gullager (1757–1826), an immigrant trained at the Royal Academy in Copenhagen, advertised as an ornamental and portrait painter in Philadelphia opposite Friends Meeting on South Fourth Street. His notice mentions drums, military silks, fire buckets, cornices, flags, and other services.

8. From 1816 to 1818, Hicks's account book lists two landscape paintings for Dr. Abraham Chapman; it also notes a landscape fire board for Dr. Phineas Jenks. Edward Hicks's Account Book, Bucks County Historical Society, Doylestown, Pennsylvania, 74, 82. It was damaged in a fire early in the twentieth century but the majority of pages and entries are intact.

9. Edward Hicks became a close friend of Elias Hicks, his second cousin once removed, who lived in Long Island. Ultimately, Edward supported Elias's views and became aligned with Hicksite Quakers.

10. *Memoirs*, 38.

11. *Memoirs*, 50.

12. The couple lived in rented rooms in Milford until Edward acquired a lot and

built a small house there. Edward borrowed money to fund the construction of his dwelling. This was the first of several loans that ultimately contributed to his difficult financial situation in 1815–16. The Hickses' first child, Mary, was born on October 12, 1804 or 1805; later children included Susan (1806–72), Isaac Worstall (1809–1898), Elizabeth (1811–92), and Sarah (1816–95). Weekley, *The Kingdoms*, 182–83.

13. *Memoirs*, 57.

14. *Memoirs*, 71.

15. *Memoirs*, 71.

16. *Memoirs*, 71–72.

17. John Comly to Isaac Hicks, June 15, 1817, Friends Historical Library, Swarthmore College, Swarthmore, Pennsylvania (hereafter FHL). Isaac was one of Edward's New York cousins.

18. John Comly to Isaac Hicks, June 15, 1817.

19. John Comly to Isaac Hicks, October 23, 1817, Alice Ford files, Newtown Historic Association, Newtown, Pennsylvania. Edward's financial situation improved both through his painting and through the generosity of relatives and one anonymous Friend who assumed one of Edward's mortgages. By the next year Edward's debts had been reduced and he was encouraged by the increase in his ornamental painting business.

20. *Doylestown Democrat*, May 31, 1848, Alice Ford files, Friends Historical Library, Swarthmore College.

21. Weekley, *The Kingdoms*, 85. Thomas Hicks left Edward's shop in 1839 to pursue formal training in New York City and abroad. He became a well-respected American painter, noted principally for his portraiture. He retired to upstate New York where he produced a number of interesting landscape pictures. His studio near Utica survives and is privately owned.

22. Weekley, *The Kingdoms*, 175–76.

23. Weekley, *The Kingdoms*, 243, n. 23.

24. *Memoirs*, 229.

25. One of these signs is owned by the Mercer Museum of the Bucks County Historical Society, Doylestown, Pennsylvania The current location of the second sign is unknown; it was auctioned at Sotheby's New York in 1997.

26. *Memoirs*, 53.

27. *Memoirs*, 7–8.

Introduction to Part III

1. Dianne C. Johnson, "Living in the Light: Quakerism and Colonial Portraiture," M.A. thesis, University of Delaware, 1991; Leanna Lee-Whitman, "Silks and Simplicity: A Study of Quaker Dress as Depicted in Portraits, 1718–1855," Ph.D. dissertation, University of Pennsylvania, 1987.

2. See Carolyn J. Weekley, *The Kingdoms of Edward Hicks* (Williamsburg, Va.: Colonial Williamsburg Foundation, 1999). Friends' preferences for silhouettes and daguerreotypes are noted in Anne Ayer Verplanck, "Facing Philadelphia: The Social

Function of Silhouettes, Miniatures, and Daguerreotypes, 1760–1860," Ph.D. dissertation, College of William and Mary, 1996.

3. For other women's roles in the centennial, see Sylvia Yount, "A 'New Century' for Women: Philadelphia's Centennial Exhibition and Domestic Reform," in *Philadelphia's Cultural Landscape: The Sartain Family Legacy*, ed. Katherine Martinez and Page Talbott (Philadelphia: Temple University Press, 2000), 149–60.

4. The HSP also acquired three-dimensional materials related to Penn, including his shaving basin in 1827 (a gift of one of the organization's founders, Thomas I. Wharton). Nicholas B. Wainwright, *150 Years of Collecting by the Historical Society of Pennsylvania, 1824–1974* (Philadelphia: Historical Society of Pennsylvania, 1974), 5.

5. George Fox, *Journal* (London: Thomas Northcott, 1694); William Penn, *No Cross, No Crown* (London: Andrew Solle, 1669). Although the works of Fox and Penn have been reprinted many times since the 1670s, their popularity was eclipsed in the early nineteenth century by more contemporary works. Thomas Clarkson, *A Portraiture of Quakerism: Taken from a View of the Education and Discipline, Social Manners, Civil and Political Economy, Religious Principles and Character of the Society of Friends*, 3 vols. (New York: Samuel Stansbury, 1806); Thomas Evans, *A Concise Account of the Religious Society of Friends, Commonly Called Quakers: Embracing a Sketch of their Christian Doctrines and Practices* (Philadelphia: Friends Book Store, 1856).

6. *Minutes of the Eighth Annual Meeting of the Shareholders of Swarthmore College Held Twelfth Month Fifth 1871* (Philadelphia: Merrihew and Son, 1872), 39; Elizabeth Kaplan, "We Are What We Collect, We Collect What We Are: Archives and the Construction of Identity," *American Archivist* 63 (Spring/Summer 2000): 126–51.

7. Westtown Boarding School, *A Brief History of Westtown Boarding School*, 2nd ed. (Philadelphia: Sherman, 1872). See also Watson W. Dewees and Sarah B. Dewees, *Centennial History of Westtown Boarding School, 1799–1899* (Philadelphia: Sherman and Co., 1899); Amelia Mott Gummere, *The Quakers: A Study in Costume* (Philadelphia: Ferris and Leach, 1901). The relationship between Gummere's research interests and her concerns about changes within the Quaker faith bears further scrutiny.

8. See, for example, Pennsylvania Board of Centennial Managers, *Pennsylvania and the Centennial Exposition* (Philadelphia: Gillin and Nagle, 1878). Like many aspects of Friends' roles in the colonial revival, Quakers' presence or absence as visitors and subjects of display deserves more attention.

9. The description of the planned "section of history" is noted in A. B. Farquhar, *Pennsylvania and the World's Columbian Exposition* (Harrisburg, Pa.: E.K. Meyers, 1892), 165. The Penn portraits are the only Quaker-associated items on the list (they are not identified as such); other objects included the Liberty Bell, Washington relics, and General Anthony Wayne's sword. A. B. Farquhar, *Catalogue of the Exhibits of the State of Pennsylvania and Pennsylvanians at the World's Columbian Exhibition* (Harrisburg, Pa.: Clarence M. Busch, 1893), 15–16.

10. Gilbert Hindermyer, "Wyck: An Old House and Garden at Germantown, Philadelphia," *House and Garden* (November 1902): 548–59. One must consider whether the terms "simple" and "plain" were allusions not to Wyck's Quaker ties but rather to the Arts and Crafts movement ideals that permeated Philadelphia and envi-

rons concurrently and were likely intertwined with the colonial revival movement. For example, interior decorator Mabel Tuke Priestman (who shared the ideals of writer Charles Wagner and others) noted in 1908, "Let us avoid ostentatious display, and cultivate the beauty of harmony and simplicity." Priestman, *Art and Economy in Home Decoration* (New York: John Lane, 1908), 18, cited in Mark Alan Hewitt, *Gustav Stickley's Craftsman Farms: The Quest for an Arts and Crafts Utopia* (Syracuse, N.Y.: Syracuse University Press, 2001), 167–68. I thank John M. Groff for this citation. A. Margaretta Archambault notes Wyck, but makes no reference to its being a Quaker house. Archambault, ed., *A Guide Book of Art, Architecture, and Historic Interests in Pennsylvania* (Philadelphia: John C. Winston, 1924), 155. The book was completed in 1917 but not published until after the war. A guidebook published for the German-town Site and Relic Society, of which Casper Haines was a member, connects Wyck to the Battle of Germantown and Lafayette's visit but makes no remarks about the house's Quaker history. Charles F. Jenkins, *The Guide Book to Historic Germantown, Prepared for the Site & Relic Society* (Germantown, Pa.: Site and Relic Society, 1904), 89.

11. The history of Wyck and other houses in Philadelphia's suburbs is the subject of ongoing research by John M. Groff; I thank him for sharing his insights about the house and its context. See also Jennifer Anderson-Lawrence, "The Colonial Revival at Cliveden," M.A. thesis, University of Delaware/Winterthur Program in Early American Culture, 1991, esp. 44–46.

12. Merion Preparative Meeting of Friends, *1695–1895: Bi-centennial Anniversary of the Friends' Meeting House at Merion, Pennsylvania* (Philadelphia: Friends Book Association, 1895); *100th anniversary of the Friends' Meeting House, Union Street, Medford, New Jersey, held Eighth Month first, 1914* (Philadelphia: William H. Pile's Sons, ca. 1914).

13. Isaac Sharpless, *The Friends' Meeting House Fourth and Arch Streets Philadelphia: A Centennial Celebration Sixth Month Fourth* (Philadelphia: John C. Winston, ca. 1904), 8. At the same time as the anniversaries of older meeting houses were being celebrated, funds for their maintenance became more readily available. The Jeanes Fund, endowed in 1899, provided funds for the maintenance of meeting houses within Philadelphia Yearly Meeting; a more detailed assessment of these records (at Friends Historical Library, Swarthmore College) might establish the degree to which maintenance projects were driven by preservation goals.

14. Frances Williams Browin, *A Century of Race Street Meeting House, 1856–1956* (Philadelphia: Central Philadelphia Monthly Meeting of Friends, 1956), 32, 36.

15. Price designed meeting houses at Westtown School, Westtown, Pennsylvania; Washington, D.C.; and Montclair, New Jersey. See, for example, Walter F. Price, "Old Meeting-Houses," *The Friend* (September 24, 1936): 115–18 and "Friends' Meeting Houses at Chester, Pennsylvania," *Bulletin of the Friends Historical Association* 21, 2 (Autumn 1932): 66–68. I thank Catherine Lavoie for sharing her research and insights on meeting houses in the twentieth century.

16. T. Chalkley Matlack, comp., *Brief Historical Sketches Concerning Friends Meetings of the Past & Present, with Special Reference to the Philadelphia Yearly Meeting* (Moorestown, N.J., 1938).

17. I thank Ellen Endslow and Mary Anne Caton for their thoughts about Quaker accessions at CCHS.

18. This point is argued more fully in Verplanck, "Facing Philadelphia," chap. 2.

19. This euphemism appears in the 1995 decorative arts installation curated by Margaret Bleeker Blades at the Chester County Historical Society, West Chester, Pennsylvania.

20. Archambault, *A Guide Book,* 175.

21. Chester County Day is a day-long series of tours of houses and other buildings, begun in 1936. Chester County Day newspaper insert, Saturday, October 7, 2000, 1.

Chapter 9. The Aesthetics of Absence: Quaker Women's Plain Dress in the Delaware Valley, 1790–1900

I dedicate this chapter to Kevin Murphy and Lilla Caton.

1. Amelia Mott Gummere, *The Quaker: A Study in Costume* (Philadelphia: Ferris and Leach, 1901), 105.

2. Susan Garfinkel, Dianne Johnson, Patricia Keller, Leanna Lee-Whitman, and Anne Verplanck have all written about the relationship of the Quaker doctrine of plainness to different aspects of the material world. For more information, see Susan L. Garfinkel, "Discipline, Discourse, and Deviation: The Material Life of Philadelphia Quakers, 1762–1781," M.A. thesis, University of Delaware, 1986; Dianne C. Johnson, "Living in the Light: Quakerism and Colonial Portraiture," M.A. thesis, University of Delware, 1991; Patricia J. Keller, *"Of the Best Sort But Plain": Quaker Quilts from the Delaware Valley, 1760–1890* (Chadds Ford, Pa.: Brandywine River Museum, 1996); Leanna Lee-Whitman, "Silks and Simplicity: A Study of Quaker Dress as Depicted in Portraits, 1718–1855," Ph.D. dissertation, University of Pennsylvania, 1987; Anne Ayer Verplanck, "Facing Philadelphia: The Social Function of Silhouettes, Miniatures, and Daguerreotypes, 1760–1860," Ph.D. dissertation, College of William and Mary, 1996.

3. Late seventeenth-century *Rules of Discipline* issued by Philadelphia Yearly Meeting convey a precise list of clothing to avoid. This list of superfluous items is somewhat repeated in rules to 1711 and thereafter becomes a plea to avoid the "superfluous." This reticence about defining plain garments leads some scholars to conclude, I believe rightly, that plainness had understood, agreed upon meanings within the Society of Friends that were fluid and changed over time. Thus the individual was left to make his or her own choice about how to adapt material goods to that meaning. See Verplanck, "Facing Philadelphia," 70–74.

4. *Journal of George Fox,* ed. John L. Nickalls (London: Religious Society of Friends, 1975), 169, 205; see J. William Frost, "From Plainness to Simplicity: Changing Quaker Ideals for Material Culture," in this volume. Frost also notes that, significantly, there was no distinct character to early Friends material culture in northern England.

5. For a thorough discussion of language in the *Rules of Discipline,* see

Garfinkel, "Discipline, Discourse, and Deviation," 5, 60. See also Verplanck, "Facing Philadelphia," 70–74.

6. The origin of this language is Fox's 1655 condemnation of colored ribbons, powdered hair, and other excesses. Fox's words were based on seventeenth-century popular styles that were part of seventeenth-century translations of the Bible into English. For discussion of the intellectual roots of plain dress in this volume, see also Frost, "From Plainness to Simplicity," in this volume.

7. Introduced in the 1690s and passed in 1701, the First Act for the Prohibition of Indian manufactures states that "all Wrought Silks, Bengals, and stuffs mixed with silk or herba, of the manufacture of Persia, China, or East Indies & all calicoes painted, dyed, printed, or stained there . . . shall not be worn or otherwise used within this kingdom of England, dominion of Wales or town of Berwick upon Tweed." See Beverly Lemire, *Fashion's Favorite: The Cotton Trade and the Consumer in Britain, 1600–1800* (London: Oxford University Press, 1991), 30–33. The connections between Quaker textile manufacturers in northern England and the practice of plain dress deserve further detailed study.

8. Verplanck, "Facing Philadelphia," 190–91.

9. *Rules of Discipline of the Philadelphia Yearly Meeting of Friends* (Philadelphia: Samuel Sansom, Jr., 1797), 102, in Verplanck, "Facing Philadelphia," 73–74.

10. Lee-Whitman, "Silks and Simplicity," 64. Brissot de Warville in 1788 noted older women Friends wearing dark colors while their younger counterparts wore the "finest" linens, muslins, and silks. Lee-Whitman comments that age was the main factor differentiating young and old women Friends dress during the early republic (1777–1826).

11. *Peter Kalm's Travels in North America,* ed. Adolph B. Benson, the English Version of 1770 (New York: Wilson-Erickson, 1937), 2: 651.

12. After 1840 the fall-front construction style was used only by the very conservative. Side skirt openings were more commonly used. Bodices generally fastened at the center front with hooks and eyes. CCHS examples are collarless with the bodice closure flanked by one or two darts. See also Jane Farrell-Beck, "Nineteenth-Century Construction Techniques: Practice and Purpose," *Dress* 13 (1987): 11–20, for a detailed discussion of sewing techniques.

13. Exhibit research notes for 1990 and personal conversation with Pat O'Donnell, 1991.

14. Noble E. Cunningham, Jr., "Political Dimensions of Everyday Life in the Early Republic," in *Everyday Life in the Early Republic,* ed. Catherine E. Hutchins (Winterthur, Del.: Winterthur Museum, 1994), 7, 8.

15. *New York Atlas* 1, 17 (January 7, 1832): 136, Quaker Collection, Haverford College, Haverford, Pennsylvania.

16. CCHS clippings files, West Chester, Pennsylvania. More work remains to be done on how plain Friends acquired their clothing.

17. Sarah Josepha Hale, *The Workwoman's Guide, containing instructions to the inexperienced in cutting out and completing those articles of wearing apparel, &c., which are usually made at home; also, explanations on upholstery, straw-plaiting, bonnet-making, knitting, &c.* (London: Simpkin, Marshall, and Co., 1838), 166.

18. The Bacon family lived in Philadelphia and were Orthodox Friends. They are listed with their children William, Carolina, Sarah, Mary Ann, Francis, and Harriet in 1838 as newly received of the Northern District of the Philadelphia Monthly Meeting. See William Wade Hinshaw, *Encyclopedia of Quaker Genealogy*, 5 vols. (Baltimore: Genealogical Publishing Company, 1969), 2: 726.

19. Stella Blum, ed., *Fashions and Costumes from Godeys Lady's Book* (New York: Dover, 1985), ii.

20. Hodgson was born in Wilmington, Delaware, and married a member of Wilmington Monthly Meeting there in 1835. Hinshaw, *Encyclopedia*, 2: 746.

21. Quoted in Verplanck, "Facing Philadelphia," 190–92.

22. Diary of Rachel Scattergood, 1 mo 14 1840, MSS 975B, 18, Quaker Collection, Haverford College.

23. Rachel Scattergood married Edward Maris in May 1876 and served on the Westtown School committee from April 1870 to April 1900. Diary of Rachel Scattergood, 1 mo 24 1840, MSS 975B, 22, Quaker Collection, Haverford College; Helen G. Hole, *Westtown Through the Years*. (Westtown, Pa., 1942), 128, 346.

24. Elizabeth Fry, *Memoir of the Life of Elizabeth Fry*, 2 vols. (London: Charles Gilpin, 1847), 2: 53.

25. Alice Morse Earle, *Two Centuries of American Costume* (New York: Macmillan, 1903), 600–601.

26. Ms Box 1, 5 mo 16 1799, Westtown School Archives, Westtown, Pennsylvania.

27. Quoted in Hole, *Westtown Through the Years*, 44–45.

28. Ms Box 1, Westtown School Archives. One tailor, Thomas Dent, worked from 1799 to 1851 altering the boys' clothes and making coats and breeches. For more details about the staff, see Susannah Smedley, comp., *Catalog of Westtown Through the Years* (Westtown Pa., 1945), 380–85.

29. Ms Box 1, Westtown School Archives.

30. Others signing the letter were Phebe Cox, Elizabeth Bellerby, John Forsythe, and Alexander Wilson. Ms Box 1, Westtown School Archives.

31. Hannah Albertson to her father Jacob, 7 mo 29 1799, Ms Box 1, Westtown School Archives.

32. Margaret Gummere to her mother, 11 mo 12 1863, Ms Box 9, Westtown School Archives.

33. 2 mo 9 1821, Ms Box 7, Westtown School Archives.

34. Mary Wood to her mother, Sydney, 3 mo 16 1825, Ms Box 7, Westtown School Archives. Mary's mother lived in Little Britain in Lancaster County. I have found no record of them in Hinshaw's *Encyclopedia*.

35. Smedley, *Catalog*, 382, 385. Manufacture of plain clothing for Westtown students and staff needs further attention.

36. Chester County Historical Society library clippings files.

37. *Historical Essays*, undated manuscript, 469. Westtown School Archives.

38. Thomas D. Hamm argues that the Hicksites changed plain dress into simplicity after 1875 as a modification of separation from the world. Although Sharpless and most of the Westtown community were Orthodox Friends, both branches of the sect had fewer plain members after the Civil War. See Hamm, "The Hicksite Quaker

World, 1875–1900," *Quaker History* 89, 2 (2000): 17–41, for discussion of how many re-
strictions were modified before 1900. I thank Anne Verplanck for this reference.

39. Fragmentary clothing owned by Sharpless includes a handkerchief (CCHS
1989.1934), a baby cap, pockets, bonnet cover, and baby dress (Westtown School).
CCHS Cope photo 576 (December 29, 1888). Cope 467 (September 25, 1888) shows
Sharpless with three other female relatives.

40. Ann Sharpless, "Dress in Early Times," Westtown School Archives.

41. In another portrait taken at Westtown ca. 1890, Ann wears a kerchief with
her high-collared dress and no cap. Hole, *Westtown Through the Years,* 272.

42. Newspaper clippings files of obituaries, April 19, 1916, CCHS Library, West
Chester, Pennsylvania. Abbott's associations are all with Orthodox Quaker Meetings.
She was a member of Arch Street Meeting in Philadelphia. I thank Pamela C. Powell
and Emma Lapsansky for this information.

43. Alice Morse Earle and Amelia Mott Gummere describe a narrow range of
patterns and colors. What Susan Garfinkel terms "the quintessential quotation" about
plainness, "Of the best Sort but plain," was identified by Frederick Tolles in the 1940s
and has been frequently, if misleadingly, used to describe all Quaker material goods
as uniformly drab. The quote actually refers to a japanned corner cupboard ordered
in 1738 by Philadelphia merchant John Reynell from his London partner. Garfinkel as
quoted in Keller, *"Of the Best Sort But Plain",* 25. CCHS clippings files, 1903.

44. When surveyed in 1988 by Margaret Vincent and Pat O'Donnell and in 1991
by Nancy Rexford, the collection yielded a group of twenty possibly Quaker dresses.
The sample considered here includes dresses with a Quaker provenance (the owner is
listed in Hinshaw's *Encyclopedia*). I have chosen to omit clothing where the prove-
nance was descent in a Quaker family as being unreliable without clear links to a spe-
cific individual. Several early garments published elsewhere unfortunately lack
reliable Quaker provenances.

45. A Quaker wedding dress, dated 1799, survives at the Philadelphia Museum
of Art. It is one of the few documented pre-1800 plain Quaker dresses.

46. Miller's family history is inscribed on the reverse of the framed silhouette.
She was the daughter of Susanna Malin and E. David Havard. I thank Ellen Endslow
for this information.

47. Bill of sale, 10 mo 28 1826, to Jane Brinton from Townsend Sharpless, Brin-
ton Family Papers, CCHS Library. The donor of the Brinton papers also gave many
undocumented early nineteenth-century dresses and accessories.

48. Hale, *The Workwoman's Guide,* 126, 127, 160, 166.

49. Christina Walkley and Vanda Foster, *Crinolines and Crimping Irons:
Victorian Clothes: How They Were Cleaned and Cared For* (London: Peter Owen,
1978), 71.

50. Hale, *The Workwoman's Guide,* 126, 127, 160. Servants' attire and children's
clothing are also treated in detail. The reprinted edition is based on a copy at Old
Sturbridge Village inscribed with an owner's signature: "Catharine H. Chidde/Or-
leton 1840." I thank Colleen Couture for the owner's mark.

51. Frost, "Plainness to Simplicity."

52. Gilbert Cope documented his world of late nineteenth-century Chester

County in hundreds of photos. Many show the Westtown School, where Cope's daughter was a student. Cope also photographed older plain Friends with their families and at meeting, as well as his daughter's contemporaries reenacting scenes in stereotypical plain dress.

53. Stella Blum, ed., *Victorian Fashions and Costume from Harper's Bazaar, 1867–1898* (New York: Dover, 1974), 227, 252, 253, 267. C. Willett Cunington, *English Women's Clothing in the Nineteenth Century* (New York: Dover, 1990), 381, 383, 402.

54. Cunington, *English Women's Clothing*, 383.

55. Frost, "From Plainness to Simplicity."

56. OO/74 CLF 24 object files, CCHS. Hole, *Westtown Through the Years*, 92.

57. The 1988 CCHS Quaker clothing survey and subsequent analysis in 1989–91 included overviews of accessories like shawls, kerchiefs, caps, and some bonnets. They are, however, outside of the scope of this study. See Sharon Ann Burston, *Fitting and Proper: 18th Century Clothing from the Collection of the Chester County Historical Society* (Texarkana, Tex.: Scurlock, 1998), for other possibly Quaker caps, capes, and shortgowns.

58. Don Yoder, "Sectarian Costume Research in the United States" in *Forms upon the Frontier: Folklife and Folk Arts in the United States*, ed. Austin Fife, Alta Fife, and Henry H. Glassie, Utah State University Monograph Series 16, 2 (Logan: Utah State University Press, 1969), 41–75.

59. These everyday dresses were grouped with Quaker clothing in the initial Quaker clothing cataloging project in 1988. Subsequent examination by costume historian Nancy Rexford in 1990 confirmed the dresses' similarities to everyday dress while noting their inconsistencies with fashionable dress. Further work needs to be done on the Quaker nature of CCHS later nineteenth century clothing. Fashionable clothing with Quaker provenance, especially at CCHS, deserves further study.

60. Hamm, "Hicksite Quaker World," 17–41.

61. I thank Pamela C. Powell for her insights into Cope's work.

Chapter 10. Sara Tyson Hallowell: Forsaking Plain for Fancy

1. *Report of the President to the Board of Directors of the World's Columbian Exposition* (Chicago: Rand McNally, 1898), 5–17.

2. Carolyn K. Carr, "Prejudice and Pride: Presenting American Art at the 1893 World's Columbian Exposition," in *Revisiting the White City: American Art at the 1893 World's Fair*, ed. Carr (Washington, D.C.: National Museum of American Art and National Portrait Gallery, 1993), 65–69.

3. Hallowell began visiting Moret-sur-Loing as least as early as 1891. See Sara T. Hallowell to Halsey Ives, August 6, 1891, Palmer Papers, Chicago Historical Society (CHS). While she spent increasing amounts of time there during the next two decades, it would appear from her correspondence with William M. R. French, director of the Art Institute of Chicago (Art Institute of Chicago Archives), that she did not give up her Paris apartment at 9 Avenue du Trocadero until about April 1912.

4. William Penrose Hallowell, *Record of a Branch of the Hallowell Family, including the Longstreth, Penrose and Norwood Branches* (Philadelphia: Hallowell and Co.,

1893), 47 (microform edition). Mary Morris Tyson and Caleb W. Hallowell were married June 11, 1840. The Hallowell and Tyson families had intermarried previously on several occasions, the first of which was the marriage of William Hallowell (1707–1794) and Margaret Tyson, daughter of Matthias (1686–1727) and Mary Potts Tyson.

5. Hallowell, *Record,* 47. Caleb and Mary Morris Tyson Hallowell's children were Francis Perot (1841–1885), Morris Lewis (1842–1911), Lewis Morris (1844–1909), Sara Tyson (1846–1924), Marshall Tyson (1852–1930), and Elizabeth Perot (1854–1883).

6. Hallowell, *Record,* 13, 47. John Hallowell and his second wife, Mary Sharpe, had nine children. They immigrated to Darby, Pennsylvania, on December 19, 1682, but soon moved to Abington. Caleb W. Hallowell, son of Chalkley (Caleb[5], William[4], Thomas[3], John H.[2]) and Susan Fisher Hallowell, was born in 1815 and died on January 21, 1857. Sara's father, Caleb W., is often confused with Caleb Hallowell (1811–1846), who was the son of Caleb W.'s uncle, Charles Tyson Hallowell (1780–1829). According to William W. Hinshaw, *Encyclopedia of American Quaker Genealogy,* 4 vols. (Baltimore: Genealogical Publishing House, 1950–69), 2: 933, Mary Morris Tyson Hallowell was read out of meeting for marrying out of unity. When or why her husband left the meeting is not known. Sara Hallowell was surrounded, however, by an extended family of birthright Quakers who remained in the faith. The obituary of Sarah Saunders Morris Tyson Biddle (1799–1883), Sara's grandmother, in the *Friends Intelligencer* 70 (1913): 286, notes that she was a member of Fifteenth and Race Street Meeting. It also implies that Mary Morris Tyson Hallowell's lack of affiliation with a particular meeting was due to her frequent change of residence, suggesting that she was not permanently disowned. Mary Hallowell's continued connection to the Friends tradition is evident in Hallowell's letter to Morris Tyson, Jr., April 11, 1913, Perot Papers, Historical Society of Pennsylvania, for she specifies that while she engaged the Reverend Van Winkle from the American Episcopal Church in Paris to do the funeral service for her mother, "he omitted everything from the ritual of a dogmatic character inconsistent for a Friend."

7. Robert C. Moon, *The Morris Family of Philadelphia: Descendants of Anthony Morris, 1654–1721,* 5 vols. (Philadelphia: Robert C. Moon, 1898–1909) (microfilm), 5: 3 ff; John W. Jordan, ed., *Colonial Families and Revolutionary Families of Pennsylvania,* 4 vols. (1911, reprint Baltimore: Genealogical Publishing Company, 1978), 1: 4ff. Morris and his wife, who belonged to Westminster Monthly Meeting in London, settled in Burlington, New Jersey, about 1685. The following year they moved to Philadelphia. There, in 1687, Morris established the first brewery in America. His son Anthony (1682–1763) was associated with him in the brewing business, but he also established various ironworks beginning about 1727. Like his father, Morris was involved in civic life as a justice of the city courts, as a justice of the orphans courts, and as a member of the Philadelphia Colonial Assembly. His son Anthony (1705/6–1780), also a member of Philadelphia Monthly meeting, continued to assist his father in the brewing business. His sons Anthony (1738–1777) and Samuel (1734–1777) both took part in the Revolutionary War. Their brother Thomas Morris (1745/46–1809) married Sarah Saunders. Two of their children, Joseph Saunders (1772–1817) and Thomas

(1774–1841), married sisters, Abigail (1773–1848) and Sarah Marshall (1773–1824), daughters of Charles (1774–1825) and Patience Parrish Marshall (1745–1834) and granddaughters of Revolutionary diarist Christopher Marshall (1709–1797). Thomas and Sarah Marshall Morris had eight children. One daughter, Sarah Saunders Morris (1799–1883), married Elisha Tyson, Jr. (1796–1842) in 1819, and after his death, Clement Biddle. Another daughter, Elizabeth Marshall Morris (1802–78), married Francis Perot (1796–1885) in 1823. Thus, by the early nineteenth century, the Marshall, Morris, Perot, and Tyson families were all related.

8. Quaker Rynear (Reiner, Reynier, Ryner) Tyson (Teisen, Teissen) (1659–1745) immigrated to Pennsylvania from Krefeld, Germany, in 1683. See *Tyson-Kurtz and Allied Lines: A Genealogical Study with Biographical Notes*, 2 vols. (New York: American Historical Company, 1968), 1: 5; Frank W. Leach, "Old Philadelphia Families: The Tyson Family," *North American* (Philadelphia), July 21, 1912; Emily Emerson Lantz, "History of Distinguished Families and Personages: Tyson Lineage and Arms," *Baltimore Sun*, January 22, 1905; and Jordan, *Colonial Families*, 1: 689ff.

9. Leach, "The Tyson Family." Elisha Tyson was the son of Isaac (1718–1796) (Matthias³, Rynear², Rynear¹) and Esther Shoemaker Tyson (m. 1748), who were affiliated with Abington Meeting. He was born in Upper Dublin, Pennsylvania, but moved to Maryland around 1772. He settled in Jericho, near Little Falls, and belonged to Gunpowder Monthly Meeting. In the 1790s he sold his mills to his sons and devoted his life to philanthropic causes. He was an abolitionist and often paid lawyers to defend free blacks, who were, prima facie, thought to be runaway slaves. See Leroy Graham, "Elisha Tyson: Baltimore and the Negro," M.A. thesis, Morgan State University, 1975, and John S. Tyson, *Elisha Tyson the Philanthropist by a Citizen of Baltimore* (Baltimore: B. Lundy, 1825). Elisha Tyson was the father of ten children. Elisha Tyson, Jr., who married Sarah Saunders Morris and was the father of Mary Morris, was his youngest son.

10. Frank W. Leach, "Old Philadelphia Families: The Marshall Family," *North American*, September 15, 1912. Christopher Marshall, a descendant of William Marshall, earl of Pembroke, immigrated to America in 1727. He and his wife, Sarah Thompson, had three children, Benjamin (1737–1778), Christopher, Jr. (1740–1806), and Charles (1744–1826). As previously noted, the daughters of Charles and Patience Parrish Marshall, Abigail and Sarah, married brothers Joseph and Thomas Morris. Their third daughter, Patience (1771–1834), was the second wife (m. 1815) of Isaac Tyson (1777–1864), brother of Elisha Tyson, Jr. The Marshall/Tyson connection is graphically portrayed in a silhouette album at the Historical Society of Pennsylvania, which is presumed to have been assembled by Mary Ann Marshall (1788–1881), the daughter of Benjamin Marshall. See Anne Ayer Verplanck, "Facing Philadelphia: The Social Function of Silhouettes, Miniatures, and Daguerreotypes, 1760–1860," Ph.D. dissertation, College of William and Mary, 1996, 291–92. When, in 1890, Mary Morris Tyson Hallowell became the twentieth member of the Daughters of the American Revolution, she did so on the basis of her descent from Christopher Marshall. See *Daughters of the American Revolution Lineage Book* (Washington, D.C.: Daughters of the American Revolution, 1890), 1: 10.

11. Jordan, *Colonial Families*, 3: 1215–16; and Quaker Collection, Perot Papers, ms. 1147, Haverford College. Francis Perot (1796–1885), son of Elliston (1746/47–1834) and Sara Samson Perot (1764–1808), who married (1823) Elizabeth Marshall Morris (1802–1878) (sister of Sarah Saunders Morris—Mrs. Elisha Tyson, Jr.), had three children—Elliston (1824–1865), Thomas Morris (1828–1902), and Sarah Morris Perot (1831–1912). Sara Hallowell was particularly close to Thomas Morris and his son Thomas Morris Perot, Jr. (1872–1945). She and her five siblings were witness to his marriage to Rebecca C. Siter (1833–1913) on November 5, 1858. Quaker Collection, The Perot Papers, ms. 1147, contains a copy of the Perot/Siter marriage document recorded February 25, 1867, in volume 3 of the records books of Fifteenth and Race Street Meeting.

12. In 1815 Elisha Tyson's son Nathan (1787–1867) married Martha Ellicott (1795–1783). For information on the Ellicott family, see Charles Worthington Evans, Martha Ellicott Tyson, and G. Hunter Bartlett, *Fox-Ellicott-Evans: American Family History* (Cockeysville, Md.: Fox-Ellicott-Evans Fund, 1976). For evidence of the ongoing connection between the families of Sara Hallowell and Martha Tyson Ellicott, see Francis Perot Hallowell to Martha E. Tyson, April 13, 1851, and January 1, 1856, Henry Maynadier Fitzhugh Family Collection, Special Collections, MSC 4688, microfilm 11760, Maryland State Archives, Annapolis.

13. Surprisingly little is known about Caleb Hallowell. McElroy's *Philadelphia City Directory* (Philadelphia: E.C. and J. Biddle, 1845, 1853, 1854, 1861) shows that in 1845, the year preceding Sara's birth, Hallowell was a merchant at 143 High Street (later Market Street) and that he lived at 107 New Street. In 1853 he was employed at 143 Market, but lived at 128 N. Ninth Street. In 1854, his place of employment remained the same, but he lived at 599 Arch Street. From the early 1840s until his bankruptcy in the mid-1860s, Caleb's cousin Morris Longstreth Hallowell (1809–1880) was a merchant at the same location. He dealt in "silks and fancy goods." Presumably Caleb and his cousin were in business together, although the nature of the partnership or the employee/employer relationship is not clear. Caleb W. Hallowell does not appear in Philadelphia street directories in either 1855 or 1856, suggesting that he may have been living out of the city prior to his death. Morris L. Hallowell had business locations both in the American south and in Paris, with "with a member of our firm permanently located there to superintend our purchases in Europe" (Morris L. Hallowell to esteemed friends, January 25, 1855, Cannon Family Papers, acc. no. 1002, reel 10, Hagley Museum and Library, Wilmington, Delaware). Whether Caleb W. was his representative in Europe is not known. Morris L. Hallowell's prosperous business became bankrupt during the Civil War because southern creditors failed to pay their bills. See Edward T. James, ed., *Notable American Women, 1607–1950: A Biographical Dictionary*, 3 vols. (Cambridge, Mass.: Harvard University Press, 1971), 3: 122–23, and Julianna R. Wood, *Biographical Sketch of Richard D. Wood*, 2 vols. (Philadelphia: Lippincott's, private edition, 1871), 1: 217. If Sara Hallowell's deceased father had invested in this company, it is entirely possible that this bankruptcy impacted her family as well. Mary Morris Hallowell's name is absent from the Philadelphia city directories until 1860. In that year, she is listed as living at 124 N. Thirteenth Street, the residence of her mother, Sarah Samson Morris Tyson Biddle. I wish to thank Phillip Lapsansky,

Library Company of Philadelphia, for confirming the addresses and business relationship between Caleb W. and Morris L. Hallowell.

14. The impact of the Civil War on the health of Hallowell's three brothers can be seen in their petitions for Civil War pensions. Morris Lewis Hallowell's records state that he joined Company H of the Seventy-First Pennsylvania Volunteers on June 4, 1861. He was ill during most of 1862 and discharged in February 1863 from Mount Pleasant Hospital, Washington, D.C., where he had been sent after the Second Battle of Bull Run. In March 1865 he reenlisted in Company F of the Twenty-First Regiment, but was discharged the following November. Between 1867 and 1871 he lived intermittently with his brother Lewis Morris and his wife Sarah Aldrich Hallowell. Beginning about 1877 he began living in Sonoma, California, at Smith's Ranch, where he remained at least through 1909. His records indicate that he had Bright's disease and heart problems, and was deaf in his left ear (National Archives, Record Group 15, Records of the Veterans Administration, pension no. 573.950). Lewis Morris Hallowell joined Company K, Ninety-Fifth Pennsylvania Volunteers, on September 24, 1861. His left leg was injured at Malvern Hill, near Charles City, Virginia, on July 1, 1862. He was discharged on August 4, 1862 (National Archives, Record Group 15, Records of the Veterans Administration, Pension no. 279092). Francis Perot Hallowell served in the army from January 18 until September 13, 1862, as a second lieutenant in Company J of the Ninety-Ninth Pennsylvania Regiment. He then joined the navy as an engineer on September 8, 1863, but resigned due to complications from malaria on November 12, 1867. Subsequently, he lived in various Midwestern cities, including Riverton, Iowa (1871), Lowell, Nebraska (1873), Millington, Illinois (1875), Kinsley, Kansas (1877), and McPherson, Kansas (1879), before moving to Washington, D.C. in 1881 (National Archives, Record Group 24, Records of the Bureau of Naval Personnel, M 330, roll 12, January 1864–1871, vol. L–Z, Abstracts of Service Records of Naval Officers, 1798–1893).

15. In the 1870 census, Cook County, Illinois, ward 4, roll 200, 106, National Archives, Mary Morris Tyson Hallowell is listed as living in the Chicago with five of her six children. This record indicates that Lewis Morris, Morris Lewis, and Marshall Tyson are employed (broker, clerk, and clerk, respectively); the two girls are listed as "at home."

16. *Catalogue of the Inter-State Industrial Exposition,* 1879, 1880–90, n. p. The fair was located on the present site of the Art Institute of Chicago.

17. Leach, "The Tyson Family"; Leach, "The Marshall Family"; Jordan, *Colonial Families,* 1: 50ff; Perot Family Papers, HSP; Quaker Collection, Perot Papers, ms. 1147; Martha Ellicott Tyson, *A Brief Account of the Settlement of Ellicott Mills* (Baltimore: J. Murphy, 1871).

18. L. Brockett, M.D., and Mary C. Vaughan, *Woman's Work in the Civil War: A Record of Heroism, Patriotism and Patience* (Philadelphia: Ziegler, McCurdy, 1867), 710–12; *Report to the East Tennessee Relief Association* (Knoxville: Printed for the Association, 1865), 11.

19. For Anna Hallowell, see Gertrude B. Biddle and Sarah D. Lowrie, eds., *Notable Women of Pennsylvania* (Philadelphia: University of Pennsylvania Press, 1942), 175–76; *Who Was Who in America,* 4: 397; Hallowell, *Record,* 53–54; and James, *Notable*

American Women, 3: 122–23. Hallowell's father, Morris L. Hallowell, was also known as a major supporter of the abolitionist cause, as were his two sons, Richard Price (1835–1904), who, in 1859, married Anna Coffin Davis, granddaughter of James and Lucretia Mott, and Edward Needles (1837–1871).

20. Sarah Catherine Fraley Hallowell was the second wife (m. 1855) of Joshua Longstreth Hallowell (1819–1873), who, like his brother Morris Longstreth Hallowell, was a noted abolitionist, as well as a cousin and business colleague of Caleb Hallowell. She was the daughter of Frederick Fraley, a Philadelphia banker and president of the Western Savings Fund. For her activities, see Biddle and Lowrie, *Notable Women of Pennsylvania,* 181–83; Robert C. Post, ed., *1876: A Centennial Exhibition* (Washington, D.C.: National Museum of History and Technology, 1976), 171; J. Thomas Scharf and Thompson Westcott, *History of Philadelphia,* 3 vols. (Philadelphia: L.H. Everts, 1884), 2: 1701; James, *Notable American Women,* 3: 122; *Who Was Who in America,* 4: 397; and Hallowell, *Record,* 42–43.

21. See Elizabeth Brown and Susan M. Stuart, eds., *Witness for Change: Quaker Women over Three Centuries* (New Brunswick, N.J.: Rutgers University Press, 1989); Carol and John Stoneburner, *The Influence of Quaker Women on American History* (Lewiston, Me.: E. Mellen Press, 1986); Jean Fagan Yellin, *Women & Sisters: The Antislavery Feminists in American Culture* (New Haven, Conn.: Yale University Press, 1989); Jean Fagan Yellin and John C. Van Horne, *The Abolitionist Sisterhood: Women's Political Culture in Antebellum America* (Ithaca, N.Y.: Cornell University Press, 1994); Margaret H. Bacon, *Mothers of Feminism: The Story of Quaker Women in America* (San Francisco: Harper and Row, 1986); Philip S. Benjamin, *Philadelphia Quakers in the Industrial Age, 1865–1920* (Philadelphia: Temple University Press, 1976), 148–69.

22. Thomas D. Hamm, "The Hicksite Quaker World, 1875–1900," *Quaker History* 89, no. 2 (Fall 2000): 17–41, points out the increasingly liberal attitude of Hicksites toward suffrage, women's professionalism, and art in the last decades of the nineteenth century.

23. Beverly Gordon, *Bazaars and Fair Ladies: The History of the American Fundraising Fair* (Knoxville: University of Tennessee Press, 1998).

24. Scharf and Wescott, *History of Philadelphia,* 2: 1699–1700; Thomas W. Humes, *Report to the East Tennessee Relief Association at Knoxville* (Knoxville, Tenn.: Brownlaw, Hawes, 1865), 11, mentions Mary Hallowell's involvement in the Philadelphia Sanitary Fair, but he does not describe the role she played in it.

25. The worldwide import of the fair cannot be underestimated. It was a magnet for both national and international visitors. For example, it impelled John Singer Sargent (1856–1925), who was born in Florence to American parents from Philadelphia, to make his first visit to the United States.

26. Virginia Grant Darney, "Women and World's Fairs: American International Expositions, 1876–1904," Ph.D. dissertation, Emory University, 1982, 12–64; Judith Paine, "The Woman's Pavilion of 1876," *Feminist Art Journal* 4, 4 (Winter 1975–76): 5–12. Given the active role her cousin Sarah Catherine Fraley Hallowell played at the fair, it is possible that Sara Hallowell served as a volunteer on one of the women's committees, but there is no proof of her participation.

27. In fact, there are no known records documenting Hallowell's early educa-

tion. An unidentified newspaper clipping in the scrapbook of a descendant indicates that she studied at the Pennsylvania Academy of Fine Arts, but the academy has no record of her attendance. However, not all their early records are complete. This article also indicates that her father was among its early founders and there is no proof of this either.

28. Katharine Martinez, "A Portrait of the Sartain Family and Their Home," in *Philadelphia's Cultural Landscape: The Sartain Family Legacy*," ed. Katharine Martinez and Page Talbott (Philadelphia: Temple University Press, 2000), 5.

29. In June 2001, the National Portrait Gallery acquired the portrait of Elisha Tyson by Robert Street. A copy of this portrait, which originally hung in an African American meeting hall in Philadelphia, is in the Maryland Historical Society (Nancy Davis to Carolyn Carr, April 5, 2001). Hallowell mentions a miniature of her grandfather, Elisha Tyson, Jr., in a letter to T. Morris Hallowell, October 19, 1921, Perot Papers, HSP. The portrait of Caleb Hallowell descended in the family of Marshall Tyson Hallowell.

30. Edward Biddle and Mantle Fielding, *The Life and Works of Thomas Sully, 1783–1872* (1921; reprint New York: Da Capo Press, 1970), 236, no. 1283. The Sully portrait is currently in the possession of a descendant. For the participation of Thomas Morris in the founding of the Association of Artists in America in December 1794, see Lillian B. Miller, ed., *The Selected Papers of Charles Willson Peale and His Family* (New Haven, Conn.: Yale University Press, 1983), 2, pt. 2: 103.

31. Both the Maryland Historical Society (MHS) and the HSP possess silhouette books with cuttings of the Marshall/Tyson/Hallowell family. See Verplanck, "Facing Philadelphia," 289–92. Verplanck speculates that the silhouettes in the Philadelphia collection were assembled by Patience Marshall Tyson and descended in the Perot family through Patience's sister Mary Ann Marshall, who left money in her will to her Perot and Hallowell relatives. The Tyson-Ellicott album descended through the family of Lucy Fitzhugh (Martha Ellicott Tyson's daughter).

32. Leanna Lee-Whitman, "Silks and Simplicity: A Study of Quaker Dress as Depicted in Portraits, 1718–1885," Ph.D. dissertation, University of Pennsylvania, 1987, provides an overview of Quaker taste in portraiture.

33. Martinez, "Sartain Family," 12–13; Augustine J. H. Duganne, *Art's True Mission in America* (New York: George J. Appleton, 1853).

34. Compare, for example, Mary Cassatt (1844–1926), *Tea (Five o'clock Tea)*, 1879/80 (Museum of Fine Arts, Boston); Julius LeBlanc Stewart (1855–1919), *Five o'clock Tea*, 1884 (sold, Christie's New York, November 30, 1990).

35. John Graver Johnson is among the Quakers who fits this mold of the exceedingly prosperous businessman of Quaker origin. See E. Digby Baltzell, *Puritan Boston and Quaker Philadelphia: Two Protestant Ethics and the Spirit of Class, Authority and Leadership* (New York: Free Press, 1979), 9–12, 214ff. Hallowell's own extended family from an earlier generation also provided models of living well. Christopher Marshall's house on Chestnut Street was not small; the Deshler-Morris house, home of Elliston Perot Morris, was among the more stately homes in its time; Thomas Morris owned both an impressive town home at 1032 Arch Street as well as a substantial country home, Swarthmore, on the Old York Road; and Anthony Morris (1766–1860),

although a somewhat more distant relative, owned the Highlands in Fort Washington, Pennsylvania. Roger W. Moss, *Historic Houses of Philadelphia: A Tour of the Region's Museum Homes* (Philadelphia: University of Pennsylvania Press, 1998), 190, notes that an 1805 advertisement described the property as "a Mansion House . . . not exceeded by any in Pennsylvania."

36. The obituary for T. Morris Perot, *New York Times*, November 16, 1902, sec. 7, col. 8, notes his numerous civic and charitable affiliations, including the fact that he was one of the most prominent of the Committee of One Hundred and that he was actively identified with the Society to Protect Children from Cruelty, the Society for the Prevention of Cruelty to Animals, President of the Mercantile Library, vice-president of the Philadelphia Board of Trade, chairman of the Board of Trustees of the Philadelphia College of Pharmacy, director of the United Security Trust Company, and president of the Woman's Medical College.

37. *Catalogue of the Inter-State Industrial Exposition, 1879–1890.*

38. *Catalogue of the Inter-State Industrial Exposition, 1879.* Palmer also served on the Executive Committee in 1880 and 1881 as well as in 1873, as the exhibition was being launched.

39. For published sources regarding the relationship between Hallowell and Mrs. Palmer, see Carolyn K. Carr and Sally Webster, "Mary Cassatt and Mary Fairchild MacMonnies: The Search for Their 1893 Murals," *American Art* 8, 1 (Winter 1994): 53–69; Carr, "Prejudice and Pride," 65–69; Jeanne Madeleine Weimann, *The Fair Women* (Chicago: Chicago Academy, 1981), 191–214; Erica E. Hirshler, "Helping 'Fine Things Across the Atlantic,' " in *Mary Cassatt: Modern Woman*, ed. Judith Barter (Chicago: Art Institute of Chicago, 1998), 200 ff, and Judith Barter, "Mary Cassatt: Themes, Sources, and the Modern Woman," in *Mary Cassatt*, 87–93.

40. Barter, "Mary Cassatt," 87–88. Hallowell's advice, together with that given by Mary Cassatt, accounts to a large extent for the outstanding collection of paintings by French impressionists that Mrs. Palmer bequeathed to the Art Institute of Chicago.

41. Sara Tyson Hallowell to T. Morris Perot, Jr., November 12, 1921, Perot Family Papers, HSP.

42. Sara Tyson Hallowell to T. Morris Perot, Jr., June 25, 1913, Perot Family Papers, HSP. On occasion, but not consistently, Hallowell dated her letters in the Quaker fashion using the number rather than the name of the month.

43. *Catalogue of the Inter-State Industrial Exposition, 1879.*

44. *Catalogue of the Inter-State Industrial Exposition, 1879–1890* (excluding 1886).

45. *Catalogue of the Inter-State Industrial Exposition, 1887.*

46. *Catalogue of the Inter-State Industrial Exposition, 1879–1890* (excluding 1886). Frank Benson, Robert Blum, William Dannat, Charles H. Davis, Walter Gay, Sanford and R. Swain Gifford, John McLure Hamilton, George Hitchcock, Robert Koehler, John La Farge, Will Low, Mary Fairchild MacMonnies, Gari Melchers, Edward and Thomas Moran, H. Siddons Mowbray, Charles Sprague Pearce, Walter Shirlaw, Julius Stewart, Julian Story, Edmund Tarbell, Dwight Tryon, John H. Twachtman, Frederick Vinton, Robert W. Vonnoh, and J. Alden Weir were also among the leading artists of the day whom Hallowell showed.

47. For an overview of Quaker taste, at least in terms of portraiture, see Verplanck, "Facing Philadelphia" and Lee-Whitman, "Silks and Simplicity."

48. H. Barbara Weinberg, *The Lure of Paris: Nineteenth-Century American Painters and Their French Teachers* (New York: Abbeville, 1991), details the significance for American artists of studying and exhibiting in France; Lois Marie Fink, *The Role of France in American Art* (Chicago: University of Chicago Press, 1970); Fink, *American Art at the Nineteenth-Century Paris Salons* (Cambridge: Cambridge University Press, 1990).

49. *Catalogue of the Inter-State Industrial Exposition, 1883*. In addition to *Les Amateurs*, Hallowell's imports of work by Americans who had shown in the Salon included (all exhibited there in 1883, unless otherwise noted): Henry Bacon, *The Open Air Painter*; Ellen K. Baker, *Le Tricot*; Frank M. Boggs, *Fishing Boats Going Out into the Tide—Isigny*; Ralph Wormeley Curtis, *Lilacs from Fontainebleau*; Charles H. Davis, *The End of the Village*; Sarah Paxton Ball Dodson, *Bacidae—Initiation of a Descendant of Bacis in the Mysteries of Augury*; G. Ruger Donoho, *Edge of the Forest* (1882 Salon) and *Primevère*; Clifford Grayson, *A Rainy Day—Point-Aven, Brittany*; Alexander Harrison, *Un Esclave*; Henry Mosler, *Spinning Girl-Brittany Beauty*; Frank Moss, *The Resurrection of the Daughter of Jairus* (1880 Salon); Frank C. Penfold, *Autumn*; and F. D. Williams, *Farms on the English Channel* (1882 Salon).

50. *Catalogue of the Inter-State Industrial Exposition, 1884*. Among the works sent from Paris to Chicago were those by Henry S. Bisbing, *Morning in Holland*; Walter Blackman, *Un Jour Gras* (1883 Salon); Frederick A. Bridgeman, *La Cigale* (1883 Salon); Walter F. Brown, *Fishers of Isigny*; Frank M. Boggs, *Old Houses on the Canal, Dordrecht*; George W. Chambers, *The Dunes*; Sarah B. Dodson, *The Invocation of Moses*; G. Ruger Donoho, *The Shepherd* and *The Outskirts of a Farm, Étaples, France*; Walter Gay, *The Apprentice*; Clifford Grayson, *Ahoy!*; Alexander Harrison, *Créspule*; Birge Harrison, *The Return from the First Communion* (1882 Salon); Frank C. Penfold, *The First Trousers*; and James Roger Rich, *At Grand Manan* (1883 Salon).

51. [Montague Marks], "My Notebook," *Art Amateur* (November 1885): 110.

52. [Marks], "My Notebook," 110.

53. Gabriel Weisberg and Jane R. Becker, eds., *Overcoming All Obstacles: The Women of the Académie Julian* (New Brunswick, N.J.: Rutgers University Press, 1999); Weinberg, *Lure of Paris*, 221–62; Lois Marie Fink, *From Amateur to Professional: American Women and Careers in the Arts* (New York: Gordon and Breach, 1988); Christine Huber, *The Pennsylvania Academy and Its Women, 1850–1920* (Philadelphia: Pennsylvania Academy of the Fine Arts, 1973).

54. *Catalogue of the Industrial Inter-State Exposition, 1880–1890*. Among the other women artists of professional note that she featured in her shows were Maria Brooks, Lucy Scarborough Conant, Margaret Freer, Letitia B. Hart, Ida Haskell, Ellen Holmes, Josephine Jessup, Adah C. Murphy (Mrs. J. Francis), Eleanor Norcross, Mrs. Francis Palmer, Louise Catherine Pearce (Mrs. Charles Sprague Pearce), Helen E. Robey, and Mary Kempton Trotter.

55. Sara Hallowell to Bertha Honoré Palmer, Palmer Papers, CHS, quoted in Weimann, *Fair Women*, 281.

56. Sara Hallowell to Bertha Honoré Palmer, 281.

57. Carr, "Prejudice and Pride," 83. As with their male peers, many of these women would also show at the 1893 Columbian Exposition, where more than 20 percent of the exhibitors were female.

58. Ibid., 206, 218, 275, 286, 327, 341.

59. *Catalogue of the Inter-State Exposition, 1890*; John D. Kysella, "Sara Hallowell Brings 'Modern Art' to the Midwest," *Art Quarterly* 27, 2 (1964): 150–67.

60. See Alice Cooney Frelinghuysen, *Splendid Legacy: The Havemeyer Collection* (New York: Metropolitan Museum of Art, 1993); *John G. Johnson Collection: Catalogue of Paintings* (Philadelphia: Philadelphia Museum of Art, 1941); Barter, *Cassatt*, 87ff, 177ff. These collectors, with the probable exception of Johnson, each had close ties to Mary Cassatt, as did Hallowell. Whether or not Hallowell played a role in the development of Johnson's collection is not known. Although Hallowell borrowed from Johnson for the loan exhibition she organized for the 1893 World's Columbian, Johnson's papers at the Philadelphia Museum of Art contain no correspondence between the two (K. Luber to Carolyn K. Carr, September 26, 2001). Charles Tyson Yerkes (1837–1905), the prototypical Gilded Age speculator, was also a major collector with Quaker roots with whom Hallowell had professional contact. But his tastes in contemporary art were more conservative. See *Catalogue of Paintings and Sculpture in the Collection of Charles T. Yerkes* (Boston, A.W. Elson, 1904).

61. Carr, "Prejudice and Pride," 65–66, 115 n.10.

62. Carr, "Prejudice and Pride," 66, 115 n.12.

63. Carr, "Prejudice and Pride," 65, 115 n. 9. In 1995 Adelman Gallery, New York, owned the original petition.

64. Carr, "Prejudice and Pride," 66, 115 nn. 15–17. This correspondence can be found mostly in the Palmer Papers (CHS).

65. Carr, "Prejudice and Pride," 66, 115 n. 10.

66. Carr, "Prejudice and Pride," 69–71.

67. To give a sense of the significance of Hallowell's $3,000 salary, it should be noted that her brother Lewis Morris Hallowell received a military pension of $12 a month in 1892. See A. Morris Tyson to United States Pension Agent, July 10, 1909, in Lewis Morris Hallowell, National Archives, Record Group 15, Records of the Veterans Administration, Pension no. 279092.

68. Moses Handy, ed., *Official Directory of the World's Columbian Exposition, May First to October Thirtieth, 1893*, sec. ten (Chicago: W. B. Conkey, 1893), 61–63.

69. Hirshler, "Helping 'Fine Things Across the Atlantic,' " 210 n.11, provides a partial bibliography related to the Palmer collection.

70. "Modern Phases of Art: Impressionism Reigns Supreme," *Chicago Herald*, May 28, 1893.

71. "The Fine Arts: A Boston Artist's Comments on the Art Galleries at the World's Fair," *Boston Daily Evening Transcript*, May 26, 1893, 5, col. 1.

72. Hallowell to Bertha Honoré Palmer, February 8, 1894, Palmer Papers, Art Institute of Chicago.

73. The correspondence of William M. R. French in the Archives of the Art Institute of Chicago partially documents Hallowell's work for the museum between 1894 and 1914.

74. Harriet Hallowell was the daughter of Morris Lewis and Harriet Hawley Hallowell. It is not clear when she first came to live with Sara and her mother, but by the mid-1890s, she was exhibiting in France and presumably in close if not constant contact with her aunt and grandmother. She presumably summered with them in Moret-sur-Loing as she listed this as her address when she submitted her entry to the 1901 annual exhibition at the Art Institute of Chicago. See Peter H. Falk, ed., *The Annual Exhibition Record of the Art Institute of Chicago, 1888–1950* (Madison, Conn.: Sound View Press, 1990), 402.

75. Sara T. Hallowell to T. Morris Perot, Jr., 1915–1918, Perot Papers, HSP; Sara T. Hallowell to A. Morris Tyson, Tyson Papers, MHS. A. Morris Tyson, who lived in Baltimore, was the son of Marshall Tyson, Mary Morris Hallowell's brother.

Chapter 11. What's Real? Quaker Material Culture and Eighteenth-Century Historic Site Interpretation

Thanks go to Stenton staff members Stephen Hague (executive director) and Laura Stutman (curator) and to National Society of The Colonial Dames of America in The Commonwealth of Pennsylvania member Margaret Richardson (Stenton guide and Collections Committee Chair), the Philadelphia Museum of Art's Martha Crary Halpern (assistant curator for Fairmount Park Houses, Department of Art) and Linda Anderson (Park house guide), and Independence National Historical Park Rangers Tom Degnan, Nan Byrne, Patricia Frederick, and Don Grace for their invaluable assistance with this project.

1. J. P. Brissot de Warville, *New Travels in the United States of America, Performed in 1788* (New York: T. and J. Swords, 1792), 175.

2. Roy Rosenzweig and David Thelen, *The Presence of the Past: Popular Uses of History in American Life* (New York: Columbia University Press, 1998), 106.

3. On Quaker economic success, see Frederick B. Tolles, *Meeting House and Counting House: The Quaker Merchants of Colonial Philadelphia, 1682–1763* (Chapel Hill: University of North Carolina Press, 1948), chaps. 3, 6, and Thomas M. Doerflinger, *A Vigorous Spirit of Enterprise: Merchants and Economic Development in Revolutionary Philadelphia* (Chapel Hill: University of North Carolina Press, 1986), 60–61. On Quaker consumption, see Morrison H. Heckscher, "Philadelphia Furniture, 1760–90," in *The American Craftsman and the European Tradition, 1620–1820*, ed. Francis J. Puig and Michael Conforti, Minneapolis Institute of Arts (Hanover, N.H.: University Press of New England, 1989), 93 and Jack L. Lindsey, "Pondering Balance: The Decorative Arts of the Delaware Valley, 1680–1756," in Lindsey, *Worldly Goods: The Arts of Early Pennsylvania, 1680–1758* (Philadelphia: Philadelphia Museum of Art, 1999), 69–78.

4. Abbé Flamarens in *Mémoires secrets*, February 4, 1777, quoted in Alfred Owen Aldridge, *Franklin and His French Contemporaries* (New York: New York University Press, 1957), 61.

5. Quoted in June Sprigg, *Shaker Design*, Whitney Museum of American Art (New York: W.W. Norton, 1986), 21.

6. Frederick B. Tolles, " 'Of the Best Sort But Plain': The Quaker Esthetic," *American Quarterly* 11 (Winter 1959): 499. The 1704 *Discipline* is quoted in Mark Reinberger and Elizabeth McLean, "Isaac Norris's Fairhill: Architecture, Landscape, and Quaker Ideals in a Philadelphia Colonial Country Seat," *Winterthur Portfolio* 32 (Winter 1997): 269; on contemporary context, see 270. On "inherent ambiguity," see Susan Laura Garfinkel, "Discipline, Discourse and Deviation: The Material Life of Philadelphia Quakers, 1762–1781," M.A. thesis, University of Delaware, 1986, 62.

7. Garfinkel, "Discipline, Discourse and Deviation," 38–39; Patricia J. Keller, *"Of the Best Sort But Plain": Quaker Quilts from the Delaware Valley, 1760–1890* (Chadds Ford, Pa.: Brandywine River Museum, 1996), 25 n. 3; on the "situational" nature of plainness, see 17.

8. Raymond V. Shepherd, Jr., "James Logan's Stenton: Grand Simplicity in Quaker Philadelphia," M.A. thesis, University of Delaware, 1968, chaps. 1–3.

9. Lita H. Solis-Cohen, "Cedar Grove," *Magazine Antiques* 82 (November 1962): 511–14; Jack L. Lindsey, "Cedar Grove: A Quaker Farmhouse near Philadelphia," *Magazine Antiques* 146 (December 1994): 777–85.

10. *Historic Building Survey on Dilworth-Todd-Moylan House in Independence National Historical Park* (Philadelphia: National Park Service, 1958), chap. 2.

11. James Logan, Preface to *The Charge Delivered from the Bench to the Grand Jury . . .* (Philadelphia: Andrew Bradford, 1723), quoted in Lindsey, "Pondering Balance," 75.

12. Dianne C. Johnson, "Living in the Light: Quakerism and Colonial Portraiture," M.A. thesis, University of Delaware, 1991, 2; Anne Ayer Verplanck, "The Silhouette as Emblem of Quaker Identity," paper presented to the 1993 American Studies Association Conference in Boston, Massachusetts, 2; Verplanck, "Facing Philadelphia: The Social Function of Silhouettes, Miniatures, and Daguerreotypes, 1760–1860," Ph.D. dissertation, College of William and Mary, 1996, chap. 2. For an interpretation that calls the surviving body of Quaker portraits "sizeable," see Leanna Lee-Whitman, "Silks and Simplicity: A Study of Quaker Dress as Depicted in Portraits, 1718–1855," Ph.D. dissertation, University of Pennsylvania, 1987, 150.

Some scholars have been perhaps overzealous in their interpretation of a letter from James Logan to his brother (in which he describes the negative response given by his wife and daughters to the prospect of their sitting for a portraitist) as having a religious bias. Logan wrote, "nothing on earth could prevail with my spouse to sitt at all, or to have hers taken by any man and our girles believing the Originals have but little from nature to recommend them would scarce be willing to have that little (if any) ill treated by the Pencil the Graces never favour'd." This seems to be about insecurity, rather than piety, on the Logan women's part. James Logan to Dr. William Logan, May 31, 1733, Logan Papers, Logan Letter Books, vol. 4, p. 331 (HSP), as quoted in Richard Saunders, "The Development of Painting in Early Pennsylvania" in Lindsey, *Worldly Goods,* 56. For the Todds' use of prints, see above. For Cedar Grove's "two Pictures," see Will and Inventory of Isaac Wistar Morris, 1831, #98, Register of Wills, Philadelphia. For the flower prints at Stenton, see Shepherd, "James Logan's Stenton," 46.

13. "A Sample Tour of the Main House at Stenton," 5, typescript at Stenton; "A Self-Guided Tour of Cedar Grove," unpaginated typescript at Cedar Grove; *Furnishing Plan for the Todd House, Independence National Historical Park* (Philadelphia: National Park Service, ca. 1960), part D, sec. 4, p. 5. I am indebted to Sandra Mackenzie Lloyd and Dr. Doris Devine Fanelli for suggesting the nostalgia characterization.

14. Lindsey, "Cedar Grove," 781. Thanks to Dr. Doris Devine Fanelli for pointing out the general appropriateness of thrift in the eighteenth century.

15. Timothy H. Breen, "An Empire of Goods: The Anglicization of Colonial America, 1690–1776," *Journal of British Studies* 25 (1986): 467. On gentility, see Richard L. Bushman, *The Refinement of America: Persons, Houses, Cities* (New York: Knopf, 1992), 182. On balancing faith with profit, see Marcia Pointon, "Quakerism and Visual Culture, 1650–1800," *Art History* 20 (September 1997): 423.

A Glossary of Quaker Terms

Note: Philadelphia Yearly Meeting is referred to as PYM.

Acknowledgment: A formal, written statement of apology by an offending member to the meeting for having acted in a manner contrary to the rules of discipline.

Birthright member: A person whose parents are both members of the Society of Friends, thus making the person a Friend from birth.

Certificate of removal: See Removal.

Clearness: An understanding of a decision or direction for action, following a period of deep spiritual thought or discussion. Within a meeting, a Clearness Committee may be appointed to assist an individual in reaching such an understanding.

Continuing revelation: The belief that Eternal Truths are revealed gradually and continuously, and that while Truth does not change, human capacity to absorb and comprehend it can increase with spiritual growth.

Convinced Friend: A person who is not a birthright Friend who joins the Society.

Convincement: The Quaker equivalent of what many other Protestants call a "conversion experience." It may be instantaneous, but in most cases it is presumed to be a gradual "growing into goodness."

Discipline: A book compiling guidelines for Friends behavior in matters of religious behavior and government such as establishment and management of meetings; qualification, description, and transfer of membership; duties of ministers; attitudes toward marriage, family life, death, and bereavement; inspirational readings; and "Queries" (challenging questions to encourage

self-reflection.) Among unprogrammed Friends, these guidebooks are often called *Faith and Practice* or *Christian Faith and Practice*. These theological and behavioral guide books have been published since the mid-eighteenth century and are revised about every generation.

Disownment: The involuntary termination of membership in a meeting, when a member of a meeting behaves in a way that the meeting deems contrary to established discipline, e.g., marrying a non-Friend, public drunkenness, excessive debt. Reasons for disownment have changed over time, often reflecting contemporary societal mores. A disowned member of a meeting might, in some cases, continue to attend meeting, but would have reduced influence in meeting decisions. Today, very few people are disowned.

Elders: A small group of men and women appointed to assist and oversee the ministers. In modern unprogrammed meetings, this function is usually assumed by a committee of Overseers. When this group meets with an individual for disciplining, it is said to be "eldering."

Free Quakers: In 1781 some Quaker supporters of the Revolution, following their disownment, established an independent body called the Free Quakers. One of them, Samuel Wetherill (1786–1816), a Quaker minister, insisted that an individual Quaker could interpret truth in his own way and thus reject the peace testimony. The Free Quakers ceased to exist in 1836, partly because they could not define a common religious belief. Their meetinghouse, built in 1783 at the corner of Fifth and Arch Streets in Philadelphia, still stands.

Gurneyite Friends: A branch of the Orthodox Friends. Following the Separation of 1827–28 in PYM, the Orthodox Friends embraced many of the organizational strategies of other Protestant churches (e.g., Sunday Schools and Bible Societies) on the theory that maintaining the strength of Christianity took precedence over maintaining unique Friends practice of faith. One branch of these Orthodox Friends followed the leadership of Joseph John Gurney (1788–1847), emphasizing the importance of the Bible over the Inward Light, and the sacredness of Jesus Christ. In some locales—primarily west of the Appalachian Mountains—Gurneyite Friends adopted worship formats that resembled other Protestant services, with paid, professional ministers, and stylized prayers, sermons, communion, water baptism, and singing. Gurneyite Friends have been especially active in missionary work, and have been known to ally their religious and social service programs with non-Friends. With the 1940s reconciliation of branches of PYM, the "Gurneyite" designation has become increasingly irrelevant. See Wilburite Friends.

Half-yearly meeting: A meeting held twice a year, composed of monthly meetings within a coherent geographical or ideological grouping, with the responsibilities of a quarterly meeting. These meetings are under the umbrella of a yearly meeting.

Hicksite Friends: The Friends called Hicksite resulting from the Separation of 1827–28 placed special emphasis on the Inward Light, a divine spark within each person. They objected to creedal tests and to the authority of ministers and elders. Originally inspired by New York minister Elias Hicks (1748–1830), these Friends became increasingly liberal in theology, social practices and church organization over the decades, often openly questioning the divinity of Christ.

Independent meeting: A worship group with no formal tie to any established meeting.

Indulged meeting: Fledgling meeting, lacking the structure of a monthly meeting, under the care and oversight of a nearby monthly meeting. Similar to a Particular meeting.

Inward/Inner Light: Used interchangeably here, the term generally preferred among Friends is "Inward Light," referring to the illumination that guides one in exploring the Divine depths of one's self.

Joint meeting: Beginning at the end of the nineteenth century, men and women ceased to hold separate business meetings, meeting instead in joint session.

Keithian Quakers: George Keith (1638–1716), a prominent Quaker leader and schoolmaster in Philadelphia, was an early opponent of slavery and criticized the close relationship of the leaders of PYM and the provincial authorities in Pennsylvania. He and his followers, sometimes called Christian Quakers, accused Philadelphia Quaker leaders of spiritualizing religion, making anything physical or fleshly nonessential. Keithians considered the bodily resurrection of Jesus to be a crucial aspect of Christian doctrine, while the majority within PYM considered the resurrection to be purely spiritual. Keithian Quakers ceased to meet early in the eighteenth century.

Laid down: Denotes the official termination of a meeting, committee, or other endeavor, after which the meeting's records usually are deposited with some other Friends entity.

Leading: An individual's irrepressible conviction to pursue a course of action. Similar to what many Protestant religions refer to as a "calling," it may

take a very secular direction, such as going out to plant trees or to teach school. A leading is often tested in a clearness committee.

Marriage certificate: A document containing the marriage vows, signed by the couple and by all in attendance. Marriage occurs during the meeting for worship after approval is obtained from the meetings of which the two people are members. Approval is based on a statement of good character and clearness from any other engagements. The clerk usually records a copy of the marriage certificate in the meeting's records.

Meeting for sufferings: Committees to assess and alleviate persecution of Friends. Modeled on similar committees established to investigate prison suffering among seventeenth-century English Friends, PYM established such committees in 1756 to raise and administer relief to Friends who suffered distress as a result of Indian conflicts or governmental persecution. Later, similar committees were appointed by quarterly and monthly meetings to assist Friends who encountered hardships due to their opposition to war and slavery. The Meeting for Sufferings in behalf of the Yearly Meeting between sessions later developed into Representative Meeting of the Yearly Meeting.

Meeting for worship: Meetings for worship within PYM have always been organized on the principle of silent waiting, where each person may pray, meditate, or listen to the Light of God within himself or herself and within the group. Vocal ministry arises when a member feels inwardly led to offer a specific message, prayer, or song. In semi-programmed meetings, more planning, structure, and/or pre-designed speaking may occur.

Membership register: Volume in which the monthly meeting records its members, often including information about births, deaths, marriages, and removals. Such composite registers were unusual prior to the 1827–28 Separation but became common thereafter.

Memorial: On the death of a minister or other important member, the monthly meeting might prepare a brief biography testifying to the decedent's spiritual contributions. The memorial might read at the monthly meeting and/or forwarded to the quarterly and/or yearly meeting and/or printed in a Friends periodical. This practice is unusual today.

Men's meeting: Monthly, quarterly, and yearly meetings for business were held by men and women in separate sessions until the late 1800s and early 1900s when men and women gradually began to meet in joint session.

Minister: Historically, men and women who were recognized as being un-

usually inspired by the Spirit of God and provided most of the vocal messages in meeting for worship. Ministers were formally designated or "recorded" by the monthly meeting, and regular meetings of ministers and elders, called Preparative Meetings of Ministers and Elders or Select Meeting were held to consider the spiritual life of the meeting. The practice of recording ministers has for the most part been discontinued in PYM.

Ministry and Counsel Committee: Committee which has special responsibility to guide the spiritual welfare of the meeting, particularly the meeting for worship. Ministry and Counsel committees were established in 1918 by Hicksite meetings, which no longer designated members as ministers or elders. The predecessor of Ministry and Counsel was the Preparative Meeting of Ministers and Elders.

Minutes: Official records of proceedings kept for all Quaker business meetings (preparative, monthly, quarterly, and yearly meetings), along with their committees.

Monthly meeting: The basic unit of Quaker administration, which holds regular monthly business meetings. In earlier times only Quakers could participate. Today, many meetings include both members and regular "attendees" in the meeting decision-making. The monthly meeting has responsibility for care of members, authorizing removals and marriages, maintaining discipline, considering the queries, managing meeting property, fostering social concerns, and reporting regularly to the quarterly meeting and yearly meeting. Business meetings are also to be held in a spirit of worship, and so are in effect meetings for worship for conducting business.

Nicholites: Religious movement with many similarities to Quakers which formed under the leadership of Joseph Nichols (ca. 1730–70), a farmer from Delaware. Nichols underwent a spiritual transformation which caused him to preach and gather followers in Delaware and the eastern shore of Maryland in the 1760s. Nicholites called themselves "Friends," held meetings for worship in silence, valued plainness and simplicity, rejected oaths, opposed priests, freed their slaves, were pacifists, and conducted religious business in the Quaker manner. Most Nicholites became Quakers around 1800.

Opening: A spiritual insight or revelation.

Orthodox Friends: Members of a branch of Quakers resulting from the Separation of 1827. They stressed the divinity of Jesus Christ and the importance of the Bible as the authoritative source of religious truth. Through the

decades following 1827, Orthodox Friends suffered further divisions characterized by doctrinal and regional differences. See Conservative Friends, Gurneyites, Primitive Friends, and Wilburites.

Overseer: A member of a committee of meeting members assigned special responsibility for the welfare and discipline of members of the monthly meeting.

Particular meeting: A formally established meeting for worship under the care of a monthly meeting.

Plain speech and plain dress: Traditions developed by Friends to set themselves apart from what they perceived as the corruption of the "world's people," plain speech was designed to remove class distinctions between people and to remove pagan descriptions from days of the week and months of the year. Likewise, class distinctions in clothing and fashion fads were eschewed by early Friends. In modern times, some families continue to use these markers of Friends uniqueness, especially among themselves. In general, however, these traditions have passed away.

Preparative meeting: A regularly organized business meeting of a single worship group—usually too small or too remote to constitute a full monthly meeting—which prepared business to be presented to the monthly meeting. The scope of business as recorded in its minutes was normally limited to responses to queries and matters of property and school oversight. Most preparative meetings within PYM have become monthly meetings or have been discontinued.

Primitive Friends: Small group of Wilburites, sometimes called Conservative Friends, which separated from PYM (Orthodox) in 1860 to form the General Meeting of Men and Women Friends for Pennsylvania, New Jersey, and Delaware. This General Meeting of Primitive Friends was based in Fallsington, Bucks County, Pennsylvania, and continued to meet until 1949, when it merged into Falls Monthly Meeting (United) of PYM. Primitive Friends wanted to restore what they considered the primitive simplicity and purity of the Christian Church as expressed through the writings of early Quakers. They considered PYM (Orthodox) to be too closely identified with the views of English Quaker minister Joseph John Gurney and complained about neglect of the testimonies of plainness, pacifism, and rejection of oaths.

Progressive Friends: A reform movement developed among Hicksite Friends, which drew in many non-Quaker liberals and radicals. It became formally organized as the Pennsylvania Yearly Meeting of Progressive Friends,

which met at Longwood in Chester County, Pennsylvania, from 1853 to 1940. Progressive Friends advocated a religion of humanity that stressed the inherent goodness and perfectibility of humankind and promoted such reform causes as abolition of slavery, temperance, women's rights, opposition to capital punishment, prison reform, homestead legislation, pacifism, Indian rights, economic regulation, and practical and coeducational schooling.

Quarterly meeting: Meeting for business held four times per year, attended by representatives of all monthly meetings in a region. An intermediary between the monthly and yearly meeting, Quarterly Meetings serve as an appellate body for disciplinary matters, and consider problems too large for a local meeting to solve. A quarterly meeting holds the authority to establish or discontinue a monthly, preparative, or particular meeting for worship. It collects financial assessments from each monthly meeting in accordance with the quota established by PYM.

Queries: A formal set of questions, first adopted by PYM in 1743 and revised periodically since then, which were to be reflected upon and/or answered in writing by preparative, monthly, and quarterly meetings. The queries concern conduct of individuals and practices of the meetings and provide one means of pursuing unity. From time to time, queries are read in monthly meetings, and discussed, or left for members to ponder.

Representative meeting or committee: Appointed by PYM and given administrative and executive authority to act for the Yearly Meeting between its annual sessions, representative meeting replaced the Meeting for Sufferings (1756–1827), and has been reorganized and renamed several times since.

Removal: A member's transfer from one meeting to a new meeting is accomplished by a certificate of removal, a document prepared by the old meeting testifying to the member's good standing.

Separation of 1827: As a result of a social/economic/theological disagreement among Quakers in 1827–28 in Philadelphia, two Philadelphia Yearly Meetings were formed, which were called informally Hicksite or "Race Street" and Orthodox or "Arch Street." In the subsequent splintering, Arch Street became the Wilburite Meeting and Twelfth Street Meeting became the home of the Gurneyites. Although Philadelphia was a major locus of the split, Friends throughout the United States chose different branches. By the middle of the twentieth century, these distinctions lost their clarity and importance.

Testimonies: Traditionally, Quakers developed a series of deeply held principles, often called testimonies, which prescribed a commitment to truthful-

ness, simplicity, equality, and peace. Testimonies include rejection of oaths, use of "thee" and "thou" in speech, plain dress, refusal to take off hats to social superiors, equality of men and women, opposition to slavery, and refusal to bear arms. Testimonies also can refer to official documents, frequently disownments and memorials, prepared by Quaker business meetings as part of what they considered witnessing to Truth.

Traveling certificate or minute: A document issued by a meeting to a member in good standing (normally a recorded minister), allowing him or her to travel to other meetings to visit or preach.

"Treat with": To "talk with" with the intent to chide. A monthly meeting committee may visit a member to persuade him/her to change some behavior deemed inappropriate. This committee's assignment may also be referred to as "eldering."

United meeting: A monthly meeting affiliated with both PYM (Hicksite) and PYM (Orthodox). This term was not used after 1955 when the two Philadelphia Yearly Meetings formally reunited.

Wilburite Friends: Evolving out of the Orthodox Quakers, Wilburite Friends identified with prominent Rhode Island Quaker minister John Wilbur (1774–1856), who took issue with the position of English Quaker minister Joseph John Gurney (1788–1847). Beginning in the 1840s, Wilburites emphasized the plain life and distinctive dress, separation from the outside world in both religious and secular organizations, strict enforcement of the discipline, guidance by the Inward Light, and, in addition to an emphasis on Biblical scripture, they advocated close adherence to writings of early Quakers. A major schism developed among Orthodox Quakers in the Midwest, where some Gurneyites advocated religious rituals such as baptism. But PYM (Orthodox) maintained a fragile unity, despite tensions between a Wilburite majority and a Gurneyite minority.

Women's meeting: Separate business meetings for women alongside the men's meetings were held by preparative, monthly, quarterly, and yearly meetings. Women appointed representatives, communicated with other women's meetings, granted or received certificates of removal, and approved marriages for women members. The men's meeting rarely overruled the women's meetings on removals, marriages, or questions regarding matters of discipline. Women usually had to work with much smaller funds than men's

meetings. Gradually, beginning late in the nineteenth century, men and women met jointly to conduct business.

Worship and Ministry: Name currently used for the committee responsible for the spiritual life of the meeting for worship and for the religious development of members of the meetings. Formerly the Meeting for Minister and Elders (or Ministry and Counsel committee in Hicksite meetings) had this responsibility.

Yearly meeting: A grouping of monthly and/or quarterly meetings which usually meets for several days once a year. Its role is to provide temporal and ideological connection between the monthly and quarterly meetings within its community and to coordinate the committees and staff which carry out the work of the yearly meeting. It meets annually to conduct business, discuss the discipline, receive reports and concerns from its constituent meetings, review the state of the Society, and communicate with other yearly meetings and non-Quaker organizations. Originally conceived as the sinew of regional groupings, yearly meetings now are more representative of theological communities than of geographical ones.

Contributors

CAROLYN KINDER CARR is deputy director and chief curator of the National Portrait Gallery. Her most recent publications include *A Brush with History: Paintings from the National Portrait Gallery*, coauthored with Ellen Miles, and *Hans Namuth: Portraits*.

MARY ANNE CATON is an independent curator whose work includes the exhibition and catalog *Fooles and Fricassees: Food in Shakespeare's England* for the Folger Shakespeare Library.

KARIE DIETHORN has been chief curator at Independence National Historical Park in Philadelphia since 1994; she coauthored *History of the Portrait Collection, Independence National Historical Park, and Catalog of the Collection*.

J. WILLIAM FROST is Jenkins Professor of Quaker History and Research and director of the Friends Historical Library at Swarthmore College. He is the author of several books on Quaker history.

SUSAN GARFINKEL has taught at several universities in the Washington, D.C., area since receiving her Ph.D. from the University of Pennsylvania in 1997. Her doctoral dissertation is titled "Genres of Worldliness: Meanings of the Meeting House for Philadelphia Friends, 1755–1830."

JOHN M. GROFF, a graduate of the Winterthur Program in Early American Culture, is executive director of Wyck, a house in the Germantown section of Philadelphia that was lived in by nine generations of one Quaker family.

BERNARD L. HERMAN is Edward and Elizabeth Rosenberg Professor of Art History and the director of the Center for American Material Culture Studies at the University of Delaware. He is the author of *The Stolen House* and coauthor of *Everyday Architecture of the Mid-Atlantic*.

DIANNE C. JOHNSON is an independent art historian and Associate Director of Gift Planning at Bryn Mawr College. She is coauthor of *American Silver at the H. F. du Pont Winterthur Museum.*

EMMA JONES LAPSANSKY is Professor of History and Curator of Special Collections at Haverford College. She has published on Quakers and on African American history.

CATHERINE C. LAVOIE is senior historian for the Historic American Buildings Survey of the National Park Service and a coauthor of *Landmarks of Prince George's County.*

PATRICIA C. O'DONNELL has been archivist of the Friends Historical Library of Swarthmore College for sixteen years. She is a graduate of the Winterthur Program in Early American Culture.

ANNE A. VERPLANCK is Curator of Prints and Paintings at Winterthur and an associate professor in the Winterthur/University of Delaware Program in Early American Culture.

CAROLYN J. WEEKLEY is Juli Grainger Director of Museums for the Colonial Williamsburg Foundation.

Index

Numbers in italics refer to illustrations.

"All the Quakers Are Shoulder Shakers (Down in Quaker Town)" (sheet music), plate 2, 11
Abbott, Ruth, 259, *260*
Academy of Natural Sciences, 99, 112–13
acknowledgment, 47, 58–59, 61
Adams, John, 311n2
aesthetics, 43–44, 50–53, 86–89, 150, 188–89, 193, 204–8
Affleck, Thomas, 53; acknowledgment by, 58–59; furniture attributed to, plate 4, 53, *54*, *56, 57*, 59, 77, 83, 86, 139, 312n10, 317n74, 319n83; marriage violations, 53, 58–60, 61–62, 70, style of, 59; testimony against, 58. *See also* furniture
AFSC. *See* American Friends Service Committee
Alcott, Bronson, 117–18
Allen, Irene, 11
Allestree, Richard, 129
Les Amateurs (Harrison), 282
American Friends Service Committee (AFSC), 8
American Philosophical Society, 114, 119, 141
Apology for the True Christian Divinity (Barclay), 21, 23, 65
apparel. *See* dress
Archambault, Margaretta, 245
architecture: plainness, 64–65, 315n41; simplicity, 165, 167, 171–75; Swarthmore College, 35
Armstrong, Robert Plant, 66
Art Institute of Chicago, 272, 285, 357n3, 366n73
Arthur Merwyn (Brown), 9
artists: shown by Hallowell, 281, 282–83, 284,

285; women, plate 21, 135, 146, 280, 282–83, 365n54. *See also* individual artists; portraits
arts: collection at Wyck, 119–20, 327nn98, 99; collectors, 280–85; community in Philadelphia, 277–78; dealers, 281–82; faith and, 298; Impressionist, 283, 285; management, 237–38; 272, 274, 275; patrons, 123–24, 137–39, 141, 279, 281, 284–86, 335nn89, 99; plainness and, 122. *See also* Hallowell, Sara Tyson; Hicks, Edward; portraits
Ashton house, 194, *196*
Association of Artists in America, 279
Augee, Samuel (hatmaker), 258

Bacon, Ellis, *244*
Bacon, Mary Ann Warder, 252, *252*–53
Baker, May Corliss, 267–68
Barclay, Robert, 1–2, 21, 23, 65, 183
Barnard, Hannah, 28
Bartram, James, furniture of, 83, 86
Bauman, Richard, 65–66, 315n48
Benezet, Anthony, 2, 28
Benjamin, Phillip, 180
Benson, Frank, 283
Bernard, Nicholas and Martin Jugiez, 313n25
Book of Discipline. See Rules of Discipline
Bordley, John Beale, 138, 139
Bowers, Mary Sherburne (Mrs. Jerathmael), 135, 146
Bowne, Jane. *See* Haines, Jane Bowne
Bowne, Robert, 97
Breen, Timothy, 123–24
Brinton, Jane Pyle, 262–63, *265*
Brissot de Warville, Jacques-Pierre, 127
Browin, Frances Williams, 242

Brown, Charles Brockden, 9
Bryn Mawr College, 36
business meeting. *See* meeting for business
Butler, David, 184, 187, 342n31
Byatt, A. S., 10

cabinetmakers: price books of, 84–85, 86,
 318n79, 319n87, 320n88. *See also* Affleck,
 Thomas; Bernard, Nicholas and Martin
 Jugiez; Cartaret, Thomas; Clifton, Henry;
 furniture; houses; Randolph, Benjamin;
 Stevens, Stephen Foster
Cadwalader, Hannah Lambert, 124, *125*, 139, 141
Cadwalader, John and Elizabeth, portraits of,
 plate 12, 139, 141, 145
Cadwalader, Thomas, 139, *140*, 145
Callender, Hannah, 132
Canby, Joshua C., 216
Canton, Gustavus, 228
Carlisle, Sarah. *See* Moulder, Sarah Carlisle
Carroll, Charles, 138
Cartaret, Thomas (cabinetmaker), 75, *76, 77*
Cassatt, Alexander, 283
Cassatt, Mary, 281, 285, 364n40
Cazin, Jean-Charles, 283
Cedar Grove, 288, 291–92, *293*, 295–97, 298
Chalkley, Thomas, 128
Chapman, Abraham, 217, 219, 349n8
Chase, William Merritt, 283
Chattin, James and Rebecca, *12*
Chester County Day, 245
Chester County Historical Society (CCHS),
 242, 247, 262–70
chests. *See* furniture, Chippendale; furniture,
 tall case
Chew, Benjamin, furniture of, 83, 319n84
Chew, Mary (Mrs. Samuel), 291
Chicago Inter-State Industrial Exposition, 272,
 275, 277, 280, 283
Chippendale furniture. *See* furniture,
 Chippendale
Churchman house, 205
Civil War, 33–35, 274, 275, 277
Clarke, Thomas B., 284
Clarkson, Thomas, 2, 122–23
class. *See* social hierarchies
Claypoole, James, portraits by, plate 7, plate 8,
 134–35
Clifton, Henry (cabinetmaker), *76, 77*
clothing. *See* dress

Coale, Edward, 31
Collection of Christian and Brotherly Advices,
 62–65, 314n39. See also *Rules of Discipline*
colonial revival movement, 234, 239–42, 246, 271
Comly, John, 216, 220–22, 223
confession of faith. *See* testimonies
Conservative Friends, 12, 34, 36
consumption: public/private, 44–45, 87–89,
 120–21, 132; wealth and, 44, 49, 94, 97, 98–101,
 109–110. *See also* material culture
Cope, Gilbert, photographs by, 258–59, *259*,
 260, 261, 270–71
Copley, John Singleton, portraits by, plate 13,
 135, 142–43, 146
Corbit, Eliza Naudain, quilt by, 154–55, *155*
Cornell, John J. and Eliza, *31*
Cornell, S., *31*
Country Wife (Wycherley), 20
Cox house, 201, *202*
craftsmanship, 100, 151, 167, *168*
Crèvecoeur, Hector St. John de, 138

De Angeli, Marguerite, 10
Degas, Edgar, 283
Deshler, David, furniture of, *56, 57*, 83, 85,
 319n83
The Diary of Elizabeth Drinker, 73
Dickinson, Gaius and Mary, 262
Dickinson, John: portrait of, plate 11; wealth of,
 128, 137–38
Dickinson, Mary (Mrs. John), portrait of, plate
 9, 124, 138
Diligence in Love (Newman), 11
disciplinary actions: for commissioned
 portraiture, 46; for conscience, 47; for dress,
 248–49; disownment, 345n70; furniture
 owners and, 62, 87–89; for housing, 189; for
 marriage, 57–59; the meeting house and, 47,
 71–73; for practice of slavery, 81; Wallis,
 60–61. *See also* meetings, business; *Rules of
 Discipline*; violations
discipline, *Discipline*. See *Rules of Discipline*
discourse: of plainness, 65–67, 69, 74, 88–89; of
 Quakerism, 51–53, 57, 68–70, 72, 74, 75,
 86–87; of speech, 65–69
Donaldson, Mary Ann, 108, 324n54
dress: bonnets and caps, 247–48, 250, 253, 259,
 264–66, *265*, 271; changing meaning of, 246; of
 children, 255–61; color, 247–49, 250–51, 253,
 257, 261, 266, 269, 355n28; construction and

purchase, 247–48, 258, 261, 264–68, 270; discipline and, 46–47, 64–65, 246–50, 261, 269, 307n27, 308n43; drab, 109, 269, 307n27, 356n43; fashion and, 109–10, 138, 247–48, 248–50, 250–51; function of, 22, 249, 261; Hicksite/ Orthodox schism and, 255–56; 266–67; as indicator of character, 109, 247, 255, 261, 289; as indicator of faith, 47–48, 247–50, 261, 270–71, 280; of older women, 46–47, 262, 267–69; of Orthodox Quakers, 255–61, 259, 259, 260, 261, 308n43; plainness and, 253, 255, 271; of Quakers/non-Quakers, 19–20, 126, 129, 134–37, 144–45, 250–53, 259, 267, 268; simplicity and, 267–69, 270–71; theology and, 48, 269, 290, 305nn4, 7; wedding, 262, 263, 356n45; women's, 8–19, 33–35, 46, 47, 64, 249–55, 262–71, 309n47; worldliness and, 246, 308n33. *See also* plainness

Drinker, Elizabeth Sandwith, 28, 73–74
Drinker, Henry, 73
Durand-Ruel Gallery, 281, 283

Edmundson, William, 128
education: elders and, 8; religious, 32, 255–56; restrictions in, 3–4, 36–37, 309n47; of wealthy Quakers, 116–19; of women, 26, 36, 72, 116, 321n4, 322n14. *See also* individual schools and colleges
Eliot, S., 142–43
Ellis, Sarah Stickney, 9–10
Enlightenment, 29–30
The Etcher (Tolman), 283
evangelicalism, 29–34, *31*, 36, 37, 269
expression: expressive codes, 74–75, 87–89; forms of, 69–73; individual versus object in, 43, 88–89; of plainness through speech, 66; Quaker discourse and, 86–87

Fager, Chuck, 11
Fairhill, 138
Fais le Beau (Vonnoh), 283
Faith and Practice, 1, 4, 38. See also *Rules of Discipline*
The Falls of Niagara (Hicks), 217, *218*
Federal Philadelphia (Garvan), 91–92
Fell, Margaret. *See* Fox, Margaret Fell, 2, 18, 19, 24, 128
Fell, Sarah, 19
Female Anti-Slavery Society, 116
Female Association Schools, 116

Ferris, Benjamin, 53
Ferris, David, 50
Fisher, Sarah Logan, furniture of, plate 4, 77–78, 83, 85, 88
Fisher, Sidney George, 130
Fisher, Thomas, furniture of, 77
Frost, J. William, 266
Foulke, William, *31*
Fox, George: dress of, 19; epistle, 305n7; internal discipline, 6–7; Inward Light, 4–5, 122–23, 126–28; on marriage, 199; on vanity, 19, 248; on wealth 127–28; worldliness, 2
Fox, Margaret Fell, 2, 18, 19, 24, 128, 246
Franklin, Benjamin, 49, 122, 132, 137, 289
Franklin Institute, 99, 119
Free Quakers of Philadelphia, 28, 150, *151*
French, William M. R., 285
Friendly Persuasion (West), 11
Friends at Their Own Fireside (Ellis), 9–10
Friends Historical Society, 240, 224
Friends: American, 8–11; Baltimore, 31; British, 1, 2, 19–22, 29–32; Conservative, 13, 34, 36, 305n2; Dutch, 90; English, 24–27, 28, 33, 53; evangelical, 30–34, *31*, 36, 37; German, 90; Gurneyite, 370–71; Holiness, 33; Illinois, 31, 272, 274; Indiana, 30–31; Iowa, 12, 34; Irish, 24, 30; Kansas, 34; Keithian, 371; New England, 34, 36; New York, 97; North Carolina, 28; Ohio, 30–31, 34, 36; Ontario, 31; Primitive, 374; quietist, 30–31, 36–37, 182–83, 187; Rhode Island, 305n2; Vermont, 13, Wilburite, 34, 36, 238, 243, 305n2, 376. *See also* Conservative Friends; Free Quakers of Philadelphia; Hicksite Friends; Orthodox Friends; Progressive Friends; Quakers
Fruits of Solitude (Penn), 21–23
Fry, Elizabeth Gurney, 47–48, 246
furniture: discourse of Quakerism and, 70, 74; disownment for, 63–65, 88; as ornament versus utility, 45, 249; ownership, 73–87, 88; plainness and, 51, 59–66, 87; worldliness and, 51–53, 61–62, 63–65, 88–89. See also cabinet-makers; houses; museums; historic house
furniture, Chippendale: discipline and, 87–89; ornamental elements, 74, 75, 77–78, 81–86, 319n86; Philadelphia-style, 52, 75–89, 311n5, 318n79; plainness and, 51, 59–66, 87; Quaker-associated versus non-Quaker, 73, 74, 86–87, 88; as signifier of meaning, 73, 74, 86–87; use of terms, 311n5. *See also* material culture

furniture, tall case: chest-on-chest, plate 4,
55–57, 77–78, 83–85, 88, 319n83; comparisons
between, 78, 81, 83–87; high chest, plate 3, 53,
54, 75, 76, 77, 79, 78, 80, 81–86, 88;
ornamentation, 74, 75, 77–78, 81–86, 87–89,
319n86; price books of, 84–85, 86, 318n79,
319n87, 320n88; as signifier of meaning, 73,
74, 86–87; theology and, 87. *See also* material
culture

Galloway, Anne. *See* Pemberton, Anne
Galloway
Galloway, Joseph, furniture of, 88
The Game: A Novel (Byatt), 11
gardens. *See* Wyck
Garfinkel, Susan, 126, 290, 329n16
Garrigues, Abraham, 110
Garvan, Beatrice, 91–92
George Washington Crossing the Delaware River
(Hicks), 231–32, 232
Germantown, 90–91, 117, 119, 240–41, 291,
321n5, 325n69
Germantown Academy, 117–18
Germantown Site and Relic Society
(Germantown Historical Society), 241
Girl with a Red Shawl (Benson), 283
Goslin, Thomas, 220
Grimké, Angelina, 11
*Guide Book of Art, Architecture, and Historic
Interests in Pennsylvania* (Archambault), 245
Gullager, Christian, 349n7
Gummere, Amelia Mott, 37–39, 48, 240, 246
Gurney, Joseph John, 5, 370–71

Haines, Ann, 101–2, 108–9, 115, 117–18, 322n14,
323n15
Haines, Caspar Wistar, 91, 107, 321n6
Haines, Caspar II, 241
Haines, Jane Bowne: arts and music, 99,
119–20; dress, 109–10; education, 116–18;
furnishings, 97–101, 98, 116; horticultural
pursuits, 102, 104, 107–8; involvement in
society, 91–92, 97–99; marriage, 91, 96–7;
membership in spiritual community, 91–94,
121; simplicity, 94, 120–21; social awareness,
102, 115–16; social life, 91–92, 96–97, 100–102,
119–20; and Wyck, 44–45, 90, 91, 99, 102–7,
119. *See also* Quakers, wealthy; Wyck
Haines, Jane Reuben, 240–41
Haines, Reuben I, 91, 321n4

Haines, Reuben III, 103, 112; agricultural
pursuits, 94, 102, 108, 110; arts and music, 99,
119–20; business affairs, 102, 110–12; city
living, 96–102; education, 95–96, 116–18, 120;
furnishings, 97–101, 98, 116; genealogy, 91,
320n1; interest in Shakers, 92; involvement in
society, 91–92, 97–99, 114; scientific interests,
94, 102, 110, 112, 112–14; simplicity and, 94,
101, 120–21; social awareness, 102; social life,
91–92, 96–97, 100–103, 119–20; spiritual life,
91–94, 121; and Wyck, 44–45, 90, 91, 99, 119,
102–7, 119. *See also* Quakers, wealthy; Wyck
Haines, Robert, 108
Haines, Robert, III and Mary, 108
Hale, Sarah Joseph, 264–66
Hall, Deborah, portrait by William Williams,
135, 146
Hall, Stuart, 51
Hallowell, Anna Coffin Davis, 275
Hallowell, Caleb, portrait of, plate 20, 274
Hallowell, Harriet, 286
Hallowell, John H., 274
Hallowell, Mary Morris Tyson, 274–75, 276
Hallowell, Morris Longstreth, 275
Hallowell, Sara Tyson, 14, plate 21, 273;
aesthetic preferences, 282–83; Art Institute of
Chicago and, 272, 285, 357n3, 366n73; artistic
training, 276–77, 362n27; artists of, 281,
282–85, 364n46, 365nn49, 50; Bertha Honoré
Palmer, 280–81, 283–85; Chicago Inter-State
Industrial Exposition, 272, 275, 277, 280, 283;
collectors, 280–85, 366n60; dealers, 281–82;
in France, 272–73, 280, 285–86, 357n3;
gender and, 238, 272, 274, 275, 282–84;
Impressionists and, 283, 285; Mary Cassatt,
281, 285, 364n40; patrons, 279, 281, 284,
285–86; personal history, 274–75, 277–80;
philanthropy of, 286; plain dress and, 280;
professional history, 272, 275, 277, 283–86;
Quaker heritage, 237–38, 274, 277, 280, 281,
286, 364n42; social justice and, 280, 282;
social position of, 274, 275, 280; women
artists and, 282–83, 365n54; World's
Columbian Exposition (1893), 272, 281, 283,
284–85, 362nn25, 26. *See also* material
culture; Quakers, wealthy
Hallowell, Sarah Catherine Fraley, 275
Hambleton, Rachel Kester, 267
Hamilton, Dr. Alexander, 141
Hamilton, James, 132

Hancock house, 199, *200*
Harrison, Alexander, 282
Hartshorne, Catherine, 257
Hartshorne, Richard, 92, 257
Havemeyer, Louisine, 283
Haverford College, 4, 36, 243, 309nn47, 48
Heckscher, Morrison, 82–83
Henry Vanhorn Signboard (Hicks), plate 17, 217
Hesselius, Gustavus, portraits by 129, 136, 146
Hicks, Catherine (Kitty), 212
Hicks, Edward, 14, *213*; birth, 212; death, 234; family history, 212–14, 216, 220; finances, 217–21, 349nn8, 12, 350n18; fine painting, 212, 215, 217, 220–24, 229–34; Hicksite Quakers and, 150, 222, 229–30, 233, 349n9; life with the Twinings, plate 16, 214; ministry, 216, 217, 219–20, 229–30; ornamental painting, plate 17, 150, 214–17, 220–24; painterly style, 150, 223, 224–30, 231–34; *Peaceable Kingdom* paintings, plate 18, 225–27, 229–31, 233, 234; plainness and, 151, 219–20, 222, 224–26, 228–29; Quakerism and, 150–51, 214, 216–17, 219–21, 224–26, 228–30, 349n9; on Revolutionary War, 231–32; social station of, 213–14; testimony on, 234, training, 214–16
Hicks, Edward, paintings: *The Falls of Niagara*, 217, *218*; *George Washington Crossing the Delaware River*, 231–32, *232*; *Henry Vanhorn Signboard*, plate 17, 215, 217; *James Cornell's Prize Bull*, 227–28, *228*; *Leedom Farm*, plate 19, 227–28, 232–33; *Peaceable Kingdom* (1826–28), 225–26, *226*; *Peaceable Kingdom* (1832–34) plate 18, 225–26; *Peaceable Kingdom* (1844), 225–26, 227, 230–31; *Peaceable Kingdom of the Branch*, 225, *225*, 229; *Penn's Treaty*, 223, 224, 231; *Residence of David Twining*, plate 16, 232–33
Hicks, Elias, 5, 15, 93, 121, 371
Hicks, Gilbert, 212, 214
Hicks, Isaac, 212, 214, 220, 223
Hicks, Mary Rodman, 212
Hicks, Sarah Worstall, 216
Hicks, Thomas, portrait by, *213*, 223, 350n21
Hicksite Friends, 34–36, 229–30, 233, 349n9, 362n22; art and, 362n22; beliefs of, 30–31; dress of, 253, 255–56; 261, *261*, 266–67, 269, 270, 308n43; Edward Hicks and, 150, 222, 229–31, 233, 243, 349n9; plainness and, 34–36, 238

Hicksite/Orthodox schism, 30–31, 35–36, 150, 229–31, 243, 255–56, 266–67
high chest. *See* furniture, Chippendale; furniture, tall case
historic house museums. *See* museums, historic house
Historical Society of Pennsylvania (HSP), 239–40
Hodgson, Elizabeth Richardson, dress of, 253, *254*
Hollingsworth, Hannah Paschall: furniture of, 53, *54*, 77–78, 83; marriage violation, 77
Hollingsworth, Levi, furniture of, 53, *54*, 77–78, 83
Hooper, Abby, 253, 271
Hoover, Herbert, 8
house museums. *See* museums, historic house
houses: aesthetics and, 151, 188–89, 193, 201, 204–8, 211; architectural vocabulary of, 189; date/initials on, 189, *191*, *194*, 198, 199–201, *202*; exteriors, 189, 190, *191*, 194, *196–98*, *200*, 201; family and, 189, 199; furnishings, 206, 207; heritage and, 151, 199, 204, 210–11; interiors, 190, *191–94*, *192*, *193*, *195*, 205–7, 209; plans, 189, *192*, 194, 201, *204*, 205; regional culture and, 150, 188–89, 194, 198–99, 201, 204–5, 210–11; rural, 188, 201, 207; social position and, 189, 193–94, 198–99, 201, 204–7; wealthy Quakers and, 96, 100, 101, 103–7, 120–21, 320n3; worldliness and, 207–8, 211. *See also* individual houses; museums, historic house
Hudson, Thomas, 132
Humphreys, Richard, 98
Hunt, John, 46
Hutchinson, Matthias, 344n57

Independence National Historical Park, 293
Inward Light: discipline and, 6–7, 127–28; Hicksites and, 30, 35; outward life, 4, 16, 17, 69–73, 127–28; silence and, 65–66; worldliness, 149
Inward Monitor: plainness and, 48, 50–53, 69–71, 88–89; dress and, 48, 248
Ives, Halsey, 284

Jackson, John, 48
James Cornell's Prize Bull (Hicks), 227–28, *228*
Jenings, Edmund, 138
Jenks, Phineas, 217, 349n8

Jervas, Charles, 129
Johnson, Howard Cooper, *244*
Johnson, John Graver, 283
Jones, Acquila, furniture of, 82
Jones, Rufus, 4, 37, 309nn47, 51
Journal of George Fox, 19

Kalm, Peter, 49, 249–50, 312n12
Kauffmann, Angelica, portraits by, 135, 146
Keith, George, 5
keywords, 67–69, 315n49
Kimber, Thomas, 11
Kirkbride-Palmer house, 204–5
Kneller, Godfrey: artistic style, 130, 144;
 portraits attributed to, plate 10, 128, 130
Koehler, Robert, 283
Kraak, Deborah, 126
Kurtz, Charles, 284–85

The Ladies Calling (Allestree), 129
Lady in Pink (Chase), 283
Lambert, Hannah. *See* Cadwalader, Hannah
 Lambert
LaRouche, Lyndon, 8
Lea, Sally Ann, 100
Lee-Whitman, Leanna, 126, 250, 307n27,
 308n43
Leedom Farm (Hicks), plate 19, 227–28, 232–33
Leedom, Jesse, 233
Leedom, Mary Twining, 232–33
Levering, Frank, 13
Lewis, Abraham III, 105
Lidbetter, Hubert, 170–71
Light of God. *See* Inward Light
Linenthal, Edward, 7
Little Present for Friends and Friendly People
 (Hicks), 230–31
Lloyd, Elizabeth. *See* Cadwalader, Elizabeth
 Lloyd
Lloyd, Thomas, 128
Locke, John, 20
Logan, Charles, furniture of, *55*, 78, 83, 88
Logan, Deborah (Mrs. George), 291
Logan, George, 291
Logan, James, 126, 129, 135–36, 290–91, 295
Logan, Mary Pleasants, furniture of, 78, 317n71
Logan, Sarah. *See* Fisher, Sarah Logan
Logan, William, 77–78, 83, 132, 291, 295
Lovell, Margaretta, 123, 135
Luff, Nathaniel, 43–44, 46–47

Mackenzie, Sandra (Lloyd), 96, 110
MacMonnies, Mary Fairchild, portraits by,
 plate 21, 280, 281
Malvern School, 270
Marietta, Jack D., 28–29, 58–59, 182
Marshall, Benjamin, 275
Marshall, Charles, 275
Marshall, Christopher, 110, 274, 275
Marshall, Elizabeth, 275
Marshall, Mary Ann, 275
Marshall, Sarah (seamstress), 262–66
Mason, Jane Edge, 269
material culture, 51–53, 69–71, 88–89, 287,
 297–98; collecting and preserving, 239, 241,
 243–44, 291–94; as indicator of character,
 109, 122, 126, 141–145; as indicator of social
 position, 123–24, 134–35, 139, 144–45;
 interpreting, 288–90, 296–99; Inward Light
 and, 127–28; of Quakers/non-Quakers, 126,
 129, 134–35, 136–37, 144–45. *See also*
 museums, historic house; wealth
Mather, Eleanor Price, 228
Matlack, T. Chalkley, 242
Media Friends School, 259
Meeting House and Counting House (Tolles), 1,
 51
meeting house design: architectural
 vocabulary of, 153, 156, 157; autonomy in,
 179; building practices, 157, 175–79, 185–86,
 344nn54–57, 344n60, 345n61; craftsmanship
 in, 151, 167; development of, 163, 184–86;
 domestic architecture, *168*; economics of,
 177–78, 344nn54, 55; indigenous materials,
 157, 165, *166*, 167, *170*, 178; interior elements,
 plate 14, 160–62, 167, 169–70, 340nn15, 18,
 341n28, 342n31; prototypical, 184–86;
 "Quaker Plain Style," plate 14, 150, 165, 167,
 168; regional variations, 157, 167, 169; scale in,
 171; simplicity and, 149, 165, 167, 171–75;
 spiritual reform impact on, 157–58, 186–87,
 343n53; standardization of, plate 15, 153, 157,
 158, 184; versus traditional religious
 architecture, 150, 153, 159, 167, 170, 339n9;
 theology and, 150, 157–59, 170–72, 342n32;
 vernacular building traditions, 151, 157, 167,
 169, 171, 175, 179; women's sections, 156, 161,
 162, 183, 339nn3, 12, 340nn17, 19, 341n23,
 346n84; worldliness and, 69–71, 72–73;
 worship and, 156, 158–61
meeting house plans: back-to-back

apartments, 161; conventional church, 159, 339n9; doubled, plate 14, plate 15, 158, 159, 171, *172*, 184–86, 339n3, 340nn17–19; English pattern, 158, 161, *162*, *172*, 185, 339n12; separate apartments, 161, 165; single celled, 163, 169, 170, *171*; square-plan, *163*; telescoping, *164*, 164–65, 185; T-shaped, *160*, 339n8
meeting houses: Abington Quarter, 169, 185; Arney's Mount, 169, 170, *170*, 171; Boarded, 160; Bradford, plate 14, *166*; Buckingham, plate 5, 158, 184–86, 341n28, 344n57, 345n61; Bucks Quarter, 185–86; Burlington, 159, 160; Center Square, 160–61, 341n20; Chichester, 161, *162*, 164; coastal New Jersey, 171; Concord Quarter, 169, 185–86; Fall Creek, *31*; First Bank, 161; Frankford, 185, 340n19, 344n54; Great (High Street), 160, 161, 185, 340n18, 344n54; Little Egg Harbor, 165; London Grove, 165; Lower Alloways Creek, *152*; Merion, 159, *160*, 169, 178, 339n9; Plymouth, 341n28; Queen Street, 186, 346n88; Radnor, 163–64, *164*, 169, 178, 340n19; Roaring Creek, *172*; rural, 163, 171, *172*; Sadsbury, 161, *163*, 340nn15, 17; Salem Quarter, 169; Second Bank, 161; southern New Jersey, 169, 171; Third Haven, 186, 339n8; Upper Providence, *168*. *See also* houses
meetings: autonomy and, 182; for discipline, 47, 72; minutes, 47, 62, 63, 69–70, 72, 173, 249; plainness and, 24; roles within, 71–73, 80–84; for Sufferings, 25, 183; weighty Friends and, 14, 25, 26, 61; the World and, 72–73
meetings, business: clearness committees, 8, 369; separate, plate 14, 156, 161, 339n3, 345n65, 346n80; women's, 161, 162, 183–84, 340nn17, 19, 341n23, 346n80. *See also* disciplinary actions
Melcher, Gari, 283
Mifflin, Sarah Morris, plate 13, 142–43
Mifflin, Thomas: portrait of, *133*, 134; with Sarah Morris, plate 13, 142–43
Miller house, 194, *197*
Miller, Sarah Havard, *262*, 271
ministers: dress of, 238, 258–59, *260*, 261; evangelical, 30, *31*, 33; Edward Hicks, 216, 217, 219–20; Elias Hicks, 5, 15, 93, 121, 371
modernism, 37–39
Monet, Claude, 281, 283
Moore, Dr. Samuel Preston, furniture of, 75, *76*, *77*, 78
Moore, Hannah Hill, furniture of, 75, *76*, *77*, 78

Morgan, John, 135, 146
Morris, Anthony, 274
Morris, Isaac Wistar, 291, 295
Morris, Lydia Thompson, 291–92
Morris, Sarah. *See* Wistar, Sarah Morris
Morris, Sarah. *See* Mifflin, Sarah Morris
Morris, Thomas, 275
mortification, 18–19, 23, 24
Mott, Lucretia, 34–35
Moulder, Joseph, furniture of, 82–83
Moulder, Sarah Carlisle: furniture of, 82–83, 86; disownment, 82
museums, historic house: accuracy of, 287–88, 290, 294–99; interpretive philosophies, 239, 296–97; public responses to, 287–88, 290, 295; Quakerism and, 239, 240–41, 288–90, 295, 297–99; simplification within, 239, 287–88, 290, 299. *See also* individual houses; material culture

National Park Service, 293
National Society of The Colonial Dames of America in the Commonwealth of Pennsylvania (NSCDA/PA), 291, 296
Nayler, James, 5, 18, 19
New Century Club, 275
New Century for Women, 275
New York Etching Club, 281
Newman, Daisy, 11
Nicholson, Abel and Mary, house of, 189–94, *190*–*93*, *195*, 198–201, 347nn4, 5
Nickalls, John, 19
Nixon, Richard M., 8
No Cross, No Crown (Penn), 21–22
Norris, Charles, 129, 146
Norris, Isaac I, 45, 128, 130, 131, 332n44
Norris, Isaac II, 129, 130, 131, 146
Norris, Joseph, 131
Norris, Mary Lloyd, portrait of, plate 10, 128–29;
Norris, Sarah Logan, 129, 146
November (Vonnoh), 283
NSCDA/PA. *See* National Society of The Colonial Dames of America in the Commonwealth of Pennsylvania
Nuttall, Thomas, 114, 117

Observation on the Principles and Methods of Infant Instruction (Alcott), 117
Old Broadbrim Weekly (dime novel), plate 1, 10

Orthodox/Hicksite schism. *See*
 Hicksite/Orthodox schism
Orthodox Friends, 30–34, *31*, 36, 37, 93, 229,
 373–74; dress of, 255–61, *259*, *260*, 266–67,
 308n43; ministers, 259, *260*, on painting, 229,
 233; at Westtown School, 255–61
Ortner, Sherry B., 67, 69
outward life: inward discipline, 2, 11; Inward
 Light and, 4, 69–73, 127–28; public/private,
 44–45, 120–21, 132

pacifism, 25–26, 28, 32, 36, 74, 145, 180
painting: discipline and, 222, 228–29; fine, 212,
 215, 217, 220–24, 229–34; ornamental, plate
 17, 150, 214–17, 220–24. *See also* individual
 artists and portraits
Palmer, A. Mitchell, 8
Palmer, Bertha Honoré, 280–81, 283–85
Palmer, Margaret, *244*
Palmer, Potter, 280–81, 285
Parke, James Pemberton, 94, 99, 110
Paschall, Beulah, 291
Paschall, Elizabeth Coates, 291, 295
Paschall, Hannah. *See* Hollingsworth, Hannah
 Paschall
peace testimony, 25–26, 28, 32, 36, 180
Peaceable Kingdom (Hicks), plate 18, 225–26,
 226, *227*, 230–31
Peaceable Kingdom of the Branch (Hicks), 225,
 225, 229
Peale Museum, 279
Peale, Charles Willson: patrons, 119, 138–39,
 140, *141*, 335n99; portraits by, plate 9, plate 11,
 plate 12, *125*, 130, 137–39, *140*, 141, 223, 335n99
Peale, Hannah Moore, 223
Peale, Rembrandt, *103*, 119–20
Pearson, Anthony, 19
Pemberton, Ann Galloway, portrait of, plate 6,
 134–35, 144–45
Pemberton, James, furniture of, 88
Pemberton, Joseph: art patronage, 122; portrait
 of, plate 8, 134–35, 144–45
Penn's Treaty (Hicks), 223, *224*, 231
Penn's Treaty with the Indians (West), 223
Penn, Hannah, 240
Penn, William: Meeting for Sufferings, 183,
 plainness, 21–23, 173; Puritans and, 18;
 represented at World's Fair, 240; social
 justice and, 7; social hierarchies and, 131;
 testimonies, 305n2; vanity, 21–23, 173

Pennell, Sara, 96, 105
Pennell, William and Mary, house of, 201, *203*,
 204, 205, 348n11
Pennock House, 208–10
Pennsylvania Academy of the Fine Arts, 99, 119,
 277, 283
Perot, Thomas Morris, *279*, 280–81
Perot, Thomas Morris, Jr., 281, 285
Perot, Thomas Morris III, 280, 364n36
Perrot, John, 19
Pestalozzi, Johann Heinrich, 117
Philadelphia Centennial Exposition (1876), 247
Philadelphia Museum of Art, 291
Pike, Joseph, 45, 173,183
Pissaro, Claude, 283
plainness: arts and 219–26, 229; class and, 23; in
 context, 13, 43, 51–53, 63–64, 87–89, 188–89,
 311n4; craftsmanship and, 44, 64, 100;
 discipline and, 63, 314n39; discourse of,
 65–67, 69, 74, 88–89; eighteenth century,
 25–29; evangelicalism and, 31–33, 36; family
 and, 25; furniture and, 51, 59–66, 87;
 Hicksites and, 31, 34–36; identity and, 23,
 25–26, 29, 48, 52–53; Inward Monitor and,
 48, 50–53, 69–71, 88–89; language and, 62–69;
 meetings and, 24; modernism and, 14, 37–39;
 modern Quakers and, 13–14; mortification,
 18–19, 23, 24; nineteenth century, 29–37;
 Orthodox Friends and, 31–32 36; of
 Quakers/non-Quakers, 43, 52–53, 126, 129,
 134–35, 136–37, 144–45; in schools and
 colleges, 34–37, 309n47; seventeenth century,
 18–23; simplicity and, 17, 37–40, 305n3; in
 speech, 65–69, 314n34, theology and, 23;
 utility and, 21–23, 38; 45; vanity and, 21–23;
 wealth and, 24; worldliness and, 311n2
plain speech 65, 314n34
Pleasants, Mary. *See* Logan, Mary Pleasants
Polk, Charles Peale, 349n7
Porter, Rufus, 215
Portrait de Mille S.H. (MacMonnies), plate 21,
 280
portraits: artistic styles, 129–130, 132–36, 141–42,
 144–45; attributed to Godfrey Kneller, plate
 10, 128, 130; dress in, 124, 128–29, 132–39,
 141–44; as indicator of character, 122, 123–24,
 126, 141–43, 145; as indicator of social
 position, 123–24, 134–35, 139, 144–45;
 mezzotints and, 124, 135; of Quakers/non-
 Quakers, 129, 134–37, 144–45; utility and, 45;

by women, plate 21, 135, 146, 280; of women, plate 7, plate 9, plate 10, plate 12, plate 13, 124, *125*, 128–29, 135–36, 138–39, 141–44, 329n14; at World's Columbian Exposition, 240. *See also* Claypoole, James; Copley, John Singleton; Kauffmann, Angelica; Hesselius, Gustavus; MacMonnies, Mary Fairchild; Peale, Charles Willson; Street, Robert; West, Benjamin; Williams, William; Zorn, Anders

Portraiture of Quakerism (Clarkson), 123

preservation movements, 239–40, 241, 243, 352n13

Preziosi, Donald, 315n41

Price, Walter, 242

Priestman, Mabel Tuke, 352n10

Progressive Friends, 12, 34, 308n41

Public Ledger (Philadelphia), 275

Pusey, Jesse, 267

Pusey, John, 48

Pusey, Joshua and Mary, house of, 206–8

Pusey, William and Elizabeth, house of, 205–8

Pyle, Howard, 270

Pym, Jim, 13

The Quakers: A Study in Costume (Gunmere), 37–39, 240, 246

Quakers and the Arts: "Plain and Fancy" (Sox), 14

Quakers: arts and, 222, 223–24, 362n22; class and, 14; in fiction, 9–11; identity and, 23, 25–26, 29, 48, 52–53, 124, 287; modern, 7–9, 11, 13–14; non-Quakers and, 43, 126, 129, 134–35, 136–37, 144–45; outward expression of heritage, 199, 204, 210–11, 243; rural, 242, 245; Shakers and, 289; social injustice, 7; in song, 11; theology, 2–3, 16–17, 287, 312n14; stereotypes of, plate 1, plate 2, 10–11, 48, 188–89, 239, 250–51, 271, 287–90; worldliness, 222. *See also* Friends

Quakers, rural: houses of, 188, 201, 207; meeting houses of, 163, 171, *172*

Quakers, wealthy: arts and, 119–20, 327n98; dress and, 33–35, 49, 109–10, 126, 128–29; education and, 116–19; fashion and, 49, 134; furnishings of, 73–74, 97–101, *98*, 116; houses and, 96, 100, 101, 103–7, 120–21, 149, 189, 193–94, 198–99, 201, 204–7, 320n3, 363n35; Inward Light and, 24; material consumption and, 44, 49, 73–74, 94, 97, 98–101, 109–10; portraits and, 123, 124,

128, 130–31, 137–38; simplicity and, 96, 100, 101, 120–21, 131, 144; slavery and, 359n9, social awareness, 102, 115–16; social hierarchy and, 5, 6, 13, 31, 131; theology and, 23, 27; women, 275, 277, 321n4, 322n14; worldliness and, 128. *See also* material culture

queries, 172, 173–75, 181–82, 342n37, 343n46. *See also* disciplinary actions; violations

quietism, 30–31, 36–37, 182–83, 187

quilts, 154, *155*

Ramsey, Allan, 132

Randolph, Benjamin (cabinetmaker), 139

Read, William T., 137–38

reform movement: discipline and, 180–84, 186; meeting houses and, 157–58, 186–87, 343n53

Renoir, Pierre-Auguste, 283

Residence of David Twining (Hicks), plate 16, 232–33

Revolutionary War: discipline and, 13, 28, 145, 313n23, 314nn33–35; Edward Hicks and, 214, 231–32; support for, 274

Reynold, James, furniture by, plate 4, 85

Reynolds, Richard, 46

Richards, Phebe Thompson, 267

Richardson, Elliot, *244*

Richardson, Jonathan, 129–30, 132, 141–42

Rigge, Ambrose, 2

Roberts, John, 178

rococo. *See* furniture, Chippendale

The Rudiments of Genteel Behavior (Nivelon), 134

Rules of Discipline: acknowledgment, 47, 58–59, 61; arts and, 123, 222, 228–29; *A Collection of Christian and Brotherly Advices*, 17, 62–65, 314n39; disownment, 28–29, 35, 38, 46–47; dress and, 246, 248–49; enforcement, 143–44; *Faith and Practice*, 1, 4, 38; formation of, 63, 314n36; on furniture, 63–65, 88; Orthodox/Hicksite schism, 30–31, 35–36, 150, 229–31, 243, 255–56, 266–67; Inward Light and, 127; on marriage, 25–26, 53, 58–62, 183–84; meeting minutes and, 63, 173; meetings for discipline, 47, 72; plainness and, 63, 127, 314n39; queries, 172, 173–75, 181–82, 342n37, 343n46; reform movement and, 180–84, 186; slavery and, 81; testimonies; 173–75; women's meeting and, 183–84; worldliness and, 69, 72–73. *See also* disciplinary actions; Inward Monitor; violations

Russell, William, 117–18
Ryle, Gilbert, 51

Sanitary Fairs, 277
Savage, Scott, 13
Savery, William: compared to Affleck, 317n74; high chest by, 78, *79*, 83, 86, 317n74
Scattergood, Joseph, 253, 255
Scattergood, Mary, 253, 255
Scattergood, Rachel, 253, 255, 271, 355n23
schools and colleges: dress in, 255–61, *259*, *260*; Female Association Schools, 116; plainness and, 34–36, 36–37, 309n47; restrictions in, 3–4, 36–37, 309n47. *See also* education; Bryn Mawr College; Germantown Academy; Haverford College; Malvern School; Media Friends School; Swarthmore College; Westtown School
Scoffield, Joseph, *31*
The Sermon (Melcher), 283
Shakers, 92, 289
Sharp, Isaac and Margaret, house of, 207, *208*
Sharpless, Ann, 258–59, 261
Sharpless, Benjamin, 53
Sharpless, Isaac, 241
Sharpless, Susanna Forsythe, 258, *259*, 271
Sharpless, Townsend, 262
Shepherd, Raymond, 126
Sherburne, Mary. *See* Bowers, Mary Sherburne
Shippen, Edward, 128
Shippen, William, 144
Shoemaker, Alvan, *31*
silence: Inward Light and, 65–66; speech and, 65–66; in worship, 4, 65–66, 71–72, 127
silhouettes, 11, *12*, 279, 262, *265*, 327n98
simplicity, 31–33, 38–40, 94, 99, 138, 165–167, 171–73, 267–70, 309n51. *See also* plainness
singularity, 43–44
Sisley, Alfred, 283
Sketch of the Wistar Party, 114
slavery, 7, 10–11, 30, 44, 81, 116, 318n76
Smith, Billy G., 14
Smith, Hannah Logan, 136
Smith, John, 132
Smyth, Anna Canby, 268
Sober, Eliot, 67
sobriety, 18–23
social justice: civil rights, 274, 275; evangelical Friends and, 30; Meetings for Suffering, 24;

simplicity and, 32; social justice, 5, 8–9, through fiction, 9–11, 13–14; simplicity and, 171; wealthy Quakers and, 102, 115–16
social position: collecting/preserving and, 241, 289–90, 290–91, 295, 296, 298–99; hierarchies and 72, 187, 131; homes and, 150, 189, 193–94, 198–99, 201, 204–7, 297–98; material culture and, 123–24, 130–31, 134–35, 139, 144–45; preservation movement and, 243. *See also* Quakers, wealthy
Society of American Artists, 281
Sox, David, 14
speech, 65–69, 309n51
Spurr, John, 20
St. George, Robert, 123–24
St. Louis Art Museum, 284
Staiti, Paul, 123–24
Stenton, 130, 288, 290–91, *292*, 295–96, 298, 331n41
Stevens, Stephen Foster, 12
Stowe, Harriet Beecher, 11
Street, Robert, portrait by, *278*
Strickland, William, 44, 90, 99, 119, 105–6
The Strike (Koehler), 283
Sturge, Joseph, 32
Sully, Thomas, portraits by, *279*, 363n30
Super, Jacob, 92, 98
superfluity, 19, 21–23, 109–10, 353n3
Swarthmore College, 34–35, 240, 309n45

Teisen, Rynear. *See* Tyson, Rynear
testimonies, 17, 23, 58, 173–75, 222, 234, 247
textiles, 109–10, 154
Thee, Hannah! (De Angeli), 10
Thelen, David, 1, 7, 14–15
theology: education and, 255–56; individualism, 145–46; Inward Light, 30, 127; meeting house design and, 157–59, 170–72, 342n32; mortification, 18–19, 23, 24; Orthodox/Hicksite schism, 35–36, 150, 187, 229–31, 233, 243; plainness and, 23, 124, 126–27; wealth and, 5, 18, 23, 27, 127–28, 137, 144. *See also* discourse; *Rules of Discipline*
Thomas, Allen Clapp, 4
Thurpen, Lucy, 116
Todd house (London Grove), 209, *209*
Todd House (Philadelphia), 288, 292–94, *294*, 296–98
Todd, Dolley Payne, 292–93

Todd, John, 294, 295
Todd, John, Jr., 292–93, 295
Tolles, Frederick. B., 1, 13, 51, 126, 186, 289, 290, 311n4, 328n4
Tolman, Stacy, 283
Tomlinson, William and Rachel, 214–16
Trusted, Hannah Builder, *263*, 266
Truth, 43–44, 48, 65–68, 88–89, 342n35
Twining, Beulah, 214
Twining, David and Elizabeth, plate 16, 214
Twining, Elizabeth, 214, 349n5
Tyson, Anthony Morris, 286
Tyson, Elisha, 274, 275, *278*, 359n9, 363n29
Tyson, Elisha, Jr., 278, 363n29
Tyson, Martha Ellicott, 360n12, 361n17
Tyson, Rynear (Ryner, Reiner, Reynier), 274

Ullman, Roland, *244*
Uncle Tom's Cabin (Stowe), 11
utility, 18–23, 249, 256–58

Vanderlyn, James, 120
vanity, 1–2, 12, 23, 27, 120, 122
Vaux, Roberts, 110, 117
Verplanck, Anne A., 249, 367n12
violations: for dress, 26–27; for furniture, 62, 87–89; for marriage, 25, 26, 35, 53, 58–62, 77, 314n35, 318n76; moral codes, 26–28; for peace testimony, 26; worldliness and, 27–28
Vokins, Joan, 1
Vonnoh, Robert, 283

Walker, Deborah Dickinson, wedding dress of, 262, *263*
Walker, Isaac, 262
Wallis, Samuel: acknowledgment by, 61; furniture of, plate 3, 82, 85, 86; marriage violations, 60–62, 70
Walton, Bernard, *244*
Walton, James, 216, 220
Walton, Margaretta, 31
Watson, John Fanning, 291
Way, John, 267
Way, Sydney Jeffers, dress of, *251*, 267
Wayne, Jacob, 92, 97
Wayne, William, furniture by, plate 3, 60, 82
wealth, as God's favor, 5, 18, 127–28, 137, 144; historic house museums and, 287, 288, 295, 298–99. *See also* material culture; Quakers, wealthy

West Chester Meeting, 261, *261*, 271
West, Benjamin, portraits by, 132–34, *133*, 223
West, Jessamyn, 11
Westtown School, 95, 247, 255–61, 270, 309n47, 322n14
Wetherell, Samuel, 53
Wharton, Joseph, furniture of, 78, *79*, *80*, 81, 83–84, 86, 88
Wilburite Friends, 34, 36, 238, 243, 305n2, 376
Wilkinson, Signe, 9
Williams, William, portraits by, 132, 146
Wilson, Nicholas, 110
Wilson, Ruth C. and Isaac, 31, *31*
Winslow, Mr. and Mrs. Isaac, 143
Winterthur Museum, 247–48
Wistar Institute, 114–15
Wistar, Caspar, 114, 320n3, 321n6, 326n75
Wistar, Isaac, 114
Wistar, Margaret, 91
Wistar, Sarah Morris, 291
Wollaston, John, 132
women: artists, plate 21, 135, 146, 280, 282–83, 365n54; Bryn Mawr College, 36; education of, 36, 116, 321n4, 322n14; Female Anti-Slavery Society, 116, Female Association Schools, 116; meetings for, 72; 183–84; paintings by, 135, 146; portraits of, plate 7, plate 9, plate 10, plate 12, plate 13, 124, *125*, 128–29, 135–36, 138–39, 141–44; as professionals, 238, 272, 274, 275, 362n22; property inheritance and, 90–91; seamstresses, 264–66; social justice and, 277. *See also* dress, women's; individual names
Wood, Mary, 257
Woodward house, 208–9
Woolman, John, 5, 7–8, 28, 44, 46, 47
The Workwoman's Guide (Hale), 250–51, 264–66
World's Columbian Exposition (1893), 240, 272, 281, 283, 284–85, 362nn25, 26
worldliness: discipline and, 69, 72–73; in discourse of Quakerism, 68–69; in dress, 308n33; furniture ownership and, 51–53, 61–65, 88–89; homes and, 189, 198, 201, 204, 207–8, 211; Inward Light and, 149; meeting house and, 69–71; plainness and, 311n2; theology and, 70–71; violations and, 27–28
worship, 4, 65–66, 71–72, 127
Worstall, Sarah. *See* Hicks, Sarah Worstall

Wright house, 194, *196*

Wycherley, William, 20

Wyck, 90, 91, 320nn1, 3, 327n105; architectural structure, plate 5, 104–6; art collection, 119–20, 327nn98, 99; furnishings, *95, 98,* 103–4, *106,* 322n14; gardens, plate 6, 90, 91, 104, 107–8; museum room, *112,* 112–13, 322n14; public/private, 44–45; remodeling of, 44–45, 90, 91, 99, 104–6, 119; simplicity and, 103–7, 120–21

Yeatman, Hannah, 267

Zorn, Anders, portraits by, *273, 276*